STILL LIFE PAINTING

STILL LIFE PAINTING

FROM ANTIQUITY TO THE TWENTIETH CENTURY

Second Revised Edition

Charles Sterling

ICON EDITIONS

HARPER & ROW, PUBLISHERS, New York

Cambridge, Hagerstown, Philadelphia, San Francisco,

London, Mexico City, São Paulo, Sydney

This work was first published in France under the title *La Nature morte de l'Antiquite a nos jours* in 1952 by Editions Pierre Tisne. A revised edition was published in France in 1959 under the same title and the first English edition under the title *Still Life Painting from Antiquity to the Present Time* (translation by James Emmons) by Editions Pierre Tisne.

STILL LIFE PAINTING: FROM ANTIQUITY TO THE TWENTIETH CENTURY (*Second Revised Edition*). Copyright © 1981 by Charles Sterling. All rights reserved. Printed in the United States of America. No part of this book may be used or reproduced in any manner whatsoever without written permission except in the case of brief quotations embodied in critical articles and reviews. For information address Harper & Row, Publishers, Inc., 10 East 53rd Street, New York, N.Y. 10022. Published simultaneously in Canada by Fitzhenry & Whiteside Limited, Toronto.

ISBN: 0-06-438530-2 81 82 83 10 9 8 7 6 5 4 3 2 1
ISBN: 0-06-430096-X pbk 81 82 83 10 9 8 7 6 5 4 3 2 1

To Halina

TABLE OF CONTENTS

STILL LIFE PAINTING

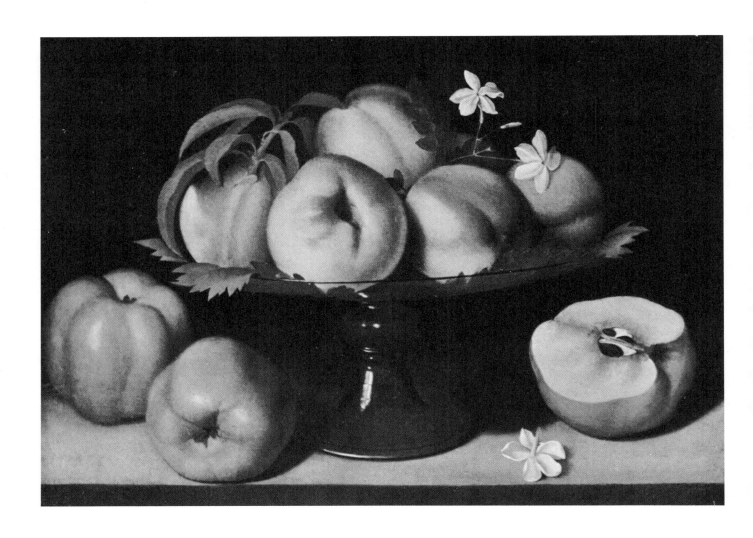

FEDE GALIZIA (1578? - ca. 1630).
Apples and Peaches in a Cup. Wood, 11 3/4 × 16 1/8.
Formerly Vitale Bloch Collection, The Hague.

FOREWORD

THIS book has grown out of the exhibition of " Still Life from Antiquity to the Present Day " which has just been held at the Musée de l'Orangerie in Paris. There it was intended to show a representative selection of easel paintings in which still life was treated as an independent subject and not as part of a composition. Such is also the object of the following pages. The exhibition was designed to illustrate two leading ideas, one artistic, the other historical. The first took account of the extraordinary importance assumed by still life in recent painting, from Cézanne to Matisse and Picasso; it was therefore of the greatest interest to give the artists of our time an opportunity of confronting their conception of this subject with all those that have followed one another in the course of two thousand years. The second lay in the conviction that the origins of modern still life painting have by no means been clarified by art historians. It is usually assumed to have originated in the countries north of the Alps at the end of the 16th century. It can, however, be traced back to the Middle Ages, to the first half of the 14th century, and momentous innovations can be discerned in Quattrocento Italy, where the humanist spirit, by reviving certain ideas of antiquity, rendered possible the emancipation of still life at the same time as that of landscape and other subjects destined to develop into independent branches of painting.

The evolution of still life in the past two thousand years is a long story; it embraces the history of all Western painting as reflected in one particular branch of it. The space available in this book would have been insufficient to go into the subject with an equal amount of detail throughout. From the 17th century to the present day we can follow step by step the developments of still life and of the different schools in which the artists who excelled in it are now well known to us.

I shall therefore sum up this long, rich period in a more synthetic manner, confining myself to the essential aspects of its evolution. I shall analyze the early period at greater length, fascinating as it is owing to the obscurity in which it is still shrouded, and which solicits new ideas and new investigations. No book, in any case, could hope to comment on everything remarkable in the field of still life painting without becoming otiose. It will be worth while, however, to trace and elucidate, in a volume of convenient size, the changing conceptions of this subject, in various periods and countries, depending on the different resources of art and different ideas of the world and nature. Books dealing with the whole history of Western still life painting are, as a matter of fact, very few in number, no more than two or three, and these are thirty years old.

This book reflects the exhibition at the Orangerie, but improves on it, completes it, brings it nearer to what it might have been, if the usual obstacles to ephemeral showings of this kind could have been overcome: the state of preservation of certain works preventing them from being moved, refusal or statutory prohibition to lend pictures, limited space available in the exhibition rooms. For those interested in the details of scientific data and discussion, the Catalogue of the exhibition, particularly in its second edition, will prove to be a useful complement to the ensuing text. But they will find that in many places it has been corrected by these pages, which have benefited by the criticisms of art historians who came to the Orangerie, and by the latest discoveries made since the exhibition was held.

The plates, in monochrome and color, provide a significant but by no means exhaustive sequence of examples showing the different conceptions of still life through the ages. The figures accompanying the text are intended to illustrate and justify, in the only really effective language of the modern historian—that of juxtaposed pictures—, some new views on the origins of the modern still life.

What they attempt to suggest is thrown into vivid relief by an admirable observation of Paul Valéry: " Truth and life are disorder; filiations and relationships that are not surprising are not real."

October 1952.

10

PREFACE
to the First English Edition

URING the seven years that separate this first English edition (the first to appear in English) from the preceding one, the interest taken in still life painting has greatly increased. A dozen exhibitions held in Europe and America (to mention only the more comprehensive showings of pictures), two or three general surveys and many articles have been devoted to the subject. These recent investigations have added materially to our knowledge of artists hitherto relegated to undeserved obscurity. But on the whole they enter only exceptionally into this study, which is, I repeat, not a repertory of all the artists who have left us fine still lifes ([1]), but *an account of the evolution of the different conceptions of this great pictorial theme*. One chapter, however, which called for serious modifications in view of recent discoveries, was that dealing with 17th-century Italy. Here, within the space of a few years, Italian art criticism has succeeded in filling a large gap in the history of painting.

One of the theses put forward in the Catalogue of the Orangerie exhibition (1952), and developed at length in this book, is that the painting of independent still life pictures originated, in the 14th, 15th and 16th centuries, not in the Low Countries, as is usually supposed, but in Italy, and was directly connected with the revival of the ideas of antiquity. This view has found its advocates and its opponents. Among the first I shall only mention Charles de Tolnay, one of the foremost authorities on the art of these centuries, both North and South of the Alps; he has subscribed to this view the more easily as he himself has provided a fundamental argument in favor of it ([2]). Among the others, I shall only cite Ingvar Bergström, the excellent specialist in Dutch still life painting, who, in studying its origins, was the first to draw attention to Italian marquetry. In 1952, in the first edition of this book, I repeatedly emphasized the credit due to him, at a time when his

fine book of 1947 was as yet only available in Swedish and had thus remained relatively little known. In the recent English edition of this work (1956) Bergström devoted three-quarters of a page in reply to the three chapters of my book. He upheld the traditional thesis (with only slight modifications), maintaining that the Netherlandish still life preceded that of the Italians " in many instances " (³); and at the same time he presented a thesis of his own, to the effect that still life painting in the Low Countries developed in isolation, by virtue of a historical " rule " (⁴) which Bergström regards as sufficient and calling for no explanation: " certain artists were attempting to separate the customary symbols from the religious scene and to give them an independent existence as a symbolical still life." Thus, for example, the representation of *St. Jerome in his Study*, in which the *Vanitas* symbols, a skull and an hourglass, often figured, would one day have given birth to a picture representing these objects alone, a genuine, independent *Vanitas*. It is an undeniable fact that the repertory of symbolic objects is the same in both pictures, and that the day a Netherlandish artist had the *idea* of separating these objects and using them as an independent plastic theme, he had only to draw on the resources offered him by the representations of St. Jerome. This is a fact, and I have never dreamed of questioning it. But how did the Netherlandish artist arrive at this *bold idea?* How did he find a public capable of appreciating this signal novelty and willing to pay for the pleasure of looking now, not at the picture of a saint in a well-appointed interior or in front of a smiling landscape, but at a towel hanging over a basin or a vase with flowers? Of this fundamental problem Bergström only suggests a purely iconographic explanation: the taste for " hidden symbolism," intensified in Flemish art after Van Eyck, would have sufficed for the artist to invent and for the public to appreciate the first still lifes, composed, as it so happened, of ordinary objects with a symbolic religious significance attaching to them. But the first independent still lifes made up of objects with a symbolic religious significance are to be found not in the Low Countries but in Italy, over a century earlier : these are the *Niches* painted in fresco in 1337-1338 by Taddeo Gaddi at Santa Croce in Florence. When Tolnay pointed out these works, it was still possible to regard them as exceptional tokens of an approach to art soon to be consigned to oblivion. But the *Niche* published in the present edition of this book, painted in fresco about 1490 at Kutná Hora in Bohemia, no doubt by a Florentine artist named " Roman," proves that the tradition persisted and that it crossed the Alps; it may henceforth be assumed that, from the 14th century on, in Italy and elsewhere, these incunabula of still life painting were often to be found in frescos, countless numbers of which have suffered destruction. It is thus an established fact that Italy preceded the Low Countries with regard to the *idea itself* of separating symbolic objects in order to embody them in independent plastic compositions; and to explain this *plastic decision*, as I propose to do, by tracing it back to the inspiration coming from Roman frescos and mosaics, and from descriptions of pictures of antiquity, familiar to the humanists, seems by no means arbitrary.

Now Italian still lifes executed in fresco and marquetry were large-scale works, on view in famous public buildings, both churches and palaces (very different

12

in this respect from the first Netherlandish still lifes, which served to decorate manuscripts kept in the shadows of libraries, or small diptychs intended for the intimacy of oratories). This being so, who would venture to assert that the idea of grouping symbolic objects as independent still lifes, already a century old, remained unknown to Flemish artists, to a Roger van der Weyden or a Memling ? It is characteristic that for the 16th century Bergström should be obliged to lay stress—after myself ([5])—on the importance of mannerist ideas in Aertsen's and Beuckelaer's work; but surely Mannerism and its continual references to the examples of antiquity, to Piraikos, have their origin in humanist Italy. The great historical problem is that of determining at what period humanist suggestions began filtering into the studios north of the Alps; there are no serious objections to situating that period in the mid-15th century. And it is important here not to isolate the problem of the origins of still life from that of the origins of all the other independent branches of painting (landscape, townscape, genre scene, animal picture), for the whole movement towards " specialization " in painting came as a result of humanism, of the revival of the traditions of ancient painting. *The historical role of the Netherlanders has often been to render the inventions and ideas of the Italians in a more directly, more sensually realistic manner.* Herein lies the whole meaning of the evolution of Franco-Flemish and Flemish painting and book illumination in the 14th century. In the 15th, while the still lifes in the religious scenes of the Master of Flemalle and the Van Eycks were far more palpable than those of Uccello, while they impressed the next generation of Italian painters, while their esthetic was revived at the end of the 16th century in the pictures of a *Meal on a Table* by Beert, Flegel and other Northern artists, the fact remains that they never played so important a part in the evolution of the independent still life in the whole of Europe as the Italian still lifes figuring in frescos, marquetry and grotesques. We need not linger over the old conventions of art criticism, which called for rigid divisions between the historical roles played by the " major " and the " minor " arts, between decoration and easel painting, between the great universal painter and the modest specialist. Artists look eagerly around them and take what they need wherever they find it. Artistic *ideas* travel more quickly than the works themselves. And it is the movement of these ideas in Europe in the 15th and 16th centuries, in the studios where the first still lifes were being painted, that forms the true subject of this controversy.

September 1959

13

PREFACE
to the Second Revised Edition

DURING the last twenty years, since the First English edition of this work (1959), there has appeared no other synthesis of the history of Occidental still life painting from Antiquity to the middle of the 20th century, at least in the form of a book. I have been repeatedly encouraged by students and publishers (mostly Italian) to renew my edition of this book, long out of print. Being well aware, however, of the great enrichment resulting from the research stimulated by the Louvre exhibition and the first edition of this book in 1952, I wished to augment my text and, above all, its illustrations. I had to abandon this ambition, however, as I was entirely absorbed with the study of the 15th-century European painting in the following twenty years.

What then are the reasons for publishing a second edition, almost unchanged, in the form of a photomechanical reprint, allowing very few corrections or changes in the text and with no color illustrations? The first of these reasons is that the main lines of this synthesis do not seem to require important changes, in spite of the fact that the discoveries of good painters of still life and the new chronological precisions concerning painters already known are, so to speak, innumerable. The second reason is the perspective, so attractive to every writer, of reaching, through a paperback edition, a larger public— artists and students first of all. The more so as, thanks to the comprehension of my publisher, Mr. Cass Canfield, Jr., I am able to freshen up this edition. I have introduced some pressing corrections in the text; added the more important bibliography for the period 1959–1979; enriched the illustration with several reproductions, some of them previously unpublished (pl.48, 63 *bis*, 66 *bis*), and others replacing old plates by better examples (pl.64); provided reproductions for painters mentioned in the book but not previously illustrated (pl.57 *bis*, and pl.122 *bis*) and other reproductions still (pl.60 and 65 *bis*) which reveal signed works by remarkable artists whose names do not appear in

any book on still life. Thus, even the specialized scholar would find some interest in this edition. Finally, in this preface, I shall briefly allude to some of the results of recent research which seem to me of particular interest and which correct the imperfections of my book or fill in its principal gaps.

The preparation of the *Additional Bibliography* was considerably facilitated by the recent multiplication of books and catalogues dealing with the subject. Still life has indeed become one of the favorite themes of contemporary art history. This infatuation brings about a certain gigantism. Already in 1964, the fundamental exhibition of *La Natura Morta Italiana* presented 371 pictures and *Natura in Posa,* published by Rizzoli in 1977, is a superb volume (for all titles abbreviated in this preface, see the *Additional Bibliography*). Its price is as impressive as its size and weight. It is one of those volumes the arrival of which upsets a private library; it almost requires looking for a new apartment! A collective work, very well and abundantly illustrated, and entrusted to outstanding specialists, it is the 'dernier mot' on 17th-century still life in Europe. It is to be feared that it may remain the last for a long time because it often occurs that the appearance of such a monumental *summa* discourages a whole generation of scholars. But it also stimulates and facilitates exhibitions. For example, the catalogue of the Bordeaux exhibition *De Brueghel à Soutine* (1978) contains a bibliography exhaustive enough to make further research in the matter seem useless. In general, it appears more purposeful to draw the attention of the student to publications which seem to me to be particularly fruitful. The same is true of the bibliographies of some painters of still life (Chardin, Boselli, etc.) which are exemplary.

In the field of what is usually called the "prehistory" of still life painting (before c.1600), the results of research in the last twenty years are not spectacular. I was hoping that new works of art would be brought under discussion. Only one such work has appeared and it seems to corroborate my interpretation of the historical evolution as a constant interchange between the North and Italy, where humanistic culture and, perhaps, even some antique paintings still to be seen among the ruins, encouraged the very idea of making a still life into a self-sufficient painting. In his outstanding and not entirely unfavorable critical review of my book, Ernst Gombrich draws attention to a *trompe l'oeil* mural by Pintoricchio (1501), the artist's self-portrait surmounted by a charming still life on a shelf (*The Burlington Magazine,* May 1961, figs. 32 and 33). Whereas the humanistic climate of this decorative *trompe l'oeil* is as obvious as it is in the *tarsie,* the religious symbolism, the analogy with contemporary Italian book illumination preceded by Fouquet and his school (see p. 50) and the minute execution of objects testify to a Northern spirit. In his *Bodegones y Floreros,* Ingvar Bergström insists on a *Vase of Flowers in a Niche* painted by Juan de Borgoña in the cathedral of Toledo (1509–1511). The niche is part of a mural decoration representing a garden with tall trees against a sky full of birds. The historian did not forget that Post had already pointed out (1947) that this decorative *trompe l'oeil* closely followed the Italian tradition (Domenico Ghirlandaio) while betraying a Northern attitude in the detailed rendering of flowers and leaves. Flemish influence on Ghirlandaio is well known. But I have good reasons to believe that Jean de Bourgogne (Juan de Borgoña), before his unquestionable Italian sojourn, received his first schooling in Avignon. And in the Pope's palace there were the famous gardens and *trompe l'oeil* still lives (bird cages, plants and vessels on shelves), not to mention the numerous palaces of

16

the cardinals in Villeneuve-les-Avignon and elsewhere in the neighbourhood, with their frescoes sill visible in the 15th century. Thus Juan de Borgoña was well prepared to assimilate the old Italian decorative traditions. On the other hand, this tradition of gardens seen behind a wall is strikingly similar to what we see in Pompei (I have compared some of them to the decorations of Palazzo Davanzatti (in *L'Art et l'Homme*, II, 1958, p. 354) and above all in the Villa of Livia, Prima Porta, Rome (fig. 130, in color in R. B. Bandinelli, *Rome le centre du pouvoir,* Univers des Formes, 1969).

But the early works, whether Northern or Italian, reproduced in all the books are practically still the same as those shown by Bergström (1947) and in this book (1952 and 1959) as well as in the present edition.

It is in the investigation of the hidden meaning of still lives that research has progressed in a spectacular way. In this field, Bergström and A. P. de Mirimonde, to mention only these two masters of a solid, convincing and never arbitrary interpretation, have enriched our knowledge. The reader of this book cannot neglect the intellectual refinements of the long chain of still lives prior to the 18th century. He will, however, notice that the religious and philosophic problems in these still lives produced by Western Christian and humanistic civilization are fundamentally but two. However ingeniously "disguised," they suggest the vanity of all life and the idea that the only hope to vanquish death is in faith.

I must now rapidly point out the most important results of the search which, since 1952, has engaged an army of scholars of all nationalities. First of all, I shall mention new precisions which correct some details of my text concerning Italian, Netherlandish and German, Spanish and French still lives. The 17th century, the Golden Age, is of course the best-explored period. The 18th century, especially in France, is now very well known. But the last two centuries—19th and the 20th—are still relatively neglected.

Concerning Italy, no new and fully authenticated, independent still life by Caravaggio has been found. But several beautiful pictures have been assembled around the Hartford one (pl.55) by Federico Zeri (*Diari di Lavoro* 2, 1976, pp. 92–103, figs. 92, 93, 96, 97, 98), and this outstanding critic proposes, on good documentary and stylistic grounds, to recognize in them the works executed by the young Caravaggio in the workshop of Cavaliere d'Arpino before 1607. This identification is to be considered very seriously, and its historical implications are far reaching. When we take into account that these works could have been painted shortly after 1593, their importance, not only for Italy but also for Spain, appears decisive. It is indeed in these pictures, and perhaps in two others (figs. 100 and 101 of Zeri's essay), that we might find the long-expected antecedents of Cotán's and Blas de Ledesma's still lives. Here might be the source of the two features which were going to become so characteristically "Spanish": the powerful chiaroscuro and a composition not only regular but often strictly symmetrical, not to mention the earlier appearance of particular motives (such as hanging fowl, giant cardoons, etc.) so familiar to Cotán, Blas and Alessandro de Loarte.

All other Italian problems, however interesting, seem somewhat secondary. A more precise filiation of Caravaggesque heritage has been successfully disentangled, not only in the three major centers directly marked by the master—Lombardy, Rome and Naples—but even in Emilia and Tuscany. In the first of them, the stature of Fede Galizia

rises with the increasing number of her discovered works, and our present knowledge of the production of Evaristo Baschenis and his school is now practically complete thanks to the research of Marco Rosci. In Rome, Pietro Paolo Bonzi (pl.59) appears more significant, and the confusion between Tommaso Salini, born in that city, and Simone del Tintore, who came from Lucca (their initials being the same), has been cleared up by Mina Grigori and Federico Zeri. Consequently, the picture in pl.53, my attribution of which to Tommaso Salini had been at first rather generally accepted, is to be recognized as an early work by Simone. Similarly, in Naples, after the several members of the Recco dynasty had been more clearly differentiated, the striking painting in pl.58 is undoubtedly signed by Giovanni Battista Recco and not by Giovanni Battista Ruoppolo. The brilliant Giuseppe Recco is now represented in this edition by pl.57 bis, a picture signed and dated 1676 where Caravaggesque influence, experienced both in Lombardy and Naples, seem to merge. He was famous as a painter of fish, endowing them with enchanting and bold hues; but in a colorless illustration, it seems preferable to show one of his still lives composed of objects, where he constantly varied his motives and their arrangement.

Among the many achievements of the Exhibition *La Natura Morta Italiana* (1964), was the welcome reconstruction of the work of Michelangelo da Campidoglio, the nickname of Michele Pace (1610–1670), who now emerges as one of the most enjoyable painters of fruit and flowers in Rome, in the middle of his century. In Florence, Bartolommeo Bimbi was his rival, spreading heaps of pears, figs or cherries; in one of his pictures (fig. 80*a* of the catalogue), he hangs up a branch laden with fruit on a stone wall, a rare motive, strikingly similar to the one painted by Pierre Dupuis (pl.48), who travelled in Italy as early as 1630–40.

In the North of Europe, the Flemish and Dutch Schools are very well explored; no sensational discovery modifies the general lines of their evolution. The travels of these artists in Italy and the commercial success of their works in Spain have been stressed. Conversely, to explain the mysterious affinity of the Dutchman Adriaen Coorte (pl.36) with the Spaniards, it has been reasonably suggested that he could have known their still lives in the neighbouring Flanders. But in general, it is the vast influence on a European scale—in Italy, France, Spain, and Germany—of Flemings (Jan Brueghel, Osias Beert, Frans Snyders, Daniel Seghers) and Dutchmen (Matthias Withoos and Otto Marseus van Schrieck) that becomes more and more apparent. The German still-life painters gradually acquire an original common visage, distinct from that of their Netherlandish teachers: Gotthardt de Wedig (pl.26), Georg Flegel (pl.18) and Ludger tom Ring the Elder (pl.13) are now much better known. It is probably to the latter that we must now attribute the charming *Ducks* (fig.19). It is clear that the Alsatian Sébastien Stoskopff, although he learned a great deal in France, remained essentially Germanic; this is what I meant when I called him "the Faustian wizard" (pl.43).

It is, however, the study of Spanish still life which has made the most conspicuous progress, an enrichment second only to that in the field of French painting to be discussed next. The Pelican volume by Martin Soria (published in 1959, too late to be used by me), the relatively short but excellent synthesis by Bergström (1970) and a more recent one by Gaya Nuno (in *Natura in Posa*), the accounts of the school of Toledo by Angulo Iniguez and A.E. Pérez-Sanchez (1972, to be continued) and of the early period of the

school of Madrid, by the latter author, are the principal studies of large scope. A quite remarkable contribution has been made since 1976 by Eric Young. The work by Blas de Ledesma, a painter not to be confused with the earlier Blas de Prado (an urgent correction I was able to introduce in the present edition) found its most meritorious historian in Ramon Torres Martin who succeeded in cataloguing sixty of his "bodegones" (1976). We have now gained more clarity with respect to the work of Juan van der Hamen which was first seriously studied by William Jordan (1964) and, more recently, well analyzed by Joan-Ramon Triado (1973, published in 1977). Thanks to Eric Young, we know that Pedro de Camprobin painted quite personal works as early as 1623; that Francisco Burgos y Mantilla, although a pupil of Velasquez, made (in 1631) a small, minutely refined, delightful still life. The late work of Francisco Palacios, whose two pictures were convincingly dated by Young in the late 1660's, seems to be influenced by Giuseppe Recco, who, apparently, visited Spain in 1667.

The art of the long elusive El Labrador, a nickname of Juan Fernandez, is now less mysterious thanks to Enrique Valdivieso (1972) and Enriquetta Harris (1974). A *Flower Pot,* a wooden *tondo,* has been found, bearing on its back an old reliable inscription: *El Labrador, Juan Fernandez, 1636.* It confirms the early attribution to this painter of the still life in Hampton Court and the analysis of its style as post-Caravagesque (French edition of this book, 1952, p. 63), thus contradicting the traditional dating of Labrador's career in the 16th century. The newly discovered *Flowers* is a splendid example of a large, monumental treatment of light and form in this subject; this stylistic approach would explain the favour Labrador found in the eyes of such a conservative classical judge as Félibien. But the composition of the exceptionally small *tondo* (41 cm. in diameter) is almost certainly not the original one. Although I have stressed the *horror vacui* in the Hampton Court painting, the complete absence of a surrounding background in the *Flowers* is highly questionable. Even more so is the entirely incomprehensible surface (a table?) on which the pot is placed; no other example of such an absence of foreground is known. It seems obvious to me that, because of some accident, the panel had to be cut (skillfully cut, trying to follow the circular arrangement of flowers, but many instances of such intelligent mutilations are known). The lower part of the panel which, most probably, bore the original signature, carefully repeated on the back, has disappeared (best reproduction, in color, in the Münster exhibition Catalogue, p. 335).

Last but not least, Eric Young published a radiograph of pl.66 showing that the original composition of this masterpiece of 1633 most probably consisted of no more than two unequal elements, that its striking symmetry was an after-thought. And he convincingly attributed to the master a beautiful still life (color pl.p.397 of the Münster exhibition Catalogue) combining with a sophisticated rhythmical elegance fruit and luxurious metal vessels; the exact dating of this picture in the 1630's remains debatable.

As to the hanging of fruit and fowl in the dark niches of Sánchez Cotán (whose still lives were recently studied by José Gudiol Ricart, 1977), it seems obvious that it follows the practice of all Mediterranean countries, the purpose of which was to preserve those perishable foodstuffs in the warm climate by avoiding their contact with stone or wood, the niches themselves being cooling spaces frequently built in Spanish houses and not market displays as has been recently suggested.

The *Flowers* by Juan de Arellano were not perhaps so fully appreciated in my book as they deserved, especially in the light of some newly discovered pictures. Although I did mention the Italian influences increasing toward the end of the 17th century (p. 101), I failed to stress the specific importance of Mario Nuzzi.

There is little doubt that the superb Spanish 17th-century still life painting is much richer than has been suspected. Here I am reproducing an unpublished picture which, although unsigned, seems to be a masterpiece by Tomas Yepes (or Hiepes) (pl.66 bis). This *Four Pots of Flowers in a Garden Niche* (in the J. and D. de Menil Collection, Houston) probably belongs to a little-known period of his career, perhaps the early part of it when he was directly influenced by Flemish painting. The treatment of flowers and leaves is more naturalistic, their arrangement freer, less ornamentally regular, than in the several dated pictures of the 1660's; the butterflies on the wall are an old and typically Netherlandish motive (J.de Gheyn, R. Savery, etc.); the vases are Talavera productions, not as strange as in the pictures dated 1663 and 1664. As regards extravagant vases, there exists in the same collection a brilliant *Allegory of Scent,* no doubt part of a series of *The Five Senses* (pl.63 *bis*). The dark skin of the Negro boy stressing the blue and the pink of his dress and the reddish carnations combine into a crisp and sonorous color harmony. The vase of flowers in this picture, also close to Yepes, is not necessarily by him; it suggests to the historian that a school may have existed around this personal artist.

It is still possible to find Spanish still lives with unrecorded signatures. Such is the *frutero* reproduced here (pl.60) signed by a Francisco de Vargas and dated 1679; its unsigned companion piece shows a *Hanging Branch of Lemons.* We have here a belated follower of Francisco de Zurbaran, delicate and elegant in his simplicity. Even more interesting is the *Oranges, Onions, Fish and Crab* signed B^{ar} *Gomez* Fig^a *1645* (pl.65 *bis*). This must be the signature of Baltasar Gomez Figueira, Portuguese by birth but Spanish by training, first mentioned in Sevilla, in 1621, later in Obidos, Portugal (from 1636 onwards); I mentioned him in my book in connection with his daughter, Josefa d'Obidos (p.97). But his still lives were unknown. The identification is fully confirmed by the fact that both the fish on the dish and the crab are copied by Josefa in her *Month of March,* signed and dated 1668 (reproduced pl.7 in the book on Josefa by L. Reis Santos). In Gomez Figueira, whose only known painting is a religious one, we now discover a brilliant follower of the early type of *bodegon,* with a symmetrical composition inherited from Blas de Ledesma and Van der Hamen. But the almost aggressive volume of objects owes a great deal to the tradition of Cotán. Thus the pictures of Gomez Figueira, of 1645, and of Francisco de Vargas, of 1679, tend to contradict the opinion, still fairly common twenty years ago, that the old, authentically Spanish, rather solemn type of *bodegon* did not survive after the first third of the century. This persisting tradition helps us to understand its reappearance in the middle of the 18th century under the brush of Melendez.

In this respect, it is interesting to note that the study of documents published in 1972 by Eleanor M. Tufts establishes that Melendez was never appointed painter to the king. There is no proof either that he was officially commissioned to paint the series of still lives for Aranjuez, as it is still affirmed by historians.

Two exceptional features characterize the recent research in the field of French

17th- and 18th-century still life painting: it has been enriched in the most conspicuous way and by the almost solitary effort of one historian. Since 1962, Michel Faré (later joined by his son Fabrice) has published books, essays and articles summed up in *Natura in Posa.* He has made known, on the basis of documents and mostly unknown paintings, dozens of still life painters. A kind of Atlas, supporting on his shoulders the ever increasing weight of inanimate objects painted in France during two centuries, his writings are a mine of information. They too will probably discourage young students, unless they endeavour to question, or supplement, this great achievement in some detail, as young scholars usually do, with more or less success.

A much vaster pictorial map stretches now before us; scores of names could be added to my text and to the list mentioned in my note 195. But very few belong to artists important enough to change the general line of evolution as sketched here. It has been confirmed that *grosso modo* French 17th-century still life painters looked closely to the Low Countries during the first part of the century, and to Italy in the second part. And it is equally obvious that they almost never simply imitated the models they chose, but interpreted them in the spirit of a specific equilibrium characteristic of their national civilization. Michel Faré's investigation has ramified this scheme like the branch of a tree. It is now beyond doubt that Italian baroque influences were accepted in France, even by the Academy, and domesticated; and that painters of Flemish origin, such as J.-M. Picart or Pieter van Bouckle, enjoyed success in France and assimilated the taste of their French colleagues and clients. We now understand much better the links between successive representations of different categories of still life—*Kitchen Pieces, Allegories of the Senses, Seasons, Elements, Vanitas, Trompe l'oeil,* the single *Vase of Flowers,* and the decorative *Display of Metal Plate,* all of which survived in surprising numbers. One of the merits of Faré's research is the observation that many of the artists, principally devoted to religious and historical themes or to portraiture, did not disdain still life painting. One of them —and indeed one of the very best in the latter category—seems to have been Lubin Baugin. I am now yielding to this identification of pl.52, after long hesitation because I was waiting for the discovery of at least one still life signed with an initial before Baugin's name, or of at least one religious painting by Lubin in which the objects do not look as if made of soap (see note 97*a*). But there is a limit to doubt. Most of the time, the historian is dealing with probabilities; he must choose between them.

If I am unable to add a single important French still life painter to those studied by Faré, I can reproduce in this edition an unpublished masterpiece by Pierre Dupuis (pl.48). It is, of course, a simple matter of chance: I saw the painting before Faré who would not only have identified its author instantly but also recognized the "reception piece" for the Academy made in 1663 and described very precisely in his book of 1974 (p.200). A deep agreement of color dominates the grey wall, the red and mauve plums, the rather yellowish pomegranate enhancing the blue of the vase, the snow white lilies; thus the apparent division of the composition in two halves is compensated by a color harmony and tends toward classical equilibrium.

Faré's book on the 18th century is equally well documented and illustrated. It abounds in discoveries of lesser artists as well as works of leading painters already known, such as Largillière, Desportes and Oudry. We can now better grasp the transition between

the ponderous opulence of the Louis XIV era and the new delicate and bright color scheme announcing Chardin and Anne Vallayer-Coster, both of whom are now very well known—the former thanks to Pierre Rosenberg's excellent exhibition catalogue of 1979, the latter through an exemplary monograph written in 1970 by Marianne Roland Michel. Faré brought to light many secondary artists who worked not only in Paris but also in the French provinces. They give us interesting insight into the transitional periods at the end of the 17th and the late 18th centuries on a European scale. Louis Tessier (c.1719–1786), almost neo-classical in his cold, smooth and linear precision, is curiously anticipated by Cristofano Monari (or Munari) of Reggio (1667–1720). The provincial painter Claude-Joseph Fraichot (who died in Besançon about 1803) is a perfect stylistic parallel to his contemporary Carlo Magini (1720–1806), who worked in Fano.

The study of 19th- and 20th-century still life in Europe, as well as in North and South America, awaits its synthesis. In Italy, it has been treated in the 1964 exhibition catalogue. In France, by Michel Faré in the second volume of his book of 1962. A brief but interesting analysis of the still life painting of our century appeared in the last chapter of the catalogue of the very recent exhibition in Münster, of which I must now speak.

The writing of this preface was concluded in October 1979, and in November there opened in the Westfälisches Landesmuseum in Münster a very important exhibition of European still life (Stilleben in Europa) organized by this institution in collaboration with the Staatliche Kunsthalle of Baden-Baden, where it was also shown during the spring of 1980. It has confirmed the Pantagruelian appetite for still life already displayed by *Natura in Posa* and the Bordeaux exhibition. But it is a fundamental refreshment of the study of still life.

The catalogue, a ponderous book of 619 pages, well illustrated, edited by Gerhard Langemeyer and Hans Albert Peters and entrusted to about twelve collaborators, is a monument of collective learning, investigation and meditation. The exhibition studies the subject starting not with Antiquity but with the great discoveries made around 1500; on the other hand, although rapidly, the survey continues to the advent of Pop Art. Still life painting is considered almost exclusively in closest relation to civilization, material and spiritual (Kulturgeschichtliche Zusammenhang), as a mirror of human life (Spiegel menschlichen Lebens). It is a most ambitious attempt to analyse all aspects, all categories and sub-categories of still life painting in the light of changing economic, social, religious and philosophical conditions. Of course, my book did not neglect these implications; titles such as "bourgeois intimacy and opulence" or "the humble, mystical still life" are explicit enough; nor did I forget the great theme of *Vanitas* (see figs. 35 to 39). But, though emphasized, they were not systematized. They compare with the combined chapters of the Münster catalogue as a *lied* compares with a symphony. Perhaps the aim at completeness has been overstated. Was it really indispensable to give us a survey of the theory of perspective and of proportion when we know that, starting in the early 15th century, they became important for all painting and not only for that of still life? Or is it sure that the giant cardoon in Spanish still life (it occurs also, and perhaps even earlier, in an Italian Caravagesque picture published by Zeri) alluded to Christ, because it was eaten in winter, in the time of Nativity? Do the beautifully healthy apples of Fede Galizia (frontispiece) carry a hidden meaning? The limits of iconographic interpretation are dangerously fluid,

as has been warningly foreseen by the father and master of "disguised symbolism," Erwin Panofsky. But these doubts are trifles when confronted with the sum of new information this catalogue contains. Such an enterprise is more than welcome when we see some books on art equipped with synoptic tables paralleling the artistic creation, literature, science, political events, etc., but omitting to draw the slightest precise conclusion.

The introduction to the catalogue (p.14) takes as a sort of *leitmotiv* Gombrich's observation that the appearance of a fashion (such as the sudden popularity of still life) always depends on more than one reason. So does its disappearance. When I pointed out that the striking lack of interest in still life during the French Revolution and the Napoleonic period might be related to the exaltation of human action and adventure in these times of constant wars, I certainly meant to suggest only one, perhaps the most obvious psychological reason. And I stressed the contrast between the Europe of these "total" wars and the Holland of localized hostilities, "which, while waging war, also produced still lifes of Claesz and Heda" (p.117). The historian knows that, as in nature, everything is linked with everything else in human society. And he also knows that he will never be able to disentangle all the links. Indeed, it would be quite interesting to investigate the reasons accounting for the relative absence of need for still life painting in the first half of the 19th century.

Although the artistic quality of pictures chosen to be shown is impeccable, the very conception of the Münster exhibition is deliberately devoid of aesthetic considerations. It is an impressive product of the intellectual trends in art history which started early in our century as a necessary reaction against an essentially stylistic art criticism. Iconographic and iconological, social and psychological investigations, so characteristic of our century, are the main preoccupations of the catalogue. The achievements of individual painters and the national artistic traditions (although they are nothing but pictorial expressions of various national civilizations) are here secondary. The word "beauty" and the attempts to describe it are absent. Or perhaps only apparently absent, because no sensitive and lucid historian of art can avoid them. See how Christian Klemm was led to define in a few excellent terms the *initimate correspondence* between, on the one hand, a specifically French play of lines, rhythms, light and color, and, on the other, the iconographic symbols, in a *Vanitas* still life (p.212,n°124, color illustration). Indeed, the emotional impact and the quality of meditation directly depend on the need of serene order or, conversely, of overwhelming pathos in the *Vanitas* pictures conceived by various artists moulded by their respective civilizations. After deciphering Vases of Flowers all over Europe, not only for their iconographic meaning but also their diverse compositional formulas, Paul Pieper finally concluded that there was something which united them all, and that this link was simply the fascination induced by the beauty of the flowers: a deep, though seemingly banal, conclusion (p.336). These two examples (they could be multiplied) vindicate once more the truth that the art historian's chief tool remains a sensitive and precise analysis of pictorial language, however important the reading of a work of art may be as an intellectual message and a mirror of the social life of the past. The exact evaluation of a work of art as a *visual fact* is essential, precisely in the context of the concrete circumstances of life. It is crucial to the birth of the still life painting.

23

Let me take a 15th-century example. The painter of pl.9 made a still life in which every object is a religious symbol; and he painted it on the back of a Madonna. Without this knowledge we are unable to evaluate what it meant to the people who commissioned it. But without making clear the conditions in which these people looked at this painting in their daily lives, we understand it as a painting even less. Because there is no doubt that this panel was a part of a diptych, and when the diptych was closed—and this was the case most of the time—only this still life was to be seen. No one was more aware of this than the painter himself. He knew that this exterior part of the diptych was going to be seen very often as an isolated panel. He wanted it to be admired for its beauty which had to be worthy of the sacred Madonna. After choosing objects already familiar in his time and civilization as symbols of her purity and piety, he made them arrestingly tangible, ordered them rhythmically into a well closed, solemn composition, and immersed them in the warm, intimate light of a niche in the Virgin's chamber. With a personal combination of pictorial means at his disposal, he made a self-sufficient picture intended to inspire sacred meditation.

Where then lies the difference between pl.9 and the Baugin (pl.23) which is considered as an "authentic" still life, when we now know that it is full of combined meanings, some of them strictly religious, such as the eucharistic allusion to wine and bread? When we find today only one or two pictures out of an original set of *The Five Senses* or *The Four Seasons* or *The Four Parts of the World* (such as the brilliant *Allegory of America* by Cavaliere Maltese and an unknown figure painter, in the de Menil Collection, Houston), are these remnants intellectually less "independent" than is pl.9 from the other panels of the diptych?

These are the reflections which led me to the conviction that true still life painting was born the day a painter made the fundamental decision to organize into a plastically self-sufficient work a group of inanimate objects. And I am not worried by belonging to the family of traditional art historians—connoisseurs who still believe that a historic account of the innumerable aspects of beauty disclosed by so many artists according to the civilization they represented and the attempts to describe these aspects, however subjective they may be, remain an indispensable cultural enterprise.

Paris, January 1980

24

CHAPTER ONE

ANTIQUITY

As far as we can tell from our limited knowledge of the past, the Greeks were the first people in the West to paint pictures which can properly be described as still lifes. These, together with several other forms of painting (household scenes, landscape, animal pictures), were the most original creation of that Hellenistic civilization which reached its height in the third and second centuries B.C. Not a single still life has come down to us from this remote period. Our only notion of this art derives from descriptions of it left by ancient writers and from later works brought to light in excavations. Paintings and mosaics have survived at Pompeii, Herculaneum, Stabiae, Rome, and in many parts of the Roman Empire from North Africa to the Rhine. They date from the first century B.C. to the fourth century A.D., and in some of them archeologists have good grounds for discerning direct reflections and more or less faithful reminiscences of lost prototypes of the great period shrouded in the silence of the ages.

Pliny the Elder, who perished in the eruption of Vesuvius in 79 A.D. (when Pompeii, Herculaneum and Stabiae were buried under the ashes), tells us that the most famous Greek painter of still lifes was Piraikos (⁶). Exactly when he lived and worked is not known; the few scraps of evidence we have point to the late fourth or early third century B.C., i.e. to the early Alexandrian period. He painted interiors of barbers' and bootmakers' shops, donkeys, and—the important point here—*foodstuffs*. These were probably small easel pictures on wood, fitted with folding shutters, such as were later represented in *trompe-l'œil* in the wall paintings of Pompeii and Rome (Villa of the Mysteries, House of the Ara Massima, House of the Cryptoporticus, House of the Vestals, at Pompeii; House of Augustus, also called House of Livia, on the Palatine Hill, Rome). Easel paintings seem to have made their appearance as early as the time of Alexander the Great (second half of the fourth century), under the brush of Antiphilos, the rival of Apelles. These were neither votive nor funerary paintings (both religious in character) but genre pictures, often comic or humorous scenes, "slices of life," painted on portable panels or tablets which, being unconnected with the mural decoration of a room, could be moved about at will, placed on a ledge

or cornice, for example, hooked to a nail on the wall or hung from a string. They were pictures similar in every respect to the panel paintings reinvented in Europe in the 15th century.

This was a momentous step in the history of Western culture. The mere fact that genre scenes and still life had come to form the exclusive subject of an easel painting, and that the small compositions of Piraikos fetched higher prices than large-scale " noble " subjects (7), implies the existence of a particular conception of the world and a propitious phase of development of the painter's technique and vision.

Inanimate objects made their appearance early in Greek painting in the decoration of vases. These objects, however, were only accessories and in spite of the increasingly skilled application of linear perspective, in spite of the exactitude of forms and the accuracy of foreshortenings, they fail to convey any particular impression of visual intensity. As far as we can judge today, the same is true of wall paintings, though they were more realistically treated than vase paintings. Then suddenly, at the height of the classical period in the second half of the fifth century B.C., Greek painting branched out in new directions. No longer satisfied with dispassionate transcriptions of natural forms tinted with a few basic colors, in the manner of Polygnotos, painters deliberately aimed now at illusionist realism. It has been suggested that they took this step under the influence of the theater, after being employed to paint stage scenery. Aeschylus " borrowed one of his most beautiful similes from the art of the fresco " (8) and he was the first, according to Vitruvius, to accept and make use of scenery painted by Agatharchos; this, very probably, was a painted curtain suspended from a wooden scaffolding. And if so great a playwright as Aeschylus felt that a painting would enhance the effect of his tragedy, then it is safe to assume that the painting of that day already contained illusionist elements constituting an advance on the mere rudiments of perspective. Working for the theater naturally led painters to develop an art of imitative realism. A generation later, about 400 B.C., the famous anecdote recorded by Pliny about the birds that flew down to peck at the grapes which Zeuxis had painted on a curtain, proves that the technique of *trompe-l'œil* had secured a place for itself on the stage, even if the stage was not responsible for its development. Apollodoros received the name of *skiagraphos* (shadow painter) for inventing chiaroscuro, that interplay of light and shade combined with color made of blended tones which creates the illusion of relief; and without that illusion neither birds nor men would have paid their naïve homage to Zeuxis. A contemporary artist, Parrhasios, was also a master of the art of painting seemingly tangible pictures.

By all accounts we have here a fully developed art of nature imitation, based on the sensory response to optical and tactile effects, and no doubt possessed of a suitable technique, vibrant and supple. Such an art presupposes an enthusiastic appreciation of nature, of the forms and colors of objects, of light and its effects and qualities.

Then as in every other period of history, the painter's attitude to the world was not an isolated mental attitude. To begin with, it corresponded to that of the sculptor. Both expressed an outlook on life and a conception of the world that were common to the culture of their generation. It has recently been shown (9) how closely the illusionism of Zeuxis and Parrhasios (which may be described as impressionist, and indeed, are we not told that their pictures were delusive because they changed completely according as seen from close at hand or from a distance ?) is linked up with the Heraclitean relativism of Protagoras and the esthetic based on illusion as expounded by Gorgias. The philosophy of relativism is typical of periods of crisis, and the age of Apollodoros, Zeuxis and Parrhasios witnessed the Peloponnesian War (431-404), the terrible plague epidemic at Athens, the alternation of tyranny and democracy, the establishment of new contacts with distant cities. It witnessed the collapse or revision of traditional values and ushered in the reign of doubt so thoroughly codified by the Sophists. There was a rankling sense of dissatisfaction with the classical equilibrium of thought and art, with the serene balance between stylization and nature imitation achieved in the works of Pheidias and Polygnotos. A yearning for spontaneity and lyricism led artists to concentrate on movement and expression, which they carried to the point of suggesting an instantaneous glimpse of a given action. The play of light and shade breathed life and vibrancy into paintings. The ideal of individualism was increasingly valued, and if man, according to Protagoras, was the measure of all things, the painter was the judge of nature, his judgment being based solely on the outward appearances of nature. The painter's art became more accessible to the people at large, and his skill in conjuring up an optical illusion engendered a keen awareness of the singular powers with which the artist is gifted. Like many painters of the Renaissance, Apollodoros, Zeuxis and Parrhasios

took a naïve and insolent pride in their abilities. They composed and flaunted pompous mottos and epigraphs; they wore expensive and outlandish clothes calculated to shock the bourgeois; they were always on the look-out for unusual, eye-catching themes and motifs.

Athens numbered over 100,000 inhabitants and city life in ancient Greece produced its inevitable effect, just as it did in Holland in the 17th century and in France in the 19th: it gave rise to a nostalgic yearning for the " natural " and " genuine " things of life. The sophisticated townsman came to appreciate the humbler realities, hitherto disregarded or dismissed as vulgar. Everyday street scenes, domestic animals, the well-stocked shelves of a pantry—these became the subject matter of painting, and did so at the very moment when painters were perfecting a technique capable of achieving more or less complete illusionism. Such was the situation on the eve of the Hellenistic period; at this point it was practically inevitable that the small pictures of Piraikos should appear.

The rise of several independent genres is now recognized as the most original feature of Hellenistic painting. And that painting, to be understood, has to be studied in the spirit of the times that produced it. In a sense it is the counterpart of contemporary science. It reflects the methods employed in the observation and study of natural phenomena; it reflects the importance then being accorded to matter and appearances. Its philosophical parallels are no doubt to be found in the investigations in natural science of Aristotle and Theophrastus, in the sensualist doctrines of Aristippus and Epicurus. Surely we are entitled to read an Epicurean allusion into Roman and Hellenistic still lifes representing rich assortments of food. The writings of the period, from Theocritus to Lucretius, bear witness to an almost impressionistic sensitivity to color, to the integument of things, to the changing face of nature in the variable light of day. When in the first half of the third century A.D. Philostratus wrote: " Everything has a color of its own, clothes, weapons, houses and apartments, woods, mountains, springs and *the air that envelops all things,* " he was summing up the ocular experience and the pictorial consciousness of many generations of artists.

Piraikos was only the most famous of the Hellenistic genre and still life painters. Greek and Roman estheticians seem to have considered these subjects to be inferior to the lofty themes of fable and history; yet the public delighted in them and Pliny could not refrain from expressing his admiration for the artistic qualities displayed in such pictures, and from dwelling on the high prices which art lovers paid for them [10]. The art world of Late Antiquity oscillated between this vogue for familiar subjects and the rigid standards inherited from the classical age, according to which such subjects were low and contemptible. This indecision of critical judgment gave rise to a significant pun. A still life painting was originally designated in Greek by the term " *rhopography* " (i.e. depiction of insignificant objects, of odds and ends); then, forcing the pejorative nuance a little, it was mockingly baptized " *rhyparography* " (i.e. painting of the sordid). One of the most famous of such works was a mosaic by Sosos of Pergamum (third or second century B.C.), entitled *The Unswept Room* (*asarotos oikos*), in which remnants of food—fish bones, chicken bones, claws of shellfish, half-eaten fruit, nutshells and pips—are seen scattered over the floor, as if the servants had neglected to sweep the triclinium after a banquet (pl. 4). But the humorous touch here merely put the seal on a popular fashion. Now too the term " *megalography* " (i.e. large-scale painting) was coined in contradistinction to *rhopography.* But it was not so much a matter of size as of the nature of the subject, the latter category corresponding to our *minor genre* as contrasted with the *grand manner.*

There is reason to believe that the appearance of these new themes was linked up with the mannerist esthetic of Hellenistic art. Indeed that art offers some striking analogies with the mannerist movement of the 16th century: the inordinate elongation of trunk and limbs which lends figures charm and grace, the quest of expression at any price which often degenerates into merely pointless agitation, and a wholly intellectual taste for allegory—in a word, an attitude to art in which imagination prevails over the data of visual reality. The resources of the imagination, however, soon run dry, only to be replaced by conventions, and in order to get his effects the mannerist is condemned to become a novelty hunter. Paradoxically enough, he finds these novelties in certain bizarre or unusual aspects of reality, such as nocturnal lighting effects and glimpses of " low life," plebeian street scenes, humble objects of daily use. He delights in combining man and animal in arbitrary, caricatural creatures. All these procedures were calculated to startle the public, and it is striking indeed to find them appearing both in Hellenistic painting and in that of the 16th century. Pliny's description of a picture by Antiphilos (ca. 310-280) in which " one admires

a boy blowing a fire which lights up both the room, which is very handsome, and the boy's own face," applies equally well to certain paintings by Luca Cambiaso and Jacopo Bassano, while the genre pieces and still lifes of Piraikos are closely paralleled by those of Pieter Aertsen. The *grylloi* (i.e. caricatural or fantastic creations) of Antiphilos have their counterpart in the freakish monsters of Arcimboldo (pl. 16). At the same time, in keeping with the singularity or willfulness of the subject, the style grew self-conscious and artificial, broad and cursory, both in the work of an ancient like Antiphilos and in that of a modern like Rosso.

Even before they created the independent still life, Greek painters were accustomed to representing groups of inanimate objects, the attributes of athletes, intellectuals and actors: arms, writing materials, masks, simply laid out side by side, frieze-wise. When the still life picture made its appearance, it assumed at once a highly distinctive character. Its stock theme was food, and it was designated by the name *xenion* (i.e. the present made to a guest) (pls. 1, 2, 3). Such pictures seem to be an allusion to the gifts of food supplies which the owner of a rich house presented each day to his guests who, according to the Greek custom, prepared their own meals, even though they lived on the premises of their host ([11]). Favorite subjects were loaves of bread, fresh fruit and vegetables, eggs and dairy products, seafood, choice meats such as game and fowl, jugs and vases containing water, oil and wine, together with terracotta ware, fine glassware, metal bowls and goblets, and table napkins.

The painting of *xenia* continued in Roman times, and in the excavated houses of Herculaneum and Pompeii we find many examples of them. In all probability, as has been pointed out ([12]), the choice of foodstuffs painted at Pompeii was dictated by the economic standing of those who commissioned the paintings; and, at Pompeii, they were either well-to-do owners of vineyards and orchards or prosperous merchants dealing in wine and agricultural produce. In larger cities like Naples and Rome, still life paintings tended to include other objects, notably a greater profusion of vases and silverware.

The *xenion* still life appears in two forms. Either we have a niche-like pantry or larder divided in two by a shelf, so that the objects are seen on two superimposed levels (pls. 1, 2); or else we see them displayed on one or two stone slabs, as if the painter were representing a dessert table laden with dishes about to be served in the triclinium (pl. 3). In both a familiar sight is depicted in a realistic spirit of *trompe-l'œil*. And this realistic approach, standard practice in an easel picture, continued to prevail when, in the first century B.C., still life became the theme of mural decorations: a painted vase on a ledge or in front of a bay or recess did duty for the real vase which might have stood in the house at such a spot—and the illusion was complete.

Objects are often accompanied by live animals. Birds, barnyard fowl, rabbits, dogs and cats were shown nibbling at food, as if " to suggest their savor " ([13]). Sometimes the animals introduced an amusing note of anecdote by contending against each other, just as they appeared later in Flemish still lifes of the 17th century, those of Snyders and Fyt, for example.

In addition to the *xenion*, the painters of antiquity were familiar with another type of still life containing food, which also has its parallels in Dutch and Flemish art. This was the theme of the *Meal on a Table*, fairly common in the mosaics of Roman times. As a rule, only a particular dish or a particular phase of a meal is represented. But a mosaic from Antioch displays all the courses of a great Roman banquet in their abundance ([14]).

The Greeks practised another form of still life whose popularity with artists has continued down to the present day: flower painting. That it already existed at the dawn of the Hellenistic period is proved by Pliny's charming anecdote of the painter Pausias who, vying with his mistress Glycera, a flower girl adept in the art of weaving garlands, " succeeded in reproducing in painting all the varied hues of flowers." A little later, in the time of Alexander the Great, " small pictures of birds and flowers " were popular enough for the Athenian painter Nikias to despise them. Here already is the old quarrel over the artist's high-minded intentions which flared up again at the Renaissance, when Michelangelo voiced his contempt of landscapes teeming with paltry details " in the Flemish manner."

We can easily imagine what these early Hellenistic flower paintings were like: decorative compositions of juxtaposed wreaths and garlands accompanied by birds and insects, such as we find at Herculaneum ([15]). But later generations of Greek artists took to painting baskets of flowers in every way

28

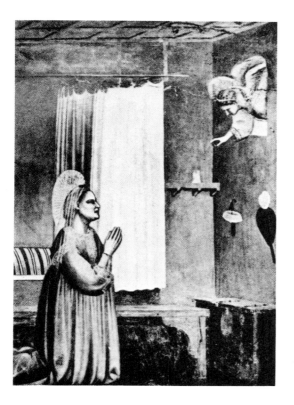

1 - GIOTTO. The Room of St. Anne. Fresco. 1303-1305. Scrovegni Chapel, Padua. — **2** - TOMASO DA MODENA. St. Jerome's Desk. Detail. Fresco. 1352-1366. San Nicolo, Treviso.

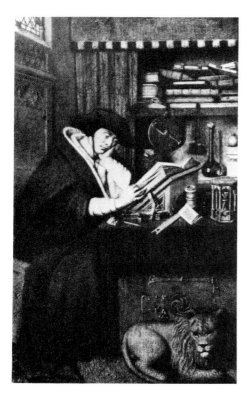

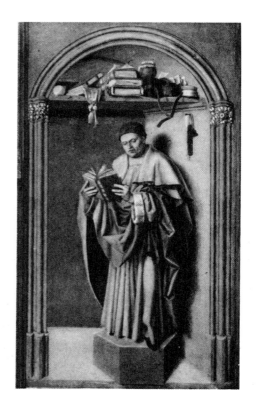

3 - St. Jerome in his Study. Copy of a lost original by VAN EYCK ? 1442. Institute of Arts, Detroit. — **4** - MASTER OF THE AIX ANNUNCIATION. The Prophet Jeremiah. 1443-1445. Musée des Beaux-Arts, Brussels.

IN THE NORTH

Still life conceived as a minutely detailed trompel'œil stemming from Northern book illumination.

5 - MASTER OF MARY OF BURGUNDY. Miniature. Ca. 1485-1490. Vases, Bowls of Fruit, and Flowers in a Glass. Bodleian Library, Oxford. **6** - HANS MEMLING. Irises and Lilies in a Vase. Ca. 1490. Collection of Baron Thyssen, Lugano.

IN ITALY

Flemish influence combined with the Italian tradition of marquetry.

7 - ANTONELLO DA MESSINA. Fragment of a St. Jerome. Ca. 1460 ? National Gallery, London. — **8** - CARLO CRIVELLI. Fragment of a Virgin and Child. Before 1470. Harding Coll., New York.

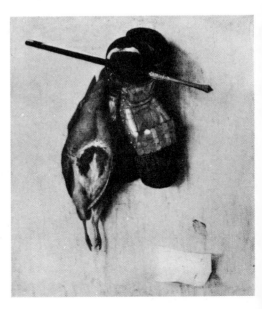

9 - JACOPO DE BARBARI. Partridge and Arms on a Board. 1504. Alte Pinakothek, Munich.

comparable to those of the early 17th century, as painted by Velvet Brueghel, Linard (pl. 47) and others. Such is the famous mosaic at the Vatican discovered in a Roman villa of the second century A.D. (pl. 6). Placed on a patch of grass, a basket of flowers stands out against a background which has been blackened by successive restorations, but which at one time must have been much lighter. It is filled with a great variety of flowers of the field and garden. Whether a Hellenistic work or a faithful Roman copy of one, it is virtually a painting executed in cubes of color, of the most amazing delicacy, which play the part of tiny brushstrokes. The supple relief of petals, the light of day, the transparent shadows saturated with moist air, are all rendered with touches of color whose diversity, when seen from a distance, merges into exactly the right tones. Here we are entitled to speak of an impressionism comparable to that of the 19th century.

At the 1952 exhibition at the Orangerie, this *Basket of Flowers* was shown in the main hall alongside a group of works dating from the 15th to the 18th century. All these later paintings looked dark beside the Vatican mosaic, with its bright and vibrant colors rendered from the life, in broad daylight, nearly two thousand years ago. Not till one reached the following rooms, where the Monets and Renoirs were exhibited, could anything like it be seen. Not a single ancient fresco that has come down to us can give a better idea of the lengths to which Hellenistic illusionism was carried.

The realism of this art was essentially limited to the delights afforded by optical and tactile sensations. Both painter and mosaicist concentrated on the surface of objects, whose quality they suggested under a grazing light. They gave nature a sharp glance, but a fleeting one. They were content to record the sensory aspects of things with a spontaneity that seemed to register an instantaneous impression rather than capture any of the more durable aspects of form and substance. The same thrill of sensual pleasure experienced before the perpetual flux of life was felt by Philostratus, who has left us descriptions of paintings which he claimed to have seen in a gallery at Naples. It matters little to us here whether he faithfully described the pictures he saw or embroidered on them, as Sophists were wont to do. The point is that his pictorial sensibility and his literary imagination were conditioned by the Greek culture on which he had been nourished, and what he saw or pretended to see in a painting is certainly a reflection of Hellenistic and Roman esthetic. " Here," he writes, " are black figs heaped on vine leaves, secreting their sap in abundance. The painter has represented the cracks in the skin of the figs, some of which have broken open and are discharging a kind of honey, while others, over-ripe, have split in two." And again: " On another leaf we see a newly curdled cheese which still seems to be quivering; then there are some bowls full of milk, I won't say white, but lustrously white; it owes this luster to the cream floating on the surface." " Why do you not help yourself to this fruit piled up in two baskets ? Do you not realize that if you hesitate even but the space of a moment, you will never find them again just as they are now, with their new beads of dew ? " (16).

There is an obvious rationalism and Epicurean hedonism in this description. The same philosophy embodied in the motto *Carpe diem* led a mosaicist of Pompeii to place a skull, an allusion to death (fig. 35), in a summer triclinium in front of the dining table, just as Trimalchio exhibited the *larva convivialis* (the " skeleton at the feast ") to his guests in the *Satiricon* of Petronius.

The finds made at Herculaneum and Pompeii enable us to reconstitute the evolution of still life during the late Hellenistic period and Roman times, from the second century B.C. to the year 79 A.D., when these two cities were buried in the eruption of Vesuvius. Two invariable characteristics are observable: still life was realistic, sometimes to the point of becoming a *trompe-l'œil*, and it served a decorative purpose. In the period corresponding to the earliest type of Pompeian mural decoration, known as the First Style, the only still lifes we find are mosaics. The famous mosaic pavement from the House of the Faun contains dead fish and shellfish together with live animals; their arrangement in three superimposed horizontal strips is purely decorative, but each scene is treated as a picture in its own right, with effects of relief and depth. It is quite possible that at the same time there was still a demand for the old Hellenistic still life pictures, painted on wood with folding shutters, which could be placed on the projecting cornice high up on the wall. For in the period of the Second Style we find such pictures simulated in painting and represented in mural decorations of architecture also painted in *trompe-l'œil* (House of the Cryptoporticus). At the same time other still lifes occupy decorative compartments of the wall space; they too are more than mere decorations, they are autonomous pictures, some of them measuring over three feet

in width (pl. 3). Their sensitive, spontaneous naturalism is striking, no doubt a direct heritage of the Hellenistic tradition. These are the finest still lifes that have come down to us from antiquity.

The Third Style reacted against this compelling plastic realism and, in keeping with its tendency to flatten and diminish the ornamentation of walls, it reduced the still life to small, minutely executed pictures or to motifs of birds and flowers—often charming works. It looked as if the still life of antiquity was about to bring its career to a close in an attitude of humble subordination to its architectural setting. But then the Fourth Style revealed a new passion for the still life picture. This was the heyday of *trompe-l'œil*. A décor of simulated architectural fantasies, borrowed from the theater, stretched across the walls, as if to abolish them by creating the illusion of powerful volumes and brusque perspectives. The arbitrariness of this decoration is completed by the representation of pictures on the wall with their shutters open, even with the string and the nail from which they hang (fig. 12). This *trompe-l'œil* effect comes as an added surprise. The old theme of the *xenion* recurs in these simulated pictures with all its illusionistic flavor, but it also figures in wall compartments flanking a central subject, usually a mythological scene or a landscape. To this latter category belong the great majority of the many still lifes brought to light at Pompeii and Herculaneum. Their technique is even more expeditious than that of Second Style paintings. We often get the impression that they are the work of artisans who were drawing on a centuries-old culture of pictorial illusionism; academic formulas seem to show through in the rendering of cast shadows and reflections, always handled spiritedly but always falteringly. Yet they have a fascination, imbued as they are with a deep sense of life which a second-rate virtuosity cannot efface. We can easily believe that the paintings of the great age of Piraikos and Sosos, and perhaps even those which adorned the richest Roman houses and palaces of Naples and Rome, may well have ranked among the masterpieces of European still life.

What, in sum, was the prevailing conception of still life painting in ancient times? The domestic animals and humble objects represented indicate a passionate attachment to the familiar realities of daily life. And while the artist carefully grouped them with an eye to rhythm and balance, he also took care not to destroy the effect of a random disarray, a spontaneous occurrence. The Hellenistic and Roman way of life is faithfully reflected in these pictures; the society of that day gave rise to well-defined types of still life, just as the Dutch bourgeoisie of the 17th century gave rise to analogous types. Conditioned by the predominance of an agricultural or an industrial economy, depending also on the part of the house which it served to adorn, we have the *xenion*, which usually figured in the winter triclinium, the *meal on a table* executed in mosaic and placed in the summer triclinium, and lastly the *garland of fruit and flowers* decorating the tablinum. These categories long remained unchanged. Presumably many painters specialized in a particular subject or genre; witness Nikias' condemnation of artists who devoted themselves to small pictures of birds and flowers. Undoubtedly there were great artists who introduced novelties and nuances that are lost to us today, for we have no more to go on than the shattered remnants of an art that spanned several centuries. But it seems unlikely that ancient painting ever witnessed such daring innovations as those of Van Gogh, for example, who painted just an old pair of shoes or a chair (pl. 102)—innovations not only due to his powerful personality, but rendered possible by the artistic freedom of his time. The esthetic conceptions of Greece and Rome show a certain kinship with those of Chinese art, with its fondness for fixed categories and a stock repertory of subjects It would be interesting to analyze both the similarities and differences between these aspects of the two great civilizations of East and West; but such a study would of course exceed the scope of this book.

In describing the style of ancient still lifes, I spoke of Impressionism. The term applies in fact to both the pictorial conception and the technique of Hellenistic mosaics and of certain Roman mosaics, built up as they are in separate tones so contrived by the artist as to blend in the eye of the spectator when seen at a certain distance. It is highly probable that this bold procedure was also used in a number of wall paintings. But as far as the most advanced and the best preserved still lifes in fresco are concerned (particularly those of the Second and Fourth Styles), it must be admitted that the term Impressionism is misleading. The vibrant surface life of objects and the sharply accentuated volumes derive from an illusionism of light, not of color. They are obtained by accurate contrasts of tones of shadow and tones of light. It is a painting in which values are handled with great sensitivity, and analogies to it must be looked for in the art of the precursors of Impressionism, such as Velazquez, Goya, Manet, each a master

of values; or in that of the Post-Impressionists who simplified the color handling of Monet and Renoir and emphasized tonal values, Bonnard for example, whose fruit, though more brightly colored (pl. 105), resemble the famous *Peaches* of Pompeii (pl. 2). Ancient writers often mention the monochrome painting of the Hellenistic period. The practice of a form of painting reduced to the play of values seems to have been fundamental to the vision and technique of the Greeks. In the present state of our knowledge, it is impossible to say exactly when, or to what extent, the art of painting was enriched by a genuinely impressionist handling of color.

The high general level of skill with which Roman painters represented fruit, flowers and all sorts of metal objects, was turned to account in the painting of grotesques, which appeared in the time of Nero (54-68 A.D.). This, together with the stupendous profusion of simulated porticos and pediments in Fourth Style painting, constitutes the most original mannerist invention in the field of mural decoration. Here the imagination of the ancients ran riot, combining fruit, animals and objects in an arbitrary interplay of incongruous forms. Nothing could be more alien to the classical spirit; and when Vitruvius describes these grotesques only to condemn their irrationality and artifice, we can almost hear Félibien criticizing Rosso's stucco decorations at Fontainebleau. In grotesque decoration the still life was no longer treated for its own sake; it was only one type of ornament scattered among others. If mention is made of them here, the reason is that, after being discovered in Rome at the end of the 15th century, grotesques greatly contributed, it seems to me, to the creation during the Renaissance of an independent branch of painting devoted to flowers and fruit.

All these art forms—the still life conceived as a true easel picture; as a simulated picture represented on a wall; or as a more or less isolated decorative motif—disappeared along with the rest of Roman culture when it was swept away by the barbarian invasions. But for a long time the mosaics of the Roman Empire, from Tunisia to Cologne, preserved a decoration of household objects, vegetables, baskets of fruit, and game (pl. 5 and fig. 18). Their style varied with periodic fluctuations between the illusionist realism consecrated by tradition and the first currents of abstract stylization coming in from the East. During the third century and at the beginning of the fourth, artists reverted to Hellenistic picturesqueness. Rapidly sketched forms, lit up by glancing rays, and the flickering play of cast shadows again evoke no more than the fleeting existence of objects. But the tide of art was running inexorably in the opposite direction, towards the laconic definition of such features of bodies as seemed solid and immutable: contours grew harder and stiffer, volumes were indicated by simple bands of color, shadows were held rigidly in place as if welded to objects. These were the rigors of an austere age, of a spirituality in reaction against the facile hedonist vision of pagan antiquity, and visual appearances were bent now under the yoke of stylization. One is reminded of the reaction of Cézanne and the Cubists against the glittering iridescence of Impressionism: the basket of pears and the dish of mushrooms in the large mosaic at the Vatican (pl. 5) strikingly resemble some of Fernand Léger's paintings (pl. 117).

From the fifth century on, Early Christian art and then Byzantine art confined still life to a strictly symbolic and decorative role. The objects painted or built up in mosaic cubes were now liturgical objects or attributes. Representations of the Last Supper included a display of food and utensils inherited from the *Meal on a Table* of Roman mosaics. The writing desk of the Evangelists, with their inkwell, phials, tablets and *scriptorium*, derived from the antique tradition of author-portraits. But the realistic spirit of older times has given place to a purely allusive art. Forms are merely schematized; objects, fruit and flowers are deprived of their outward blandishments and take on the purity of ideograms. Thereby they acquire a new, wholly mystical beauty. The almost unearthly gorgeousness of color and texture which we find in Byzantine mosaics has the effect of intensifying this triumph of the spiritual over the physical. Still life elements seem to be imbued with a celestial perenniality and splendor. Rigidly outlined, powerfully modeled with flat strokes, the fruit, flowers and Gospel books that figure in the great Ravenna mosaics look as if they had been chiseled out of a dense mass of color and gold, such as the mind's eye alone can perceive.

THE ORIGINS OF THE MODERN STILL LIFE

IT took the Middle Ages a long time to reascend the path of naturalism along which the ancients had pushed so far. Not until earthly life and its everyday realities had been given a place in the Christian conception of the world did the essentially religious painting of the Gothic age begin to show an interest in the representation of objects for their own sake. The day came when St. Francis of Assisi spoke to the birds and hymned the flowers. By regarding all created things in the light of divine grace, he opened men's eyes to the humblest surroundings of life. The irresistible rise of a nominalist, Aristotelian philosophy awakened the spirit of inquiry and observation, and put a new value on empirical knowledge of concrete things. The German mystics of the 14th century, Eckhart and Suso, declared God to be immanent in the whole of creation and marveled at the beauty of the world. By now inanimate things had become worthy of the Christian's admiration, and worthy too of the artist's attentions.

To this new outlook on the world Giotto gave pictorial expression with all the power of his genius. In the interiors in which his religious scenes take place appear familiar objects: a chest, a pair of bellows (fig. 1). And for the first time in a thousand years they are not allusive, schematized forms serving merely as ideograms or symbolic attributes, in accordance with the Byzantine tradition. True, they still perform a spiritual function: they characterize a scene, they evoke for example the candid domestic austerity of the pious matron St. Anne, to whom an angel announces tidings of the birth of Mary. But the means on which the painter draws in order to convey the spiritual significance of these household objects are those of a surprising realism and immeasurably surpass anything produced by Byzantine art in the period of its greatest curiosity about life—i.e. in the 13th century, when the miniaturists of Constantinople were sifting the debris of Hellenistic naturalism ([17]).

Giotto accurately rendered the form and volume of bellows and chest, and their tangible, full-bodied density betokens the atmosphere of the home. These objects have the evocative power of simple theatrical properties. It has been shown that the stage setting of the medieval mystery play is reflected

in Giotto's architectural structures and in his layout of space; from here it is only a step to surmising that he also took to including household objects in his pictures after seeing them used on the stage to identify biblical episodes.

Giotto scrutinized the world with searching intensity and nothing seemed to him beneath the painter's notice. Inanimate objects figure prominently in the frescos of the Scrovegni Chapel at Padua. On the edge of the canopy above the table in the *Marriage at Cana*, he placed a large ewer, isolating it against a uniform background. He even contented himself, in two compartments of this decoration, with representing only a vaulted ceiling, with a large wrought-iron chandelier hanging from it in the foreground. No painter since antiquity had attached so much importance to objects. Yet, curiously enough, of all the art historians who have written about the frescos in the Scrovegni Chapel, the overwhelming majority have paid no attention to these compartments; most of the time they omit all mention of them, as if the novelty of the subject embarrassed them. The notion that Giotto's art posted man at the center of the universe is so firmly planted in the mind that it distorts the judgment. As though it were possible to conceive of each new definition given us by painters, from antiquity onward, of man's place in the universe without a precise description of everything that surrounds him.

For all the power and originality of Giotto's genius, he was not the only painter to give expression to the new interest then being taken in the different aspects of reality. His contemporary, Duccio, in one of the panels of the Maestà, not only shows long white towels hanging from the rafters in readiness for the apostles, while Christ washes their feet, but makes a point of including the sandals which they have just taken off. The Sienese master owes much more than Giotto to the Byzantine tradition. But he revived a good part of the Hellenistic suppleness which had lain dormant in that tradition for centuries past. Like Giotto, however, he omitted all indication of the cast shadows which accompanied objects in ancient painting. He by no means introduced inanimate things in profusion, but he endowed the Sienese School with a taste for that homely atmosphere which approximates a religious episode to a genre scene in which the object assumes increasing importance.

From now on painters tended to linger over objects more and more, and by developing the suggestion contained in the two *Vaulted Ceilings with Chandeliers* at the Scrovegni Chapel, Giotto's immediate followers came to create genuine still lifes, i.e. paintings whose subject matter consisted solely of objects. This occurred before 1340. This important fact was established by Charles de Tolnay, one of the most discerning and productive art historians of our time.

In organizing the Still Life Exhibition at the Orangerie in 1952, I tried to correct the prevailing misconception as to the beginnings of modern still life painting, which is usually assumed to have originated north of the Alps, in the 16th century, in the workshops of Flemish painters and miniaturists. It was made clear at the time that genuine still life pictures are to be found in Italy as early as the middle of the Quattrocento, executed in wooden inlays, a technique derived from the mosaic work of antiquity and closely bound up with painting. I raised the question of their possible relationship with Roman mural decorations in *trompe-l'œil*. Then, even before the exhibition had closed its doors, Charles de Tolnay drew attention to two still lifes painted in fresco by Taddeo Gaddi in 1337 or 1338 ([18]), and their resemblance with the decorations at Pompeii and Herculaneum did not escape his notice. This tied in perfectly with the views set forth in the exhibition catalogue. The beginnings of still life painting must therefore be moved back not one century but two and a half centuries; it unquestionably originated in Italy and the hypothesis as to its connection with ancient painting is thus strongly reinforced.

Gaddi's still lifes decorate the Baroncelli Chapel at Santa Croce in Florence. In two simulated niches, each divided in two by a shelf, we find objects of liturgical use: bread, paten, perfume jar and cruets, in one; a candlestick in a basin and a prayer book, in the other. These simulated niches, painted in *trompe-l'œil*, serve to replace the real niches in which liturgical objects were customarily placed, and which were a common feature of Gothic chapels ([19]). In the same church, among the frescos in the Peruzzi Chapel, Giotto painted a *Presentation of St. John the Baptist*, datable to about 1322; the wall of the temple in which the scene takes place is decorated with two simulated niches, each containing a jug. These are only the accessories of a religious composition but, in the light of Tolnay's discovery, it is quite possible that Giotto had painted independent decorative niches, just as he conceived the compartments at Padua, mentioned above, representing a vaulted ceiling with a chandelier.

At the time when Tolnay made his discovery, those historians who clung to the notion that still life originated north of the Alps could comfort themselves with the thought that Gaddi's still lifes were an exceptional case; today, however, this view is no longer tenable. Our knowledge of the past is so fragmentary, and the number of surviving wall paintings so small, that each extant example must come as a warning to the art historian not to discount a piece of evidence merely because it runs counter to an established idea. After the discovery of Gaddi's *Niches*, it was only to be expected that others would be found. Since the first edition of this book appeared, I have come across a similar work which proves that the Italian tradition of the 14th century lasted into the 15th and, furthermore, that it crossed the Alps. In the church of St. Barbara at Kutná Hora in Bohemia, on the wall of the chapel of the Smišek family, a painter has represented a *Niche* very similar to those of Gaddi. This painting, reproduced here (pl. 7), dates from the last years of the 15th century. It shows a simulated niche containing, at its lowest level, two candlesticks with tapers; above, on a shelf, are two service books; a little above these, fitted into a smaller shelf, are two ewers, each with a eucharistic cup tied to it by a string. That such an example should come to light at Kutná Hora, a rich and important center of the Bohemian mining industry, is significant: documents record the presence there, in 1502, of a Florentine painter of repute, one Roman Vlach (i.e. Roman the Italian), employed in the service of King Vladislav II. Thus there is every reason to suppose that the appearance of this iconographic theme on the walls of St. Barbara's at Kutná Hora was due to his influence [20].

Gaddi's simulated niches are merely an extension of the system of *trompe-l'œil* decoration which the Christian Church no doubt inherited from antiquity. The Byzantine mosaics in the Orthodox Baptistery at Ravenna include several niches in *trompe-l'œil*, each containing a simulated altar on which a book of Holy Scripture lies open. Romanesque and Gothic churches were covered with polychrome paintings simulating marble, architectural moldings, hanging drapery and the like, all figured with illusionist effects of full relief. The inclusion of shade and cast shadows was standard practice, though very often, keeping as they did to studio formulas, these decorators only half understood the plastic value of these elements of modeling. This long tradition accounts for the ease with which Giotto handled the shadows cast by architecture and by moldings, while failing to take any notice of those cast by figures and objects. The niches in the Peruzzi Chapel are accurately lighted, but the jugs standing in them cast no shadows.

The fact that Gaddi's simulated niches are filled with familiar objects standing on two superimposed levels brings them singularly close to the still lifes of antiquity (figs. 10 and 11). Tolnay noted at once, and this is a highly important point, that shadows are duly cast by these objects [21]; this led him to observe that " their illusionist style is perhaps not completely devoid of reminiscences of ancient still life painting, in which objects are often arranged on two levels." When we remember that the practice of substituting a painted still life for real objects was also customary in ancient times, then we may state the problem in its fundamental terms: is this analogy the effect of a direct influence of ancient painting, or is it simply the result of a similarity of outlook between the naturalism of the Giotteschi and the illusionist realism of Hellenistic painting ?

Whenever the art historian thinks himself confronted by a choice between direct influence and similarity of outlook, the problem is only apparent: the one presupposes the other and is inseparable from it. No influence can take effect without there being first of all a similarity of outlook between the two parties concerned; and this affinity is the important thing to bring to light when its presence is indicated by an influence.

The relationship between the artists of the Renaissance and those of antiquity has long been studied from this point of view. The work of Jakob Burckhardt, of Heinrich Wölfflin, of Abe Warburg and his fervent disciples, together with the recent studies of Arnold von Salis, tend to emphasize the discrimination with which Italian painters from the 14th to the 16th century borrowed plastic motifs and ideas from the ancient works they saw around them. These historians are at one in concluding that the esthetic of Italian art was close enough to that of antiquity for Italian artists to find in ancient painting the points of departure they needed in working out original solutions to their own problems. Such was the case, in my opinion, with Gaddi's still lifes in the Baroncelli Chapel. Still, the question arises: is it unreasonable to presume that Gaddi was acquainted with ancient painting at first hand.

There is no lack of evidence to show that ancient Roman frescos and mosaics were more familiar to the men of the 14th century than to those of the 15th and 16th centuries. Since the first edition of this book, an incontrovertible instance of a Trecento Italian artist making use of an ancient painting has come to my knowledge. In a fresco representing the *Earthquake at Ephesus*, painted about 1330-1340 in the church of Sant'Agostino at Rimini, an antique stele is seen breaking and falling to the ground. Now this stele consists of a column to which is attached a painted tablet, surmounted in turn by a gilded statuette. The painted tablet represents what is, beyond the shadow of a doubt, an antique interior shown in perspective and so lighted as to produce a *trompe-l'œil* effect. Painted steles depicting an interior in *trompe-l'œil* were common in ancient times; suffice it to mention those preserved at Helixo and in the museum at Pagasae ([22]). And since the scene represented by the Rimini master is taking place in an ancient city, we are thus provided with a particularly early example of an Italian painter drawing authentic archeological details from antique art. Another century had to elapse before Mantegna, as H. G. Beyen has shown, drew inspiration from the Pompeian Second Style in decorating the Sala della Mappa Mondo in the Palazzo Venezia in Rome.

The number of ancient works extant in Italy during the Middle Ages and the Renaissance was far greater than it is today, and the reader should bear this in mind in the pages that follow. Medieval Rome was littered with gaping ruins, many of which preserved their mural decorations and mosaic pavements up to the middle of the Quattrocento. The number of such works since destroyed in one way or another is incalculable. Frescos have faded away under the action of air and humidity; those of Baiae were already described as all but obliterated in 1194 ([23]). Mosaic pavements cracked and disintegrated under the footsteps of men and flocks. But pillaging took an even greater toll. In the 12th century we find the monk Theophilus urging artists " to seek out the precious mosaic cubes in the ancient buildings of the pagans " ([24]). The Cosmati had no scruples about appropriating large quantities of this choice material. Paintings perished almost daily as the walls of ruin after ruin were wantonly torn down and cleared away. Other works, relatively well preserved, were admired and copied by artists, then in time were buried over and forgotten. Such was the fate of many Campanian ruins visited (according to Vasari) in the late 15th century by the painter Morto da Feltre; in Rome the same fate befell several rooms of Nero's Domus Aurea on the Esquiline (formerly known as the Baths of Titus), whose grotesques were imitated by Raphael and Giovanni da Udine ([25]). In the early years of the Cinquecento Amico Aspertini made many drawings after ancient paintings, from which he borrowed for his fresco in Santa Cecilia at Bologna (1506) and for his miniature in the *Horae Albani* (1512), as was noticed simultaneously in 1957 by Phyllis Pray Bober and Ingvar Bergström ([26]). Aspertini also drew inspiration from the decorations in the Domus Aurea, chiefly from those which at that time were underground. Strange as it may seem, the " Golden House " was abandoned and forgotten after the 16th century, until only a few years ago when excavations again restored its decorations to the light of day. It must be borne in mind that the work of destroying or dismantling the monuments of antiquity went on relentlessly in Rome throughout the 15th and 16th centuries, even while laws were being promulgated for their protection and indignant voices were raised in protest against this vandalism. Seldom has the absurd incoherence of civilized society been so obvious. On the one hand, monuments were being written about in loving detail, excavations were being carried out in search of works of art (chiefly sculptures), which when found were drawn, imitated, praised to the skies; on the other, lime-burners were a daily sight in Rome, tending their kilns in the streets and feeding ancient marbles into them. The wits of the day nicknamed Bramante " Il Ruinante," yet between 1585 and 1590, after two centuries of the Renaissance, Fontana was allowed to tear down the Septizonium, the most imposing ruin in Rome !

Let it not be presumed that we are merely groping in the dark when we seek to evaluate the influence of works long since destroyed. It is easier for us to form an idea of them than might be supposed. First of all, we have prints of the 17th and 18th centuries reproducing paintings and mosaics that are no longer in existence. Others figure in the sketch books of artists from the 15th to the 18th century; many of these sketches have never been adequately studied and are commonly assumed to represent sculptures when actually they may well be copies of paintings or mosaics ([27]). But our most trustworthy and abundant source of information about lost works of art is provided by those that have survived, notably at Pompeii and Herculaneum, where excavations began in the 18th century and are still going on today. The fact

37

that these works have been brought to light so recently has tended to distort the present-day estimate of their influence. It has been taken for granted that no artists prior to the 18th century could possibly have been familiar with ancient painting in all its aspects, since, it is argued, the ruins of Rome could have shown them no more than insignificant vestiges of it. But this assumption takes no account of the fact that ancient painting adhered to rigorous traditions and to established types of representation. We may rest assured that everything that has been brought to light on the walls of Pompeii and Herculaneum, both provincial towns, also existed in Rome; and that the paintings and mosaics of Rome were not only similar to those of Pompeii and Herculaneum, but far more numerous and on the whole of finer quality. So that the paintings salvaged from the ashes of Vesuvius, though they were unknown to artists of the 14th, 15th and 16th centuries, nevertheless give a pretty clear idea of the works which these men could then have seen in Rome. As far as ancient mosaics are concerned, an extremely large number of them have been excavated, especially in North Africa, not to mention those brought to light at Rome and Tivoli from the Renaissance to the present day.

Students of painting are only just beginning to realize that the Old Masters had before their eyes not only ancient sculptures, bas-reliefs and engraved gems, but also frescos and mosaics. A remarkable archeologist, Arnold von Salis, has recently devoted several chapters of a book to analyzing the borrowings made by Renaissance artists from ancient painting (28). It would be easy to swell the list of borrowed motifs drawn up by Salis; he would have done so himself, moreover, were it not that the observations he gives are more than enough to make it quite clear that ancient painting played as influential a part in shaping the spirit of the Quattro- and Cinquecento as ancient sculpture did. This view, however, is still too novel to gain currency among art historians. They continue to attach too much importance to the fact that sculpture was constantly being commented on by ancient writers, whereas mentions of paintings and mosaics are the exception (29). But this could not have been otherwise. Art theorists from Alberti to Vasari were dedicated to the prestige of sculpture and relief. The painters themselves—who may always be depended upon to outdistance the theorists—were much broader in their outlook, much more receptive. True, their own visual and technical conventions prevented them from fully understanding the pictorial originality of Roman decorations. Some generations, however, must have been more attracted than others by certain stylistic aspects of ancient painting: thus, when Giotto and later Piero della Francesca were experimenting with light, their contemporaries could hardly have been blind to the role assigned by ancient painters to cast shadows as a means of suggesting spatial recession. Likewise, when naturalism was on the increase, and the bourgeois and urban sense of life had come to prevail, Italian artists accordingly fell under the spell of certain ancient themes which were a revelation to them, such as pictures devoted exclusively to landscape or to still life. In the days of nascent Mannerism, of the triumph of princely patrons, artists on the contrary delighted in fanciful grotesques and the vagaries of these palace decorations.

Everything points to the conclusion that Giotto and his followers, whose interest in ancient sculpture has been abundantly proved, may also have been familiar with ancient painting; and that their frame of mind predisposed them to find stimulating suggestions in these works. What could these suggestions have been, in the case of Gaddi's still lifes? And to what extent did they influence his art?

Gaddi's simulated niches in the Baroncelli Chapel are clearly not direct imitations of a *xenion* seen on the walls of some ancient ruin. Their style cannot be described as "illusionist," unless the term is taken to mean no more than the general intention to produce a *trompe-l'œil* painting by means of sharply focused, naturalistic lighting. There is nothing here of the vibrant modeling, the shimmering gleams of reflected light, or any of the refinements of Hellenistic painting. The logically controlled lighting of these niches is no more advanced than that of the niches painted by Giotto in the Peruzzi Chapel. Their only novelty is the indication of shadows cast by objects. The fact that this "illusionist" conception is here applied to a subject that was new to the medieval tradition but common in ancient decorations, makes it likely that the initial inspiration came from ancient painting. Precisely because architectural *trompe-l'œil* was standard practice in the Middle Ages, Giotto was able to take over from a Fourth Style painting (of which there must have been plenty of examples in Rome) the idea of placing an isolated vase on a high cornice; and Gaddi, in the same way, was able to fill a simulated niche with liturgical objects in the manner of a *xenion* encountered on a Roman wall. What is important here is that in neither case would

THE ORIGINS OF THE INDEPENDENT MODERN STILL LIFE
Analogies with Antiquity in Medieval and Renaissance Italy.

14th CENTURY

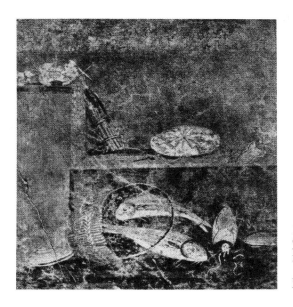

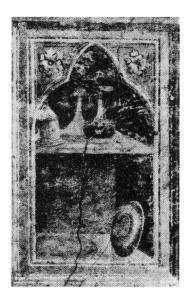

10 - First century (before 79 A. D.). Asparagus, Cakes and Basket of Fish. Xenion. Fresco from Pompeii. Museo Nazionale, Naples. — 11 - TADDEO GADDI. Niche with Bread, Paten, Jar and Cruets. 1337-1338. Fresco. Santa Croce, Florence.

15th CENTURY

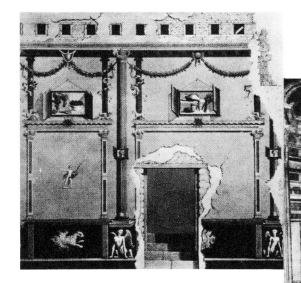

12 - First century B. C. Painted decoration in *trompe-l'œil*, representing simulated pilasters, columns and still life pictures hanging on the wall. House of the Vestals, Pompeii. — 13 - First

century B. C. Architectural decoration painted in *trompe-l'œil*. Fresco. Villa of the Mysteries, Pompeii. 14 - Architecture and still lifes in *trompe-l'œil*. Marquetry in the Studiolo at Urbino. 1476.

Caravaggio !

THE ORIGINS OF THE INDEPENDENT MODERN STILL LIFE
Analogies with Antiquity in the time of the Renaissance.

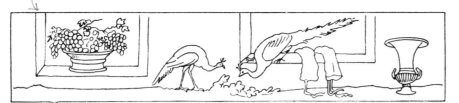

15 - First century B. C. Basket of Grapes, Peacocks and Vase in front of Bays. Fresco from Pompeii. After the sketch in the Répertoire Reinach. — 16 - Basket of Fruit and Squirrel in front of a Bay. Fragment. Marquetry in the Studiolo at Urbino. 1476.

15th CENTURY

16th CENTURY

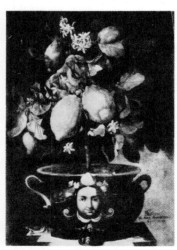

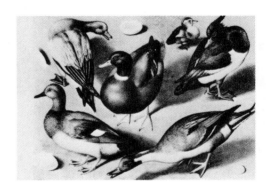

17 - Third or second century B. C. (copy of the second century A. D.). Scraps of a Meal (The Unswept Room). Mosaic. Fragment. Museo Laterano, Rome. — 18 - Roman Art. Fourth century A. D. Ducks. Fragment of a mosaic. Museo Vaticano, Rome. — 19 - Ludger tom Ring (1522-1584)? Ducks and Hard-boiled Eggs. Painting. Private Collection, Italy.

The Origin of Flower Painting is to be sought for in Grotesques.

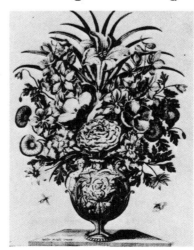

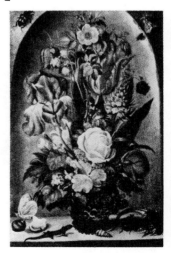

20 - GIOVANNI DA UDINE (early 17th-century copy ?). Vase of Flowers with a Lizard. Dated 1538. Private Collection, Italy. — 21 - JAN SADELER. Vase of Flowers. Engraved at Venice, 1595-1600. — 22 - R. SAVERY. Vase of Flowers, Lizards, Insects. 1603. F. Petschek Collection, New York.

there be any question of an imitation, but only of an encouragement to tackle a new theme: still life serving independently as a mural decoration. From his contact with ancient painting the Gothic artist would have drawn not so much a plastic inspiration as the intellectual resolution to create a new subject. On the strength of what still remained of ancient tradition in the illusionist decorative system of medieval churches, Gaddi could have reconstituted that tradition in his own way, spurred on by a chance encounter with an ancient *xenion*. The significant thing to note is that here we see Western painting committing itself ineluctably to a familiar line of evolution, whose origins are shrouded in the mists of time.

Making the above remarks in connection with still life pictures executed in marquetry in the mid-15th century (which will be discussed at length in a later chapter), I was much struck by the fact that this technique also produced the first landscapes of modern European painting ([30]). In publishing Gaddi's frescos, Charles de Tolnay did not fail to notice a similar phenomenon in the 14th century, and he drew attention to Ambrogio Lorenzetti's famous landscape in the Siena frescos illustrating the Effects of Good Government, which is strictly contemporary with Gaddi's painting in Florence. Now it is remarkable that this innovation should have been made by an artist whom we know to have been interested in antiquity. Lorenzetti made a drawing of a statue of Aphrodite discovered at Siena, and a scrutiny of his famous allegorical figure of *Peace*, with its coy Sibylline grace and the " damp folds " of its drapery, reveals not so much the influence of an ancient relief as that of a painted Roman figure similar to the women of Boscoreale and Herculaneum, with their full-blown faces heavily poised on powerful arms, their thin draperies and their pensive gaze. The style of Lorenzetti's *Peace* is by no means imbued with the full-bodied plasticity that might have been expected, had the model been a piece of sculpture; on the contrary, it is rich in the fine shadings of chiaroscuro which are peculiar to the modulations of painting. The landscape painted in the vicinity of this figure is a vast fragment of the earth's surface conceived in the fanciful, cartographic spirit of imaginary travels—the very spirit breathed by Fazio degli Uberti's *Dittamondo*, which appeared only a few years later. There is nothing to suggest that Lorenzetti was directly influenced by decorative Hellenistic landscape. And yet one cannot help suspecting that it was the sight of an ancient landscape that prompted Lorenzetti's boldness in devoting an entire wall surface solely to the representation of a scene of nature, in which the human figure appears on a very reduced scale. It was not the style of ancient painting that would have struck Gaddi and Lorenzetti, but a type of figuration peculiar to it. Early in the 15th century we find a specific example of this attitude in a medieval artist who was also dedicated to naturalistic representation: Pol de Limbourg. It was noticed long ago that his figure of Adam in the *Très Riches Heures du Duc de Berry* is an almost exact copy of the *Fighting Persian*, and his *Lazarus raised from the Dead* is inspired by the antique personification of a River. Yet, in these nudes, he made no pretence of keeping to the proportions of his models; what he took over was the attitude and movement of the antique figures.

The link with antiquity is even more apparent in two small landscape panels, in the Academy at Siena, which are attributed to Ambrogio or Pietro Lorenzetti. One represents a town beside the sea; the other, fields, hills and houses surrounding a bay in which a ship is sailing. The single figure of a nude bather, the seascape and architecture, and the bird's-eye perspective are reminiscent of the views of busy seaports, peopled with tiny figures, which occur so frequently in ancient paintings and mosaics.

Both Gaddi's niches and Ambrogio Lorenzetti's landscape, however, are essentially medieval creations: the still life has a religious import, while the landscape is allegorical, it serves as the setting for a detailed portrayal of the effects of good government in the country. Yet the fact that each stands in isolation is significant and definitely modern. It testifies to a new intellectual attitude towards the various domains of the visible world. Let it be borne in mind that this was the age of men like Meister Eckhart, whose pantheistic sense of life (as has often been pointed out) seems to reflect the conceptions of the Alexandrian mystics. An all-important question thus arises, namely, whether the reappearance in Renaissance art of the independent branches of painting was not in some measure due to the inspiration of antiquity. We shall have occasion to come back to this point when dealing with the re-emergence in Italy of still life and landscape in the middle of the Quattrocento. For, as Tolnay has aptly observed, the practice of using these as independent themes seems to have disappeared after Gaddi's and Lorenzetti's attempts to introduce them, owing apparently to a regression to the medieval spirit. Significantly enough, Gaddi's still lifes, Lorenzetti's landscapes and the Rimini master's copy of an antique stele all date to the same period:

1330-1340. We are left with the very distinct impression that Italian painting at that time was evolving in the direction of naturalism, taking over in the process some of the themes (but not the style) of ancient painting and moving straight towards the conception of still life, landscape and the interior treated as independent subjects. But this trend was abruptly broken off, and not till a century later, revived by a fresh current of inspiration from antiquity, did it reappear in Italian marquetry. What had happened, as Millard Meiss has shown in his penetrating analysis of these events, was that an economic and social crisis combined with the first great plague epidemic led Florentine and Sienese painting about 1350 to veer away from sensuous naturalism towards a more abstract and intellectual art—an art that harked back to the reassuring certitudes embodied in the traditions and hierarchy of the Church. A very decided reaction against classical antiquity made itself felt: at Siena the mob smashed a statue by Lysippus which had just been brought to light, and which was seen and admired by Ambrogio Lorenzetti ([31]). And while the great dogmatic and allegorical themes of the third quarter of the century (in the Camposanto at Pisa, in the Spanish Chapel at Florence) admitted of many realistic details, these are indicative not of an orientation towards the naturalistic esthetic of antiquity, but of the artists' determination to urge the faithful to penitance with a doctrinal demonstration set forth in more concrete and familiar terms. So that the interest taken in realistic detail did not diminish; if anything, it increased. But the taste for dogmatic narrative and intellectual programs, which now pervaded Florentine painting, had the effect of relegating motifs taken from nature to the role of anecdotal and illustrational accessories. The painter's delight in discovering the visible world now flagged, pending a new wave of enthusiasm for nature in the next century, when landscape and inanimate objects once again became self-sufficient themes, both spiritually and plastically.

In the second half of the 14th century, it was at Siena and in North Italy that painters continued to show a certain curiosity about objects, which figured more and more prominently in religious scenes. Three subjects in particular, each involving the representation of a domestic interior, lent themselves to this treatment: the *Annunciation*, the *Last Supper* and other themes of meal-taking, and the *Saint in his Study*. In the first we find the symbolic vase of flowers and prayer books, tokens of Mary's piety; in the *Last Supper* or *Herod's Feast*, food and utensils; in *St. Jerome in his Study* or an *Evangelist*, books and writing materials—all increasingly varied and lifelike. Here we catch the artist in a more expansive mood: with a dinner table or a cleric's cell he could take liberties which the strict requirements of religious iconography usually forbade. This was an age of passionate bibliophiles, and books overshadowed all other objects in the picture whenever the theme permitted. In the 1350s, in the San Nicolo frescos at Tolentino, we find books cluttering the lecterns, small open cupboards and stools which accompany Evangelist portraits. Towards 1360 Tomaso da Modena assigned an exceptionally important role to books in his portrait series of great Dominicans at Treviso, and he transmitted this motif to the mysterious Theodoric at Karlstein in Bohemia.

Meanwhile, simulated niches containing familiar objects continued to figure in Italian religious scenes: in Pietro Lorenzetti's *Last Supper* at Assisi, for example, where it assumes a more intimate character than in Giotto's and Gaddi's frescos. Painters also took to including small cupboards, with their doors ajar, giving a glimpse of shelves laden with objects, especially books. One of the earliest examples is to be found in the mosaics of the Upper Church of San Francesco at Assisi, ascribed to Rusuti; they represent St. Ambrose and St. Jerome, and date from the early 14th century. This theme of the open cupboard originated in Byzantine art, where it often figures beside the Evangelists in a group of manuscripts believed to have been illuminated at Constantinople in the first half of the 13th century ([32]). In the wake of the Latin conquest and domination of Constantinople, at this very time, came a wave of Byzantine influence on the art of Italy and Germany. That the theme of the open cupboard should have enjoyed so great a vogue in the mid-15th century, both in Italy and north of the Alps, is not surprising. It was an age of inquiry and open-minded curiosity about life, and this antique, unsophisticated motif involving problems of linear and aerial perspective must have appealed to artists' minds. It is important not to lose sight of its Byzantine origin, which may very well go back to antiquity. In the 14th century there was no lack of intermediaries for the transmission of realist motifs from Italy to transalpine Europe. Both Rusuti and his son were employed in France in the service of Philip the Fair. A whole colony of Sienese artists gathered round Simone Martini at Avignon, and his influence—which was momentous—made itself

felt directly both in the Parisian workshops and in those of the Grand Duchy of Burgundy, not only at Dijon but also in the Flemish provinces. From Bohemia, moreover, invigorating reflections of Sienese art combined with the lessons of Tomaso da Modena made their way into Germany.

Tomaso may well have played a leading part in the slow rediscovery of aerial perspective by the generation immediately preceding that of the Master of Flémalle and the Van Eycks. And this in close connection with still life painting, for the books and utensils surrounding Tomaso's *St. Jerome*, painted in 1353-1358 or 1360-1366 on one of the columns of the church of San Nicolo at Treviso, are duly accompanied by delicately thrown shadows (fig. 2). Indeed, those cast by nails, string and a flask are amazing in their precision. This comes as a great surprise, inasmuch as Tomaso showed no such concern in any of his forty portraits of monks painted in 1352: books here are solid cubic forms, vigorously delineated, but they cast no shadows. Obviously the progress made by Gaddi in this direction had failed to bear fruit; Tomaso, at any rate, was ignorant of it. How then are we to account for his sudden interest in relief effects? Pictures of saints studying in their cells carried on the antique tradition of authors' portraits, and in the Evangelist portraits of Carolingian manuscripts we still sometimes find rough, garbled indications of the cast shadows that figure in ancient prototypes. One cannot help wondering whether Tomaso, a painter particularly sensitive to chiaroscuro, may not have been led to explore the problem of cast shadows by the sight of an ancient manuscript in the monks' library at Treviso.

Tomaso da Modena's *St. Jerome* represents the farthest advance made by Italy in the investigation of objects, not only in the 14th century but in the period spanning the first half of the 15th. Generally speaking, North Italian painting of the late 14th century, whose finest flower was the art of Tomaso da Modena, Altichiero, Avanzo, and the Lombard miniaturists of the *Tacuinum Sanitatis*, led the way in studying effects of relief and in expressing the relationships of solid bodies with the surrounding space. Nothing more plastic, more palpable is to be found in painting between Giotto, on the one hand, and the brothers Limbourg, the Master of Flémalle and the Van Eycks, on the other. There is no ruling out the possibility that the Franco-Flemish miniaturists of about 1400, whose contacts with Italy are certain, may have been influenced by these investigations into chiaroscuro which, if taken up and developed by them, would have prepared the way for the amazing plasticity of the Master of Flémalle and the dense aerial envelope of Jan van Eyck, which gave to the painting of objects a new richness and power unsuspected by the ancients ([33]).

THE CONTRIBUTION OF THE NORTH

THE years from about 1375 to 1425 witnessed the expansion of a trend of painting now known as International Gothic or Courtly Gothic. Outdistanced during the Trecento by the schools founded by Giotto and Duccio, the countries north of the Alps now to some extent got their own back. This trend was grafted on to the Sienese influence which nourished it—an influence that was already essentially international, half French, half Italian. But it was determined, at bottom, by the art of the French miniaturists, to which the painters from the Low Countries, realists by instinct, had imparted a new vitality. The Franco-Flemish miniature and the easel painting dependent on it underwent a rapid development in the art centers created by the French princes of the blood, the king and his brothers in Paris, the Dukes of Burgundy at Dijon, the Duke of Berry at Bourges. By the end of the 14th century this new painting had come abreast of the most advanced forms of Italian realism, those of the Lombards.

These works arose in the shadow of the castles and catered for feudal society—the most cosmopolitan of all societies. From court to court, from castle to castle spread pictures imbued with the romance of chivalry, French and archaic in their elegant arabesques, their flat decorative patterning and their courtly grace, Flemish in their realistic, bourgeois-minded boldness. In a short time the contributions of different nations enriched the Franco-Flemish stock, and introduced various shades into it. The essential contribution was that of North Italy. By the end of the 14th century the Lombard miniaturists seem to have outstripped those of France and the Duchy of Burgundy. The pictures in the *Tacuinum Sanitatis* at Vienna, a treatise on hygiene, represent interiors whose homely atmosphere is due above all to a number of familiar objects rendered with verisimilitude and modeled with delicate shadows. The most " modern " of Franco-Flemish illuminations—those in the Bourges *Lectionary*, in Boccaccio's *Livre des Femmes Nobles*, in the Calendar of the *Très Riches Heures du Duc de Berry* by the Limbourg brothers— seem to have profited from the experiments of the Lombards. Painters and miniaturists from the courts of France and Burgundy are known to have gone to Italy. Perhaps they found in the Italian cities a distinctly bourgeois atmosphere such as might have prompted them to introduce a popular vein into their

aristocratic inspiration. It is not in the purely Flemish tradition, as is still too commonly supposed, that we find for the first time the loving description of inanimate things lying in the warm penumbra of a domestic interior. Earlier examples are provided by the North Italian painters, always so sensitive to chiaroscuro and heirs of Sienese realism.

Leaving out of account the best pages of the Calendar in the *Très Riches Heures*, whatever is most lifelike and independent in the still life painting produced by the International Style is to be found in North Italy. In Masolino's *Annunciation* at Castiglione d'Olona the Virgin's writing desk opens out towards us and discloses a shelf of books: this theme of the half-open cupboard, destined soon to play a leading role in the history of still life, held its ground in Italy. In Miretto's allegorical frescos illustrating the influence of the stars on man's destiny, in the Salone at Padua (ca. 1425), objects of all kinds fill several compartments, which thus form independent still lifes. Here perhaps we have a link in a tradition of monumental, decorative still life which may have been practised in Italian castles, and whose significance was wholly secular, whereas that of Gaddi's frescos was religious. Owing to the purpose they served, these compositions are marked by a certain breadth of treatment; but the ambience of anecdotal narration, peculiar to the International Style, prevents them from retaining even the faintest reminiscence of Giotto's epic gravity.

Yet, when we look about for a new definition of inanimate nature, it is not in the Gothic current that we find it. It came into being of its own accord when, putting an end to the fragmentary realism of the International Style, the great founders of the Flemish School, the Master of Flémalle and the Van Eycks, revealed the visible world in its pristine integrity. It is all very well to search out their precursors and urge—what is undoubtedly true—that their art embodies the pantheistic Christianity of the 14th-century mystics: the fact remains that, notwithstanding the most advanced paintings in the *Tacuinum Sanitatis* and the Calendar of the *Très Riches Heures*, the Master of Flémalle and the Van Eycks stand out as unparalleled innovators. Their appearance, like Giotto's, like that of all geniuses, remains enigmatic. What strikes us straightaway in their religious compositions is the absolute equivalence of inanimate nature with all other parts of the picture. For them, man inhabits the world, he does not dominate it by monopolizing our attention, or nearly so, as in the art of their Italian contemporaries. True, his presence—the presence of his thoughts and feelings, rather than that of his body—weighs heavily in each composition. But all the rest, down to the merest pebble in the sand, is rendered with a devout sense of wonder which seems to justify the art historians of our time, when they discern in these paintings the conviction that the divine spirit pervades all created things. We find everything treated with the same intensity of form, color, integument and texture. In the paintings of the Master of Flémalle and Jan van Eyck, every inch of the picture surface is imbued with the tension induced in the artist by the revelation that any object whatsoever raises all these pictorial problems at once. We feel this above all in the Master of Flémalle. Here is a painter obviously at grips, almost step by separate step, with the problems of line, relief, light and cast shadows; whereas Jan of Bruges, whose genius lay in his perfect equilibrium, achieved the miracle of a complete, flawlessly integrated rendering—a pictorial counterpart of the profound organic unity which reality itself presented him with in all its aspects. This tends to corroborate the view that the Master of Flémalle preceded Van Eyck ([34]); and this is why his lesson, amplified by that of his pupil Roger van der Weyden, proved more fruitful than the example, too difficult to follow, of the Ghent Altarpiece.

Indeed, turning to the basin, towel rack, candle and books in the Master of Flémalle's *Annunciation*, we have no trouble in making out their form, their relief, their lighting. At every point their plasticity meets the test of our eye and touch. Their salient volumes are almost aggressive in their utter simplicity, for they stand out in crystalline air, under a harsh light that casts shadows as strong and sharp as those of sculptures. The eye readily discerns the part played by contour and modeling in the evocation of each body. A painter's eye discerns and assimilates it at a glance. Such is hardly the case with objects as painted by Van Eyck. In front of the apple lying on the window sill or the shoes on the floor in the *Portrait of Giovanni Arnolfini and his Wife*, one is left with a feeling of bafflement. Is it their precise design, persuasive lighting and sensual richness of texture to which we owe the certitude of their existence ? But part of the contour is blurred by a patch of shadow; the full swell of volumes is flattened out by impinging light; the density of the air filtering the rays of light renders the integument uneven. It is precisely by means of the intimate fusion of everything which the Master of Flémalle almost seems to enumerate that

Van Eyck depicts reality with such compelling directness. This cohesion has always seemed mysterious and inimitable. Not till the end of the 15th century did the Flemish School feel mature enough to pry into its secret.

So it was mainly the lucid demonstration of the new aims of painting, as set forth in the work of the Master of Flémalle, that won over at once a whole generation of "moderns." Painters throughout Europe, from about 1440 to 1460, produced more and more pictures in which objects stand out with an energy unknown to International Gothic: witness in France the Master of the Aix Annunciation; in the Germanic countries, Conrad Witz, the Bavarian painter employed in 1437 by Hans Multscher, the Master of the Tucher Altarpiece (fig. 24), the Annunciation of the Master of the Polling Altarpieces, and Justus Amman of Ravensburg who, in 1451 at Genoa, left an *Annunciation* which seems to be closely connected with that of Aix; in Italy, Fra Filippo Lippi (from 1437 on), and Niccolo Pizzolo and Antonio da Fabriano (from 1451 on) [35]. Each of these men painted objects with a kind of emphatic verisimilitude—objects not only caught in a sudden shaft of light and jutting out as if thrown into the air towards us, but minutely figured with all the particularities and accidents of their surface. Wood displays its knots and graining, stone its anfractuosities, metal its texture and abrasions. Around the saint, studiously ensconced in his cell, books and utensils, bottles and boxes clutter the writing desk and the wall cupboard. Recorded with cool, bright colors and incisive contours by the painters stemming from the Master of Flémalle, these objects are like the characteristics of a habitat, carefully stated one by one by a naturalist. Painted with saturated tones and immersed in a soft penumbra by such Eyckian adepts as Collantonio and Antonello, they are linked together in an atmosphere of lyrical intimacy which seems to convey an echo of long vigils and solitary meditations. Their haphazard position and often precarious equilibrium tell of their incessant manipulation by human hands and suggest the instantaneous touch which the rhythm of daily life impresses on the existence of material things, on their placid and ponderous mass (fig. 3).

The fact of their sharing a general conception of painting, Flemish in origin, did not prevent all these artists from handling objects on more or less individual lines dictated by their own temperament and by the exigencies of their own countries. The books of the Aix Master, who was either a Flemish-trained Frenchman or a Gallicized Fleming, lie interconnected in a continuous, clear, harmonious movement (fig. 4). The grouping of miscellaneous objects in the Tucher Altarpiece is crowded and confused (fig. 24). The German painter has interpreted the Flemish lesson with vehement effects of rhetoric and lyricism. The Latin temperament of the Aix Master has drawn from the same source a serene handling of lines and volumes. For all its easy familiarity, his still life has an air of solemn grandeur, accompanying as it does a statue of a prophet. In South Germany were such men as Witz, and the Tucher Master, bourgeois-minded (like the Flemings) and peasants at heart, eager for expression in the Germanic sense of the term; they built up objects in a way that made their utilitarian virtues plain, and showed an almost relentless eagerness to put them within reach of our hand and under its control. But Niccolo Pizzolo arranged books and bottles in a dazzling clarity, echeloned in space in strict accordance with correct perspective, as if classified and labeled by an accountant of the Medici for whom the Latin love of order was the great light of a new era.

In the course of the 15th century, in all the countries north of the Alps, painters increased the amount of furniture and the number of objects in the room of the Annunciation and in St. Jerome's study. In keeping with the medieval spirit, these invariably consisted of certain familiar objects, with a symbolic meaning attaching to them; but they are combined with others, also borrowed from daily life, so that the Virgin or the particular saint portrayed appeared to the faithful in the guise of a contemporary. In the Annunciation, as we have seen, the basin, pitcher and towel evoke the purity of the Virgin; the many books beside her indicate her piety (pl. 9). In clerics' cells we find symbols of sacred learning and patient studies pursued in the silence of the night: books and parchments, an inkstand, a candle or lamp, instruments for measuring time and space, a compass, a square, an hourglass; amidst the disorder in which the absent-minded scholar lives and works, they stand side by side with bottles, boxes and remnants of a frugal meal, a piece of fruit and a crust of bread.

Almost as soon as they realized the pictorial interest of these objects, artists showed a tendency to isolate them from the rest of the religious composition, in such a way as to focus attention on them. Already, in the Ghent Altarpiece, Van Eyck had filled niches with fascinating still lifes, and showed no

hesitation about devoting an entire compartment to this theme. Thereafter a niche in the wall or a small half-opened cupboard, already known in 14th-century Italian painting, came into use in painting north of the Alps, constituting motifs on the verge, we feel, of detaching themselves from the religious scenes in which they figure. The books lying on a shelf above the prophet Isaiah, on the left wing of the Aix *Annunciation*, have been separated from the rest of the panel, in conformity with the modern taste for independent still lifes. They now form a picture which we today find wholly satisfying. Yet the artist himself would never have dreamed of painting them alone on a separate panel and proposing such a work to his contemporaries. If by the 15th century the pictorial interest of a motif like this was fully recognized, the purely esthetic idea that the beauty of inanimate things justifies their representation in separate pictures was still unthinkable in the Low Countries. For objects, like plant life and everything else which painters represented, were permeated with religious significance. For certain objects or groups of objects, that significance had to gain sufficient breadth of meaning in men's minds for the artist to run the risk of embodying them in an independent painting. The still lifes thus obtained did not cease to be religious pictures.

Two types of such still lifes appeared in the Low Countries in the course of the 15th century: the *Vanitas* and the *Attributes of the Virgin or of a Saint*. These are invariably to be found on the outer sides of the wings of diptychs or triptychs.

The earliest known example of a *Vanitas* in easel painting is the picture of a skull placed beside a chipped brick, painted by Roger van der Weyden about 1450 on a panel of the famous Braque Triptych (Louvre). Charged with symbolic meaning, these objects stand in the full glare of bright light, against a black, impenetrable background. A *trompe-l'œil* effect thus reinforces the moral import of a *memento mori*, in which the skull and a worn or broken object evoke the precariousness of man's existence and time's inexorable sway over life and matter. The artist feels the full force of the impact added to the highly realistic image of a death's head by intense light and sharp relief; and he reckons with the shock produced by the hallucinating physical presence of this symbol. By exploiting the resources of "magic realism," which the Surrealists have reinstated in the painting of our time, he induces a mood of mystical pensiveness.

From Van der Weyden on, *Vanitas* pictures appeared regularly in Flemish painting [36]. They are sometimes reduced to a single skull, sometimes composed of a skull and an object with symbolic associations, for example a candle steadily burning away, just as the days of human life are inexorably consumed. They often include explanatory inscriptions, written on sheets of paper or parchment, which have nothing abstract or decorative about them, but are so many tangible objects (pl. 8). Such pictures seem to disappear after the first quarter of the 16th century, at the very time, that is, when the Italian Renaissance invaded the Low Countries and banished the medieval spirit. And yet, however Gothic and medieval these *Skulls* are, simple incunabula of the complex, symbol-charged *Vanitas* pictures of the 17th century, there is reason to believe that they may have been based on ancient traditions of which no perceptible trace now remains. For the Romans were familiar with pictures of a skull accompanied by a symbol suggestive of the vanity of earthly things in the face of death. A mosaic discovered at Pompeii shows a skull surmounted by a level and flanked by attributes of the beggar and the king, thus evoking the equality of all men in the shadow of death—"*mors omnia aequat*" (fig. 35) [37].

That these classical images, richer in symbols and more intellectual in their allusions than the medieval *Skulls* of Northern Europe, were familiar to the Italian humanists of the Quattrocento can hardly be doubted when we find, at the beginning of the 16th century (but probably in pursuance of an earlier tradition, traces of which cannot fail to be detected in due course), that Italian marquetry contains symbols of earthly power. The inlaid panel reproduced here (fig. 36), executed by Fra Vincenzo dalle Vacche, displays emblems of ecclesiastical power, the papal cross and the miters of a bishop and an abbot, placed beside the royal crown, emblem of secular power, and surrounding a skull and an hour-glass, symbols of death and the irreversible flow of time; other symbols accompany them [38]. Another panel of the same decorative sequence represents geometry books and scientific instruments, together with guttered tapers, still smoking, and cords that have snapped under strain—further symbols of the fragility of the things of this world. These two compositions inculcate the notion that all man's power and science must humble themselves before those of God, Supreme Architect of the Universe, and before the leveling powers of death. The thought and feeling behind these pictures are medieval and humanistic at once, in accordance

with the humanism of the Quattrocento, which sought for and still readily found a synthesis between the new conception of the world and Christian doctrine. We feel here a kind of romantic sentimentality, which must have touched the creators of the Baroque *Vanitas* picture. This is the very reverse of the stoic thought, rationalistic and objective, which inspired the antique *Vanitas*. And yet it seems difficult to admit that, in taking up the idea of these complex, allusive themes, the humanist monks who produced so much of the great marquetry of the Quattrocento could have been ignorant of the allegories of the ancients, whose procedures and aims, if not their exact iconography, were so similar. Let it not be forgotten that Italian marquetry descended in an unbroken line from antique mosaic work, and that the Pompeian *Vanitas* is executed in precisely this technique. Who would be rash enough to affirm that no other Roman mosaics on this subject were known in the 15th century ? ([39]).

The Italians of the late 15th century also adopted the practice of representing a skull on the back of a portrait, as the Flemings did. Thus, on the back of Boltraffio's fine *Portrait of a Young Man* (Chatsworth Collection), we find a skull lying in a niche painted in *trompe-l'œil*, and accompanied by a Latin inscription signifying: " I am the image of Girolamo Casio." Although Boltraffio belonged to the circle of Leonardo's followers, whose connections with Flemish painting were marked, it is unnecessary to look to the North in order to explain the presence of this *Vanitas* symbol in an Italian painting. Here, as in the *Vanitas* pictures in Italian marquetry, we may very well be in touch with a southern iconographic tradition. The inscription is significant in this respect: the talking skull (like the talking skeleton or tomb) forms part of an undeniably antique tradition ([40]).

It has been hitherto assumed that the Dutch *Vanitas* of the 17th century grew out of pictures of St. Jerome meditating in his cell; the skull, hourglass, candles and books standing beside him seem already to provide the subject matter that went into the compositions of David Bailly, Steenwijck and so many others. But it has never been explained how the theme of St. Jerome, so well defined iconographically, could have given rise to the autonomous, genuine, emblematic *Vanitas*. Suggestions to the effect that the humanist milieu of Leyden University might have played a decisive part in the creation of the *Vanitas* picture pointed in the right direction, but nevertheless have remained very vague ([41]). In the light of Italian marquetries, which often turn on the *Vanitas* theme, those of Fra Vincenzo dalle Vacche being the most highly developed, it is clear that the origin of the Dutch compositions (and others) of the 17th century is to be sought for in the humanist circles of 15th-century Italy, which, in turn, may to some extent have drawn on the antique tradition.

From then on, the *Vanitas* theme never ceased to attract artists. The 17th century virtually made a cult of it. And when, with Cézanne (fig. 38), the 19th century reacted against the art conception of the Impressionists, devoid as it was of either romanticism or intellectuality, the terrible incarnation of death in the guise of human bones reappeared, sometimes—as in Braque's work—with a traditional repertory of religious symbols (fig. 39). This is a striking example of the inflexibility of certain themes which touch man at the core of his being; it would seem that the artists who seize on them make a point of showing that the new grandeur they discern in them needs no more its expression than renewed forms. Yet Picasso, after coming home from the funeral of his friend Julio Gonzalès, set to work and painted a *Bull's Skull* (pl. 120). The moving whiteness of these animal bones and the blank stare of this skull, which voices the harrowing perplexity of every living creature in the face of death, make it a *Vanitas*, one of the simplest and most powerful ever conceived.

After the *Vanitas*, the independent pictures of *Attributes of the Virgin or of a Saint* represent a liberation as far as subject matter goes. Only a few examples of these are so far known to exist. All are the work of the Flemish School and date from about 1470 to 1500. On the back of the *Virgin and Child*, painted by an artist who followed Roger van der Weyden and Hugo van der Goes, a niche is represented in a wall; on a shelf half way up stand five or six books; below are a basin and a ewer; on the wall, to the left, a white towel hangs from a rack adorned with a metal plaque (pl. 9). Each of these elements had been common in Flemish *Annunciations* ever since the Master of Flémalle and Jan van Eyck. But here they are brought together to form a genuine still life. The quality of this picture is so much superior to that of the *Virgin and Child* on the other side, its accent is so much more vigorous and deeply felt, that it may be wondered whether this is not the work of an artist who specialized in painting objects. By this time, in the large medieval studios, there may already have been a division of labor according to individual

48

ability. Another picture of the *Attributes of the Virgin*, painted by Hans Memling, forms the reverse of a *Portrait of a Man ;* here, in a niche, we see a table covered with an Oriental rug on which stands a vase containing lilies and irises; this is the vase of the *Annunciation* with the flowers symbolizing Mary's purity and heavenly sovereignty. What we have here is one shutter of a diptych; when it was closed, these attributes covered the image of the Virgin. Memling has also left us a picture of a niche containing the *Chalice of St. John the Evangelist*, painted on the back of a *St. Veronica* (⁴²). Finally, a later example, dating from the early years of the 16th century, is provided by Jan Provost's *Virgin and Child* (Galleria Alberoni, Piacenza), on the back of which is a charming *Vase with a Carnation* (⁴³).

There have been attempts to belittle the importance of these still lifes on the backs of shutters by alleging them to be merely secondary parts of the polyptychs in which they figure. But the very opposite is true. These polyptychs were only opened on great occasions; it was precisely the reverse sides of the shutters that remained visible all the rest of the time. First thing in the morning, the eye was met by a *Vanitas* or a symbolic representation, in terms of still life, of the Virgin or saints; they often stood close to the bed, on the domestic altar or hanging on the wall. So these were already pictures in their own right, on an equal footing with religious scenes. But while they were plastically independent, they were not intellectually independent, for once separated from their iconographic context, from the other subjects on the diptych or triptych, they lost their spiritual significance.

All these pictures are remarkably small (the largest does not exceed 13 3/4 by 10 inches) and their connection with contemporary Flemish miniatures seems obvious (⁴⁴). In countries where the miniature was still a living branch of painting, there could not fail to be exchanges between it and easel painting. So it was in France and the Low Countries in the 15th century. For their reciprocal borrowings to prove fruitful, it was indispensable for the two fields of painting to tend to attain the same phase of plastic evolution. By the end of the 14th century the easel picture had laboriously risen to the level of the miniature. After the Master of Flémalle and Van Eyck, it was illumination, on the contrary, that borrowed the illusionist esthetic from easel painting. But the most advanced miniatures of the mid-15th century, those of Fouquet and the Master of King René, though they were nothing less than small pictures in their own right, still retained flat decorative harmonies and the use of gold. It was only about 1480 that the *trompe-l'œil* esthetic destroyed the decorative prestige of illumination. By this time, in manuscripts illuminated in Ghent, Bruges and in France, we find the same features of relief and depth in the margins as in the main scene, which had long been treated as a picture. The whole page was now made to conform to a perspective vision. In the work of the great innovator known as the Master of Mary of Burgundy, margins are sprinkled with isolated flowers and plants painted in *trompe-l'œil*, with their shadows cast over the page. Elsewhere a religious scene is framed in a window, on the sill of which, in the foreground of the composition, lies a still life composed of a jewel case, a cushion, a flask and a book. Other margins show small niches in which a vase, a bowl of fruit or a glass with flowers stand out clearly against the background, forming an exquisite still life.

Here, as often in the Middle Ages, we catch a bold artist taking liberties that were still unknown in mural and easel painting. They sprang from the untrammeled freedom enjoyed by the miniaturist, who worked for enlightened, open-minded patrons, avid of the new and, on occasion, of the rare. So that no sooner had the miniaturist equaled the realism of the easel picture than he went one better and painted objects for their own sake. And it was the example of miniaturists like the Master of Mary of Burgundy that prompted Memling and others to represent the vase of the *Annunciation* in a niche (⁴⁵).

As painted in *trompe-l'œil* by the Master of Mary of Burgundy, these vases and bowls of fruit are reminiscent of *xenia*. It comes as no surprise to find Otto Pächt, in his discerning study of this artist, turning to the mosaics of antiquity in search of the origins of this illusionist style. The effect of flowers and rinceaux disseminated on the white ground of the page (⁴⁶) singularly resembles that of the *Unswept Room*, by Sosos (pl. 4), or that of mosaics much closer to the Middle Ages, for example the decorations in Santa Costanza in Rome. Early manuscripts, both Carolingian (Sacramentary of Drogo, 9th century) and Byzantine (Psalter of Theodoros of Caesarea, Constantinople, dated 1066, British Museum, Add. 19352), show the spell periodically cast on the imagination of medieval artists by natural forms sharply modeled and freely distributed over a light-colored background, invariably stemming from the antique tradition.

By the end of the 14th century this ornamentation, which stands apart from Gothic decorative rhythms, made its appearance in North Italy. Pächt has drawn attention to a manuscript whose border, tinted blue in imitation of water, is sprinkled as if at random with lifelike seashells and crustaceans (47). That this is an instance of Hellenistic inspiration seems to me highly probable. This was the period in which the Sienese passion for studying nature was transmitted to the Lombards, and the question of a stimulus coming from the age-old Mediterranean tradition has already arisen in connection with Gaddi and Lorenzetti. Now, as once before around 1340, the Italians seem to have abandoned an art form which they only reinvented incidentally. But Pächt makes much of the fact that the first attempts at illusionism in the borders of Flemish manuscripts were made by artists whose ties with Italy were most direct, such as the Limbourg brothers. Thus there are grounds for holding that the idea of isolating a plant, a flower, a piece of fruit or an object and evoking its tangible appearance may have been suggested to the Flemings by the Italians, and to the latter by their discovery, at the very time of a passionate inquiry into nature, of the amazing effects achieved in ancient mosaics.

Whatever the origins of the new ornamentation of manuscripts, the Master of Mary of Burgundy seems to have created his still lifes within the framework of the Flemish tradition, without looking to Italy. He was one of the first, at the end of the 15th century, to go back to the very sources of his school, to the Eyckian spirit of total illusion, which he sought to resuscitate. He succeeded in creating not only still lifes but also tiny independent landscapes in which the " modern " spontaneity of the views of open country in the Turin Hours seems to come to life again. This simultaneous appearance of two genres proves that there can be no question here of accidental fancies; this art was a coherent expression of all the aspects of the visible world which were now rousing artists to a particularly intense effort of concentration.

The position of Flemish painting about 1480 was thus comparable to that of Italian painting in the 14th century. The Netherlandish School was on the point of creating the independent genres of still life and landscape, but it ventured as yet no more than a timid essay, in miniature painting and afterwards in the small shutters of diptychs; in works, that is, which were intended for private libraries or bedrooms, and whose action therefore was very limited in scope. Their courage failed the Netherlanders, for their public was not yet ripe for these innovations. Medieval habits of thought had first to be broken, the object and the image of nature had to be freed from religious tutelage and made worthy of being represented and esthetically appreciated for their own sake, cleared of the sacred allusions in which the centuries had steeped them. In other words, men had to adapt themselves to the secular spirit, to the scientific and humanistic way of thinking, to the outlook of the Renaissance. If this is so, and if I am not mistaken, it is in Italy that we have to look for the first still lifes and the first landscapes on a large scale, treated as independent subjects and proudly displayed before the eyes of all in public buildings, in churches and palaces. And in fact it is in Italy that we find them, a quarter of a century before the earliest innovations of the Master of Mary of Burgundy. When recent study found even earlier examples (dated 1465) of Northern trompe-l'oeil in book illumination, it was, significantly enough, in the work of Jean de Laval, an artist closely connected with Jean Fouquet, whose debt to the Florentine Quattrocento is a fundamental one.

50

CHAPTER FOUR

THE RENAISSANCE AND STILL LIFE

Marquetry.

THERE is one category of art produced in Quattrocento Italy to which historians have never attached the importance it deserves. I refer to marquetry, inlays of colored pieces of wood—often admirable works. Their technique assimilates them to mosaic, but the effects aimed at are those of painting. Marquetry thus provides us with information about the contemporary tendencies of Italian painting, on which it depended and which it reflected. Excellent painters showed no reluctance to furnish models for decorations of inlaid wood: Piero della Francesca, Sandro Botticelli, Alessio Baldovinetti, Lorenzo Lotto. And in interpreting the cartoons in accordance with the laws of their technique and medium, the marquetry makers showed themselves on more than one occasion to be artists of exceptional stature. The names of Lorenzo and Cristoforo Canozzi da Lendinara, Baccio Pontelli, Giuliano and Benedetto da Maiano, Fra Giovanni da Verona and Fra Vincenzo dalle Vacche deserve to appear even in a brief survey of the history of Quattrocento Italian painting.

According to Vasari, the origins of the art of making pictures out of inlaid wood go back to the time of Brunelleschi and Paolo Uccello, i.e. to the second quarter of the 15th century. In his remarkable little book on *Tarsie*, Francesco Arcangeli reckons that none of them are to be dated any earlier than about 1450. But we are very ill-informed about the exact nature of the work carried out by the great *maestri di legname* contemporary with Brunelleschi, and Vasari may be right after all (48). I am inclined to share the opinion of André Chastel, who is preparing a fundamental study of the subject, and who assigns the beginnings of marquetry and certain extant examples of it to the first third of the 15th century (49). However this may be, no milieu could have been more favorable to the new orientation towards *trompe-l'œil* decoration in mosaic than that of the most advanced Florentine studios, where painters were fascinated by the problems of volume and perspective. Uccello's pictures, with their geometrically simplified forms and contours, their schematized light and shade, and their flat tints equivalent to so many planes in space,

51

bear a striking resemblance to the earliest extant pieces of Tuscan marquetry. Though the brothers Lendinara depend directly on Piero della Francesca, we are nonetheless aware in their work of traditions that go back to Uccello. Certain of the latter's paintings, the predella scenes of the *Miracle of the Host* (Urbino), for example, could be transposed into marquetry without being distorted in their essential effect. And whenever we meet with a motif foreshadowing the repertory of wood inlays, it is in the orbit of Uccello's influence that we find it: such are the still lifes surmounting the mosaic of the *Visitation* in the Mascoli Chapel at St. Mark's in Venice [50], such too are the desks of Niccolo Pizzolo's *Four Evangelists* in the Eremitani at Padua.

The inlays by the Lendinaras decorating the stalls in Modena Cathedral, executed between 1461 and 1465, contain many compartments devoted to still life. Closed and open books, whose significance in a choir decoration is patently religious, alternate with motifs apparently devoid of symbolic allusions, a carpenter's plane, for example, or a parrot [51].

Their style is severe and limpid at once; a well-defined light impinges on surfaces and hems contours, in such a way that forms appear almost ghostly, as if reduced to their geometrical framework. Objects are represented in the half-light of small cupboards whose doors open out towards us. Our eye probes the shadows for them, and they slowly materialize with a kind of dispassionate magic. In spite of a relative simplicity of technique, we feel that this is a consummate art, fully conscious of its plastic and poetic resources. The Lendinaras' major work comprised a very similar type of decoration; this was the choir of the " Santo " at Padua, executed between 1462 and 1469 and destroyed in the 18th century, but known to us by an enthusiastic description of it [52]. Here, beside piles or shelves of books, open or closed, there were candles in wooden bowls, musical instruments, cages with slender bars, baskets full of fish, some of them slipping out and falling. Presumably these still lifes met with an immediate success, for in 1473 Cristoforo da Lendinara finished a marquetry ensemble in Parma Cathedral which was virtually a replica of that at Modena.

Three years later similar still life panels appeared in one of the leading centers of the Renaissance—the Ducal Palace at Urbino. There Duke Federico da Montefeltro had the walls of a *studiolo* covered with marquetry. Illusion is the keynote of the work (fig. 14). Entering the room the visitor finds himself in front of fluted pilasters flanking large wardrobes whose open doors display a variety of objects. Lower down, the wall is hollowed out by niches in which more objects shine in half-light, while benches stand there on which a musical instrument or a piece of armor has been nonchalantly placed. Elsewhere a bay opens on the arches of a portico giving on a vast landscape [53]; in the foreground of this bay stands a basket of fruit, while hard by a squirrel is peacefully nibbling at a nut. All this seems to lie at arm's length, but the hand, as it reaches out, meets only the smooth surface of the colored wood. In another *studiolo* made for the duke a few years later at Gubbio (now in the Metropolitan Museum of Art, New York), the illusion is even more complete and more successful. Here the artist shows no interest, or very little, in imitating living beings. At Urbino, in addition to the portrait of Duke Federico, there were allegorical figures of Virtues, the squirrel and the landscape filled with water and shifting light. At Gubbio a single bird is discernible in the shadows of a cage, behind serried bars. As we cross the threshold, the spell cast by inanimate nature takes on the compelling force of an obsession. In this small closed room we are almost overwhelmed by objects and the furniture on which they stand. They seem to reveal themselves to us in their essential forms, hitherto unsuspected under the aspects lent them by daily use. We take in their protrusions and their hollows, and the full weight of their bodies. They suddenly people the silence with insistent life. All the more compelling in that they elude the control of touch while never losing their power of conviction over the eye, they lead the mind to engage in a brisk dialogue, as it were, with the eye; to discover with amazement a whole world of forms with the help of a sense whose isolated powers have seemingly increased tenfold; and lastly to surrender to the enchantment of the equivocal. The representation of inanimate objects, which plays a secondary part in painting, here becomes a source of esthetic and intellectual enjoyment. The choice of exclusively profane motifs contributes to the satisfaction of the mind: both at Urbino and Gubbio the familiars of the duke and his lettered guests could readily decipher the symbols of the arts and sciences, tokens of the prince's tastes, and recognize the high distinctions of knighthood that ministered to his pride [54].

There has been a good deal of discussion as to the possible authors of these remarkable decorations. The names most often put forward, and with the greatest plausibility, are those of Francesco di Giorgio

and Botticelli. The latter was suggested by Roberto Longhi, and it must be admitted that, in addition to the rather striking Botticellian features in the figures of the Urbino *studiolo*, the accompanying still lifes present some genuine analogies with the books and astronomical instruments in the *St. Augustine* painted by Botticelli in the Ognissanti at Florence ([55]). It is generally agreed that Baccio Pontelli was probably responsible for the actual execution of the work.

But little thought has been devoted to tracing to its source the conception of this highly original decorative system ([56]), in which interest centers so conspicuously on still life and landscape both treated as independent subjects. The *studioli* present a whole complex of simulated architecture, which either houses objects or opens on a landscape of water and mountains, dotted with grandiose buildings in the classical style. We also find a basket of fruit and a squirrel nibbling at a nut. All these motifs, one after another, figure in antique decorative paintings of the Second and Fourth Style. Compare the simulated pilasters and cornices at Pompeii with those at Urbino and Gubbio, and this simulated wardrobe with its lattice-work doors, embedded between two columns above a projecting entablature (figs. 13 and 14). For the pictures representing niches with still life, shown with their shutters open, substitute wardrobes with their doors ajar and projecting outward (figs. 12 and 14). Bring to mind landscapes dotted with vast buildings, and baskets of fruit accompanied by living animals and placed in the foreground of a window or in an embrasure, exactly as at Urbino (figs. 15 and 16). You will then have a series of analogies which a common conception—that of a *trompe-l'œil* wall decoration incorporating realistic still life and landscape —proceeds to render quite remarkable. Court circles at Urbino were humanistic *par excellence*; their desire to seek inspiration from the ancients comes as no surprise. But it may be rewarding to inquire into the manner in which that inspiration came into play, and the extent to which it took effect. Should we assume that the men who conceived the Urbino decorations had seen ancient paintings? The possi-bility that they had seen such works is by no means to be ruled out around 1475. Some fifteen years later the painter Morto da Feltre went underground in order to copy ancient paintings and mosaics in Rome and in many towns in Campania. It is perfectly conceivable that all the elements contained in these inlays may have been suggested, one by one, by paintings glimpsed in ancient ruins. What seems to me quite certain is that the conception itself of this *trompe-l'œil* wall decoration did indeed derive from antiquity. It could have been deduced from fragments of then existing decorations and completed by the reading of a Greek or Latin text, by a description of wall paintings, such as are to be found in Vitruvius, in Pliny, in Lucian, in Philostratus. Our knowledge today does not extend to all the ancient texts that might have been consulted by the humanists at the court of Urbino before imagining the highly elaborate décor of the duke's *studiolo*. Philostratus, for example, mentions descriptions of paintings that " others had made before me." The men of the 15th century took great liberties with ancient models. They had a keen awareness of their period and made an arbitrary choice among the treasures of the past which they resuscitated only to the extent required by their own needs. Botticelli, in particular, had undoubtedly seen antique stuccos, and perhaps paintings as well; but the supple silhouettes into which he transmuted them are no more than a dream on an antique theme. The marquetry at Urbino and Gubbio seems to me to reflect what the Urbino humanists, painters and scholars, believed to be a decoration worthy of a modern Caesar.

One of the essential contributions of Italian marquetry is that it promoted still life and landscape to the rank of independent subjects and triumphantly displayed them in churches and palaces. The intel-lectual decision to create these two new genres of painting was therefore made by the Italian humanists of the 15th century; they were not, as histories of art persist in repeating, a creation of the North, of the Low Countries in particular, where they did not appear till the following century. The great panoramic view in the Urbino *studiolo* (1476) and the townscapes in marquetry at Modena and Lucca (1488) antedate the first pure landscapes of Flemish painting by several decades. It is quite possible in fact that Patinir's landscapes, whose appearance coincides with the first direct contacts between Flemish and Italian painting, owe their origin to humanistic ideas. All their elements had been prepared long ago by the Eyckian school, and Bosch seemed on the verge of making landscape independent. But for some reason the last great medieval-minded painter failed to take the decisive step. The credit for it goes to the Italians, tireless creators of types and themes, and their decision was inspired by the heritage that had come down to them from antiquity. When other independent genres came into being shortly afterwards, it is in

Italy, not in Flanders, that they first appeared. The first animal subjects occur in Italian prints—combats of animals deriving from the circus scenes in ancient mosaics ([57]). In Italy too we find the first flower pictures, under the brush of the decorators whose imagination was dominated by the grotesques in Nero's Domus Aurea ([58]). It is not unreasonable to regard this breaking up of painting into different genres as but one aspect of the revival of ancient thought, and to see it as corresponding to the rationalized conception of the world propagated by the humanists. The Northerners, naturalists and specialists by instinct, were apparently predisposed to follow up this approach to painting and did so at once with brilliant results. They were, however, the virtuosi of this method, not the creators of it. But that is the subject of a whole book in itself, and a fascinating subject.

A close study of these marquetry still lifes reveals two characteristics: a powerful, purely Italian tradition and a certain contamination by the Northern spirit. The motif of the niche with objects, painted in *trompe-l'œil* in a wall decoration, had been known in Italian painting since Taddeo Gaddi and practised in the 15th century. Marquetry had simply been substituted for fresco painting in an illusionist decorative system deriving from antiquity ([59]). The style of this inlaid work was also essentially Italian, such as could have taken shape only in the entourage of Piero della Francesca. Its composition is ordered with a wholly Latin clarity; volumes are defined with geometric purity; the rigorously scientific perspective, inspired by Piero, totally differs from the purely empirical perspective of the North. This is brought home with full force as soon as we compare a panel from Urbino with a similar motif in a German picture of the mid-15th century, for example the Tucher Altarpiece (figs. 24 and 25).

Yet, at the same time, such a comparison makes us aware of an underlying spiritual kinship. The abundance of objects in the wardrobes represented at Urbino and Gubbio and a certain weakening of the monumental rhythm of their composition seem to estrange these still lifes from the pure Italian tradition. They betray an echo of the anecdotal taste of the North, which led the Flemish and German masters to multiply details in their niches and cupboards, and to throw objects into sharp contrast, stamping them as a whole with a fortuitous character. At the time these marquetries were made, about 1476-1480, Urbino was a center of Flemish influence, which stemmed both directly from Flanders, through Joos van Ghent, and from South Italy, through the Spaniard Berruguete, who seems to have come to Urbino from Sicily and Naples, after studying the quasi-Flemish art of Collantonio and Antonello da Messina ([60]). Antonello himself, apostle of Flemish art in Italy, very probably passed through Urbino in 1475. Thus the Italian artists who designed the marquetry cartoons and those who executed them both worked in a Flemish atmosphere. But they were only superficially imbued with it, just enough to give their still lifes an air of abundance and lively disorder, without impairing their robust nobleness.

Soon, however, a contrary movement took place: the North came under the influence of Italian marquetry. Ignorant of the complex technique of *tarsie*, Northern artists proceeded to interpret it in terms of oil painting, with which they were thoroughly familiar. The latter technique, too, was more expeditious and much less expensive. We find irrefutable proof of these contacts in South Germany which, by way of the Alpine passes, communicated directly with North Italy.

Indeed, there are several Northern pictures of the late 15th or early 16th century whose subjects are so puzzling that art historians have either refrained from commenting on them or dodged the issue by regarding them as fragments arbitrarily cut out of large-scale compositions. One such picture shows only an open book, presented without any support, against a black ground; the book is seen from above and three of its pages seem to be turning (fig. 27) ([61]). Its very incisive style points to a South German or perhaps a Tirolian studio. Now the choir of Modena Cathedral is full of marquetry panels, each of which represents an open book (and nothing else), whose pages are turning and which stands against the black ground of a small open cupboard. Again, among the famous pieces of marquetry in Santa Maria in Organo at Verona, begun in 1491 by Fra Giovanni da Verona, we find two panels decorating the lectern and representing a large open Antiphonary (fig. 26). The analogy with the German picture is obvious, and the purpose served by the latter becomes clear: it too must have decorated either a sacristy wardrobe or a lectern ([62]).

Another enigmatic painting, only recently brought to light, shows a cupboard with one door ajar, above a niche containing books, bottles and an inkstand (pl. 10). On a slip of paper attached to a flask is an

inscription in German which, so far as it can be deciphered, signifies: " for the toothache "; on the clasps of a book, on the right, may clearly be read: " Ihesus " and " Maria " ([63]). This panel then, as Erwin Panofsky has suggested, probably formed the door of an apothecary's or a physician's cupboard; it may be taken as a kind of shop-sign displaying their professional attributes; the two religious inscriptions suggest that it might have come from the pharmacy of a religious hospice ([64]). Broader than that of the Flemish School (by which it was directly inspired, however), the style of the picture seems to be German, which is in keeping with the probable language of the inscription. The work is datable to about 1470-1480, or even slightly later. But what can scarcely be questioned is that the idea of a trompe-l'œil decoration like this was suggested by Italian marquetry. The composition consisting of a half-open cupboard above a niche filled with objects occurs frequently in marquetry (figs. 28 and 36). The German work in question, however, is not a direct copy, all the objects and ornaments in it being definitely Northern, while the general setting is the same as that of many niches visible in the background of Flemish and German pictures of the second half of the 15th century ([65]). But the idea of decorating a wainscoting or a piece of furniture with a niche painted in trompe-l'œil and treated in a monumental spirit originated in Italy.

The Low Countries must have become acquainted with this practice at the same time as Germany, or a little later when, early in the 16th century, their art entered into direct contact with that of Italy. Inasmuch as these furniture decorations served a utilitarian purpose—many of them were doors, constantly being opened and closed—they have nearly all been destroyed by use. The remaining examples have become extremely rare; only a single one of Flemish origin is now known to exist, and it is a very late work. I refer to the Cupboard reproduced here (pl. 14), dated 1538 and bearing an artist's signature which has so far remained undecipherable ([66]). In all likelihood this panel was originally embedded in the door of a cupboard serving as a pantry or storage shelf. The painter responsible for it is to be sought for among the immediate successors of Quentin Massys. He seems to have more in common with Jan Sanders van Hemessen than with Marinus van Roemerswael, whose sharp, contorted, mannerist linework is nowhere to be seen here.

From the beginning of the 16th century on, the imitation of marquetry in painting spread through both North Italy and Germany. Church stalls, marriage chests and the furniture in sacristies and pharmacies now offered perspective vistas and still lifes borrowed from marquetry or inspired by it ([67]). The practice of these illusionist decorations gave rise to the idea of easel pictures treated in trompe-l'œil—pictures which, instead of being an open window on a scene shown in depth, simulated a fragment of reality which seemed to " burst out of the frame " and stand between the painted surface and the spectator. The oldest type of this picture represents a wall or a vertical wooden panel against which an object stands out in sharp relief. Such is the famous Partridge by Jacopo de Barbari, dated 1504 (pl. 11 and fig. 9). To Ingvar Bergström goes the credit for pointing out its connection with marquetry and thus throwing light on the origin of painted trompe-l'œil ([68]). To this it may be added that Venice, Barbari's native city, possessed some extensive ensembles of inlaid work, and that, even before the coming of Antonello da Messina (fig. 7), Venetian painters were familiar with trompe-l'œil as used in miniature painting, in the Flemish manner. The Crivellis and Vivarinis took more and more to using objects and fruit standing out sharply against a ground which often simulates wood (fig. 8). Here we have the art milieu by which the Partridge was entirely determined, even though it was painted in Germany, and which at the same time accounts for similar subjects in Dürer's watercolors, whose analogy with Barbari's picture has been wrongly interpreted as a token of the great German's influence on the Venetian. It is quite possible that this picture embodies an allusive meaning, that it is meant to evoke war and hunting by means of their attributes; it may have formed a pendant to a Mandolin and Glass by Barbari, a picture now lost which may have been meant to symbolize the pleasures of music and drinking; these would have formed a set of panels conceived in terms of a humanistic program and intended to decorate the home of a German cortegiano, as a modest souvenir of the ducal studiolo at Urbino ([69]).

Inaugurated by Barbari, the simulated wooden panel with objects hooked or nailed to it was destined to meet with singular success in Western painting. The Dutch, French and Italian masters of the 17th and 18th centuries never tired of varying its repertory of motifs and the arresting effects of illusion which it produced (pl. 34). This elementary but authentic form of wizardry—authentic because it stems from the fundamental virtue of the art of painting, from its poetic power of metamorphosing real things into

impalpable images—ensured an inexhaustible youth to *trompe-l'œil* painting. Throughout the last century, up to about 1890, it was practised by such American painters as William Harnett and Frederick Peto with an acuteness of vision and a devout solicitude worthy of the Primitives. In our day the Surrealists have freely acknowledged what they owe to the old masters of *trompe-l'œil* who, fancying themselves to be faithfully reproducing reality, were actually rendering it intense beyond anything known to our conventions of eye and mind.

Germany, the first country to translate the magic of *tarsie* into painting, was slow to give it up. Ludger Tom Ring's series of pretty *Vases* filled with symbolic flowers (pl. 13), dated 1562 and 1565, is to be explained as an imitation of marquetry. These were doubtless panels embedded in woodwork or furniture—their flat, decorative style vouches for this. In the same way, the style of the flowers and fruit painted by Hans Asper in 1567 (Stadthaus, Zurich) betrays the transposition of the style peculiar to marquetry.

The custom of painting a *trompe-l'œil* still life on cupboard doors and on woodwork lasted a very long time. Gerard Dou painted some on the small cupboards in which he stored his most valuable pictures ([70]). There are good grounds for thinking that Carel Fabritius' exquisite *Goldfinch* (Mauritshuis, The Hague) was originally a cupboard door; the wooden panel on which it is painted still shows, apparently, traces of hinges ([71]). As for Italy herself, there the tradition of illusory library cupboards initiated at Urbino remained very much alive. As late as the first or second decade of the 18th century, Giuseppe Maria Crespi replaced the doors of a music library by large canvases on which simulated volumes piled on simulated shelves give the illusion of the library itself (pl. 70) ([72]). Well into the 19th century, provincial art in France, Spain and Mexico ([73]) clung to these artifices and often rendered them with guileless simplicity. Thus *trompe-l'œil* pictures did away with walls and added an illusory space to real space, or peopled the latter with factitious presences.

The Dutch of the 17th century exploited the resources of *trompe-l'œil* to the very limit: taking a still life picture, they cut out a group of objects and separated it from the painted background, or else they cut out the silhouette of a painted figure; these they then placed in the middle of their rooms, amid the turniture, inextricably mingling the true and the false, to the good-humored surprise of their visitors. The signboard silhouettes of white-bonneted chefs with a menu in their hand, which greet motorists today on our highways, are the last relic—now almost a part of folklore—of these conceits which were so well in keeping with the passion for spatial illusion peculiar to Baroque. The 18th century, in spite of its plain, gilded wainscoting and its panels painted in clear, flat tints, was not exempt from this craze. The greatest of its still life painters, Chardin, Oudry and Melendez, are connected by strong, direct ties with the Baroque tradition of *trompe-l'œil*: their overdoor panels are often marked by palpable relief and convincing depth, and the pictures they painted for use as firescreens (pl. 69) place a whole " slice " of fictive reality in the middle of a room ([74]).

Grotesques and the Painting of Flowers and Fruit.

The influence of ancient painting on marquetry can only be plausibly inferred today. Such is not the case, however, for another branch of Renaissance Italian art which is no less important as far as certain aspects of still life are concerned: the famous decorations called grotesques. These were known from the end of the 15th century on; many of them figured in Hadrian's Villa at Tivoli and in the corridors of the Coliseum, not to mention monuments which have failed to come down to us. But they became the object of a real craze when, in 1493 at the latest, " flat on their belly with a torch in their hand " ([75]), artists began making their way into the buried " grottos " of Nero's Domus Aurea on the Esquiline. When in fairly recent times archeologists forced a passage through the rubble of these vast ruins, they found dozens of artists' names incised on the walls, many of them accompanied by dates. Vasari tells of the passion which these phantasmagoric decorations, so spirited and varied, inspired in a painter from Feltre, nicknamed "Il Morto" because he spent so many years underground studying and copying them.

Grotesques entered Italian painting well before we find them in the Loggie and the Villa Madama (1515-1521), but it was in Raphael's studio in the Vatican and under the specialized brush of Giovanni da Udine that they acquired a style of their own and an extraordinary vitality. They borrowed many elements from ancient painting without changing them an iota; but they enriched its repertory of motifs and embodied them in much more intricate compositions. Their unreal character, their arbitrariness, which seemed to know no bounds, intimately corresponded to the spirit of nascent Mannerism—as had also been the case at the time grotesques were invented, in the days of Neronian mannerism. It is striking to note, moreover, that these pagan conceits were contemporary with the pious nightmares of Bosch: both in fact bear witness to the profound spiritual crisis through which Western civilization was then passing.

The grotesques of antiquity and, with greater reason, those of modern painting included a large number of still life motifs: tabernacles, candlesticks, tripods, pearl necklaces, garlands or baskets of fruit and flowers. And these were accompanied by living animals, squirrels, birds and others. Vasari relates that in Raphael's studio Giovanni da Udine met one " Giovanni fiammingo " ([76]), who is supposed to have taught him to paint fruit and flowers. Which should be taken to mean: taught him to " paint from the life." For it was this knack of rendering the exact surface quality of things that the Italians appreciated in Flemish pictures. It is quite possible that the powerfully naturalistic character of Giovanni da Udine's fruit and flowers, so different from the hasty, sketchlike manner of antique grotesques, was inspired by an artist schooled in the atmosphere of Gerard David's paintings and miniatures. The Italian nevertheless retained the sense of monumentality peculiar to his school. He devoted himself to still life with enthusiasm and displayed ability enough for Raphael to entrust him with the execution of the musical instruments in his *St. Cecilia*, the well-known picture now in the Pinacoteca at Bologna. The result is a superb piece of painting, focused in a steady light which already brings to mind the art of Caravaggio, who, moreover, often isolates musical instruments in the foreground of his pictures, in a way not without analogy with Raphael's composition.

The importance of this still life denotes—as do those of Caravaggio—a painter capable of conceiving pictures reduced to inanimate objects alone. Now we have information about the existence of two signed and dated pictures by Giovanni da Udine which antedate the earliest pictures of fruit and flowers that we know of at the present time. One of them, to judge by a photograph (unfortunately the whereabouts of the original cannot be traced) may only be a faithful 17th-century copy, executed presumably by a Caravaggesque painter, for its lighting seems very advanced; but its fidelity to the original is vouched for, beyond any doubt, by the fact that the whole composition, strictly decorative, and all the elements in it, vase, mascaron and plinth, breathe the very spirit of the first half of the 16th century. This picture (pl. 12) represents a vase adorned with a mask in the antique style and containing a small lemon tree in blossom; on the plinth beside the vase, to the left, is a small lizard. The painting bears the name of Giovanni da Udine and the date 1538, together with the mention: *In Casa Spilimberga*. The second picture, known to have been in Naples in 1860, represented a vase, also decorated with a mascaron, with tufts of grass and small flowers growing in it; tied to a stake in the middle of the vase were branches laden with fruit, flowers and all kinds of leaves; on the left was a bee; on the right was a painted *cartello* bearing the signature and date: *G. d. Udine A.* 1555. This, like the *Lemon Tree*, was a *trompe-l'œil* painted in oils; possibly the two vases formed part of the decoration of the castle of Spilimbergo, where Giovanni da Udine is known to have been working in 1555, perhaps even earlier ([77]). The presence of the lizard and bee is highly significant as showing that the first oil paintings in which plants are combined with insects were the creation, not of the Flemings only, but of the Italian painters of grotesques under whom the Flemings worked, who took the idea from the stock repertory of these decorations.

The historical problem which at once arises is that of determining whether the Flemings or the Italians led the way in creating one of the basic forms of still life: the flower picture. In the 15th century, as we have seen, glasses with flowers were represented in Flemish miniatures and certain pictures also included vases of flowers painted on the back (figs. 5 and 6). While the latter undoubtedly had a symbolic meaning, this was apparently not always the case with the small still lifes in miniatures. As far as their plastic conception goes, they were invariably *trompe-l'œil* paintings. Bergström, in his researches, has pointed out two Netherlandish painters of the 16th century who painted *Vases of Flowers*. One, the Dutchman Lodewijck Jansz. van den Bosch, is cited by Carel van Mander as an excellent painter of flowers

(rendered in minute detail with their drops of dew), fruit and insects; these vases of flowers were independent pictures. As he was born about 1525-1530, it is possible that he was painting such pictures by 1555 or 1560, but certainly after Giovanni da Udine, who was born in 1487. Unfortunately not a single painting by Van den Bosch has survived. Very probably he was a Mannerist, for Van Mander showed a warm appreciation of his figures and usually, in dealing with Netherlandish artists of the second half of the 16th century, he keeps this kind of compliment for those who had been won over to this esthetic. Van den Bosch, then, may be taken as belonging to the same Italianizing current as the second Northern flower painter, Georg Hoefnagel, whose works have been brought to light by Bergström. But these, all dating from the last quarter of the 16th century, provide further proof of the close relationship between the painting of grotesques and the first flower pictures: Hoefnagel was famous for his grotesques, which he painted in miniature, and his flower pieces included shells and insects in abundance. Van den Bosch, as Van Mander describes him, and Hoefnagel, as revealed in his own work, both belonged to the humanistic tendency of scientific naturalism—that vast movement which also included the " rustic style," so ably studied by Ernst Kris, which was closely connected with Mannerism. Unlike Bergström, I find it hard to believe that the flower pieces of Jan Brueghel or Jacques de Gheyn could have grown out of Hoefnagel's watercolor miniatures, round about 1590-1600, by a kind of automatic evolution—without the intervention of the *decisive idea* that a flower picture is worthy of large-scale easel painting, whether decorative or intended for the cabinet of the private art lover. The example of Giovanni da Udine proves that this idea, in the specific form of flowers combined with insects, first came to fruition in a milieu of painters who harked back to antiquity, of painters of grotesques. For Giovanni da Udine can hardly have been the only one to paint decorative flowers in mid-16th-century Italy. Methodical investigation will surely bring similar examples to light, both on the walls of houses and in the form of easel pictures. The vase of flowers was a motif that spread to every part of Europe where Italian influence took effect. We find it in France, abundantly represented at the Château de Tournoël, about 1564 ([78]). No less regrettable than the loss of Van den Bosch's flower pieces is that of pictures on the same theme by Carlantonio Procaccini, born at Bologna about 1555. Member of a family of well-known mannerist painters, he no doubt belonged to the same spiritual current as the two Italianizing Northerners.

A close study of the earliest Flemish flower pictures shows that in spite of all the realism of details, they keep to a wholly decorative arrangement, and that they often contain vases which are Italian or antique in character. Such, for example, are the bouquets of Sadeler (fig. 21). It is a striking fact, as we have just observed, that Hoefnagel, one of the first flower painters, was also a painter of grotesques, in constant contact with Italy and antiquity. Giovanni da Udine's *Lemon Tree* contains a reputedly Flemish feature: the combining of flowers and fruit with small animals, birds and insects. But this was current practice in grotesques. Though the Flemings had been painting these things on a reduced scale in their miniatures since the 15th century, it had never occurred to them to use these motifs as the sole subject of a picture, until the day when, encouraged by Giovanni da Udine or by other painters of grotesques, they took over the decorative flowers of the latter and made them into realistic bouquets. The mere tradition of the herbals and books of natural history, in which plants and animals were studied with analytical care, would not have been enough to give rise to independent flower pictures. Here, as in the case of the niche with objects, the Italian example, consisting as it did of paintings at once naturalistic and decorative in character, deriving from the antique tradition, must have been decisive.

Developments in Spain at the same period go to confirm the view that fruit and flower painting grew out of the painting of grotesques, of which it was originally a kind of independent branch. In their decorative symmetry and the artifice of their arrangement, the baskets of fruit and flowers by Blas de Ledesma of Granada (not identical with the earlier Blas de Prado) betray the lessons he received from the painters of grotesques (pl. 24). Blas de Prado and another fruit painter, Antonio Mohedano, are said to have been formed by the study of flowers and fruit painted at Granada by Giulio de Aquiles (or Giulio Romano, son of Antoniazzo Romano) and Alessandro Mayner (perhaps the son of Gian Francesco Maineri of Parma). These two Italians were pupils of Giovanni da Udine. In 1589 Blas worked at the Escorial alongside other Italians, painters of grotesques, who excelled in representations of fruit, flowers and birds.

Let it not be forgotten that Caravaggio painted his first flowers in Arpino's studio, alongside Prosperino delle Grottesche. It may not be merely by chance that the copy after Giovanni da Udine mentioned

above is marked by a sharp and powerful chiaroscuro, Caravaggesque in spirit (fig. 20). This goes to show that Caravaggio's followers were still interested in the incunabula of flower painting. Thus, not only in Italy and in the Low Countries (Hoefnagel) but also in Spain, we can trace a line of descent which goes back towards a common source, which appears to be the art of the great master of grotesques, Giovanni da Udine.

The Influence of Antiquity increases : Motifs are borrowed from the Ancients and Inspiration is taken from their Writings.

By the opening years of the 16th century, with the direct influence of grotesques changing the decorative system of the Italians, and later that of all Europe, it was clearly to be foreseen that antiquity would soon be taken as a model much more literally than in the Quattrocento. At the time the Urbino marquetries were made, antiquity generally served as no more than a source of plastic ideas, of encouragement in introducing certain types of pictorial representation. Now, going a step further, artists began borrowing motifs from the works of the ancients, and by studying their writings it was believed that their art could be recreated. The immense prestige of the Greeks and Romans seemed to justify the new interest being shown in everything in painting which lies outside man himself. From ancient thought a hierarchy of subjects was deduced, in accordance with which everything that directly concerns man—Sacred and Profane History, Fable—had the priority attaching to what is inherently noble. But it was also deduced that artists could from now on take a serious interest in the representation of landscapes, animals, plants and objects.

Thus the landscapes of painters like Polidoro da Caravaggio, Martin van Heemskerck, Niccolo dell'Abbate and Paolo Veronese are dotted with buildings in the antique style and display panoramas of water and rocks, where piers jut out at the foot of white colonnades in imaginary harbors; or we have views of a bucolic countryside, like those of Matteo da Siena ([79]), in which peasant cottages, such as Theocritus sang of, nestle in the shade of great trees. Reading Vasari, one cannot help wondering whether the father of this humanist landscape was not Giovanni da Udine ([80]). At the same time, in prints—especially those of the Flemings, ardent neophytes of antiquity—we find animals in combat, echoing the shows held in Roman amphitheaters, and naïvely exotic hunting scenes supposed to have come from the tombs of the Nasonii ([81]). Examples of antique mosaic work were, we feel, present in the artists' minds. When a Flemish painter of the second half of the 16th century—perhaps Georg Hoefnagel, who was so fond of grotesques, flowers and animals ([82])—set out to paint different species of ducks on a single panel, like a plate from a book of natural history, intended to decorate a Cabinet of Curiosities, he did so with antique mosaics in mind, which so often represent ducks (figs. 18 and 19). This explains the unusual perspective of this picture, seen from above, like the pictures on mosaic pavements, while the quarters of a hard-boiled egg and their cast shadows recall the remnants of food, accompanied by a live animal, which are scattered over the *Unswept Room* of Sosos (figs. 17 and 19).

It may be wondered whether the subjects of the first still lifes of the 16th and early 17th century, painted in Italy or elsewhere under the influence of Italian ideas, may not have been determined by the art and thought of antiquity. Most of them represent shops, with displays of meat, fruit and vegetables; laid out to begin with in the forefront of compositions whose background showed a religious episode or a genre scene, these foodstuffs gradually spread out, reducing the part played by the human figure and becoming the exclusive subject of paintings (figs. 30 to 34). But what were the pictures of Piraikos, his donkeys, his barbers' and bootmakers' shops, so highly praised by Pliny, if not displays of foodstuffs or genre scenes combined with still life ? When we find Vasari describing Jacopo Bassano as so successful in painting *cose piccole ed animali*, we recognize the *rhopography* of the ancients. One cannot help being struck by the fact that it was precisely to Piraikos that the humanist Hadrianus Junius likened Pieter Aertsen. And that the name of this Greek painter occurs in the writings of Felipe de Guevara and, in 1642, of

Baglione as soon as they come to deal with still life ([83]). Genre painting as practised by Aertsen undoubtedly took shape in Italy under Bassano's influence. The realistic Flemish temperament and the tradition of his school, which, from Van Eyck to Quentin Massys, Jan van Hemessen and Marinus van Roemerswael, laid stress on the inanimate objects in a composition, naturally led Aertsen to develop, with Rabelaisian eloquence, the part played by still life in Venetian pictures (Titian and Bassano). But only humanist ideas, only the *benediction of the ancients*, only the tutelary shade of Piraikos, can explain both the audacity of Bassano ([84]) and Aertsen and the success which the latter and his disciple Beuckelaer met with in Renaissance Europe, not only in the North but also in Italy.

All genre painting in Renaissance Europe owes its origin to the influence of antique ideas. We have only to read Baglione to convince ourselves of this. In order to justify the artistic interest of Salini's still lifes, he writes: " This man devoted himself to painting from the life, and he painted sundry things and imitated them very well. And just as it is said of ancient Painters, that some among them, of their own accord, took delight in creating certain particular *bizarreries*—Kalates was fond of painting comic actors performing on the stage, Aristodemus wrestlers, Kalamis two- and four-wheeled chariots, Piraikos barbers' and tailors' shops, Ludius country houses, seascapes, hunting and fishing scenes—so Thomasso, or Mao, Salini, a Roman, has set about painting flowers and fruit and other things, well rendered after nature." ([85])

At the end of the 16th century, just as Baroque naturalism was coming into existence, we feel what almost amounts to an obsession with antique *trompe-l'œil*.

May not the famous *Basket of Fruit* (pl. 51) by Caravaggio himself have been undertaken in emulation of the ancients ? It is seen from a low point of view, it stands on a high cornice or shelf; its uniform bright background shows traces of nail holes, as if the canvas had been fastened directly to the wall ! This is all the more likely in view of the fact that the earliest mention of the *Basket of Fruit* in 1607, barely ten years after Caravaggio had painted it, in the inventory of the collector who offered it to the Ambrosiana, specifies that the canvas was unframed. For ten years this much admired picture remained unframed. Why ? Because it was precisely in this way that a veritable *trompe-l'œil* could be seen to best advantage ([86]). Imagine the picture placed high up on a light-colored wall: its background would blend indistinguishably into the wall surface, and the basket would then stand out vividly like a real object, in a *trompe-l'œil* effect entirely similar to that of Second and Fourth Style frescos. We need not be led astray by the powerful realism of this painting: the silhouette of every single form is calculated to produce a decorative effect. Here we catch Caravaggio bringing off a " scherzo," doing the antique over again after nature—just as Cézanne aspired to " do Poussin over again after nature "—to the satisfaction of his scholarly friends, Cardinals Del Monte and Borromeo, who knew very well that the virtue of flawless illusion was what the ancients prized most highly in their still lifes, painted, nevertheless, as decorations.

Caravaggio's *Basket of Fruit* and that in the Urbino marquetry (fig. 16) are not the only examples of a remarkable analogy with the same motif as treated in antiquity (fig. 15) ([87]). The many *Baskets of Flowers* of the early 17th century, both Flemish and French (pl. 47), standing out in multicolored splendor against a uniform dark ground, are in many ways comparable to the famous Vatican mosaic on the same theme (pl. 6). It is enough to compare at a glance the *xenion* reproduced here (pl. 3), composed of bowls of fruit and a transparent vase placed on different levels and on clean-cut projecting stone slabs, with the *Fruit and Crystal Vases* by Juan van der Hamen (pl. 64), to realize the remarkable extent to which they agree both in motives and in composition. However, in the present state of knowledge, in the case of the Spanish master, the analogy seems coincidental ([88]).

Mannerism and Still Life.

The idea of reviving still life under the auspices of the ancients formed part of the romantic dream of the humanists, who aspired to translate antiquity into a modern idiom. Even so, after long centuries

of religious and historical painting in which man reigned supreme, it came as a remarkable novelty. An attempt was made not only to paint inanimate objects in so-called " noble " compositions—this had been done for several hundred years past, ever since Giotto and Van Eyck—but to give to things, and to things alone, *the prestige of great art*. It was the mannerist movement that undertook to achieve this. The Venetian studios of the mid-16th century, where the young Flemish painters came to seek instruction under Bassano and Tintoretto, served as the laboratory in which the new still life formula was worked out.

Mannerism was essentially a reaction against classical idealism, against the balance between embellishment and truth which found supreme expression in Raphael and Titian. To upset that balance by an arbitrary handling of composition, perspective, light and proportions, and by the novelty of the subjects themselves—this was the program of the Mannerists. They deliberately set out to startle the public with the original and unexpected. By locating the vulgar reality of shops and food displays in the foreground of religious compositions and genre scenes, they attained their end. In doing so they acted on the authority of the ancients, on that of Piraikos in particular.

From Bassano and Aertsen, from Giovanni da Udine, who by coming under the influence of Giulio Romano participated in Mannerism; by way of Beuckelaer, Delff, Van Rijck, Dirck de Vries and Uitwael; up to Vincenzo Campi and Passerotti—all the painters of food displays and flowers were Mannerists. The echo of their conception of art is still perceptible in Spanish *bodegones*, in the young Velazquez, in Juan Esteban and Alejandro de Loarte. Between Aertsen, who imparted to his fruit and vegetables a movement and relief whose aggressive and gratuitous dynamism is typically mannerist, and Velazquez, who painted his with unruffled, concentrated realism, the *bodegone* evolved from the mannerist esthetic to that of Baroque, which reverted to nature, to its direct appeal.

The truth is, nevertheless, that this realistic subject originated as a kind of *boutade*, in the hands of painters who could not have been less concerned than they were with rendering reality for its own sake. Perhaps nothing better sums up this situation than the paradoxical " still lifes " of the mannerist Arcimboldo, who made monstrous human faces out of vegetables, fruit, fish and shells. The head reproduced here (pl. 16), when turned upside down, becomes a quite acceptable heap of vegetables in a basin. This " scherzo," fit to adorn a Cabinet of Curiosities and take its place there beside a grotesque fœtus, proclaims the negation of nature, introduces an arbitrary confusion into its kingdoms, and flaunts the artist's pride in creating unusual forms wholly with the resources of his own imagination. After the long reign in painting of idealized man, to reduce him now to an assemblage of vulgar objects, such as had been hitherto relegated to an out-of-the-way corner of the picture, amounted to ironically signing a mannerist manifesto.

The Share of Italy and the North in the Development of Still Life from Giotto to Caravaggio.

Observable in the slow birth process of the independent still life is a kind of continual emulation between the South and the North of Europe. If he is not to falsify the very real complexity of life and the constant exchanges between the South and North, the historian must make a point of following, step by step, the progression of artistic ideas and facts.

It is clear that this evolution closely depended on the intensity of realist trends. In the 14th century, from Giotto and Duccio on, Italy preceded the North: it was more advanced both in the building up of form and in the rendering of space by means of perspective and lighting. Whenever Italian art was oriented towards realism, it showed itself receptive to the suggestions of antique art and thought, and tackled the painting of landscape, objects and genre scenes taken as independent subjects: this occurred about 1330-1340 at Florence and Siena (Gaddi and Lorenzetti), about 1400 in North Italy, and from the mid-15th century on, when Florentine *trompe-l'œil* came into fashion (marquetry).

But with the Master of Flémalle and the Van Eycks the North revealed an extraordinary talent and passion for the representation of inanimate objects. Artists timidly began by painting skulls on the backs

of portraits; it cannot yet be said with certainty whether this idea (known to the ancients) filtered across the Alps or whether the Northerners discovered it for themselves. Then, on the back of Netherlandish Madonnas and portraits, small symbolic still lifes appeared; they were also introduced into manuscript illustrations. The Italians created this religious still life as early as the first half of the 14th century on the frescoed walls of churches, that is, in public places; and, as we have seen from an example found in Bohemia, the *Niche* was known in the North. But the extension of this subject to the domains of illumination and oil painting, in the second half of the 15th century, would seem to be due to the Netherlanders.

At the same time, however, a new, momentous development took place in Italy: the decorative *trompe-l'œil* of antiquity was revived in marquetry. The most important and the most realistic of the still lifes produced in this quasi-pictorial technique appeared at Urbino, in a milieu influenced by the realistic vision of the Flemings—the first example of a fusion between the monumental Italian conception and the Flemish esthetic of realistic detail. Its effects are evident both in Piero della Francesca and Antonello da Messina. Again placed in the great churches and famous palaces, monumental compositions in marquetry immediately exerted an influence: again the painters of the North—now, apparently, chiefly those in the Germanic lands around the Alps—exploited these examples by imitating Italian marquetry in oil paintings.

The appeal of Flemish realism and attention to detail grew in Italy, and about 1520 there was a second fusion of the two schools: in Giovanni da Udine's studio, where the painting of grotesques kept alive the esthetic of decorative *trompe-l'œil*, Flemish realism entered largely into the rendering of flowers, fruit, objects and insects; the idea arose of painting pictures of fruit and flowers in vases placed in the shadow of niches, and of accompanying them with insects and reptiles. This conception of illusionist and realistic decoration was rapidly contaminated by the humanist passion for scientific biological investigation: in the hands of the Netherlanders the first flower pictures came to look like pages out of a botanical and zoological album (Georg Hoefnagel).

Towards 1540 another art center where Italian and Flemish painting had come into close contact —Venice—created a new conception of still life: *foodstuffs* and *household objects* accompanying and dominating religious scenes and genre scenes. These *shop and kitchen pieces* were products of Mannerism. Having set out in quest of novel, anti-classical subjects, and emboldened by the famous example in antique art (Piraikos), the followers of Jacopo Bassano arrived at the idea of placing a still life in the foreground of a figure composition. Again it was a Fleming, Pieter Aertsen, who exploited this humanist suggestion. Heir of the century-old Northern practice of increasing the number of inanimate objects in pictures, he painted huge assortments of "vulgar" objects enlivened by a mannerist dynamism. The *shop and kitchen pieces* of Aertsen and Beuckelaer, the modern edition of similar subjects by Piraikos, found an immediate echo in the work of such Italian Mannerists as Campi and Passerotti.

So that by the second half of the 16th century two types of still life were being practised simultaneously in Italy and the North: on the one hand, *fruit* and *flowers*; on the other, *foodstuffs* and the *meal on a table*. As concerns the former, very probably inaugurated by Giovanni da Udine, we have no more to go on today than recorded mentions of such pictures by Lodewijck van den Bosch and Carlantonio Procaccini. As for the *meal on a table*—a common subject in antiquity, especially in mosaics, some of which (in North Africa) have come down to us—it is not known whether it was practised in Italy; we have a Flemish example, however, of about 1565, clearly determined by Aertsen's art (fig. 32).

By the time Caravaggio appeared on the scene, all these types of still life were being practised by specialists. With him, a great master took it upon himself to paint still lifes for their own sake. He did not invent the subject; on the contrary, he took it over from the Italian and Flemish Mannerists. But he showed how such a subject could be handled with monumental nobility in keeping with the rules of great art, and how this breadth of treatment could be reconciled with a rigorous yet grave and sober realism, very different from the redundance and gratuitous tumult of the Mannerists. In the *Basket of Fruit* at the Ambrosiana, Caravaggio did not shrink from vying with—and outdoing—the illusionism of the ancients. This marks the birth of the modern still life, definitively stripped of religious or intellectual allusions and ranked on an equal footing with the human figure.

This, then, is the historical rhythm traceable over a period of three centuries: Italy, drawing on the antique tradition, periodically put forth new ideas; the Low Countries, followed by the rest of the North, promptly exploited those ideas by giving expression to them with an innate prolixity and sense of realism. Thus the Flemings periodically outstripped the Italians, for a time, both in number and intensity. But fresh ideas were continually arising from the ancient homeland of humanism, where examples of antique art, still present or surviving in famous descriptions, commanded attention and were an unfailing source of stimulation.

In Search of a Name : "Still Life".

It was also in mannerist circles that art criticism was first made fully aware of the representation of everything that lies outside man. Writers felt the need of a name to define this new field of painting, of a technical category in which to classify it. To begin with, they simply referred to the painting of landscapes, animals, flowers, fruit and objects. Baffled by Giovanni da Udine's skill in depicting sundry objects, Vasari wrote: " per dirlo in una parola, tutte le *cose naturali* d'animali, di drappi, d'instrumenti, vasi, paesi, casamenti e verdure." Pablo de Cespedes merely copied him when, in connection with Giovanni's grotesques, he spoke of "*cosas naturales*". Van Mander described the pictures of Aertsen, Dirck de Vries and others as " kitchens," " fruit markets," or " all kinds of food." Inspiration came, as might have been expected, from the antique tradition: to define Bassano's specialty Vasari translated *rhopography* by *cose piccole*. But most important of all, Vasari and Van Mander, both of them Mannerists, looked upon all subjects, all the " genres " of painting, with an equal tolerance and curiosity.

The theory of modern art thus groped its way forward over a period of centuries, its hesitant evolution being doubtless due to the equivocal attitude of the ancient writers: the contempt they express for everything that departs from the "grand and noble" painting of history, and at the same time their admission of the celebrity attained by artists who specialized in painting landscapes, still life and genre scenes. When the Academy of Lebrun and Félibien had to adopt a definite position regarding this thorny problem, it chose in the end to take from ancient thought only what suited its purposes: it established a rigid hierarchy of genres, which began with the painting of sacred and profane history and ended with the painting of inanimate objects.

But the generic term covering everything included in the latter genre had still to be found. Painters and writers went on speaking of *flower, fruit and fish pieces* and, from the early 17th century on, of *banquets* or *breakfast pieces*. This question of nomenclature, so very interesting for the light it sheds on the history of artistic ideas, has been studied by A. P. A. Vorenkamp [89], who has come across no other terms than these in Dutch inventories up to about 1650. Not till then, at a time when hundreds of still lifes were circulating in the Low Countries, did the jargon of the studios coin the term *Still-leven*, which was carried over into the Germanic languages. It is a name much envied today by French writers, for, with facile romanticism, it may be interpreted in the exquisite sense of " silent life," which, however, was not the original meaning. In the Dutch art jargon of the 17th century, *leven* (life or nature) simply meant " model " or " living model "; *still*, of course, meant " motionless." *Still-leven*, then, in contradistinction to the painting of figures or animals, was the painting of things incapable of moving. Thus Sandrart uses the term, translating it literally as *still-stehende Sachen:* things standing still [90].

The French language at that time had no equivalent of the Dutch expression: it was sometimes translated literally with a charming awkwardness. Under the engraved portrait of David Bailly (1649) we read: " Un fort bon peintre en pourtraicts et en *vie coye* " (arrested life). This obvious " Hollandism " failed to gain currency in France, and in 18th-century Paris, under the influence of the Dutch tradition, still lifes were designated not as *vie coite* but as *nature reposée*, i.e. things at rest.

The term *nature morte*, which has finally prevailed in all the Romance languages, was probably coined in France in academic, anti-Baroque circles [91], for it undoubtedly connotes a shade of contempt.

It came into use when the idea of motionlessness was extended to include everything that is inanimate or dead. Writing in 1667, Félibien says: " He who paints living animals is more to be esteemed than he who only represents *des choses mortes et sans mouvement.* "

Not till the middle of the 18th century does the expression *nature morte* appear. No one has better elucidated the hesitant beginnings of this term than Mlle Suzanne Sulzberger [92]. She tells us that it was first used in 1756. It arose as an unfortunate limitation of the content suggested by the expression *nature inanimée,* used by Diderot and others. In my opinion, it was very probably Chardin's mastery of this type of picture which compelled French critics to make some effort to qualify it with respect to the other categories of painting. Art itself is always in advance of theories, anyhow in periods of great vitality. But this effort was unfortunate. Ever since Théophile Gautier (1855) and Thoré-Bürger (1860) [93], French writers on art have deplored the term *nature morte* as poor and even misleading in its implications, especially as compared with *still life* and *Stilleben* which, while departing from the 17th-century meaning of the Dutch *Still-leven,* have acquired exquisite connotations of silent and tranquil life.

But however ill-chosen it may seem, the term *nature morte,* in use for two hundred years, has become so closely identified in France with the poetry and plastic prestige of her great still life painters from Chardin to Cézanne that there would be no point in discarding it now. Words, after all, are only worth what their associations make them, and it is safe to say that there are few Frenchmen today for whom the term *nature morte* evokes the opposite of life.

CHAPTER FIVE

THE GOLDEN AGE

S TILL life has never had a greater vogue in Western painting than in the 17th century. At that time the easel picture devoted to this theme definitely emerged and soon took shape in several clearly marked categories: the representation of a meal, the flower piece, pictures of fruit, game and fish, the allegorical *Vanitas,* and decorative displays of precious objects. The countries north of the Alps made a specialty of these themes and stamped them with a particular character. To begin with, under Netherlandish influence, they took up an archaic, half " primitive " form of still life, which became international. Then Holland, Flanders and France each adopted a national type of still life peculiar to itself. For their part, Italy and Spain gave proof of a powerfully original conception of the theme, and their greatest masters painted still life along with other subjects.

Chronologically speaking, no particular country can be said to have priority over the others in this capital chapter of the history of still life: the first easel pictures representing still lifes appeared simultaneously on both sides of the Alps about the year 1600. The Renaissance had borne fruit: encouraged by the example of antiquity, the North joined with Italy to raise the painting of objects from the level of mere decoration, whether of walls, furniture or books, to the status of an independent picture very much in demand with a public who not only understood it and enjoyed it thoroughly, but paid high prices for it. A fundamental difference of conception, however, separated Northern Europe from Italy during the first quarter of the 17th century. The North kept to the Eyckian tradition and favored an archaic form of still life composed of displays of objects separated from each other, seen in evenly diffused light and rendered with painstaking attention to detail, in an almost medieval manner. Italy on the other hand, thanks to Caravaggio, inaugurated the modern still life: seen no longer from above, but in profile so to speak, level with the eye; monumental because grouped according to the rhythmic patterns of large-scale painting; striking in its effect because modeled in sharply focused light. In other words, to the *description* of nature's wonders offered by the North, Italy opposed the *expression* of nature's protean forces and aspects. This basic Italian conception of Baroque naturalism made its way into the studios of the Low Countries about 1620-1625 and spread in time to the rest of Europe.

65

The Archaic Type of International Still Life.

The Low Countries in the 15th and 16th centuries were the only country, along with Italy, to venture to treat still life as an independent art form. They did so timidly at first in miniatures, in the wings of small polyptychs, and in *Vanitas* pictures. Then, under the influence of Italian marquetry and at the same time as the Germans, Dutch and Flemish painters adopted the meticulous technique of decorative *trompe-l'œil:* the niche with objects, and the bowl or vase of fruit and flowers. Finally, again stimulated by the Italians (notably by Jacopo Bassano), Pieter Aertsen, Joachim Beuckelaer and others displayed rich assortments of objects in the foreground of their figure compositions. A series of such pictures reproduced here (figs. 30–32) shows how this foreground was gradually enlarged at the expense of the figure group, which dwindled to a mere pretext for selling the picture as a religious scene and for maintaining the artist's status as a historical painter, since the category of still life painting was as yet unrecognized. One of these pictures (fig. 32 and pl. 17) represents a rustic meal on a table. The fact that four examples of this composition have come down to us (the original seems to have been lost) proves that it was regarded as very much of a novelty. And it was a novelty in so far as it isolated the theme of a table spread with food, which soon became the subject of hundreds of pictures. Who was responsible for the original work, executed between about 1560 and 1570? There are good grounds for assuming it to be the creation of an artist working at Antwerp in the circle of Pieter Aertsen. A rebus and some inscriptions suggest that the picture was meant to point a moral. It is worth while noting that another *Dinner Table*, painted about 1580 (⁹⁴), shows the Temptation of Christ in a small landscape in the background: the succulent dishes and beverages on the table thus symbolize the wiles of Satan. This ulterior motive behind the picture savors of Puritanism, and this, together with the style of the work, enables us to assign it to the northern part of the Low Countries, to a studio familiar with the animated, overcrowded composition of Aertsen's kitchen pieces. Later on, Dutch pictures of a *Meal on a Table* were often intended to convey a moral allusion.

These two paintings, datable to about 1560-1570 and 1580 respectively, make it clear that Netherlandish art was about to take a decisive step and treat the theme of food served on a table for its own sake —a theme, be it noted, quite unconnected with the decorative illusionism of Italian tradition. And once this step was taken, still life acquired its modern meaning: an easel painting whose subject matter is limited to inanimate things. Art historians have so far been unable to ascertain how and thanks to what artistic personality, perforce an eminent one, so great an innovation was brought about. Nor is it possible to say whether the Dutch *Meal on a Table* without figures preceded Caravaggio's independent still lifes, which can be traced back to as early as 1596. At any rate it seems to proceed from a purely Netherlandish tradition and constitutes a remarkable innovation. This is not to belittle the achievement of the Italians in their frescos, in their marquetry, in the paintings of Jacopo de Barbari and Giovanni da Udine, who wrote the first chapter in the history of modern still life. True, their works were decorations, but only in the way in which they were used, not by virtue of their style, for their *trompe-l'œil* had all the qualities which the easel picture aimed at.

The earliest extant pictures of a *Meal on a Table* without figures, those of Nicolaes Gillis, Floris van Dijck, Floris van Schooten (pl. 19), Clara Peeters and Hans van Essen, date to about 1600. They are painted with a great minuteness of detail and fixity of grouping in marked contrast to Aertsen's manner, which never lost a certain breadth of execution and monumental dynamism deriving from Italian Mannerism. These paintings, more refined when originating from Antwerp, more energetic when originating from Haarlem, but always archaic in style, revert to the past by devious ways that have not yet been elucidated and link up with an art anterior to Aertsen. Discernible in them are the traditions of the miniature painters in the circle of Gerard David and traditions going back to Quentin Massys, Joos van Cleve, Jan Sanders van Hemessen and Martin Heemskerck. Inherent in those works was an all-important artistic element : the notion of composing a picture devoted solely to objects, fruit or flowers. In all likelihood the Netherlandish painters were encouraged by the initiative shown by the Italians in creating the independent still life, and were thus prompted to paint such pictures themselves. Being the heirs of a long and glorious experience in the painting of objects, they were able to execute these works on the strength of an autochthonous style of their own.

66

The earliest Netherlandish flower pieces we have go back to the end of the 16th century. Unlike the *Meal on a Table*, they bear obvious traces of their decorative—and no doubt Italian—origin (figs. 20, 21, 22). Conceived as a *trompe-l'œil*, the *Bouquet* appears in a niche, to which are sometimes added curtains symmetrically drawn aside. But the intensely realistic rendering betrays a direct filiation with the Flemish miniature. Their fondness for specialization, so characteristic of the Lowlanders, soon led them to break the subject down into well-defined categories: the *Glass of Flowers*, the *Vase of Flowers*, and then the *Basket of Flowers*. These in time were combined with fruit and shells, and often accompanied by insects, birds and small reptiles.

This was the age of Cabinets of Curiosities, of overseas exploration, of bourgeois prosperity founded on trade with the Indies. Still lifes now tended to become miscellanies featuring the oddities of the animal, vegetable and mineral worlds. And like the rarities they pictured, they were expected to be looked at through a magnifying glass.

To make sure that none of these treasures passes unnoticed, these archaic still lifes are shown in plunging perspective, very much like the first pure landscapes, those of Patinir. Both the *Meal on a Table* and the *flower piece* are dominated by the eye, which explores them freely and easily. Each object stands in isolation so as not to conceal its neighbor. These still lifes have been called " *disposées* "—" arranged." But the term is not a happy one; all still lifes are arranged, and always have been. Neither Willem Kalf nor Cézanne took up their brush till they had arranged their still life to their satisfaction, nor did the Pompeian painters before them. These archaic still lifes might more suitably be described as " dispersed," in contradistinction to those which, seen on a level with the eye, are " composed " or grouped in keeping with a more stable, more obvious plastic configuration. The mind takes control of this multitude of juxtaposed dishes and imposes geometric order on them; no still life of the past more closely resembles a composition by Picasso or Braque of the 1920s than the red-and-yellow checkered pattern of Floris van Schooten's *Table with Food* (pl. 19).

The art movement that diffused this type of still life throughout Europe took its rise in the Low Countries, though it cannot yet be said with certainty whether it originated in Flanders or Holland. Flower painting, for example, seems to have been practised simultaneously as early as the 16th century by the Dutchmen Lodewijck Jansz. van den Bosch and Cornelis van Haarlem ([95]) and by the Fleming Hoefnagel. The *Meal on a Table*, as we have just noted, seems to have taken shape in the circle of Pieter Aertsen, whose activities at Antwerp and Amsterdam begot a double line of artistic descendants. At the end of the 16th century, religious persecution drove many Flemish artists to Holland, where they took root; the result was a hybrid art, in which the miniaturist delicacy of Antwerp art was blended with the sharpness and vigor of Dutch painting.

The flower pieces of Jacques II de Gheyn and Ambrosius Boschaert the Elder testify to these qualities (pl. 25). The latter uses bright, limpid colors applied in thin coats, a technique approximating to that of watercolor and gouache. Very archaic, he proceeds by subtle juxtapositions of objects, scrupulously respecting the integrity of each, without attempting to forge any link between them or to strike a dominant accent. To their decorative arrangement he adds *trompe-l'œil*, and his flowers, arrested in supernatural limpidity before a landscape as pale and faint as a mirage, compel awareness of their hallucinating presence. Childlike and refined, Gheyn and Boschaert, along with Roelandt Savery and Jan (" Velvet ") Brueghel, are the inventors of flower painting as an independent genre—anyhow for us today, for we know little or nothing of their forerunners, Giovanni da Udine and Carlantonio Procaccini in Italy, Lodewijck Jansz. van den Bosch and Georg Hoefnagel in the Low Countries. Younger son of the great Pieter Brueghel, Jan was a great lover of silk and velvet (hence his nickname), and his goldsmith's eye grasped the subtlest nuances of the chiseled outlines and satiny gloss of corolla, stem and leaf. His " floral architectures " (pl. 20) mirror the sense of wonder inspired in him by the revelation of the inexhaustible beauty of nature. In a letter to Cardinal Borromeo, Brueghel speaks of painting a bouquet made up of over a hundred varieties of flowers, some of which he went to Brussels to paint, as they were not to be found in Antwerp. His flower pictures are nothing less than gigantic herbals, still moist with dew and instinct with life, which must have been the delight of botanists of that day. At the dawn of Baroque naturalism, a temperament like his had a substantial contribution to make, just as Rubens had, to that expression of lyrical vitality so dear to 17th-century Europe.

Thereafter Holland took up the flower picture as one more field in which to sow the many-splendored colors of tulips, narcissi and roses. And here the general evolution of style made its effects felt. To begin with, the Boschaerts, Balthasar van der Ast and Bartholomeus Assteyn present their flowers, fruit and shells (pl. 21) in limpid air buzzing with insects, under sharp but impassible lighting which brings out the vividness of local tones. But gradually these variegated colors are superseded by refined harmonies of gray and brown in subdued light. The bouquets of Roelandt Savery and Hans Bollongier are thrown into full relief by a shaft of light, they are partly absorbed by the penumbra of the background and enveloped in a dense atmosphere charged, it would seem, with the humid mist of plains and dunes. Painters have now abandoned the simple justaposition of flowers, and take to combining them in lively groupings, often governed by a diagonal axis. Under Flemish influence, Jan Davidsz. de Heem painted a gaudy profusion of bouquets, to which he added garlands and festoons arranged in decorative rhythms. To his thin texture Abraham van Beyeren opposed a thick impasto and the petals of his flowers take on a full-bodied succulence which brings to mind the painting of Courbet's day.

In the second half of the 17th century appeared a galaxy of consummate flower painters. Outstanding among these virtuosi were Willem van der Aelst and Rachel Ruysch, who painted bouquets as glittering and chiseled as the marble plinths on which they stand. Colors grew steadily cooler, the gliding brushstroke became indistinguishable to the eye, drawing tended towards precise verisimilitude. The poetry of these works is that of an ideal perfection such as might be dreamed of by an inspired botanist amidst the rarities of his greenhouse. These bouquets, with their impeccably fresh leaves and their stems full of sap, consist of flowers which it would be impossible to bring together in the same season, much less keep in bloom day after day in the artist's studio. The early flower painters, modest chroniclers of plant life, kept to the model before them and had no hesitation about reproducing yellowed leaves, with their sear and shriveled edges, even worm-eaten leaves (pls. 25 and 46). But the truthfulness of the "Primitives" was a thing of the past by the time classical ideas, which enjoined the artist to "correct" nature, had reached the Dutch studios. For though Holland had no Academy, she was by no means free of academicism. By the end of the century Jan van Huysum, "the phoenix of all flower painters," had carried his specialty to an uncalled-for, almost mechanical pitch of technical skill; he became the god of porcelain painters.

The second major theme of the archaic still life, the breakfast piece, developed along parallel lines to the flower picture. Here the respective contributions of Flemings and Dutchmen are indistinguishable. On the whole, however, it may be said that the Flemings showed a finer sense of design and lighting, while the Dutch tended towards a robust plasticity. Which is to say that the heritage of miniature painting and of the gouache technique seems to have carried more weight in the southern part of the Low Countries. This is the impression we get when we compare the pictures of Osias Beert and Clara Peeters (before her stay in Holland) with those of the Haarlem painters Nicolaes Gillis, Floris van Dijck and Floris van Schooten. Shaped by Flemish painting, Georg Flegel (pl. 18) shows precisely that fragile delicacy which has caused his work to be confused with Beert's. But these were only the nuances of a common formula, strongly characterized by an outspread composition avoiding gaps (pls. 18 and 19). Each object is isolated and as fully defined as possible. Patient, analytic observation and minutely detailed execution make these pictures unmistakably "primitive" in spirit. We sense in them an extraordinary enthusiasm for exploring the world of inanimate things, almost a revival of the Eyckian spirit. This answered to the taste of the bourgeoisie for whom they were painted; that class of society, wielding power in the world thanks to its holdings of earthly goods, had a kind of cult for material things and cherished the lifelike image of them.

The militant intolerance of the Spanish régime in Flanders drove Reformed Flemish artists into exile by the hundreds. They emigrated to all parts of Europe, and brought with them the archaic still life. The Flemish colony that settled in the Rhineland, at Frankfort and Hanau, had a decisive influence on both Georg Flegel (pl. 18), a delicate painter fond of ash-gray, of Bohemian extraction, and the Alsatian Sébastien Stoskopff, Faustian wizard of evanescent gleans of light on glass (pl. 43), who later came under the influence of French taste in Paris. Lodewijck Susi was working in 1619-1620 at Turin and Rome, where he was known as Lodovico de Susio. There he painted his charming panel showing the corner of a table with fruit and sweets on it, the scattered remnants of a dessert, on which mice can be seen nibbling contentedly (pl. 22). The intimate picture he gives us of this small secret world is so convincing that

we are made to feel almost a part of it, as if we had been reduced to its proportions. We feel, indeed, very much as if we were looking at it through the eyes of a mouse. Apples and lemon loom up as large as houses, each almond is like a boulder. the metal platter like a lake mirroring calm reflections. Susio, then, brought with him to Rome this love of a Lilliputian world and its naïve mysteries, so alien to the Italian spirit; he himself, however, was soon to fall a victim to the insidious charm of the Italian world. In Spain the pictures of Blas de Ledesma are the earliest indication we have of the appearance of the archaic still life outside the Low Countries. Reproduced here (pl. 24) is one of the simplest, most archaic of the numerous pictures now known to be by his hand; all of them represent tables laden with cakes, baskets of fruit, round boxes and vases, surmounted by branches with birds perched on them, and framed by curtains drawn aside. Objects are seen from above; they are almost always spaced out with striking regularity. This latter trait proved to remain typically Spanish. The early work of Juan van der Hamen y León (1596–1631) also display a tendency toward symmetry. His choice of objects and their scale are obviously influenced by such Flemish contemporary works as those by Osias Beert. Van der Hamen's father hailed from Brussels and could well have been a painter. The son, a major representative of the early Spanish still life painting, always retained a touch of archaism in his precious groupings of objects (pl. 64).

It was perhaps in France, however, that the archaic still life had the greatest number of adepts over the longest period of time. In Paris, at Saint-Germain-des-Prés, lived and prospered a whole colony of Netherlandish artists during the reigns of Henry IV and Louis XIII. A still life by one of its members, Abiah Gibbens, has been identified thanks to the researches of H. Gerson [96]. Representing a dish of fruit, it conforms to a type that was quite common in the Low Countries and is obviously related to the fruit pictures of such French painters as Jacques Linard and Louise Moillon. The sloping table was a stock motif that lingered on in France for a long time; it was still common as late as 1630-1650, being treated by François Garnier—father-in-law and doubtless the earliest teacher of Louise Moillon—whose two known pictures are dated 1637 and 1644 (pl. 41). Baugin, the most interesting and mysterious of French still life painters, also kept to the theme of the sloping table.

In Baugin's *Five Senses* (pl. 23), painted probably before 1630, the date of his *Books and Papers by Candlelight* (Galleria Spada, Rome), we again find a high viewpoint, a design almost medieval in its sharpness, and a uniform play of light. The composition fills the picture surface with forms from one end to the other. The archaic still life painters have all these traits in common. But Baugin arranges his composition with a geometric rigor and a rationalism that one is tempted to describe as Cartesian. It has nothing of the naïve regularity of Floris van Schooten, for example, whose bowls and dishes form a checker pattern punctuated by yellows and reds (pl. 19); what Baugin gives us is a concord of rectangles, octagons and circles orchestrated with unerring taste and subtlety. This fine feeling for the purity of forms and the harmony of their spatial relationships is no less evident in the beautiful *Dessert with Wafers* (pl. 52), although the entire conception of the work seems freer and easier, altogether less archaic. The circles formed by the pewter plate, the curling wafers and the bulging flask of wine fit smoothly into the network of cubes formed by the table and wall. The shadows cast by all these objects, now compact and sharply defined, now dim and smoky, are like deep and quiet echoes of the objects themselves. By virtue of this musical instinct for well-tuned forms, this hushed refinement, this extreme sobriety, Baugin ranks as the greatest French still life painter of the 17th century. He was perhaps the only one, moreover, to paint still lifes that are genuinely French in spirit. What Dutch or Flemish master would ever have confined himself to a glass, a flask and a platter of wafers? Not one but would have added some cakes for good measure. Only certain Spanish still lifes (pl. 66), with their austere alignments and regular rhythms, can stand comparison in this respect with Baugin's *Dessert with Wafers*. But the latter is not, as they are, flooded with a visionary light or made to loom up in monumental grandeur. Taking familiar objects, Baugin dwells on their elegance and simplicity, not on their sudden majesty. He stands in relation to the Spanish still life painters much as chamber music stands in relation to the oratorio. Yet, at the 1952 Still Life Exhibition at the Orangerie, when Baugin's work was hung alongside Zurbaran's admirable *Lemons and Oranges* (pl. 66), it was by no means overshadowed; its commanding forms and poetic originality easily held their own. The analogy between certain French and Spanish still lifes sprang from a profound affinity in the spirit of the two nations in the time of Louis XIII; hence, for example, the extraordinary vogue in French society for the taste and manners of Spain, and though French writers imitated Spanish literature, they did

not imitate it slavishly. Baugin, as a true Frenchman and descendant of Fouquet, aimed at uniting the domestic intimacy of the North with the noble Latin stylization. Standing midway between them, he contrived to strike a balance between the plain truths of daily experience, on the one hand, and abstract beauty on the other; in this he abided by the time-honored aspirations of the art and civilization of his country. He alone of 17th-century French artists anticipated something of the modesty and harmonious grace of Chardin.

Though less pronounced, all the features characteristic of Baugin are to be found in his compatriots and thus enable us to distinguish their work from that of the Netherlanders, to whom, however, they owe much. Their composition is often quite simple: a dish of fruit or a basket of flowers standing in the middle of a table. If a few petals have fallen or a piece of fruit has dropped on to the table, we are likely to find them grouped fairly symmetrically round the central motif. The impasto of Linard's and Nourrisson's canvases is more opaque and creamy than that of the Flemings, which is fluid and glassy. Linard's pigments are often veined with silver-gray gleams, which we meet with again in the work of Dupuis, and which French painters seem to have been especially fond of. The French, then, sought to obtain a particular color harmony. This marked a departure from Flemish coloring, to which such French painters as François Garnier and Louise Moillon still adhered, and which consisted in playing off bright and cool tones against each other. Nor did the French handling of color have anything in common with the monochrome tonal accords of the Dutch masters.

From the 15th century on (figs. 3 and 4), it was a stock device of still life painters to place an object or two on the very edge of a shelf or table, overhanging it and jutting out towards us, thus creating the illusion of three-dimensional space between the spectator and the scene represented. The Baroque esthetic, which relied so heavily on the free play of forces in space, revived these already well-tried effects. It is hard to find a Dutch, Flemish or Italian still life of the 17th century without a spiraling lemon-peel, a folded napkin or a piece of fruit projecting over the edge of a dish or table. French painters adopted this device, but used it discreetly, almost reluctantly, we feel. Sometimes they eschewed it; at other times they placed an object on the very edge of the table, as if they had stopped it from falling in the nick of time (pls. 44 and 46). Chardin usually did the same. Here, as in the other branches of painting, we note in 17th-century France a tendency to extend the composition along the picture surface, to avoid any suggestion of great depth, to unfold a quiet theme without resorting to vehement or surprising effects of spatial rhetoric. The French, in other words, clung to classical velleities in an atmosphere in which some overtones of Baroque lyricism were by no means lacking in appeal and charm.

Holland : Bourgeois Intimacy and Opulence.

The first quarter of the century, in Holland as elsewhere in Europe, was dominated by the archaic type of still life. But about 1620, in the studios of Haarlem and Amsterdam, there developed a new conception of the *Meal on a Table*. The pictures of Pieter Claesz. (pl. 27) and Willem Claesz. Heda (pl. 37), soon followed by those of Jan Jansz. den Uyl (pl. 29), diverged more and more from the old grouping by mere juxtaposition. They made a conscious effort to marshal objects in depth, but were careful not to disperse them; they were fond of groupings along a diagonal axis (pls. 27 and 37). This compact composition went hand in hand with a reduced scale of colors, usually a monochrome tonality in a subdued key of gray or brown, rendering the placid glow of light tinged with delicate shades of color. The picture as a whole, in fact, owes its perfect cohesion to the manner in which the light is focused. Before achieving that cohesion by means of a pale luminosity, Pieter Claesz. first saw to it that objects were linked up by the light of a flame isolated amid the prevailing darkness. *Meal by Candlelight* by the German Gotthardt de Wedig (pl. 26) is the same type of picture: a world of things that owe their visible presence to a source of light located in their midst. This use of artificial lighting has no connection with the art of Caravaggio and his followers, but derives from a purely Netherlandish tradition going back at least as far as Geertgen tot Sint Jans, and handed down to Wedig, who was a direct descendant of Barthel

Bruyn. The sought-after effect is that of a still life which moves us by showing fresh traces of man's presence. The lid of the salt-box is still open, a crust of bread is sticking out of the eggshell. This intimation of unseen life, taken by surprise in the silence of the night, comes as a prelude to the calm existence of familiar objects which Claesz. and Heda were soon to present in broad daylight.

As compared with the early painters of a *Meal on a Table*, they reduced the number of objects, with the result that we get a more vivid impression of everyday reality. Within a very few years they had settled on their repertory of themes: these were usually " breakfasts " or " luncheons," sometimes consisting of no more than a red herring, a bun and a scallion, or an onion (pl. 28); sometimes of a dainty repast of ham or lobster (pls. 29 and 27)—but invariably accompanied by glasses of beer or wine. As if to round out this evocation of the pleasures of the palate, they added a recently imported luxury item often frowned upon as an immoral indulgence: tobacco. But the Puritan spirit hovered above it all, calling for sobriety: hence the watch or timepiece which we find so often, symbolizing moderation and temperance (pl. 37), and which might otherwise seem out of place among the heaped-up foods and precious objects of the Dutch still life (pl. 42) (⁹⁷).

The evidence is there and cannot be overlooked: it is a mistake to regard these pictures as capricious miscellanies of objects, chosen to please the eye; it is a mistake to suppose them devoid of any intellectual significance. In the 17th century each combination of food corresponded to a particular meal or to a particular phase of a meal. It is merely our limited knowledge of the customs and menus of the period that prevents us, in many cases, from defining the subject exactly. What we have no doubt are " breakfasts, " " banquets," " luncheons," " desserts," and so on as the case may be. When a half-eaten meat pie is found together with a basket of empty glasses, rinced out or turned upside down, then we have an " after-dinner " piece or the " end of a meal " (pl. 43) (⁹⁸). Connoisseurs of that day recognized and appreciated the details, the composition, the quality of each set of dishes. And to these, more often than not, were added objects of symbolic significance (a watch, a candle), which induced a mood of thoughtfulness.

The vases, goldsmith's work, Ming porcelain and Oriental rugs which later accompanied the food were only intended to create an atmosphere of opulence and well-being; an orange or lemon, sugar and wine, sufficed to indicate a rich man's table (pl. 33). It was only outside Holland, in the second half of the 17th century, that the grouping of objects became capricious and purely picturesque, once the taste for decorative effects had broken the link between the still life and everyday reality.

Meanwhile, however, the School of Haarlem created a simple type of still life which stands out as one of the most remarkable expressions of the Dutch genius. Such anyhow is the present-day opinion, based on our predilection for a secret, reassuring scheme of things which we seek to discern in the universe. Collectors and critics in the days of the Barbizon painters preferred the minutely naturalistic, anecdotal still lifes of De Heem, with their glistening lobsters and translucent grapes. Those whose eyes were conditioned by Impressionism took more pleasure in the freedom of touch and rich tonal modulations of Van Beyeren and Kalf. As for us today, with our gaze almost magnetically attracted in the direction indicated by Cézanne, we find a deeper satisfaction in the evident, rhythmically arranged volumes of Heda (pl. 37).

It was Heda, in fact, even more than his contemporary Pieter Claesz., who gave its most perfect expression to the Haarlem still life. The trend towards monochrome painting dominated the Dutch School between 1625 and 1640, not only in still life but also in landscape. Claesz. employed a uniformly yellowish or brownish tonality. To this Heda added faint shadings of ash-gray, and to this dominant he made a point of subordinating all the objects in the picture. With unerring taste and finesse he multiplied his modulations of grays tinged with green, beige and white, which he discreetly toned up with pink or brown. Gray, the most philosophic of colors, the color of meditation, must have suited the moods of the Puritan mind. The mists of Holland, moreover, trained the eyes of Dutch painters to discern the faintest gradations of values—and values are the very basis of monochrome painting. Round his objects Heda succeeds in throwing a suggestion of boundless space: there they stand, charged with quiet gravity. Thus isolated in a transparent void, they represent the solid durability of matter which reassures the mind. Their grouping has not been left to chance; each form overlaps its neighbor, composing a firmly linked, rhythmically ordered whole. If he saw them (and they were painted during his sojourn in Holland),

Descartes must have found the refined structure of these still lifes to his liking. Chardin, we know, saw them and obviously profited by them.

The "monochrome banquet," as the Dutch call this type of picture, found many practitioners not only at Leyden but also at Amsterdam. As long as it is simple, its laconic distinction is impressive (pl. 29). But after mid-century a concerted effort was made to develop it in the direction of greater richness and complexity; this only resulted in disrupting its unity and blurring the clarity of its structure.

If the banquet picture, thanks to its composition and the presence of a few symbolic objects, offered matter for reflection in addition to the pleasure it gave the eye, the *Vanitas* picture was wholly intellectual in conception. This type of still life originated at Leyden early in the 17th century. This Calvinistic university city kept alive the traditions of humanism, and it is not surprising to find Italian philosophical symbolism—such as that in Italian marquetry (fig. 36)—being developed and adapted there to the needs of the Puritan spirit. Whether born of the Counter-Reformation which, as Knipping has shown [99], had considerable influence in the Low Countries, or of Calvinism, as Bergström suggests [100], the Dutch *Vanitas* was only a rejuvenated version of a type of *Vanitas* put forward by 16th-century Christian humanism and a renewed form of an old theme which appeared in Netherlandish painting as early as the 15th-century. The University of Leyden was one of the strongholds of Calvinism, whose austere moral code outlawed the sensual enjoyments of life, and it was also devoted to the science of emblems and attributes. There were certainly good reasons for believing that the idea of the *Vanitas* may be traced back to this twofold spiritual preoccupation. The painter David Bailly may well have been the first to imagine compositions made up of a whole repertory of symbols. His pupils, the brothers Pieter and Harmen Steenwijck (pl. 30), stand out as the leading *Vanitas* painters, and these were numerous at Leyden [101].

This theme promptly found a host of zealous interpreters outside Leyden, among them such fine painters as Pieter Claesz., Willem Claesz. Heda, Jan Davidsz. de Heem, Pieter Potter and Gerard Dou, to mention only the best-known names. It was steadily developed and expanded, its increasing number of attributes being presented in combinations and groupings which, for all their ingenuity, are often tedious. Ingvar Bergström [102] has been able to sort out and classify these symbols. In his very fine study of them he distinguishes between signs of intellectual activities (arts, sciences, letters), signs of power and material possessions (precious objects, money bags, deeds), and signs of sensual indulgence (fine foods, wine and beer, tobacco, musical instruments). He draws a very convincing parallel between these and the three categories laid down by Hadrianus Junius: the contemplative life, the practical life, and the sensual life. We also find symbols of the destruction of life and matter (shabby books, wilted flowers, blighted fruit, stale bread, worm-eaten cheese, severed ropes), and symbols of the inexorable flight of time (hourglasses, timepieces, guttering candles). Still other symbols remind us of the precariousness of man's life, by likening it to a soap bubble, or of the brief duration allotted to earthly things, by likening them to a flitting butterfly, a flower, a cloud of smoke. In most *Vanitas* pictures these symbols take on their full meaning only when accompanied by a human skull or tibia. The painter sometimes achieves his effect by throwing life and death into sharp contrast; for example, the blunt juxtaposition of a skull and fresh fruit, full-blown flowers or precious objects.

The *Vanitas* picture varied according to the tastes of different schools and different générations, without developing a particular style of its own. It was sometimes keyed in monochrome harmonies and presented either in pitiless clarity (fig. 37) or in a dramatic shaft of light (pl. 30). The painter sharpened the impact of the picture by tightly grouping objects in a triangle or by strewing them on the table in a disorder that haunts the mind. But common to the majority of 17th-century Dutch still lifes is a compositional device which was probably nowhere applied so effectively as in the *Vanitas* picture. This consists in suggesting a latent movement which, we are made to feel, is already going on under our very eyes. "The Dutch still life," wrote Paul Claudel, "is an arrangement in process of disintegration, it is something that has fallen a prey to duration." In the *Vanitas*, which is entirely devoted to the idea of transitoriness, this Baroque dynamism was perhaps pursued with greater lucidity than in any other type of picture.

From Holland the *Vanitas* spread throughout both Protestant and Catholic Europe. It was one of the most effective pictorial expressions of the 17th century's earnest faith and profound religious yearnings —the century that heard Shakespeare, Milton and Pascal.

72

CREATION IN 15th-CENTURY ITALY OF THE INDEPENDENT DECORATIVE STILL LIFE
It originated in Italian fresco painting but was influenced by the North.

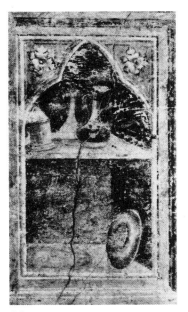 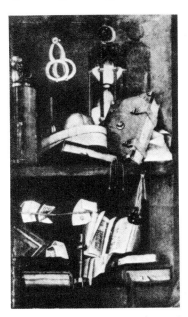 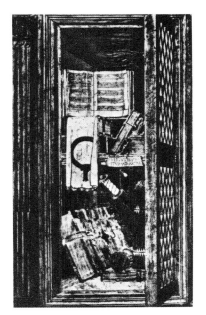

23 - TADDEO GADDI. Niche with Bread, Paten, Jar and Cruets. 1337-1338. Fresco. Santa Croce, Florence. — 24 - Tucher Altarpiece. 1440-1450. Niche with Objects. Detail. Frauenkirche, Nuremberg. — 25 - BACCIO PONTELLI. Still Life in an Open Cupboard. Marquetry in the Studiolo at Urbino. 1476.

Decorative Italian trompe-l'œil was taken over by the North.

26 - FRA GIOVANNI DA VERONA. Open Book. Marquetry on a Lectern. 1491-1499. Santa Maria in Organo, Verona.
27 - German School. Late 15th century. Open Book. Painting (decoration of a lectern ?). Collection of Baron Thyssen, Lugano.

28 - FRA VINCENZO DA VERONA. Open Cupboard and Niche with Objects. Marquetry. Louvre, Paris. — 29 - German School. Ca. 1470-1480. Open Cupboard and Niche with Objects. Painting. Mortimer Brandt Collection, New York.

THE MANNERIST STILL LIFE
The painting of objects freed itself from figure compositions.

IN THE LOW COUNTRIES

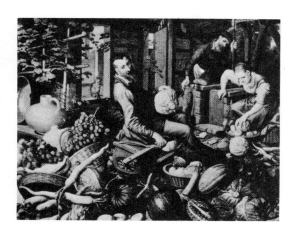

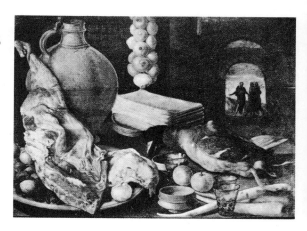

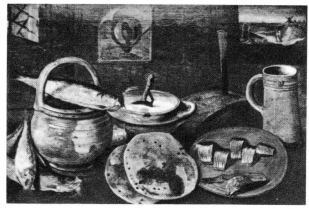

30 - PIETER AERTSEN. Vegetable Display. Ca. 1550. Museum Boymans-Van Beuningen, Rotterdam.
31 - JOACHIM BEUCKELAER (?). Food Display with a Quarter of Meat.

Ca. 1560-1570. Museo Civico, Castelvecchio, Verona.
32 - Circle of PIETER AERTSEN. Table with Food. Ca. 1565. Musée des Beaux-Arts, Brussels.

IN ITALY

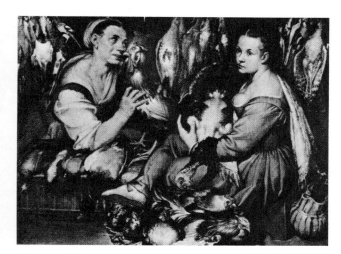

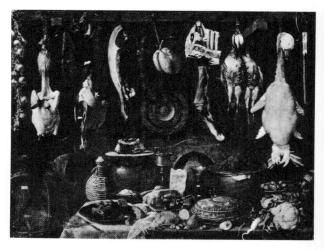

33 - BARTOLOMEO PASSEROTTI (1529-1592). Poulterers. Ca. 1580. Professor Roberto Longhi Collection, Florence.

34 - JACOPO CHIMENTI, called EMPOLI (1551-1640). The Shop. Signed and dated 1624. Palazzo Pitti, Florence.

Though the cities of Holland lie very close to one another, each has a distinct character of its own. Each, furthermore, showed a predilection for some particular type or types of still life. Haarlem produced many flower pieces and monochrome banquets, while Leyden was the home of the *Vanitas* picture and The Hague, located near the beaches of Scheveningen, specialized in pictures of fish and seafood. This subject greatly gained in pictorial power and on occasion even took on a certain grandeur of composition in the hands of Abraham van Beyeren, who was born and schooled at The Hague. As for Amsterdam, its wealth attracted artists from all over the country, and the clientele for whom they catered, including many foreigners, encouraged them to tackle all themes without exception. Widely different styles and influences mingled freely in this vast output of pictures. To this melting pot, however, the presence of Rembrandt gave considerable importance and both the plastic and spiritual implications of his art opened up unexpected paths. Rembrandt is the first instance north of the Alps of a great master setting out to paint still lifes. In doing so he transposed them forthwith into a superior order of art.

It was not so much the actual example set by his still lifes (which are very few in number) as his whole approach to reality which enabled Rembrandt to renew this branch of painting. He taught Dutch painters to go beyond the analytic way of seeing. He prompted them to render the forms and surface texture of things in terms of color and impasto, with a breadth and freedom of treatment hitherto unknown in the Dutch School. To the resources of saturated tones, he led them to add the resources of a new chiaroscuro which bathed even the most commonplace objects in a lyrical atmosphere. His *Flayed Ox* (pl. 32), marked as it is by that supreme inward synthesis which great artists achieve late in life, is a kind of manifesto proclaiming the sovereign power of art over nature. Seldom has the concentrated impact of the human mind been so plainly, so triumphantly mirrored in the object which it transforms and bends to its will. The dismal cellar of a butcher's shop is eerily lit up by the golden, ruby-tinted glow of a gaping, blood-stained carcass. Dead flesh is made to convey the formidable energy of animal life, still perceptible in the broad girth of the breast and the pathetic movement of the forelegs. Rembrandt turns a carcass into a tissue of the rarest textural beauties painting has to offer—richly molded impasto, now creamy, now granular, smooth streaks of molten pigments, pools of color now translucid, now unblended and opaque.

Like every momentous achievement of the human mind, this still life could not remain without posterity. It gave rise to further developments. Goya's pictures of raw meat and Soutine's of flayed poultry (pl. 103), no doubt Daumier's *Butcher's Shops* as well, could never have existed without Rembrandt's *Flayed Ox*. Painters eager to assert and express themselves in everything they paint have been stimulated by this picture. Delacroix made a copy of it.

We know from documentary evidence that Rembrandt painted all kinds of still life: a *Vanitas* with a skull, an hourglass and books (perhaps an early work done while he was still at Leyden, under the influence of David Bailly) [103], pictures of fish, and one of a dead hare. All his extant still lifes include figures in the background (pl. 32); their composition is monumental. In these two traits we recognize the long-standing tradition that goes back to Pieter Aertsen, and in fact the oldest known version of the theme of the *Flayed Ox* is a work of Aertsen's follower, Joachim Beuckelaer, the composition of which, moreover, shows striking analogies with Rembrandt's great picture in the Louvre. Rembrandt's other still lifes belong to the category of game pieces: *Bittern, Gun and Bittern, Dead Peacock*. So it would seem that he made no innovations in the way of subject matter or particular types.

Yet there is something new here. For all the mastery with which plumage and flesh are rendered, these dead animals are no longer the exact representations or the pretexts for decorative harmonies so complacently produced, after Aertsen and Beuckelaer, by such Flemish painters as Adriaen van Nieulandt (1616, Brunswick), Frans Snyders and Paul de Vos. Rembrandt reduces the motif to one or two animals and this sobriety complements an emotive, strongly focused lighting. The picture becomes a kind of intimate stage, and game a kind of fabulous booty disclosed in depths of darkness by a probing shaft of light. Rembrandt swept the still life—like all the themes he treated—into the orbit of his mysterious dramaturgy and lifted it to the level of pure painting. We may well ask ourselves whether he was not the first (as early as 1637) to simplify the game piece and locate it in a lyrical setting. Elias Vonck's *Dead Birds* (Copenhagen), dating to 1640, already reveals these two features and establishes the type of the Dutch game picture, which is much less ambitious than its Flemish counterpart, and much more intimate in feeling.

Here was one of the sources of Chardin's inspiration—and Chardin, remember, was known in his own day as the French Rembrandt.

Rembrandt changed the climate of the Dutch still life. Though indirect most of the time, his influence proved nevertheless to be decisive. When we turn to a basket of fish painted late in life by Salomon van Ruysdael (pl. 31), we find that, though he kept to the monochrome coloring of his youth, their viscous bodies are now bathed in a lunar clarity that seems to filter down through a sea mist. The lighting of his kitchen pieces, in which dead game play a large part, is marked by the same dramatic overtones. Abraham van Beyeren, the great master of the fish piece (and the game piece too on occasion), followed suit.

Those still life painters who confined themselves to a few familiar objects deepened the intimacy of their presentation by enveloping them in a chiaroscuro whose principle, if not always its exact quality, was Rembrandtesque. The fragments of forms and surfaces spared by the penumbra now offered a more telling combination of pictorial effects than those of Claesz. and Heda. Painters with a wonderful skill in conjuring up the physical life and actual presence of objects now followed up this lead. With incredible subtlety and cunning they played off the whiteness of a meerschaum pipe against the froth of a glass of beer; they struck a flawless balance between the mellow gray of stoneware and the limpid red of wine. The masters of this new poetry of painting, weaving their spell around the most unassuming objects, were Jan Jansz. van de Velde, Pieter van Anraedt and Gabriel Metsu (pl. 28). On the whole they aspired to a condition of calm stability; they rejected the overturned jugs, the crumpled napkins about to slide off the table, the Baroque restlessness of so many of their contemporaries. Their composition is strictly architectonic: the verticals formed by glasses and jugs and the horizontal of the table-top are always strongly emphasized. The rustic breakfasts and plain luncheons of old now acquired a classical nobility. Far from blurring this quality with its lyricism, chiaroscuro only had the effect of rendering it gravely melodious.

It may be worth noting that several of these artists did not specialize in still life to the exclusion of other subjects. The experience gained in painting landscapes and interiors with figures gave their vision a synthetic elasticity which they turned to account in rendering objects.

Baroque artists reaped even greater benefits from the legacy of Rembrandt. If Van Beyeren's sideboard pieces continue to fascinate in spite of their confused and, very often, overcrowded composition, this is due to his freedom of touch and the succulence of his tones. Of all the still life painters who came after Rembrandt, it was Willem Kalf (pl. 33) who took advantage in the most original way of the new possibilities of lighting and coloring opened up by the master. With his crimson-tinted reds, his yellows and oranges, set aglow by a vesperal ray cleaving through transparent darkness, Kalf drew on all the resources of pure painting to express the luxurious " feel " of choice objects. His concern, unlike that of so many other Dutch painters, was not with a literal image of the object minutely delineated down to the last detail of form and texture, but with an evocation of its pictorial aspects by means of a few unerring accents. Instead of describing the object, he shrouds it in semi-darkness. The glitter of burnished metal, the gleams thrown off by glass, the soft and muffled sheen of woollens—this was the subject matter of his pictures. Kalf handled color with greater refinement and originality than any other Dutch painter of the 17th century, Rembrandt and Vermeer excepted. He showed inimitable taste in matching the blue of a Ming bowl with the yellow of a lemon; a kind of poetic certitude prompted him in his choice of tone, of its density and sonority.

Leaving Rembrandt out of account, the work of Heda and Kalf represents the supreme achievement of Dutch still life painting. One was as great a master in the way of sobriety as the other was in the way of sumptuousness. Kalf, indeed, was patronized by the magnates of Holland's lucrative trade with the Indies, and he offered harmonious combinations of objects which could not but flatter their taste. He belonged to the generation of painters that catered for a new-rich bourgeoisie eager to live like lords after the French and Italian fashion. But in the painting of the most luxurious objects Kalf alone showed unimpeachable sobriety and distinction. Of all the still life painters of his country he is the only one who may be described as an aristocrat.

It was from about the middle of the century on, after the Treaty of Westphalia had put an end to the Thirty Years' War, that a new era of peace and prosperity led the Dutch bourgeoisie to expect more splendor in still life paintings. There was also an increasing tendency to use them for decorating the rooms

where parties were held and meals taken. This no doubt reflected the fashion of aristocratic life at the royal courts of Naples, Madrid and Versailles. Flanders contributed decisively to the rise in Holland of the abundant, decorative still life, a type of picture which spread throughout the country in the second half of the century. For these were precisely the features of Flemish painting, and one of the most prolific and skillful of Dutch painters (if not one of the most original) served as intermediary between the two schools.

Jan Davidsz. de Heem spent many years at Antwerp; he settled there at an age when influences are readily assimilable. His sensibility and receptivity were great and, without imitating them slavishly, he adopted the animated and decorative displays of Rubens' followers, Adriaen van Utrecht and Frans Snyders, in addition to the flower garlands of Daniel Seghers. He depicted them with the meticulous exactitude of a Dutchman. While there is nothing Flemish about his actual technique, De Heem's cool, sonorous palette and his pictorial composition, built around a bright note of red (pl. 42), clearly indicate their connection with Antwerp. He took to specializing in large compositions intended for the drawing room in the castles of great noblemen and in the palatial homes of rich merchants. His art, then, stands at the opposite pole from the intimacy of Dutch still life painting. But he falls short of the clarity of Flemish compositions which, with their oppositions of masses and their powerful linework, set order among the abundance of objects represented. De Heem is at heart an eclectic. The prodigious architecture of fruit and objects which he builds up in the shadow of columns and curtains in front of a lordly park is executed with unruffled attention to detail (fig. 40). Lyrical abundance, broad decorative rhythms and a realistic precision of rendering— all this combined to produce what seemed to Baroque Europe the ideal formula for still life painting. No still life painter of that day could vie with De Heem in the extent of his influence. His fruit and lobsters, piled high on a sideboard or in front of a landscape, set the fashion in Italy and Spain. Up to the 19th century his name was synonymous with the finest achievement in still life painting. Today we regard him, rather, as a skillful virtuoso who threatened to carry the Netherlandish still life, in both its Dutch and its Flemish forms, to the very threshold of academicism.

It was not only in the established types of still life that the decorative trend gained ground, changing their style and spirit. It also led to the use of still life as a mural decoration, in the form of panels placed, as a rule, over doors and mantelpieces. These usually consisted of flowers and fruit. The origins of this practice, which comes under the heading of decorative trompe-l'œil, are doubtless Italian, though it is difficult to say precisely how it was transmitted to Holland towards the middle of the century.

From Italy too came a special variant of the decorative still life: pictures containing illusionist imitations of sculpture. The finest examples of these were left by Caesar Boetius van Everdingen, author of naïve and radiant classical compositions on the walls of the Huis ten Bosch at The Hague. He painted a bust of a woman placed on a high cornice in front of fluted columns (pl. 35). Sprigs of laurel encircle her hair and neck, a tinted drapery clings to her shoulders. Pale light plays gently on the stone and illuminates the head of a putto whose blind gaze is turned towards the woman's face. It has been rightly said that the artist aspired to give life to the sculptured figure, that he seemed to make it breathe, and that this was a Dutch idea [104]. And indeed, in this immobility about to stir, in this silence about to be broken, we divine the Northern dream of antique beauty and serenity come to life again. Dutch Vanitas pictures and studio interiors are full of busts and statues which seem to quiver with life. But the emotive expression of these simulated sculptures reflects the Baroque spirit of the artists who painted them. Everdingen alone heralds the calm Pompeian elegance of the 18th century, he even hints at the graces of post-Davidian painting. He stands anyhow at the head of a line of painters of trompe-l'œil statuary: the Netherlanders Jacob de Wit, Gerard van Spaendonck and Piat Sauvage (the last-named became a naturalized Frenchman).

From about the middle of the century on, a whole movement got under way in Holland which introduced southern influences into the country. Dutch painters who had lived and worked in Italy— Matthias Withoos, Jan Baptist Weenix, Willem van der Aelst—brought back a repertory of classical accessories, pyramids, obelisks and ruined plinths, which they used as a background for still lifes. And what is more important, they brought back, Weenix especially, a particular style and moral tone. They made use of a mellow sfumato and a coloring whose richness and warmth were more facile and showy than those deriving from Rembrandt. Their brushstroke grew smoother and the surface of all the objects represented became silky and shimmering.

It would seem, on the other hand, that the powerful originality of Spanish still life painting did not go unnoticed in Holland. S. Adriaen Coorte painted small pictures, but their composition is grandiose. *Three Medlars and Butterfly* (pl. 36) or a *Bunch of Asparagus* ([105]) sufficed him in the way of subject matter. While so many of his compatriots, like Matthias Withoos and Otto Marseus van Schriek, peopled factitious undergrowth with insects and reptiles, as if they were out to draw up an anecdotal inventory of natural history, Coorte discerned a poetic significance in the symbiosis of the animal and vegetable kingdoms. He seemed to overhear a mysterious nocturnal dialogue between butterfly and ripe fruit; his bunch of asparagus, seen in a bright ray of light, takes on a lustrous enamel finish and turns into a strange glassy object. The contrast between violently illuminated objects and an impenetrable background, the geomtric plinths and the pure forms of fruit and vegetables, together with the sober, monumental composition, recall Spanish pictures in the traditions of Cotán and Zurbaran. Active relations were kept up between the two countries, and the influence exerted by the Dutch still life south of the Pyrenees was by no means negligible. But how are we to account for the apparent influence of so remote an art on a Dutch master active round about 1700? Perhaps Coorte turned to Spanish art in search of that power it has of rendering familiar objects unreal. The 18th century, from its very beginning, delighted in fiction and make-believe, and reacted against the earnest-minded naturalism of previous generations. The sleek nudes of Adriaen van der Werff look as if they had been carved out of alabaster, pieces of fruit as painted by Coorte turn into precious jewels and the resources offered him by the old Spanish masters inevitably contributed to this metamorphosis ([106]).

Flanders and the Heroic Still Life.

Working at Antwerp, the Flemish masters of the late 16th century were the first, along with the Dutch, to create the archaic type of still life. Later driven into exile by religious persecution, they diffused it throughout Europe. But the well-chiseled pictures of a *Meal on a Table* of Osias Beert and Jacob van Es and the precious flower pieces of Jan Brueghel went out of fashion overnight as soon as Rubens turned his attention to the still life. A mighty breath seemed to sweep them away as if they had never existed. Steeped in Italian art, Rubens' vision transformed the whole spectacle of the world. Man, landscape, animals, inanimate objects, all these had their place in it. But it was not their exact image that preoccupied the artist, it was the vital forces animating all forms and binding them together—this was his real subject. His conception of still life painting was profoundly affected by this pantheistic synthesis. In a mythological composition, fruit and game assumed significance for Rubens only in so far as they formed expressive accessories whose glow and movement sustain and re-echo the action and dramatic setting of the human scene. In the same way, when painting them as an independent subject, Rubens saw to it that they retained a certain dynamism and grandeur, that they emphatically certified to the sensual splendor of life. There is a streak of Latinity in this rhetoric, and a kind of aristocratic romanticism. Nothing could be further removed from Dutch art, essentially bourgeois and Protestant, and from its realistic or discreetly lyrical intimacy, often overlaid with intellectual allusions.

No still lifes by Rubens himself are known to exist. The nearest thing to them that we can attribute to him is the sketch of a historical scene whose foreground is occupied by a prodigious display of game, meat and vegetables. It is conceived as Snyders' pictures are, and very possibly we have here a preparatory work proposed by the master to his most trusted collaborator ([107]). For as soon as he opened his large studio at Antwerp Rubens imposed the principles of his esthetic on all his assistants, even on those who proved capable of keeping their personality intact. He quickly stamped a uniform character on the Flemish still life, whose essential feature in his hands became a heroic and decorative tone. Some hint of action is always present in it, conveyed either by figures, by the presence of animals sniffing at the food or tussling with one another, or (when objects are shown alone) by the contrasting rhythms of game, vegetables and fruit, a procedure in which we detect a distant echo of the mannerist animation of Aertsen and Beuckelaer. Particularly frequent in Rubens' work is the union of animal painting with the painting of foodstuffs. This was also characteristic of the antique still life. Great humanist that he was,

Rubens may well have read descriptions of antique painting (in Philostratus for example) and been influenced by them in his choice of motifs. By virtue of its decorative character, his conception of still life painting corresponded to that of the ancients.

Rubens' great innovation was to apply to still life the style of his large-scale paintings. This was the lesson he passed on to Frans Snyders, in particular, to whom, from about 1613 on, he entrusted the fruit pieces contained in his own compositions. His very talented pupil thereupon proceeded to amplify the spirited design, fluid touch and brilliant color which he had learned from Jan Brueghel (who occasionally collaborated with Rubens); and indeed a photographic enlargement of any detail of Brueghel's still lifes or animal pictures reveals the pictorial language of Snyders reduced to the scale of miniature painting. Within a short time, nevertheless, Snyders was creating large, highly original still lifes of his own (pl. 38). He revealed himself as a brilliant orchestrator of the traditional opulence already characteristic of Aertsen's and Beuckelaer's pictures. By following very simple graphic schemes, he built up his vast canvases around a few pilot lines and a few contrasting masses. Thanks to this structure, which for all its animation, remains solidly architectonic, his scenes, crowded though they are, produce an impression of clarity and monumental power. A dynamic breath blows through his forms, and colors cohere in sonorous harmonies. Snyders brings together fabulous accumulations of the fruits of the earth, ordered in broad, stately rhythms. He thus created one of the most accomplished forms of Baroque still life.

Snyders' influence was considerable and took effect at once. Nicasius Bernaert introduced it into France, Juriaen Jacobsz. into Holland. But none of his followers could match the brio and resourcefulness of his decorative arrangements. When Jan Fyt took inspiration from them, however, he produced an exceptional masterpiece (pl. 39). As a rule Fyt showed no aptitude for the eloquent counterpointing of dominant accents, his compositions consisting of more or less confused juxtapositions of admirable fragments of fine painting, glittering with all the brilliance of precious stones. He was at his best in the working out of details and never rose above the level of achievement required for adjusting tones in refined harmonies, which, in his mature works, are often somber and silvery, with racy touches of black. His color schemes are warm, those of Snyders are cool. His luxurious impasto, sometimes soft as velvet, sometimes enameled and grainy, stands in sharp contrast with Snyders' broad, fluent textural effects. Every feature of Fyt's work strikes a note of earnest, concentrated intimacy, as unlike the outspoken rhetoric of Snyders as it can be. They are to each other what Van Dyck is to Rubens: poetry, elegance and refinement on the one hand, a powerful, hearty, lusty hymn to life on the other.

Perhaps the most original side of Fyt's personality is to be found in his flower pictures. Some of his bouquets—modeled by a sudden shaft of light, couched in a deep, warm vein of color, accentuated by a generous brushstroke—already have intimations of that direct hold over nature later exemplified in Courbet's work. Such a picture is his *Vase of Flowers*, dated 1660, formerly in the Schloss Collection.

To some extent, Fyt probably owed his fondness for saturated coloring to the stay he made in Italy. His imitator Pieter Boel also developed a certain breadth of treatment and a certain lushness of impasto after making a journey south of the Alps. Yet it so happened that these two Flemish painters exerted a strong influence abroad, an influence that largely shaped the development of still life at Genoa, whither it penetrated about 1645-1650 through the intermediary of Boel. The latter also introduced into France the decorative formula of the game and the breakfast piece accompanied by animals—a formula which held its own there down to the 18th century, when we still find it in the works of François Desportes.

After being enriched with Italian elements, the Antwerp still life came under Dutch influences through the art of Jan Davidsz. de Heem. Mention has been made of the eclectic creations of this painter, who sought to combine the broad compositional order of Flemish art with the meticulous rendering peculiar to his own school. I have told how successful the Antwerp conception of still life proved to be in the form he gave it. About 1650, after having worked in Antwerp for ten years, Andrea Benedetti returned to Italy and there acclimatized De Heem's manner of painting.

There was, however, one modest realm of Flemish painting which remained almost unaffected by the heroic aspirations of Rubens. I refer to the tradition founded by Jan Brueghel. An exceptionally gifted painter, responsive to every flicker of life and capable of handling the tiniest forms with breadth

and freedom (no doubt it was this that prompted Rubens to solicit his collaboration), Brueghel went on painting flowers, objects and animals with minuteness at a time when Snyders' studio was already turning out gigantic compositions in number. He had the good fortune to see his style perpetuated in the small pictures of Jan van Kessel; these are like exquisite pages from a book of natural history, treated in discreet *trompe l'œil*, in which the old traditions of medieval manuscript illumination seem to come to life again. But Brueghel found his most original disciple in Daniel Seghers. This artist (who was also a Jesuit priest) specialized in a particular type of flower painting which Rubens had been fond of: a garland woven round a devotional scene. Rubens painted several versions of the *Virgin and Child* encircled with a wreath of flowers executed by Jan Brueghel (Louvre, Paris; Alte Pinakothek, Munich, and elsewhere). Seghers adopted and varied this arrangement. Instead of wreathing flowers together in an unbroken chain, he often bunched them in small bouquets attached to a cartouche carved in stone, painted in *trompe-l'œil*. Although he learned his art from Brueghel, he let himself be won over in the course of time (perhaps under Dutch influence, notably that of De Heem) to a smoother, cooler, more impersonal technique than that of his master. He showed a good deal of taste in setting his scenes and figures within a painted framework whose subdued tonality is never lacking in finesse. He expressed a tender piety in such works which, in keeping with the ideas of the Counter-Reformation, are almost popular in their appeal: his fruit and flowers are offerings to the Virgin and saints. The spirit that moved him to paint as he did exactly corresponds to that of St. Francis of Sales who, in his famous *Introduction à la Vie Dévote*, never wearies of comparing the diversity of pious thoughts to that of a bouquet which each man can make up and vary as the fancy takes him. That the Jesuits promoted flower painting for religious ends is proved by the example of Seghers' contemporary, Sebastian Assenberg (also a Jesuit priest), who worked at Cologne [108]. The success his art met with, however, led Seghers to put this formula to other than purely religious ends. So it was that, amiably flattering his model, he inserted portraits of more or less well-known figures in haloes of flowers (pl. 40) [109]. Small religious pictures and small portraits of this type were also executed by other painters, sometimes very fine ones, such as Adriaen Brouwer, Jan Lievens, David Teniers and Gonzales Coques [110]. Thus adapted to both religious and secular ends, the practice inaugurated by Seghers soon found many imitators, especially in Spain, where it was encouraged by the Jesuits. Juan de Arellano and Bartolome Perez slavishly fell into line [111]. Mario dei Fiori in Italy and Jean-Baptiste Monnoyer in France were not unaffected by it, while in Flanders itself Seghers' followers carried on his art down to the end of the 17th century. In his own day, moreover, Seghers numbered among his patrons Charles I of England, Christina of Sweden and Archduke Leopold Wilhelm. The Princes of Orange, the Emperor, the Count Palatine and the Marquis of Brandenburg gratefully accepted his flower pictures and loaded the artist with regal gifts [112].

Thanks to their technique and their peculiar sense of color, both inherited from Rubens, the Flemish masters imbued their still lifes with a limpid brilliance and a cheerful warmth of feeling. Even on the rare occasions when they deliberately set out to imitate the sober, monochrome color schemes of Dutch painting, as in the case of a fine *Still Life with Books* (Brussels Museum) which it is tempting to attribute to Teniers, an elegant fluidity of texture and a light touch preserved their pictures from the rather stilted earnestness which the same theme would have assumed in the hands of a Leyden painter.

The Flemish still life failed to produce as many particular forms as the Dutch. But its international influence was far deeper and more widespread. This was due to its rhetorical and decorative style, which commended it to the Latin spirit and to the aristocratic way of life of the great monarchies and princely courts, in Spain, France and Italy. This was also due, in the case of Seghers and his imitators, to its religious character, which found an immediate echo in all Catholic countries.

Italy : From Caravaggesque Firmness to Baroque Lyricism.

In the Low Countries, in the late 16th and early 17th century, the independent still life first began as the work of modest specialists. In Italy it assumed a modern form, thanks to the intervention of one of the most independent, most revolutionary masters of European painting: Caravaggio.

80

When the young Caravaggio was painting his first fruit and flower pictures in the Cavaliere d'Arpino's studio in Rome, about 1589-1596, what was the historical situation in Italy at the time in the field of still life ? It was then being practised in two forms. The first, represented above all by Barto-lommeo Passerotti (1529-1592) and Vincenzo Campi (1536-1591), consisted of food displays or shops in which the figure of the shopkeeper accompanies his or her wares; we saw in the previous chapter the mannerist traits of this type of picture, and everything it owed to the Netherlanders. The second, purely Italian in origin, consisted of flowers or fruit, decorative in character, treated in *trompe-l'œil*, and deriving from the painting of grotesques; executed not only on walls but also on panels and canvas, these were true pictures; they were intended both for decorative purposes—witness the two extant compositions by Giovanni da Udine dating from the mid-16th century—and for the cabinets of private art lovers; they were current as early as the second half of the same century, as is shown by Malvasia's text concerning the works of Carlantonio Proccaccini, born about 1555. Not a single one of these has yet come to light, nor, in the Low Countries, have we any of the flower pieces of Lodewijck van den Bosch, who was presumably active from the third quarter of the 16th century on. Belonging to a well-known family of Milanese mannerists and a contemporary of Vincenzo Campi, Proccaccini most probably painted *bodegones* with figures; but the express mention of " very elegant pictures of flowers and fruit " together with landscapes makes it certain that he also did independent still lifes. This painter thus appears as the earliest known still life specialist in Italy.

The two great new forces to emerge in Italian painting about 1590—the art of the Carracci and that of Caravaggio—inevitably affected the genre that concerns us here: both currents, though in different ways and to an unequal degree of intensity, came, after Mannerism, as a return to nature. Only recently begun, the study of them has not yet been carried very far, but we find them on the rise at Rome about 1600, and to some extent interpenetrating. But while the independent still life was already coming into its own in Caravaggio's work, it appeared in the circle of the Carracci either as more faithful to the old mannerist alliance with the human figure, or as independent but clearly marked by the decorative spirit; and it was perhaps only the example of Caravaggio and his direct followers that set it on the way to independence and enabled it, from about 1630, to play a decisive role, by initiating the whole subsequent development of Italian still life in its Baroque form. So it is fitting to begin this chapter with an account of Caravaggio's contribution.

Although, as we have seen, the *Basket of Fruit* in the Ambrosiana seems to have been conceived as a decorative *trompe-l'œil* in the antique manner, the underlying spirit of Caravaggio's fruit and flowers is diametrically opposed to that of decoration. He aimed at rendering *cose naturali* really natural, with all their succulent life. It might even be surmised that the young artist deliberately set out to show all the new effects that could be elicited from this traditional subject, an offshoot of decoration. He did nothing else but this in the fields of mythological and religious painting.

In his fruit and flowers Caravaggio recorded the details most apt to horrify the academic idealism then developing under the auspices of the Counter-Reformation: transparent drops of water, worm-eaten leaves, with shriveled or wilted edges, just as they look after serving as a model for several days in a painter's studio. In mannerist pictures from Aertsen to Campi the indication of these defects of nature is exceptional; their fruit have the heroic size and the spectacular perfection of present-day American produce. They are typical samples of nature, not its creations as individualized by life. But the Flemish and Dutch masters who painted pictures of a *Meal on a Table* showed preoccupations similar to those of Caravaggio and contemporary with them. Does this mean that the great Italian had been influenced by them ? Some have thought so and have gone so far as to trace his baskets of fruit back to those of Joos van Cleve, among others. But this seems rather doubtful. Caravaggio painted motifs which many Italians before him had painted throughout the 16th century. And his worm holes have by no means the same spiritual and plastic significance as those of the Netherlanders. For the latter, these were merely minute details added to other details; their vision, like that of the Primitives, saw the sights of nature as so many juxtaposed fragments of equal value. For Caravaggio, these were expressive tokens of the natural decay of life; he used such details more sparingly than the Flemings, but he laid more stress on them. They were elements of an esthetic program which looked to everyday reality as a direct source of poetry: the virile glorification of vitality, as opposed to mannerist willfulness.

But Caravaggio was an Italian, he was familiar with the whole 16th-century tradition of stylistic grandeur. After duly recording them, he embodied these details in an overall rhythm, so that neither eye nor mind lingers over them any longer than is needed for it to realize that it is not being asked to believe in an impossible, flawless nature. What the eye and mind notice straightaway in his paintings is the solemn cadence of a lighting which restores a crystalline purity to apples and grapes, which sets up harmonic relationships between objects echeloned in depth, which draws a lustrous peace from transparencies and reflections. A wrinkled leaf takes on a mineral firmness; the petal of a daisy, as true to life as painter ever made it, seems chiseled out of ivory; a worm-eaten apple asserts its spherical density. Still life, for Caravaggio, was the pretext for an admirable transposition, and matter for a symphony of forms. Here we stand at a far remove from the scattered microcosms of Netherlandish painting.

We stand equally far from the famous, sempiternal realism to which critics persist in reducing Caravaggio's art. Hordes of painters have gone in pursuit of " nature " and " truth," yet the end result is diversity; the best praise the early critics could find was to extol the " truthfulness " of the painters they liked. There are a thousand varieties of realism—the Cubists give us one, Caravaggio another. These are only certain facets of nature, certain harmonies hidden in the chaos of forms under changing light, and painters suddenly reveal them to us. Caravaggio never set out to show the whole of nature; had he tried, he could never have done so. He is said to be a great realist, but above all he was a great poet, a seeker after a certain effect which revealed nature strictly as he saw it: rich in life yet held fast in precise forms, arresting yet serene.

By treating it in the style of his large compositions and devoting easel pictures to it, Caravaggio conferred on still life its letters patent of nobility. He was the first of the great masters of modern painting to produce independent still lifes. Roberto Longhi, in a few words, with his usual acuteness [113], has described this capital contribution of the painter who amazed his contemporaries by assuring them " that it cost him as much trouble to make a good flower picture as it did to make a figure painting." No statement could come as a greater shock to the academic mind: the hierarchy of genres was wiped out, the reign of man was over. Still life took its place definitively in the domain of " great " painting. It was only after this example set by one of the most famous—because the most discussed—religious painters of the day that the leaders of schools free of academic tutelage began painting still lifes: Velazquez, Zurbaran, Rembrandt, Goya, and thereafter nearly all the great painters from the 19th century to the present day.

Thus Italy once again put still life at an unsuspected level. Even were this her last great contribution, it would be no less decisive than that of Giotto, than that of the *marqueteurs* of Modena and Urbino (behind whom looms up the great silhouette of Piero della Francesca), than that of Titian and Bassano. But Italy, though she disseminated the fundamental ideas, did not exploit them herself. It was left to the Northern masters of the 14th, 15th and 16th centuries to do so. And after Caravaggio no great Italian master, except Guardi, painted still lifes.

Much has been discovered about Italian still life painting in the 17th century. Hundreds of works, many of them quite remarkable, have yet to be assigned to their rightful author. The museums of Corsica, that of Ajaccio in particular—to take but one example—contain fifty or more fine still lifes in storage, mostly of the Neapolitan School, formerly in the famous collection of Cardinal Fesch. Since the first edition of this book appeared, Italian historians have done a large amount of work and the personalities of several outstanding still life painters have been firmly outlined. Nevertheless, for want of accurate chronological data, the relations between the different art centers remain obscure. For the time being, we can do no more than distinguish the main currents and the approximate stages of evolution: the influence of Caravaggio taking effect in Rome (1600-1625), then radiating out to the North (Bergamo) and to Naples (up to the middle of the century); the Bolognese-Roman formula, contemporary with it (1600-1635) and less realistic; then, from about 1635 on, but more marked after mid-century, the steadily increasing sway of Baroque, chiefly centered, apparently, in Rome; but other centers, very active and original, soon arose elsewhere, in the North (at Genoa) and above all at Naples.

In Rome Caravaggio's example encouraged painters to practise the independent still life and imposed on it a sober, powerful style. It would seem that the naturalistic spirit was propagated by the studio—actually a kind of academy—in the Palazzo Crescenzi in Rome where, early in the century, several

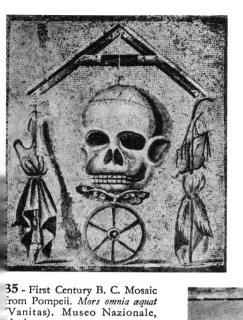

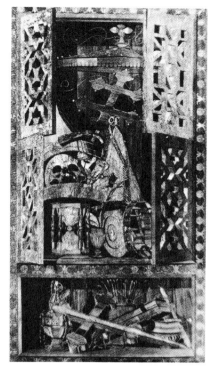

THE THEME OF THE
VANITAS
THROUGH THE AGES

35 - First Century B. C. Mosaic from Pompeii. *Mors omnia æquat* (Vanitas). Museo Nazionale, Naples.

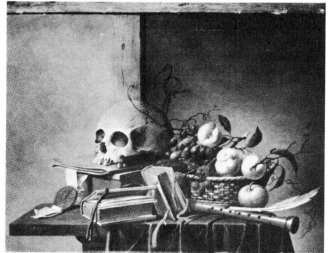

36 - FRA VINCENZO DA VERONA. Vanitas. Marquetry. 1520-1523. Louvre.

37 - HARMEN STEENWIJCK. Vanitas. Ca. 1640. Lakenhal, Leyden.

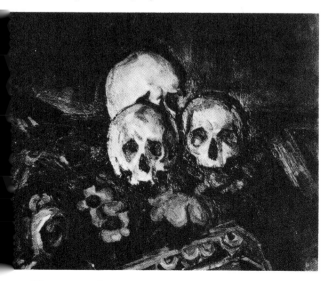

38 - PAUL CÉZANNE. Three Skulls (Vanitas). 1904. Dübi-Müller Collection, Solothurn.

39 - GEORGES BRAQUE. Vanitas. 1938. Private Collection Paris.

STILL LIFE
as seen
BY THE OLD MASTERS
AND THE MODERNS

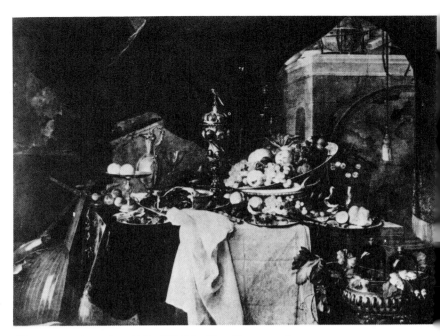

40 - JAN DAVIDSZ. DE HEEM. The Dessert. 1640.
Louvre, Paris. — 41 - HENRI MATISSE. Interpretation
of De Heem's Dessert. 1915-1917. S. A. Marx Coll., Chicago.

painters worked together who were to distinguish themselves in still life. Outstanding among them were Tommaso (called Mao) Salini, Giovanni Battista Crescenzi and Pietro Paolo Bonzi of Cortona, called Gobbo de' Frutti or de' Carracci. All three, born around 1575, belonged to Caravaggio's generation. The works by two of them so far recovered represent the first phase of 17th-century still life in Rome, from 1600 to about 1625, a phase in which Caravaggio's influence—a strictly realistic setting without any romantic undertones, concentrated lighting bringing out the full plasticity of volumes, and clearly ordered composition—mingled with a tradition still unspecified but probably originating from Bologna, from the followers of the Carracci, and calculated to " ennoble " still life either by decorative rhythms or by the addition of a landscape.

Salini has come to be known to us only recently by some first-rate works, in which he shows himself a faithful follower of Caravaggio, powerful and elegant at once ([114]) (pl. 54). But a painting which ought to be assigned to Salini, the *Woman buying Eggs* (pl. 53) in the Minneapolis Institute of Arts (where it is unjustifiably ascribed to Nicolas Regnier) ([115]), reveals a peculiarity foreign to a Caravaggist of the strict obedience: the presence of a landscape background. There has been much discussion lately as to who first took the initiative of coupling a landscape with a still life, some attributing it to Bonzi (Gobbo), who died in 1636, others to his pupil Cerquozzi. Here we find a landscape background in a *bodegone* previous to 1625 ([116]). The truth is, however, that the problem has been wrongly stated: the landscape background in a still life was a mannerist innovation, and the tradition initiated by it continued both North and South of the Alps, flourishing again with renewed vigor in the 17th century, especially in Italy. After all, Aertsen painted a landscape behind a still life as early as 1551 (pl. 15), Beuckelaer did the same and so did Vincenzo Campi in Italy. Though Caravaggio departed from this traditon, it was only a short-lived interruption, locally limited. For within a few years after his death the tradition had been actively revived and we find it not only in Rome in the works of Cerquozzi, but also of Gobbo de' Carracci. In the shop of the *Woman buying Eggs* hangs a dead hare, just as the picture from the Orsi Collection exhibited in Rome in 1956 shows live ducks; Baglione says in fact that in addition to flowers and fruit Salini painted "altre cose dal naturale ben espresse." Here again Salini overstepped Caravaggio's still life repertory, which was limited to flowers and musical instruments. It would seem to be at Bologna in particular, following the tradition of Passerotti, that animal painting was practised. A painter of fish and animals is mentioned at Rome in 1619, Tommaso Campana, and, characteristically enough, he was a pupil of Lodovico Carracci ([117]).

As for Giovanni Battista Crescenzi, an architect and painter who was also a nobleman and a bel-esprit, art historians are now in search of his still lifes in which Baglione admired glass vases with fruit immersed in water; he painted some for the King of Spain about 1617. Such motifs are distinctly Cara-vaggesque, but there is no drawing conclusions in the absence of the works themselves ([118]). Yet it would be important for the history of still life painting in Spain to know more about the contributions made in that country by Italian painters more or less influenced by Caravaggio.

Finally, the third member of the Crescenzi " academy," a man of the generation representing the first phase of still life painting in Rome (from 1600 to about 1625), is Pietro Paolo Bonzi of Cortona, called Il Gobbo (the hunchback), no doubt because of a very real infirmity. His artistic personality is beginning to take shape. If the large *Shop* (Collection of the Duke of Valencia, Madrid) brought to light by Julio Cavestany bears a genuine signature by Gobbo, and if the *Fruit and Vegetable Woman* (formerly National-museum, Stockholm) was really by the same hand ([119]), then the young painter from Cortona was drawn into the Caravaggesque orbit but, like Salini, remained receptive to other suggestions, as we see from the landscape behind the *bodegone* and from the figures, whose grimacing faces are still mannerist and derive from the Bolognese tradition of Passerotti and the young Annibale Carracci. Gobbo's undisputed works —the festoons of fruit in the Palazzo Mattei in Rome (ca. 1621-1623) ([120]) and two signed pictures in the Wetzlar Collection, Amsterdam—form a profoundly homogeneous whole and tell of an art from which Caravaggism is altogether absent. They show in fact a decorative symmetry deriving directly from the Raphaelesque festoons in the Farnesina, and they breathe a temperate naturalism—traits which tally very well with the teaching of the Bologna masters. So there is no reason to deprive Bonzi of his old nickname, Gobbo de' Carracci ([121]). Other works certainly his, like the two landscape prints (with his signature), show the same hesitation between Elsheimer *(Baptism of Christ)* and Annibale Carracci

(Rest on the Flight into Egypt). The examples of both Salini and Gobbo seem to indicate that the Caravaggesque still life formula in all its purity only imposed itself in Rome for a few years, and that from about 1620 on the classicizing naturalism of the Bolognese actively mingled with it, orienting it towards decorative rhythms. Outside Rome Caravaggio's influence lasted till the 1640s.

This period is marked by a feature common to still life painting in Rome, Naples and Bergamo, whatever the spirit, Caravaggio's or that of the Bolognese, by which it is dominated: a friezelike composition in which objects are spaced out at regular intervals along the picture surface. This is indeed a striking feature of the art of Salini (pls. 53 and 54), Bonzi (pl. 59), Luca Forte (pl. 62), Porpora (pl. 57) and Baschenis, anyhow in the early work of the two last-named painters. Later, after the middle of the century, the Baroque spirit gave rise to a composition more deeply receding into space, more confused, more abundant, more vivacious. Baroque sensuality reacted against the Caravaggesque rigor of forms in which the mind found its satisfaction.

Yet, even in the reign of Baroque, the Italian still life preserved a stock of decisive qualities, strikingly evidenced in Caravaggio: it was monumental; it aimed at rhythm and grandeur; it almost completely ignored the archaic formula, with its dispersion, its evenly diffused lighting, and its precision of detail sought for its own sake. Indeed, the influence of the Netherlanders, who spread this formula over the continent, is exceptional South of the Alps. A few traces of it can be detected in North Italy, at Milan for example, in the incisive minuteness of Fede Galizia (pl. p. 2); it is a matter of record that Jan Brueghel passed through Milan and, later, Lodovico de Susio through Turin. But Galizia's apples and peaches are firmly shaped by sharply focused light, they owe the essentials of their style to the Lombard tradition and to the synthetic plasticity of Caravaggio. As for Susio himself, who went to Rome, his fruit have a certain fullness which may possibly owe something to Italian art.

Outside Rome, it was precisely in the North, in the person of Evaristo Baschenis, a Bergamask compatriot of his, that Caravaggio found a follower of talent. Baschenis was the most original Italian still life painter of the 17th century. He painted many *Kitchen Tables* loaded with plucked chickens and fish. But it must have been Caravaggio's compositions that opened his eyes to the possibilities afforded by musical instruments to the painter bent on making still life into an assemblage of fascinating forms. He elicited from viols and lutes an admirable plastic music. Their fully rounded bodies, smooth or grooved, their taut necks and curving scrolls all answer to each other through the half-light with echoes of arabesques and silky gleams. It has been wondered where Baschenis might have taken the idea of this subject. From a lute lying on a chair in a picture by De Heem? From the framework of motifs around a 16th-century print? Why not from marquetry? This is certainly a much more likely source. But no matter. It is enough to glance at the lute and violin which Caravaggio crossed at the feet of his *Love Triumphant* (formerly Berlin Museum) to be certain of Baschenis' immediate source of inspiration. For here he saw more than the suggestion of a motif: he found a style and poetic resources. Although he only began his career thirty years after Caravaggio's death, he fathomed the essence of his art; perhaps because he came from the same region. Longer than any other Italian painter he succeeded in keeping to a chiaroscuro that respects the precision of forms. This Caravaggesque legacy gives their value to his compositions, even when they are weighed down by a provincial ostentation of luxury.

With his lighting, which fills the composition with a grave, almost solemn cadence, Baschenis brings to mind the Spanish masters. He painted many kitchen pieces in which livid poultry and blood-stained meat glow with a certain pathos. But while the *bodegone* painters intensify their light to the point of rendering it implacable, Baschenis feels his as a kind of tender modulation of surfaces and textures. There is nothing unreal about his light. He was a dreamer but not a mystic. This is an essential point of difference between the North Italians and the Spaniards who then ruled over Milan and whose painting is often confused with that of the Lombards. The sobriety and concrete gaze of North Italy has sometimes been taken for severe Iberian realism. Yet the vision of the Italians has a mellow lyricism about it. Their chiaroscuro is never peremptory, their impasto can be blunt on occasion but never harsh, their color is nearly always simply sensuous. The conception of their still lifes is devoid of mystery, their poetry is immediately accessible. With the Spaniards we feel an unrelenting tension between light and shade, between the object and its setting, between the passion of the senses and the rigor of the mind.

In the North, not only at Bergamo but also at Bologna, a certain taste for severity and truth to life ensured the survival of the Caravaggesque spirit. This spirit was a part of the Lombard tradition and in keeping with the natural bent of the Spaniards, who controlled the region politically. Giuseppe Recco, born at Naples but formed by a study of the art of Baschenis, painted dark, sumptuous collections of objects—caskets, books, sweets and flowers—in which echoes of Caravaggio are perceptible. His visits to Spain no doubt encouraged him to revert so often to this manner and these themes. But after settling down at Naples he let himself be carried away by the Baroque current; indeed he became one of its most brilliant exponents.

At Genoa Anton Maria Vassallo used a firm, virile chiaroscuro in spite of his Flemish training and the spell cast over him by the blatant picturesqueness displayed by Castiglione. He painted a profusion of objects and animals, usually accompanied by a figure. He handled them forcibly enough for several of his pictures to be assigned to Velazquez; among others the fine *Kitchen* (Cook Collection, Richmond) which Longhi has now given back to him ([122]). Have we here the early works of an artist oriented towards Baroque? By what channel was this remnant of Caravaggesque earnestness transmitted to Vassallo? It is not yet possible to say.

At the other end of the country, in Naples, the exact aspect of still life painting at the beginning of the 17th century still remains obscure. The first generation revealed to us by the early historians is represented—according to R. Causa ([123])—by Giacomo Recco (father of Giuseppe), Ambrosiello Faro and Luca Forte. While the first two are no more than names to us, I am now in a position to produce two signed pictures by Forte, one of which is illustrated here (pl. 62) ([124]). These works provide further proof that in 1630-1640, as had been supposed ([125]), the first phase of Neapolitan still life painting was determined by Caravaggio's influence, exerting itself mainly in the form of sharply focused lighting. In part a contemporary of Gobbo, Luca Forte handles still life in a manner devoid of any decorative arrangement, but marked on the other hand by a more explicit plastic vigor and a sensuous, narrative abundance worthy of an antique *xenion*, suggestive in fact of a succulent description by Philostratus—which, after all, need not surprise us in Magna Graecia. Coming a little after Forte, Paolo Porpora cuts the figure of founder of the local school and in his early work shows the effects (as does Giuseppe Recco) of the Caravaggesque tradition, which was handed on to him by Aniello Falcone. In this spirit Porpora painted kitchen still life and fruit and flower pieces. He may also have profited from Luca Forte's pictures; the motif of the bird hovering over the still life is significant in this respect (pls. 57 and 62). For the time being, few pictures by him in this manner are known ([126]). The finest is a large canvas showing a table laden with a tall bouquet and all the fruits of the earth, and enlivened by the sudden flight of a dove, candid and hieratic as a cherub (pl. 57). This shining whiteness of a heavy body in mid-air still belongs to Caravaggio's repertory of visionary realism. Though Porpora already betrays that ardent profusion which soon became the hallmark of the Neapolitan School, he exercises restraint in his stable, orderly composition and in the light defining forms by sharp planes. He later drifted into flickering, picturesque effects and combined plants and animals in a purely anecdotal manner, no doubt as a result of his contact with the Roman milieu haunted by Dutch painters. He may not have been the only representative of Caravaggism at Naples towards the middle of the century. Giuseppe Recco, who was presumably formed at Milan by the art of Baschenis, must have returned home about this time with his sober luminism (pl. 57 *bis*).

Long dominated by Mannerism, Florence carried to their logical conclusion the great food displays of which Passerotti has left examples: Jacopo da Empoli deprived his hanging meat and game, his vegetables and plates piled on tables, of all human company and thus created genuine *bodegones*, in 1624 at the latest. They closely resemble those of the Spaniards, not only in the subject matter but in the bleak alignment of flaccid, livid bodies looming up in shadow. Alejandro de Loarte painted similar pictures at the same period ([127]); his general conception of a market in a landscape stemmed from Vincenzo Campi, who had been to Spain. So it is certain that inspiration came from Italy. But the Caravaggesque spirit enters into it only incidentally.

The same is true of Venice, where, however, no outstanding still lifes seem to have been produced —this in spite of the all-important initiative of Jacopo Bassano and his sons in the previous century. And also in spite of the presence of the Caravaggeschi Carlo Saraceni and Jean Le Clerc, a Frenchman. No trace remains of Domenico Feti's activity at Venice, but the still life fragments in his compositions

have a powerful spontaneity which must have impressed other artists; one among many examples is his *Melancholy* in the Louvre, which he repeated with variants. As for Bernardo Strozzi, schooled at Genoa in the Flemish atmosphere, his stay in Venice between 1630 and 1635 also failed to bear fruit of any consequence. It may be surmised that Titian's vision, which combined the human figure, plant life and inanimate objects in a profound chromatic unity, was still too preponderant with the majority of 17th-century Venetian painters for them to take any interest in still life except in conjunction with figures; and in this form we occasionally find a striking example. The fruit, vegetables and flowers placed by Giulio Carpioni in the foreground of his compositions are often quite fine, broadly handled, lusterless but rare in coloring (*Vanity of Love* and *Soap Bubbles* at Vicenza, *Child with a Basket of Fruit* in the Uffizi). Still, there were painters in Venice who made independent pictures of flowers and game. Francesco Mantovano of Rovigo, for one, prints of whose fruit and flower pieces were engraved by Boschini ([128]); another was Giacomo di Castello, whose two canvases at Vicenza show little personality. Our impression is, on the whole, that the keen interest in reality shown by the Venetian painters of the 16th century, and again, equally keen, by those of the 18th, all but disappeared between these two great periods.

From the beginning of the 17th century on, Bologna must have been an important center of still life painting. In their early days at Bologna Agostino and Annibale Carracci were in direct contact with Passerotti. The *Butcher's Shop* (Christ Church College, Oxford) was very probably executed by the latter in collaboration with young Annibale (ca. 1583-1585). But both this picture and the famous *Bean Eater* (Galleria Colonna, Rome), in all probability the work of Annibale, still keep to the formula of still life accompanied by figures and are marked by mannerist restlessness. The *Bean Eater*, with his huge hands and the greediness with which he wolfs down his food, and the objects in front of him, hastily sketched in with a full brush, are animated with expressive dynamism. After reaching maturity, the Carracci gave up painting still life for its own sake. And yet a certain naturalism, which made shift with their classicism, oriented some of their followers towards still life painting.

Bonzi, as we have seen, owed his manner largely to this esthetic; his nickname, de' Carracci, even suggests that he collaborated in decorative works which these masters carried out in Rome. We also noted the presence in Rome in 1619 of Tommaso Campana, a pupil of Lodovico Carracci, who painted "various pictures of animals and fish" for the Borghese ([129]). Animal painting seems to have been a specialty at Bologna; this was no doubt a legacy of Passerotti. Indeed, when a still life painter of great repute later appeared in Bologna, he painted not only flowers and fruit but very often game and fish. This was Paolo Antonio Barbieri, younger brother of the great Guercino. His account book, begun in 1629 and carried up to his death in 1649, lists several dozen paintings, with mentions of birds, quadrupeds, fish, fruit, flowers, seashells, silverware and other objects. Malvasia states that his customers were very important people, and that his famous brother sometimes added suitable figures to his still lifes, such as the woman market-gardener in the picture which used to be in the Villa Ludovisi. His authentic works are only now being brought to light. An *Apothecary's Shop*, mentioned in the account book (in 1637), has been identified by Francesco Arcangeli in the Pinacoteca at Spoleto ([130]); some flowers accompanying a *Flora* (ca. 1642) and the fruit in a *Woman selling Fruit* (ca. 1645), two figures painted by Guercino (Palazzo Rospigliosi, Rome), have been recognized by Denis Mahon, no doubt rightly, as being by the hand of Paolo Antonio Barbieri ([131]). The *Apothecary's Shop*, strongly archaic in composition, may perhaps owe its hard, almost naïve chiaroscuro merely to its mediocre condition. On the contrary, the *Game Vendor* (pl. 60) and its pendant, the *Fruit Vendor*, which I believe to be by Barbieri, contain figures and a rich, velvety chiaroscuro in the manner of Guercino—and the elder brother's influence is clearly attested by Malvasia ([132]). The leader of Bolognese still life painting here shows himself cultivating the *bodegone* with figures and game, now located in an interior with a column, now seen with a strip of landscape in the background. The well-balanced composition spread out across the picture surface is classical in spirit, in contrast to the lyricism of the lighting. It was towards the middle of the century that Guido Cagnacci, who, though a native of Rimini, falls within the domain of Emilian painting, introduced a violent note of Baroque movement into his *Flowers* (Pinacoteca, Forlì, and Museum of Fine Arts, Boston) ([133]) and into his *Woman with Dogs* (Borromeo Collection, Milan).

As for the practice of Salini, Porpora, Vassallo and others of adding live animals to objects and plants, this appears to have been a remnant of the mannerist tradition. Was this tradition purely Italian

in origin, was it that of Giovanni da Udine (pl. 12) and the Bassanos? In the case of such a painter as Castiglione this latter filiation is obvious. But a new source of inspiration appeared: the influence of the still lifes which the Flemings had been painting since the beginning of the century. There was a steady and plentiful influx of Flemish pictures into Italy. Lodovico de Susio's *Dessert with Mice* (pl. 22) was painted in Italy in 1619. The idea itself and the spirit in which the animal intervenes in the still life might very well have been determined by examples hailing from the North. At Genoa, from about 1630 on, the Rubensian influence led to the introduction of animals on a large scale, in an essentially picturesque alliance with the rest of the picture. At Rome, from about 1650 on, and later at Naples, birds and small reptiles in woods and undergrowth, in the manner of Marseus and Withoos, were treated in the anecdotal, pseudo-naturalistic style. But wherever animals accompany still life in a landscape, we have a tradition which, though exploited by both the Netherlanders and the Italians, no doubt goes back to Bassano.

These three centers, Genoa, Rome and Naples, determined the principal forms of Italian still life painting up to the end of the century.

From the opening years of the Seicento, Genoese painting was in direct and constant contact with Flemish art. Rubens left works in Genoa. Cornelis de Wael, a painter and a leading picture dealer, settled there in 1610. Van Dyck stopped there in 1621 to carry out a large number of commissions. The Genoese studios came under the spell of the sensuous color and direct vitality of the Flemings, and these qualities contributed greatly to eliminating Mannerism in favor of Baroque. As concerns still life, the Flemish influences may be determined very precisely. In 1616 a pupil of Snyders, Jan Roos (called Rosa in Italy) brought to Genoa the manner of his master, his grandiose color orchestrations which do not prevent a perfect characterization of surfaces and textures. In the 1640s Jan Fyt and Pieter Boel introduced a warmer color scheme, a more interblended lighting, and glittering effects of fur and plumage. From then on, a very great many painters at Genoa and even elsewhere followed the lead of these two Flemings; their influence extended even down to the generation which lived on well into the 18th century: we detect it at Piacenza in Felice Boselli, at Rome in Arcangelo Resani, at Naples in Baldassare de Caro (134).

Nevertheless, Italian traditions also contributed to shaping the Genoese School; those of Bassano, first of all, but others as well. It is characteristic that Sinibaldo Scorza, a highly interesting realist painter, fascinated though he was by the animals of the Northerners, of Dürer and Roelandt Savery, should have copied a partridge by Crespi, called Cerano (135). Solicited at the same time by the minute descriptions of Northern painting and by the synthetic attitude of Italian pictorial culture, Genoese painters probably sought to combine these two visions of nature. This they achieved above all by means of a coloring peculiar to themselves, which blended detailed forms under its sumptuous coat. It might almost be said that the Genoese poured into their chromatism everything superlatively bright and gemlike that European art of the time had produced: Rubensian alternations of warm and cool tones, the saturated glow and silvery sheen of Venetian color. For Castiglione's and Strozzi's contacts with Venice are an established fact. The union of these two color scales, each conceived in so distinct an order of richness, was a felicitous and original achievement: it has a piquant *morbidezza* and ranges from Castiglione's pale yellows and russets to Vassallo's cobalt blues and bituminous browns.

An unbroken line of still life painters soon took form. Sinibaldo Scorza, many of whose works were unfortunately destroyed by war in his own lifetime, painted fruit accompanied by animals, pictures whose dense composition, plunging perspective and tender intimacy bring to mind Flemish paintings of the archaic type, like Lodovico de Susio's *Dessert with Mice* (pl. 22). But his subtle grayish color and a certain fullness of forms proceed from the art of North Italy.

While the Genoese take an interest in all still life motifs and are fond of accumulating them, they can seldom bring themselves to separate them from the human figure. Antonio Travi, Strozzi, Castiglione and Vassallo fill the composition with gigantic bric-a-brac which transforms biblical or mythological episodes into operatic genre scenes. Nothing could be more unreal than Castiglione's cauldrons and ducks. This painter opened wide the way to pastoral fiction, and it comes as no surprise to find Boucher admiring him, collecting his works and copying them. After growing up under Flemish tutelage, the Genoese School finally retained of a fundamentally realist indoctrination no more than the choice of motifs and a few echoes in the arrangement of them—kitchen pieces and heaped-up game. But its vision dispensed

with the literal transcription of things. Instead of cleaving to reality, it ran parallel to it. The color and light of the Genoese overlaid nature with an air of sumptuous enchantment. Synders' shopkeepers sell game which invites the touch of the hand; Strozzi's cooks bend over heaps of feathers which flash in colorful clusters; the eye alone admires them as a sight which mimics nature, but which lays no claim to take her place.

In Rome, by about the middle of the century, the Baroque style had swept away all traces of the Caravaggesque spirit. It followed two tendencies: it deflected flower and fruit painting towards decoration; and it was carried away by the Netherlanders. The leading representative of this generation (ca. 1630-1660) appears to have been Michelangelo Cerquozzi, now that G. Briganti has succeeded in crediting him with a group of still lifes by very rightly pointing out the intermediary character of his art, which forms a transition between Caravaggism and Baroque. Often accompanied by figures, these works are not so much still lifes in front of a landscape as pictures of fruit seen in their natural landscape setting, of vines bending under the weight of clustered grapes, in the shade of huge leaves. There is an unquestionable novelty here, not a mere revival of the mannerist tradition: Cerquozzi achieves a convincing fusion of still life, landscape and the genre scene. While the plasticity of forms still re-echoes the Caravaggesque tradition (as do the plebeian figures taken over from the repertory of Pieter van Laer), the deliberately jumbled composition and the "shifting" light reveal a painter already responsive to Baroque. Cerquozzi seems to stand at the origin of a whole line of Neapolitan painters who sojourned in Rome; and in Rome itself he influenced Mario Nuzzi, called dei Fiori, who, as his nickname indicates, became the most celebrated flower painter in Italy, and perhaps in all Europe. Schooled by his uncle Tommaso Salini, he kept no more of the Caravaggesque tradition than a direct and hearty naturalism. If the anecdotes of the time are to be trusted, his abundant garlands and his festoons tied to stone plinths came at the very moment when rhetorical taste provided a demand for them, for they were sold as fast as he could turn them out and fetched steadily rising prices. Mario was not the man to go against the current; he followed the fashion set by Seghers (who stayed in Rome from 1625 to 1627) and surrounded devotional images with joyful wreaths. The procedure itself is an obvious borrowing, but not his style, which has nothing in common with the precise, enamel-like finish of the Fleming. As for Mario's garlands, they owe nothing to those of Fyt or De Heem. Set out frieze-wise over doors, they carry on the tradition of interwoven flowers which we find at the Farnesina—with this difference, that Mario gives a realistic surface and relief to each fruit and flower and models them with skillfully cadenced lighting. He succeeds in infusing his flowers and fruit with both lyrical charm and a palpable wholesomeness. The palaces of the great and the cabinets of art lovers were soon filled with his works, which answered to the demand for conventional lifelikeness and to the need of sublimation felt by Baroque society, which came of age in the climate of the Counter-Reformation.

A whole school of " fioranti " monopolized still life painting in Rome and spread Mario's manner to other parts of Italy. Witness Domenico Bettini at Modena and Bologna; his only novelty was to introduce light backgrounds. Porpora took back to Naples the idea of painting huge bouquets, from which every trace of his former Caravaggesque grouping was banished for good.

At the same time, perhaps as early as about 1640, the Roman studios devised another category of decorative still life which was also destined to meet with international success. These were large canvases crowded with rugs, musical instruments and fine china. The idea sprang up in Rome at the time when Flemish art was bringing its influence to bear, either through the Flemings themselves, such as Willem Gabron, or through Italians familiar with the Netherlandish studios, such as Andrea Benedetti: they introduced the novelty constituted by the heterogeneous displays of Jan Davidsz. de Heem [136]. It is still difficult to say for certain who created the most sumptuous formula—the picture with a Turkey carpet. It may well have been Fioravanti, whose two pictures of this kind entered the famous collection of Archduke Leopold Wilhelm. But the best known exponent of these ponderous decorative pieces was Francesco Fieravino, known as Il Maltese (or the Cavaliere Maltese), many of whose pictures quickly found their way to France, where they were much appreciated. These hybrid products of Italian and Flemish Baroque left offshoots in classical-minded France: J.-B. Monnoyer's reception piece at the Academy is a characteristic example (pl. 49), and the Marseillais Ephrem Le Conte was only a docile imitator of the Cavaliere Maltese.

Though the "fioranti" owed nothing to the Flemings—apart from their rivalry with Seghers—other Italian artists were impressed by Dutch pictures. These were representations of plant life and animals taken unawares in their habitat and seen both with a pseudo-scientific acuity and with a wholly romantic, wholly Northern insight into the secrets of wild life spied out in the moist shadows of the woods. We have already spoken of the presence in Rome, around 1650, of specialists in this branch of painting. It has been proved [137] that Porpora was affected by their influence. Yet he lost nothing of his broad, supple vision, nothing of his warm color devoid of the mineral polish dear to the Northerners. He remained thoroughly Neapolitan.

Naples, in fact, was even more successful than Genoa in assimilating foreign influences. These were twofold: Netherlandish, coming in by way of Rome and represented at Naples itself by Abraham Brueghel, grandson of Jan ("Velvet") Brueghel; and Spanish, fostered by the many artists of that country who visited Naples at that time, owing to its political ties with Spain.

Abraham Brueghel is undoubtedly to be reckoned with in the evolution of the Neapolitan still life. It was a mistake, however, to regard him as a decisive master of that school. He added nothing to either the style or the spirit of Neapolitan painting. His historical role lay in introducing the type of the old *machine* of Flemish origin, which combined a food display, a figure of plebeian aspect, and a tritely romantic landscape background. Suffice it to compare a picture by Brueghel with a composition of this kind by Luca Giordano: here we have the contrast between a laborious juxtaposition of set pieces and the evocation of a stupendous unity of nature, in which the sky swept by birds and the earth laden with its fruits stand in a mighty embrace beneath a light shifting and torrid as the wind of Apulia; and the human figure plays its part in this orgy as a discreet, almost embarrassed onlooker. Well before Brueghel's arrival, the Neapolitan School stood in possession of a color and texture capable of building up such pantheistic visions. We even get the distinct impression that it was to the Neapolitans that the Fleming owed the generous impasto and lyrical bursts of sunlight which range him in the sphere of Italian taste. His debt to Naples perhaps equals his own contribution.

The same may well be true of the relations of the Neapolitan with the Spanish still life. The historical data of the problem have not yet been made clear. To judge by the early writers, Francisco Herrera the Younger (El Mozo) seems to have played the role of initiator in the painting of fish, which was destined to have so great a success at Naples. Towards the middle of the century he worked in Italy, where he was given the nickname of "Spagnuolo degli pesci." At that time [138], in fact, he may have brought a decisive influence to bear on the formation of Ruoppolo and Recco, two masters of seafood painting who in treating this subject show a certain kinship with the Spaniards; but up to now not a single picture of this kind has come to light which can be certified as Herrera's [139]. Recco, moreover, probably took up the painting of fish under Lombard auspices, in the tradition of Baschenis' kitchen pieces—a tradition which, as we have noted, had much in common with Spanish art. As for Ruoppolo, the very fine picture at Stockholm (pl. 58) shows him in 1653, at the age of twenty-four [140] and at the time of Herrera's prestige, working in a style Italian rather than Spanish: gleaming accents of color and instantaneous light.

However this may be, the contrary movement which carried Neapolitan influence into Spain is very much in evidence. It steadily increased in the last third of the century when Neapolitan painters of the first rank, from Giuseppe Recco (accompanied by his daughter Elena) to Andrea Belvedere, went to work in Spain. Looking through the old inventories of Spanish collections, one gets the impression that Neapolitan still lifes were being imported regularly by the shipload. The result was a certain mixture of style, especially in small pictures reduced to a few elements and thus resembling those of the Spaniards, who were generally more sober than the Neapolitans. Thus the paintings of the Neapolitan Tommaso Realfonso have been considered as Spanish and their author as a mysterious artist by the name of T.R. Alfonso.

On the whole, the Neapolitan School presents a unity of tradition and originality of conception that are quite remarkable. From Luca Forte and Porpora the line of its leaders descends in unbroken succession well into the 18th century. Porpora formed Giovanni Battista Ruoppolo; schooled in the latter's studio were Onofrio Loth and Andrea Belvedere; these were the artists who determined the principal nuances of the local art production. The art of Giuseppe Recco alone seems to originate from a

source foreign to Naples, but he easily joined in with the spirit of the school. Ruoppolo and Recco, anyhow in their early work, retained an echo of Caravaggesque chiaroscuro, broken up into clean-cut divisions. Their masterpieces of seafood painting date from this period, from before about 1660. Symptomatic of Neapolitan homogeneity is the fact that the admirable *Display of Seafood* in Stockholm seriously passed as an early work by Recco, before being recently given back to Ruoppolo, who, besides, was only a few years older than Recco. An extraordinary vigor of vision is united here with freshness of sensibility. The viscosity of molluscs, the sparkle of scales, the enamel of shells and crockery, and the gleam of metal loom up in an atmosphere of somber humidity, as if glimpsed in a cavern at the bottom of the sea. Nothing could be further from what the Dutch discerned in this same theme of a fishmonger's display on a wharf (pl. 31). The latter set out to poeticize an everyday sight by imposing on it an overall movement and a deliberately lyrical lighting. They show off the devices they use to avoid literal verisimilitude, but they only manage to remain literal-minded. The Neapolitan also reproduces a real seafood display and one that is even far less contrived. But his pictorial vision is so powerful, his insight into the marine world is so immediately sensual, that he spontaneously hits on harmonies of coral and pearl which convey our reverie well beyond what he so faithfully describes for us.

The strength of the Neapolitan School lies in this faculty of transposing themes half a century old and already exploited by several schools of painting. Whenever a Neapolitan seizes on a Northern subject, he infuses a very distinct strain of pathos into it: thus Salvator Rosa, who signed a brilliant *Vanitas* picture, all the elements of which are typically Netherlandish, but whose disquieting lyrical light is not to be found North of the Alps ([141]). From Porpora to Belvedere we have a succession of vases of flowers or heaped-up fruit in front of landscapes of rocks and water under restless skies. A decadent but wealthy aristocracy eagerly accepted these pictures on the walls of their palaces. Here were all the conditions required for the Neapolitan output to become massive and trivial. And so it became; a host of second-rate painters did their level best to keep it from rising above mediocrity. And yet this blight on Neapolitan art must not blind us to the true value of its best works, for they exemplify a new conception of fruit and flower painting. This was no longer the more or less precise description of all the beauties of corollas, petals, pulp and downy skins, as it had been practised with greater or less breadth of treatment from Velvet Brueghel to Seghers and Mario dei Fiori. It was an attempt to show flowers and fruit, by virtue of their very abundance and confusion, as a vehement emanation of the vegetable world, as an eruptive materialization of its inexhaustible fertility. In these pictures, light binds the elements intimately together—water and soil, plant life and the air in which it bathes. The coloring, whether made up of muted glowings or the rarest contrasts of cool tones, overlays forms with a veil of lyricism which imperiously dominates all details. The texture too, rich, thickly clotted, laid on with an almost sensual delight, superposes its own allurements on those of an exact rendering. Thus the skins of fruit and the petals of flowers seem to regain their original medium, they acknowledge themselves to be part and parcel of that colored clay which, for the painter, is the primary substance of the world.

It was in Baroque Naples, then, that the first modern attempt was made to treat flowers and fruit as a pretext for color orchestrations which express a profound sense of nature's pantheistic unity. Here we may fittingly look for the prefiguration of Monticelli's and Van Gogh's exuberant bouquets.

Spain and the Humble, Mystical Still Life.

In the 17th century Spain may perhaps be said to have carried still life to the highest degree of art: her painters imbued it with more soul, and more style, than those of any other country. They took for their models the humblest things around them, and made them emotionally appealing solely by virtue of colors and lines, without resorting to symbols of a literary order as the Dutch had done in their *Vanitas* pictures.

The beginnings of Spanish still life painting remain shrouded in obscurity. The facts so far ascertained, however, together with what we can infer, make it likely that some surprising discoveries are yet to be made. The younger Spanish investigators, as they continue to increase the material amassed

with so much care and intelligence by Julio Cavestany, a true pioneer in the dense forest of anonymous *floreros* and *bodegones* ([142]), will not merely clarify our ideas on the Golden Age of these paintings—the age of Velazquez and Zurbaran—but may be expected to write a new, highly revealing chapter on Spanish still life in the 16th century.

Indeed, there is every reason to believe that still life painting began in Spain before the Renaissance had run its course, as soon as the first gusts of naturalism made themselves felt. The early writers on art mention painters of flowers, fruit and objects who, by the last quarter of the 16th century, had already acquired a great reputation. They cite the names of Alonso Vázquez, Antonio Mohedano, Blas de Prado and Juan de Labrador.

The first three worked in Andalusia, at Seville and Granada, and were formed by the Italian painters of grotesques, trained in the school of Giovanni da Udine ([143]). In Spain, as clearly as in Italy, we can trace the filiation between flower painting and this type of decoration in the antique manner. In his *Arte de la Pintura* (finished in 1637, published in 1649), Pacheco used the term grotesques to designate not only fanciful motifs but also motifs taken from reality: plants, flowers, animals.

These first fruit and flower painters were no longer mere decorators, but full-fledged still life painters. This is proved both by Pacheco's mention of the vases, fruit and *colaciones* of Vázquez, and by several signed pictures by Blas de Ledesma, discovered fairly recently (pl. 24). These are already genuine *bodegones* in the sense soon to be acquired by this term in Spain: not only food accompanied by figures, but independent pictures of food and household objects. Their arrangement is distinctly decorative; objects stand on tables stretching across the entire picture surface, spaced out with remarkable regularity. The composition, moreover, is so arbitrary as to flout the exigencies of naturalistic logic: the tables are surmounted by branches, with birds perched on them, whose connection in space with the rest of the scene is inexplicable. The picture reproduced here (pl. 24) shows irises and delphiniums rising enigmatically behind a stone wall and a basket of cherries. All these features are obvious remains of a tradition of mural decoration, and the very combination of fruit, flowers and birds was inherited from the same source. These pictures by Blas, who already worked in 1602, give us an idea of one of the forms taken by the earliest Spanish still lifes. The other form, very different but strictly contemporary, is represented by Sanchéz Cotán (pl. 61). Both already reveal the characteristics distinctive of the most eminent Spanish still lifes to be painted in the course of the century.

In dealing with the diffusion throughout Europe of the archaic type of the *Meal on a Table*, I pointed out that Blas de Ledesma's pictures derive from it, owing perhaps to the influence of the Brussels painter Juan van der Hamen, who settled in Madrid in 1589 at the latest ([144]). This is borne out by the fact that the motifs used by Blas are the same as those of Van der Hamen the Younger (Juan van der Hamen y León), who was a pupil of his father: dishes and baskets of fruit, small vases, round boxes, cakes and knives left lying on the table. All these items figure in the earliest Flemish pictures of a *Meal on a Table*. The way in which Blas handles these borrowed elements, however, differs from Netherlandish practice. He lays them out with a striking concern for symmetry. It has been noticed that this arrangement recurs in the decorative art of 16th-century Spain, in ceramics and furniture. No wonder, symmetry being one of the fundamental principles of Renaissance classicism; as late as 1585, in his poem, *De Varia Commensuración*, the great goldsmith Juan de Arphe sharply opposes the "modernity" of these principles to the flamboyant fantasy of the Plateresque style. When we note that the still lifes of Van der Hamen y León, Cotán and Zurbaran often keep to a strict symmetry, we begin to wonder whether they do so wholly by reason of the deep need of rigor felt by Spaniards. If this stock device of the idealistic esthetic was used for so long, was it not rather with a view to "ennobling" the *bodegon*, which was still a "lowly" subject in the eyes of a man like Carducho as late as 1633, the very year in which Zurbaran painted his *Oranges and Lemons* (pl. 66)?

Blas aligned objects simply by juxtaposing them, frieze-wise, against a dark background, and focused them in a strong shaft of light coming in from the side. These were the procedures resorted to again and again by many masters of the *bodegon* without figures up to Zurbaran (pl. 66). Objects thus appear to be caught between the impenetrable background and the full glare of light—rooted to the spot, as it were, and revealed in all their beauty. Blas gives us no more than a mild foretaste of this contest between light and matter. But in the hands of Cotán and Zurbaran, both of whom had profited by the lesson of Caravaggio, the ray of light used by Blas became a relentless blaze, endowed with the power of

isolating objects against their background of solemn darkness and revealing their hallucinating presence. Light that one is tempted to call metaphysical, for it fills with the grace of the mind these simple collections of motley objects which, lighted in any other way, would amount to no more than clumsy and meaningless exhibits.

Blas de Ledesma thus displayed the essential characteristics of the best Spanish still life painters: the power of immersing the most familiar things in an irrational atmosphere, thanks to a particular type of composition, and the quality of light. He shared these features with Juan Sanchéz Cotán, who in turn seems to have influenced Francisco de Zurbaran. Blas de Ledesma's *bodegones*, now so numerous that they suggest a great success and a workshop production, combine choice fruit, wrought-gold vases, flasks, sweets, and birds and curtains. The type of composition suggests a decorative function, the choice of objects indicates aristocratic clients. The repertory of objects is indeed the same as that of Juan van der Hamen y León, who was a court painter and often represented sweetmeats, which, according to Julio Cavestany, were unknown in the Spain of that day to any but the wealthiest class of society, courtiers in particular [145].

It is very unfortunate that we still do not know the works of the other Blas, called de Prado. Born about 1545 (he died in 1603), he was a still life painter of great reputation in Toledo, active there and at the Escorial, having attracted the attention of Philip II. The king appreciated his talent so much that he sent him to the sultan of Morocco, in whose service the artist painted several fruit pictures. The works of this early still life painter must have been of great historical importance: He was the teacher of Cotán.

In addition to Vázquez, Mohedano and Blas, early historians mention another eminent painter, Juan de Labrador. His art was appreciated in England and in France, where he won the praise of Félibien, who as a rule was little disposed to linger over still life painters. Labrador was schooled in the studio of the "divine" Morales, in Estremadura, and presumably died in the early 17th century. He is known to have painted not only fruit and flower pieces, for which he was famous, but also pictures of books and food, in other words genuine *bodegones*. Unfortunately no work unquestionably his has so far been found. The one with the most legitimate claim to authenticity is a fruit piece at Hampton Court, assigned to Labrador in the catalogue of the collection of Charles I of England [146]. It represents a bowl of apples and grapes on a table, on which lie some acorns and other pieces of fruit [147]. Leafy vine branches hang over the apples and fill the entire picture surface; the composition is that of a painter who abhors a vacuum, an approach which in itself is archaic [148]. The perspective, however, is not a plunging one, and the light makes forms turn powerfully and renders them plastic. At the same time, the lighting respects the elegant precision of silhouettes: the faintest scalloping of leaves and the sinuous contours of apples stand out in bright lines, skillfully reserved against the shadowy sections of the background. Everything that goes to make up this style, broad and incisive at once, would be inconceivable without Caravaggio's influence; it is the very style of the *Basket of Fruit* in the Ambrosiana. On Labrador's fruit, as on Caravaggio's, there were transparent drops of water [149]. A pronounced chiaroscuro gives an advanced look to the fruit piece at Hampton Court and to several other pictures of a similar character [150]. We can understand why Palomino compared Labrador to the Neapolitan Ruoppolo; this kinship, moreover, provides an additional argument in favor of ascribing this group of paintings to the mysterious Spaniard. Labrador would thus emerge as a highly personal interpreter of Caravaggio, and would assume a leading role in the history of the Spanish still life; to him would go the credit for introducing that monumental grandeur which is so striking in Cotán and Zurbaran. For in the works presumably his there is nothing of that preciosity and minute attention to detail which are peculiar to the Flemish formula of the *Meal on a Table*, such as we find it in the court painters dealt with above.

Thus, at the end of the 16th century, we may tentatively single out two essential aspects of the *florero* and the *bodegon*: the one comparable to the contemporary creations of the North, the other dependent on Caravaggesque Italy; the first represented by Blas de Ledesma and later carried on by Van der Hamen y León; the second, Sanchéz Cotán and by the painter whom we presume to be Juan de Labrador.

From the latter form sprang the greatness of Spanish still life painting. Indeed, at the very time when Blas de Ledesma was active, round about 1600, there appeared a master of the first rank, one of the most considerable of all still life painters: the Carthusian friar Juan Sanchéz Cotán. We do not know what kind of training he received in Blas de Prado's workshop at Toledo. His preserved works, all of them probably previous to 1603, show three fundamental features: the exclusive choice of humble foods ready for

94

the kitchen; a very calculated and concentrated composition; a powerful light emphasizing the voluminous presence of objects against a dark, impenetrable background. All the pictures we have by Cotán were painted when he was about forty; of his work before then we know nothing whatever. His art, like Labrador's, presupposes a knowledge of Caravaggesque chiaroscuro and monumentality. Cotán and Labrador were contemporaries of Caravaggio; but nothing in the present state of our knowledge enables us to say how, or by what channels, they came into contact with him, unless it was through the study of Italian pictures, which, from this time on, were being imported into Spain in large numbers. It is known, for example, as already mentioned, that in 1617 Giovanni Battista Crescenzi painted, in Spain, some fruit pieces in the Caravaggio manner. But we have a much earlier *bodegon* by Cotán, signed and dated 1602. In 1603 Cotán took Holy Orders and on this occasion he drew up an inventory of his worldly belongings, which lists eleven *bodegones*; the description of one of them corresponds fairly well to the picture reproduced here (pl. 61). The fact of the extraordinary precocity of Cotán's art must be regarded as proved. He was the first master in Europe to draw lessons in the field of still life from Caravaggio's naturalism and lighting. His still lifes, together with Caravaggio's *Basket of Fruit*, were the most powerful to be found in Europe before those of Velazquez and Zurbaran. Cotán went on painting in the monastery to which he had withdrawn; from 1612 on, he worked at Granada. Only his rather mediocre, provincial-minded religious compositions are known from the time after 1603. These are the only subjects alluded to by early writers, who make no mention of his extraordinary *bodegones*; but we get the impression that the earliest still life painters, both in Spain and Italy, were formerly designated by the general term of " fruit and flower painters."

Cotán usually presents his *bodegones* in square niches, hollowed out of the wall and containing the most ordinary fruit and vegetables. These niches open on dark backgrounds. The sharp contrast of wall and fruit, gleaming and material, with the abstract ground gives these pictures an unearthly air. Our first impression is one of lofty spirituality. As soon as we begin to analyze them, this impression is deepened : the structure of the composition is carefully calculated. His *Quince, Cabbage, Melon and Cucumber* (pl. 61), one of the masterpieces of Spanish painting, brings us more closely into touch than any other of Cotán's *bodegones* with the mainsprings of his art. Fruit and vegetables are spaced out along a hyperbola which cuts diagonally across the cube of the recess; another diagonal is marked out by the shadow falling across the sill on the left, by the melon sliced down the center, and by the cucumber. Each fruit or vegetable is a volume whose dimensions, form and movement stand in contrast with the volume beside it, like notes of music following one another. Perspective and lighting are kept under control with a kind of cool passion. The color scheme, bright and faintly acid, is reduced to the alternation of yellow and green. All this breathes an art intellectual through and through, and also a mystical fragrance. Looking through the inventory of his belongings drawn up by Cotán himself [151], we find that the only books listed are a treatise on perspective by Vignola and a " Libro de Musica." Then about to take the cowl, he offered up all his flower pictures to the Virgin Mary.

All Cotán's *bodegones* are just such solemn, magical larders as this. All consist of simple, wholesome food standing on a sill or held in air by the hand of a geometer and poet adept at ordering a world of marvels: did he not suspend a quince and a cabbage at the end of a string, where they turn and glow like planets in a boundless night ?

Cotán gave rise to a school which, though as yet little known, is not without interest. The artists who followed his lead were incapable of cleaving to his geometric rigor. They belonged to a generation which expressed its restlessness in terms of more freely handled forms and a more vibrant touch. Into the huge cardoons they took over from Cotán they poured a virulent, dramatic vitality. Their light is smoother and more vagrant, their shadows less precise, their mauves and greens more strident than the master's. Such is the picture at Strasbourg (pl. 60 in the first edition of this book) whose traditional attribution to Cotán is untenable. It exemplifies a deep-seated aspect of the Spanish still life which has been revived in our time in Mexico. A comparison of these *Cardoons* with the *Gourds* of Siqueiros (pl. 123) discloses a similar order of pictorial and poetic investigation, a similar pursuit of the visionary in terms of immediate reality.

The art of Zurbaran's *bodegones* seems to derive from Cotán. He has the same rigor in his layouts, the same authority in his lighting, and resorts to the same ascetic alignment of objects arranged in front of a dark ground. Here again we have no way of ascertaining the exact connection between the two artists.

The young Zurbaran, who was friendly with Velazquez and no doubt grew up in the circle of the Cara-vaggeschi at Seville, was not far removed from Cotán, who lived at Granada. The influence of Velazquez fails to account for the geometric grouping, the intense stylization, the spiritual aspirations of Zurbaran's *bodegones*—traits which Cotán's pictures of fruit and vegetables could have imposed on them with singular forcibleness. Yet it would appear that Zurbaran painted no independent still lifes before his first stay in Madrid in 1633, the year in which he signed his *Oranges and Lemons* (pl. 66) (152). This is all the more likely in view of the fact that his *bodegones*, his *Vases* in the Prado in particular, have a certain connection with the work of the Madrilenian Juan van der Hamen y León, not in the style, which is broader than that of the artist shaped by the Flemish esthetic, but in the choice of motifs: baskets of fruit and vases standing on plates. This connection has not gone unnoticed, far from it, since some of Van der Hamen's finest pictures have been ascribed to Zurbaran, among them the one in the Thyssen-Bornemisza Collection (Cas-tagnola, Lugano) (153). When Zurbaran went to Madrid, Van der Hamen had been dead for two years. But he had left behind him in Madrid a solid reputation and a whole school of imitators. Zurbaran was obviously acquainted with his works; they may have prompted him to paint independent *bodegones*.

These are extremely rare (154). In the two most important of them, the *Oranges and Lemons* (pl. 66) and the *Vases* in the Prado, one is struck by the frieze-like composition, the symmetry and sharp light-ing—features characteristic of the Spanish *bodegon* in its most original form. *Oranges and Lemons* is one of the masterpieces of the still life painting of all time. The Caravaggesque influence is unmistakable: forms purified by light, a crystalline precision of detail, and yet a monumental density of volumes. But it appears wholly assimilated by a mind aspiring to a style more severely controlled, more deeply conscious of its powers of spiritual expression, than Caravaggio's ever was. Zurbaran was endowed in the highest degree with that " faculty of wonder " which lies at the root of all truly creative art, and which Henri Focillon knew so well how to stress. Every still life painter of originality does no more than express his sense of wonder at the beauty of things. But in the 17th century the Spanish masters—as we have seen in Cotán—apparently had a deeper feeling than others for the unexpected transformations and rhythms which sunlight imposes on objects, and in which the painter can discover almost musical accords. Zurba-ran painted only a few objects at a time, giving them up to us in all their integrity; with him, volume and line convey a simultaneous eloquence; he never allows light or shade to absorb part of a salient volume or blur the contour of an object. He thus keeps in mind the image of the object as a whole, instead of simply painting it as recorded by his eye. His composition, which Cavestany so aptly calls "compensat-ed," is no less lucid. The painter attunes the arabesque of a leaf to the curve of a lemon, and makes the mouth of a cup respond to the opening of a basket. Like Cézanne and Braque, Zurbaran was convinced that out of a still life a symphony of forms can be made.

A spiritual atmosphere emanates from his fruit, which loom up in the calm of darkness. Roberto Longhi, Julio Cavestany and Martin Soria (155) all lay stress on the mystical character of the still lifes of Cotán and Zurbaran—" this painter-monk and this painter of monks." No doubt they are right. Wher-ever symmetry reigns in the *bodegon*, one is reminded, as they are, of those flowers carefully arranged in silence by pious hands on the steps of Spanish altars. " These baskets of fruit in the foreground of the picture are like votive offerings reverently set in front of a saint's niche. Charmingly simple and natural as they are, they almost seem to give off their fragrance, like incense " (156).

If this is so, the religious thought and emotion that went into them is altogether different in quality from what we find in the patently votive garlands being painted at the same period with pietistic zeal by the Jesuit Daniel Seghers. Both his and those of the Spaniards are Counter-Reformation still lifes. But the latter are not limited to flowers, which are the ornaments of nature. They express the faith by a ray of grace which shines through the objects of daily usage. Here we are in the land of Santa Teresa of Avila, the great housekeeper saint who never entered a kitchen without thinking that " the Lord is walking among the pots and pans " (157).

Though Zurbaran painted few *bodegones*, they attracted a good deal of attention—of his *Oranges and Lemons* we have two replicas of the period—and indeed founded a school. Many fine pictures have come down to us of which the most that we can say, in attempting to situate them, is that they originat-ed in the circle of Zurbaran (pl. 65). There is often a sturdiness about them which brings them close to the spirit of the master. As against this, the pretty still life of *Vases* in Kiev Museum, signed by the artist's

son, Juan Zurbaran ([158]), already reveals a rhythmless composition, devoid of any major accent, and a finicking preciosity of detail which denote a weakening of the original conception and handling. These pictures may tentatively be divided into two groups: those which, by virtue of their simplicity and in spite of the refinement of the composition, are like rustic editions of Zurbaran's style; and those which strive after his calculated groupings, increase the number of motifs, and result in a slightly affected interpretation of his qualities.

A *Basket of Flowers* (pl. 64 in the first edition of this book) typical of the first group is much more summary in execution than the master's work. The composition, fitted into a semicircle whose vertex is suggested by three roses, has nothing rigid about it, and indeed is imbued with an ingenuous elegance. The lighting imparts a singular life to forms, simplifying them in a way that would have pleased Cézanne. With its scrupulous drawing and its style stripped of non-essentials, this picture acknowledges its filiation with the art of Zurbaran. Made up of the most ordinary objects, it contrives to lead the mind into the depths of unreality. These vases, flowers and tablecloth compose a kind of *tableau vivant* figured by light and by luminous phantoms.

The picture of *Plates, Boxes and Fruit* (pl. 65) ([159]) representing the second group is no less fantastic. It is an intricate piece of architecture in which circles, cubes and spheres interlock in mysterious patterns. The picture as a whole is like a landscape with buildings on the right and an avenue or parkway on the left, formed by a row of plates leading up to a small pyramid ([160]). We are justified in speaking of the Cartesianism of certain French still lifes of the 17th century. But the Spain of the Renaissance and the 17th century was really obsessed by speculations on the geometric purity of forms. While Juan de Arphe was publishing his *De Varia Commensuración*, the architect of the Escorial, Juan de Herrera, was reviving the scholastic reflections of Raimon Lull and writing his *Discurso sobre la figura cúbica*, whose conclusion glorified the sublime perfection of the die. No wonder Cotán set up his theater of fruit and vegetables on a strictly cubic stage. For him there was nothing abstract about this setting: it expressed perfect beauty through architecture, the creation of man, as opposed to the wild, undisciplined beauty of nature's handiwork. To make the latter acceptable, Cotán gave it the noble harmony of geometric patterns. In his *Plates, Boxes and Fruit* the same contrast of fruit and flowers with man-made objects enlivens the lucid ciphering of forms. This is geometry enlisted not in the service of reason, but in the service of makebelieve. It is lyrical geometry, with nothing Cartesian about it. It renders reality mysterious instead of introducing clarity into it. Spain alone could produce such still lifes as these.

The school of southern Spanish still life painting was carried on in Portugal by Josefa de Ayala, known as Josefa de Obidos after the name of the town where she lived. Born at Seville, but established in Portugal early in life, she was the daughter of the painter Baltasar Gomez Figueira, from whom she must have picked up the echoes of Andalusian and Valencian art that are to be found in her work. Thus her *Basket* (Espirito Santo Silva Collection, Cascais) betrays the influence of Zurbaran, while her allegorical compositions of *Months* (Siqueira Sao Martinho Collection, Alenquer) contain displays of fish regularly grouped in the Andalusian manner in front of landscape backgrounds, in accordance with the set formula of Miguel March and Tomas Hiepes, both Valencian painters. A pious spinster, full of wistful grace, Josefa de Obidos shows a charming provincial awkwardness in her religious pictures, and in her still lifes an archaism that is sometimes quite surprising: her two large *Desserts* in the museum at Santarem, dated 1676, in which vases and precious sweetmeats fill the entire picture surface, might have been painted fifty years earlier ([161]).

The pictures of a *Meal on a Table* cultivated in Madrid run parallel to the severe and glowing *bodegones* of Cotán, Zurbaran and their followers. The best of them are the work of Juan van der Hamen y León. Not a single picture by his father, a native of Brussels who settled in Spain, is known to us; but we can imagine what his art was like on the strength of his son's, which still shows many elements of the Flemish painting of about 1600 and offers striking resemblances with the still lifes of the Antwerp painter Osias Beert ([162]). Van der Hamen the Younger, who added León to his name ([163]), quickly established himself as a fashionable painter. Like other Madrilenian artists, who often lodged in their patrons' palaces, he kept open house to the public in his studio, where the fine society of the day forgathered. The studio of Juan de Arellano, famous for his flower pictures, was a particularly popular place of rendez-

vous. This gives some idea of the extent to which still life was appreciated in Spain, not only in intellectual but in fashionable circles, and this as early as the first third of the century, since Van der Hamen y León died in 1631.

This painter retained several features of his father's esthetic. His sweetmeats (so frequently painted by Beert and other Flemings), boxes of candy, fruit and jars of jam go to make up the *Desserts* of a highly refined table which in Spain was confined to the aristocracy ([164]), but which in the Low Countries had already spread to the well-to-do bourgeoisie. To these scintillating, appetizing delicacies corresponded a fastidious, scrupulously detailed rendering, full of tender modulations, thoroughly Flemish in spirit. Yet Van der Hamen the Younger was born in Madrid and the art and civilization of the country exercised an influence on him that increased steadily and became decisive. First of all, he was fond of a warm, muted harmony, in which soft gray, brown ochre and brick-red blend together; it stands quite apart from the Flemish color scheme which, even when subdued, as with Osias Beert, always has the glitter of precious jewels. His composition is more structural than that of the Flemings. It often keeps to a well-ordered regularity and symmetry. There are pictures by him in which objects stand in a niche very similar to those of Cotán ([165]). The use of stone plinths, offering the contrast of their bare cubes with the fragility of a glass or cakes, is also a characteristic trait of the Spanish *bodegon*. Hung at the Orangerie exhibition alongside *Desserts* of the archaic international type, by Beert, Linard, Flegel and others, Van der Hamen's picture stood out at once, with that serious, almost staid distinction and that sobriety of color which are so unmistakably Spanish. It is not surprising that he satisfied the taste of his Madrilenian clientele. His success was exploited for a long time to come by his son Francisco and by other imitators. Juan Bautista de Espinoza also practised this type of sumptuous *bodegon*, in which precious objects are arranged symmetrically but not monumentally.

The above applies only to still lifes without figures. But along with *bodgones* proper, painters were producing pictures of *Shops*, *Markets*, *Kitchens* and *Peasant Scenes* in which figures shared the canvas with objects or were overshadowed by them. They appeared simultaneously, at the beginning of the 17th century in Andalusia and Castile. It was in the South that the best of them were painted—those of Velazquez.

The conception of such pictures, wholly in the mannerist tradition, filtered into Spain from Italy. We know that Vincenzo Campi, one of the best exponents of the Italian *bodegon*, came to Spain in 1584 and that his pictures were imported into the country, where they were much appreciated. This movement of artistic ideas recurred at the beginning of the 17th century, when the naturalism of Caravaggio and his school renewed the theme by stripping it of its overwrought and sensational character, and restoring it to the setting of everyday reality so dear to the Spaniards. The fact of this influence is unchallengeable, even though we have no way of proving today that Caravaggesque pictures were then to be found in Andalusia, where Velazquez grew up and received his early training. For the time being it cannot be proved, but we know that steady commercial relations brought numerous Italian paintings into Spain. It is perfectly idle to assert that "naturalism and chiaroscuro were in the air at the time," and that they could have appeared independently and simultaneously in both peninsulas. There are too many direct resemblances between the works of the two countries for this to be credible, and the chronological priority of Caravaggesque Italy is too well established. Realism was also "in the air" around 1400; but what a gulf between Van Eyck and Masaccio!

To base our reconstitutions of the past on the absence of written documents, when the pictures are there and invite imperative comparisons, is a serious mistake of historical method. Precisely because in Spain there was a latent taste for realism, which only needed a spark to flare up and consume almost overnight the conventions of 16th-century mannerist academicism. The sight of a single genre scene particularly picaresque in character by Caravaggio or his school would have sufficed to bring forth the *bodegones* of the young Velazquez. We need only observe the artists who live among us: a reproduction glimpsed in a bookshop window is capable of suggesting the personal solution of a problem pondered over for years. How can the historian accurately evaluate the originality of a work of art—and this after all is his supreme concern, never fully realized—unless he seeks to discern its genesis? Is it a reflection on Velazquez, as some critics seem to fear, to point out the path that Caravaggio opened up for him and the prodigious distance he covered with unequaled daring? Of course not, it simply helps us to a more intimate understanding of his art.

Velazquez' youthful style was formed in Andalusia, where the *bodegon* of the Campi-Passerotti type was practised as early as the opening years of the century. Of this we have incontrovertible proof in the picture signed and dated at Úbeda by Juan Esteban ([166]). It shows three plebeian-looking figures and a rather caricatural nobleman, all laughing and gesticulating in front of a table laden with food, under a frieze of quarters of meat and heads of game hanging from the ceiling of a shop. Analogies of conception and color have been noticed between this painting and a *bodegon* signed and dated 1626 by Alejandro de Loarte ([167]). The latter worked at Toledo, far from Úbeda. Rather than assume a direct connection between the two artists, we do better to look for a common source—Italian art. With Esteban, the example of Passerotti would have weighed most heavily; with Loarte, the example of Campi.

It was about 1617, at the age of eighteen, that Velazquez began painting his genre scenes in which still life assumes a certain importance (pl. 63). Between these and Esteban's work there was not only the space of a decade: the two painters' conceptions of the *bodegon* are fundamentally different, and what separates them are the innovations introduced by Caravaggio. The younger man was still mindful of the old mannerist formula: he laid out his still life in the foreground of the picture and placed a religious scene in the background, just as Aertsen and Beuckelaer had done ([168]). But the scene is presented with a sober realism stamped with the unmistakable accent of daily life. Objects are few in number, so that the eye readily takes them in and registers them, whereas it is only distracted by the profusion characteristic of Mannerism; they stand in a strong light coming in from the upper left; they are arranged with the naturalness of actual life. These were the very traits which, a quarter of a century before, set Caravaggio apart from Campi, Passerotti and others like them. The young Velazquez followed this example but his vision was so fresh and powerful that it prevented him from simply interpreting Caravaggio's art. What he did was to discover with enthusiasm a particular outlook on reality which Caravaggio had rendered possible. One is reminded of the link between Manet's *Bon Bock* and the pictures of Frans Hals—a link which reveals not so much the debt incurred from the old master as the resources which those borrowings stirred to life in Manet himself. We get the impression that Velazquez did not see a great many Caravaggesque pictures; and that he made no very scholastic study of those he saw; but that he was grateful to them for having given him a direct contact with the real world which, to be sure, he could never have got through the mannerist instruction of Pacheco.

These youthful *bodegones* overflow with a passion for objects, for their texture, for the life kindled in them by sunlight. Velazquez approached nature with a more sensual vision and a freer brush than Caravaggio did. There was no concern for linear precision in his manner; no sustained or controlled stylization; but a style which seems to be an innate order of nature, a firm cadence of patches of shade and patches of light. He loses sight of neither reflections nor flickerings of light. But more laconic than Caravaggio, he gives an image of form that is more compact, more summarily divided between light and shade. His was a spontaneity of vision hitherto unknown. It suggests an immediate, almost brutal communion between bodies and atmosphere, and gives rise to a relationship of pictorial elements which is as different from Caravaggio as it is from the 17th-century Dutch masters. One has the impression that his still lifes are the only ones in all the work of the Old Masters which were not painted in a studio light. Yet on that score Velazquez made no break with tradition. But his grasp of nature was so thoroughly independent of the optical convention of his time that he restored all its virulence to the daylight enclosed in his studio. Without rendering the atmosphere of the open air, Velazquez rendered broad daylight. His ardent submission to the dictates of nature is not to be found again till two and a half centuries later. It was not without reason nor in vain that Manet turned to Velazquez.

Velazquez is known to have also painted still lifes without figures, representing " birds, fish, antlers and game with an owl "; but none of those ascribed to him can be authenticated. After painting *bodegones* for several years, he gave them up and only reverted to them very occasionally. In his maturity, when his vision had mellowed, he gave less authority, less solitude, to the inanimate objects he used in his compositions. He mingled them intimately with the setting as a whole, and allowed them to be more fully absorbed by air and light. Yet who can forget the spinning wheels of *The Tapestry Weavers* or the bouquet of roses beside the Vienna portrait of the Infanta Margarita ? They are as true to life in their spectral lightness as the pots and saucers of the *bodegones* are in their palpable density.

The realism of Velazquez is more sensual and candid than that of Cotán and Zurbaran. His *bodegones* are devoid of intellectuality; geometry and " metaphysical " light are wholly foreign to them. They seem singularly matter-of-fact in spirit alongside votive baskets and larders steeped in mysticism. But he is no less deeply Spanish: reality for him is meaningful only in terms of what is authentic and unique in each being and each object. This is not to say that Velazquez makes a faithful portrait of each egg and saucer. He does more than that: he paints them with sufficient intensity for them to become *the* egg and *the* saucer. To make them pass the test of our senses, he contrives to give them an indefinable rustic whiteness compounded of almonds, cheese and milk. No one, not even old Pieter Brueghel, can vie with him in painting genuinely peasant still lifes, so rugged and elemental in their wholesomeness.

It is easy to imagine how deep must have been the impression produced by such paintings at the very time when Spanish Baroque was becoming conscious of its particular cult of vitality. Already contaminated, mannerist academicism paid moving tribute to Velazquez in the writings of his father-in-law, Pacheco. Painters began turning out *bodegones* inspired by the young man who, within a few years, became the most famous artist in Spain, the idol of the court. There still exist some very fine pictures dependent on the manner of Velazquez; it has not yet been possible to assign them to their rightful authors or to group them tentatively in such a way as to bring out that influence clearly. This is not the place to go into the matter, for these paintings in no way modified the conception of the Spanish still life; at most they enriched it with a few nuances.

Having been treated by great painters such as Velazquez and Zurbaran, the still life attracted non-specialist painters in Spain more than in other countries. Some of the masters of Spanish religious painting—Alonso Cano [169], Mateo Cerezo [170], Antonio Pereda, Francisco Herrera the Elder— produced *bodegones* that were highly appreciated; those of Herrera were so much sought after by foreign collectors that by the 18th century there were hardly any to be found in Spain [171]. To Mateo Cerezo, in addition to some signed *bodegones* preserved in Mexico, are ascribed a few pictures remarkable for their conception and the quality of their execution [172]. These are dark canvases in which a phosphorescent quarter of meat and a few faintly indicated vegetables seem to materialize in the gloom like ghostly apparitions; objects are built up with light strokes of thin, silvery texture, almost like the membranes of insects. Into these wholly commonplace subjects went a visionary power that only Spain could summon up.

In spite of its extraordinary level of achievement, maintained not only in the works of the masters but also in a very large number of pictures that are still anonymous, the Spanish still life was unable to avoid a fairly rapid decline, brought about—as elsewhere in Europe—by the rising taste for decoration, and by the contaminating influence of other schools. Better than any other theme, flower painting sums up this evolution.

Only a very few flower pictures of the heroic period, the first third of the Golden Age century, are now known to exist. Those of Zurbaran—attributed to him by analogy with the flowers in his religious compositions—have that dignity and solemn purity of form which the Spaniards were the only painters in Europe to deduce from the data of Caravaggesque art. These qualities became exceptional in the next generation. Pedro de Camprobin was virtually alone in retaining something of them. A native of Castile, he settled at Seville where he linked up with traditions initiated by Zurbaran [173], whose tranquil, frieze-wise composition and clean-cut vision he took over. His forms, however, lack the breadth of Zurbaran's, and are seen in a lighting that lacks his force. Camprobin lingers over precious trifles: cakes gleaming in a crystal, small tables or cabinets with a drawer standing open, petals dropping from flowers, butterflies flitting about—so many infringements on Zurbaran's simple majesty, so many concessions to Netherlandish taste. Nevertheless, what remains of the master's spirit in Camprobin's work is enough to make him the best painter of *floreros* in the second half of the century.

Flemish influence came as a serious threat to the school. Already Juan de Arellano—the most celebrated Spanish flower painter of his day, while Camprobin is barely mentioned—had yielded to the spell cast by garlands and bouquets minutely figured in the manner of Seghers. The same was true of his pupil, the court painter Bartolomé Perez. A craze for *floreros* sprang up and they became a lucrative specialty produced by families of artists, the Arellanos, the De La Cortes, who ran busy studios. Palaces were glutted with flower pictures, which were sometimes placed on both sides of a panel with a gilt ground and thus used as part of a folding-screen. The decorative spirit triumphed.

One consequence of Netherlandish influence was the introduction of the *Vanitas* theme into Spain. At first sight, it might be expected that this type of picture would be welcomed in a religious-minded country where artists took pleasure in expressing themselves in the climate of direct reality. But such was not the case. Spanish *Vanitas* pictures are extremely rare; it is always the same ones that are mentioned or reproduced. It would seem that Spanish painters were repelled by the essentially Puritan conception of the Dutch *Vanitas*. This concrete tête-à-tête of the symbols of life with the emblem of death contains a moral exhortation in an atmosphere of intimidation. Here it is up to man alone to carry on the struggle creditably to its ineluctable end, without any sense of God's mysterious presence at his side. Now the image of the godhead appears in every single Spanish *Vanitas*. Over his famous *Charnel-House*, swarming with worms, Valdes Leal paints the Hand of God weighing our vices and virtues; in his *Dream of Life* Antonio Pereda shows an angel beside a typically Dutch *Vanitas* ; Andres Deleito places some jewels beside a skull, as a Dutchman or German would have done, but in a corner he paints an invocation of divine grace: the Virgin and St. John the Baptist interceding with Christ ([174]). Spanish *Vanitas* pictures always bring the supernatural powers into play; they are mystical dramas. Those of Holland sum up the drama of earthly life. They were unacceptable in Spain without some modification.

As far as we can tell, moreover, the painting of *Vanitas* pictures centered in Madrid, where Northern influences were presumably most direct; both Pereda and Deleito belonged to this school. For Valdes Leal's *Vanitas* cannot be considered as a still life; it is an allegorical composition in which inanimate objects play an important but not a decisive part.

Towards the end of the 17th century, Italian influence joined with Flemish in interfering with the purely Spanish tradition. It came mainly from Naples, which was politically connected with Spain. We have already touched on this question in dealing with the expansion of the Neapolitan School. This influence seems to have been much stronger than is usually supposed.

But the study of the mass of anonymous pictures—flowers, fruit, and still lifes of fish—has not yet been carried far enough to be summed up here. Were there echoes in Spain of Neapolitan Caravaggism, which added the rhythm of a firm chiaroscuro to the Southern profusion of objects? And what about the art of Francesco Perez Sierra, the pupil, along with Porpora, of Aniello Falcone? Signed pictures by Sierra are said to exist in private Spanish collections, but they have never been either exhibited or published. Perhaps they represent a certain restraint with respect to the proliferating Baroque of the *floreros* and *fruteros* in which decorative formulas held sway till the end of the century—formulas on the whole less sumptuous than those of the Italians and less rich in pictorial qualities.

Not till the middle of the 18th century, in the work of Luis Melendez, do we again find in Spain the sobriety and force of the age of Cotán, Zurbaran and Velazquez.

France : Inwardness and the Royal Décor.

The study of French still life painting in the 17th century has only recently begun. It almost seemed to be a special object of indifference. As recently as 1932, Werner Weisbach's book, excellent and complete though it is in all other branches of painting in the time of Louis XIII and Louis XIV, makes no reference to any still life painters except Nicasius Bernaert and François Desportes; and even they are dealt with exclusively in their capacity as animal painters; the name of J.-B. Monnoyer himself, which figures in all the manuals, is not even mentioned ([175]).

In 1934 the Paris exhibition of " Painters of Reality in France in the 17th century " drew the attention of art historians to several still life painters active in the reign of Louis XIII: Baugin, Bizet, Linard, Louise Moillon, Stoskopff. But intended as it was to throw light on the movement towards naturalism, till then very little known, the exhibition did not include the second half of the century and its classical, academic art. The research work inspired by it has been largely pursued in the same direction. Still life painting in the time of Louis XIV has accordingly been disregarded. This neglect has been made up for recently, however, by several excellent studies by Michel Faré, who is soon to bring out a large book on still life painting in 17th-century France.

In dealing with the expansion throughout Europe of the archaic type of still life, I had to allot considerable space to French productions. This art form, as we saw, was brought into France by painters from the Low Countries early in the century. It was practised by Flemish artists who had settled in Paris, in the districts around Saint-Hippolyte and Saint-Germain-des-Prés, and formed a professional guild. But French painters proved capable of interpreting a foreign type of art in their own way. They showed a spirit of synthesis in their still lifes which attenuated the dispersion and equality of accent peculiar to the Netherlanders, by reducing the number of objects represented, by clarifying the composition, by softening the vigor of local tones, by contriving subtle passages of delicate modeling between forms. An elegant simplicity often distinguishes the pictures of Baugin, Linard, Louise Moillon, René Nourrisson or Stoskopff from even the soberest Flemish work, that of Hulsdonck or Gibbens (who lived in Paris), for instance. Baugin's achievement reached an exceptionally high level. One of his three known pictures can stand comparison with the finest Dutch and Spanish works of his time—the time, remember, of Zurbaran and Heda. Like them, Baugin represented only objects of daily use. Placing a glass, a plate and a bottle on a table, he worked out their exact position with care and circumspection; he bathed them in light soft and steady at once. Treated with so much respect and discreet warmth, these simple things take on an air of chaste distinction that would have pleased Chardin. This kinship proves that French sensibility in the time of Louis XIII found expression in an original conception of still life, just as it found expression in religious painting, portraiture and genre scenes in the work of Georges de La Tour and the brothers Le Nain.

These remarks essentially sum up the subject matter dealt with in the first half of the present chapter, and there would be no reason to revert to Baugin's generation, were it not for the fact that it departed from the archaic still life and tackled the problems which had just been raised and solved by Baroque art elsewhere in Europe. Of this falling into line with the artistic ideas of the time, a few words must be said.

It took place hesitantly and belatedly: it was only by about 1635-1645 that bird's-eye perspective, naïve juxtaposition and the paltry scale of objects with respect to the picture surface began to disappear from the works of artists formed about 1620-1625. This evolution is clearly marked by the dated paintings of Stoskopff, Linard and Louise Moillon. Their pictures betray preoccupations that could only have been induced by contacts with the Low Countries and Italy. But they convey the impression that their makers are only vaguely conscious of the direction taken by still life painting in those countries: in the North, the desire to suggest intense life by animated, concentrated grouping and a lyrical use of light; in post-Caravaggesque Italy, the determination to give still life the nobility of the grand style by means of a monumental composition and the rhythm of an emotive chiaroscuro. French painters were groping for their way. It may well have been Stoskopff, a complex, impressionable artist whose pictorial culture owed as much to an essentially Germanic linearism as to a purified taste acquired in Paris, who had the most direct contacts with the art of the Low Countries, and who was best equipped to assimilate the new trends. He failed, however, to follow a coherent line of evolution. In 1644 he painted both the archaic *Basket of Rinsed Glasses* in Strasbourg Museum (pl. 43) and the *Dish of Grapes with a Glass of Wine* (R. Lebel Collection, Paris) [176], whose composition is already comparable to that of Claes or Van de Velde. Linard is less varied and, at first sight, more decidedly oriented in a given direction. Yet his last works are contradictory. His *Basket of Fruit and Sliced Melon* of 1642 shows novel textural effects and contrasts between smooth skins and rough crusts formed by a scintillating impasto; these are echoes of contemporary Netherlandish technique, and one at once recollects that Jan Fyt stayed in Paris in 1633-1634, while Willem Kalf is recorded as being there precisely in 1642. But two years later Linard painted a *Vanitas* whose composition and perspective are archaic, and in which only a certain unity of color and light notifies us that this is an artist of the 1640s. A picture by Louise Moillon painted in 1637 (pl. 46) forms a distinct contrast with the many dishes and baskets of fruit by the same artist dated from 1629 to 1633. Instead of juxtaposing separate motifs, she spreads out across the whole canvas a variety of fruit with long, leafy vine branches introducing an element of broad rhythm. The composition has become coherent and monumental; the still life is no longer a field on which we look down, but presents an imposing vertical façade. The general effect is one of robustness, and derives from Caravaggesque Italy; the motif of the vine leaf, here dark, there brightly lit, revealing its exact outline and its swelling veins, is characteristic in

102

this respect ([177]). This does not exclude careful attention to detail, noted and emphasized by a Northern eye—for Louise Moillon numbers among the French painters most closely to the Flemish esthetic ([178]).

This Italian influence, then, was actually misconstrued: the composition alone aspires to a certain grandeur, the conception of form remains paltry ([179]). The artist was ignorant of the chiaroscuro which creates powerful effects of relief and, by piercing a group of objects, lets in air. How did Louise Moillon become acquainted with the Roman manner? Was it through Italian pictures brought into France or through Spanish pictures, those of Labrador for example, which Félibien knew and thought highly of? Was it through a French painter who had been to Rome? The important researches recently carried out in the Roman archives by Jacques Bousquet ([180]) have yielded the names of an unsuspected number of French painters who lived in Rome between about 1610 and 1670—several hundred of them. From about 1650 on, it is relatively easy to trace the influence filtering into France from Italy, through the agency of traveling painters. For the preceding period our knowledge is still very meager. Only a historian who has studied in detail, with chronological precision, the artistic relations of France with Italy and the Low Countries will be able to say exactly how the generation of Stoskopff, Linard and Louise Moillon stood with respect to the problems of the Baroque still life, at the time when increased contacts were being made and different conceptions were being confronted.

Paul Liégeois, an artist little known today who enjoyed a well-deserved reputation in his own lifetime, seems to have been familiar with Dutch compositional principles, at least to judge by his signed fruit pieces in the Musée des Arts Décoratifs in Paris. In view of the enamel-like finish of his modeling, the almost mineral quality of all the objects, and his quiet elegance, he stands close to the Dutchman Adriaen Coorte. Liégeois is a painter of great refinement, with an unusual palette all his own.

Apart from the work of the artists mentioned above, the 1640s brought to light in France another type of still life painting, which, though it also stemmed from the Low Countries, was interpreted along thoroughly national lines. These pictures consisted of everyday objects and utensils of all kinds, grouped in an interior: *Kitchens*, *Farmyards* and *Cellars*, strewn with barrels, wheelbarrows, cauldrons and eatables. The conception of this type of still life is Netherlandish in origin, perhaps Flemish. We find examples of it as early as 1637. It was no doubt introduced into France by Willem Kalf, who lived in Paris from 1642 to at least 1646 ([181]). At that time Kalf was painting in a manner altogether different from that of his final period, when he did his best known and most highly valued work. He represented small farmyards with all their utensils, and also produced large compositions full of costly objects, among which rather minutely painted silver vessels attract attention. These two categories of still life served as examples to French painters. Anonymous followers of Louis Le Nain as well as Jean Michelin and Sébastien Bourdon painted rustic utensils (pl. 45). Those of the next generation, like Meiffren Conte (or Ephrem Le Conte) and Michel Gobin, catering for the taste for luxury articles, turned to Kalf's tables laden with heavy silverware for their models ([182]).

The passion for flowers, esthetic and botanical at once, which arose in Italy and spread throughout 17th-century Europe, did not fail to affect Parisian society. It was reflected not only in gardens, but in poetry, painting, prints, miniatures, embroidery and in the repertory of the decorators.

Le Nain, Michelin and Bourdon were painters of the rustic genre scenes known as " bambocciate," in which still life played a large part. Though up to now no independent still life has come to light which can be definitely assigned to these painters, the pictures of *Cellars* and *Farmyards* with utensils were clearly produced within their sphere of influence. While the Netherlanders, Kalf in particular, multiplied objects at random and threw them together in picturesque disorder, the Frenchmen—witness plate 45— arranged their still lifes with sobriety and rigor. They set each form distinctly apart, they interlocked volumes and lines with a sense of geometric correspondences. The impression of calm produced by the stability of this grouping is reinforced by a delicate gray tonality and by the pale blue of the sky glimpsed through a window. A rustic dignity and grace emanate from these humble objects bathed in silvery light: they are appropriate company for Louis Le Nain's peasants. These quiet table companions are as different from the drunkards and boors of Brouwer and Van Ostade as these barrels and cauldrons are from those of Kalf: they are seen with the earnestness, one might almost say the friendly respect, which a peasant would

have shown towards them. The Netherlanders regarded the poor man or the humble object as a motif capable of startling the bourgeois with the virulent picturesqueness of raw vitality; human sympathy is often absent from this approach.

This gravity led French painters to give an intellectual, even philosophical content to still life. Allegorical pictures of *The Five Senses* (pl. 23), based on appropriate objects, sometimes on an iconography that was already very old, became perhaps more widespread in France than in the Low Countries. Humanist in origin, they came from the North, just as the *Vanitas* picture did. They were doubtless more frequent and lasted longer than is usually supposed. Several penetrating studies (183) have been made of everything in the thought and sensibility of Baroque Europe which might have led art to deal with the idea of death. The Counter-Reformation on the one hand and Calvinism on the other contributed to make the *Vanitas* acceptable in Flanders as well as Holland, in France as well as Spain. In this century of conflict the different religious doctrines found their only meeting ground in the most imperious, most insoluble of human problems. In France, Jansenist meditativeness greatly promoted a type of picture known as *Thoughts of Death*. A least two artists who painted such pictures—one among the first, the other among the last of the century—were familiars of Port-Royal: Philippe de Champagne and Madeleine de Boulogne (184). The age of Louis XIII in particular stood under the aegis of a kind of funereal romanticism. Stoskopff, Linard, Champagne, and many others whose works have remained anonymous, treated this subject, almost always with a simplicity of arrangement and a sobriety of motifs unknown in other countries. French painters enveloped the skull in a thoughtful silence, and the nocturnal *Vanitas* which Georges de La Tour placed in front of his Magdalens owes its irresistible hold over the soul to the abyss of darkness that surrounds it. Before hastening on to the stage of Versailles, under the brilliant rays of the royal sun, French society experienced something of the anguish that racked Pascal. On these French *Vanitas* pictures of wilting flowers shedding their petals, as well as on the unsmiling portraits of the age of Louis XIII, staring at us with a gaze of haunting melancholy, no better commentary can be found than the words of Mathurin Régnier:

> *Quand sur moi je lève les yeux,*
> *A trente ans me voyant tout vieux,*
> *Mon cœur de frayeur diminue ;*
> *Etant vieilli dans un moment,*
> *Je ne puis dire seulement*
> *Que ma jeunesse est devenue.*

> *Du berceau courant au cercueil,*
> *Le jour se dérobe à mon œil,*
> *Mes sens troublés s'évanouissent,*
> *Les hommes sont comme des fleurs,*
> *Qui naissent et vivent en pleurs*
> *Et d'heure en heure se fanissent.*

In France as in all the other countries of Europe, the middle of the century brought a momentous change: from simple and intimate, the still life became rich and decorative. Two main reasons account for this change. The first is of an artistic and esthetic order: the doctrine of academic idealism, which only admitted of still life composed of picked objects—flowers and fruit, which are the ornaments of the table, or products of the sumptuary crafts, which are to other objects what flowers are to vegetables. The second is of a social order: the importance of royal and aristocratic patronage dominated and set the tone of bourgeois taste, even in democratic Holland.

In no other country of Europe was the elimination of still lifes composed of humble objects so radical as in France. For France alone possessed a really omnipotent Academy, capable of codifying ideas on art and enforcing a systematic application of them. Enlisted in the service of a monarchy that regarded art as a vehicle of propaganda—thus taking over from Rome and setting an example for the Revolution—academic doctrine dominated the conception of still life as it did all other branches of painting.

This evolution did not take place overnight, but once organized under the auspices of Colbert and Le Brun, the Academy laid down a set rule which lasted a third of a century. The transition period may probably be regarded as extending from 1650 to 1663, the year when all artists bearing the title of " King's Painter " were obliged to join the Academy, and when Le Brun, taking over the direction of the Gobelins, began exerting direct power over the distribution of commissions and over the taste of the day. From that date on, the tyranny of academic ideas steadily grew and asserted itself.

At the time the Academy was being founded (in 1648), Le Brun, who was the moving spirit behind it, was forced to appeal to all the artists who were desirous of freeing themselves from the control of the old Parisian " Maîtrise." As a result, the first members of the new company included a number of artists specializing in genres regarded as inferior; eight were of Flemish origin, among them Gérard Gosuin, a native of Liège, who painted mainly flower pictures ([185]). For several years, in spite of the support it received from the Court, the newly founded Academy met with a certain amount of difficulty. It continued to recruit members by making advances to so-called secondary artists; thus Pierre-Antoine Lemoyne and Michel Lanse, fruit and flower painters, were admitted in 1655 and 1660 respectively. When in 1663 the Academy obtained a decree enjoining all the " King's Painters " to enroll in it, a large number of genre painters became academicians. Among them were still life specialists, mostly flower and animal painters: Denis Parmentier, Nicasius Bernaert, Jacques Bailly, Pierre Dupuis, Jean-Baptiste Monnoyer, Antoine-Benoît Dubois, and Catherine Duchemin, the first woman admitted to the Academy. Most of these artists had long since formed their style and had given the full measure of their talent. Their reception was not conditional on any esthetic program, for as yet the Academy had none. Le Brun was not yet free to choose the men best suited to embody his ideas. But the background of the first academicians of 1663-1665 endowed their art with certain traits which, promoted and developed by Le Brun, were later to determine the type of the French still life.

These traits chiefly resulted from direct contact with foreign schools. Dupuis had very probably been to Rome ([186]); Parmentier was there in 1655-1656; born in 1636, Monnoyer studied in Antwerp, no doubt about the same time. They were not unacquainted with the innovation which had just appeared in those two centers: the still life conception of Jan Davidsz. de Heem, created as early as about 1640. His great sideboards laden with flowers, fruit, vases, rugs, musical instruments and parrots, accompanied by architectural elements and curtains, often seen against landscape backgrounds, were promptly transmitted by Benedetti and the Netherlanders to the Roman studios, where Fioravanti and the Cavaliere Maltese gave them a more pompous, more theatrical turn. Monnoyer became a master of this type of still life (pl. 49) and never forgot the flower pieces of the Antwerp School. It is highly significant that this mixed Italo-Flemish art should have been taken up by the Academy. For it was thanks to its acceptance in Rome that the Flemish formula appeared in Le Brun's eyes as worthy of being made the basis of a French type of decorative picture. The journey to Italy now became a decisive recommendation; thus in 1671 the Academy received Nicolas Baudesson, who had lived in Rome from 1632 or 1637 to 1666 ([187]).

Prior to 1664 the Academy admitted several still life painters of the generation born towards 1605-1613: Pierre-Antoine Lemoyne, Pierre Dupuis, Denis Parmentier, Michel Lanse; Claude Huillot, admitted in 1664, was a younger man. Lemoyne must have been an important artist, for Félibien makes mention of him; his reception piece, a fruit picture, was offered by the Academy to Cardinal Mazarin ([188]). Lanse, also mentioned by Félibien, was specializing in large decorative pictures of vases, musical instruments and rugs even before 1660 ([189]). The works of Pierre Dupuis, some extant, others known from descriptions, enable us to form an idea of what French still life painting was like just before Monnoyer. Dupuis' *Baskets of Fruit* (pl. 48), standing on plinths in the antique style and sharply lighted, is a monumental composition; its well-defined lighting issues from the upper left; it betrays an acquaintance with the Roman School of the second quarter of the century. The modeling of the fruit remains in the Flemish tradition as practised in the Parisian studios between 1625 and 1640. But there is no longer anything intimate about the general atmosphere of this assortment of fruit and marbles—it is almost abstract. Other works by Dupuis, known through early mentions of them, show him to have been as advanced by about the middle of the century as Lanse or Monnoyer were by 1660 or 1665. These are three decorative canvases, with rugs, vases and fruit; they were executed before 1659, in which year they figure in the inventory of Archduke Leopold Wilhelm's collection. Dupuis, then, was well enough known in Europe to be

represented in this famous collection. In a fourth picture, exhibited at the 1673 Salon, he combined a monkey with a still life—a touch wholly in the Flemish manner. As against these pictures, his *Baskets of Fruit*, with its sober arrangement and grayish, very French tonality, must be somewhat earlier in date, about 1640. It fuses the Parisian tradition with the earliest Italian influences. Owing to the quality of his art, to his collaboration with Pierre Mignard and his friendship with Nicolas Mignard, and to his international reputation, Pierre Dupuis appears to be particularly representative of French still life painting in the mid-17th century, in the interval between Baugin and Monnoyer.

In these same years, 1640-1664, Netherlandish influence—especially Flemish—was on the increase in France. It came directly from the North and took effect in conjunction with a parallel influence which, by a kind of ricochet, reached France from Rome, transformed by the Italians. In addition to the Netherlandish painters who resided temporarily in Paris—Fyt and Kalf for example, as already mentioned, also Willem van Aelst, between 1645 and 1649—an increasing number of artists from the Low Countries made their home in the French capital, entered the Academy, and were welcomed at court. In 1632 came Pieter van Boeckel of Antwerp, known in France as Vanboucle, and in 1643 Nicasius Bernaert, who became an academician in 1663; both were pupils of Snyders and specialized in animal pictures. Among fruit and flower painters Jean-Michel Picart, Gérard Gosuin [190] and Charles de Somme seem to be the most interesting. Picart was represented in the royal collection by a series of pictures of luxury objects, datable to the latter part of his career [191]; his small *Basket of Fruit* in the Kunsthalle at Karlsruhe is of an archaic type, and may thus be taken as an early work. This Fleming never belonged to the Academy, yet he won favor at court—perhaps because he followed the new decorative fashion in the Italian manner. For the two other Flemings, Gosuin [192] and Somme [193], had both been to Rome and, like Picart, were taken up by the court: Gosuin gave painting lessons to the Dauphin, the future Louis XIV, and Somme became " Queen's Painter." Félibien speaks of the latter as an artist of great renown.

Thus by about 1640 Italo-Flemish art had oriented the French still life in the direction it was destined to take. The adepts of this manner steadily increased in number. In 1671 the Academy welcomed Nicolas Baudesson, who had just come back from Rome, where he spent a quarter of a century or more and left a great reputation. At the 1673 Salon figured several pictures by his hand, baskets of flowers on stone balustrades, decorative in character but fairly sober works. Pierre Mignard, who no doubt made his acquaintance in Rome, owned some flower pieces by Baudesson.

This 1673 Salon proved that the French type of still life had definitely crystallized. All the pictures exhibited were decorative, sumptuous and futile: vases, rugs, monkeys and parrots alternated with trophies vaguely emblematic of the Liberal Arts or the Five Senses, in which we detect an echo of Lomazzo's ultra-academic precepts [194]. The Academy sponsored in fact the triumph of idealism. Fiction and unreality reigned supreme, without the classical rationalism of the day being aware of it. The still life became a theater in which the objects considered noble were brought together in impossible combinations affecting factitious movements. These were elements borrowed directly from Italian and Flemish Baroque. And yet, surprisingly enough, the resulting art was not Baroque. In Monnoyer's large ensembles (pl. 49), in spite of a diagonal composition deriving from Snyders, there is an indefinable stability. The movement traversing them, instead of sweeping the eye towards one side of the picture and out of the frame, seems to rise only to come slowly down again, unfailingly compensated for, unfailingly balanced. Horizontal or vertical indications of architecture, which henceforth often figure in French still life, are decisive and dominate the profusion of objects. Jean Belin, called Blain de Fontenay, Monnoyer's successor at the Gobelins and in the public favor, no longer had any direct ties with the Italian and Flemish manners. He it was, rather than Monnoyer, who created the Versailles still life *par excellence*. In his reception piece at the Academy, painted in 1687 (pl. 50), the architectural background is virile, almost severe in its majesty. Such too is the bust of the king, then still master of war and author of a prosperous peace. Hence the armor gleaming at his feet, while fruit pour forth from a horn of plenty. A large basket of flowers stands on a table, like a votive offering on the altar of an impassible god. A powerful shaft of light crosses an Olympian penumbra and falls on the flowers. They stand out brilliantly, the center of the composition and the main accent overshadowing the eloquent preciosity of detail. Thanks to a sure mastery and unerring taste, the picture as a whole appears almost sober. Seldom has the miracle of French pseudo-Baroque, of classical-minded lyricism, been more explicit. These marvelous decorations have the

stateliness of Racine's rhetoric. They bring off the feat of interpreting Baroque romanticism, with its chiaroscuro and its sheer abundance, in a spirit and setting of lofty rigor.

This tone was admirably suited to the royal and aristocratic climate, not only at Versailles but also outside France. Monnoyer spent his last years decorating the residence of his English patron, Lord Montagu, and the royal palaces of Hampton Court, Windsor and Kensington.

Still life paintings were entirely acceptable to official taste in France, as Michel Faré has shown [195]. He reminds us that at Versailles alone Louis XIV had " some sixty fruit and flower paintings by Monnoyer and almost as many by Jean Belin de Fontenay "; and that in the premises of the Royal Academy reception pieces representing still life were exhibited conspicuously and in good number; and that, with all the more reason, a great many of them were to be seen at the Academy of St. Luke, the old guild of Parisian painters, which had always been more favorable towards the " minor genres."

It is worth pointing out that in France (as in Holland), from the 17th century on, women played a prominent part in flower painting: after Catherine Duchemin, the Academy admitted Geneviève and Madeleine de Boulogne (1669), and then Catherine Perrot (1682), who painted flowers in miniature. Madame Vallayer-Coster was no less successful in the 18th century, but her official position was no more brilliant than theirs had been.

Once it had attained the peak of its royal equilibrium, however, the academic spirit did not enjoy its triumph for long. Le Brun's Academy promoted two elements which contributed to its own undoing: Flemish art and the Salon. The first represented pure, sensuous painting, which dispensed with literary allusions and even with an intellectual approach. The second meant that pictures were submitted not only to the taste of the court, but also to the judgment of the public; and that public, by and large, was the bourgeoisie. These two liberties combined were not long in shattering the rigid framework of pompous idealism which regulated life and nature like stage performances. In the last quarter of the century, the direct influence of Flemish art made threatening inroads. Its authentic representatives gained a foothold in the Academy and at the Gobelins. Already in 1668 Pieter Boel, a direct descendant of Snyders and Fyt, had become King's Painter and Le Brun's collaborator in the great tapestry manufactory. Monnoyer was schooled in the Antwerp studios, and so was Largillière a generation later, before winning admittance to the Academy in 1683. François Desportes learned his art under Nicasius Bernaert, and when he entered the Academy in 1699 he was already a man of the 18th century. He and Largillière were to inaugurate a glorious age of French still life painting: the century of Chardin.

CHAPTER SIX

THE CENTURY OF CHARDIN

The most important events in French art at the end of the 17th century were the quarrel between the followers of Poussin and those of Rubens and the founding of the Salon. In the first place, because this violent theoretical controversy, combined as it was with a concrete opportunity for everyone to judge for himself of the merits of contemporary art, signified the advent of an art-conscious society and the beginnings of modern criticism. Secondly, because these events reflected the vitality of a school destined before long to take the lead in the development of European art.

The followers of Rubens soon prevailed over those of Poussin. Before the writers of the day had begun to deal with the issue, the painters who looked to Flanders for inspiration asserted their superiority over those who looked to the Academy. They gave expression to a new and irresistible need to break free of the constraints entailed by academic art, which, by bending all its efforts towards stylization, sought to hold life sternly in check. The pretense of appearance, idealization, intellectuality, all this gave way to a feeling for the natural and immediate.

Painting soon showed obvious signs of this easing of tension, but the eloquence of the new work could not be expected to attain the same scope and force in all branches of painting. Though in many ways the reverse of the art of Louis XIV, 18th-century art was far from holding up the mirror to reality. Fidelity to life is not among the qualities we admire it for. It was not the exact likeness of the visible world that appealed to the 18th-century artist, but the vital principle which he discerned behind appearances and which stimulated his imagination. The pomp and pageantry of Versailles vanished from the religious and mythological scene and from the genre piece, but the painters of such pictures continued to indulge in the same vein of wayward poetry; theirs was a vision inspired by the theater and applied to organizing elements taken from reality. Watteau and Fragonard, once they had settled the lifelike details of a picture, never painted real life for its own sake, but as a pretext for an imagined fairyland; and they did so whatever their subject matter, whether a camp of soldiers, Gersaint's picture shop (and what could be more like a scene from a ballet than *L'Enseigne de Gersaint?*), or an easily recognizable path in the park of the Villa

d'Este. As for landscape painting, we have to wait for certain sketches by Desportes and a few exceptional canvases by Moreau, Vernet and Hubert Robert to find nature free at last of bucolic affectations. The portrait more often reflected the genuine simplicity of life, though this was repeatedly marred by the quizzical grin and curling lip conventionally denoting Voltairian skepticism. Only when we turn to the still life do we find ourselves at the furthest possible remove from the artifices of Monnoyer. Or rather only when we turn to those still lifes which rise above mere decoration. And these were the work of Chardin, one of the greatest painters of the century.

Was this mere chance, simply due to the impact of an exceptional personality? The workings of genius are inscrutable, but it may well take effect in a field that has to some extent been prepared. There is reason to believe that the emergence of this great innovator was facilitated by the peculiar position of the still life at that time in academic theory and practice. The painting of inanimate things being regarded as an inferior genre, academicians who qualified as specialists in this branch were usually not entitled to hold a teaching post. Paradoxically enough, however, still life painting was accounted the most valuable branch of all for schooling the painter in the essentials of his art, since it placed him, so to speak, in an intimate tête-à-tête with nature. Nor was the Royal Academy alone in recognizing its value in this respect. The use of still life for study purposes had probably been current practice in the studios since the time of Cennino Cennini. The painter who works from a motionless model more readily fathoms the secrets of forms and their relations with light and space. Possibly Cennini himself owed his observations on volumes and cast shadows in the first instance to the stone which he recommended as a model for the painter who is preparing to depict mountains. The first shadows we find in medieval painting are those of a flask and a writing desk in a fresco by Tomaso da Modena. Whatever precedents he may have found in antique manuscript illuminations (and to assume that he had seen such works is no more than a plausible hypothesis), it is significant that he applied this lighting effect only to his still life and not to the human figure beside it. In the 15th century the shadows cast by objects in cupboards actually serve to create space by locating bodies in the air; the attention paid to these effects in Italian marquetry and also in the small diptychs of Northern Europe is particularly striking. In a still life reproduced here (pl. 9) the suggestion of volumes in space is much more effective than in the *Virgin and Child* painted on the front of the same panel. In this niche, as in many others which figure in Flemish and German pictures of the 15th century, the rendering of a cube of space full of air and light is much more convincing than it is when the painter sets out to represent an entire interior.

With the advent of academic doctrines, official contempt for still life painting left its practitioners a freedom that was rich in promise. In the Low Countries, where Academies were unknown, brilliant results were forthcoming. In France, though it imposed an idealistic conception on still life, the Academy neglected to exercise any control over the elements that went into it, and these successfully retained a strong tincture of direct realism. This was enough to give independent-minded painters the opening they needed, and those who looked to Flanders for inspiration took advantage of it. In his youth Largillière made some still lifes in which he paid careful attention to the rendering of texture, to lighting, to the density of bodies; later, in the 18th century, he painted others which are often confused with those of Oudry, and which it would be rewarding to study closely ([196]). It was precisely by having him paint flowers that Largillière taught Oudry to solve the essential problems of painting in the " grand manner ": effects of light on tones, colored reflections and shadows, concordance of closely related values. Oudry in turn professed his famous lesson before the Academy, after it had been won over to Rubensism.

The freedom with which these men were already handling inanimate objects goes far to explain the extraordinary independence of Chardin. As a young man he was able to paint still lifes in his own way, his eye and hand unconstrained by any formal convention. So it is that only a still life by Chardin could have moved Diderot to exclaim as he did: " This is unfathomable wizardry. Thick coats of color are laid one on top of another, and their effect transpires from below upwards. At other times, one might suppose that a mist had been blown over the canvas; or again, that a light foam had been thrown over it... Draw close, and everything becomes blurred, flattens out and disappears; draw away, and everything is recreated and reproduced."

It was not Chardin, however, who opened the century. Before his time, François Desportes and Jean-Baptiste Oudry had already taken a good many liberties with the decorative still life. Both

had treated the theme of a sideboard laden with food and eating utensils, accompanied by dogs and dead game, with a landscape or fragments of architecture in the background. This of course was the time-honored recipe for such pictures, but they brought to it an airy, well-ordered arrangement and an elegant rhythm which reflect the esthetic of the Regency period and indeed constitute a genuinely French edition of this originally Flemish type of picture. When Desportes contents himself with a limited motif, he produces admirable pieces of painting, instinct with a life and directness that not even his smooth brush-work can stifle (pl. 75); a decorator at heart, he always inclines towards a unification of forms that tends to take the spontaneity out of them. Emphasis must here be laid on the momentous change that was now coming over the spirit of these decorations. Once they had become imbued with Flemish realism, they diverged from the flat composition that cleaves to the wall surface. They now tended to develop into easel pictures superficially adapted to their mural function by an orderly distribution of forms, masses and contrasting colors. This was the period when apartments were lined with mirrors; the only wall space left for paintings was on fire-screens and above doors, mirrors and mantelpieces. There was little demand for easel pictures and the production of them accordingly slackened off.

Under these circumstances, the still life reverted to a form it had already assumed several times in the past: as in antiquity, as in the 15th and 16th centuries, so now again in Chardin's day it was frequently painted in *trompe-l'œil* and employed as a decoration. The study of values initiated by Largillière and Oudry led to modulations of a single color which brought out even the faintest effects of relief with stereoscopic exactitude. Even when the picture is not an independent *trompe-l'œil*—such is the case with Oudry's famous *White Duck* (pl. 76)—the calculated purpose behind decorative monochromes of this kind is to convey, as forcibly as possible, the palpable illusion of solid bodies. It is not generally realized how very many of the still lifes so much admired today as easel pictures were originally intended to be let into a wall or placed as screens in front of the fireplace in summer time. And this was the use to which they were put throughout Europe in the 18th century. Chardin's famous *White Tablecloth* (pl. 69) was designed as a fire-screen, which explains why we see it from above, as we might see any piece of furniture standing in front of us. This painted table stood before the fireplace, thus adding one more item—but in this case an illusive one—to the rest of the furniture in the room. This is far from being the only example in Chardin's *œuvre* of work designed for a decorative purpose. Throughout his career, from 1728 to 1770, he painted a host of overdoor panels and simulated bas-reliefs; nor did he have any objection to painting shop-signs for apothecaries, which were still lifes representing the implements of that profession. Giuseppe Maria Crespi's *Shelves with Books* (pl. 70) ranks today among the masterpieces of Italian still life painting in the 18th century [197]. These simulated bookshelves intended to conceal the doors of a real library in the Academy of Music at Bologna [198] are in every way comparable to a simulated *Cupboard with Bottles* (pl. 10) of the late 15th century, which very probably figured on the door of an apothecary's shop. And the still lifes of Melendez, which it would be hard to outdo for sheer palpability, eventually formed a series of panels set into the walls in a royal apartment at Aranjuez (pl. 67); they told of the fertility of the Spanish Empire in all climes and seasons. Both plastically and spiritually, they were utilized like the *xenia* of antiquity [199].

The style of all these decorative still lifes is obviously of an unimpeachable imitative quality. They remain essentially easel paintings, with nothing to distinguish them from other easel paintings by the same artists except that the viewpoint is high when they are meant to be used as fire-screens and low in the case of overdoor panels. How are we to account for this combination of aggressive realism (as this uncompromising application of *trompe-l'œil* might be described) and decoration ? How are we to account for the joint presence (sometimes on the same wall) of the decorative arabesque, which so admirably interprets the flat verticality of the wall, and of *trompe-l'œil* paintings which break up its smooth surface with effects of sharp recession and emphatic relief ? One is tempted at first to fall back on the obvious explanation, of a practical order: the desire to utilize easel pictures at all costs by placing them in the only wall space available. And indeed we find a contemporary observer, La Font de Saint-Yenne, lamenting the fact that good painters were reduced to decorating the panels of carriages. But this explanation fails to take the esthetic side of the question sufficiently into account. Tastes were too refined in the 18th century to tolerate any such makeshifts are were liable to disrupt the harmonies on which so much store was set. It is undeniable, on the contrary, that *trompe-l'œil* painting squared perfectly with the tastes of

that day. For the truth is that *trompe-l'œil* in the hands of an artist (and not merely of a craftsman with a knack of imitation) amounts to a good deal more than an exercise in literal realism. A sensitive artist cannot help eliciting poetic overtones from it; he cannot help conveying the impression that reality as he paints it is more intense than that of life. Why is it that those who admire a *trompe-l'œil* painting so often say that it appeals to the sense of touch? Do the objects that surround us in daily life appeal to our sense of touch? Can the light, the warm or limpid atmosphere, of a *trompe-l'œil* painting be likened to the light or the atmosphere of real life? No, what the *trompe-l'œil* paintings of an artist actually show us is a reality that compels our attention, holds us fascinated, and seems to have been contrived expressly to do so—a reality, in other words, so imperious as to seem wholly arbitrary. It was precisely this skillful recasting of the elements of reality that appealed to the men of the 18th century and reconciled *trompe-l'œil* with the willful fantasy of arabesques. One was calculated to take the senses unawares, the other to startle the mind; together they impressed on the beholder a keen sense of the painter's magic powers. Magic—again and again the word turns up in reviews of the Salons of that day. The 18th century lived in a world of make-believe. And it shared with other anti-classical periods a fondness for thrilling interludes in which imagination rides roughshod over reality and reality itself appears to be peopled with imaginary forces.

Taking the most ordinary things for its subject matter, still life painting in the 18th century was essentially an art of the middle classes; so that in this sense it was the very reverse of what it had been in the reign of Louis XIV. Nevertheless, when employed as *trompe-l'œil* decoration in the luxurious homes of the well-to-do, it conformed to the esthetic of make-believe which had been cultivated by the aristocracy, at a time when that class, feeling its insecurity, took refuge in a dreamworld.

Trompe-l'œil painting was remarkably widespread in Europe throughout the 18th century, being practised by talented painters and by simple craftsmen. In Holland, France, Italy and Spain we find pictures by both ([200]), for the most part decorative panels intended for libraries, simulating books, papers, prints and a whole world of, as it were, mind-pervaded objects which loom out of their frames and fill the thoughtful man's study with an atmosphere of wizardry over which the breath of Cagliostro seems to pass. In the second half of the century this art assumed a provincial, semi-popular character. The earthenware tiles of Valencia formed kitchen decorations consisting of illusionist utensils and foodstuffs. In Mexico the provincial Spanish tradition was carried on well into the 19th century in pictures representing well-stocked pantries and larders ([201]).

In France Boilly seems to have been the last of the *trompe-l'œil* painters to maintain a certain artistic standard. The tradition was dying out in Europe, but it had been transplanted to the United States and there lingered on to the last decade of the 19th century. The School of Philadelphia produced not only its first transatlantic exponent, Raphaelle Peale, author of the mysterious *Bath Towel*, painted in 1823 (pl. 81), but also its most famous representative, William Harnett, whose last works date to 1892. Harnett's art is marked by an extremely salient plasticity and, on occasion, a composition wholly classical in its rigor, which is matched by an impassible, severely controlled execution steeped in the Puritan spirit. He often painted costly objects, chosen for their rich and varied textures. Another Philadelphia painter, Frederick Peto, discovered the charm of outworn, discarded objects—old papers, torn labels, faded snapshots—and he made them yield delicately interblending harmonies. His choice of objects and his manner of arranging them do not lack a sense of poetry, nor are they devoid of a humorous touch. Besides these artists, there were many other *trompe-l'œil* painters who failed to rise above the level of skilled workmanship; they created a kind of popular American imagery by painting illusionist dollar bills whose vogue seriously alarmed the Treasury Department. The young middle-class society of the United States, unconversant with the boldness of more highly developed types of painting, took a naïve delight in the literal naturalism of this art. Although 19th-century criticism deplored their archaism, the pictorial qualities of such painters as Peale, Harnett and Peto have been hailed with enthusiasm by present-day critics, who were led back to them by way of Surrealism.

However characteristic of the 18th-century spirit, it was not *trompe-l'œil* that gave rise to the most significant creations or to those that had the most fruitful bearing on the future. Chardin only indulged in it to the extent required by the fashion of the day. His temperament made him chary of overstating the literal aspects of reality. He was never in any sense haunted by the mystery behind the material

111

presence of things, but was, first and foremost, a painter whose intuitive aspiration was to fuse objects in a profound harmony of rhythms and color textures. He so arranged a copper kettle beside a hanging rabbit that both objects became almost musically attuned to each other in space. He no doubt accepted them for what they were, a rabbit and a kettle, whose forms and aspect had to be accurately, recognizably depicted; he was, after all, a man of his time, and this was the age of rationalist thought and the marvelous objectivity of Buffon. Nevertheless, it is safe to say that in a sense he regarded them as so many patches of color to be harmonized, so many brushstrokes to be laid in and color textures to be invented. To invent, for an artist, means to dominate. When Chardin set to painting the coat of an animal glistening in broad daylight, he did not call a halt till, by the alchemy of his brush, it had become fur and foam at the same time—a foam whose enamel finish approximated to the gleaming copper surface beside it. Of all his predecessors, Velazquez and Rembrandt alone disclosed the painter's empire over nature with a like degree of directness. Chardin was known to the critics of his day as " the French Rembrandt " (202), which meant in effect that what they admired in his still lifes was his abrupt, undisguised brushstroke, which takes the eye by surprise from close at hand and proves to be miraculously accurate when seen from a distance. Without realizing it, they discerned the place he was to occupy in the history of painting, between the old and the modern masters.

For it was not to the Flemish masters (who all had a touch of the decorator in them) but to the Dutch intimists that Chardin turned for inspiration in reacting against the manner of Desportes and Oudry. He painted commonplace objects, usually food and kitchen utensils. This came as a bold novelty after half a century of flowers, trophies, and sideboards overloaded with fine ware. But this new departure was endorsed by the increasingly widespread taste of collectors and public for Netherlandish art. To compare Chardin to the Flemings (which at that time meant all the painters of the Low Countries, including the Dutch) was to justify and extol his art, just as Aertsen's contemporaries justified and extolled his art by comparing it with that of Piraikos.

To the utter simplicity of his subject matter Chardin added a composition devoid of any apparent artifice. In this, at first sight, he seemed to be following in the footsteps of Metsu (pl. 28) or Heda (pls. 37 and 74). But an essential feature of his still lifes—their spiritual quality—sets him apart from them. Metsu bathed the things he painted in an atmosphere of frank sensual enjoyment; Heda, in a Puritan atmosphere of meditative silence; both lingered over the object for its own sake and brought out its precision and purity, as if untouched as yet by the hand of man, who, however, is obviously making use of it. Chardin is fond of well-worn objects, polished by dint of being handled; man's presence is always implied in this unfailingly moving communion of life with matter. He bathes these objects, furthermore, in a delicately varied light expressive of the comforting warmth of the home, but devoid of any deliberately lyrical effects.

With motifs similar to those of the Dutch masters, Chardin composed pictures whose plastic harmony is much more complete. Not only are forms bound together and more effectively unified by means of color than in Kalf's work, indeed in a manner whose only precedent are the golds and reds of Rembrandt's *Flayed Ox* ; but Chardin groups his objects with a freedom and subtlety that are quite unprecedented. In Dutch still life painting objects stand close together, touching one another. Chardin draws them apart, but across the air-filled gaps that separate them they are linked together by ties which we feel to be indefeasible. This satisfying effect is not produced by any obvious geometrical pattern. It is a subtle relationship resulting at once from the reciprocal proportions of objects, from their direction in space, from their proximity on the same plane or in recession. The cadences of their grouping distinguish Chardin from the soberest Spanish masters as well as from the Dutch. Compare the sequence of objects in space as handled by Cotán (pl. 61) and by Chardin (pl. 73): here we have the contrast between an equilibrium imposed on nature and an equilibrium latent in nature and revealed by the painter with an easy, almost smiling gravity. For though Chardin rendered objects in light and depth not without effort, the composition seems to be the happy result of instinct.

Of all French artists previous to the 19th century, Chardin, alongside Poussin and Claude Lorrain, is the one who has had the greatest influence on modern painting. Certain researches of Manet and Cézanne are inconceivable without Chardin. It would be hard to imagine anything more "advanced " in the way of layout and pictorial handling than the Edinburgh *Vase of Flowers* (pl. 72). It stands out

above anything of the kind painted by Delacroix, Millet, Courbet, Degas and the Impressionists. Only in Cézanne and in post-Cézannian painting can we hope to find so much power in so much simplicity. And before Chardin, Vermeer alone (though apparently he never painted a still life) would have been capable of eliciting a comparable serenity from a few harmonies of white and blue in a milky light.

By virtue of these incidences, Chardin occupies one of the foremost positions in art history. Caravaggio is the first example of a great master who painted independent still life pictures. But Chardin did more: he won recognition as a great master by specializing in what was then considered an inferior branch of art. He baffled the critics of his day. While acknowledging his superiority in art, they were at a loss to reconcile his pictorial mastery with the small degree of spiritual significance which they discerned in his pots and pans and rabbits. He set them thinking, nevertheless; they did not go so far as to question the academic hierarchy of genres—there were limits to their intellectual courage—but at least they went in search of a name for the genre of painting that he practised. As for the spiritual significance of his work, not only did it become obvious to all after the Goncourts enthusiastically paid homage to Chardin, but it suddenly revealed all the still life painting of previous centuries in a new light: such artists as Heda and Kalf were now also recognized as masters. With Chardin at last understood, it was realized that they too had enriched the human sensibility with a new fund of experience for which there was no exact equivalent in the other branches of painting.

The prestige of Chardin and the new, utterly simple type of still life which he created at once gave rise to a school. Jean-Jacques Bachelier, Henri Roland de la Porte, Anne Vallayer-Coster and Bellangé became what Diderot called " Chardin's victims." Bachelier took inspiration from him, sometimes with an engaging accent of uncouthness, but cannot be said to have imitated him directly. Roland de la Porte contributed nothing of his own to the master's manner; his chief title to fame is the fact that for a century and a half many of his pictures were ascribed to Chardin (²⁰³). But his composition gives him away; it has none of Chardin's relaxed freedom, none of the almost musical intervals that he sets up between objects. Madame Vallayer-Coster is usually written off as a mere imitator, but this is quite unfair. The truth is that, after Chardin and Oudry, she is the best French still life painter of the 18th century. She displays a sensibility of her own which leads her towards a coloring and handling that are sometimes more delicate, sometimes more spirited than Chardin's. The high lights of her flower pieces vibrate boldly and produce a chromatic animation that is almost modern. Her harmonies of russets, pinks and blues anticipate those of Fantin-Latour. In her fruit pieces, with their graceful, well-knit composition and energetic brushwork, we find her already venturing on modulations of tones so pale as to seem bleached by strong light; this is not so very far from the melting colors and vaporous modeling of fruit as handled by Renoir, who looked long and often at the still lifes of the 18th century. There are one or two very fine anonymous pictures, wrongly attributed to Chardin (²⁰⁴), in which this exquisite bleaching effect of muted pastel colors is accompanied by a refined impasto and a light that falls on objects like a fine powder (pl. 77). Is this one of those works by Madame Vallayer-Coster which Diderot, a poor judge of pictorial problems, described as resembling " a picture which the artist intends to retouch " (²⁰⁵)? Yet the color and touch of these enigmatic pictures do not seem to recur in quite the same form in the works of this artist; on the other hand, they do not differ sufficiently to rule out the attribution. Whether hers or not, however, these paintings, so full of light and air, number among the most original still lifes of the 18th century, and among the most typically French.

The same is true of those of Pierre Subleyras. When treating the *Attributes of the Arts* (pl. 78), a theme familiar to Chardin, he stamps the picture with a specifically Roman hallmark. Among the symbols of painting, sculpture and music he includes a small-scale replica of Duquesnoy's statue of St. Susanna in the church of Santa Maria di Loreto in Rome, one of the city's most famous artistic curiosities. The saint who overturned a pagan idol of Jupiter merely by blowing on it, points with a disapproving finger at a mutilated antique statue (inspired by the famous Torso of Hercules in the Belvedere) and at a flask with a glass of wine beside it: symbols of the sensual life, from which she turns away to contemplate the attributes of the arts, symbolizing the spiritual life. So that this picture allegorizes the triumph of the arts over the mere satisfaction of the senses. The mellow touch, sharp contrasts of color and decorative *éclat* of this still life (which may have been designed as an overdoor panel) show how much Subleyras was indebted to Roman Baroque. But the elegance of the drawing and of the supple composition is

undeniably French. The style of this work is so personal that it may enable us to identify other still lifes by Subleyras; very few are so far known to exist ([206]).

Outside France, Spain and Italy were the only other countries to produce work of any significance in the 18th century. In Spain, after the orgy of " floreros " and the influence of the Neapolitan School, the first half of the century was marked by repetitions of the old formulas. But towards the middle of the century there appeared a painter of considerable stature who, though born in Naples and schooled in Italy, revived and upheld the finest traditions of Spanish painting.

Luis Melendez (pl. 67), as already noted, painted a number of pictures of food and fruit designed to serve as decorations in the royal palaces. In them, however, he broke with the decorative tradition of still life painting in much the same way as Chardin had done. He concentrated on ordinary objects and presented them with an almost rustic austerity. But the comparison with Chardin holds good only for this attitude towards the motifs; their handling of forms and indeed the whole spirit of their work are fundamentally different. Without introducing any figures into his compositions, Chardin makes us feel that the objects he paints are seen in relation to man. In Melendez' paintings the object is seen for its own sake. Flooded with torrid light, rendered with intense, well-nigh pitiless objectivity, it imposes its physical presence and the richness of its texture. Melendez brings the object much closer to the eye than Chardin does, but he moves it away from the heart proportionately. Instead of appealing to our sympathies, it takes us by surprise, imbued as it is with a strange fascination suddenly revealed by the magic of the painter's art.

Here we recognize an old Spanish tradition, exemplified earlier by Cotán, in which the shock of an unexpected appearance startles the spectator out of his conventional way of seeing. Both Cotán and Melendez, like Salvador Dali today, Spaniard and Surrealist that he is, aspire to reveal a poetry of unreality in objects that have become all too familiar to the eye and mind. Something of the freshness and appetite of childhood comes back to us across the years. Again we feel capable of exploring the skin of a piece of fruit as if it were a grandiose, enigmatic world. The light Melendez focuses on his objects is " metaphysical," his keen, unswerving gaze is that of a visionary. There was no finer artist in 18th-century Spain till Goya appeared on the scene.

Italy was still very much alive as an art center, especially North Italy. From the tradition of Baschenis and his kitchen pieces with plucked fowl derives the still life by Carlo Magini reproduced here (pl. 68), showing a kitchen table and a niche with a chicken and a white jar among other objects. Magini's very name was unknown when the first edition of this book appeared (1952), and the group of pictures to which this still life belongs were regarded as Italian or Spanish works of the 17th century. I ventured, nevertheless, to assign them to mid-18th-century Italy, and this assumption has recently been confirmed by the discovery of pictures signed by Carlo Magini, " painter of Fano " (1720-1806). Treated with great linear precision, crammed with objects yet arranged with order and clarity in strong, evenly diffused light, these bourgeois still lifes testify to the mysterious survival in the midst of Baroque ostentation of an almost Caravaggesque spirit of severity. Magini shares this simplicity, this utter absence of rhetorical effect, with his Spanish contemporary Melendez ([207]).

The genre scenes of the Bolognese painter Giuseppe Maria Crespi contain still lifes whose positive spirit, if not their handling, relates them to those discussed above. Their chiaroscuro is less impassible but no less earnest ([208]). Objects are arranged just as we might expect to find them on kitchen shelves, and this quiet tidiness is the very reverse of the superabundant profusion so typical of Baroque art. Crespi's genre scenes owe a good deal to the Dutch little masters; but he achieves a Latin synthesis of their rustic intimacy by subordinating details to a deliberate light effect. Much more than a follower of the Dutch, however, he reveals himself as a forerunner of Chardin—but of a more lyrical Chardin than the one we know. The gravity and warmth of Crespi's style are such that, in spite of its animated composition, his illusionist *Shelves of Books* (pl. 70) has none of the aimless agitation that pervades the Roman and Neapolitan still life paintings of that day. It comes as a surprise to find the spirit of the first half of the 17th century reappearing virtually intact in Crespi's work. The art of Chardin represents a similar phenomenon in France; it stands apart from the art of its day and harks back to the spirit of French painting under Louis XIII, to Baugin and the brothers Le Nain.

114

It was left to Venice, now in the glorious sunset of her greatness with Tiepolo and Guardi, to give original expression for the last time to the art of still life painting as practised by the old Italian masters. Flower painting was brought to Venice from Naples early in the 18th century by Gaspar Lopez. Some of his bouquets stand out against bright backgrounds, and it may have been one of his masters, Jean-Baptiste Dubuisson, who introduced this habit (which he contracted in Monnoyer's studio) to Naples. This in itself, however, would hardly be worth mentioning, were it not that Lopez passed on this new formula to young Francesco Guardi. To Giuseppe Fiocco [209] goes the credit for bringing to light, quite recently, several baskets and vases of flowers by this great artist (pl. 71). One cannot help wondering whether Guardi's broad handling of his flowers, which look as if ruffled and tossed by the wind, and his frieze-like composition of juxtaposed motifs may not derive from the bouquets of Margherita Caffi, of Cremona, who worked at the Tirolian court of the Archdukes of Austria towards the end of the 17th century, and many of whose pictures are to be found in Spain [210]. Guardi had direct contacts with Austrian painting. Most of his vases of flowers are overdoor panels, but they have a freedom and lightness of touch unparalleled in 17th-century flower painting. The capricious asymmetry of Rococo governs the grouping and enlivens every stem and petal. The air around them shares in the quivering life of his flowers in a way that is very different from that of the Neapolitan painters. The Southerners set their flowers against a stormy sky whose dense and darkling air makes petals glow with dramatic effect; this atmosphere, contrived rather than felt, fills their pictures with an ominous tension. Guardi, like a smiling gardener, places his flowers against a clear sky and lets the breeze of the lagoon ruffle their petals. He seems to have forgotten them on a lawn of the Giudecca. Flowers, for the first time in painting, appear to merge with the sun and air—released now from the dim light of Northern studios, from decorative rigor and ponderous Baroque rhetoric. Chardin had already painted them in broad daylight, thus heralding Cézanne. Guardi's flowers, whose petals are no more than broad strokes of the brush blending together in light, remind us that the time was almost ripe for Delacroix's bold, untrammeled handling of the painter's medium.

CHAPTER SEVEN

FROM ROMANTICISM
TO THE TWENTIETH CENTURY

ROM the 19th century on, the pattern of European civilization became increasingly homogeneous, so much so that new developments in art tended to be rapidly accepted and assimilated in all countries. European art grew more and more uniform. National and even local schools did not die out, but they came to reflect the ideas and innovations that originated in the most creative art center. For over 150 years that art center has been France. Renaissance Italy alone in modern times has held a comparable position of leadership in artistic matters. In Spain and Holland too, however, in the 19th century, painters emerged whose novel conception of still life has had a decisive influence all over the world: Goya, Van Gogh, Picasso. From the last quarter of the century to the present day, the communion of spirit between the artists of France and those of other countries has been so close that the notion of " schools " has now almost completely lost the value it had in former times.

To this homogeneity of art in spite of frontiers can be added unity of time. The creation of museums and, more recently, improved techniques of reproduction have brought the whole art heritage of the past within the reach of every artist. Formerly it was quite unusual for an artist to take inspiration from the style of remote periods and cultures; during the 19th century it became frequent. All the more reason, then, for 20th-century artists to live and work as they do in close communion with their direct predecessors. The continuity between the two periods is obvious—and complex.

From this point on, therefore, it will be necessary to conduct our investigation on different lines from those followed in the preceding pages. Our subject matter will have to be studied not by national schools but by " families " of significant artists related to one another by a common conception of still life. These spiritual filiations often span both centuries. In some cases the work of an outstanding painter joins up partly with one mode of expression, partly with another; when this happens the two parts will be discussed separately, each in its appropriate context. Nevertheless, since all classifications of reality are only an expedient of the mind, it is not our intention to attach any intrinsic importance to these " families " of artists as such; their personalities being strongly marked, they are only so grouped as a means of clarifying the historical trends of still life painting which form the object of the present study.

116

The Romantics and Goya : The Expressive Still Life.

The French Revolution brought about a revision of 18th-century ideas on art. By abolishing the Royal Academy of Painting and Sculpture, the Revolution guaranteed the painter's right to choose his own themes and to exhibit freely; it gave him the opportunity of measuring his own efforts with those of others in the hard light of criticism, and of gaining a deeper awareness of his vocation. When we look through the catalogues of the seven Salons held in Paris between 1791 and 1800, we cannot help being struck by the small number of still lifes figuring in these exhibitions, the first in which painters of all tendencies could freely participate. Out of 400 pictures exhibited at the 1793 Salon, for example, only about fifteen come under the heading of still lifes. Almost all of these were fruit and flower pieces. Among the artists who went in for still life painting, the only ones who had made a name for themselves were former academicians, like Cornelis van Spaendonck and Madame Vallayer-Coster; the latter was practically the only one to exhibit other subjects besides flowers and fruit; Piat Sauvage continued to specialize in simulated bas-reliefs.

The eclipse of the still life lasted well into the early 19th century. The Academy itself had been abolished, but academic contempt of this " inferior " branch of painting lingered on. This, however, is not the whole explanation. The truth is, simply enough, that there was no demand for still lifes; artists and public alike had lost all interest in them. The portrait and landscape had also been discredited by 18th-century academic doctrine; yet the first was now at the height of fashion, and the second an object of serious attention. We can only suppose that in those troubled times, with France (and the rest of Europe with her) involved in wars that dragged on for a quarter of a century, men's minds were incapable of the calm concentration required for the appreciation of still life painting. The generation whose active life spanned the period from 1790 to 1815 was literally staggered by the immense upheaval gathering momentum around it. Conditions in France at that time cannot be compared with those in 17th-century Holland which, while waging war, also produced the still lifes of Claes and Heda. France was committed to " total " war; Holland was not, and the domestic peace of the Dutch burgher remained undisturbed. The French painters of the Revolutionary and Napoleonic periods were obsessed by the mighty actions and enterprises of their time. A brooding preoccupation with death goes far to explain the craze for portraits, while most of the landscapes of that day are either reveries on classical themes or recognizable views of sites and countries made familiar by the military campaigns.

Obviously there could be no place for still life in David's esthetic, which, among other ideas it owed to the Old Régime, inherited the dogma of a strict hierarchy of subject matter. Never, even in the palmy days of the Academy, had the " nobleness " of historical painting been so much exalted as now; never had the ideal of humanism been narrower, based as it was on the cult of the " antique," a vague denomination applied undiscriminatingly to the whole of antiquity, Greek, Hellenistic and Roman. This is not to say that David was hostile to the representation of reality. On the contrary, his great merit was to react against the artificial vision of nature cultivated by the 18th century. And if the Romantics, Gros first of all, stood so largely indebted to David's teachings, this was precisely because he opened their eyes to the pictorial possibilities of nature. But nature in what sense ? The answer is, nature in so far as it corresponded with what was then supposed to be the antique view of nature. The *xenia* of Pompeii and Herculaneum had been known for half a century and had been reproduced in the form of prints and watercolor copies; yet the Hellenistic spirit which they embodied failed to undermine or modify in any way the current conception of Hellenic antiquity. The fundamental tenet of that conception was the glorification of man and it fully satisfied artists who had grown to manhood in a strenuous age of ambitious exploits which seemed to justify great hopes and sustained their faith in humanity. None of these painters took any notice of the still lifes of antiquity. They shut their eyes to them, because if they had looked at them and understood them, they would have had to revise their conception of antiquity and of the antique outlook on the world. Archeologists, professionally bound to render an account of all discoveries made, hastened to dismiss the *xenia* as trivial " amusements " or " recreations " of a civilization; as if a mere convention, by classifying them as a " minor genre," could discredit the historical fact that, for a period of five or six centuries, pictures of inanimate objects were a form of plastic art in their own right, and appreciated for their esthetic merits. It is one of the paradoxes of history that the still lifes of Pompeii and

Herculaneum, which we know were available at the time, made no valid impress on 18th-century art (except in the field of decoration, wallpaper for example, but even here their influence is rare), whereas other antique still lifes, which we can only suppose were known in the 14th, 15th and 16th centuries, had a fecundating effect on the artistic ideas of that age, as yet untainted by academicism. At that time antique works of art were found to contain stimulating suggestions, they opened new horizons; in the age of David they came as ill-timed intrusions and were therefore regarded with indifference.

Thus the tenor of life and current ideas on art were such as to screen off the silent world of motionless objects from the eyes of David and his followers. When Géricault and Delacroix, in the ardor of their romanticism, departed from the criteria of antiquity and embraced the spectacle of life as a whole, they at once made a choice: still life regained its place in painting but it was reduced to particular motifs, to those alone which offered scope for expressing the new awareness of reality. Reality for the Romantics, however, though it was more varied than the reality accepted by David, was still no more than a vehicle of vital forces. It is significant that both Géricault and Delacroix turned towards Baroque still life; the masterpieces of all schools gathered together in Paris at the Musée Napoléon contributed to this choice. Géricault is known to have painted flowers, fruit and game ([211]); these still lifes were admired at the time but most of them have disappeared. To judge by a copy he made after Abraham van Beyeren ([212]), Géricault's still lifes must have been largely inspired by those of the 17th-century Dutch masters. There still exist, however, paintings of inanimate things by Géricault in which the subject matter is very singular indeed: I refer to the pictures of human limbs painted at the Hôpital Beaujon. Most of these are preliminary studies for the figures of dead castaways in the *Radeau de la Méduse*. But two or three of them constitute self-sufficient pictures in their own right, with their careful composition and well-knit cohesion of form and expression: *Amputated Arms and Legs* (Montpellier), for example ([213]). In these pathetic human debris, the artist sought to preserve the impress of life, just as Rembrandt had done in the *Flayed Ox*. The moving contrast between the flesh and the ills it is heir to is summed up in the supple looseness of severed limbs which seem still to respond to the will power that once propelled them. The same pathos distinguishes the severed heads which Géricault painted. Gripping though they were by the theme itself, the romantic artist went on to imbue these still lifes with expressive allusions. Here Géricault followed in the wake of Goya. But he appeals to our feelings by evoking ideas. Goya appeals to our feelings solely by a cruel realism that goes straight to the very core of our senses. Géricault was not so " modern " as Goya.

More serene and even more traditional in his approach, Delacroix painted a still life of *Trophies of Hunting and Fishing* (pl. 80) set out in a broad decorative rhythm, following the pattern of Snyders, Oudry and Desportes. Delacroix took his cue from Rubensian Baroque and its derivative, English Romanticism, and these helped him to express the concord of still life and landscape with freshness and originality. Neither here nor in his vases and bouquets of flowers with their lingering memories of Jean-Baptiste Monnoyer does Delacroix introduce innovations in the conception of still life. He fills his luxuriant bouquets with a new intensity; through them blows a breath of life which merges forms and blends colors in light that glides over them like a luminous breeze. And yet, as in the flower pieces of the 17th-century Neapolitans, a keen sense of the vitality of plant life fails to dispel the decorative character of this " floral architecture." This type of flower picture held its ground with the Romantics: Diaz, whose colors also aimed at magnifying the lustrous intensity of vegetation, decorated panels of wainscoting with still lifes of fruit and flowers.

The return to the Baroque still life—of both the Flemish and Spanish types—inspired in various ways, and with unequal results, a group of still life painters at Lyons, where the manufacture and decoration of silk gave rise to a school of flower painting. The work of such men as Antoine Berjon and Simon Saint-Jean, at once naïve and refined, is characterized by rather shrill colors and a painstaking accuracy of botanical detail. It is noteworthy that the latter revived the votive garlands of Daniel Seghers, plagiarizing them with touching conviction. Jean Seignemartin read an entirely different lesson into the brilliant colors of the old Flemish masters; he enthusiastically interpreted succulent compositions that might have been fragments cut out of the large banquet pieces of Jan Davidsz. de Heem. Antoine Vollon was more energetic and straightforward in his approach, and handled still life with a keener sensibility. His sharply defined chiaroscuro and muted reds matched with pure blacks and whites betray the basic Spanish color scale which he took over from Théodule Ribot. The fact that he was known as the " Chardin of his time " should not make us over-harsh in passing judgment on him.

But apart from this provincial School of Lyons, with its thoroughgoing sensualism devoid of any hint of sentimentality, even the greatest French painters failed to keep clear of Romanticism. We need feel no surprise at finding traces of it in Corot. He painted very few still lifes, all datable, so far as we can tell, to the very last years of his life (pl. 82). These works, though they have passed unnoticed, are not without a certain historical importance, for they mark the extreme limit of the pictorial freedom to which Corot's lyricism led him. Perhaps nowhere else does he come closer to the Impressionists. And yet his wistful meditation on a rose, on its quivering velvetiness in the shadows of a domestic interior, is almost at the opposite pole from Renoir's steady clarity and quiet pagan smile. Only the feminine insight of Berthe Morisot, who must have seen Corot's flower pieces, recaptured some of his tender contemplativeness.

Undertones of Romanticism were only to be expected in Corot. But a careful scrutiny of the still lifes of Courbet, who passes for an imperturbable realist, reveals that few of them elude the sentimental impress of Romanticism. Courbet painted two kinds of still lifes; they reflect the indecision of his art, which oscillated between objective realism and lyrical realism. Some of his flower pictures, powerfully built up in bright colors that flash out in cold light, are simply virile descriptions of the abundant vitality of plant life. Most of the others—nearly all painted in 1871 in the prison of Sainte-Pélagie—show the same enthusiastic insight into the pulsing life of nature; but they rely heavily on dusky effects of twilight, showy contrasts of red and yellow, combinations of smooth volumes and rugged impasto, and all the resourcefulness of a particularly admirable interpreter of sensual sentimentality (pl. 84). Despite the firmness of his chiaroscuro, Courbet's rhetoric is much nearer to that of the Neapolitans than to Caravaggio's noble austerity. In prison his only models were fruit, flowers and fish (pl. 85). In working out his compositions he had no alternative but to fall back on his imagination and memory. The latter, we discover, was steeped in reminiscences of 17th-century Baroque painting. The addition of a landscape background to a still life (as in Delacroix's *Trophies of Hunting and Fishing*) or of a woman's figure to a flower piece (as in Courbet's magnificent *Treille*) recalls the stock devices of the Neapolitan School. Such pictures as these go to confirm the impression that Courbet was the last of the great independent painters to follow the masters of the past, this in spite of Manet's more obvious borrowings from Velazquez, Goya and Frans Hals. The reason is that Courbet restored the authentic atmosphere of Baroque art; Manet did no more than avail himself of procedures which helped him to break free of traditional ways of seeing. Courbet's finest pictures, moreover, are those in which he draws freely on his imagination—but he seldom does so. When he does, however, as in the *Trout* (pl. 85), an imaginative reinterpretation made in 1873 of a smaller picture on the same theme painted in prison two years before, he attains an almost visionary grandeur of expression. This formidable creature, with its flinty scales, is like a remnant of prehistoric times, lying at the bottom of virgin waters.

Which of the other realists can be said to have avoided the pitfalls of a lyrical setting? Fantin-Latour comes to mind. Yet how can we help being aware of sentimental undertones in the delicate, ash-colored shadows invariably dappling his apples and flowers, which are like a feminine edition of Courbet's? These nostalgic echoes suggest the comforts of home, the vague reverie of needlework and quiet reading. There is something Victorian here that perhaps explains the popularity Fantin-Latour's flower pieces have always enjoyed in England (pl. 83).

Such was the still life in Paris, while painters in the South of France were enlarging on that sentimental setting which the bourgeois spirit required of nature in compensation for its positivism. Nourished on the busy life and coruscating light of Marseilles, Adolphe Monticelli fell in line with the most authentic Baroque tradition in French art: the tradition inaugurated by Fragonard, which led up to Daumier and the early Cézanne. A romantic dreamer, Monticelli belonged by nature to the most robust and voluptuous race of painters. His still lifes are altogether free of literary allusions, their lyricism is bound up exclusively with the physical properties of the painter's medium, with texture and color. And it was perhaps the still life, more than any other theme, that gave full scope to his bold originality. Here, working with a full brush, he built up forms whose volume and exact location are conveyed by the quality of tones, glowing but accurate (pl. 91). His color owes a good deal to Diaz, but he transformed the kaleidoscopic saturation of the Barbizon painter into a powerful masonry of colors. Monticelli was certainly one of the most independent-minded painters of the 19th century. A good part of that freedom he owed to the provincial

seclusion in which he lived and worked. It was probably not by chance that he often reverted to the theme of a table covered with an oriental rug, a type of picture painted at Marseilles in the 17th century by Ephrem Leconte, following the Baroque esthetic of the Cavaliere Maltese. Monticelli's deepest instincts link him up with the most passionate dreamers of Mediterranean art; indeed, he seems to transpose the oratorical effusions of the old Neapolitans into a modern idiom, more direct and strident. Nothing more plainly indicates the novelty of his art than its influence on the early work of two of the founders of modern painting: Van Gogh, who copied his flower pieces, and Cézanne, who greatly admired his still lifes. A comparison of Monticelli's *White Pitcher* (pl. 91) with Cézanne's *Green Pot and Pewter Kettle* (G. Bernheim de Villers Collection), painted in 1869-1870, reveals the origin of the inky pools of shadow which, in the latter picture, enclose heavily impasted surfaces of bright, enamel-like colors.

Also dating from 1869-1870 is *The Black Clock* (pl. 92), the masterpiece of Cézanne's youth. It is significant that his so-called romantic period reached its climax in still lifes. In these, for the first time, his efforts and experiments bore fruit. No doubt it was important for him to have remained so long aloof from the fret and fever of Paris; meditative by nature, absorbed in the struggle to subdue and channel the vehemence of his temperament, he needed time to find his bearings. But the theme itself may well have played a primordial role. In front of a still life, sensitive and scrupulous observer that he was, Cézanne felt more at ease than with any other subject; there was no danger of the model's moving, no danger of abrupt changes in lighting, he was free to ponder over the problems of form presented by each picture and let the solutions ripen in his mind. The striking thing about *The Black Clock* is precisely its unfaltering cohesion of style. It is conceived in the traditional manner of Dutch still life: a table laden with household objects, accompanied by spotless table-linen (pl. 29). Manet restored this type of picture to favor among the younger painters. And from him, obviously, stem the contrasts of dark and light areas and the vigorous contours binding forms. But Cézanne's realism is neither placid like that of the Dutch masters nor cursory and pungent like Manet's. His simplification of forms and sharp, steady lighting give objects a massive strength and trenchant, full-bodied plasticity. Manet's art taught Cézanne a lesson of concision, and the new vigor he gained by it straightaway lifted him above those who had inspired him. Monticelli could never bring himself to hold back any of his brilliant resources; beside the fierce young Cézanne he seems diffuse, long-winded. It never occurred to Manet to weave his dark contour lines into a coherent rhythm, into grave, majestic harmonies. In Cézanne we feel a romantic longing to infuse inanimate things with a generous breath of life. It is this surge of subjective lyricism that makes Cézanne's masterpieces the crowning and, perhaps, most powerful example of that persistent aspiration of 19th-century painting—to charge still life with obvious poetic effects.

Among those who scrutinized inanimate objects, intent solely on material beauties, there only remain the little masters of the School of Lyons, and they are few in number. The outstanding figure is Antoine Vollon who, living in provincial isolation, engrossed himself in painting rustic kitchen utensils, works in which memories of Chardin and the Dutch masters in the choice of the theme mingled so curiously with the steady gaze and laconic relief of the Spanish masters. No less indebted to the same masters is François Bonvin, more subtle and unctuous in his brushwork than Vollon but expressing himself with an equal freshness. Both men are impassible observers; objects for them are only so many marvelous surfaces; the shadows cast by objects conceal no mystery of any kind. In this respect they join up with Manet. A more isolated figure, Eugène Boudin painted some still lifes (as early as 1849) whose free handling and vibrant atmosphere, like those of his seascapes, point towards the art of Monet ([213a]).

There was, however, one painter well before Manet who boldly purged still life of literary allusions and thereby opened up new, unsuspected horizons. This was Goya, who probably painted his still lifes in the course of the latter part of his career (starting as early as about 1810), well before Géricault. About ten are known to exist at the present time. Most of them represent dead birds, game, meat and fish. *Slices of Salmon* (pl. 79) and *Sheep's Head* (Louvre) number among those which are most important in the history of still life. The composition of these pictures owes nothing to tradition. It is free of any artifice, of any concern for decorative arrangement; it is even free of that instinctive pursuit of harmonious rhythm which makes itself felt in Chardin's still lifes.

Goya seems to have painted these slices of fish and chunks of meat just as he found them, lying at random before him. To vary and stabilize their grouping, he apparently did no more than slant one piece

120

so as to oppose its movement to that of the others. He thus achieved a composition reflecting as it were a sudden glimpse of life and he heightened this effect by a spontaneous technique that made the surface of things pulse and vibrate. The whole spirit of Goya's approach was unprecedented, and did not become widespread till over half a century later, thanks to the Impressionists. Manet's debt to the painter of *Slices of Salmon* is obvious.

But this is not the full extent of Goya's innovations. He broke with tradition in still another way that opened up inexhaustible possibilities. Still life in his hands appeals to our feelings far more directly than it ever had before. It compels an emotional reaction. The only works comparable to it in this respect are Rembrandt's *Flayed Ox* and Géricault's studies of human limbs, which however already follow Goya's still lifes. But the emotional impact of the *Flayed Ox* is attenuated by Rembrandt's concern with textural beauty; the emotional impact of Géricault's studies depends for its effect on the intervention of our imagination, as (almost in spite of ourselves) we bring it to bear on the lingering traces of life discernible in dead flesh. Goya in his *Sheep's Head* resorts to a similar device: the lifeless eye of the animal, blankly staring into the glaucous void of death, seems to address a poignant reproach to human cruelty. But the picture's action on our feelings is not due merely to this romantic idea. These joints of meat, like his slices of salmon, move us to the very depths of our physical being, they pluck the most secret chords of our sensibility. Meat and flesh are painted with all the luster of satin and mother-of-pearl; red with the inimitable hue of fresh blood, they are appetizing and horrifying at the same time. At the sight of these paintings, seemingly so simple, so literal and facile in their realism, we are filled with a vague uneasiness compounded in equal measure of the brute instinct of cannibalism and a civilized sense of mortal terror. These reactions are induced without any reference to the human or humane, such as the pointless gesture of an amputated arm or the blank stare of a dead sheep; they are induced solely by the textural quality of the painting itself, by the almost physiological impact of color and brushwork. What could be more typically Spanish than to strike sharply at our feelings by confronting us with the most ordinary fragment of reality?

Goya, then, painted the first expressionist still life. He drew the final conclusion from Rembrandt's attitude and his new approach inspired Géricault's quite exceptional studies of human limbs. Had he seen them, Van Gogh would certainly have admired Goya's still lifes, which are, moreover, the true ancestors of Soutine's tragic visions of flayed oxen and plucked chickens (pl. 103).

Though it was Goya who opened the century, I have chosen to deal with him after Courbet because of all that he handed down to Manet and the Expressionists. And if I deal with him in this chapter, alongside Géricault and Delacroix, the reason is that, like them, Goya was a lyrical realist eager to express the irresistible forces of nature. Goya, however, unlike them, dispensed with sentimental rhetoric and with the whole battery of external effects of lyricism. In this respect he was the first painter to render something of that modern state of restless anxiety which affects us far more poignantly today than the sonorous pathos of Delacroix's lobsters or the crepuscular splendour of Courbet's apples.

The Impassible Realism of Manet.

About 1860 the influence of the Spanish masters on French painting gave rise to the first still lifes that are purely pictorial, devoid of sentimental associations; by 1875, thanks to Manet and the Impressionists, this conception of still life had triumphed. Only then, as Corot and Courbet passed from the scene and the young Cézanne abandoned the turbulent darkness of his early style, did the old romantic overtones disappear for good from still life.

As we have seen, the School of Lyons, with painters like Bonvin, Vollon and Vernay, was alone in keeping to the sensual colors of the Flemings, and to the intense and sober colors of the Spanish tradition. It was from the latter source that the cool, incisive gaze of Manet deduced a new vision of forms; that is, a new conception of objects and their place in the universe. Although it is difficult to prove that Manet saw Goya's still lifes before going to Spain, his *Dishes of Oysters* of 1862 and 1864 are inconceivable without some knowledge of Goya. Today we are fully aware of the many borrowings, of both motifs and compo-

sition, made from Velazquez and Goya by Manet, a painter lacking in imagination but singularly conscious of both his own vision and his aims as an artist. These borrowings he carefully concealed and assimilated to the substance of his art. Here there is no room for doubt: the Spanish touch is so unmistakable in his still lifes, with their colors set off by pure black, their free and easy grouping, simulating the accidental, that the possibility of coincidence has to be ruled out. From 1866 on, Chardin's influence can also be seen at work, and very distinctly: Manet's *Rabbit* and *Brioche fleurie* (1870) are direct transpositions of the very same themes treated by the older master. But it is characteristic of Manet that in these paintings he follows Chardin to retreat from Goya: his composition is more carefully calculated, the number of objects increased, the modeling of forms richer in texture. Very soon, however, he blended these two streams of influence into a synthesis entirely his own. From 1876 on, direct reminiscences are no longer to be found in his work.

How did he stand then with respect to these illustrious predecessors? What did he make of the lesson he learnt from them? The fact is, he pursued that lesson in a direction that involved spiritual impoverishment. There is nothing left in Manet of the emotional appeal made by Goya's tragic colors; nothing left of the determination to express a keenly, almost painfully felt reality. Nor is there any trace of Chardin's poetic earnestness, of the deep resonance of his dense texture, of the easy rhythm of his layouts. From his great elders Manet retained no more than the theme of everyday objects and the simplicity of their presentation, in which he displayed his modern sense of reality. Modern because conditioned by the aspects of daily life, whose dominant feature, throughout the 19th century, was a constant acceleration of movement. Manet was perhaps the first to feel, in a confused sort of way, that the faster means of traveling afforded by rail and steamship and the surging crowds of the big city called for a corresponding change in the artist's vision, a change involving simplification and abbreviation. How was the artist to express this ceaseless ebb and flow of people and things unless he dominated it by means of a pictorial synthesis? How was he to defend himself against the lassitude and anxiety that come over us in the face of this unstable world? All the successive simplifications of modern painting came in answer to these fundamental questions. As early as 1882 the critic Ernest Chesneau emphasized this struggle of the artist against the fluid appearances of things, when he said: " Manet catches forms in actual movement."

The Impressionists could only follow suit. Since then, after lumping together the sights and scenes of daily life in a welter of colors such as might be seen from the window of a fast-moving train, painting has come to reflect the sudden uprush or dizzy flight of things glimpsed from a speeding automobile; or such effects as those experienced by an aviator, for whom speed and altitude reduce the earth's surface to a mere chain of geometric patterns slowly unfolding in an abstract space.

The compendious vision of Manet thus laid the basis of all the syntheses to come. The powers that enabled him to achieve that vision were, first, his natural genius for painting and, secondly, his ability to record his sensations with an accuracy and economy rare in Western art. The terseness and rapidity of his touch seem to infuse things with a fugitive life of their own. His objects look as if they had been placed on the table at the very moment they meet our eye; we get the impression that we need only turn away for them to change position. This dynamism of Manet's is both his strong and his weak point: it makes him one of the most effective painters of the life around him, but prevents him from rendering the permanent aspects of things. A painter with marvelous gifts, but an artist limited to the highly refined transposition of sensations, he was adept at recording on canvas the translucent sheen of a ham (pl. 86) or the aerial freshness of a bunch of violets (pl. 87) in an image as cool and striking as a *mot d'esprit*. In front of the inanimate object he sets out to paint, he remains totally impassible. His sense relationship with the object is neither intense enough to produce that immediate impact on the spectator which Goya produces, nor tender enough to set him dreaming as Chardin succeeds in doing. In this respect Manet was the first of the great modern artists to reduce the object radically to a patch of color. With him began the definitive dissolution of the old unity of outline and relief, a unity at once optical and tactile, which Courbet had kept intact. Relief with Manet was only optical; the eye alone, owing to the force of associations, gives body and palpability to his forms, and brings home to us the savor and smell of objects. He was the first of the moderns to flatten painting out, the first to bring out its primordial quality as a plane surface covered with colors, and to suggest a certain autonomy of line and color patch; it was Manet who originated " playing-card painting," which nurtured the art of poster design and led inevitably to the abstract flatness-

of Mondrian. It was from his art that painters like Cézanne and Matisse deduced their arabesques. Baudelaire foresaw that Manet's bold departures would have incalculable consequences: "You are only the first in the decrepitude of your art." Cézanne, with his sure and penetrating judgment, simply said: "Our Renaissance dates from *Olympia*."

By the very nature of his vision, Manet was a painter of detached fragments, and still life gave him an opportunity of reducing the composition to a few elements. Before coming under Monet's influence, he isolated his motifs against somber, rather insignificant backgrounds. In this he abided by tradition, linking up with Goya and through him with 17th-century painting. The bright backgrounds of his later still lifes, together with the more intimate contact of the object with the light-drenched atmosphere around it, brought them closer to the impressionist still life. But Manet never quite contrived to blend the object indissolubly with the atmosphere in which it bathes. He never produced a really domestic still life, like those of Chardin. This it was left for the Impressionists to achieve.

From Monet to Bonnard.

Monet and Renoir always saw things in the full flush of broad daylight. They were loyal sons of the French bourgeoisie and heirs of Chardin. They painted what he painted: objects and eatables on a kitchen table (or, more often, a dining-room table), and bouquets standing on a piece of furniture. These they present in interiors, but for them no motif can have any life or value apart from the open air. Their still lifes are evocations of the intimacy of the home. But it is not the intimacy of Corot, which issues from a soft penumbra, nor that of Fantin-Latour's melancholy twilight; it is the smiling peace of a sunny interior. Chardin's kitchens, however well-lit, always smack of the city atmosphere: their parcimonious side-lighting comes from a window that gives on the street. Monet and Renoir flood their *Game*, their *Pies* (pl. 90), their *Flowers* and *Fruit* (pl. 88) with the fresh air of the country. Many of these pictures were actually painted in sunny country houses at Wargemont or Giverny. But always objects are bathed in broad daylight streaming in from all sides. With them, side-lighting and its carefully regulated poetic and plastic effects disappeared from still life. The neutral background also disappeared, except in the occasional form of a light-reflecting wall.

This conception of still life, like their conception of landscape, was peculiar to the Impressionists. Both are a reflection of the bourgeois outlook. The landscapes of the Barbizon painters were designed for the same social class; but theirs sprang from the yearning for escape felt by an urban society not yet seriously oppressed by industrialization and still bound to the country by family ties, still attuned to the rhythm of rustic life, still avid of country pleasures, of hunting and fishing. What their nostalgia called for was nature in the raw, the solitude of moors and forests. The impressionist landscape, on the contrary, is the image of nature tamed: a holiday spot, the beach or the outskirts of a big city; a suburban garden or a village orchard; or open fields whose horizon is almost invariably punctuated by houses. Still life, in Monet's and Renoir's hands, is no less domesticated. Delacroix and Courbet were fond of setting it off with a dramatic landscape background, against which objects, high in color and imperiously salient, took on a heroic resonance. The Impressionists drained still life of every reminiscence of the Flemish and Neapolitan masters, just as they freed landscape from the tutelary shadow of Ruisdael and Hobbema, and from the gilded luminosity of Claude Lorrain.

In contrast with Manet, they reintroduced an analytical rendering of the surfaces of objects. Monet always paid particular attention to the textural effects that served to render the coat and plumage of his *Pheasants* which, by rejuvenating the game pictures of men like Salomon Ruisdael and Jan Fyt, made the insistent impasto of the latter seem almost vulgar. As if the better to relish their rich flaky crust, Monet shows his *Pies* (pl. 90) in bird's-eye perspective, in the manner of a Japanese print; the absence of any gap in the composition is also a Japanese device. The result is that we enter abruptly into close contact with the white table cloth, the freshly baked pies and carafe of wine, which are like symbols of holiday cheer in the family circle. It is as if we were drawn willy-nilly into the picture, and the artist systematically exploits this dynamic suggestion. He builds up the whole composition along a diagonal. By drastically reducing

the scale of the upper wicker tray, he produces an effect of sharp recession. Spontaneous, conspicuous brushstrokes make each pie seem to be whirling round, so that the composition is swept up in a vibratory movement. There is something here of Van Gogh's irresistible dynamism, but nothing of his anguish. For the drawing is less tense, less compelling, and the color, bland and harmonious, does nothing to intensify it, but merely subdues and balances it. Even-tempered as always, Monet was content to impart a single, sparkling motion to the picture.

Nurtured on the traditions of 18th-century French painting, Renoir made no attempt to energize his composition, as Monet did, but carried on the serene simplicity of Chardin. *Peaches and Grapes* (pl. 89) is perhaps his finest, most original still life, yet it is only the transposition of a theme of Chardin's into a register of full luminosity. The main pictorial problem is the play of light over the tinted down of fruit, over the smooth whiteness of crockery and tablecloth. Pale shadows, light as a breath of air, faintly ripple across the tranquil clarity which sets off and perpetuates the perishable jewel of the skin of a ripe fruit. Renoir reconciles extreme discretion with extreme richness, and his full-bodied density is made up, it would seem, of colored air. This is a poetic idiom hitherto unknown in still life, even in those of Chardin. Between these objects and us there floats a luminous haze through which we distinguish them, tenderly united in a subdued shimmer of light.

Still life is thus the only subject, or nearly so, in which the Impressionists, who were essentially landscapists, betray a feeling for closed interiors. Here the femininity of Berthe Morisot excelled, and her *Vases of Flowers*, fragile harmonies tinged with nostalgia for the grays of Corot, subtly combine domestic cosiness and broad daylight. All the painters connected with Impressionism, whether transiently or permanently, gave their still lifes this atmosphere of a snugly enclosed interior.

While still very young, Seurat painted an exquisite *Vase of Flowers* (pl. 95) [214] already marked by his predilection for a stability based on complex jottings and the compensating play of lights and shadows. Already this nook of cool stillness formed part of his grandiose universe, intense and slumberous at once. Here, if I am not mistaken, we have Seurat's only known still life and he shrouds it in shadows; he was one of the last to employ sharply focused lighting. Thus shadows are well defined, and their firm cadence corresponds to the subtle geometry which, in Seurat's eyes, governs the spectacle of life.

Later, in one of the finest of his very rare still lifes (pl. 104), Edouard Vuillard recorded the contacts of light and objects by means of a spontaneous, diversified touch, ranging from solid concretions of pigment to the lightest flickerings of the brush. It would be hard to name another still life with objects equally evocative of the atmosphere of the room in which we find them. There is nothing of this in the Dutch masters or Chardin, for example, whose objects, though radiant with humanity, stand against rather unsuggestive backgrounds. On a small table covered with a white cloth Vuillard places a lemon beside a glass of water with a spoon in it. A piece of furniture, doubtless a bed, juts out on the left; a lighted wall serves as a background. The glass is faintly visible through a pale haze of light; the presence of the spoon is revealed by a cool gleam. These objects somehow conjure up the indefinable, almost Proustian atmosphere of a sick-room, analytically evoking as they do a fleeting moment, a stray beam of light, an evanescent melancholy—an analysis at once sensitive and incisive, tender and eager.

Art historians are fond of citing Bonnard as the last of the Impressionists. But this is only a half-truth, for he tackled a problem fundamental for his generation, which was, in point of fact, in reaction against the Impressionists: namely, how to paint objects in a flood of light not with colors appropriate to nature (this was a commonplace of Impressionism), but with colors totally free of all convention, poetically arbitrary colors justified solely by an inner vision. With their quiet glow of domestic well-being, however, Bonnard's works carry on the calm tradition of Monet and Renoir. His still lifes too were assortments of fruit on tables or in cupboards (pl. 105) exposed to the sun. But his infidelity to the literal-minded naturalism of the Impressionists gives them an air of strange enchantment. His objects are pervaded by light and heat. The rays of the sun seem to melt down his fruit to a colored essence of their pulp and savor—his interiors are fragrant with it.

Bonnard cannot conceive of inanimate objects without a setting of domestic intimacy. He reinvented the oldest still life themes: the antique *xenion* shown in a cupboard (pls. 105 and 2) and the medieval niche and larder (pls. 10 and 14). Even when he opens a window and presents objects as if they were out

of doors, he only does so in order to emphasize how closely they belong to the world of man. For the whole generation of artists who were breaking away from Impressionism, the theme of the interior centered on still life. So it was for Matisse, for example, whose *Desserte* (formerly Edward G. Robinson Collection, now Niarchos Collection) is the masterpiece of his early manner.

What, in the last analysis, was the attitude of the Impressionists towards still life? Engrossed as they were in landscape, it mattered little to them. Nevertheless the still lifes they painted are characterized by so marked, so coherent an esthetic that they represent a new conception of the subject. They banished every trace of sentimental allusion and—only after Manet, however—sought for a poetry of the senses. They made it a theme of unruffled reverie in sunlight. Deprived of its dense relief by an all-pervading clarity, rendered virtually weightless by transparencies and gleams of light, the object lost a good part of its corporal presence and prestige. It offered up its colored surface to the painter's eye. It remained the skin of a peach or a grape, but at the same time it frankly became one color patch among other color patches in the picture. Thereupon a new prospect was opened up: the object came to be regarded chiefly for its pictorial aspect and became an essential element of the composition.

Cézanne.

When Cézanne came in contact with the Impressionists, he was struck by their bright color schemes. Till then he had had a pronounced liking for dark, strongly contrasted colors; his vision had been formed by the study of the Old Masters, of prints, of Manet's works. From Pissarro he picked up the fundamentals of the impressionist esthetic: subjects (landscapes, still lifes, the human figure) taken straight from reality, and modeling by tones with a view to rendering bright sunlight, which eliminates chiaroscuro. He enthusiastically adopted this attitude to painting; by orienting him towards the analytical study of nature, it henceforth spared him the goading torments of his unbridled imagination, from which he had suffered so long. He considered himself as one of the Impressionists and exhibited with them; it is safe to say that, to the very end, he never lost the sense of belonging to the movement which had come as a revelation to him in his youth. To Lionello Venturi, in his fundamental study of the artist and his work, goes the credit for exploding the fallacy that Cézanne set himself up as an adversary of Impressionism and as the conscious initiator of a new classicism. As is obvious from his letters and paintings, Cézanne's only aspiration, which he pursued with the simplicity and single-mindedness that belong only to great creative artists, was to experience nature as keenly and deeply as possible and to render his sensations to the best of his ability. Now if ever there was an art doctrine that advocated just this, it was the doctrine of the Impressionists. To them again Cézanne owed a notion pregnant with consequences for modern art: that color, while expressing nature in terms of the artist's own sensations, becomes on canvas a harmony valid in its own right. The vibrancy of their brushwork and the harmony of their colors confer in fact on the paintings of the Impressionists an infinitely greater unity than the cohesion of balanced contrasts which we find in the paintings of the Old Masters and even of Manet.

But that unity failed to satisfy Cézanne. It conveyed the shimmering envelope of sunlight covering bodies, but nothing of their palpable density, their resistance to air suffused with light, their concrete presence. Of all this Cézanne was intensely aware; he aimed not only at a harmony of colors but at a harmony of volumes and rhythms perceived in nature. The Impressionists surrendered themselves to the motif, which they recorded with all the keenness of their sensibility, but without letting their imagination come into play. Cézanne, by the very essence of his way of seeing, was a man of imagination. He was incapable of merely transcribing nature uninventively. This is why, not only before his contact with Impressionism but throughout his career, he never ceased to devise imaginary compositions, whereas Pissarro, Monet and Sisley never did anything of the kind and Renoir only succeeded in doing so after many years.

This need to invent, even when working directly from nature, is perceptible in Cézanne as soon as he had assimilated the rudiments of the impressionist technique and esthetic. Already in 1873-1874 his *Hanged Man's House* differs considerably from contemporary pictures by the Impressionists: the composition is clearly marked and we feel the deliberate intervention of the artist's imagination in the pursuit

of a certain rhythm resulting from the opposition of masses. Cézanne's vision, as Pierre Francastel says, was always fundamentally distinct from that of the Impressionists. Like them, he held that the visual sensations conveyed by nature were the basis of the pictorial creation, but his sensations were more complex than theirs. They involved that craving for orderly structure which is reflected as early as 1870 in his *Black Clock* (pl. 92), and which underlay all his future researches.

The Hanged Man's House is remarkable for its opulent texture, whose resemblance to that of Chardin was noted by Tristan Klingsor and Paul Jamot. At the same period, in Dr. Gachet's house at Auvers-sur-Oise, Cézanne painted several still lifes marked by the same thickly clotted, enamel-like texture. One of them represents no more than a cup, a glass and a few pieces of fruit on a table ([215]) and closely resembles Chardin's *Silver Goblet* (La Caze Collection, Louvre) ([216]), both in the choice of objects and their arrangement. The latter, with its unusually bold and colorful handling, is one of Chardin's most " modern " pictures. In another still life, *Pitcher and Tomatoes*, painted in 1873, perhaps a few months before *The Hanged Man's House* (which was exhibited the following year), Cézanne employs the same texture and adds a knife that juts out over the edge of the table. It has been said that he borrowed this device for suggesting depth from Manet, but Manet himself merely took it over from Chardin. The possibility thus arises that, anyhow in *Pitcher and Tomatoes*, Cézanne was drawing inspiration directly from Chardin. Now the La Caze Collection entered the Louvre only a few years previously, in 1869. It included twelve still lifes by Chardin which attracted a good deal of attention at the time. Forthwith, in 1870, appeared Manet's *Brioche fleurie et pommes*, obviously inspired by Chardin's *Brioche fleurie* in the La Caze Collection. Very possibly, it seems to me, the origin of Cézanne's new textural richness from about 1870 on is to be sought for in a study of Chardin, at the Louvre. By this time he was looking for no more than pointers from the Old Masters, for he was now bent on painting exclusively from nature. Nevertheless he continued to visit the Louvre and up to about 1877 the spirit of Chardin hovers over certain of his still lifes.

We are therefore entitled to wonder whether the experiments Cézanne was prompted to make in the field of still life may not have been profitable to him in treating other subjects. Although between 1872 and 1877, like the other Impressionists, he concentrated on landscape painting, his structural aspirations are reflected more conspicuously in his still lifes. As we have seen, moreover, his *Black Clock* stands out as the most successful, the most balanced, and also the most powerful work of his early period.

Generally speaking, there is no overestimating the importance of his still lifes in Cézanne's work. It has been said that after he went back to Aix, after 1882, that is, the geological structure of Provence led him to emphasize the rhythms of volumes which some are pleased to describe as " cubist." This is true as far as it goes. But it was only the development of a tendency that had made itself felt earlier, between 1879 and 1882, in Paris and the environs of Paris. In those years Cézanne painted some admirable still lifes whose composition is governed by a rhythm which, if not " cubist " (so called in the jargon of modern art criticism), is anyhow very clearly marked: for example, a whole series of canvases with a white fruit dish, gleaming fruit and a white napkin arbitrarily folded over. One of the finest of these paintings, by virtue of its sobriety and apparent freedom of composition, is *Still Life with Red Apples* (pl. 93). The arrangement here is simplicity itself and the composition is not even closed off: the plate of biscuits on the right is cut down the middle by the picture frame. This picture radiates an easy freedom, a gracefulness, a delight in color and rhythm that bring to mind the music of Mozart.

All his life Cézanne painted still lifes and they reflect every line of research that he pursued. When, after 1895, he slowly made his way towards a more restless art, reverting in some respects to the romantic aspirations of his youth, his still lifes gained immensely in richness and a note of pathos crept into their arrangement. Thus, in *Pink Onions* (pl. 94), sinuous lines determine and combine the contours of the table, the bottle and the onions. A secret motion lifts the white cloth and sends it sliding off the table in a slow cascade. To the sharp, almost painful rhythm of lines corresponds a color scheme of pale blues and pinks, seemingly numb with cold, a harmony of sadness and disenchantment. It was about this time that Cézanne painted several pictures of *Skulls* (fig. 38), either alone or in conjunction with a still life. Since he also painted a picture of a young man brooding over a skull, there is no mistaking his intention: already he was haunted by thoughts of death and these are allegories contrasting life, as symbolized by fruit or sumptuous carpets, with the ineluctable doom towards which all life flows—these are *Vanitas* pictures. Their meaning and iconography are essentially traditional, except for the fact that Cézanne

went on to increase the number of skulls in a single composition (²¹⁷). He must have seen such pictures in the museums and been impressed by them; he gave his own death's heads a compelling emotional appeal.

Cézanne's still lifes are distinguishable from those of the Impressionists not by any fundamental difference of conception, but by the style and feeling for nature embodied in them. His still lifes, like theirs, are set in an interior and display the same objects: the plain table service of the bourgeois home and ordinary fruit; perhaps even more ordinary than the fruit chosen by Renoir. Cézanne never attempted to paint the traditional still life theme *par excellence*, dead game, which often attracted Monet.

On the other hand, he made his compositions much more complex. Fruit and dishes are often accompanied by napkins and rugs. One cannot help feeling that Cézanne was guided by memories of Chardin and the Dutch masters when, before painting his objects, he crumpled up a white napkin and left it hanging over the edge of the table. There is something too of the southern temperament in this abundance, and perhaps a reminiscence of Monticelli's rugs. But even then Cézanne was able to achieve the same noble order as when he painted no more than three apples side by side.

Behind his tables laden with objects Cézanne often places not a bare or patterned vertical background, but a piece of furniture or even the furnishings of a whole corner of a room, which is rare in the impressionist still life. We are conscious that he does so methodically. His aim is not to suggest an atmosphere of domestic intimacy, but to create a dynamic ambience, to give movement and life to the picture space. At the same time he seizes the opportunity of studying problems of perspective, which he evokes both by linear indications and by judiciously chosen tones defining planes in aerial recession.

What is the exact contribution of these still lifes, the finest any painter has given us since Chardin ? They are, first of all, an unimpeachable token of Cézanne's profound originality. Here, perhaps more often than in his landscapes, he " realized " his picture; by that, as Venturi has shown, he meant that he had succeeded in expressing, in terms of a certain plastic order, the sensations kindled within him by nature—an order discerned in nature herself but brought out and defined by his own imaginative temperament. Few, indeed, are the still lifes by Cézanne which fail to give the impression of an eagerly pursued equilibrium between the sense of life and the sense of a monumental grandeur peculiar to art alone.

Here a question arises that must be answered if Cézanne's art is to be rightly understood: what part did still life play in his art with respect to other subjects? It has often been said that he treated it as a testing ground. This is quite true, for while he regarded every subject as a plastic problem requiring solution, the painting of inanimate objects, as I have mentioned above, smoothed the difficulties of the problem in many ways which made him partial to it. But does this mean that he did not paint still lifes for their own sake, that these apples and jugs were no more for him than forms whose volume and color had to be rendered, whose relationships had to be worked out ? Critics hold conflicting views on the subject. Some maintain that Cézanne regarded his still lifes as " guinea pigs." Others see them as receptacles into which he poured some vaguely definable mystical emotions inspired by the sight of humble objects. Still others attribute both attitudes to him, as if their simultaneous co-existence were altogether natural and easy to understand. We should have to agree first of all on the meaning of mysticism in art. Is the artist concerned, through the respectful representation of an object, with illustrating the idea that that object is inhabited by the divine spirit ? In spite of Cézanne's religious convictions, which seem to have been deep-seated, it remains to be proved that he held any such ideas amid the prevailing positivism of his day. Was his faith the humble, quasi-mystical piety of the artist who effaces himself before the object in order to render it in all its integrity ? Such a definition of Cézanne's attitude might be accepted, but it is by no means an unusual attitude. Renoir's peaches and Monet's flowers, anyhow up to about 1890, are painted no less lovingly than Cézanne's apples; they are certainly respected to the same extent, if not in their density, at least in their surface texture, which Cézanne evokes rather summarily.

Another affirmation has been put forward, though it is not only vague but quite unfounded. It would have us believe that Cézanne ended up with " Platonic ideas " of objects rather than the representation of objects themselves. All of us are entitled to read what we like into a picture; after all, the life of a painting lies in the emotions and ideas it inspires. Cézanne's apples, each reduced as it were to its essential form and color, may be regarded as figures of ideal apples. But such was certainly not Cézanne's intention. And to convince ourselves that it was not, we have only to read his letters and, above all, to

look at the apples he painted. That he meant them to be very real, realer than those of the Impressionists, is self-evident; he meant them to be—and they are—imbued with volume and weight in addition to their resplendent soundness—that of good eating apples—under their robe of color. The fact of rounding their contours and unifying their color to obtain a uniform rhythm, an overall order, takes away nothing of the realism of this fruit, no doubt the most intense that Cézanne was capable of conceiving. It is precisely this that is moving and grandiose in Cézanne: this passion for sustaining his sensations at their original intensity and keeping them intact in spite of his striving for harmony, a striving which, in his finished pictures, is never allowed to render objects abstract.

Nearly all Cézanne's still lifes are finished pictures; the proportion of still life studies to finished still lifes is infinitesimal. Such is not the case with landscape and figure paintings. This fact alone might have served as a warning to critics that Cézanne did not treat his still lifes as mere " guinea pigs." On the contrary, calm and collected in front of this subject, which he found more easily assimilable than others because he could organize it before painting it, Cézanne more often " realized " his picture, down to the last stroke of the brush. It has been very plausibly suggested by Paul Jamot that if Cézanne seldom painted flowers, this was because they wither so rapidly. The slightest change in the model annoyed him intensely and those who sat to him for their portraits were required to maintain the strictest silence and immobility. Cézanne painted flowers chiefly during the period of his contact with the Impressionists: twelve bouquets in five years, from 1872 to 1877, only two of which are unfinished. Between 1879 and 1887, in eight years, he painted only nine, three of which are unfinished or were cut down by the artist himself. Between 1890 and 1906, in sixteen years, he painted only six bouquets, two of which are unfinished, while another, significantly enough, is a copy after Delacroix, which may be taken as bearing out both the interest he felt in the subject and the aversion he felt for treating it directly. The more his " meditations brush in hand " slowed down his execution, the fewer flower pieces he painted, and the fewer of these he finished.

By embodying his complex researches in his still lifes, of which an unusually high proportion are masterpieces, Cézanne gave this theme an importance which had never attached to it before in the whole history of painting. From Caravaggio and Zurbaran to Goya and Manet the great masters no longer ignored it; in Chardin it even found a specialist who compelled unanimous respect and established himself as a master. Manet and the Impressionists painted still lifes, but not very many of them. With Cézanne, however, still life ceased to be a side line in the career of a great artist; it vied with landscape painting and took precedence of portraiture. This was the definitive emancipation of a subject hitherto neglected, which at last took its place on an equal footing with other subjects. In the 20th century the inanimate object has cast its spell over many artists, notably the Cubists and Surrealists, with an insistence that would have been inconceivable in the past.

It has even been claimed that a so-called " still life spirit " has come over modern painting since Cézanne, impressing on both landscape and the human figure an impassiveness and immobility peculiar to still life. That modern painting has assumed such an aspect is undeniable, but it springs from neither the increased practice of still life nor its predominance in the painter's vision. It is the result, in still life as in all other subjects, of a new attitude towards the world and life: to defend himself against the pressure of the crowd and the tyranny of the machine, the artist has had to stand back from the world, like a wrestler stepping back to a better position from which to assail his opponent. Like him, the artist chooses his own ground from which to grapple with the problem of reducing the passing show of life to a plastic system, and the tension of his efforts strips his faces and trees of any immediate quiver of life. Still life too, moreover, has gone the same way: if the human figure has been dehumanized, the object has been dematerialized and has become no more than a ghostly presence.

Gauguin.

The art of Cézanne has focused attention on a fundamental truth which, preoccupied as they were with naturalism, painters had lost sight of for centuries: that each brushstroke, while contributing to build up images of natural things, also belongs to the picture surface, which it fills up in a certain manner; and that each brushstroke forms part of a certain order of lines and colors. Cézanne brought that order

conspicuously into play. Not that he sought it for its own sake. It was simply an embodiment of the eurhythmy which he felt in a " motif "; but the motif, be it remembered, is what prompts us to act, and Cézanne chose a scene of nature with care, his choice being guided by a cohesion which he discerned in it and which he called " decorative." With him the concordance of contours and colored volumes never resulted in a plastic system valid in its own right, independently of nature. It issued from the lucid control exercised by his mind over his hand, without, however, making him an intellectual painter. Cézanne would have deemed an intellectual attitude as unsound as the spontaneous transcription of sensations, to which the Impressionism of Monet confined itself. He would never have concurred in separating the plastic order of his canvas from the order of nature which, in his eyes, it faithfully expressed; in a word, he would have been unwilling to consider that plastic order for its own sake. So it came to be considered, however, by those who followed him, and they were encouraged to do so by the unwitting example of Cézanne himself.

The first to take inspiration from Cézanne were Emile Bernard and Gauguin, who made much of the lessons they gleaned from his art, though they deflected it from its original meaning. Their art in fact is inconceivable without his. It was by his conscious style that Cézanne struck them, for the pursuit of style was unappreciated by the Impressionists. Bernard and Gauguin realized all the power of subjective suggestion that might be elicited from this deliberate pictorial language. René Huyghe has brilliantly defined this particular period, around 1885, when a profound reaction against naturalism was reinstating spiritual values in art and literature. Yet, to assert the will to style not in order to interpret nature in terms of the sensations it produced, but with a view to conveying ideas and feelings, was tantamount to replacing style by stylization. Bernard and Gauguin launched a movement which aimed at simplifying form and color, at emphasizing the musical power of line; what they called " synthetism " rapidly turned into symbolism. Bernard described his *Still Life with Earthenware Pot and Apples* (pl. 96), dating to 1887, as " the first attempt at synthetism and simplification." Van Gogh would have found this work to his liking, with its fine, compact texture, its vigorous, unified color scheme, its well-marked contour lines. He would have seen in it " something willful and very wise, something fixed, firm and self-reliant." This picture and those of Gauguin painted shortly afterwards make good a highly subjective mastery of nature. But Bernard had no eye for the mysterious side of nature, which for him remained essentially a repertory of forms to be pondered on and dominated.

Gauguin, on the contrary, was never indifferent to the poetic overtones of a formal innovation, indeed he was invariably stimulated by them. He started off with what might be described as a plastic emotion, which is the quality communicated by a line or a color as it dimly impinges on the mind's eye. He thus broke off that direct connection, essentially sensorial though filtered by the mind, which Cézanne had maintained with the visible world. He painted not directly from nature but " apropos " of nature. Always present to his mind, as he looked at her, were all the great style-creating arts, from those of Egypt and India onwards, as well as the massive simplifications of Polynesian carving, a whole conception of art utterly foreign to the Greco-Latin tradition. Gauguin's art moves on a plane running parallel to the plane of reality. In this he differed from Van Gogh who, in his eagerness to unbosom himself, though he also distorted the world, only did so because he seized it in too fierce an embrace.

Gauguin's still lifes show his debt to Cézanne more clearly than do his other pictures. In the first place, they keep very closely to those of the Aix master, for it was he who liberated Gauguin from Impressionism, as we see in a painting offered to the singer Faure ([218]) in 1884; here, in addition to a vibrant rendering of surface effects, there appears a sense of palpable volume conveyed by a Cézannesque brushstroke. Two years later this influence was even more pronounced, more thorough, and thanks to it Gauguin attained a flawless unity of the picture surface. As late as 1890 he acknowledged this filiation by reproducing a still life by Cézanne in the background of his *Portrait of Marie Henry* (Art Institute of Chicago). Yet, by 1888, his synthetic simplifications had led him in quest of arabesques whose expressive, purely rhythmic value prevailed over the interpretation of nature. From then on, inanimate objects became for Gauguin a plastic theme and a poetic theme. Whether we turn to the *Still Life with Three Puppies* painted in Brittany in 1888 or the *Exotic Fruit* in Oslo Museum and *Vase of Sunflowers*, both painted in Tahiti, we find the composition dominated by interrelated patterns of curves and straight lines, reminiscent of Japanese prints. To this idiom Gauguin added intimations of an ambience which obsessed

him, and which, for him, was fraught with mysterious relationships between colors, sounds and odors: the " dull, muffled, mighty resonance " which he sought for in painting and which he heard " when his clogs struck the granitic soil of Brittany " ; the heady fragrance and luscious bloom of flowers under the inscrutable gaze of Polynesian idols.

It is curious to note how Gauguin's expressive stylization led him to unify objects and figures in an even rhythm suggesting the homogeneity of the forces that animate the world. The founder of symbolic mannerism, Gauguin, in his conception of still life accompanied by figures, resembles the 16th-century Mannerists, Pieter Aertsen for example. This, however, was a mere coincidence of art tendencies. His *Tahitian Meal*, also known as *The Bananas* (pl. 97), intimately links the three children with the inanimate objects on the table, and aims at a dynamic, monumental effect. The modeling and contours of fruit and faces abide by the same cadence; the swelling forms of bowl and fruit seem to move forward and over-flow the picture plane; the plunging perspective, borrowed from Japanese prints, draws us into the picture and subjects us to the forces of the world created by the painter. If Gauguin falls in line with the artists of the remote past, perhaps the reason is that he strove to bring painting back to its essential pro-blems. He renewed the artist's vision and opened up horizons which the art of our time was to explore thoroughly over a long period. The bananas on the table of the *Tahitian Meal*, uniformly red and drawn with the utmost concision, evoke the essential form and color of this fruit, but above all else they evoke its thick-set, elementary vitality. Deep shadows indicate a sharply focused source of light, diametrically opposed to the diffuse lighting of the Impressionists who ruled out every hint of chiaroscuro. But while they convey the strong sunlight of the tropics, these colored shadows also constitute well-defined forms welded to the objects that cast them. Together with those objects they form islets or landmarks in space; at the same time they represent an essential rhythmic element in the flat composition of the canvas. They paved the way for the firm arabesques of Matisse and the marquetry of Braque, made up of shadows and bodies of equal intensity.

Gauguin's last still lifes, those he painted at Atuana about 1902, present something of a problem, harking back as they do to the earlier works of his impressionist period (*e.g. Table with Dead Parrots*, Pushkin Museum, Moscow) ([218a]). The motif of the table laden with fruit, flowers and game, the realistic composition in which the linear arabesque is now no more than a discreet presence, above all the vibrant, lashing brushstroke—all this suggests that Gauguin was looking back to the early days when he got his start under the guidance of Pissarro and Monet. These still lifes perhaps account for the fact that the *Breton Village under Snow* (an early canvas which he had preserved for old times' sake, or on which he had recently resumed work) was found on his easel the day he died.

Gauguin's dual aspiration, to express a deeply felt poetry and to devise a plastic order capable of conveying this message, promptly imposed itself upon the art of the early 20th century. A group of artists shaped at Pont-Aven formed the symbolist movement properly so called. But what for Gauguin was intui-tion kindled to lucidity and exteriorized with superior pictorial powers, became for them a program and took a literary, illustrative turn. The weakness of this art soon made itself obvious. So that Gauguin's most vital legacy consisted in focusing the attention of painters on problems of form.

In a short time there sprang up a kind of cult of the picture surface. Theorists and painters so much absorbed themselves in it that they came to regard it as the artist's prime concern. They almost went so far as to consider it for its own sake, as if the picture surface could really be distinguished from the image which it serves to support. The organization of color patches, of lines and volumes, to which Gauguin devoted so much of his energies, exercised a fascination over many painters. But Gauguin distorted nature only in so far as he was driven to it by his hankering after expression and his urgent need of harmony. Cézanne distorted it even less. The volcanic Van Gogh himself, while he gave nature a buffeting, did so not to shake it to pieces, but to impart a fresh significance to its image. After these three great painters, the last two of whom were no doubt what we call geniuses, the time was ripe for subduing reality once and for all by bending it to a plastic order conceived for its own sake, like a musical theme. Thereupon the image of nature was dislocated; it fell apart and lent itself to the most arbitrary interpretations. Here was the greatest revolution known to Western painting since Merovingian times, when the ornamental esthetic of barbarian art replaced the Hellenistic and Byzantine tradition of naturalism.

Cubism.

Instead of taking a century, this sweeping change was brought about by the lucid efforts of a single generation, moved by an admirable boldness, by a determination to go back to the very sources of the creative act, by a consuming desire to discover new forms outside the accumulated conventions of centuries. A liberation of such scope could not but bear fruit. But being so highly conscious of its novelty, this attitude ran the risk of lapsing into a system of novelties, a pursuit of purely formal discoveries unquickened by contact with life. With nature subordinated to imagination as the artist's prime resource, painting stood on the brink of an arbitrary mannerism, not unlike that of the 16th century. Only great artists responsive to nature and life could safeguard the emotive potential of the new language. They did not fail to appear. One of them, Picasso, displayed a power of plastic and poetic imagination which ranks him beside Cézanne and Van Gogh.

The influence of Cézanne, Gauguin and Seurat, combined with that of the primitive arts, helped a whole group of painters to renew our vision of the world, and to renew it radically. By way of plastic harmonies and interplays of lines, volumes and colors, they discerned and conveyed the workings of vital forces. On the one hand Matisse created a highly original art of colored arabesques; on the other, Picasso and Braque took to modeling a face or a body, a tree-trunk or an earthenware bowl, by geometric facets and surrounded them with colored planes overlapping and dovetailing, which suggested the three dimensions of a volume and the infinity of atmospheric space. The latter two launched a movement christened " cubism," which made much of still life. For Picasso, Braque and Derain this theme rapidly became an all-important field of investigation and experiment; it thereby gained a new nobility.

In an art which imposed on nature a plastic order conceived *a priori*, the image of inanimate things lent itself readily to geometric distortions. After all, most of the objects around us are manufactured objects and assume calculated or abstract forms. The regular, symmetrical volume of a guitar or a bottle, partially deprived of its conventional aspect, was easy to reconstitute in the imagination. Among Picasso's and Braque's first cubist pictures, of about 1907-1908, still lifes are more numerous than landscapes, and they are often made up of manufactured objects. When Roger de La Fresnaye later approximated to the cubist way of seeing, he chose objects with simple forms—a pot, a book, a cardboard box (pl. 114)—and kept their silhouettes and volumes intact; these purified forms he immersed in a harmony of mellow, deep-toned colors, harboring bright gleams and blurred reflections. The inventors of Cubism, however, went further. " Several aspects of one and the same object are brought together on a single canvas, so that the object is presented broken up, displayed from all sides, turned inside out, somewhat as children conceive it, not as it is seen, but as it is thought of, as it exists in itself and in our minds " (Jean Leymarie). Not only the forms of objects but air, light and shadows too become in their hands so many surfaces broken up into facets, so many mineral concretions bristling with crystalline proliferations. Recognizable only by tell-tale fragments of their usual selves, objects emerge mysteriously from these tumultuous yet perfectly stable accumulations of forms, into which they seem about to sink out of sight, like snow-capped peaks among cloud banks. The Impressionists suggested the continuity of the world in a light-filled atmosphere; they steeped themselves in a feeling of pantheism by the intermediary of the senses. The Cubists discovered the same unity, but of a deeper, more secret order, a unity in which the eye informed the mind of well-nigh cosmic correspondences between all forms and between forms and space. " *Picasso ne fait pas de trompe-l'œil, il fait du trompe-l'esprit*," says Jean Cocteau. This uprooted the illusionism practised in Europe since Van Eyck and the Quattrocento Italian masters, and replaced visual space by an allusive space.

In the initial phase of Cubism, the artist began with a subjective interpretation, to achieve in the end an impersonal, hieratic stylization of forms. Inanimate objects, perhaps more than any other theme, benefited by this new grandeur of style.

It is curious to note that in a short time there grew up a whole new repertory of still life motifs, a cubist iconography. Partial to music, Braque painted musical instruments, notes, and clefs from 1908 on. These have never lost their fascination for him, and Juan Gris smilingly remarked that in the guitar Braque had found a new Madonna. Soon other objects were cropping up regularly: bottles, glasses, pipes, tobacco, playing cards, newspapers, sometimes fruit—grapes displaying their perfect roundness—

shown as often as not on a table. Some critics have read a symbolic meaning into this stock repertory. It is safe to assume, however, that these familiar objects, such as the Parisian artist sees around him in his studio and in cafés, simply serve the purpose of radiating a glow of human warmth in the austere labyrinth of the cubist structures; they offer, furthermore, the great advantage of being readily identifiable beneath the analytical breaking up of their conventional forms. And if the painter makes no attempt to vary his objects, the reason is, precisely enough, that they are devoid of intellectual significance and are no more to him than combinations of forms.

Up to 1911-1912, Picasso and Braque worked side by side in an intimate give-and-take of ideas which made their works look very much alike. By then, tiring of monochromy and abstraction, they had introduced color and palpable reality into their canvases. They introduced in fact a reality either materially present or imitated in *trompe-l'œil*. They mixed various materials into their oil paints; on or round the painted portions of the canvas they pasted colored paper, strips of newspaper and wallpaper, cork and oilcloth. Juan Gris, enthusiastic theorist of Cubism, closely followed them in this practice, and in doing so displayed a rich sense of pictorial properties. Round witty, evanescent evocations of a bottle, a basket of grapes, a glass, a pipe, he pasted strips of wallpaper, simulated the veining of marble, figured a pack of tobacco on which he pasted a real printed label (pl. 118). In the general harmony, full of unexpect- ed effects, the fine colors and strong contrasts of values provided by these new materials play an essential role. So after detaching painting from the imitation of reality, the leading Cubists—unwilling to commit themselves to servitude of any kind, not even to the abstractions which they set so much store by—para- doxically varied their highly stylized compositions with elements which, while introducing a charming note of mystification, in no way impaired the plastic harmony of their pictures. This was not the first time in the history of European painting that effects of tangible relief and even objects had been added to the purely pictorial texture: in Spanish and Venetian pictures of the late 15th century we sometimes find figures holding enormous real keys in their hands; or saints whose clothes and haloes have all the ponderous relief of gilt stuccowork. But, as Alfred H. Barr observes, the idea of making pictures out of the bottoms of wastepaper baskets undermined the academic dignity of painting and the traditional virtuosity of oil painting. The vogue of *papiers collés*, however, did not last beyond 1914.

The painter who remained most faithful to Cubism in the long run was Juan Gris, and he raised it to the level of a classical equilibrium. In his quest for the absolute, so characteristically Spanish, Gris was franker than Picasso and Braque in admitting the intellectualism of the cubist movement, which drew the extreme conclusions logically inherent in the anti-impressionist attitude of Cézanne and Gauguin. Over half of the entire body of his work is devoted to still life. Objects are interlocked by the most unexpected combinations and fusions, ceaselessly renewed, of their surfaces, volumes and contours. The miraculously permeable mass of the most opaque bodies is seen to contain other bodies whose silhouette goes to form still other objects which suddenly emerge in all their conventional integrity. Gris was a master of transformations whose key never eludes us, for seldom has a more limpid, more crystalline geometry been enlisted in the service of so free and fertile an imagination. Painting for him was " a sort of flat, colored architecture " (pl. 121). His esthetic was " based on the mind." Yet he felt that " you can very well make use of Chardin's means without taking over either the look of his painting or his notion of reality. Those who believe in abstract painting remind me of weavers setting out to produce fabrics with thread running in a single direction, without the cross-threads that connect them. Without plastic intentions how are you going to limit and connect representational liberties ? And without some concern for reality how are you going to limit and connect plastic liberties ? " Adept as he is at theoretical considerations, Gris conveys in a few words the extent to which Cubism differs from abstract art and shows how much its " classicism," striking a balance between the disciplines of the mind and the claims of the senses, owed to the fact that it never broke the link with reality.

The retention of this link and the position of the Cubists with respect to nature, these are the factors governing the different phases of Cubism. We have seen the scaffolding of monochrome facets suddenly superseded by the use of *collages* and their physical realism. Neither Picasso nor Braque ever denied Cocteau's statement to the effect that modern painters seek inspiration in natural objects only to metamorphose them into pure painting, but without draining them of their realist vigor, for reality alone, even though carefully concealed, has the power of arousing emotion.

Since the First World War each of these two great painters has gone his own way, and the temperament of each has asserted itself more and more forcibly. Braque has shown greater steadiness in his tendencies and tastes. Picasso's restless genius has led him to tackle the most highly varied aspects of the world, working with a superb freedom of action which delivers him from the greatest threat that can hang over a creative artist: the crystallization of one of his own innovations into a convention.

Still life bulks large in the work of both men; indeed it represents three-quarters of Braque's entire output. Both painters have expressed the whole range of their sensory contacts with the world in terms of still life: sometimes in serene and exquisite harmonies (pls. 116 and 119), sometimes in contrasted and dramatic groupings of forms (pls. 115 and 120).

Between 1924 and 1926 Picasso turned out a series of large, brightly colored still lifes organized around well-marked linear patterns (pl. 119). Volumes flattened into surfaces; depth rendered solely by colored planes dovetailing into one another or overlapping; the scene to be represented shown from several points of view; objects decomposed and reconstituted in terms of plastic harmonies—all these characteristic traits of Cubism were now brought to their " classical " maturity. This was the triumph of a lordly art no longer directly dependent on conventional nature either for form, color, spatial illusion or the physical properties of painting; an art that sets out to be truly parallel to nature.

The extent, however, to which Picasso's vision sinks its roots in reality, just as Cocteau said, is nowhere more clearly shown than in the *Bull's Skull* (pl. 120). This picture was painted in 1942 a few days after the death of the sculptor Julio Gonzales, a close friend of Picasso's. It is an unforgettable funeral oration and a kind of *Vanitas* in which the traditional death's head has been replaced by an animal's skull. Blacks, violets, greens and blues form a grandiose harmony of cool tones, out of which the icy whiteness of the bones flashes and glows. This cruel, bristling skull, built up as much with empty as with full spaces, is an admirable creation, a summing up of Picasso's genius, of his faculty of evoking life by a wholly new and amazing interpretation of forms. There is as much suggestive power here as in Gauguin's most ambitiously " symbolist " pictures. In front of this impenetrable window, amid these harsh triangular shadows, with the image of death within hand's reach, we feel something of the bleak oppression, the hopelessness and dread of the war years in France.

More steadfast and subtle in his pursuit not only of the plenitude but also the fragility of objects, more direct and matter-of-fact in evoking the sensual blandishments of material things, Braque has no less forcibly renewed our perception of inanimate objects. Such a picture as *Still Life with a Tobacco Jar* (pl. 115), all in tones of clay and stoneware, brings us face to face with a surprising unity. Our hand is about to glide smoothly over the enamel of the vase and the shells of the walnuts, while our eye discerns intimate relationships between the gleams of a glass, though opaque, and the density of a jar, though weightless. We find ourselves moving easily in a world of familiar objects that have become enigmatic. We overlook the extraordinary liberties which the painter has taken with all the elements of our traditional way of seeing. For what he has done is to separate the old married couple light-and-shade, hitherto united by the logic of the lighting. He handles patches of light and patches of shade as if they were earthenware tiles; he cuts them out, adjusts them and fits them into the mosaic of his composition. Braque's shadows are like inky liquids, they flow round forms and patches of light. He exercises unlimited power over shadows. He can turn them into a plastic theme fraught with the most paradoxical wizardry: dark, impenetrable shadows, in his hands, can fill a glass and yet leave it weightless and transparent. The art of Picasso and Braque breathes a boundless freedom, proud and joyful. Not only does their art confer on the object an inexhaustible power of metamorphosis but, far from crippling it by dissection, invests it with a monumentality that it had not enjoyed since Caravaggio, Cotán, Zurbaran and Chardin. The number of Spanish names to be found among the forebears of the great modern still life painters is hardly surprising in a branch of painting in which Picasso and Juan Gris excel. But it was only after Cézanne had prepared the way that the Cubists invested still life with this new grandeur by making the object share in a hieratic nobility of harmonies that are sometimes stark, sometimes extremely rich, but always freely conceived by art and filled with echoes of nature and life.

All the painters affected by Cubism, even those who did not accept the principles behind its handling of form, were led to treat inanimate objects with a certain grandeur. Deliberately working within strict limits, persevering in a harsh and rigorous stylization, Fernand Léger felt irresistibly impelled to

express the objects of our time, their abstract, machine-made forms, their dynamism as magnified by the artificial light of our cities. He introduced a whole new repertory into still life: machine parts, utensils, tools. At the same time he took the traditional themes—the fruit dishes of Cézanne, for example (pl. 117) —and imbued them with the calculated frenzy peculiar to our mob civilization saturated with advertising. He linked up objects and fragments of vegetation by means of plastic figures conducive to an unexpected symbiosis of forms drawn from widely different sources. Léger shared this arbitrary outlook on nature with the Cubists. But the transformations he wrought on nature were not so radical as theirs. They were not, moreover, of an intellectual order; his arabesques were governed by a plastic imagination essentially dependent, from first to last, on the visible world. Léger's schematizations of contour, light and shadow stand in the same relation to Impressionism as the simplifications of Late Empire mosaic-work stand in relation to Hellenistic painting.

Purism, a derivative of Cubism launched by Amédée Ozenfant, who was soon joined by Edmond Jeanneret (Le Corbusier), was confined almost exclusively to still life themes. The Purists claimed to exploit the scientific study of the physiological and psychological effects produced on man by forms and colors; in this way they hoped to arrive at a means of arousing emotion grounded on universal constants. But they were afraid that a purely abstract play of forms and colors might turn into " something other than an ornamental ensemble "; thus Purism remained a figurative art. Quite logically the Purists chose commonplace objects whose very familiarity detached the mind from the subject and left it free to enjoy the language of art for its own sake. The artist exercised his imagination on carafes, plates, glasses, jugs and guitars, whose " standard " forms gave rise to concatenations, imbrications and transparencies. Ozenfant's and Jeanneret's compositions are marked by an architectural rigor and geometric purity; the poetry of their work lies in its elegance. But with their restricted repertory and coolly systematic approach, it was not long before they had exhausted their plastic inventions. Ozenfant's limpidity and Jeanneret's discreet lyricism were not enough to make Purism more than a short-lived movement.

Matisse.

Arising before the cubist movement and running parallel to it, Fauvism endowed painting with a new freedom. The Fauves freed line and color from their old function of imitating nature and used them as independent vehicles of lyrical expression. Matisse, their leader, was one of the creators of the modern way of seeing. Still life does not preponderate in his work as it does in that of many of his contemporaries, Gris and Braque for example. But as a young man Matisse copied De Heem's *Dessert* and Chardin's *Skate* at the Louvre, and his earliest known work is a still life of books treated in a spirit of literal truth to life which verges on *trompe-l'œil*. Throughout his career Matisse painted still lifes and they reflect his successive researches and preoccupations. We find in them a tendency to express himself in intense colors combined with a concern for the patterning of the picture surface. Matisse achieved an equivalent of the Cubists' innovations by transposing nature into an order of pure painting, and thereby imparting a new significance to the image of inanimate things. Matisse is at his best when he orders his acute feeling for form and color, and he often does so with admirable ease and assurance.

Thus in the *Pink Tablecloth and Oranges* (pl. 111), one of his most perfect still lifes, he combines tones that are so closely related as to form very dangerous company: purples and carmines, pinks and mauves. Yet each of these colors is made to yield its purest radiance, and their juxtaposition results in a fresh and opulent harmony. This is one of the masterpieces of the modern handling of color, comparable, for rarity and richness of tone, to the harmonies of Veronese, but outdoing in boldness all known color schemes in the painting of the Old Masters. Amidst these gleaming reds, the oranges take on the quiet breadth of some fabulous fruit, the flower patterns of the tablecloth are alternately rutilant or muted, like those of Persian pottery. Serenity compounded of vibrant plenitude—here Matisse completely fulfilled his high aspiration, so typically French, towards an ardent and strenuous, yet calm and restful art.

This equilibrium of vital forces constituted by Matisse's colors is sometimes reinforced by the linear structure of the composition. The *Dish of Oysters* (pl. 112) stands in the middle of three rectangles

134

of different colors; these are laid out slantwise, but the resulting movement is compensated for. The composition as a whole is both capricious and stable, light and mysteriously solid. Objects seem almost emptied of substance by the clarity in which they bathe; yet the pitcher has all the robustness of a rustic utensil and the oysters shine with a glaucous viscosity. Not since Manet had reality been so succinctly defined. The mind, however, is more fully satisfied by Matisse's arbitrary harmonies than by Manet's precise and positive descriptions.

Nothing better reveals Matisse's way of looking at objects—and with it the most vital art of our time—than his transposition of a 17th-century still life. In his prentice days, about 1894, he made a faithful copy of Jan Davidsz. de Heem's *Dessert* at the Louvre. Some twenty years later, about 1915-1917, on the basis of this copy, he undertook a free interpretation of the Dutch master's still life (figs. 40 and 41). De Heem's picture is very large, measuring over six feet in width. Matisse's version of it is even larger. Comparing the two, we note at once that Matisse has cleared away his model's overwhelming wealth of detail and retained only the most striking motifs. He tightened up its proportions, eliminated the curtains, and let in a flood of light. He remolded all the objects of the original, with their forms and contours, into a limpid, well-aired construction enlivened with dynamic lines, consolidated by those lines and by a vertical axis which is not to be found in De Heem. The color scheme of greens, grays and ochres, set off by pure black, adds a crowning touch of cheerfulness and a breath of fresh air to Matisse's picture. We get the impression that he took De Heem's well-appointed table and set it up on the sunny deck of a yacht in Mediterranean waters. But what is the exact quality of objects under this flood of light, peculiar to Matisse, which locates all forms on the flat plane of the picture surface? For Matisse, of course, as for Gauguin and the Cubists, inanimate objects and indeed all other elements of nature are simply themes on which to weave plastic harmonies. Does this mean that they are reduced to mere patches of color? Compare Matisse's apples and pears, uniformly yellow and red, with those, lovingly modeled, of the Dutch master. Are they less convincing pieces of fruit? Is there less bloom to them, less flavor, less relish? No, certainly not. Anyhow not to eyes attuned to the modern way of seeing and to its spiritual resonances; but we have had time now to adjust ourselves, we have had half a century. De Heem is convincing when he delineates an apple just as we see it from close at hand and feel it with our fingers; he invites us to judge of his fruit by comparing it with real fruit. The modern artist evokes the idea of the apple, the quintessence of its form and color, and the associations of ideas that may be connected with it; it is as if he invited us to compare his image with our memory of the fruit. His ability to convince us is all that matters. If he wins us over, then we follow him, we see what he sees. And this, in the last analysis, is what happens every time we scrutinize a work of art, whatever its period and whatever side of nature, visual or spiritual, the artist reveals to us.

So the object, for artists who aim at plastic harmonies, is something more than a mere pretext for those harmonies. It retains a vital significance even if it is only partially recognizable. It retains that significance in its new shape, unexpected but suggestive: Picasso's biscuits (pl. 119), delineated with a few ochre lines amid the whiteness of a round plate, represent as it were the aerial soul, the angelic immateriality of biscuits. It is only in second-rate cubist pictures, whose distortions fail to give a direct expression of the sense of life, that the object, whether recognizable or not, is reduced to the status of a linear arabesque or color patch.

Matisse and the Cubists were not the only ones to go in for this subtle, equivocal interplay between the object-souvenir of reality and the object-arabesque. The Fauves achieved a wonderful freedom of line. André Derain contributed a great deal to that achievement, and when in 1920 he turned to antique art, he was able to deduce from the Knossos frescos and archaic vases a linework full of poetic fantasy. In his still lifes, a theme for which he showed a predilection (pl. 113), he reduced his palette to a dominant tonality punctuated by a few accents of color; he limited the drawing to white contours suggesting forms and assimilating them to the decorative simplicity of the color scheme. Objects lose their weight and density, but retain a ghostly presence. A sophisticated composure emanates from the flat, thinned-out colors, from the lazily evolving linework, from this bare, transparent world. These spectral still lifes are less incisive, less intense than those of Matisse; they are not so bold as Picasso's and Braque's. They nevertheless herald the triumph of modern painting which, capitalizing on the unlimited power of the artist's imagination, discloses the secret harmonies of life.

Van Gogh.

The cardinal feature of all painting since Impressionism is the conviction that art must be an act of subjective interpretation. The Impressionists themselves, anyhow in the early days of the movement, naïvely believed their way of seeing to be objective. But after a decade of hard work in common they stood too far apart from one another for it not to be obvious to them that, though they shared the same realist esthetic and the same technique, the determining factor was still individual sensation. This is also true of Cézanne, in spite of his intent resolve to subordinate his " *petite sensation*," as he called it, to an impersonal plastic order. His art commanded attention by its profound originality and encouraged strong personalities to look at nature with their own eyes. The pointillist movement founded by Seurat was among the last to claim that a scientifically objective painting was possible. And even then a comparison of Seurat's pictures with those of his disciples, Cross and Signac, proves, paradoxically enough, that it was precisely the highly personal and expressive quality of Seurat's line that ensured his superiority in a system which aimed at establishing painting on the basis of a new vision of color.

Every major painter in France and in Northern and Central Europe, from about 1885 on, set out to paint not what he saw, but what he wanted to see. The pictorial realization of ideas and feelings became fundamental to the modern esthetic. All the artists whom I have passed in review under various headings in this chapter might equally well be considered as Expressionists, including the Cubists at a given moment, notably Gris and Braque, even though their main concern was with the working out of an impersonal order. The greater part of Picasso's work tells with dramatic gravity of the deep-seated anxieties that move him (pl. 120). Bonnard handles color with a waywardness all his own (pl. 105). Line and color in the hands of Gauguin and Matisse serve the sole purpose of expressing the lyrical intensity of forms, and thereby conveying the painter's particular sense of life (pl. 112).

Then why divide my discussion of these painters into several headings? I have already made it clear to the reader that, while I attach no intrinsic value to any historical classification, at the same time I feel it necessary to propose some such classification of the shapeless mass of fact with which the historian grapples: the mind cannot renounce the effort to dominate the chaos of life. So long as we divide artists into " families " in strict accordance with a basic approach to art, *i.e.* according as the painter deliberately surrenders to nature or attempts to dominate nature, either by plastic harmonies independent of visual reality or by impetuous self-expression; so long as everyone concerned, the historian himself first of all, is aware that the classification adopted is merely an expedient and by no means discounts the very real complexity of each artist; then, with these allowances, such a grouping will on the whole be less misleading than the absence of any order at all.

It is, in fact, the chief intention of the artist and the influence which his decision exerted in his own time or later that should determine the judgment of the historian. Now at the end of the 19th century painters loudly insisted upon the expression of their inner life. Odilon Redon, Gauguin and Van Gogh freed form and color from their traditional function of imitating nature and invested them with a personal message. To touch off a train of thought, to appeal to the emotions, to set the spectator dreaming in a predetermined vein, this became the program of the art of painting. The reliance on mind and imagination linked up this generation with the Romantics, and heralded a new Romanticism, with which the art of our own time is still thoroughly imbued. Expressionism and Surrealism, to mention only the most explicit and enduring art movements of the 20th century, are merely offshoots of this trend.

Among the artists who exteriorize their innermost thoughts and feelings, no fundamental distinction can of course be made between Expressionists and others, by whatever name they describe themselves. The most that can be said is that thoroughgoing Expressionists—those who descend from Van Gogh, certain Fauves, and others outside France—take nature as the stimulus or pretext of their art. An urgent need to exhibit their emotional response to life is combined with an irresistible eagerness to voice their philosophical, religious and social ideas; from here it is only a step to sermonizing or to satire. By no means, then, do they stand aloof from intellectualism, but they do not replace nature by the figments of their imagination; the data of reality are sufficient to their purpose. The Symbolists and Surrealists, on the contrary, following in the footsteps of their precursor Odilon Redon, deliberately appeal to the imagina-

tion, juxtapose real objects and symbolic objects, and tend to upset the accepted order of the everyday world. This being so, I feel justified in dealing with these artists separately under the next heading.

By the time Van Gogh met Gauguin in Paris in 1887, the trend towards deliberate self-expression was gaining ground among French artists. But Van Gogh had been moving in this direction ever since he had begun to paint. Both his instinct and his background made him one of the spiritual heirs of Hieronymus Bosch and Rembrandt. He shared their gift for a highly personal pictorial idiom, and like them he put it to the service of a generous reforming zeal. Everything he painted was steeped in human meaning. His first still lifes, dark works painted in a thick impasto, recall in some ways those with which Cézanne began his career some fifteen years earlier. The latter, however, in his attempts to cope with reality, showed more haste to assert himself and more style; no doubt the artistic ferment of France and the lesson of Manet fostered his efforts. Van Gogh breathed the atmosphere of old Dutch painting and started out from the social realism of certain of his compatriots; the compassionate pessimism of Israels weighed for a long time on his mind. He could not help respecting the appearance of inanimate objects as they present themselves in daily use; he could not conceive them except in relation to man, or rather in relation to the poor and destitute. Van Gogh gave a good deal of thought to still life. As early as 1884 his choice of objects is significant. When he painted *The Loom*, the machine fills the entire canvas but owes its expressive power to the small figure of the weaver himself, in the background, working it with his hands. When he painted objects on a table, he chose the simple fare and stout crockery of workmen and peasants. His potatoes, dark and heavy as cobble-stones, symbolize the elementary union of the peasant with the soil he tills. Herrings, another staple of the poor man's diet in Holland, he shows as sorry-looking, monotonous heaps of lustrous scales. All these pictures, arresting in their utter cheerlessness, are painted in the dismal tones of mud, dead leaves and winter moss. Through the form and lifelike integument of objects Van Gogh effectively communicates his own emotion. The masterpiece of this series of still lifes is the famous picture of a pair of peasant's shoes. Though he painted the picture in Paris, where the Impressionists had already done away with chiaroscuro, Van Gogh still relies on values; his vision is still that of an engraver, as in his very early works. A sudden shaft of light isolates the shoes against a bleak background and lays them bare. Scuffed and worn down at heel, battered and crumpled, they sum up a whole world of distress and destitution; they vouch for the implacable daily round of exertion and fatigue which is the poor man's lot. No trace here of any literary allusion. Strictly accurate observation was enough for the artist, who recorded what he saw with an astonishing power of both plastic and spiritual synthesis. Van Gogh's still lifes are sometimes traditional (his tables with bottles and herrings are the time-honored themes of Dutch painting), sometimes boldly original, as when he made a heap of potatoes or an old pair of shoes the only theme of a picture, which no one had ever done before. But in both cases the spirit in which he treats them is always modern. His earliest works mark him out as a visionary interested in the object only to the extent to which the painter can give it life. It was not till much later that this attitude reappeared in painting, with Soutine, who displayed it, if not with the same genius, anyhow with the same conviction.

This tendency in Van Gogh's work was momentarily attenuated by his contact with Impressionism in Paris. The Dutchman was struck almost at once by the French painters' positive scrutiny of nature, by their sunny optimism indicative of the serene equilibrium of a middle-class society in its heyday. After the burning zeal of religious humanitarianism, he felt the pangs of a new ordeal: his yearning to achieve an unruffled domination over the spectacle of nature had to contend against his congenital hatred of every restraint, of every check that might stand in the way of his eagerness to commune with the forces of life. During his stay in Paris, in 1886-1887, a change came over both the themes and style of his still lifes. He turned out picture after picture of baskets of fruit and bouquets, brightly colored, evenly lighted works quite devoid of dramatic effects of chiaroscuro. The flickering brushstroke betrays the influence of Pointillism rather than orthodox Impressionism. His color scheme is composed of pure tones in contrast and foreshadows his later use of zones of uniform color. His contact with the Impressionists revived Van Gogh's truly Dutch feeling for the mineral purity of a tone, such as those fine greens and reds on the shutters of Dutch houses, those green enamel backgrounds we find in Jan Scorel and in Corneille de Lyon, who brought them from his native Hague. In the still lifes of his Paris period, in accordance with the impressionist esthetic, Van Gogh subordinated the object to a delicate color harmony verging on preciosity.

Though he added racy accents vigorously enlivening the coat of subtle color, and though he stressed the density of bodies much more than the Impressionists did, the object as he now handled it lost a good part of its compelling presence.

As far as we can tell, his meeting with Gauguin was a decisive turning point in Van Gogh's career. In Gauguin he found a man who had given serious thought to the problems of painting, and who had reached conclusions which confirmed his own aspirations: to free color and line from purely representational service and to make them express ideas and emotions. Van Gogh espoused this esthetic, but the intensity of his vision and his respect for tangible reality made it difficult for him to work in terms of partitioned areas of flat tints, as Bonnard and Gauguin did. He stuck to the accentuated brushstroke and to a vibrant texture, directly expressive. In the solitude of his life in Provence he quickly succeeded in achieving a mature vision of his own and in working out a technique suited to it. In the space of three years he painted hundreds of canvases—a feat probably unexampled in the history of painting—and many of them are masterpieces.

During that time he produced a good many still lifes, but their number in proportion to the rest of his output is no greater than it is in the work of the Impressionists. Nevertheless he attached more importance to them than the Impressionists did, for the good reason that they were directly bound up with his daily life. Most of the time he painted whatever objects came to hand in his room (pls. 101 and 102). By using a plunging perspective, in the Japanese manner, he brought them sharply into focus in an intimate "close-up." His coloring is only remotely connected with reality, yet it is never abstract in its arbitrariness. When he departs from the conventional color, he does so in order to give individual life to the object. His composition too is dictated by the vagaries of self-expression. Never is the vehement prestige of each object attenuated (as it so often is in Gauguin's work) by a deliberate striving after a harmony of line and color.

Van Gogh reinvented or revived certain features of the old still life. In the *Drawing Board and Onions* (pl. 101) we find his signature in the form of a letter addressed to himself, a stock device of the little masters of the 17th century. Almost always, when painting a book, he carefully recorded the title on the cover. We thus learn something of his reading (the brothers Goncourt, Dickens, Maupassant) and something too of his pathetic concern for his health (lying on the *Drawing Board* is a copy of the popular *Annuaire de la Santé du Docteur Raspail*). His still lifes are intellectual in content, touching in their sincerity and earnestness, and amount to a system of personal symbols. *Gauguin's Chair* (pl. 102) stands vacant in the middle of the room, with two books and a lighted candle on it; Van Gogh intended it as a pendant to his own deal chair, on which he has placed a pipe and a pack of tobacco. These pictures he described as experiments in different lighting effects by day and by night. But they are much more than that: they are moving confessions of loneliness in which inanimate objects take the place of living beings and stand for friendly presences. Never had still life been so profoundly humanized.

Van Gogh also painted a great many flower pictures. He was always attracted by the profusion of nature, and the more uniform nature appeared to him, the more her vital forces exalted him. Hence the fact that his bouquets often consist of a single kind of flower: rich clusters of irises, of sunflowers, of white roses (pl. 100). He painted a whole series of *Sunflowers* against a yellow background, and liked to imagine them all hung together in a single room. He regarded them as "lamps or candalabra." And indeed these paintings give off an extraordinary radiance. Their colors must have been even more intense when they were first painted, the ochres seem to have faded. Consciously aspiring to "musical painting," a term which often recurs in his letters (and which he no doubt took over from Gauguin), Van Gogh modulated his yellows like a single harmonic theme suggestive of the intoxicating omnipresence of the sun. The brushstroke and the exact value of the tone evoke the supple volume of the flower. With their heavy impasto, looking almost like plump furry animals, his sunflowers sway in front of a background of thickly interwoven dabs of pigment, which set up an all-pervading pulsation not unlike the quivering heat of a summer's day. Gauguin was very fond of these still lifes and Van Gogh himself regarded them as his most successful pictures.

His flowers reflect and epitomize his anxious scrutiny of nature. He humbly admired, surprisingly enough, the "objective" view of nature as he found it in the work of both Meissonier and Monet, but he himself transposed nature fiercely, surrendering to the powers within him. He begins by placing a

bouquet of white roses in the center of the canvas, with the utmost simplicity (pl. 100); the first flower painters, such as Ambrosius Boschaert and Jan Brueghel, used the same layout. But, as he goes on, a wild upsurge swells the vase and elongates petals; pointed stems and leafage shoot out, propped up by short, taut outlines; a sharp gust of wind seems to sweep through the whole picture. " All the same I think this endlessly blowing wind must have something to do with the haggard look of the studies painted down here. After all you can see it in Cézanne too," he wrote from Arles. He failed to realize the power of his own vision, which led him to discern in Provence and Cézanne what he alone experienced. His wholly subjective painting made him the master of modern Expressionism. Van Gogh, even more than Gauguin, opened to the Fauves the resources of pure, vibrant colors, whether simply fresh or frankly shrill, bright color mysterious in full light. The florid serenity of Matisse and the vehement urgency of Vlaminck and Soutine are latent in the art of Van Gogh who, in the innocence of genius, reconciled contradictions.

After successive exhibitions in the early years of the century had familiarized them with his work, a great many painters found inspiration in Van Gogh. Matisse, leader of the Fauves, owed two essential principles to him: the independence of tones and the power of lines. Vlaminck too deduced from Van Gogh's intense colors the possibilities of lyrical painting, which, in keeping with his temperament, had to be violent to the point of brutality. Round about 1908, however, feeling that the dynamism of his pure, juxtaposed tones was getting chaotic, Vlaminck turned to Cézanne in search of some means of control. He now fell to painting still lifes whose saturated coloring, emphatic design and lumpy impasto give us an inkling of the veteran Fauve's struggle with Cézanne's compositional armature. Vlaminck later settled for a personal manner in which he gave free rein to his spontaneity, while endeavoring to strike a balance of strong contrasts in his composition. His landscapes often lapse into stereotyped effects, but his still lifes offer a more varied range of color harmonies, at once less contrasted and more sensitive. They are tinged with a popular Romanticism and filled with a rather gloomy light; they look as if they had been washed by a winter rain (pl. 109), which has left them enlivened with fugitive gleams and transparencies. The physical texture of objects is alternately rendered by opaque and glassy colors, like a watercolor heightened with gouache. Abiding by the principles of Fauvism, Vlaminck sacrificed nothing of the direct expression of the object to the organization of the picture surface. So that his color patches and his shadows never defer to any controlled rhythm, either abstract or expressive. They candidly cleave to the order of nature, with light pouring in from the side in the traditional manner.

Another artist who rallied to Fauvism made his color yield dramatic contrasts by an interplay of dense and translucent pigments. For Georges Rouault, however, these effects were not (as they were for Vlaminck) the outpourings of a sensual lyricism; they were the reflection of his spiritual life. Rouault's art is steeped in deep religious feeling; always uppermost in his mind is man, even when he turns to subjects in which the human figure is absent. His still lifes are very rare, amounting to no more than a few pictures of fruit and flowers. But the originality of their colors and the beauty of their texture rank these flower pieces among the very finest of our time. His training as a glass painter taught Rouault to make the most of the strips of lead which enhance tones by partitioning them off from one another, and whose rhythm consolidates the whole composition. Thick black outlines form the powerful framework of his paintings and make his blues, reds and violets sing out, in spite of their complex opulence, rich in undertones and iridescences. Great shimmering patches of translucent color, Rouault's flowers are unreal, almost unearthly, and apprise us at once of the painter's mystical response to nature. Rouault, however, never superadded either allusive images, like Chagall, or intimations of mystery, like Odilon Redon. He remained a Fauve Expressionist, relying for his suggestive effects on the agency of color alone, with its variations of intensity and cadence.

Some of the independent painters worked out an art of spontaneous color effects whose line of development ran parallel to that of Fauvism. André Dunoyer de Segonzac, like Bonnard, often painted still lifes set in a landscape. His light, however, has none of the unity we find in that of the Impressionists, which merges objects into the surrounding air. Yet, with their clayey impasto and their movement, his vegetables, fruit and flowers seem to preserve the raw vitality of produce fresh from the soil or the tree (pl. 110). They express " a sensual materialism verging on lyricism " (René Huyghe), which explains the attraction Segonzac always felt for the romantic realism of Courbet.

Expressionism has always been the exception in French art. It corresponds, rather, to the moods of the Germanic and Northern mind in general. No wonder, then, that the essential contributions to this movement have been made by the artists of Northern and Central Europe. The Norwegian Edvard Munch, the Swiss Ferdinand Hodler, the Belgian James Ensor, the German Emil Nolde and the Austrian Oskar Kokoschka all show, each in a highly personal way, a strong determination to charge their paintings with a moral message or to make it mirror the life of the soul. They are not nearly so much concerned with the plastic order of their pictures as French Expressionists are. They work out their technique on the spur of the moment, as they go along, and their style re-echoes the variable music of the emotions. With their interest centered on human problems, they seldom paint still lifes; but when they do, they can often be counted on to show the subject in a fresh light.

James Ensor was in this respect the most significant of them all. Still life numbered among his favorite themes. Up to about 1884 he painted it in fairly dark tones and his choice of motifs revealed a Fleming and a man of the sea: fish, vegetables, copper pots and pans, such as we find in the old Netherlandish painters. But thereafter, beneath a lavish or an evanescent texture, we sense the painter's quixotic fancy at work, eliciting the disconcerting or uncanny sides of nature. In painting fish Ensor was especially fond of the skate, with the strangely human features of its small, mask-like face. He painted it in 1882, showing it outstretched on a bed of straw, which looks like a strange tissue of asbestos fibers, a shapeless mass of white fluorescence from which two bright, upturned eyes stare out piercingly. He painted it again ten years later (pl. 99), its flabby body looking more real now but more grotesque amid arbitrary gleams of bright color, and above all more monstrously human with its cruel, sardonic face. How different from *The Skate* of Chardin, from the old master's pungent, steady observation. Goya alone comes to mind as a precedent of this peculiar sense of life and physical substance. Here already Ensor foreshadows his favorite carnival masks, the major symbol of his poetic intentions, which he combined with death's heads, gaudy finery, and things of the sea in scintillating, faintly sinister ensembles. Every summer at Ostend he watched the motley crowds at the seaside, representing all races and colors, an uninterrupted, almost mechanical succession of distinct but empty faces. As a child he spent hours staring at the curios, the seashells, the trinkets and tourist souvenirs on sale in his parents' shop. Like all great still life painters, Ensor created his own repertory of objects and, at the same time, imparted a new significance to them. Mysterious gleams play over and transfigure his vegetables, his pots and pans, his meat and fish, his seashells, his masks and skulls, all in heaps of rare and glittering things that look as if they had just been fished up from the depths of the sea. This predilection for the rare and precious bears out Ensor's affinity with his ancestors, the old Flemish masters, so many of whom treated still life as a miscellany of curios. As for his affinities with his contemporaries, his still lifes give him a place among the independent Expressionists and also in the Symbolist camp: to reality he added imagination and vitalized inanimate things with a sly, almost malevolent life whose existence he alone detected in them.

Emil Nolde was struck by the still lifes with masks which he saw in Ensor's studio when he paid a visit to the Belgian painter in 1911. He took to painting such works himself, fascinated by the spellbinding atmosphere which, to his thinking, their mere presence sufficed to create. Nolde's flower pictures afford a deeper insight into the true nature of his Expressionism, which is merely a modern variant, conditioned by Van Gogh and Gauguin, of older German Romanticism.

The last great exponent of European Expressionism was Chaïm Soutine. He displayed an essentially Oriental exaltation which lifted him on occasion to the level of a rapturous visionary. This is particularly true of some of his landscapes, which produce the effect of having been disintegrated or liquified by the torrid breath of some mighty, pantheistic passion. Related to Van Gogh by the sufferings he underwent, by the tragic poverty in which he lived, by his high-minded devotion to art, by his humble, painstaking craftsmanship, Soutine looked within himself and found there all the stimulus he needed. But of all his predecessors he stands closest to Goya and Rembrandt, especially in his still lifes, in which, oddly enough, to a far greater degree than in his landscapes and portraits, he disciplined his impulsive art. In addition to a few of his portraits, some of his still lifes rank among the masterpieces of the first half of the 20th century. Born and brought up in a Lithuanian ghetto, where icons and folk painting on glass conditioned his youthful vision, he arrived in Paris with the uninhibited freedom of a

Primitive and an innate sense of texture, which dazzled and allured him. The academic training which he had received in a provincial town of Eastern Europe was effaced at once by his first contacts with Parisian art, and left no trace behind. The Fauves were then setting their canvases ablaze with expressive colors, barbarous to most onlookers. But Soutine was thereby encouraged to set to work and learn for himself, to persevere in seeking out the exact pictorial equivalent of his yearning desire to commune with reality. The art world of Paris decisively oriented his work. The French tradition taught him to investigate reality and to prize pictorial texture. More than once he harked back to Courbet, as when he painted a girl asleep in the shade of a tree or a large fish under water. His realistic turn of mind and his love of a rich impasto set Soutine apart from most of the Fauves; Rouault alone, another mystic, attached the same importance to the expressive virtues of full-bodied textural effects.

Soutine's still lifes vouch for an incorruptible scrutiny of reality. Their riotous, deep-toned colors are never fanciful or gratuitous. He found them in rotting flesh, just as Hieronymus Bosch had done, and like the old Netherlandish mystic he touched the deepest chords of our being by the sensory appeal of his color. Haunted in his *Flayed Oxen* by the memory of Rembrandt, linking up with Goya in his *Plucked Chickens* and *Turkeys* (pl. 103), Soutine brings us face to face with the arresting spectacle of dead flesh, which contains the germs of new life. He utterly transformed the stock theme of *Game* and *Dead Fowl*, in which, before Goya, painters saw no more than a picturesque or anecdotal motif. Soutine, who knew what it was to be poor and go hungry, one day hit on the theme Van Gogh had interpreted in his youth: herrings on a table (Katia Granoff Collection, Paris) (219). He painted them in bitter tones of gray and brown. The simplicity and power of the composition, with the table viewed from above, are quite extraordinary. The herrings themselves are poor, emaciated creatures with gaping jaws, their eyes popping out of their heads in the death agony. To Van Gogh's treatment of the theme Soutine added a singularly effective touch: two cheap tin forks converging on the fish like thin, avid, terrifying hands—the very claws of poverty. This is certainly one of the masterpieces of the expressive still life. Everything in it is a transmutation of the hard facts of life into pictorial terms; it owes nothing to literary allusion.

Still Life as a Pretext for Dream and Make-Believe.

The painters who, in the last three-quarters of a century, have sought to express themselves by breaking direct contact with reality form a spiritual group distinct from the Expressionists properly so called. Even when it supplies them with certain representational elements, they make free with nature, they add to it and fill it out with their imagination. They aspire to poetry expressed in terms of painting. Some of these painters simply obey the dictates of their instinct; more often than not, they are self-taught; though usually described as " naïve," the fact is that they simply work outside the established conventions, they are free from both pictorial and intellectual conventions; their means of expression are far from being naïve. Others are inclined to this form of art by certain exigencies of the mind; their imagination is of an intellectual order and their culture counts for a good deal. In this connection Germain Bazin has aptly pointed out that painting dedicated to ideas, the painting of Gustave Moreau, Odilon Redon, and the Surrealists, has always taken its lead from men of letters, from the Parnassians, from Rimbaud, Mallarmé, Apollinaire, André Breton, " as is only to be expected in an art dominated not by ' pure Form ' but by ' pure Idea ' " (220).

Granted that artists of this allegiance have never pursued form for its own sake, the fact remains that they by no means overlooked problems of form. In committing their ideas to canvas in the guise of lines and colors, they very naturally gave a great deal of thought to their handling of line and color. In this, moreover, they showed themselves the heirs of Romanticism; indeed, Gustave Moreau was a direct descendant of the Romantics through his master Chassériau. As for the influence of his studio on the most independent-minded of the Fauves who studied there (Matisse, Manguin, Marquet, Rouault), it is a common mistake to reduce that influence merely to the atmosphere of kindly tolerance in which Moreau gave his lessons. It was much more than that, for the guiding principles which Moreau enjoined on his pupils were diametrically opposed to the naturalistic doctrine of Impressionism and contained

the very essence of Fauvism: color set free from nature imitation, color as a vehicle of thought and expression. " Bear this in mind, that color has got to be thought out, has got to be pictured in the imagination. . . To evoke ideas with lines, arabesques and plastic means, that's what I aim at. . . Only that painting will endure, I firmly believe, which has been dreamed about, thought out, pondered over, made by the mind and not merely by the hand with its facility for throwing off tinsel from the tip of the brush " (221).

Poor Moreau had the misfortune to compound his own work of both " mind " and " tinsel." He took the painter's idiom for a veritable language—one so well capable of expressing the sense of his message that the language itself no longer matters, it disappears, its task accomplished. He was like those who " throw down the manure and think themselves gardeners," to use the words, ironically enough, which a " thinker," Eugène Carrière, applied to the naturalists. And though the advice Moreau gave his pupils was not given in vain, he himself remains a striking example, as relevant today as ever, of the divorce between enlightened insight into art and a halting performance; an example of the historical impact an artist's ideas may have, even though his own work (often fascinating) remains isolated.

It was left for Odilon Redon, who admired Moreau, to give significant expression—pictorial expression—to this spiritual heritage. He too linked up directly with Romanticism, by way of his veneration for Delacroix and the influence of his master, the astonishing engraver Rodolphe Bresdin (222). But he was a man of his own time, and painter enough to assimilate to his own vision the new artistic developments gathering strength around him. Georg Schmidt (223) very plausibly maintains that Redon owed the principles of his color to Seurat, with whom he helped to found the Salon des Indépendants in 1884. The example of Degas doubtless played its part as well. Redon aimed at expressing ideas in terms of painting, but he nevertheless attached the utmost importance to problems of form. He was acutely aware of the suggestive potential of the color patch and abstract line, and capitalized on them as a novel means of expression with an immediate psychological impact. His colors, in particular, are among the most original, the most mysterious that we have; they make their appeal to an " eye susceptible of thought." His pastel-like color scale embraces a wealth of nuances in the lighter tones, which retain all the pristine freshness of pigments newly crushed alongside dusky mists of powdery color. His orchestration of color patches and linear jottings imparts a secret and persuasive cohesion to Redon's work.

This enabled him to renew one of the oldest forms of still life painting: the flower picture. A pupil of the botanist Clavaud and enamored of mystagogical studies, Redon seemed to have taken up the traditional language of flowers; he made use of its emblematic significance or charged it with personal symbols. Thus the poppy, flower of dreams, often blossoms out amid his bouquets, surmounted by the bluebottle, whose azure petals testify to the soul's candid contact with the celestial regions (pl. 98). Butterflies are often to be seen flitting among his flowers, and the harmonies of tints and forms between petals and wings, between the pistils of the flowers and the villous bodies of the insects, set up such haunting echoes as could only be elicited by a man with a profound poetic insight into the underlying unity of life—an insight fostered perhaps by biological speculations familiar to Clavaud. Even when he merely painted *Vases* filled with the commonest wild flowers, the artist succeeded in inducing a kind of musical uneasiness, sustained by the recurring or shifting arabesques of contours, by the unexpected rhythm of colors, above all by the unreal quality of tones, of large, fitful patches of shimmering tones which, looming up tremulously, seem about to sink away into the depths of the picture. He evokes an image of nature, transfused and spellbinding, parallel as it were to nature as we know her, from which man seems to be forever shut out.

The Symbolists, his heirs in many ways, shared the outlook of Odilon Redon, but only up to a certain point; Gauguin, his Pont-Aven disciples and the Nabis all paid lip-service to the resources of the unconscious but they never really exploited them. They were too much engrossed in the rhythmic and decorative patterning of their pictures to be able to indulge in such inventions and improvisations of line and color as are prompted by obscure instinctual drives. Gauguin's incursions into the irrational were strictly limited to his attempts to reproduce the atmosphere of tribal magic which he found in the mythology and customs of the island people whose life he shared. He steeped himself in that atmosphere and rendered it with the natural gifts of a poet and painter. But he explained all too well the means by which he claimed to achieve mysteriousness; this is abundantly proved by his commentary on *The Spirit of the*

Dead keeps Vigil. Gauguin's poetic symbols actually do no more than replace the traditional repertory of Christian and antique myths by an unfamiliar Polynesian repertory, which he interpreted in a highly personal manner, like the great artist that he was. But it was not his way to probe into the depths of his unconscious and reveal those strange worlds which remain a riddle to the conscious mind. When he endowed flowers with symbolic meaning, he did so by a lucid effort. In 1901 he painted *Sunflowers* in a large bowl decorated with carved idols; in the background he reproduces Puvis de Chavannes' *Hope*, which represents a female nude holding an olive branch. He gives us the key to this still life in a letter written the same year: " Puvis explains an idea, granted, but he doesn't paint it. He's a Greek, whereas I'm a savage." Gauguin stands in opposition to the Greek spirit not only because he replaces the Mediterranean esthetic and civilization by that of the Pacific islanders, but also because he replaces the accepted symbol by the sunflower which, by the power of his thought and his painting, he raised to the level of a symbol. What enlightens us in this respect is the juxtaposition of his still life with Puvis' *Hope*—and his own letter. As for Odilon Redon's flowers, they are enough in themselves to set us dreaming. The reason is that between them and reality stands the beacon of the visionary imagination, which finds its sustenance in everything that is inconceivable to the mind.

While the painters of ideas, the *idéistes*, as they were called in France, were becoming more acutely aware of their aspirations and their means of realizing them, the liberal spirit of the new Salon des Indépendants, founded in 1884, was giving a foothold in the French art world to a group which had never before been granted a hearing: the self-taught, the so-called " naïve " painters. His great gifts as a painter and his ingenuous sense of poetry ensure the survival of the Douanier Rousseau's works. If the artists and writers of several generations have paid tribute to them, this is because they regard them as an outstanding example of subjective lyricism and refined plastic harmonies—the two major art tendencies of the last three-quarters of a century. Rousseau's style signified the consecration of " Primitivism," and the prestige of the Primitives has played the same role in modern art that the prestige of Greek and Roman antiquity played from the Renaissance to the time of David.

Yet the Douanier himself aspired simply to paint realistically, and when he imagined his compositions he intended them to be made up of lifelike elements. He painted (more or less to order) several still lifes, chiefly flower pieces, and these number among the finest of his time.

The whole of his art is summed up in them. The most unassuming of his bouquets testifies to the sense of wonder, to the almost mystical rapture, that filled him at the sight of leaves, petals, flowers; and testifies at the same time to his keen pictorial instinct. Wilhelm Uhde, who probably knew Rousseau better than anyone else and has written about him surpassingly well, describes the infinite pains the painter took to carry out his ideas, and the careful thought he gave to every brushstroke, to every dab of color. His *Vase of Flowers* (pl. 106) is the fruit of just such labors. The nucleus of the composition consists of dark pansies, whose burnished density is crowned by a light, transparent network of flowers and leaves radiating round it. The leaves of the pansies are arranged with flawless symmetry; to the yellow flowers on the left corresponds the complementary blue of the flowers on the right; the delicate graphic precision of the plants is set off by the calm uniform tones of white vase, pink background and red rug.

The result is a sustained, thoughtful style; but nothing mars the unbelievable purity of the painter's initial impression. Rousseau fulfills the dream of everyone who has dabbled in paints in his childhood: he keeps the gaze of a child, yet invents the language of an accomplished painter. Which, however, is not at all the language of an adult painter, for it remains foreign to every optical or pictorial convention. His imagination alone stands between him and nature, for the true painters of this stamp always embroider imaginatively on what they see in front of their eyes. This indeed is what safeguards them from the influence of other artists. The only pictures likely to influence them are pictures with no pretention to art, such as calendars and color prints. Nor are naïve painters capable of exerting deep influence. There is no common measure between their way of seeing and that of painters schooled by other painters. No one sees a bouquet of ordinary flowers as Rousseau sees it: for him it is a dense forest full of heady aromas, out of which pansies gaze at us like soft, furry animals. It matters little whether flowers and leaves resemble their natural models, or whether they are rendered in lifelike detail: they are symbols of a lifetime of dreams, and as such have their roots in the unconscious mind.

Rousseau marked the first generation of naïve painters; he exhibited from 1886 to 1910. His success, backed as he was by Jarry, Apollinaire, Uhde, Max Jacob and Picasso, attracted attention to many other self-taught artists. A new generation sprang up after the First World War. As far as still lifes go, those of Louis Vivin, a post-office clerk, and Séraphine Louis, a charwoman, show most originality. Vivin painted assortments of objects and fruit on tables, in the traditional manner. Some of his canvases, keyed in a dark scale of colors, have reminded Wilhelm Uhde of Chardin. But we have to go back even further than Chardin to find Vivin's spiritual affinities: to the first artists to deal with still life and the peculiar problems it presents. In a private collection in Paris is a *Banquet Table* by Vivin, painted in 1923 ([224]); the similarity of its general conception with Floris van Schooten's *Table with Food* (pl. 19) is striking: the same bird's-eye perspective, the same symmetrical juxtaposition of dishes. Yet the painting of 1617 is infinitely more realistic; its chiaroscuro serves to produce the illusion of powerful volume and deep spatial recession; the particular surface of each object is well characterized. As for Vivin, he is the impassible cartographer of his dinner table; his objects are so many ideograms. In fact the comparison with Schooten shows how pointless it is to draw any parallel (as is so often done) between the naïve painters of our time and the Primitives, those heirs of an age-old tradition which imposed its optical and plastic conventions on them. Vivin harks back to the very sources of the artist's vision; not to the childhood of art, which we know nothing about and probably never will, but to the art of childhood, which is eternal and universal.

Séraphine specialized in painting flowers, or rather in painting the extraordinary profusion of plant life that filled the world of her imagination (pl. 107). Trees, shrubs, flowers, ferns, palm trees interspersed with bunches of grapes and seashells—Séraphine's gleaming, exuberant creations take their rise in abstract space and fill up her canvases from end to end. Their tangible presence thus impinges on us as something sudden and startling, like that of stained-glass windows which, set as they are in a neutral wall space, draw their solitary life from an invisible source of light.

At a time when art was moving irrevocably into intellectual channels, spontaneous lyricism could only be looked for among painters whose early years had been uninfluenced by the refinements of a highly developed civilization; among those painters, that is, who either came from the humbler classes of society or had grown up in a secluded milieu, cut off from the rest of Europe by centuries-old traditions. So now, along with the naïve painter, there appeared the ghetto painter, whose flights of fancy evolved entirely within a fabulous world of his own, a messianic dream world. He is, however, anything but naïve; the isolation and miserable living conditions of the ghetto simply ensure a certain freshness of inspiration; but as the heir of an antique civilization, sensual and cerebral at once, he is able to assimilate the most recent innovations of the pictorial culture of our time. Such is the case with Marc Chagall, whose contact with Parisian art promptly fertilized his exceptional gifts as a colorist. The sight of pictures by Van Gogh, the Fauves and the Cubists encouraged him to seek out his own mode of expression, which remained independent and many-sided. This freedom (and the word sums up the only credo and the only method known to Chagall) soon entitled him to a position of high standing in the art life of his time, the more so as that freedom gave full scope to a poetic imagination whose sources lie entirely beyond the ken of Westerners. He has been recognized as a leading exponent of Expressionism and a remarkable precursor of Surrealism. There is no denying that he draws to a large extent on the resources of the unconscious mind; but in doing so he has never followed a cut-and-dried method.

His art being essentially the reverse of naturalism, we cannot expect him to regard still life as anything but a theme on which to weave poetic fancies. He has often painted flowers, either alone or accompanied by an image which re-echoes the suggestive music of a cluster of unreal colors. Like the painters of the late Middle Ages (*e.g.* the miniaturists of the 14th century and Hieronymus Bosch), Chagall plays fast and loose with the familiar scheme of things; he mixes up the animal and vegetable kingdoms and humankind with them; he tampers with the interrelationships of objects, varies their proportions and dimensions to suit himself. We find him arbitrarily placing a vase of flowers on a chair—image evocative of an interior—in front of a vast southern sea, with the tiny figure of a woman lying dreamily on the beach, looking up towards the flowers (pl. 108). What we have here is not hermetic symbolism, but a pictorial language of refined simplicity, whose allusions have the naïveté and gracefulness of folklore.

144

Similar ties with their native soil and with a people whose ways are rooted in the remote past also led certain Mexican Expressionists to explore the world of the imagination. The huge *Gourds* of David Siqueiros (pl. 123) reveal traces of the Spanish tradition, of its Baroque dynamism, of its earthy realism which, in humble objects, finds matter for a visionary transposition. But the haunting breadth of forms and overwhelming heaviness of bodies, which seem to have been hewn out of blocks of lava, create an atmosphere of nocturnal terror resounding with echoes of the immemorial world of the Aztecs.

Ever since the beginning of the century a growing sense of restlessness and anxiety has given rise to "escapist" painting, much of which comes under the heading of Surrealism. Several of the most advanced of these painters were inevitably led to explore the resources of the unconscious mind. It was impossible for them to disregard the theories of Freud, which opened up limitless horizons on the abysmal world of dreams, of their symbols and irrational cross-references. With a new vein of poetry thus laid bare, these artists went in search of suitable means of expression. Most of them opted for an almost photographic realism, for they aimed at literally illustrating poetic metaphors. But the world of visual reality only interested them in so far as it offered them hidden meanings behind everyday appearances. The practice of painting in terms of traditional subjects taken from nature was incompatible with the aims the Surrealists set themselves. Nevertheless, though still life as such had no place in their program, they renewed the painting of inanimate objects and extended its range of subject matter. Not, however, in order to make those objects the exclusive theme of a picture: the secret relationships between all the elements of life form the single, invariable subject of surrealist painting.

Giorgio de Chirico was one of the first, as early as 1910, to make his appeal to the associations latent in the subconscious, to childhood memories and dream images, and in expressing them he very often resorted to still life elements. He confronts us, for instance (pl. 122), with a cluster of bananas and a female torso, looming up, vividly and insistently, in the motionless shadow of an Italian town; a " metaphysical " uneasiness emanates from the sharply drawn perspective, the implacable light, the horizon giving on infinity, where the gaze is set adrift and swept away in the smoke of a passing train. Chirico himself has explained what he was about: "Sometimes the horizon is screened off by a wall behind which rises the noise of a train getting under way. All the nostalgia of the infinite is revealed to us behind the geometric precision of the city square. We experience unforgettable moments when such aspects of the world, whose very existence we should never have suspected, suddenly emerge, disclosing mysterious things that stand before us, within reach, ever present, though our short-sighted eyes are unable to distinguish them, our imperfect senses unable to perceive them. Their muffled calls come from close at hand, but resound like voices from another planet... It must not be forgotten that a picture should always be the reflection of a deep feeling, and that deep means strange, and strange means little known or quite unknown. For a work of art really to be immortal, it is necessary for it to go altogether beyond human limits. Good sense and logic have no part in it. In this way it will approximate to the dream and the childlike mind " [225].

The period of the First World War promoted the formation in Italy of so-called " metaphysical " art, of which Chirico was the guiding spirit. After him its major representatives were Carlo Carrà and Giorgio Morandi. What they proposed was a new iconography for the painting of inanimate objects. Their main idea of inducing a mood of poetic uneasiness by bringing together unrelated elements of reality, presupposed a predilection for unusual and impersonal objects which, when divorced from their normal function and setting, were capable of suggesting a kind of magic aura: plaster casts of heads and torsos taking the place of human figures, manikins, rubber gloves, boxing gloves. Overtones of Quattrocento Italian art often imbue these pictures with serene harmonies and a grave monumentality.

Giorgio Morandi gradually drew away from this movement and created an art of his own, centering on still life, which became his favorite theme. An atmosphere of unreality and solemn meditation pervades his pictures, which are usually small in size. Since 1940 his palette has brightened up and his texture—rather thin and impersonal in Chirico's work—has grown considerably richer. He uses the most ordinary objects to hand: vases, bottles, household utensils. They are grouped very close to one another, as if huddling together for comfort in the solitude of the emptiness in which they stand, in the uncertain light that pervades them. Morandi repeats this particular grouping again and again, never tiring of it, each time varying the harmonic modulation ever so slightly, and each time, with the starkest

of forms, achieving a plastic pattern refined in its cohesion. These are variations or fugues on a theme whose possibilities, we feel, are inexhaustible. The name of Chardin has often been invoked in connection with this art, so unassuming in appearance, but in reality charged with lofty spiritual aspirations and tender musicality. But if there is anything of Chardin here, it is very much a 20th-century Chardin, whose humanity is less direct and less confiding; underlying Morandi's sober equilibrium is a profound sense of uneasiness (pl. 110).

Among the Surrealists properly so called, Salvador Dali has paid particular attention to inanimate objects. He developed into the leading exponent of one of the major tendencies of the movement, calling for the most tritely naturalistic representation of real elements assembled in an order dictated by the painter's subconscious—elements reproduced so literally as to ridicule and discredit the conventional vision of the world. " Painting will be no more than the hand-made color photograph of concrete irrationality and of the imaginative world in general." Following Chirico and paralleling the work of Pierre Roy, that modest and charming poet of magic realism, Dali has sought to express that irrationality by detaching objects from their familiar setting. His work is a systematic springing of poetic surprises, the classical example of which is Lautréamont's " chance meeting of a sewing machine and an umbrella on a dissecting table." By inducing and maintaining a "delirious, durable, systematic and coherent paranoiac state," he believes he can throw open the floodgates of the unconscious, otherwise oppressed by reason. He thus surrenders to the automatism of suggestions that well up from the depths of his being. In his compositions the object, painted with complete illusionist realism, plays a leading role in the dramatic mental shocks and surprises on which Dali rings the changes with so much cunning. We find, for example, an unwired telephone receiver lying on a dish beside two or three grilled sardines (pl. 124). Shown in the glare of a light as raw as that of an operating room, these objects are hallucinating in their banal truthfulness. But behind them stretches an unearthly landscape, dotted with lay figures, struck by light pouring in from a source distinct from that in the foreground, a landscape built up round a broad empty plateau receding into infinity. Riveting our attention with the details of his " paranoiac confession," Dali thus evokes "late September."

This art represents a point in time at which the ever-changing conception of inanimate objects in painting is seen to complete a full cycle of evolution: from the first still lifes, in which objects were scrupulously rendered to the life, for their own sake, to the surrealistic still life, in which again, though to different ends, objects are rendered with painstaking exactitude, like trance-bound fragments of a dream world.

CHAPTER EIGHT

FINAL OBSERVATIONS

What is the connecting link between this succession of paintings, spanning two thousand years ? They abide by manifold conceptions of the world and nature. They are the work of hundreds of artists, each one of whom was a definite personality in a particular civilization; each of these paintings, in the last analysis, is a unique, wholly individual creation. For what reason, then, were we led to consider them together ?

The connecting link between them, as I indicated in the opening sentences of the Foreword, is simply the fact that motionless things form the exclusive subject of all these paintings. This division may seem very traditional, and in commenting on the Orangerie exhibition, several critics, more or less directly oriented by the ideas of the great esthetician Benedetto Croce, professed to see no point in it. If, when all is said and done, the true significance of a work of art lies in the personality of its author, what point can there be in dividing a painter's work into pictures representing only human figures and pictures representing only trees or bottles ? Is not everything he paints marked by the same spirit ? Since here we touch an essential artistic problem, and since one of the critics who raised it numbers among the masters of art history, it may be well to go into the matter for a moment.

Let us consider the following questions bearing on the general idea of this book and on certain historical developments dealt with in it.

1. Is there any justification for classifying paintings in accordance with their subject ? In other words, do the different " genres " of painting correspond to any artistic reality ?

2. Can we validly compare still lifes treated in *trompe-l'œil* for decorative purposes with still lifes treated as easel pictures, to which the modern esthetic assigns a " higher value " ? Can we compare mural paintings and other decorative works, designated as " minor "—marquetry, for example—with easel paintings ? In other words, *trompe-l'œil* and decoration having preceded the easel picture, is there any historical continuity between these aspects of the painting of objects ?

3. What exact historical importance should be assigned to the fact that, till about 1875, still life painting was held to be an inferior genre ?

4. Are there any constant features in still life painting from antiquity to the present day ?

For the sake of clarity, the observations resulting from these questions may best be divided into separate headings.

The Problem of the Subject.

I make no claim here to go to the heart of the philosophical reflections necessarily involved in such a problem, as in all problems bearing on man's immediate relationship with the world. Obviously it is the artist's attitude—his " intuition," as Croce would say—that determines the work of art. The subject, whatever it is, even the most unassuming subject—a bowl on a table, for example—, once painted is only a projection of the painter's inner life. It is never the content of the work; this content consists in the emotion and thought which the artist puts into the work.

Even so, however, this emotion has to be roused *apropos of a motif* taken from the world around us. " Motif " means that which makes us act, makes us move—or moves us. Now in observing what has been painted in the past two or three millennia, not only in the West but in the Far East and particularly in China, and in talking with our contemporary artists, one gets the impression that the motifs supplied by the outer world fall into three categories only: *man* and his concerns—his actions, his myths, his ideas, his feelings; *nature* and all the life bound up with it, both animal and vegetable; and *things*, both lifeless objects and those that lead the precarious existence of plant life, whose immobility assimilates them to inanimate things. In short, three essential motifs: man and his life; all life outside man; and inert matter.

Most of the time painters have joined these motifs together or combined some of them. They have, however, often represented them separately. Is this voluntary limitation on the artist's part of any deep interest in itself ? It obviously points to a real and particular need, for it persistently recurs century after century, over longer or shorter periods, both in Europe and in China.

If an artist has often applied himself to a single one of the three great motifs; if certain great artists have painted many still lifes (Cézanne); or mostly still lifes (Chardin); or if they have left still lifes which number among their masterpieces, works, that is, on which they concentrated themselves entirely and in which they embodied the essence of their genius (Zurbaran, Rembrandt, Goya); then we may conclude that some particular magnetic virtue lies, not in the inanimate object in general—that virtue lies in all the elements of the visible world—but in the *isolation* of the inanimate object. This Croce is unwilling to admit, for having situated the determining force of a work of art in the artist's soul, he cannot *logically* assign any role to the motif; from the point of view of pure philosophy, he is no doubt right. But history, whose substance is life itself, cannot be bent to the laws of logic and pure philosophy. Inquiry guided by an eye and mind entirely free of any preoccupation with systems leads one to conclude that the artist has always reckoned with the motif, no doubt because of the vital, particular and—I venture to say— mysterious incitement which he gets from it. He always reckons with it; the passionate interest we find him taking today in the problem of abstract art abundantly proves it.

The issue has been considerably obscured by the fact that the esthetic ideas of the past overemphasized the importance of the motif in art: by the creation of " genres ", absurdly divided into religious, mythological and historical painting, together with the genre picture, the flower piece, the animal picture, the dead game piece etc.; each " genre " having its " laws " and classified in accordance with a hierarchy of values. These, in the course of time, came to be taken for *particular forms of art ;* whereas in reality they are only to be regarded as a few essential motifs offered by the outer world and *expressed in terms of all possible art forms.*

The reaction—in itself salutary—against these ideas, ceaselessly belied as they are by artistic and historical reality, has nevertheless been carried to the opposite extreme, to the point of no longer attaching any importance at all to what brings the artist's intuition into play. It is curious to note that the sense of

the motif's importance obscurely haunts those who deny that it has any, and leads them into surprising illogicalities. After declaring that the mere fact of painting still life fails to constitute any real link between the artists who treat this subject, they discover the existence of a " still life approach " to painting. This approach, they tell us, is not necessarily to be detected in all the artists who paint still life; it may, on the other hand, characterize a painter who never made an independent still life; such, for example, as " Vermeer, the greatest still life painter of all time" ([226]).

From this it would clearly follow that there is a whole artistic attitude corresponding to such and such a subject. A way of seeing and feeling adequate to inanimate objects; another, to landscape; a third, to man or animals—and so on. If the *Woman with a Pearl* is seen in a "still life spirit," why then it may be that Géricault's *Madwoman* is painted in an " animal picture spirit." And Renoir's *Portrait of Chocquet* in a " landscape spirit "? Are Chardin's portraits of children or his self-portrait painted in a " still life spirit "? ([227]). How are we to decide? To begin with, this approach would have to be defined. It would seem only natural to look for it in painters who found in still life their most congenial theme. But no, we are told, these painters often fail to show it at all; the only ones who give evidence of it are, apparently, those who have felt the serenity, the perenniality (" durata sentimentale ") suggested by the inanimate object: Caravaggio and a few rare painters like Vermeer, Metsu, Chardin, Courbet, Cézanne; none of the others ever made a " genuine " still life, neither Zurbaran, nor Heda, nor Van Gogh; but, by a kind of plenary indulgence, Rembrandt and Goya painted some all the same, apparently, though they fail to qualify as interpreters of " sentimental duration."

There is no point in lingering over these pleasures of the arbitrary and paradoxical. An artistic vision predestined to a given subject or motif is a mere fiction, a phantasmagoria. Attitudes to art are various, temperaments differ, they correspond to an instinctive or a lucid conception of life. Some artists are prone to feel intensely the serene and static harmonies of the world rather than those harmonies which might be called tense and unstable. These artists readily—but not necessarily—paint inanimate objects. When they are men of great breadth of mind, they paint all the aspects of the world in accordance with their sense of serene equilibrium: human figures, trees, flowers, objects. Thus Vermeer, or Chardin, who did not content himself with painting objects alone; or Cézanne; or Seurat, who painted still life only exceptionally and who, nevertheless, seemed predestined to the painting of motionless things as much perhaps as Vermeer. Other men of the same family had a vital appetite and poetic capacity more limited in scope: they made still life their exclusive subject, they became specialists. It often happens, in artists of this temperament, that the mind builds slowly, it requires certitudes patiently extracted from material things; the immobility of the model and the ease with which it can be arranged count for a great deal with them. So it is that certain individuals and even certain peoples, of a thoughtful, concrete, prudent turn of mind, instinctively fond of material things, take pleasure in still life : the Dutch.

Still life is by no means neglected, however, by artists with a dynamic vision. They give it movement by incorporating it in the flow of light, in the flux of air, by making the surface of the object vibrate by means of conspicuous brushstrokes. In Baroque still lifes movement is suggested, often with much force, by opposing the axes of objects, by a diagonal composition. Goya, the Impressionists, Van Gogh resort to many other means. Still life thus partakes of all the modes of expression, it reflects all the ways of seeing which have followed one another in the history of painting, and in all it has produced masterpieces.

But then, if still life corresponds to no particular way of seeing, if no " still life approach " really exists, what link can there be between the painters who, in the course of centuries, have contented themselves with taking objects as the exclusive theme of their painting? *Precisely this, and this alone: that they have thus limited themselves to extracting inanimate things from the world in order to make them into a work of art.*

I shall confine myself to a few observations. I see that a pebble represented by a painter in a landscape has not at all the same power of emotive prehension as the same pebble represented alone on a table. In thus isolating it, the painter performs an intellectual and poetic act with far-reaching implications: he disrupts the natural unity of the world, he takes an inanimate object out of an organic whole which gave it life. There the pebble stands, all alone, in all the nakedness of its material attributes—its dead weight, its elemental density, its dull, blind inertia. The painter approaches it with his temperament,

his " intuition ": he can accentuate all this indifference, this strangeness, this hostility to man; he can struggle with them, overcome them, and breathe life into matter; these are but the simplest, most obvious approaches, and from them, by way of the mind or the senses, the painter can deduce untold ramifications, extensions and allusive echoes.

Take Chardin. He often paints objects on a table in a genre scene. He paints the same objects in independent pictures. However attentively they may have been treated on the table of *Saying Grace*, they do not have at all the same eloquence as when they stand in isolation. Then they are not subordinated to an entire scene—an interior with men, animals etc. They themselves form a whole which stimulates the artist, and which suffices him at the same time to express his whole sensibility, his whole philosophy of life. Chardin shuts us in the world of matter and compels us, in his train, to discern therein an expression of the inner life, all the more moving for the fact that it is conveyed in terms of lifeless matter.

In our own day cubist painting has provided further proof of the attraction exerted on the artist by inanimate things. Cubism reverted to the strictest isolation of the object, to the most traditional formula of the " genre." It availed itself only of the most familiar objects, as if the better to fathom their secret by stripping them of their time-honored blandishments—literal form, palpable volume, enticing texture. And never perhaps, contrary to what is all too often heard from the lips of those for whom painting " worthy of the name " can only be imitative, never has so much importance been given to the object. Reduced, abbreviated, transposed and yet present beneath all its metamorphoses, rich in unsuspected aspects, it gains a sudden, stirring grandeur amid a geometric aridity (Juan Gris).

This is only one of those moments in history when still life took on so much importance that it is impossible to define the painting of the period without giving a prominent place to this theme. The 17th century and the end of the 19th, from Cézanne on, are just such periods. Still life then really throws light on the history of painting. Then this " genre " becomes one of the poles, one of the keys, of art. At other times it is no more than a variant of it.

For then the need to confront and explore matter was not so pressing, or was altogether lacking. Antiquity waited several centuries for it; Europe knew nothing of it for over a thousand years. This need of the mind and sensibility to isolate inanimate objects in order to concentrate all the processes of art on them—a need which I hold to be of great significance in the history of art and thought—could not make itself felt until a revision of essential values had been effected, until a new conception of the world and life had made its appearance. And this occurred when the world as a whole became matter for investigation, for classification, not only matter for mystical wonder; when culture, from medieval, became humanistic. It was at the dawn of humanism—in the first half of the 14th century, and perhaps by the help of some encouragement from the antique tradition—that there appeared not only the first pictures composed solely of objects but the first independent landscapes. This simultaneity in the segregation of the painter's motifs, of the subjects of spiritual and lyrical excitement coming from the outer world, is highly significant. It proves that the manifestations of the autonomy of still life and landscape well before the 16th century—the period which saw the first still lifes and landscapes in the form of easel pictures—are not accidents of history, but the tentative though persistent movement of slowly ripening ideas which, as in Hellenistic times, were inevitably carried in the direction of Western naturalism, towards the poetic and plastic exploration of two of the primordial motifs offered by nature.

This, to my mind, is what justifies the grouping, under the hackneyed vocable of " still life," of painters who have expressed themselves, according to their temperament and to the pictorial modes of their time, under the exclusive stimulus of inanimate things.

It may be added—and here Croce will not contradict us—that the usefulness of classifying art according to themes and motifs is indisputable. The aim of art criticism is to succeed in apprehending the personality of each artist, even in apprehending each work, in those qualities which are uniquely its own. So that to group works of art on the basis of an element lying outside the artistic attitude—and among the essential motifs inanimate things constitute just such an element—amounts to bringing out the personal or historical variations which artistic interpretation has displayed in the course of centuries.

150

Of "Trompe-l'œil", "Decoration" and the Conventions which underlie these Terms.

The paintings dealt with in these pages represent different conceptions which have found expression through the image of inanimate things. Their artistic and historical importance is obviously not the same in all cases. But in order to assess it we have to establish certain criteria, and this can only be done by first attempting to put some clarity and precision in the ideas and terms that enter into our judgment.

The current notion of art criticism has hitherto been that the history of " genuine " still life only begins when a group of objects is represented in an easel picture. Till recently, moreover, such still lifes were the only ones known and the historical account of the genre was made to begin around the year 1600, with the pictures of Caravaggio and the Netherlanders. There was only one stumbling block in this recital of the facts : Jacopo de Barbari's *Partridge*, dated 1504 (pl. 11), a picture famous for its beauty. Here was a great source of embarrassment; finding it impossible to account for this astonishing precursor, who stood alone—a little master, nevertheless, in whom nothing gave notice of an independent, innovating spirit—critics were led to belittle this painting as best they could. It was dismissed as being—or so we were told—only the reverse of a portrait of a hunter. But they forgot that Barbari proudly signed it, not once but twice, with his full name and with the caduceus he took as an emblem. A picture thus signed was certainly not intended to be kept out of sight; for it is hard to imagine, even in a Northern country (Barbari painted the panel in Germany), a portrait of a hunter with the attributes of the chase being used as the wing of a diptych or a triptych—the only arrangement which would have allowed this shutter, when closed, to show the *Partridge*. Now, thanks to the light shed on the question by Ingvar Bergström, the *Partridge* is seen to be directly inspired by marquetry: it is a decorative *trompe-l'œil* which, as an attribute and perhaps along with similar panels, adorned the woodwork of a room in accordance with a humanistic program. *Trompe-l'œil* and decoration ! Why, these are contemptible characteristics, we are told, without any interest for " great " history [228]. But in the same study, on another page, the critic who proclaims this contempt cites Barbari's *Partridge* as ranking among the masterpieces of the Orangerie exhibition, together with Zurbaran's *Lemons*, Rembrandt's *Flayed Ox* and Chardin's *Vase of Flowers* [229]. In the same way, as regards another decorative *trompe-l'œil*—Crespi's *Shelves in a Library* (pl. 70) —there is no denying that it numbers among the finest still lifes produced in 18th-century Italy; adjectives aimed at belittling the artistic interest of this work only betray a vagueness of historical judgment [230].

Critics imagine that with the same expeditious treatment they can dispose of several complete and independent paintings which represent only inanimate objects and which have recently come to light: backs of shutters from small diptychs or triptychs (fig. 6 and pl. 9), decorative panels from cupboards and woodwork (pls. 10, 11, 14). It was thought that backs of shutters could easily be brushed aside: being hidden from view, they must be " second-rate " paintings. But it was forgotten that polyptychs were kept closed most of the time, and that the backs of panels were accordingly far from being kept out of sight. Indeed, the back of a shutter reproduced here (pl. 9) is of a finer quality and a more careful execution than the *Virgin and Child* on the other side; it proves that the artist attached importance to it and that he expected his work to be seen and appreciated.

It has also been alleged that these backs of panels cannot be considered as independent paintings because their symbolic significance bound them up closely with the subject represented inside the polyptych. The same objection might be applied to Gaddi's frescos (fig. 11) or to Italian marquetry of the 15th and 16th centuries (figs. 14, 25, 26, 28), tainted as they are with an intellectual servitude, since they contain religious or other symbols conditioned by humanistic culture. More will be said presently about this particular argument.

Thus, as this doctrine would have it, all representations of still life previous to the end of the 16th century—previous to the easel picture—cannot be considered on the same plane as the paintings of the Dutch masters, Caravaggio and all the artists who have followed them up to the present day. These older works, we are told, are mongrel creations which come under the heading of applied or " minor " art; side issues of religion or humanism—the pastime of scholars; mere decorations, mere *trompe-l'œil*— the amusement of amateurs. At most they might fill up a chapter in the prehistory of still life.

To speak my mind in plain words, I think the very opposite is true. I hold that a pictorial figuration made up of objects alone, whatever the technique (fresco, miniature, marquetry, mosaic or easel picture),

whatever its intellectual content (symbolic or not), provided it constitutes *a complete work of pictorial art*, beautiful and moving, is a still life worthy of the name and offers an obvious interest for the history of art, which is a discipline devoted precisely to the study of beautiful, moving works of painting, sculpture etc. All other considerations are merely side issues. Side issues which have their due place in the general history of civilization and culture; which are highly important for the understanding of art and its history; exactly as much as for the understanding of literature or music; and which, for this very reason, can never be *decisive* in questions of art.

A single touchstone, then, to guide us: the presence of art. Take a painting or a piece of marquetry (I repeat that there are serious grounds for believing the cartoons of certain marquetry panels to have been supplied by such men as Piero della Francesca and Botticelli): if it is well composed, well executed, in other words conceived, felt and realized in such a way as to carry conviction and exalt us, then it cannot help counting for something in the history of art, it *will* count sooner or later.

In order to verify this very simple idea, it may be well to inquire more closely into the side issues on which so much emphasis has been laid: the *trompe-l'œil*, the decorative character, the symbolic content of still lifes previous to the end of the 16th century. We shall see how nugatory they are.

What is a *trompe-l'œil*? I feel sure that few people who use this term have given any real thought to its meaning. Some order has recently been put into the problem by an exhibition organized in San Francisco and, above all, by a study, remarkable for clarity and precision, written by a painter of talent, Raoul Michau ([231]).

As the easel picture, ever since Van Eyck, has been essentially an "open window on nature," an illusive representation of depth and relief, what is the difference between it and *trompe-l'œil*? This difference comes down to the following points. A *trompe-l'œil* is a *painting which sets out to make us forget the fact that it is a painting, which aspires to be a fragment of reality*. To achieve this end, it suggests not only spatial recession but also the space *in front* of the picture surface; it sets up a *continuity* between the space figured in the painting and the real space in which the spectator stands—and does so by making the relief of the body represented (an object, a hand etc.) project out aggressively beyond the frame, towards us. It keeps the *exact dimensions* of nature. Lastly, it employs a smoothly blended, *invisible execution*.

When this aim and these three conditions are rigorously respected, then—but only then—we can speak of a perfect *trompe-l'œil*. But this perfect *trompe-l'œil* is very rarely achieved: it may be said that it can only be achieved by pure craftsmen, by non-artists; this moreover is obvious, inasmuch as the essential purpose of such a work is to make us forget that it stems from art, that it resorts to an artifice. A certain number of recipes and "tricks of the trade" suffice. But ask a real painter, an artist, to abide by the three conditions: he will try hard, but the chances are he will prove incapable of not transgressing them; he will produce a work of art in spite of himself. He will exactly reproduce the dimensions of nature, he will make his brushwork invisible, he will create the impression that the picture surface does not exist, that objects really stand in the same space as we do; but instinctively, in the arrangement of objects and in the color scheme, he will cause a rhythm, a harmony, a choice, a taste to show through, and we shall at once be made to feel *the presence of art*, we shall at once be given notice that *we are in front of a painting* and not in front of reality. The fundamental, the exclusive purpose of *trompe-l'œil* will have miscarried; the work in question will be a painting of a particular realistic tone, often more powerful than that of reality itself, imbued with a disquieting magic of the palpable, of the present. Such is the case with the "*trompe-l'œil*" paintings of Wallerand Vaillant (pl. 34), Liotard, Peale (pl. 81) or Boilly, who took great pains to produce a literal image of nature, to become artisans instead of artists, but without managing to do so; and such, with greater reason, is the case with Barbari (pl. 11), Everdingen (pl. 35), Crespi (pl. 70) and Chardin (pl. 69), who, while aspiring to make decorations indistinguishable from reality, all ended by frankly acknowledging their capacity as poets and artists. Their works are examples of *artistic trompe-l'œil*. Hence the fact that they are reproduced in this book, which is a book on art. The Dutch of the 17th and 18th centuries were so keenly aware of the illusionist inadequacy of artistic *trompe-l'œil* pictures that they cut groups of objects from them and arranged them on tables or mantelpieces among real objects, in real space. In thus depriving painted objects of their painted background, they destroyed an artistic unity, a certain extra-real harmony, which prevented the eye from surrendering to total illusion.

Particular circumstances in the last three-quarters of a century have contributed to obscure these notions and to confer on *trompe-l'œil* a distinctly pejorative connotation. First of all, the abominable recipes for imitative trickery purveyed by the academic instruction of the eighties and nineties led to a confusion between craftsmanship and art. Then the freedom of interpretation enjoyed by anti-academic art, from Impressionism to the present day, produced a violent reaction: every painting which set out to reproduce nature in minute detail was baptized " *trompe-l'œil* " and assimilated to academic painting or tainted with suspicion. In our own day, the *papiers collés* of the Cubists and the fragments painted in " *trompe-l'œil* " in surrealist pictures have led to mistakes and misunderstandings: the first, by putting the imperceptible technique of *trompe-l'œil* to the service of a paradoxical intention; the second, by letting it be supposed that their " hand-made color photograph " of objects had its antecedents in the works of the worthy " magicians of reality " of the past, the painters of contrived or artistic *trompe-l'œil*—for in their eagerness to find themselves a historical filiation, there was no time to consider the matter carefully.

Art criticism has inherited much of this confusion. With the result that, nowadays, to describe a picture as a *trompe-l'œil* is to discredit it ([232]). But what certain critics fail to realize is that, when they admire many paintings which they assume to be easel pictures, they are actually admiring works which were originally intended as decorative *trompe-l'œil* pictures by the men who made them, and who were true painters, sometimes even great painters, like Melendez and Chardin.

Are we to conclude that the use of the term should be exclusively reserved to successful *trompe-l'œil*, in other words to the craftsman's entertaining mystifications? For my part, I cannot approve of any such purism. These works are quite rare, whereas artistic *trompe-l'œil* pictures have been preserved in large numbers—which proves, incidentally, that the public was not taken in, that it sensed the presence of art and acquiesced in the destruction of paintings which were no more than playthings. The latter I would designate " *trompe-l'œil* properly so called "; and I shall speak of a " *trompe-l'œil* quality " or " *trompe-l'œil* procedures " in connection with fine paintings which on the surface tend towards literal verisimilitude—on the surface, for actually they go well beyond it.

Decorative—this is another epithet which is supposed to have the power of lessening the interest of still lifes in marquetry or those which adorned furniture or woodwork. Here the vagueness of ideas is no less dangerous than in the matter of *trompe-l'œil*. The decorative character of a painting may be twofold: it may apply to its style or to its purpose. In the case concerning us here, it can only be a question of the purpose the picture was meant to serve. For the style, even that of marquetry panels, in which shadows and lights tend to be flat surfaces, is nevertheless essentially imitative; it is the style of artistic *trompe-l'œil*. The feeling for volume and texture in oil paintings intended for decorative purposes (pls. 10, 11, 12) is neither more nor less intense or rich than it is in other pictures of the period, or than it is in still lifes of the 17th century. This is proved by the fact that, till ten years ago, Barbari's *Partridge* had always been taken for an easel picture and admired as such. The stylization of marquetry, which is often admirable, involves interlockings of slightly geometrized forms which invite comparison with those of the Cubists, notably Braque (fig. 25; lower part of fig. 28). The object never suffers from a decorative puniness; on the contrary, it appears enlarged, monumental; it loses nothing of its prestige. But what about its decorative purpose, its lowly task of acting as a cupboard door, or as a kind of shop-sign telling us what is contained inside? How can such a painting be taken seriously? The fact that its author took it seriously should be reason enough for us to do so. The *Cupboard with Bottles and Books* (pl. 10) is a very fine piece of painting, carefully composed, with its stately rhythm, its color at once intense and harmonious, its sharp lighting, its powerful, monumental effect. The *Cupboard* dated 1538 (pl. 14), product of a less polished art, is also a sensitive painting easily worth the similar still lifes which form part of contemporary compositions by Jan van Hemessen. These pictures are the work of talented artists, not of craftsmen. We need only note that, in the late 15th and early 16th century, in the North, such artists were not above painting fine pictures on furniture. Later the custom continued: the charming and celebrated *Goldfinch* by Carel Fabritius, at the Mauritshuis in The Hague, served as the door of a small cupboard or cage; Chardin's *White Tablecloth* (pl. 69) was a firescreen, equivalent to a folding screen or a piece of furniture; Watteau, who grew up in a Flemish atmosphere, intended his finest picture to serve as a shop-sign for Gersaint. I utterly fail to see how the decorative purpose of a painting can in any way impair its artistic

value. Perhaps it limits its radiation, its influence, its action as a historical agent? I shall come back to this point under the next heading.

Nevertheless, it may be objected, all these paintings previous to 1600 convey a symbolic meaning, they do not have the total intellectual independence of later pictures, in which still life is painted " for its own sake." When we have the back of a panel representing *Books and Basin in a Niche* (pl. 9), these books and this basin, we are told, are not painted " for their own sake," but in relation to the Virgin on the other side of the panel. Imagine such and such a *Vase* (fig. 6) separated from its Virgin (by sawing the panel through between the two paintings): it will lose its meaning.

Let there be no mistake: it will indeed lose its meaning, but only its conventional meaning. It will not lose its underlying artistic meaning, which is the revelation of the beauty which the artist glimpsed in that still life and which he expressed in a self-sufficient painting. It will lose nothing of its plastic autonomy, it will still be the same complete picture, the same intensely realistic representation of inanimate objects that it was before being separated from the image of the Virgin. The diptychs and triptychs of that day often include a wing on which the donor is portrayed, his hands clasped, his gaze turned towards the Madonna figuring on the other wing. It sometimes happens that these donor portraits have been separated from the rest of the polyptych. Today more than one of these figures turn in prayer and stare into vacancy; one of them, in Washington, leans on a table covered with a rich carpet which continues in the Madonna panel, in Berlin (233). Looking at them, one feels at once that these portraits are incomplete, that they depend on some missing element. Yet no one has ever questioned their quality as portraits. They are considered to be authentic links in the history of portraiture. They figure in exhibitions of portraits without causing any surprise; they are regarded as portraits painted " for their own sake." And all this is as it should be. Yet, from the point of view of their spiritual significance, they are not painted for their own sake. They portray strongly characterized persons as such, but portray them in their capacity as Christians in the act of faith. They are portraits with a religious significance. Well, the *Books and Basin in a Niche* (pl. 9) and the *Vase of Flowers* (fig. 6) are strongly characterized portraits of a basin and a vase represented as accepted religious symbols. They are still lifes with a religious significance.

All medieval painting had a religious significance, and when the portrait, the still life and the landscape developed into independent pictures, they retained for a time their symbolic, intellectual servitudes. No one would for a moment dream of questioning the landscape quality of Patinir's panoramic views. Yet they are religious paintings, they include a tiny scene with human figures which, at the time, qualified them as such. Furthermore, it is highly probable that the landscape itself has a symbolic significance, that it evokes the image of the earth or the universe: around 1500, in pictures representing the globe of the world (Bosch, Van Cleve etc.), this globe, instead of being a crystal ball or a *mappemonde*—abstract images— is covered with veritable panoramic landscapes. The landscapes of the great Pieter Brueghel are still, nearly always, provided with an intellectual pretext: they are allegories of the months or seasons; or they illustrate proverbs. They nevertheless rank among the finest, most important of all landscapes from the historical point of view.

Thus the early still lifes were charged with symbolic, neo-Platonic, astrological (in marquetry) or other allusions. But so were the still lifes subsequent to 1600, more often than is realized. First there are all the *Vanitas* pictures; then the allegories of the *Five Senses*; then most of the Dutch *Desserts* or *Meals* of the 17th century, in which a watch lying beside choice foods evokes the Puritan exhortation to temperance. So far no one has denied their quality as perfect still lifes; yet they are *peintures à clé*, just like the backs of polyptych shutters and marquetry panels. In modern times too, still life may be charged with allusive significance: this is often the case with Van Gogh, and with Gauguin in his *Sunflowers with Puvis' " Hope."*

So that neither their *trompe-l'œil* character, nor their decorative function, nor the fact of comprising a spiritual content, prevents us from considering still lifes previous to 1600 on the same artistic plane as those which have followed them up to the present day. Let us turn now to historical considerations and see whether they really form an insuperable barrier between these two groups of paintings.

154

The Appreciation of the Period and the Judgment of History.

Indeed, though we attach to these early still lifes an artistic importance equal to that of later still lifes, it may be that contemporaries set no very great store by them. And if this were so, would our judgment be tantamount to a distorted view of history? Would we be numbering mere accidents and curiosities among the factors of life?

There are two kinds of contemporary witnesses who count: artists and art critics (or art lovers). Since the voices of artists of that distant period have only reached us in exceptional instances and through the agency of critics, it may be well to begin with the latter.

For art criticism of the 17th century, more or less throttled by academic ideas, there was no hesitating: it regarded still life painting as an altogether secondary " genre," almost contemptible. This judgment applied not only to older examples—*trompe-l'œil* or decorations—but to everything in the way of still life that was then being painted in Europe. How cautiously Pacheco comes to the defense of Velazquez' *bodegones!* Though convinced that " it is owing to *bodegones* and portraits that Velazquez has found the true manner of imitating nature," he hastens to emphasize that the painting of motionless things is easier than that of living things. One feels that, in the end, it is the irresistible talent and brilliant success of his son-in-law that tip the scales here, and not any deep esthetic conviction. Pacheco's attitude is identical to that of Pliny when he speaks of Piraikos; besides, it proceeds from that of the ancient writer, as does the position taken by Vasari and the Mannerists, which is contradictory and hesitant: a still life may be admirable, yet it has to be confessed that it is not as " noble " as other subjects.

To be sure, there must have been many artists who, without resolving the contradiction, realized that it was artificial. And many art lovers too, not only in the North but also in Italy, and even if they were " classicists ": the cabinet of Cassiano del Pozzo, Poussin's friend, included—in the first half of the 17th century—a whole roomful of pictures of flowers, fruit, fish and animals. The Royal Academy of Painting in France, theoretically won over to the hierarchy of " genres " in which still life was relegated to the bottom of the scale (or nearly so), nevertheless admitted to membership a very large number of still life specialists [234]. But the theory itself, in spite of a few nuances introduced into its strictness by the artists of the North, such as Gérard de Lairesse, remained unshakable. Reading Lanzi (1789) one might gather that everything ever painted in the way of still life—by Caravaggio, by the Dutch masters, by Zurbaran, Velazquez, Rembrandt, Chardin—amounted to no more than craftsmen's handiwork, manifestations of "pittura inferiore." Imagine for a moment that all these paintings had been destroyed, that only Lanzi's book was left to give us an idea of them: think of the kind of art history that might result. And so things remained up to 1865, when a certain Gonzague Privat echoed academic opinion and declared, referring to Manet, that it is " less difficult to paint a saucepan or a lobster than a nude woman " [235].

Art theory always lags behind art practice; in the field of still life this backwardness is monstrous. So we do best to leave critical writings aside and take the artists themselves as guides in order to decide whether or not the still lifes painted before about 1875 count in the history of art. But before consulting the artists or rather their works, let us pause for a moment over the opinion of a theorist, a contemporary, as it so happens, of the first still lifes: Vasari.

It is surprising to find that he is much more impartial in his appreciation than the men of the 17th century. True, he did not yet distinguish the painting of inanimate things as a special branch of painting. But he distinguished a mental category of motifs comprising the whole of nature outside man. He called it " tutte le cose naturali " and included in it objects—vases, instruments—as well as flowers and fruit. He by no means despised the painting of these things; and the fact of their being sometimes decorations did not matter to him. Thus in speaking of Giovanni da Udine's grotesques it seemed as if he could not praise them enough: " But what should I say of divers kinds of fruit and flowers which are to be found there in boundless profusion and in which are respected all the manners, all the qualities, all the colors that nature can produce in all parts of the world and all seasons of the year? And, likewise, what should I say of sundry musical instruments which are to be found represented there with the greatest possible naturalness? " What Vasari admired here was not the skillful decorative arrangement, but the realism of the work and the genuinely pictorial manner of rendering it. Indeed, he tells us—and he saw

Giovanni da Udine's paintings in all their freshness—that this painter succeeded in treating objects broadly, with a thick impasto, " con una certa maniera morbida e pastosa," while his Flemish master, a certain Giovanni, rendered them somewhat drily and laboriously, " di maniera un poco secca e stentata." Vasari, then, considered these objects in their intrinsic nature—for him they were objects painted " for their own sake " (236). Proof that Giovanni da Udine was regarded as capable of painting objects both with the highest degree of realism and with style is provided by the fact that Raphael entrusted him with painting the musical instruments in his *St. Cecilia*. Vasari describes them as being admirably true to life and perfectly in keeping with the rest of the picture. It is obvious that the requirements of the realism of the period were fully satisfied by Giovanni da Udine. But these requirements change; at the end of the 16th century the first Baroque generation required a more intense, more thoroughgoing realism, and it was Caravaggio who felt this need in Italy, while in the Low Countries, independently, a number of little masters felt it at the same time.

Let us see now what the artists themselves thought of still life, particularly in Italy, in the 16th century. If Giovanni da Udine was an excellent painter of objects, Raphael, by entrusting him with that part of the picture, seems to show that he was not enough interested in it to paint it himself. But the other great Italian masters themselves painted the objects in their compositions: Titian, Veronese. Still, there is no denying that *the idea of separating objects and taking them as the theme of an independent painting* did not yet interest them. This being so, are we to infer that the idea is of no account in art history ? As regards pure landscape, the great Italian masters no more devoted themselves to it than they did to objects. Veronese was the only one among them to do landscapes without figures, in the decorations of the Villa Maser. Yet no one denies the existence before him of pure landscape represented in Italy, from the beginning of the 16th century, by such " little masters " as Lotto, Dosso, Niccolo dell'Abbate and many others.

An artistic idea is not kept alive only by the great masters. It is not kept alive only in this or that technique regarded as " superior, " for example the easel picture. Art history is still encumbered by the conventional notion of these partitions, these hierarchies separating the " great " masters from the " little " ones, marquetry from fresco painting, the miniature from the easel picture, and so on. These are purely utilitarian categories, convenient for historical accounts. They are too often taken for realities of life. A little master may hit on a momentous innovation of which a great master will one day avail himself to produce a masterpiece; the fact is that the more extensive our knowledge of art history becomes, the more we realize that there is not a single instance of a great master without a precursor. An art form—an artistic idea—often passes from the domain of the fresco to that of the easel picture, from that of the easel picture to that of the stained-glass window, and so on. The role played by prints, by engraved gems, by coins, is not always sufficiently emphasized in the transmission of plastic ideas from other media to " great " painting. What is more, the painter of the past, prior to the High Renaissance, never confined himself to a single technique. He made frescos, easel pictures, cartoons for stained glass and tapestries, prints, designs for ceramics, and he polychromed statuary. Painting for him was a many-sided activity. Academicism laid down classifications and specialties based on the difference of techniques and their purely conventional, traditional hierarchy. In our own day the strongest, most vital artists have reverted to the simultaneous practice of several techniques.

But even when he did not practice several techniques, at the time when the academic point of view prevailed, towards the end of the 16th century, can it seriously be believed for a moment that the strong and vital easel painter was blind to the novelties that might be offered by decorative painting or marquetry ? Can it seriously be believed that, at the time when still life was playing an increasingly important part in the figure scenes of a Passerotti or a Campi, painters took no notice of the other forms assumed by still life: those independent compositions which appeared in mural decoration or in the oil paintings of Giovanni da Udine, and those flower and fruit pictures of Carlantonio Proccaccini of which all trace has been lost for the time being, but which are known to have existed ?

We have seen that Caravaggio, while reacting against Mannerism, took over its themes, in order to give a lesson of " true painting after nature." Here, in Italy, is proof of historical continuity—continuity achieved by antithesis as well as by development.

This continuity is no less evident in the Low Countries, and there too it came about through a reaction against Mannerism and a return to unruffled, minutely detailed realism, that of the miniatures and decorative *trompe-l'œil* pictures of the late 15th and early 16th century. The pictures of a *Meal on a Table* by Floris van Schooten (pl. 19) or Osias Beert have a much more remote connection with the kitchen pieces determined by the art of Aertsen or Beuckelaer (pl. 17, fig. 31), surging and aggressive displays of food, than they have, by virtue of their " primitive " spirit and style, with the *Meals* which figure in the compositions of such painters as the Master of Frankfort, Teunissen and Heemskerck (²³⁷), and with the older niches (pl. 9), cupboards (pl. 10) and *Vanitas* pictures (pl. 8). Why this return to the spirit of the early still lifes ? First, because they offered the example of pure still lifes, without figures, whereas those of the Mannerists could never quite do without figures (fig. 30-32). Secondly, because the object here was not dominated by a curvilinear stylization and an agitated rhetoric in keeping with mannerist figures: it was seen " for its own sake," it was conceived in a spirit of earnest realism. This realism answered better to the naturalistic aspirations of the late 16th-century Flemings, who, without coming into contact with Caravaggesque Italy—though they were Caravaggio's exact contemporaries—felt the need of a reaction against Mannerism, a need characteristic of emergent Baroque. Owing to the scarcity of surviving paintings, it is not now possible to say who was responsible for the appearance of pictures of a *Meal on a Table* of the type exemplified by Floris van Schooten and Osias Beert. Probably it was not a great artist, more likely some bold little master.

It is a fact that still life in its early days was only kept alive by the efforts of " little masters." The situation was much the same with landscape. Patinir was the bold " little master " who expressed in painting the humanistic, Italian idea of representing a panoramic view for its own sake, just as it was expressed in marquetry, notably in the large landscape in the Urbino *studiolo* (fig. 16). Thereafter, by way of the works of a whole series of specialists—Herri met de Bles, Lucas Gassel, Frans Mostaert, Cornelis Massys, Cornelis van Dalem, Hans Bol and others—landscape found its grand master in the person of Pieter Brueghel the Elder. But already the *vedute* and still lifes of Italian marquetry had embodied the striking idea of making these two " genres " independent (²³⁸). They could be seen in famous buildings accessible to the public, comparable to our museums, and were thus able to exercise a far-reaching influence. Since this remote manifestation of the Quattrocento, the idea of pure landscape and pure still life has existed for art and has been able to affect artists. It accordingly exists for history.

The Human Attraction of Inanimate Things.

By expressing himself through the image of inanimate things, the painter shows his art in all its power. For unless he deliberately charges these things with a symbolic meaning, still life provides no food for the spirit of anecdote. Nor is the painter himself helped out by the associations of ideas which are born of movement—in landscape they spring from the very image of a tree or a cloud—and which propose to the mind a semblance of action. These two traits of austerity, these two difficulties of still life, have been regarded for centuries as degrading traits. It has been claimed that still life fails to awaken any thought, and that its immobility offers the painter a facility not only of procedure but of result. We know today that a still life can satisfy the mind; that a few pieces of fruit in a dish can evoke all possible harmonies of the universe, all its rhythms, lights, color accords, just as music does. We know too that Chardin's *Pipe* is worth Watteau's *La Finette*. Since still life came into existence artists have realized this, more or less obscurely, more or less timidly, for the pompous reprobation of the theorists kept them silent. They acknowledged it by the fervor with which they concentrated on the object. Though we know nothing now of the opinions held by the artists who preceded Caravaggio—he had the courage to proclaim the equality of a bouquet of flowers and a figure, and his remark has come down to us—we need only observe the depth of sensibility and wonder mirrored in their pictures of objects, whether marquetry, *trompe-l'œil*, backs of small diptychs etc. Not only did they paint each object with the same care which their period accorded to the human figure, but—and this is all-important—*they made the effort to compose with objects alone an autonomous work of art comprising an internal cohesion and a complete plastic life.* Yes, artists

have known for centuries that a vase of flowers may be worth an angel. But critical thought and the general consciousness only acquired this notion in recent times, about 1875, when the cult of nature in its two forms—realist and impressionist—definitively restored the old masters of still life to a place of honor.

We know today that the only thing to be read into a still life is the life the artist imparts to it, for he finds in inanimate things the stuff of dreams, and is prompted to evoke a crystalline calm or dramatic tension, to suggest the ever mysterious alliance of a body with space invaded by shadows, or the mystery of the sudden presence of a body in full light, at times more disquieting, more refractory to the total prehension of our senses and our mind than indistinct twilight.

So many still lifes, so many expressions of personal thoughts, feelings, temperaments. And yet, oddly enough, this inner life has been expressed for two thousand years by a choice of objects which has remained remarkably constant. Each period of course has introduced the objects in use at the time. In *Vanitas* pictures the watch replaced the hourglass, and Cézanne's fruit dish has sometimes given place to tubes and gear wheels. Today we are surrounded by unparalleled quantities of machine-made objects. We live, as it were, redoubled by objects which prolong the effective action of our limbs and extend our field of vision. But though we create them ourselves, their substance and forms are alien to us and take us by surprise. The mechanical processes of their manufacture remain enigmatic for us and leave us indifferent. They have not yet found a place in our inner life. So that repeated attempts to renew the still life repertory by introducing either objects newly cast, or tools, or machines, have so far remained sterile.

These attempts are only an interlude in the centuries-old monotony of still life themes. From the artists of Pompeii to Picasso, Braque and Matisse, the paintable things have remained the same: flowers, fruit and other items of food, the receptacles containing them, and a few objects which intimately accompany us through life—a book, a pipe. These are commonplace things, within hand's reach. They have been, as it were, domesticated by man since time immemorial. An exhibition of still life pictures resembles a huge larder decked with flowers. It radiates a warm sense of domestic intimacy. Everything in it seems made for man, and made to his measure. If we never tire of a still life as we tire of a portrait or a composition, this is not only because its play of lines and colors is almost entirely free of anecdote and of the precise suggestions of a subject which we end by exhausting. It is not only because of the latitude which still life leaves to our imagination. But also because inanimate things, so closely bound up with daily life, represent man's most immediate commerce with matter. They afforded each of us—when we were babes in the cradle, toying with objects for hours—our first contact with the world, and by way of these things the artist revives our maiden sense of wonder and our first dreams.

158

NOTES

PREFACE

1. – Thus, for example, in his excellent article on *Les Bêtes et les Humains de Roelandt Savery* (in *Bulletin des Musées Royaux de Belgique*, 1958, p. 76, note 18), Jan Bialostocki regrets that Savery was no more than " barely mentioned " (pp. 43 and 58) in my book. But as a painter of *Vases of Flowers* in niches, Roelandt Savery was not the inventor of this type of picture; he did no more than follow Jacques de Gheyn, as is made clear by Bergström's investigations. He is only a remarkable exponent of a " conception " of flower painting, and as such deserves no more, in an overall survey, than the mention of his personal contribution to this conception (the application of a new chiaroscuro) and a reproduction (fig. 22).

2. – *Revue des Arts*, 1952, p. 15, and *Gazette des Beaux-Arts*, 1955, p. 182.

3. – I. Bergström, *op. cit.*, English edition (1956), p. 291.

4. – I. Bergström, *op. cit.*, English edition (1956), pp. 14, 291, 292.

5. – The 1952 edition of my book included (pp. 38-39) a short chapter entitled " Mannerism and Still Life " in which I emphasized the importance of this movement for 16th-century still life painting and for the *bodegone* in general. In the Swedish edition of his *Dutch Still Life Painting* (1947) Bergström makes no mention of the Mannerism of Aertsen and Beuckelaer (pp. 19-24). In the English edition of 1956, however, he speaks of it insistently (pp. 23-24 and 292) but the only author he cites as having dealt with the matter is Baldass (see Bibliography, chapter on the Middle Ages and the Renaissance), of whom he says, however, that " he does not draw any general conclusions as to the origin and development of still life painting " (p. 297, note 61).

CHAPTER ONE: *ANTIQUITY*

6. – It has often been inferred from Pliny's mention of him that Piraikos was the first to treat the subjects to which he owed his celebrity. But nothing in the sentences that follow justifies this conclusion (cf. *Recueil Milliet, Textes grecs et latins relatifs à l'histoire de la peinture ancienne*, edited by Adolphe Reinach, Vol. I., 1921, pp. 390-393, No. 519): " This is the place to add the artists who made themselves famous by the brush *in a less lofty genre*. One among them was Piraikos. I know not whether he did himself harm by the choice of his subjects; the fact remains that, by confining himself to humble subjects, he has nevertheless, for all their lowliness, *obtained the greatest glory*. We have by him (he painted) barbers' and bootmakers' shops, donkeys, *foodstuffs* and suchlike things, which earned him the nickname of *rhyparographer*. His pictures *give infinite pleasure* and fetch higher prices than very large works by many artists." As Adolphe Reinach suggests (*op. cit.*, p. 393, note 1), Antiphilos, Nealkes, Philiskos and Simos appear to have preceded Piraikos in treating subjects of the category called " rhopography " or " rhyparography."

7. – See the previous note. The passage as a whole seems indeed to imply that the " very large works by many artists " are to be understood as being examples of " megalography " in the sense which Vitruvius gives to this category, namely works with noble subjects.

8. – Pierre-Maxime Schuhl, *Platon et l'art de son temps*, 1952, p. 8, note 3. I am much obliged to M. Pierre Devambez for having drawn my attention to this remarkable book. I also take pleasure in recording my warmest gratitude to another colleague at the Musée du Louvre, M. Jean Charbonneaux, for invaluable bibliographical advice and much enlightenment in the field of ancient painting, with which I am not familiar.

9. – Pierre-Maxime Schuhl, *op. cit.*, pp. 22 and 35. The reflections of this author seem to me highly pertinent and might be profitably meditated on by critics of the art of our time.

10. – Cf. note 6.

11. – According to Pfuhl, *Meisterwerke Griechischer Zeichnung und Malerei*, 1924, p. 87, this explanation appears to be more correct than the one formerly proposed (*e.g.* by A. Bougot, *Philostrate ancien, Une Galerie Antique*, 1886, pp. 350-352), which held *xenia* to be the gifts offered by guests from the country to their hosts in the city, and which was adopted in the *Catalogue de l'Exposition de la Nature Morte, Orangerie*, 1952, p. 1, No. 1.

12. – Amedeo Maiuri, *La " Nature Morte " dans la peinture de Pompéi*, Preface to the *Catalogue de l'Exposition de la Nature Morte, Orangerie*, 1952, p. VIII.

13. – Amedeo Maiuri, *op. cit.*, p. X.

14. – Cf. Doro Levi, *Antioch Mosaic Pavements*, 1947, 2 vols., pp. 132-136, pls. CLII and CLIII (The House of the Buffet-Supper).

15. – Reproduced in color in G.E. Rizzo, *La Pittura ellenistico-romana*, 1929, Tav. D.

16. – Quoted from Bougot's edition (cf. note 6), p. 349. Compare the translation of Adolphe Reinach, *op. cit.*, note 1, p. 392.

CHAPTER TWO: *THE ORIGINS*

17. – See the reproductions of the miniatures representing the *Four Evangelists* of Garret MS. 2, Princeton University Library, in the *Catalogue of the Exhibition of Early Christian and Byzantine Art*, Walters Art Gallery, Baltimore, 1947, No. 725, pl. CIV, and the article by K. Weitzmann, *Gazette des Beaux-Arts*, LXXXVI (1944), p. 201 ff., fig. 5.

18. – Charles de Tolnay, *Les Origines de la Nature Morte*, in *La Revue des Arts*, 1952, No. 3, pp. 151-152, figs 1 and 2.

19. – This remark made by Tolnay himself could not be included in the text of his article cited in the previous note. But he provided a striking illustration of it by publishing a very early example, of the 12th century, in the church of Santa Maria Maggiore at Tuscania, which has a real niche, the back of which is painted with three liturgical vessels (the large jar for wine, the small ones for oil ?) (cf. *Notes sur les origines de la nature morte*, in *La Revue des Arts*, 1953, pp. 66-67, reproduction p. 66). There is a parallel here with antiquity which it is worth while pointing out and emphasizing: the idea of replacing the real arrangement of objects, as they were to be found in daily life, by a pictorial representation of them conceived as an artistic *trompe-l'œil*. As in antiquity, objects of a " minor " character placed in niches accompanied large-scale religious compositions on one and the same wall: the " vulgar " subject was offered to the attention of artists and public at the same time as the " noble " subject *par excellence* and claimed its artistic rights, despite the reservations of theoretical thought and its hierarchies.

20. – Jaroslav Pesina dates the mural decoration of the Smisek Chapel to about 1490 (*Malirska Vyzdoba Smiskovske Kaple v*

Kostele sv. Barbory v Kutné Hoře, in *Umeni*, XII, 1939, pp. 253-266). The same author sums up the documents concerning Roman the Italian in *La Peinture tchèque du XVᵉ et du XVIᵉ siècle*, Prague, 1958, p. 10. I am much obliged to Mr. Novotny, Director of the Institute of Art History in Prague, and to Miss Vera Mixova of the same Institute, for having enabled me to publish a photograph of the Kutná Hora painting.

21. – Though no definite statement to this effect is contained in the text of his article (cf. note 18), Tolnay has assured me that, in spite of the deterioration of the two frescos, the existence of cast shadows is indubitable. A recent examination of them leads me to share this opinion. The shadow cast by the book, which projects beyond the shelf on which it lies at an angle—a device for suggesting depth which became common in still life painting up to Cézanne—is visible even in the reproduction (fig. 2) contained in Tolnay's article. There can be no question here of later retouchings.

22. – The two stelae are cited by G.E. Rizzo, *La Pittura ellenistico-romana*, 1929, p. 31; the one at Pagasae is reproduced, pl. XLVIIIa. A good color reproduction of the Rimini fresco is to be found in *Gothic Painting*, by J. Dupont and C. Gnudi, Skira, 1954, p. 113. This fresco has sometimes been attributed to Baronzio (B. Berenson, 1932 Lists, p. 44).

23. – Jean Adhémar, *Influences antiques dans l'art du moyen âge français*, 1939, p. 91. This excellent book abounds in unpublished material and information that is difficult to find.

24. – Jean Adhémar, *op. cit.* (previous note), p. 254. This historian emphasizes the unquestionable fact that medieval artists had seen antique mosaics.

25. – The most important studies dealing with the influence on 15th- and 16th-century artists of the finds made in the Domus Aurea are: the article by Schmarsow in the Berlin *Jahrbuch*, II, p. 134 ff.; that of F. Weege, of capital importance, in *Jahrbuch des deutschen Archeol. Inst.* XXVIII (1913), p. 127 ff.; and the first chapter of the book by Arnold von Salis, *Antike und Renaissance*, 1947, p. 37 ff. Cf. also R.-A. Weigert, *Jean Berain*, Book II, p. 193 ff.

26. – Phyllis Pray Bober, *Drawings after the Antique by Amico Aspertini*, 1957, p. 35, note 1, figs. 132 and 135; Ingvar Bergström, *Revival of Antique Illusionistic Wall-painting in Renaissance Art*, Göteborg, 1957, pp. 27-35, figs. 7-11.

27. – An excellent recent summing up of the investigations so far made into this problem was given by Ingvar Bergström, *loc. cit.*, previous note; see in particular p. 25, note 1. See also Suzanne Sulzberger, *Rubens et la peinture ancienne*, in *Revue Belge d'Archéologie et d'Histoire de l'Art*, XI (1941), I, p. 64, note 13, which cites Vol. XIX of the collection of drawings made for Cassiano del Pozzo (died in 1657) at Windsor Castle, entitled: "Antiche pitture raccolte dalle ruine di Roma."

28. – *Op. cit.* (note 25).

29. – One 16th-century mention of the paintings in the Domus Aurea seems to have escaped the notice of historians. It was discovered by Mme Denyse Métral in the *Décades* (1583) of Blaise de Vigenère, French archeologist and art critic of the Renaissance (1523-1596). The interest presented by the work of this forgotten writer was aptly pointed out by Mme Métral in her book, *Blaise de Vigenère*, E. Droz, Paris, 1939 (see in particular pp. 144-145).

30. – Catalogue of the exhibition *La Nature Morte de l'Antiquité à nos jours*, Orangerie, Paris, 1952, p. 22.

31. – Millard Meiss, *Painting in Florence and Siena after the Black Death*, 1951, p. 71.

32. – Cf. note 17.

33. – Luigi Coletti, *L'Arte di Tomaso da Modena*, 1933, pp. 139-140, pls. XX-XXI, establishes a link between Tomaso's art and that of Van Eyck; he makes his point by juxtaposing the head of Albertus Magnus (Treviso) and that of Canon van der Paele. This affinity cannot be dismissed as an accidental analogy. What we no doubt have here is a persistent current of bourgeois realism which, through the instrumentality first of Altichiero and Avanzo, then of the Lombard miniaturists of the *Tacuinum Sanitatis* and the Franco-Flemish miniaturists who knew Lombard art either directly or indirectly, penetrated into the Flemish art which nurtured the Van Eycks and the Master of Flémalle in their youth. But this filiation seems to hold good for the latter rather than for the Van Eycks. It is with the vigorous plebeian heads of the Master of Flémalle (see his earliest works, those in the Prado) that Tomaso's faces, at once fleshy and energetically detailed, link up; it is of his smooth, tactile, heavily shadowed relief, of his incisive contours, that we are reminded by the figures and architecture of Altichiero (Padua) and by those of the *Tacuinum*. Among the Franco-Flemish miniatures which show a knowledge of the art of the *Tacuinum* or, in a general way, of Lombard art, and which owe their emphatic plasticity to them, mention must be made of the " *Térence des Ducs* ", *Le Livre des Femmes Nobles et Renommées* of Boccaccio, and several pages of the *Très Riches Heures* at Chantilly, whose cool, bright colors directly announce those of the Master of Flémalle; these miniatures, dating as they do to 1400-1415, represent the art that must have counted in the formation of the great Flemish innovator.

CHAPTER THREE: *THE NORTH*

34. – This thesis was put forward by Charles de Tolnay, *Le Maître de Flémalle et les Frères Van Eyck*, 1939.

35. – The Polling Altarpiece is dated 1444 (reproduced in *Pantheon*, 1941, p. 225). The *Annunciation* by Justus Amman of Ravensburg, signed and dated 1451, is in Santa Maria di Castello at Genoa (reproduced in A. Stange, *Deutsche Malerei der Gotik*, IV, figs. 47, 48). Lippi's picture, dating to 1437, is the *Virgin and Child* in Tarquinia Museum; its *cartellino* is perhaps the earliest we know of in Italian painting. Niccolo Pizzolo's *Four Fathers of the Church* (destroyed by bombing), formerly in the Ovetari Chapel at the Eremitani, Padua, dated from 1450 (reproduced in *Mantegna, Klassiker der Kunst*, pp. 150-151; cf. Giuseppe Fiocco, *Mantegna*, n.d., Gallimard, p. 21 ff.). These paintings are of the highest importance as evidence of the influence in Italy of the Master of Flémalle's stereoscopic realism; Padua seems to have been a focal point of Flemish and German influences round about 1435-1450. The painting in question by Antonio da Fabriano is *St. Jerome in his Study*, signed and dated 1451, Walters Art Gallery, Baltimore.

36. – At least one example can be cited for each successive generation from 1450 to 1525: for Memling's generation, a *Skull* with an inscription from the Book of Job in a small polyptych in Strasbourg Museum (No. 73, Catalogue by Hans Haug, 1938), by an artist in the immediate circle of this master; for that of Gerard David, the *Skull* in Gossaert's Carondelet Diptych in the Louvre, dated 1517; for that of Joos van Cleve, the *Vanitas* by Barthel Bruyn the Elder, dated 1524, reproduced here (pl. 8). A particularly striking example of a skull in a niche treated in Flemish miniature painting is to be found in an illuminated page by the Master of Mary of Burgundy (reproduced in Otto Pächt, *The Master of Mary of Burgundy*, 1948, pl. 34).

37. – Cf. Otto Brendel, *Untersuchungen zur Allegorie des pompejanischen Totenkopf-Mosaiks*, in *Mitteilungen des deutschen Archäologischen Instituts*, Vol. 49 (1934), 3-4, pp. 158-179. This historian gives the right interpretation of the Pompeii mosaic; the one

in my catalogue of the Orangerie exhibition, 1952, No. 9, p. 22, based on inaccurate reproductions, is erroneous.

38. – Cf. Catalogue of the Still Life Exhibition, Orangerie, 1952, No. 6, pp. 11-17.

39. – To mosaics should be added glyptics and such objects as lamps, which were often adorned with funerary symbols. Cf. O. Brendel, *op. cit.* (note 37).

40. – The back of the Chatsworth portrait was published by W. Suida, *Pantheon*, 1930, p. 564, who sees in this picture the collaboration of Leonardo with Boltraffio. The identification of the figure with Girolamo Casio, portrayed by Boltraffio in the Brera and Louvre pictures, is not at all certain; it might well be another member of the same family.

41. – Cf. Ingvar Bergström, *Hollandskt Stillebenmaleri*, 1947, pp. 161-165. English edition referred to in the present work: *Dutch Still-life Painting in the Seventeenth Century*, London, 1956, pp. 154-161. This is a very remarkable book: not only does it provide the most accurate history to date of Dutch still life painting in the 17th century, but its introduction is the best study so far made of the origins of still life painting. — B. Knipping, *De Iconografie van de Contra-Reformatie in de Neder-landen*, Vol. I, p. 110 ff.

42. – Also in the Thyssen Collection. The catalogue of this collection (1937, Vol. I, No. 281) assumes that this panel was the wing of a diptych whose other panel (Alte Pinakothek, Munich, No. 652) represents St. John the Baptist. But the chalice is the symbol of St. John the Evangelist. Inasmuch as St. Veronica is represented in a landscape, it is possible that the other wing showed St. John the Evangelist in Patmos. However, contrary to the assumption made in the catalogue, this cannot be the diptych seen by the Anonimo Morelliano, early in the 16th century, in Pietro Bembo's house at Padua, for the latter work showed beside St. John the Baptist (no doubt the one in Munich) not a St. Veronica but a Virgin and Child. In view of the fact that the Thyssen panel and the one in Munich are of about the same size, it may be inferred that Memling painted, as pendants, two small diptychs with the two St. Johns.

43. – Pointed out by R. Longhi, *Paragone*, No. 39, 1953, p. 62. Corresponds to No. 167 of M. J. Friedländer's catalogue of Provost's paintings (Vol. IX), where the back of the panel is not mentioned.

44. – Cf. I. Bergström, *op. cit.* (note 41), pp. 12-14.

45. – Cf. I. Bergström, *op. cit.* (note 41), figs. 9 and 10, and the miniature by the Master of Mary of Burgundy with a glass containing irises, reproduced pl. 12 of Otto Pächt's book, *op. cit.* (note 36).

46. – Cf. O. Pächt, *op. cit.* (note 36), p. 28, pls. 41b and 43.

47. – Cf. O. Pächt, *op. cit.* (note 36), p. 29, pl. 42a.

CHAPTER FOUR: *THE RENAISSANCE*

48. – Francesco Arcangeli, *Tarsie*, Ed. Tumminelli, Rome, 1943, p. 5. As for the decorations executed by Arduino de Baisio from 1434 on for the *studioli* of Lionello d'Este at Belfiore and Belriguardo, we can only conjecture what they were like. No doubt they were far more than mere ornaments, for we know that he delivered " wooden busts " of St. Peter and St. Paul which were placed over the sacristy doors in the Episcopal Palace at Belfiore, as were later the Four Evangelists by Lendinara in the sacristy of Modena Cathedral. A decorator who is referred to in the accounts of Ferrara as " maestro subtilissimo e nobilissimo " and " faber prestantissimus et eximius " must have been a considerable artist.

49. – A. Chastel, *Cités Idéales*, *L'œil*, 1957 (Christmas number), marquetry panels in the Palazzo Pubblico at Siena, reproductions on pp. 33 and 35.

50. – Reproduced in Mario Salmi, *Paolo Uccello, Andrea del Castagno, Domenico Veneziano*, Gallimard, n.d., pls. 32, 33, 36. Cf. A. Chastel, *La mosaïque à Venise et à Florence au XV*e *siècle*, *Arte Veneta*, 1954, p. 122, fig. 126. The date of this composition, and of its exceptional architecture in particular, has been much debated: suggestions range from 1425-1430 to 1450-1454. The same is true of the attribution of the design (the execution being signed by Giambono), which oscillates between Uccello or Castagno and Jacopo Bellini. However this may be, the singular character of this illusionist architecture can only be explained by an inspiration coming from antique painting —from *trompe-l'œil* architectural décors of the Second or Fourth Style.

51. – The plane may, however, have a symbolic significance. Cf. Meyer Schapiro, *Art Bulletin*, September, 1945, pp. 182-187. It would be well worth while making a complete study of marquetry from the iconographical point of view and from that of their general influence. For a long time André Chastel has been gathering material connected with it.

52. – F. Arcangeli, *op. cit.* (note 48), p. 14.

53. – Reproduced in F. Arcangeli, *op. cit.* (note 48), pl. 15. This marquetry dates from 1476.

54. – A highly interesting study of the symbolism of the objects figuring in the *studioli* of Urbino and Gubbio was made by Emmanuel Winternitz, *Quattrocento Science in the Gubbio Study*, in *Bulletin of the Metropolitan Museum of Art*, October, 1942, pp. 104-116.

55. – Not only is the repertory of scientific instruments and of books with open pages covered with simulated writing the same as at Urbino, but the style of these objects in the fresco shows simplifications of planes and volumes, together with a linear precision of contours, which correspond to the style of Pontelli's marquetry panels.

56. – To the best of my knowledge, the only explicit remark indicating the possibility of a filiation of marquetry with antique decoration was made by Ingvar Bergström, *op. cit.* (note 41). Referring in a note (p. 298, No. 78) to the *trompe-l'œil* character of the Urbino marquetry, he says: " In this connection the role played by the descriptions of the *trompe-l'œil* works executed by the painters of antiquity must be taken into account." Generally speaking, Bergström is the only art historian to have pointed out the importance of Italian Quattrocento marquetry in the history of still life painting. It is interesting to note that Botticelli, who very probably designed several of the Urbino marquetry panels, painted his *Allegory of Calumny* after Lucian's description of a picture on this theme supposed to have been made by Apelles. A bas-relief figuring in Botticelli's picture is composed after Zeuxis' *Family of the Centaur* as described by Lucian.

57. – The origin of Italian prints representing animals fighting has been sought for in the influence of Oriental textiles or ceramics. But this source of inspiration unquestionably came by way of models furnished by antique mosaics. It is quite possible that Piero di Cosimo had them in mind when painting his *Hunting Scene* in the Metropolitan Museum of Art, New York. Some of these antique models later appeared in albums of prints (*e.g.* Bartoli, *Lucernae*, Rome, 1691, pl. 33, showing a bear fighting with an ox).

58. – Notably Giovanni da Udine, pl. 12.

59. – For centuries, in early Christian basilicas and early medieval churches, mosaics and frescos figured indifferently in the same places (chiefly on the lower part of walls, frieze-wise). The subjects of the frescos were illusionist in character: simulated draperies, ornaments in perspective and *trompe-l'œil*.

60. – Cf. Hulin de Loo, *Pedro Berruguete et les Portraits d'Urbin*, 1942. As regards Antonello's probable visit to Urbino, see Jan Lauts, *Antonello da Messina*, 1940, p. 23.

61. – For an exact description of this picture (Thyssen Collection, Lugano) and the 16th-century copy of it (Matthiessen Gallery, London), see the Catalogue of the Still Life Exhibition, Orangerie, 1952, pp. 19-20, Nos. 8 and 8 bis. A late 17th-century copy of the picture in the Thyssen Collection is also known to exist; it was on the London art market about 1950. The existence of these copies is proof of the interest constantly being taken through the years in these still lifes—decorative *trompe-l'œil* pictures.

62. – Much earlier examples of the motif of the open book are to be found in marquetry: the choir of Modena Cathedral is decorated with a whole series of panels each representing an open volume, with its pages turning, standing out against the dark ground of a niche or a half-open cupboard. These inlaid panels were executed between 1461 and 1465 by the brothers Lorenzo and Cristoforo da Lendinara (reproductions in F. Arcangeli, *op. cit.* [note 48], p. 17). Thus the book in the Thyssen Collection may have been inspired by an example unknown to us today, and may well date to shortly before the last decade of the 15th century.

63. – This information, not contained in the catalogue of the Orangerie exhibition, No. 5, pp. 7-10, resulted from an examination of the picture carried out in October 1952 in the laboratory of the Musée du Louvre. For further material details of this painting, see the above-mentioned catalogue.

64. – But not necessarily; it might have come from a private pharmacy. A curious detail, however, would seem to suggest that the painting stood at the end of a long corridor, such as are often to be found in hospices: distinctly reflected in the stoppered decanter is a corridor illuminated, on the left, by a long horizontal window. The reflection of real space in front of the picture, caught in a convex mirror or a transparent glass, had been traditional in Flemish art since Van Eyck (the Arnolfini portrait).

65. – These niches and open cupboards figure chiefly in German pictures. In addition to the *Tucher Altarpiece*, the *Polling Altarpiece* and the *Annunciation* by Justus Amman of Ravensburg (cf. note 35), the following examples may be cited: the *Angel of the Annunciation*, school of Conrad Witz, in Zurich (A. Stange, *Deutsche Malerei der Gotik*, IV, fig. 217); the *Annunciation* by the Austrian painter known as the Master of Maria am Gestade, in Vienna, painted about 1460 (reproduced in O. Pächt, *Oesterreichische Tafelmalerei der Gotik*, 1929, pl. 18); in South Germany (Upper Palatinate), a *St. John the Evangelist* and a *St. Matthew* formerly in the Streber Collection, Munich (reproduced in A. Feulner, *Kunstgeschichte des Möbels*, Propyläen Verlag, 1927, p. 94, figs. 89 and 90); in the Behaim Codex, Cracow (reproduced by F. Winkler, *Pantheon*, 1941, p. 42). In the three last-named pictures the iron fittings of the furniture are similar to those in the picture reproduced here, pl. 10.

66. – The study of this signature, undertaken by paleographers in laboratories in Holland and at the Louvre, has unfortunately failed to result in any clear reading of it. The date is perfectly legible. For details concerning this picture, see the catalogue of the Still Life Exhibition, Orangerie, 1952, pp. 22-24, No. 10.

Cf. also the recent Catalogue of the Rijksmuseum Kröller-Müller, Otterlo, compiled by A. M. Hammacher, 1959, No. 27.

67. – Thus, for example, early in the 16th century, the marquetry panels in the sacristy of Santa Maria delle Grazie, Milan, were replaced by painted imitations of them. In 1523 Defendente Ferrari added paintings in the style of marquetry to the real inlaid work on the choir stalls of San Gerolamo at Biella (pls. 78, 79, 80 in the catalogue, *Seconda Mostra Gotico e Rinascimento in Piemonte*, Turin, 1939, by Vittorio Viale). Already in the catalogue of the Orangerie exhibition, 1952, No. 14, p. 30, it was conjectured that the four *Vases of Flowers* by Ludger Tom Ring, dating from 1562 to 1565 were (because of the symbolism of the flowers and the text of the inscription) decorations embedded in the woodwork of the choir of a church or chapel, or in the wardrobe of a sacristy (one of these Vases is reproduced here, pl. 13). Shortly afterwards Kjell Boström published a piece of information (*Oud Holland*, 1952, I, pp. 51-55) proving that these panels had actually adorned furniture in an apothecary's shop. The same author proposes interpretations of the religious inscriptions different from that put forward by J. G. van Gelder. Another example of a painting inspired by the style of marquetry is the large decorative panel by Hans Asper, dated 1567, representing flowers and fruit grouped around the arms of the canton of Zurich (Rathaus, Zurich).

68. – *Op. cit.* (note 41), p. 26, fig. 23-24; p. 298, notes 74-81. See also in this connection the catalogue of the Orangerie exhibition, 1952, No. 15, pp. 31-33.

69. – Catalogue, Orangerie exhibition, 1952, *loc. cit.* (see previous note). R. Longhi (*Paragone*, No. 33, 1952, p. 49) also assumed that it might have decorated the door of a cupboard in which hunting tackle was stored.

70. – I. Bergström, *op. cit.*, pp. 182-184, figs. 156-158; pp. 309-310, notes 80-84.

71. – Kjell Boström, *Oud Holland*, 65 (1950), pp. 81-83.

72. – Cf. catalogue, Orangerie exhibition, 1952, No. 85, pp. 109-110.

73. – A particularly interesting example, of the 18th century, figured in the Exhibition of Mexican Art in Paris, 1952 (catalogue, No. 700). Signed by Antonio Perez de Aguilar and dated 1769, this painting represents a whatnot or kind of cupboard, composed of three shelves laden with food, pottery, sundry objects and musical instruments.

74. – Cf. J. Wilhelm, *Silhouettes and " Trompe-l'œil " Cut-outs*, *Art Quarterly*, Winter 1953, pp. 294-304. A remarkable *trompe-l'œil* cut-out, much admired by the Président de Brosses at the Chartreuse of Villeneuve-les-Avignon (*Le Président de Brosses en Italie, Lettres écrites en 1739 et 1740*, edited by Colomb, Paris, Didier, 1858, Vol. I, pp. 16-17), has recently come to light; acquired by the Louvre, it has been deposited in the Musée Calvet at Avignon. It represents an easel laden with a palette, a copy of Poussin's *Empire of Flora*, a red chalk drawing repeating the same composition, a Dutch genre scene, a print by Leclerc and another by Perelle—all this simulated. It is dated 1686 and signed with a name, difficult to read, which the Président de Brosses deciphered as Antonio Forbera, whom he described as a Venetian painter.

75. – A poem entitled *Antiquarie prospetiche Romane composte per prospetivo melanese depictore*, written shortly before 1495 by an unknown Milanese painter, contains a description of an expedition in the " grottos " where antique paintings were to be found (cf. Weege, *op. cit.* [note 25], pp. 153-154). Though they took an abundant supply of food with them (" pane, pre-

sutto, poma e vino"), the poor artists had rather a hard time of it crawling among the ruins.

76. – According to H. Dollmayr, Vienna *Jahrbuch*, 16 (1895), 2nd Part, the man in question might be Johann (Giovanni) Ruysch, a Benedictine monk, astronomer and painter, born at Utrecht, who died at Cologne in 1533 (Thieme-Becker, *Künstlerlexikon*, XXIX, p. 243). In 1508, with Sodoma, he worked in the Stanze of the Vatican. He is known to have illuminated a manuscript; the practice of this branch of painting might have enabled him to acquire considerable skill in rendering fruit and flowers from life; what Vasari says of the manner (" un poco secca e stentata ") of Giovanni da Udine's Flemish master could well be in keeping with the style of a Flemish miniaturist of about 1500.

77. – This picture was described by Vincenzo Joppi Bampo, *Contributi. . . alla storia nel Friuli*, ed. R. *Deputazione di Storia Patria per la Venezia*, 1892, p. 15. It was an oil painting (" depinto ad olio, alto palmi 3 oncie 4 e mezza circa e largo palmi 2 ed oncie 5 circa ") and was owned about 1860 by Ottavio Federici, a lawyer at Naples. (I am much obliged to Professor Giuseppe Fiocco for having supplied me with the exact reading of Joppi's text.) The artist worked in the castle of Spilimbergo in 1555. Are we to infer that the date inscribed on the picture is erroneous or that he may have worked at the same place in 1538 ? I put the question to Mr. G. A. Dell' Aqua, author of an excellent article on Giovanni da Udine in the Thieme-Becker *Künstlerlexikon* (XXXIII, pp. 531-532), and he informs me that the latter alternative is not to be ruled out. Actually the date matters little; if, as I believe, the picture is an early 17th-century copy, then the copyist may have made a mistake in transcribing the date. The important thing is that we have here the exact copy of a picture by Giovanni da Udine, quite analogous to the one of 1555; perhaps the artist took both oil paintings from the decorations at Spilimbergo. Still preserved in this castle is an extensive frieze by his hand with festoons, trophies, fruit etc.; it bears the same date, 1555, as the Naples picture.

78. – M. Faré, *Gazette des Beaux-Arts*, March 1959, p. 138, note 31, gives this date and mentions vases of flowers in the chapel of this castle. The tradition of this decorative theme lingered on in France in the 17th century; outstanding among several extant examples is the small cabinet in the castle of Saint-Marcel-de-Félines, entirely decorated with vases of flowers and large Chinaware and Delft jars simulated in *trompe-l'œil* (reproduced in color in *Connaissance des Arts*, November 1958, p. 44, article by J. Wilhelm).

79. – Of the group of 16th-century landscapists *à l'antique*, this artist is the one who seems to take inspiration directly from the small decorative landscapes of ancient painters (cf. A. Mayer, *Das Leben und die Werke der Brüder Matthaeus und Paul Bril*, 1910, pls. VI and VII).

80. – " Imparó anco a far paesi con edifizi rotti, pezzi d'anticaglie, e cosi a colorire in tele paesi e verzure, nella maniera che si è dopo lui usato, non pur dai fiamminghi, ma ancora da tutti i pittori italiani." *Vita di Giovanni da Udine*.

81. – Such are the hunting scenes designed and engraved in Italy in the second half of the 16th century by Giovanni Stradano (Jan van der Straet); the same compositions were engraved and published by Bartoli-Bellori, 1693, pl. XXVI, as coming from the tombs of the Nasonii.

82. – He made several albums with miniatures representing all kinds of animals. The most important is that painted for the Emperor Rudolf II; one of its four volumes is devoted to birds (probably between 1591 and 1593).

83. – I owe the reference to Hadrianus Junius (*Batavia*, Antwerp, 1588) to Mlle Suzanne Sulzberger's study (which she was kind enough to lend me in manuscript), an excellent survey of the monuments and literary sources relating to still life painting. Felipe de Guevara, *Comentarios de la Pintura*, written in the early 17th century, published by Ortega, 1788, with annotations by A. Ponz. G. Baglione, *Le Vite de' pittori etc.*, Rome, 1642, p. 288 (with regard to Mao Salini).

84. – Already in Titian's work still life recurs insistently and, it would seem, under the auspices of the ancients. Well in evidence in the foreground of Titian's *Annunciation* in the Scuola di San Rocco, painted in 1525, is a partridge near a piece of fruit and a work basket; a bird approaching fruit is a characteristic motif of antique still lifes.

85. – G. Baglione, *loc. cit.* (see note 83).

86. – Since the 1951 Caravaggio Exhibition in Milan the *Basket of Fruit* in the Ambrosiana has been the subject of much discussion. Some have maintained that it is a fragment cut out of a figure composition and that the light background was added later; but a recent X-ray examination has failed to reveal any hidden forms under the uniform ground (this examination is referred to in the best documented book on Caravaggio, Walter Friedländer's *Caravaggio Studies*, 1955, p. 143). Much has been made of the fact that a long stem on the right is cut off by the edge of the canvas, which is supposed to prove the fragmentary character of the composition; actually this merely proves that the canvas has been cut down on the right, doubtless no more than a few centimeters. It has also been alleged that this stem does not rise out of the basket but " seems to reach into the picture from outside the frame so that it hangs in mid-air " (W. Friedländer, *op. cit.*, p. 144). But the whole structure of this stem, which grows thinner on the far right, proves that its base (cut off) lies towards the basket and not outside the canvas; and a careful scrutiny reveals that, without actually coming out of the basket, the stem is nevertheless linked with it by a long cluster of grapes which it (*i.e.* the stem) carries and which lies in the basket. Indeed, visible just beneath the two red grapes to the left of the wilted, curling leaf is a secondary stem, modeled in full light, which links the bunch of grapes to the main stem; but the point where the two stems meet is hidden behind this shriveling leaf. Emphasis should also be laid on another inexactitude which is often repeated (by W. Friedländer, for example, *op. cit.*, p. 143): the Ambrosiana *Basket* is not placed " on the eye-level of the beholder ", but is obviously seen slightly from below. As for the traces of nails which at one time were driven through the Ambrosiana canvas, these are visible even in our reproduction (pl. 51): two dark points on the left, very close to the edge, one at the very top and one on the right near the edge.

87. – See note 84.

88. – Van der Hamen favored the compositional device of superposed clean-cut stone slabs and Pedro Camprobín followed suit.

89. – A.P.A. Vorenkamp, *Bijdrage tot de Geschiedenis van het hollandsche Stilleven in de XVII eeuw*, Leyden, 1933. The amusing expression " vie coye " was recorded by this author; the portrait in question is that of David Bailly engraved by C. Waumans in a book by Cornelis de Bie, *Het gulden Cabinet. . .*, Antwerp, 1661, p. 271.

90. – Joachim von Sandrart. *Academie. . .*, edited by A. R. Peltzer, 1925, pp. 164 and 182, in speaking of Daniel Soriau or Sébastien Stoskopff. It is interesting to note that Italian usage in the 17th century was divided between the traditional reference to " small objects " (rhopography) and the new term

coined by the Dutch: motionless things (" Stillleven "). About 1620 Marquis Giustiniani spoke of " fiori ed altre cose minute " (quoted by R. Longhi, *Paragone*, No. 1, January 1950, p. 34); a little later critics spoke of " oggetti di ferme " (R. Longhi, *Paragone*, No. 33, September 1952).

91. – Félibien indeed was not far off in speaking of " choses mortes " (Preface to the *Conférences de l'Académie... augmentées de l'Idée du Peintre parfait*, Amsterdam, 1706, p. 16).

92. – See note 83.

93. – Thoré-Bürger, *Musées de la Hollande*, 1860, Vol II, p. 317: " We have argued a great deal against this sorry term ' nature morte,' we do not yet know how to replace it by a term including at one and the same time dead game, animals and birds, fish —fish in water have not often been painted—flowers and bouquets, fruit, vases and utensils, arms and musical instruments, jewels and various ornaments, drapery and costume, and the thousand and one objects that can be grouped together as a pretext for a colorful, amusing representation in a shaft of light. ' Nature morte ' is absurd."

CHAPTER FIVE: *THE GOLDEN AGE*

94. – This important picture first appeared at the exhibition *Het Nederlandsche Stilleven*, Gemeente-Museum, The Hague, 1926, No. 6, pl. 1; it next figured in the large-scale still life exhibition *Het Stilleven*, Goudstikker Gallery, Amsterdam, 1933, No. 152, reproduction No. 6. It is now in the Van Abbe Museum, Eindhoven, Holland. Reproduced and discussed by I. Bergström, *op. cit.*, fig. 21, p. 26.

95. – Pointed out by M. L. Hairs, *Les Peintres flamands de fleurs au XVIIe siècle*, 1955, p. 253. According to Van Mander, Cornelis de Harlem's *Vase of Flowers* was painted at Antwerp, that is to say between 1579 and 1583.

96. – H. Gerson, *Ausbreitung der holländischen Malerei des XVII. Jahrhunderts*, 1942, p. 57, note 7, and p. 84. Cf. also the catalogue of the Orangerie exhibition, 1952, pp. 53-54, No. 33, where all the information we have about this little known artist is summed up.

97. – I. Bergström, *op. cit.*, p. 154.

97 a. – The attempt made by Michel Faré to identify Baugin, the still life painter, with Lubin Baugin (ca. 1610-1663), a well-known Late Mannerist (*Bull. Soc. d'Hist. Art franc.*, 1955, pp. 15-26), has not been generally accepted by art historians (see C. Sterling, notice of No. 8, Catalogue, *Mostra del Seicento Europeo*, Rome 1956, where several opinions are quoted). Indeed, the comparison of objects figuring in pictures by Lubin with those in still lifes signed simply Baugin shows an irreducible difference: in Lubin's objects the definition of texture is vague, form is flabby (this comparison was facilitated by the exhibition *Artistes Orléanais du XVIIe siècle*, Musée d'Orléans 1958). Such is not the case with other 17th-century artists whose career was divided between still life painting and religious painting: the still lifes in Cotán's figure compositions have a firmness that stands out conspicuously and clashes with the conventional mediocrity of the figures; the same is true of the work of Josefa d'Obidos. So it is that Félibien cites Lubin Baugin as an example of a painter who, to his own detriment, despises the study of nature (*Entretiens*, 1666-1679, II, pp. 329-330); would he have said this of the man who painted *The Five Senses* and

the *Still Life with Wafers?* However, a recent appearance of a picture signed by Lubin Baugin in which the figure is accompanied by a subtle and firm still life makes Faré's identification acceptable.

98. – Cf. the catalogue of the Orangerie exhibition, 1952, pp. 75-76, No. 55, where Stoskopff's pictures with empty, rinsed glasses are defined as representing the " End of a Meal " or the " Table after a Meal."

99. – *Op. cit.* (note 41).

100. – *Op. cit.*, pp. 155-158.

101. – Kjell Boström, *David Baillys Stilleben*, in *Konsthistorisk Tidskrift*, XVIII (1949), 4, pp. 99-110, figs. 1-9.

102. – I. Bergström, *op. cit.*, pp. 154-158 and 307, note 2.

103. – Cf. I. Bergström, *op. cit.*, pp. 162-164, fig. 137.

104. – Vitale Bloch, *Pro Caesar Boetius van Everdingen*, in *Oud Holland*, Fasc. VI, 1936, pp. 1-8. A pendant to this picture, representing the bust of the *Young Augustus* crowned with laurel, is in the Kaapstad Museum, Capetown, South Africa. The two pictures probably served originally as overdoor panels. An overmantel by Everdingen belongs to the Rhijnlandshuis, Leyden. Mr. A. Staring kindly informs me that he found a plaster cast of the same bust of Venus in a picture by N. Verkolje (in 1941, then owned by P. de Boer, Amsterdam).

105. – Exhibited at the Orangerie, 1952, as No. 49 (signed and dated 1697), belonging to the Rijksmuseum, Amsterdam.

106. – The name of this highly original artist does not figure in the book, often referred to here, by I. Bergström. A recent exhibition devoted to Coorte (*Adriaen Coorte*, Dordrecht Museum, 1958) grouped 21 pictures by his hand, all reproduced in the catalogue. The compiler of this precious working instrument, L. J. Bol (p. 10, note 9), believes that the relationship between Coorte and Spanish painting which I emphasized (1952), and which also struck Jean Leymarie (*Dutch Painting*, 1956, p. 176), is an " accidental " spiritual relationship and not the result of any influence. But he makes no attempt to explain this spiritual kinship, interesting though it is for the history of Dutch painting.

107. – I refer to *Philopoemen recognized by an Old Woman* (Louvre). Reproduced in Edouard Michel, *Ecole Flamande*, p. 55, pl. 57, and p. 58 (in *La Peinture au Musée du Louvre*, Vol. II, Ecoles Etrangères). The attribution of this very fine sketch is still not certain. It has been thought to be by Van Dyck, whose angular drawing comes close to that of the figures in the sketch. But the existence in the museum at Nantes of a large composition from Rubens' studio, repeating this sketch, is a strong argument in favor of its attribution to this master.

108. – W. J. Müller, *Der Maler Georg Flegel und die Anfänge des Stillebens*, 1956, p. 106, quotes St. Francis of Sales in connection with the floral illustrations of a prayer book executed by Flegel for Maximilian I of Bavaria. This parallel between the great propagator of the Counter-Reformation and the Protestant painter working for a Catholic prince is interesting and seems by no means far-fetched. But it is striking in the case of the Jesuit painter Seghers. There exists an oval portrait of St. Francis of Sales engraved after Philippe de Champagne and wreathed around with roses (reproduced in L. Lecestre, *Saint François de Sales*, Coll. L'art et les Saints, Paris, Laurens, 1934, p. 40).

109. – The portrait in the picture reproduced here (pl. 40) has never been identified. On the other hand, among the personages whose portrait Seghers added to his flowers, I find one that comes as something of a surprise: Nicolas Poussin. In the center of a cartouche wreathed with flowers, signed by Daniel Seghers,

in the National Museum, Warsaw (Catalogue of Paintings of Foreign Schools, 1938, No. 158, pl. 99, described here as a self-portrait of the artist), is a sculptured bust turned towards the right, which exactly copies the self-portrait which Poussin made for Pointel (referred to in the catalogue of the exhibition *Peintres de la Réalité en France au XVIIᵉ siècle*, Orangerie, 1934, No. 93, p. 134; studied pertinently and at length by B. Dorival, *Les autoportraits de Poussin*, in *Poussin et son temps, Bulletin de la Société Poussin*, premier cahier, June 1947, pp. 39-48, reproductions pp. 38, 43, 45). The original was recently discovered in the storage vaults of the Berlin Museum. A copy is at present owned by Mr. Gimpel Fils, London. The bust in the picture by Seghers was added by an indifferent painter; judging by its metallic plasticity and harshly accentuated folds, it must have been copied from the print by J. Pesne and not from the original itself, and this in spite of the fact that it is turned to the right, as in the painting, and not reversed as in the print. Seghers' picture could not have been painted in Rome; Seghers lived there from 1625 to 1627, long before the execution of Poussin's self-portrait in 1649; the dates of Seghers' stay in Rome are given by L. van Puyvelde, *La Peinture flamande à Rome*, 1950, p. 196. The painting in Warsaw Museum therefore dates to the period running from 1649 to 1661, the year of Seghers' death. During that period Poussin's self-portrait passed—at an unknown date—from the hands of Pointel into those of Cerisier. It was engraved by Pesne while in the possession of Cerisier.

110. – The unknown man in the picture by Seghers reproduced here (pl. 40) appears to have been painted by Gonzales Coques.

111. – Cf. Julio Cavestany (Marquis of Moret), *Floreros y bodegones*, Madrid, 1936 and 1940 (*sic !*), catalogue of the exhibition held at Madrid in 1935 and published in 1940, reproductions pl. XL (Arellano) and pl. XLII (Perez).

112. – M. L. Hairs, *op. cit.*, notes 55-58.

113. – *Un momento importante nella storia della natura morta*, *Paragone*, No. 1, January 1950, pp. 34-39.

114. – The reappearance of this artist's still lifes, mentioned with praise by Baglione, is due to Roberto Longhi, who divined them in two remarkable pictures published by him in 1950 (*Paragone*, No. 1, figs. 13 and 14), and to G. Testori, who found two others, one of them signed, very similar in composition but slightly later in date, to judge by the style (*Paragone*, 1954, No. 51, figs. 21 and 22). The pictures published by Longhi are in fact more sober, more purely Caravaggesque, while their lighting is quieter. The third picture published by Testori (*loc. cit.*, fig. 23), part of which is borrowed from one of the paintings published by Longhi, seems to show an evolution towards the Baroque spirit: confused composition, uneasy lighting, free brushwork. But this picture may only be the work of an artist working about 1630-1640, who copied, after Salini, the lefthand part of his composition. Two other paintings were then added by the Seicento exhibition at Rome, 1956, Catalogue, Nos. 270 and 271, pl. 14. One of them combines a figure with the still life, like the Minneapolis picture.

115. – The *Woman buying Eggs* is apparently unsigned. But the basket on the left is the same one which served as a model in three undisputed pictures by Salini (*Paragone*, No. 51, fig. 22, and Nos. 270 and 271 in the Seicento exhibition, Rome, 1956). What is more, the arrangement of fruit accompanying this basket is identical, or nearly so, to that in two of the undisputed pictures.

116. – This date (the year of Salini's death) holds good of course even if the figures and the landscape are not by Salini but by a collaborator. At first sight, the figures do not seem very close

to those in Salini's undisputed pictures: *St. Nicholas of Tolentino* (church of Sant'Agostino, Rome) or *Still Life with a Young Boy* (No. 271, Seicento exhibition). But a more careful examination shows a very distinct relationship between the Virgin's profile in the large altarpiece in Rome and that of the woman buying eggs. The small boy at Minneapolis betrays the Caravaggesque influence, especially that of Baglione. Probably Salini had no very firm stylistic convictions in the painting of figures, but had very decided ones in the painting of still life.

117. – Paola della Pergola. Document concerning payment for pictures intended for the Palazzo di Mondragone, owned by the Borghese (*Paragone*, 1954, No. 51, p. 26).

118. – A picture which, to my thinking, might correspond to Baglione's description and whose style denotes the Caravaggism of Salini's day is the *Still Life with Fruit and Flowers* (formerly Galleria Corsini, Rome, now in the Palazzo Barberini). In the center is a broad glass vase with fruit immersed in water; on the right is another glass vase with flowers. This picture was formerly attributed to Caravaggio.

119. – After a good many more or less gratuitous attributions (Marangoni, Hoogewerff etc.), the basis of our knowledge of Gobbo's art has been established by Eugenio Battisti (*Commentari*, 1954, pp. 290-301 and pls. LXXXII-LXXXVII; the author is unaware, however, that the *Shop* bearing Gobbo's name, in the collection of the Duke of Valencia at Madrid, has already been published by J. Cavestany, *Floreros y Bodegones*, 1936-1940, p. 47, fig. 23; it is true that this initial publication contains no critical analysis). I next added (catalogue, Seicento exhibition, Rome, 1956, pp. 77 and 78, No. 20) two large still lifes which I came across in 1953 in the Wetzlar Collection, Amsterdam. These pictures are both signed: *Pietro Paolo di Cortona*. This signature is in keeping with that inscribed on two engraved landscapes by Gobbo: *Pietro Paolo Bonzi Cortonese*. As against this, the picture in the Duke of Valencia's collection has this inscription on a *cartellino*: *Pietro Paolo Gobbo f.* It may well be wondered whether we have here a genuine signature or only an early "attestation"; the more so as the composition devoid of decorative rhythm and the contrasted lighting of this *bodegone* differ from those of both the two still lifes in the Wetzlar Collection and the festoons of fruit in the Palazzo Mattei, a work unquestionably by Gobbo. Battisti feels that in the early 17th century there was nothing disobliging about the nickname "Gobbo" and that the artist may well have signed his name in this way. The uncertainty which, in my opinion, clings to the attribution of the Madrid picture to Bonzi, anyhow until fresh proof is forthcoming, prevented me in the first edition of this book from taking this painting as the basis for an analysis of Bonzi's art. As for the other pictures (unsigned) published under Gobbo's name by Eugenio Battisti, the *Boy with a Melon* (Berlin) and the *Fruit and Vegetable Woman* (formerly Stockholm, now destroyed), they differ from each other and at the same time differ from the two signed pictures in the Wetzlar Collection; the melon at Berlin is painted in a free, oily manner that is absent in the two last-named paintings. The picture formerly in Stockholm (of which only a photograph now remains) has affinities only with the one at Madrid. All the other Stockholm canvases assigned to Gobbo by Battisti are clearly by another hand and are painted in a more advanced spirit corresponding to Cerquozzi's manner. It is worth while examining the value of the attribution to Gobbo of all the Stockholm pictures; they come from the Martelli Collection and here is what Mr. Bo Wennberg, Chief Curator of Paintings at the National Museum, Stockholm, wrote to me on March 18, 1959: " As regards the value of Martelli's attributions, it must be said that they are not to be credited with too much exactitude. The

man was either unacquainted with art or deceitful and **very** little of his collection has any high or even middling **artistic** value."

120. – The soundest study of these frescos is that of J. Hess, *Commentari*, 1954, pp. 303-315, pl. LXXXIV, fig. 4; pl. LXXXV, fig. 6; pl. LXXXIX.

121. – As proposed by Roberto Longhi (*Paragone*, 1950, No. 1, p. 37), who attributes to Malvasia an erroneous reading of Gobbo de' Carracci for Gobbo de' Frutti.

122. – *Paragone*, No. 1, January 1950, p. 39.

123. – Cf. R. Causa, *Pittura Napoletana dal XV al XIX secolo*, 1957, pp. 56-57. To the recent research work of this critic we owe the basis of our knowledge of the Neapolitan still life.

124. – Both pictures, very similar in composition, were owned in 1954 by Mr. Mortimer Brandt of New York. They are pendants of exactly the same size. The one reproduced here shows, on the lower left, the monogram *L.F.* and an inscription held in the bill of a dove flying over the still life: *Don Joseph Carrafa*. The other is signed in full (also on the lower left): *Luca Forte F.* On two stone steps, one above the other, is a display of figs, pears, cherries, pomegranates and grapes of all sorts; some of them are presented on plates, others are lying on the stone steps. These pictures by Forte come very close to the one I published in the first edition (pl. 59) as an anonymous work of the Neapolitan School, painted about 1630-1640, precisely Forte's period. But since the canvas and texture of the last-named picture do not seem to be strictly Neapolitan, I persist in thinking that we may have here the work of an artist who combined the Roman spirit (stratified composition) with Neapolitan lavishness.

125. – First surmised by R. Longhi, *Paragone*, 1950, No. 1, p. 39.

126. – See the fundamental article on this artist by R. Causa, *Paolo Porpora e il primo tempo della natura morta napoletana*, in *Paragone*, No. 15, March 1951, pp. 30-36, fig. (Cf. Catalogue, Orangerie exhibition, 1952, pp. 92-93, No. 69 bis).

127. – See the reproduction in J. Cavestany, *op. cit.* (note 111), pl. XIII (signed and dated 1626).

128. – I find this piece of information in the manuscript of Mlle Suzanne Sulzberger referred to in note 83.

129. – See note 117.

130. – Catalogue, *Mostra della Pittura del Seicento Emiliano*, Bologna, 1959, No. 154, p. 280.

131. – Verbal communication which Denis Mahon has kindly allowed me to publish.

132. – The two pictures, unpublished, are pendants and were owned in 1956 by the Galleria Sestieri in Rome. The one not reproduced here includes a young woman holding a basket of fruit. Her form and features are typical of Guercino, as are those of her companion in the other picture; from the same source comes the column behind the young woman, an element that balances the composition in the spirit of Bolognese classicism.

133. – The Boston picture, which has striking similarities with the one at Forli (rightly assigned to Cagnacci by F. Arcangeli as early as 1952; catalogue, *Mostra della Pittura del Seicento Emiliano*, Bologna, 1959, No. 145, pl. 145), was published by H. Swarzenski (*Bulletin of the Boston Museum of Fine Arts*, June 1954) as a work by Caravaggio—an unwarranted attribution which has not been accepted by art historians. The flowers in the picture in the Borromeo Collection (catalogue, Bologna exhibition, 1959, No. 149, pl. 149), more animated than those in the Forli painting, mark the transition towards the Boston picture and provide a conclusive argument for accepting the latter as a work by Cagnacci.

134. – A. Resani, example: Pinacoteca Vaticana, Nos. 431 and 440; B. de Caro, example: same museum, No. 417.

135. – Soprani, *Le Vite... genovesi*, 1674, p. 127 ff., speaks of a partridge which Sinibaldo Scorza is said to have painted " in the manner of the Milanese Serrano " (for Cerano).

136. – Northern influence is also represented at Rome by Christian Berentz, of Hamburg, whose art made an impression on Cristofano Monari. The latter was the object of a study by G. Briganti (*Paragone*, No. 55, 1954, p. 40 ff.), who attaches a certain importance to him in Roman painting of the late 17th century. But I am inclined to share the old opinion of Marangoni, who considered this painter as unoriginal, superficial and monotonous.

137. – R. Causa, *op. cit.* (note 126).

138. – Herrera went to Italy when " very young " (about twenty years old ?), *i.e.* towards 1642; he lived there until his father's death, in 1656.

139. – The attributions to this painter of three pictures of fish in the catalogue of the exhibition *Floreros y Bodegones* (see note 111), Nos. 73, 74, 75 and pls. XXXVII and XXXVIII, actually rest on no signed or documented work; the only ground for them is a close analogy of style with other pictures by Herrera which are not still lifes. These *Fish* very closely resemble those of Recco, but their colors are brighter.

140. – The very fine picture at Stockholm, reproduced here (pl. 58), has hitherto passed for an early work of Giuseppe Recco, or rather for his masterpiece. It was exhibited under his name at the Orangerie (catalogue, No. 69). The signature, however —G. B. R., 1653—is hard to reconcile with the attribution to Giuseppe Recco who, in 1653, was only 19 years old. The catalogue of the Orangerie exhibition, 1952 (p. 91), drew attention to the exceptional character of this signature. Since the exhibition, Raffaello Causa has expressed the opinion (and he is no doubt right) that this is the work of Giovanni Baptista Ruoppolo, who, in 1653, was 24. (This artist's date of birth is wrongly given in the Thieme-Becker *Künstlerlexikon* as 1620; the correct date, 1629, was supplied by R. Causa in the article mentioned above, note 126.) The attribution of the Stockholm picture to Ruoppolo adds an item of exceptional quality to this artist's *œuvre*. At the same time, the old attribution to Recco has been invalidated by the very recent discovery of a signed picture of Recco's youth, which offers no resemblance to the Stockholm picture and proves, moreover, that Recco formed his style on that of a painter in the circle of Baschenis, probably Bartolomeo Bettera (F. Zeri, *Paragone*, No. 33, September 1952, pp. 37-38, fig. 20).

141. – This picture was owned in 1954 by Mr. Harry G. Sperling of New York. It represents a skull, an antique torso of Venus (sculpture), a palette with brushes (painting), and a book with a crown of laurels lying on it (poetry). Canvas, 20 1/4 by 27 1/8 inches. Signed on the book: *S. Rosa*.

142. – The work by this author mentioned above (note 111) is indispensable for a knowledge of Spanish still life painting and abounds in interesting information.

143. – Cf. text p. 38 and J. Cavestany, *op. cit.* (note 111); see index under the names Giulio de Aquiles, Alessandro Mayner and Antonio Mohedano.

144. – Since his son was born in Madrid in 1596. Cf. J. Cavestany, *op. cit.* (note 111), p. 72.

145. - J. Cavestany, *op. cit.*, pp. 30-31.

146. - J. Cavestany, *op. cit.*, p. 66; *Catalogue of the Pictures at Hampton Court* (by C. H. Collins-Baker), 1929, p. 86, No. 539; another picture in the same collection (catalogue, p. 86, No. 467) is listed under the name of Labrador; it also comes from the collection of Charles I; inventoried in 1649 as a work by Labrador, it is described in the catalogue of the collection of James II as painted by " Michael Angelo " (Cerquozzi ?).

147. - J. Cavestany, *op. cit.*, p. 66, states that these fruits are indeed native to the Estremadura region, where Labrador came from.

148. - Reproduced in J. Cavestany, *op. cit.*, p. 25, fig. 4.

149. - J. Cavestany, *op. cit.*, p. 66.

150. - Among the pictures similar to the still life at Hampton Court may be mentioned: No. 8 in Cavestany's catalogue (*op. cit.*, note 111), pl. XII; No. 4, also pl. XII; No. 12, pl. XVIII, all representing large transparent grapes, which look as if they were made of glass. A fine picture in the Prado, ascribed to Juan de Espinoza (first half of the 17th century), is closely related to No. 4 mentioned above.

151. - Credit for publishing this inventory and other important documents on Cotán goes to J. Cavestany, *op. cit.*, pp. 134-138.

152. - Zurbaran's stay in Madrid is set in 1633 by H. Vollmer (Thieme-Becker, XXXVI, p. 600); in a recent book, however, Paul Guinard puts it in 1634 (P. Guinard and Jeannine Baticle, *Histoire de la Peinture Espagnole*, 1950, p. 167). The same date is given by Maria Luisa Caturla (*Zurbaran*, catalogue of the exhibition at Granada, 1953, p. 29). Martin S. Soria (*The Paintings of Zurbaran*, Phaidon, 1953, p. 30) admits the possibility of a sojourn of a few months in Madrid between 1626 and 1628, before the work undertaken for the Court of Madrid in 1634.

153. - Attributed to Juan van der Hamen y León and reproduced pl. 64 in the 1959 edition of this book. Indeed, not only the style and the execution of this picture but also the choice of objects, such as crystal cups and wooden boxes, are characteristic of this painter.

154. - Actually none of the pictures at present ascribed to Zurbaran offer exactly the same quality of execution as the *Lemons* in the Contini-Bonacossi Collection, signed. The *Vases* in the Prado come closest to it and may claim to be by the master's hand. Other paintings are too much deteriorated for us to judge of their quality, for example the *Basket of Fruit*, No. 15, pl. XX, in Cavestany's catalogue (*op. cit.*, note 111). A very fine *Bowl of Pears* published by Martin S. Soria (*Zurbaran, Right and Wrong, Art in America*, July 1944, pp. 128-129, fig. 2) has a scattered composition, with little that is monumental about it, and a fragile linearism, which do not appear to be in keeping with Zurbaran. The existence of quite a large number of works, whose attribution to Zurbaran could have been considered seriously shows that his still lifes must have exerted a great influence.

155. - R. Longhi (and A. L. Mayer), *Catalogue des peintres espagnols anciens de la collection Contini-Bonacossi*, 1930, p. 35, pl. LXIV; J. Cavestany, *op. cit.* (note 111), pp. 28-29; Martin S. Soria, *The Art Quarterly*, Summer 1945, p. 228.

156. - J. Cavestany, *op. cit.*, pp. 28-29.

157. - J. Cavestany, *op. cit.*, pp. 29-30; and Mlle Suzanne Sulzberger, *op. cit.* (note 83).

158. - It is the picture in the Khanenko Collection on which Ghilarov (*Burlington Magazine*, 1938, p. 190, reproduction) discovered the signature of Juan Zurbaran. Cf. K. M. Malitzkaia, *Ispanskaia Jivopis XVI-XVII vekov* (Spanish Painting of the 16th and 17th Centuries), Moscow, 1947, pp. 109-110, in which the author pertinently discusses the attributions to Francisco and Juan Zurbaran of several important still lifes. This picture is still maintained as a doubtful work of Francisco Zurbaran by Martin S. Soria, *op. cit.* (note 152), cat. 175, fig. 122. A picture signed and dated 1639, belonging to a private collection in France, figured in the exhibition *L'Age d'Or Espagnol* at Bordeaux, 1955, catalogue No. 80, reproduced pl. 23. This picture still shows connections with Labrador.

159. - This picture appeared in London at the Exhibition of Spanish Masters, organized by Thomas Harris in 1931.

160. - In the reproduction this pyramid is barely distinguishable behind the plates.

161. - A careful monograph was recently devoted to this artist by Luis Reis-Santos, *Josefa d'Obidos*, Artis (no place or date of publication given; Lisbon ? 1955 ?).

162. - In fact Van der Hamen y León's choice of subjects and his velvety shadows proceed from the same esthetic as do those of Osias Beert. On the latter, see the fundamental article by Curt Benedict, in *L'Amour de l'Art*, October 1938, pp. 307-314. The parallel between these two painters brings out at the same time what Van der Hamen retained of the Flemish instruction he received from his father, a compatriot and contemporary of Beert, and what he acquired in Spain: sobriety of form and color.

163. - J. Cavestany, *op. cit.*, p. 72.

164. - See above, note 145.

165. - J. Cavestany, *op. cit.*, pls. XVI and XVII; this latter picture, attributed to Zurbaran as a doubtful work by this catalogue, is actually by Juan van der Hamen, as Cavestany surmised (p. 150, No. 7).

166. - J. Cavestany, *op. cit.*, pp. 74 and 36, fig. 15, signed and dated 1606. The connection with Passerotti, in the general conception, is flagrant.

167. - J. Cavestany, *op. cit.*, pp. 70, 150-151, pl. XIII.

168. - Such is the composition of the picture in the National Gallery, London, *Jesus in the House of Martha and Mary*, and that of the *Servant* (Sir Alfred Beit Collection, South Africa), in which a cleaning carried out in 1933 revealed, on the upper left, a small scene representing the *Supper at Emmaus* (for a reproduction of the picture after cleaning, see E. Lafuente, *Velazquez*, Phaidon, 1943, p. 17). Before being cleaned this picture had a uniform background and was similar in every way to its replica in the Art Institute of Chicago, reproduced here (pl. 63).

169. - J. Cavestany, *op. cit.*, pp. 35 and 36. Catalogue of the exhibition *Art Ancien Espagnol*, Charpentier, Paris, 1925, No. 5, *Books and Flowers*, signed and dated 1659, R. Abreu Collection, Seville.

170. - J. Cavestany, *op. cit.*, p. 83.

171. - J. Cavestany, *op. cit.*, p. 71.

172. - J. Cavestany, *op. cit.*, pp. 40 and 83.

173. - See the pictures reproduced in J. Cavestany, *op. cit.*, pls. LI, LII, LIII; biographical data on this artist are given on p. 79.

174. - Pereda's *Dream of Life* is the well-known picture in the Academy of San Fernando, Madrid. The picture by Deleito is reproduced in J. Cavestany, *op. cit.*, p. 32, fig. 9.

175. – Werner Weisbach, *Französische Malerei des XVII. Jahrhunderts*, 1932. Even today this indifference is still sometimes to be met with. Thus in his *Art and Architecture in France, 1500 to 1700* (Pelican History of Art, 1953), in many respects a remarkable book, Anthony Blunt devotes no more than a note to still life painting in 17th-century France (p. 218, note 176), simply giving the names of a few artists, for the most part those of the first half of the century. As regards the age of Louis XIV, this historian repeats the traditional judgment, according to which the Academy despised this branch of painting and only tolerated it in the form of decorations, such as are associated with the name of Jean-Baptiste Monnoyer. But the first edition of the present book (1952) and above all the studies published since then by Michel Faré make it perfectly clear that the theory of the Academy did not correspond to actual practice: still life at that time in France had many exponents who were members of the Academy and were by no means simply decorators.

176. – Reproduced in Hans Haug's article on Stoskopff, *Revue des Arts*, 1952, No. 3, p. 145, fig. 4.

177. – A similar play of large leaves alternately light and dark is to be found in Spanish pictures influenced by the Caravaggesque still life, notably in the paintings ascribed to Juan Labrador and in other, similar ones, mentioned above, note 150.

178. – Thus the two large pictures recently brought to light, representing a *Fruit and Vegetable Woman* (Louvre) and a *Luncheon* (a lady at table, attended by a page, Collection of the Comte de Chavagnac) are of the type that is common in Flemish painting, in which life-size figures accompany a still life displayed in the foreground. The work of Louise Moillon was accurately and thoroughly studied by Jacques Wilhelm, *Louise Moillon*, in *L'Œil*, September 1956, pp. 6-13, where 19 pictures are reproduced.

179. – A striking example of archaism, not only in the form of objects but even in the composition, is provided by Jean Garnier's reception piece at the Academy, painted in 1672: the *Portrait of Louis XIV* surrounded by attributes which form, as it were, a glorification of his reign, both from the material and the intellectual point of view (reproduced by M. Faré, *Gazette des Beaux-Arts, op. cit.*, p. 262, fig. 3).

180. – J. Bousquet, *Recherches sur le séjour des artistes français à Rome, au XVIIe siècle*, thesis at the Ecole du Louvre, 1952. J. Bousquet, chief archivist of the Aveyron Department, carried out methodical research work in the archives of Rome, with very remarkable results. He brought to light a very large amount of unpublished information, not only on the dates of their sojourn there, but on the living conditions and works of French artists, most of whom are little known.

181. – I find, in the unpublished inventory of pictures owned by the painter Jean Blanchard (younger brother of Jacques Blanchard), drawn up in Paris on December 13, 1645 (Archives Nationales, Minutier Central, Etude IV, 119): " Quatre petits tableaux, deux ronds et deux carrés... représentant paysages et fruits de Calfe." Some landscapes by Kalf are known (cf. H. E. van Gelder, *Heda, Beyeren, Kalf*, Becht, Amsterdam, n. d., reproduction p. 41, signed and dated 1652).

182. – A picture by Kalf with silver plate and copper utensils, dated 1643 (made, therefore, during his stay in Paris), is reproduced in Bergström, *op. cit.* (note 41), fig. 218. Its composition differs from that of Gobin, being dynamic and laid out along a diagonal receding into the picture; Gobin uses a decorative, frieze-wise composition. Yet there is a close analogy between the choice of objects and the handling, at once gleaming and blurred, of the two artists.

183. – After Emile Mâle's famous studies, it is interesting to recall those of Knipping, referred to above, note 41.

184. – On the *Vanitas* of Philippe de Champagne, see Adeline Hulftegger, *Bulletin des Musées de France*, July 1946, p. 4 ff., an excellent study of the moral atmosphere in France which explains the *Vanitas* pictures and notably their Jansenist inspiration. As regards Madeleine de Boulogne, she exhibited a picture entitled *Pensée de la Mort* at the 1704 Salon.

185. – Mainly but not exclusively, for he would not have been appointed professor (in 1659), had he been only a specialist confined to flower painting. We hear of this from Dubois de Saint-Gelais (cf. A. Fontaine, *Académiciens d'autrefois*, 1914, p. 12).

186. – H. Voss (article on Dupuis in Thieme-Becker, X, p. 185) assumes that Dupuis met Nicolas Mignard in Rome: the two artists were friends and Mignard painted the portrait of Dupuis known through a print by Antoine Masson, made in 1663. If they met in Rome, it was in 1637 or 1638, the period of Mignard's stay there. J. Bousquet, *op. cit.* (note 180), failed to come across the name of Dupuis in the Roman archives; but he himself does not regard his researches as exhaustive. It is the Italianizing style of his work and the accessories *à l'antique* or *à la romaine* that tell in favor of Dupuis' Italian journey.

187. – These dates are given by J. Bousquet, *op. cit.* (note 180).

188. – Michel Faré (*Arts*, December 28, 1951): " P. A. Lemoisne had been delegated by his colleagues of the Royal Academy, at the same time as Le Nain, to call on Cardinal Mazarin and thank him, one with a St. Peter, the other with fruit." The minutes of March 4, 1656, relate that " l'Académie, au plus grand nombre et au meilleur estat que faire se pourra ira voir son Eminence " and " afin de témoigner à son Eminence notre gratitude, il luy sera présenté le tableau de fruits fait par M. Lemoyne, seluy de Saint Pierre de desfunt M. Le Nain." Antoine and Louis Le Nain died in 1648.

189. – According to A. Fontaine, *Les Collections de l'Académie Royale*, 1930, p. 231, the reception piece presented by Michel Lanse (February 28, 1660) was "a picture 5 feet by 4 representing flowers, fruit, antique vases and musical instruments on a table covered with a rug."

190. – A pupil of Gérard Douffet, Gosuin may have preserved from this training, anyhow in his youth, a certain tincture of Caravaggism.

191. – As noted by M. Faré (*Arts, loc. cit.*, note 188), several opulent compositions with Turkey carpets, musical instruments etc., testify to the influence on Picart of the type of picture launched by Il Maltese. Now, the Roman period of the latter's career does not go back before 1650 and the pictures in the style of Il Maltese are not to be met with before that date.

192. – Gosuin's stay in Rome is recorded by the early historians of the School of Liège (cf. Zoege von Manteufel, article on Gosuin in Thieme-Becker, XIV, pp. 416-417).

193. – Although J. Bousquet, *op. cit.* (note 180), did not come across the name of Charles de Somme in the Roman archives, there are no grounds for doubting that this artist made a stay in Rome. The fact that Félibien mentions Somme among Italian painters and alongside Labrador, whose work has obviously undergone the Caravaggesque influence, suggests that the Flemish painter was trained in Italy.

194. – Lomazzo, *Trattato dell'arte de la pittura*, Milan, 1584, chapters LX and LXIII.

195. – M. Faré, *Gazette des Beaux-Arts*, April 1958, pp. 255-266, and March 1959, pp. 129-144, two excellent articles of fundamental importance, to which this chapter owes much of the

information to follow. Faré also reproduces undisputed pictures by several painters who cannot be included here, notably Paul Liégeois, Nicolas Baudesson, Jean Garnier, Baudrin Yvart, Madeleine de Boulogne, Simon Renard de Saint-André and Claude Huillot.

CHAPTER SIX: *THE CENTURY OF CHARDIN*

196. – Yet, in the general arrangement, these overdoor panels are rather to be likened to those of Desportes. Known at the present time are one picture in Amiens Museum; two, with attributes of the arts and sciences, in a private collection in France (formerly owned by P. Cailleux); one very important composition formerly in the collection of Baron Henri de Rothschild; several pictures which have passed through the auction rooms. M. Jean Cailleux is preparing a study of Largillière's still lifes.

197. – The picture reproduced here (pl. 70) has, as its pendant, a similar painting fixed to the other side of the library door (reproduced in the catalogue of the Giuseppe Maria Crespi Exhibition, Bologna, 1948, Nos. 34-35, pl. XX); the dating was proposed by this catalogue.

198. – The G. B. Martini Conservatory at Bologna was one of the best-known musical institutions in Italy in the 18th century. Mozart no doubt went there in 1772 when the Philharmonic Academy of Bologna admitted him as an ordinary member after a " formidable contrapuntal examination." Cf. Dr. A.-E. Cherbuliez, *Mozart*, in *Les Musiciens célèbres*, Mazenod, Paris, 1946, p. 129.

199. – J. Cavestany, *op. cit.*, p. 97. It is interesting to note that Melendez is not the only painter to testify to the return to the sound and serious pictorial tradition of the 17th century: Cean owned a still life by Andrès Rubira (first half of the 18th century) which reminded him of Velazquez' early *bodegones* (cf. Cavestany, p. 94).

200. – Every visitor to the Museo Nazionale delle Terme in Rome (former Carthusian convent) will remember the false monk in front of the false cupboard of his cell filled with books and utensils, painted in the cloister. In Spain, notably at Valencia, *trompe-l'œil* invaded semi-popular decorative art: kitchens there are decorated with earthenware tiles forming compositions that represent a whole illusive kitchen with food etc. (in the Museum of Decorative Arts, Madrid; my thanks go to Señor Juan Ainaud de Lasarte for calling my attention to it).

201. – Several interesting examples figured in the Exhibition of Mexican Art, Paris, 1952. Cf. note 73.

202. – Huquier Fils, *Lettre sur l'Exposition des tableaux au Louvre*, 1753, pp. 27-28; Estève, *Lettre à un ami*, 1753, pp. 87-89; *Lettre sur l'Exposition des Ouvrages de Peinture*, 1769, pp. 21-22: " Vous reconnoîtrés, monsieur, la touche ferme et libre, la couleur vigoureuse, et la magie des effets dans les tableaux, dont M. Chardin a enrichi ce Sallon. Une belle pâte de couleur, un dessein précis, une grande vérité se caractérisent dans le *Tableau des arts et des récompenses qui leur sont accordées*. Il semble que le cordon noir sorte de la toile. Vous serés surpris de la fabrique de la *Hure de Sanglier* et des tableaux de *Gibier*, c'est toujours la même force dans ceux de *Fruits* et des *Bas-Reliefs*. Il y a un grand mérite de traiter ainsi le genre; et c'est avec bien de raison qu'on a nommé M. Chardin, le Rembrandt de l'Ecole Française. " (Cf. Georges Wildenstein, *Chardin*, 1933, pp. 14, 87, 88, 122.)

203. – For bibliography and details of the *Orange Tree* (Kunsthalle, Karlsruhe), see the catalogue of the Orangerie exhibition, 1952, pp. 105-106, No. 80.

204. – Notably the one in Rouen Museum (G. Wildenstein, *Chardin*, 1933, No. 1017, who does not regard it either as Chardin's; this critic also eliminates the Rotterdam picture—our pl. 77—from the master's *œuvre*, in spite of its signature followed by the date 1767).

205. – Review of the 1781 Salon (cf. catalogue, Orangerie exhibition, 1952, p. 107, No. 82). Mme Vallayer-Coster's work has just been studied with great care, in the most useful manner, by Mme Marianne R. Michel (*Une académicienne du XVIIIe siècle : Anne Vallayer-Coster. Essai sur sa vie ; catalogue de son œuvre*, thèse de diplôme d'études supérieures d'histoire, Sorbonne, 1959).

206. – The attribution of this picture to Subleyras dates from the 18th century, when it was in the Cambolas Collection, Toulouse. It is borne out by the supple handling and sustained color characteristic of the painter and by the presence of the reduced-size copy of Duquesnoy's famous statue of St. Susanna, a plaster cast which also figures in the *Studio of Subleyras*, a picture in the Vienna Academy. A fine still life with the bust of Vincenzo Gonzaga by Bernini (in the Minneapolis Institute of Arts) has been very plausibly ascribed to Subleyras by Walter Friedländer.

207. – The discovery of signed pictures by Magini is due to Brigani, Corbora, Longhi and Zauli Naldi (cf. *Paragone*, No. 39, 1953, p. 63, and No. 49, 1954, pp. 57-60). The kitchen pieces of Evaristo Baschenis are reproduced in Luigi Angelini, *I Baschenis, pittori bergamaschi*, 1943, in particular pl. XXVI (Attilio Steffanoni Collection, Milan). Magini's pictures are very numerous and often composed of continually recurring elements. Twelve of them were reproduced by G. Isarlo in *Connaissance des Arts*, No. 38, April 15, 1955, pp. 56-57; but the scientific utility of this publication is nullified by the fact that the whereabouts of none of the pictures is indicated. Others, several of them particularly interesting, were published in the fundamental study of the artist by Alfredo Servolini (*Commentari*, April-June 1957, pp. 125-137). Still others exist. The picture reproduced here is no doubt a youthful work, or anyhow of the artist's early period when his motifs harked back to those of Baschenis and his composition betrayed the robustness of the 17th century, with objects closely grouped together and of considerable proportions. Later his composition grew lighter, objects were spaced out and their size decreased. The still lifes in the Billi Collection, Milan, take on a decided air of the 18th century; no one would venture to date them to an earlier period.

208. – See in this connection the *Kitchen* in the Collection of Count Alessandro Contini-Bonacossi, Florence (catalogue, Giuseppe Maria Crespi Exhibition, Bologna, 1948, pp. 36-37, No. 33, pl. XVIII).

209. – G. Fiocco, *Francesco Guardi, Pittore di Fiori*, *Arte Veneta*, 1950, pp. 76-85.

210. – J. Cavestany, *op. cit.*, p. 93.

CHAPTER SEVEN: *19th AND 20th CENTURIES*

211. – C. Clément, *Géricault*, 3rd edition, 1879, No. 80 (" in the style of Snyders "); No. 81, p. 33, copy after Weenix. These still lifes date from 1812-1816.

212. – The copy after Beyeren figured in the exhibition *Natures mortes françaises du XVIIe siècle à nos jours*, Paris, Galerie Charpentier, 1951, No. 73. Quite recently a still life by Géricault has come to light (Private Collection, Switzerland), representing fruit, vegetables and a small bird on a table. It may be a copy

169

of a fragment from a large composition by Snyders. Mireur's *Dictionnaire de Ventes* mentions five sales in which there figured six still lifes attributed to Géricault. The latest book on Géricault (K. Berger, *Géricault und sein Werk*, Schroll, Vienna, 1952) does not so much as mention the existence of still lifes by the artist.

213. – Reproduced in K. Berger, *op. cit.* (note 212), pl. 53.

213 a. – An excellent study of Boudin's still lifes by Charles C. Cunningham has just appeared in *Studies in the History of Art dedicated to William E. Suida*, 1959, pp. 382-392.

214. – According to J. Rewald, *Georges Seurat*, New York, 1943, No. 46, pl. 81, and the *Catalogue of the Wertheim Collection* by the same author: " It is one of the artist's earliest paintings, in which he indicates his future researches; it was very probably executed shortly after Seurat's return from his military service, in November 1880."

215. – Reproduced in L. Venturi, *Cézanne*, 1936, Vol. II, No. 187 (two variants of the same composition are reproduced under Nos. 186 and 188, which goes to show the interest Cézanne took in the work). The texture of No. 187 is particularly rich.

216. – Reproduced in G. Wildenstein, *op. cit.* (note 204), pl. CII, No. 154.

217. – A few old *Vanitas* pictures exist, however, in which the skull is multiplied. A fine example, dated 1551, recently entered the Louvre; it represents a nude, recumbent tomb effigy in front of a niche with three skulls (reproduced in Marcel Brion, *Lumière de la Renaissance*, 1948, fig. 37).

218. – Reproduced in J. Rewald, *Gauguin*, 1938, pl. 90.

218 a. – Reproduced in C. Sterling, *Musée de l'Ermitage, La Peinture française*, 1957, pl. 110.

219. – Reproduced in *History of Modern Painting, Matisse, Munch, Rouault*, Skira, 1950, p. 125 (in color).

220. – G. Bazin, *L'Époque Impressionniste*, 1947, p. 57.

221. – Pierre du Colombier, *Les plus beaux écrits des Grands Artistes*, 1946, p. 307. A collection highly interesting for the judicious choice of texts.

222. – To Claude Roger Marx goes the credit for drawing attention to Bresdin (*Print*, 1927, pp. 251-270; *L'Amour de l'Art*, 1928, pp. 137-141). Michel Florisoone recently marked out the place Bresdin occupies in art history, by including his works in the exhibition *Eugène Carrière et le Symbolisme*, Orangerie, Paris, December 1949, catalogue, pp. 58-59.

223. – Georg Schmidt, *Lessons of the Past*, introduction to the volume mentioned above (note 219), pp. XIII-XXIII.

224. – Collection of Madame Grégory, Paris. Reproduced in R. H. Wilenski, *Modern French Painters*, 1947 edition, fig. 84 a.

225. – Cited in *History of Modern Painting, From Picasso to Surrealism*, Skira, 1950, p. 105.

CHAPTER EIGHT: *FINAL OBSERVATIONS*

226. – Vitale Bloch, *Burlington Magazine*, July 1952, p. 208.

227. – It has been said, for example, that Manet's *Balcony* may be considered as a still life (Paul Mantz, *Gazette des Beaux-Arts*, July 1869). In a general way, it was felt round about 1860-1870 that Manet was painting in a " still life spirit."

228. – R. Longhi, *Paragone*, No. 33, September 1952, p. 49.

229. – Article referred to in the previous note, p. 47.

230. – R. Longhi, *op. cit.*, p. 52: " Le meditazioni dello Chardin in Francia, e, in Italia, più somessamente, entro lo sguardo affettuoso del nostro Crespi, le librerie del Liceo Musicale di Bologna." V. Bloch, *Burlington Magazine*, July 1952, p. 209 : " Crespi's two sham libraries, beautiful as they are, are accidental in his œuvre."

231. – Exhibition *Illusionism and Trompe-l'Œil*, California Palace of the Legion of Honor, San Francisco, 1949 (catalogue by T. C. Howe, Jermayne MacAgy, A. Frankenstein, Douglas MacAgy). Raoul Michau, *Arts Plastiques*, December 1952.

232. – Thus, for example, V. Bloch, *loc. cit.* (note 226), simply says: " For after all, Jacopo de Barbari's surprising panel is a trompe-l'œil."

233. – Master Michiel (Michiel Sittow): the *Virgin and Child* in Berlin Museum, No. 1722; the donor, an elderly man, with the insignia of the Order of Calatrava, in the National Gallery of Art, Washington (Mellon Collection).

234. – The article by M. Faré (*Gazette des Beaux-Arts*, March 1959, pp. 129-144) accurately studies the problem of academicians who specialized in still life.

235. – Michel Florisoone, *Manet*, 1947, p. 119.

236. – *Vita di Giovanni da Udine*. The fact that these flowers and fruit constitute, at the same time, a kind of repertory of natural history does not make Giovanni da Udine a mere chronicler of botanical curiosities. Like Melendez, who set himself a very similar program (J. Cavestany, *op. cit.*, p. 97), he was an artist who was attracted by the particularity of objects, in keeping with the scientific thought of his time, but who aspired above all to an artistic end: to render those particularities as a painter, through fine color and fine texture. All the Mannerists, from Aertsen to Passerotti, have the notion in the back of their minds of drawing up complete inventories of the motifs they are dealing with: vegetables, fruit, poultry. In spite of this quasi scientific eloquence, their still lifes cannot be excluded from the history of the genre. R. Longhi, *op. cit.* (note 228), admits as much himself.

237. – Reproductions of them will be found in the article by Curt Benedict, *L'Amour de l'Art*, October 1938, p. 307, figs. 1 and 2, where this critic aptly points out the direct connection between the still lifes of the early 17th century and those of the early 16th. See also I. Bergström, *op. cit.* (note 41), figs. 4 and 7.

238. – Just as marquetry still lifes were replaced in the early 16th century in church decorations by oil paintings, so landscapes painted in oils appeared, at the same period, in the churches of North Italy in the very place where *vedute* in marquetry had figured before. The chronology of these landscapes, some of them panoramic, would have to be studied closely in order to determine whether or not they preceded those of Patinir.

PLATES

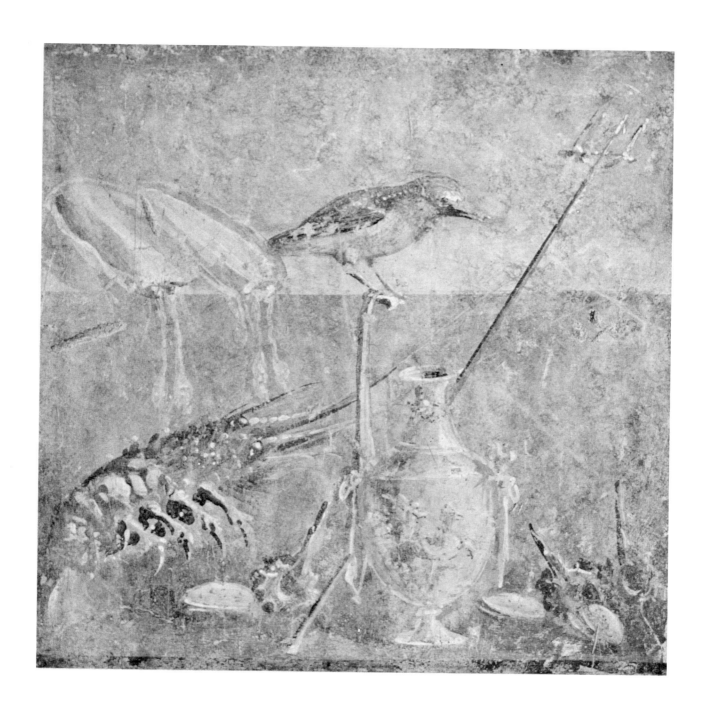

FRESCO FROM HERCULANEUM. First Century (before 79 A. D.)
Shells, Lobster, Vase and Bird.
Museo Nazionale, Naples.

1

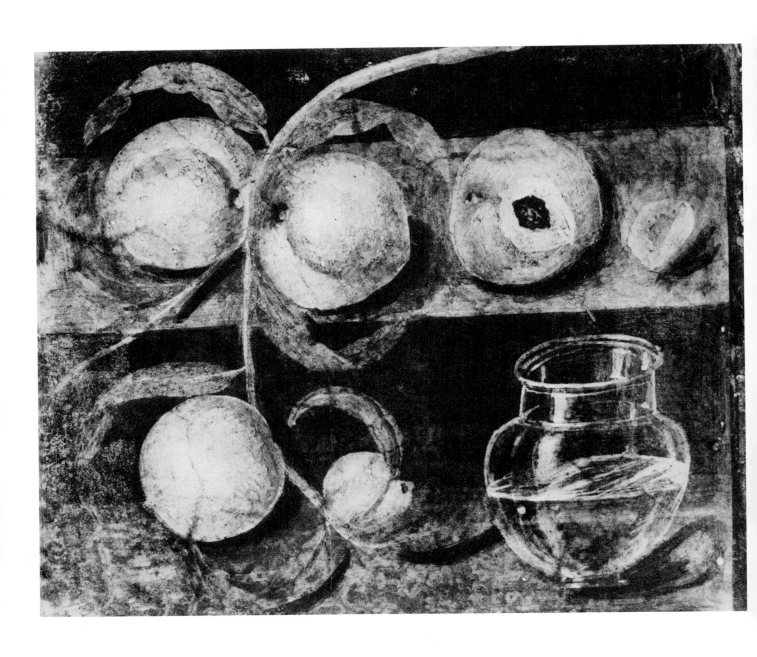

FRESCO FROM POMPEII. First Century (before 79 A. D.).
Peaches and Glass Jar half-filled with Water.
Museo Nazionale, Naples.

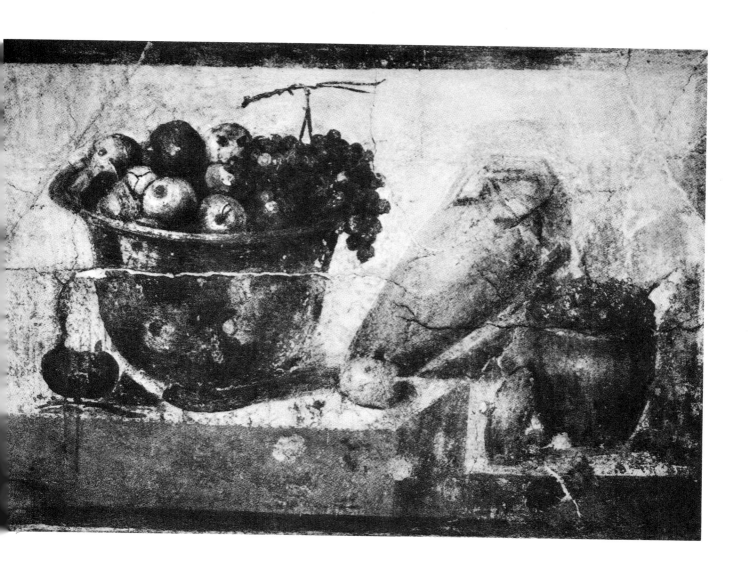

FRESCO FROM POMPEII. First Century B. C.
Bowl of Fruit and Vases. 42 1/2 × 27 1/2.
Museo Nazionale, Naples.

3

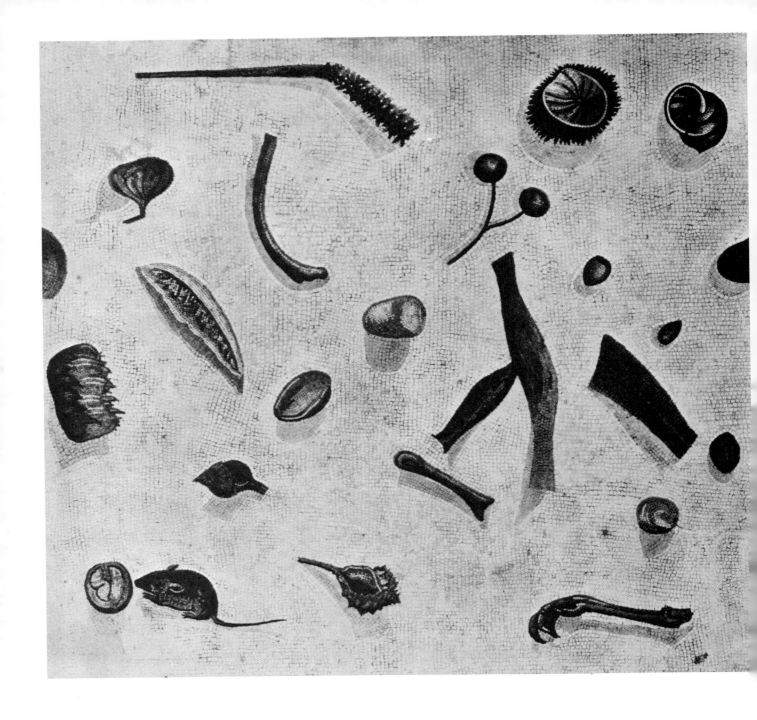

MOSAIC. Copy by Heraclitus (2nd century A. D.)
after Sosos of Pergamum (3rd or 2nd century B. C.). Fragment.
Scraps of a Meal (" The Unswept Room ").
Museo Laterano, Rome.

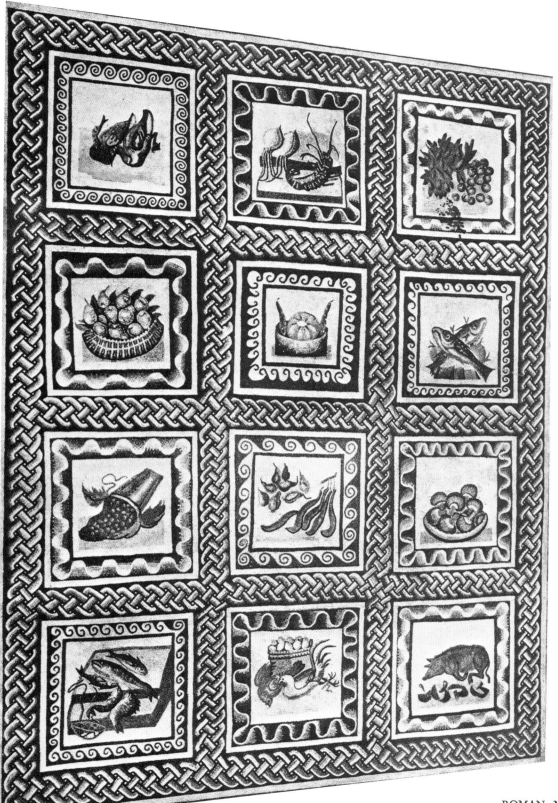

ROMAN MOSAIC. 4th Century.
Pavement decorated with Still Life.
Vatican Museum, Rome.

5

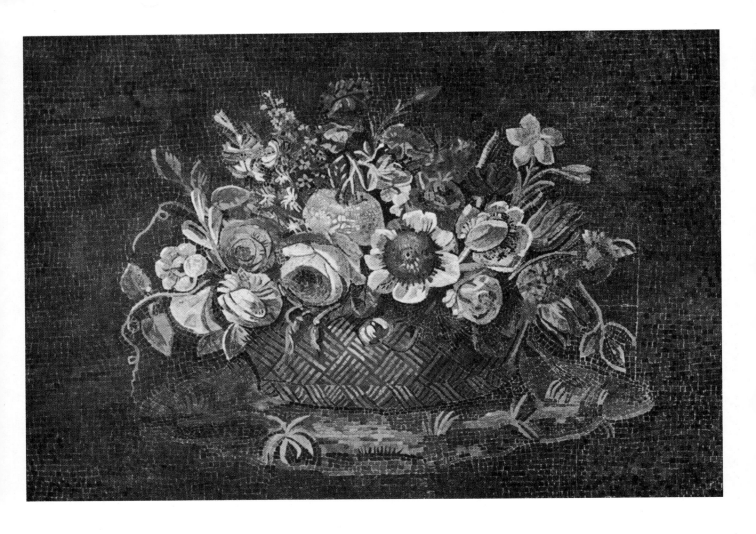

ROMAN MOSAIC. 2nd Century.
Basket of Flowers. 26 3/8 × 41.
Vatican Museum, Rome.

WALL PAINTING. Ca. 1490.
Niche with Liturgical Objects.
Church of St. Barbara, Kutnà Hora, Czechoslovakia.

BARTHEL BRUYN THE ELDER (1492 or 1493-1555).
Vanitas. Dated 1524. Wood, 24 × 20.
Rijksmuseum Kröller-Müller, Otterlo, Holland.

8

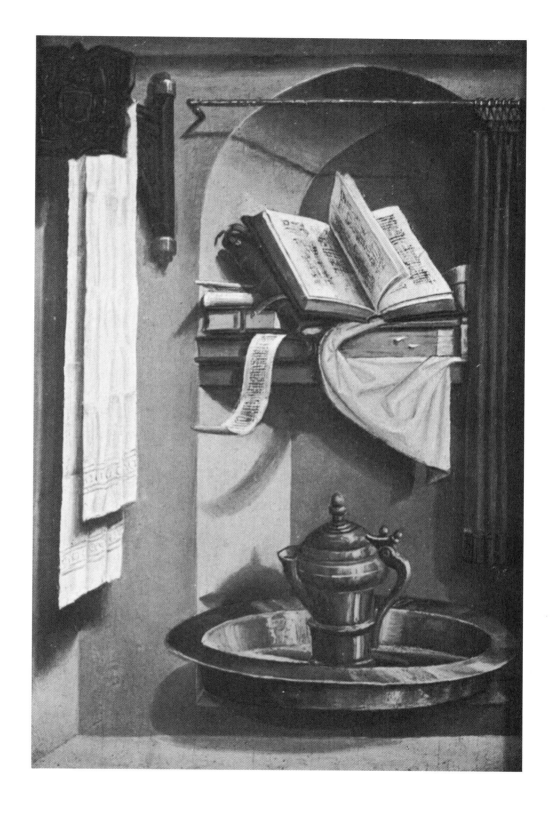

FLEMISH SCHOOL. Ca. 1480.
Books and Basin in a Niche. Wood, 9 1/2 × 8 1/4.
Museum Boymans-Van Beuningen, Rotterdam.

9

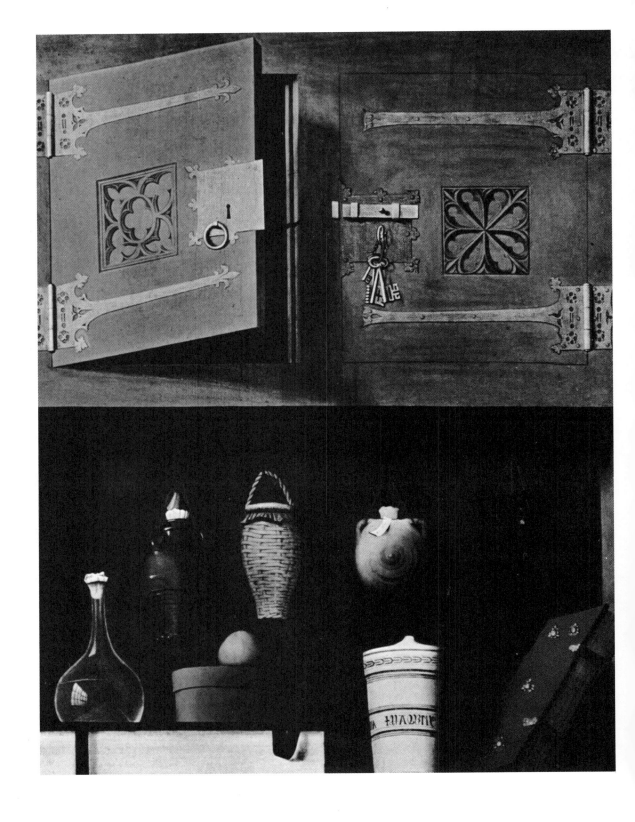

GERMAN SCHOOL. Ca. 1470-1480.
Cupboard with Bottles and Books. Wood, 41 3/4 × 31 7/8.
Mortimer Brandt Collection, New York.

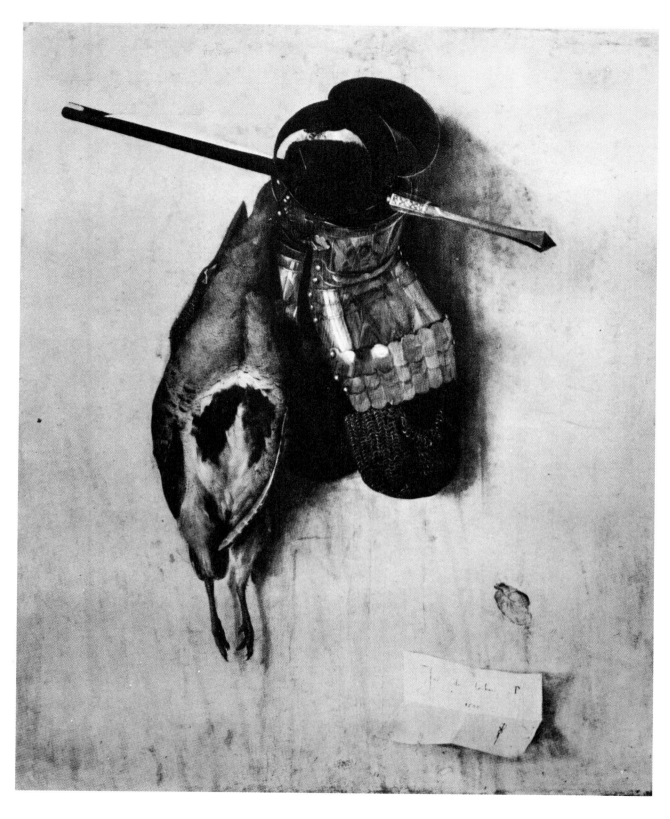

JACOPO DE BARBARI (died in 1516?).
Partridge and Arms. Signed and Dated 1504. Wood, 19 1/4 × 16 1/2.
Alte Pinakothek, Munich.

11

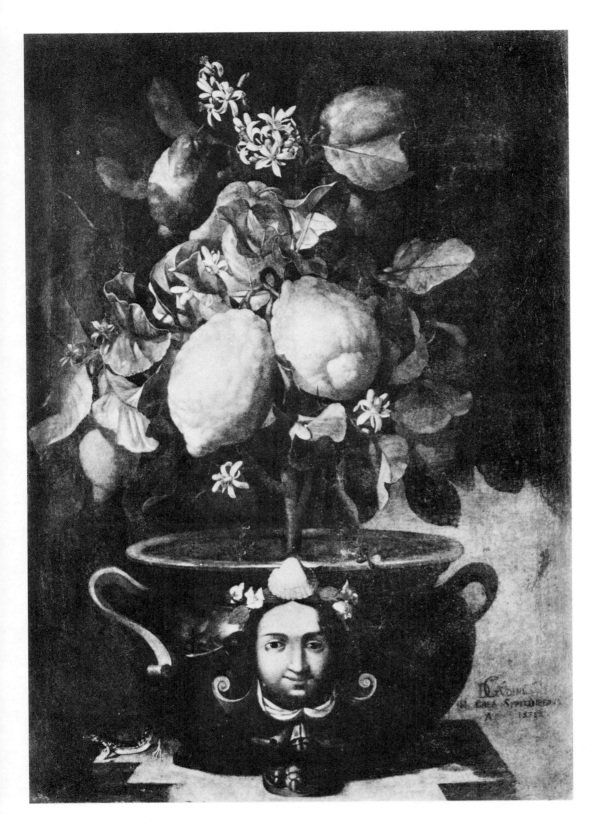

GIOVANNI DA UDINE (1487-1564).
Vase of Flowers with a Lizard. Signed and Dated 1538.
(Perhaps a 17th-century Copy).
Private Collection, Italy.

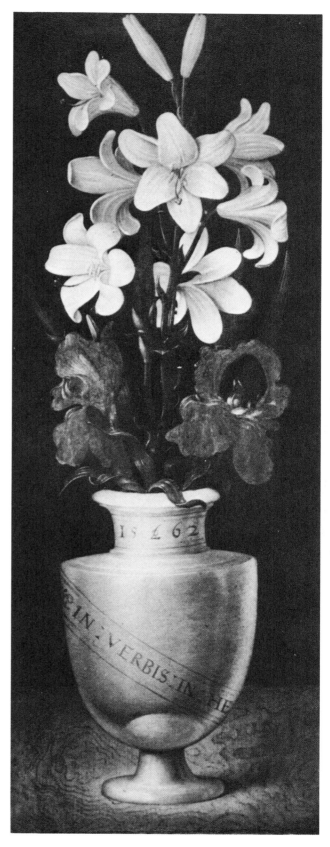

13 LUDGER TOM RING THE ELDER (1522-1584).
Vase of Flowers. Signed and Dated 1562. Wood, 25 × 9 3/4.
Landesmuseum, Münster, Westphalia.

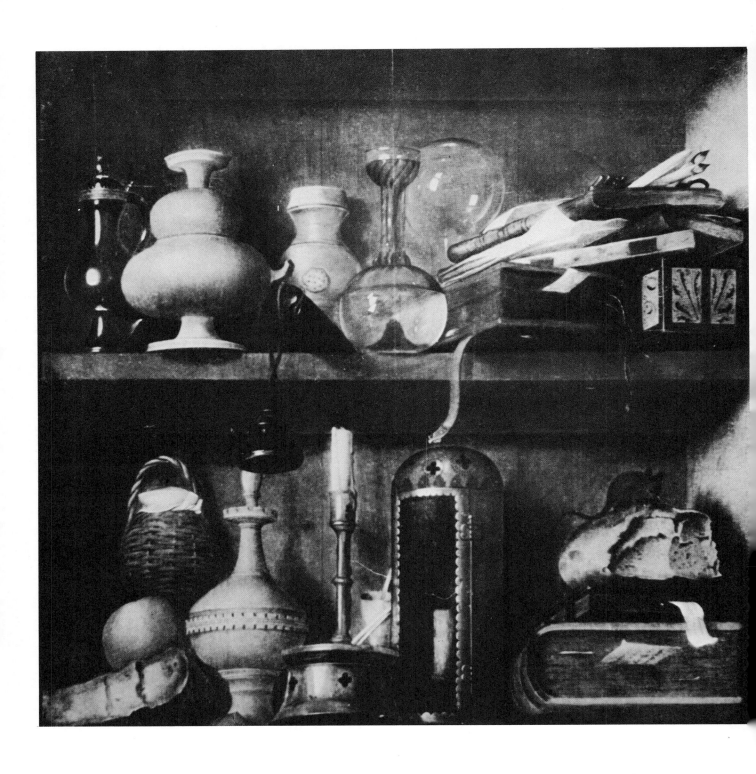

FLEMISH SCHOOL. Second Quarter of the 16th Century.
The Cupboard. Dated 1538. Wood, 17 1/4 × 17 1/4.
Rijksmuseum Kröller-Müller, Otterlo, Holland.

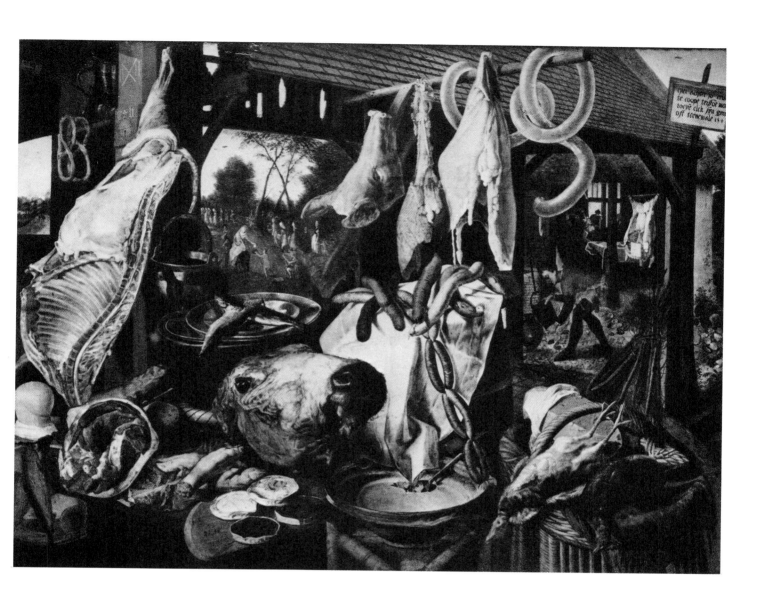

PIETER AERTSEN (1508-1575).
The Butcher's Stall. Dated 1551. Canvas, 66 1/2 × 48 3/4.
University of Upsala, Sweden.

15

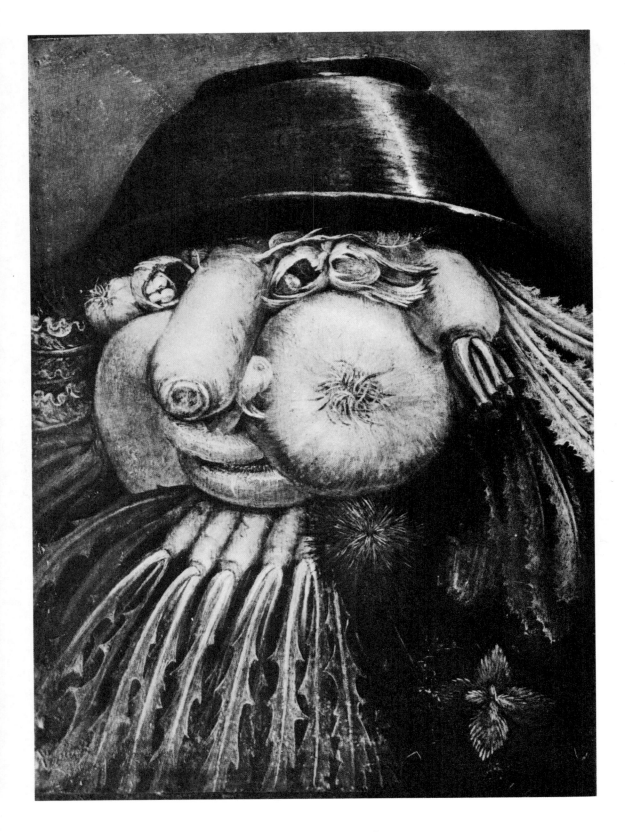

FOLLOWER OF GIUSEPPE ARCIMBOLDO (ca. 1530-1593).
Still Life forming a Human Face (*turn upside down*).
Wood, 13 3/4 × 9 1/2. *Pinacoteca di Cremona.*

16

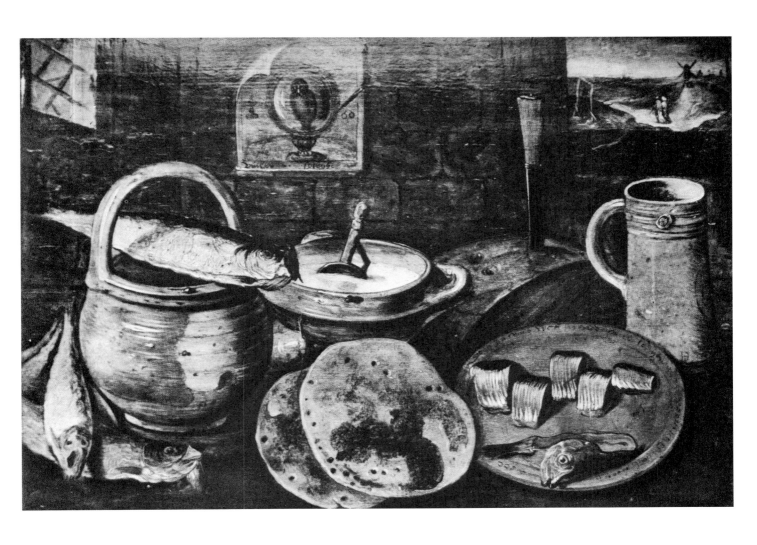

FLEMISH SCHOOL (circle of PIETER AERTSEN). Ca. 1560-1570.
Table with Food. Wood, 13 3/8 × 19 1/8.
Musée des Beaux-Arts, Brussels.

17

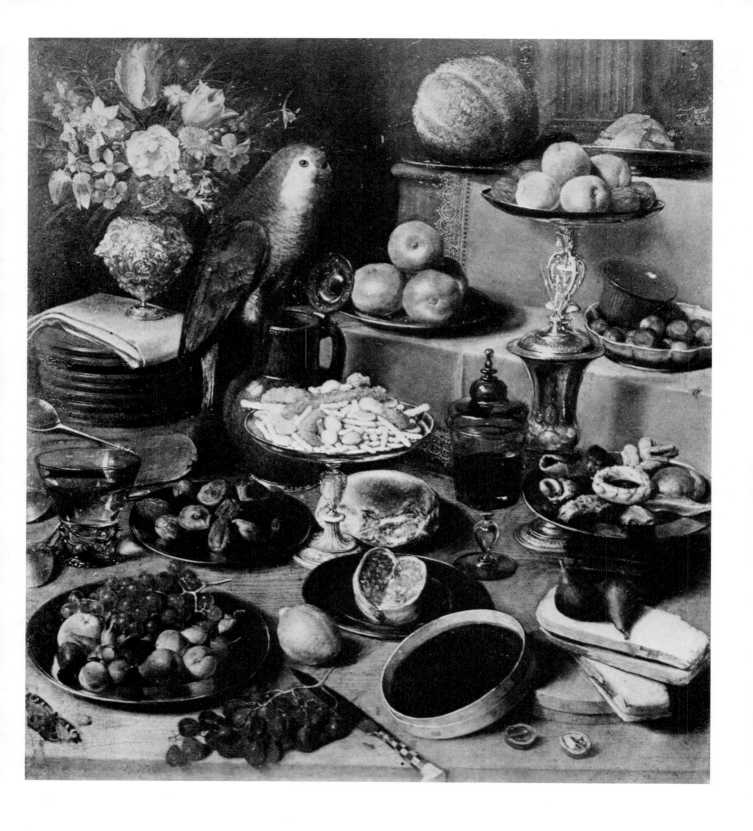

GEORG FLEGEL (1563-1638).
18 The Dessert. Copper, 30 3/4 × 26 3/8.
Staatsgemäldesammlung, Speyer.

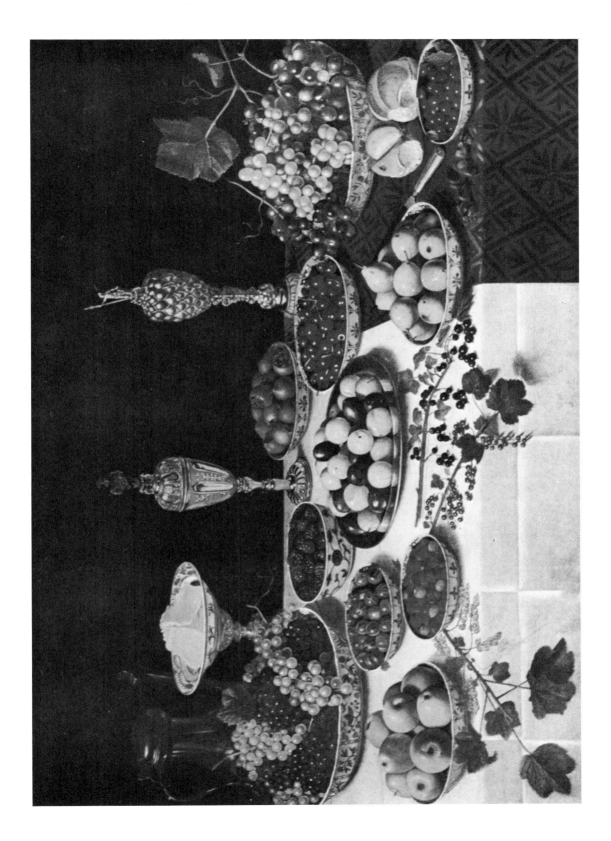

FLORIS VAN SCHOOTEN (active from 1612 to 1655).
Table with Food. Signed and Dated 1617. Wood, 31 1/2 × 44 1/2.
Private Collection, Switzerland.

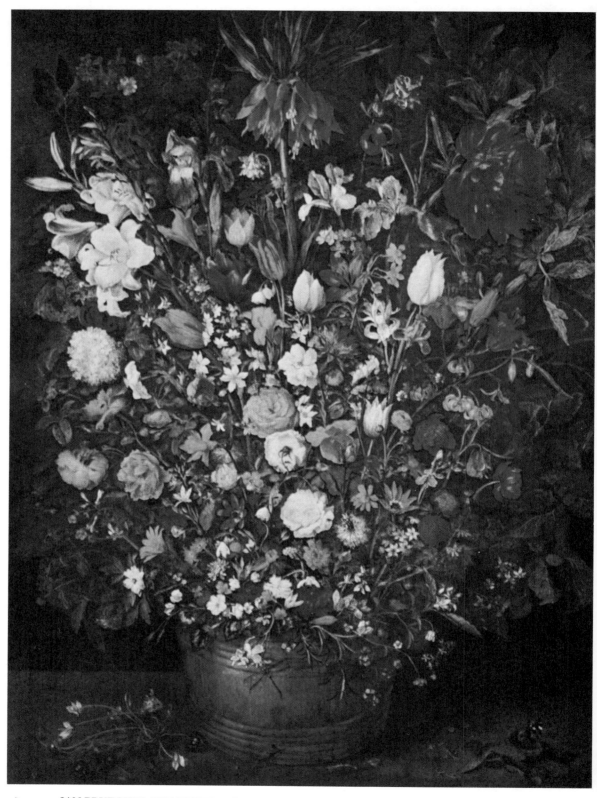

JAN BRUEGHEL THE ELDER, called VELVET BRUEGHEL (1568-1625).
Large Bouquet of Flowers. Wood, 38 5/8 × 28 3/4.
Rijksmuseum, Amsterdam.

20

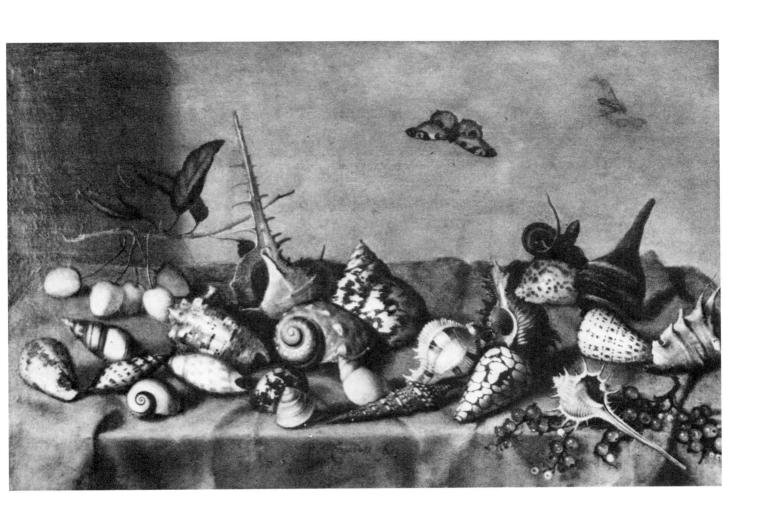

BALTHASAR VAN DER AST (1593 or 1594-1657).
Shells. Signed. Wood, 11 3/4 × 18 1/2.
Museum Boymans-Van Beuinngen, Rotterdam.

21

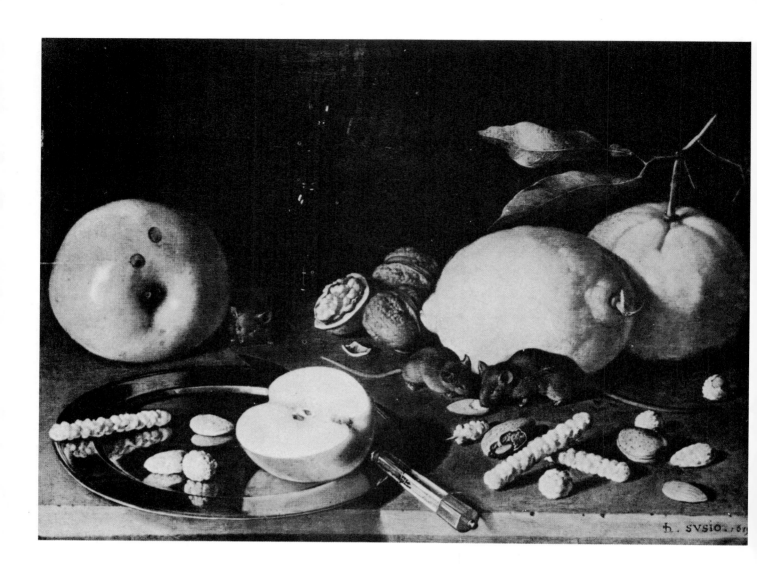

LODOVICO DE SUSIO (active from 1616 to 1620).
Dessert with Mice. Signed and Dated 1619. Wood, 13 3/4 × 18 1/4.
City Art Museum, St. Louis, Mo.

22

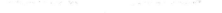
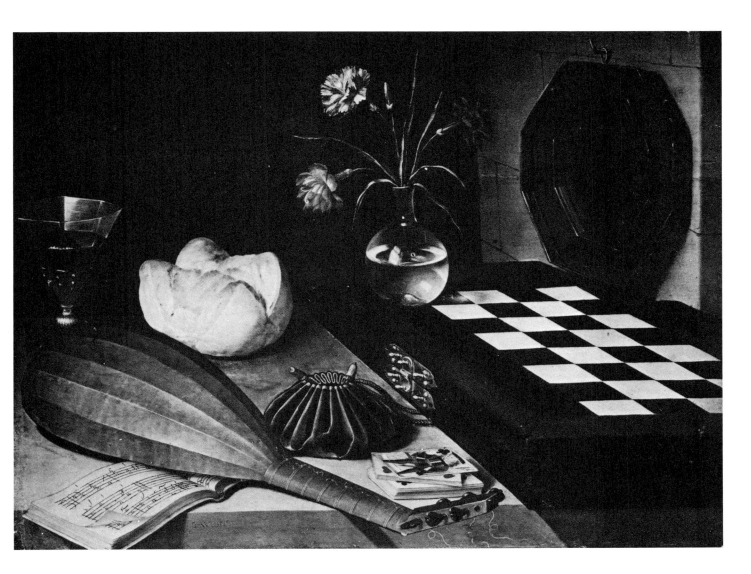

LUBIN BAUGIN (ca. 1611-1663).
The Five Senses. Wood, 21 5/8 × 28 3/4.
Musée du Louvre, Paris.

23

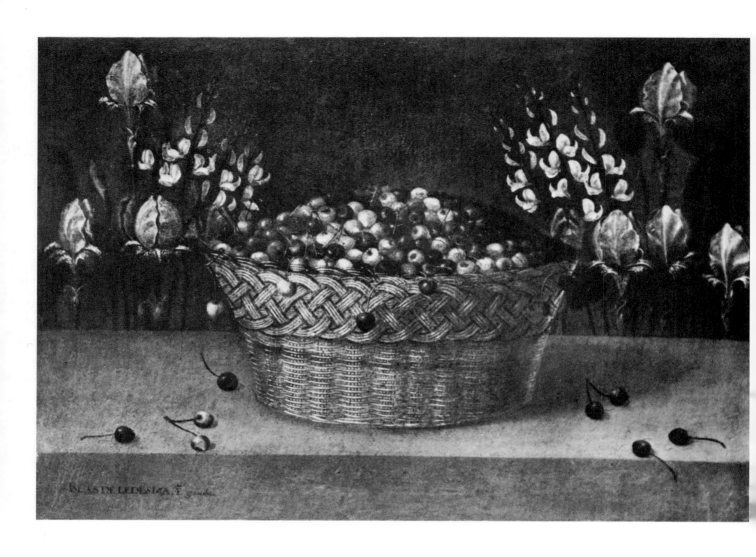

24

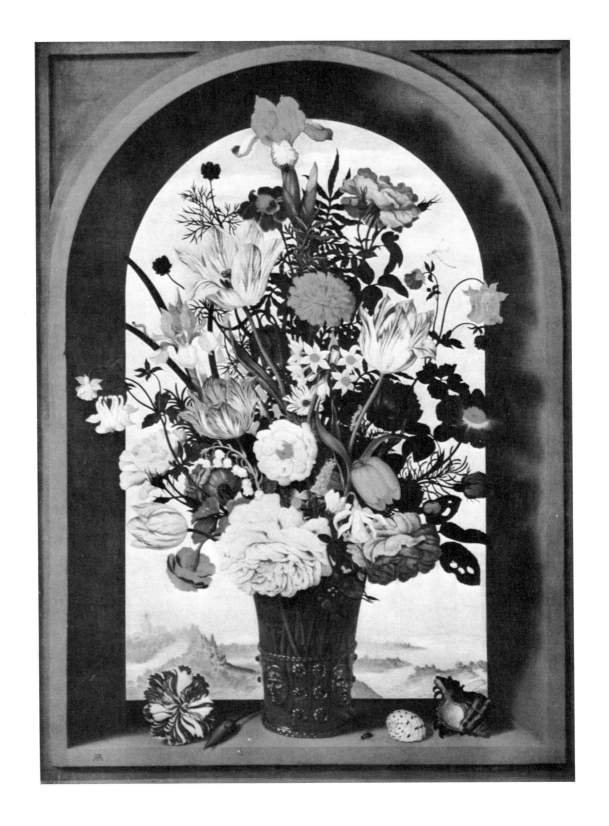

AMBROSIUS BOSCHAERT THE ELDER (1573-1621).
Bouquet in a Niche. Signed. Wood, 25 1/8 × 18 1/8.
Mauritshuis, The Hague.

25

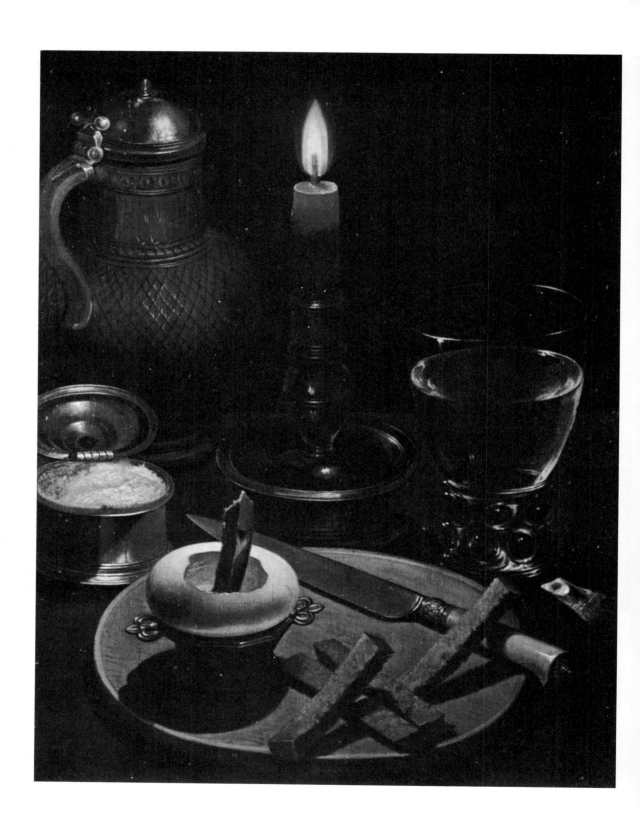

GOTTHARDT DE WEDIG (1583-1641).
Meal by Candlelight. Signed. Wood, 13 5/8 × 10 5/8.
Hessisches Landesmuseum, Darmstadt.

26

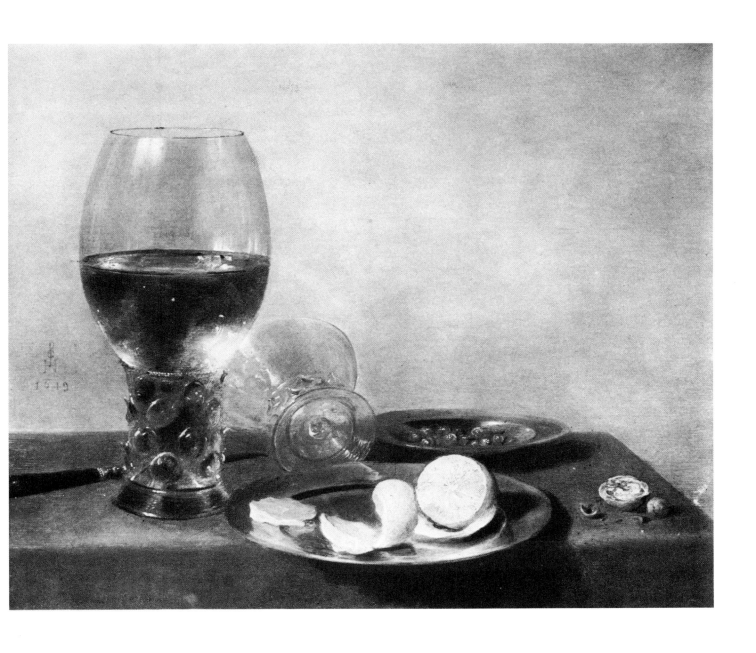

PIETER CLAESZ. (1597 or 1598-1661).
The Large Glass. Signed and Dated 1649. Wood, 15 3/4 × 19 5/8. 27
Formerly Dr. H. Wetzlar Collection, Amsterdam.

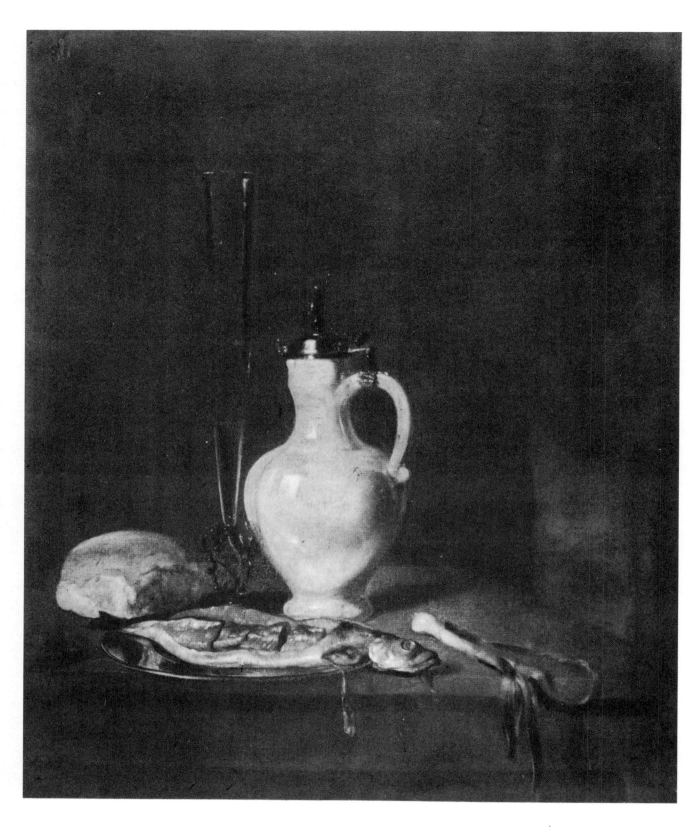

GABRIEL METSU (1629 or 1630-1667).
28 Luncheon with Herring. Signed. Canvas, 21 1/4 × 17 1/4.
Musée du Louvre, Paris.

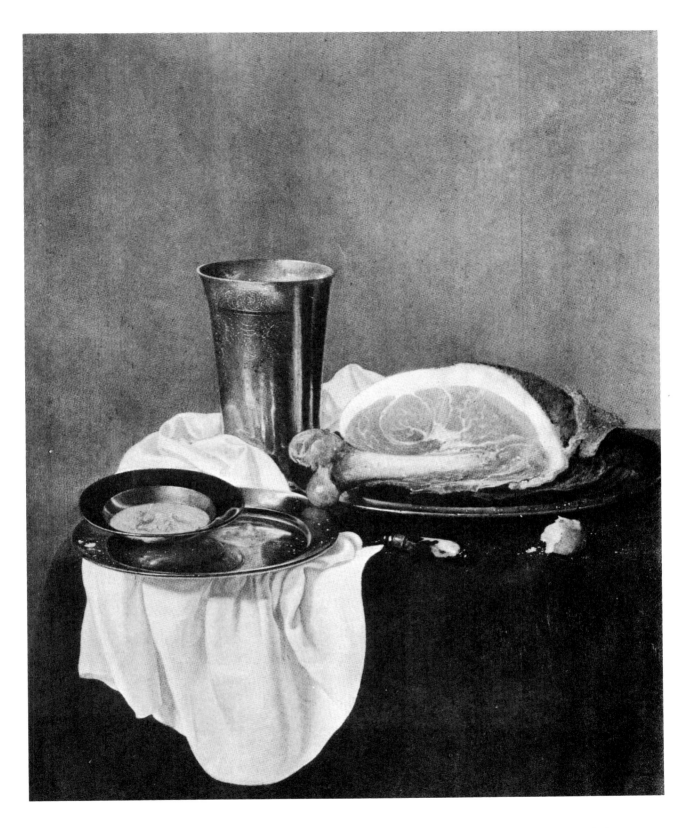

JAN JANSZ. DEN UYL (1595 or 1596-1639 or 1640).
The Ham. Wood, 24 3/8 × 19 5/8.
Wadsworth Atheneum, Hartford, Conn.

29

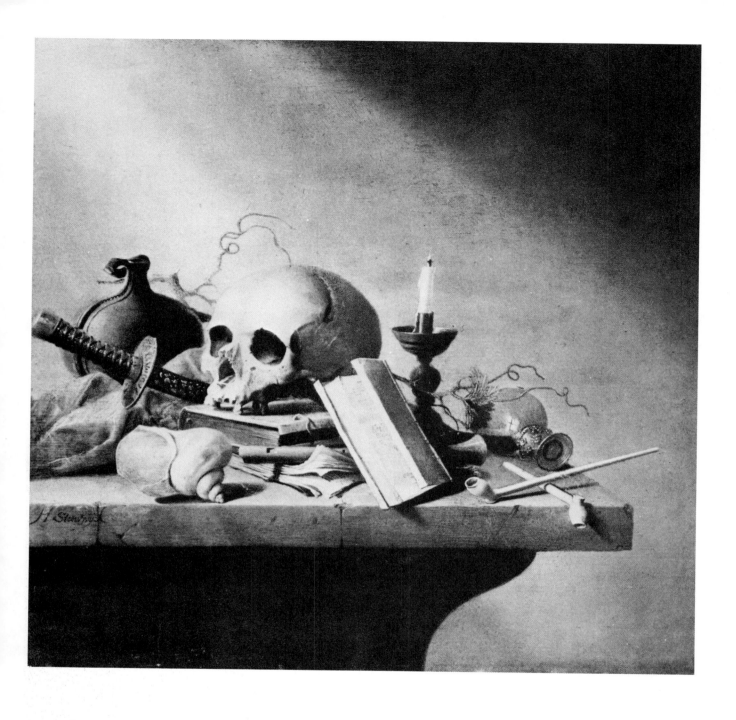

HARMEN STEENWIJCK (1612 - active up to 1664).
Vanitas. Signed. Wood, 23 1/8 × 29 1/8.
Stedelijk Museum de Lakenhal, Leyden.

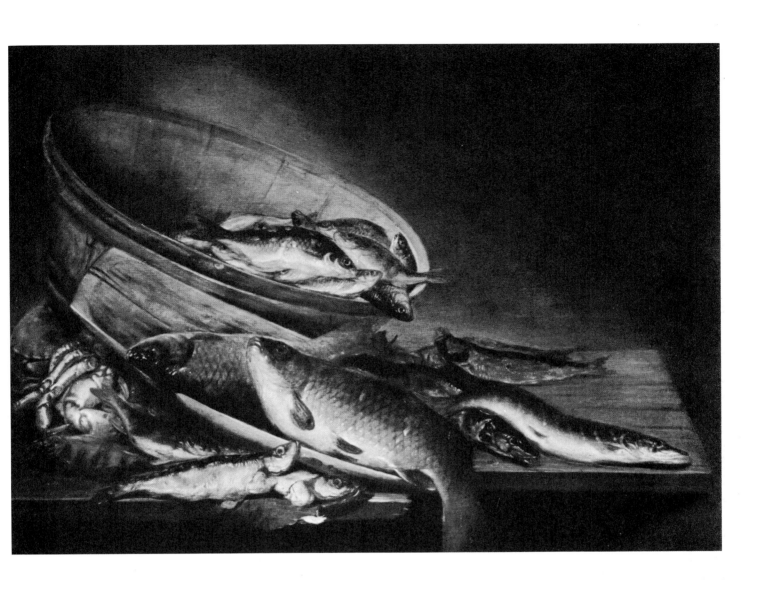

SALOMON VAN RUYSDAEL (ca. 1600-1670).
Fish. Signed and Dated 1666. Wood, 24 3/8 × 38 1/8.
Formerly Dr. H. Wetzlar Collection, Amsterdam.

31

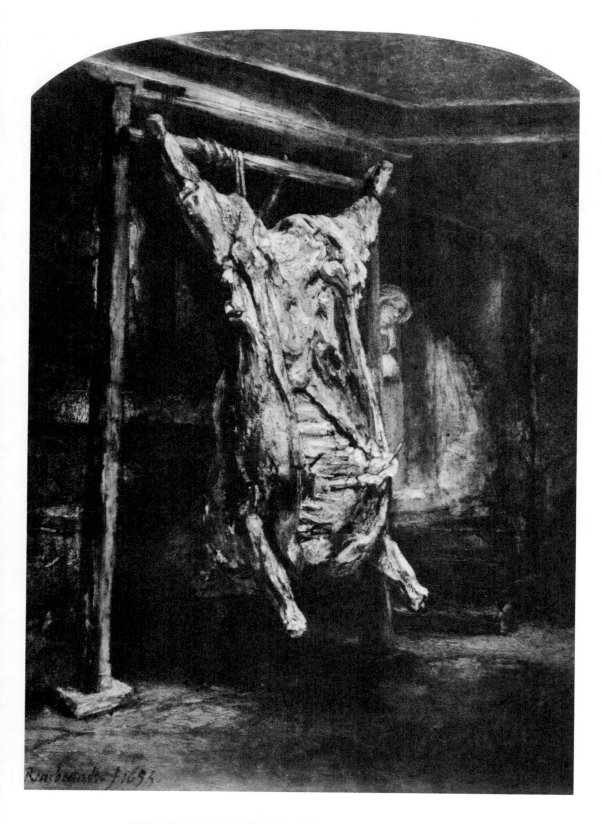

REMBRANDT VAN RIJN (1606-1669).
The Flayed Ox. Signed and Dated 1655. Wood, 37 × 25 1/8.
Musée du Louvre, Paris.

32

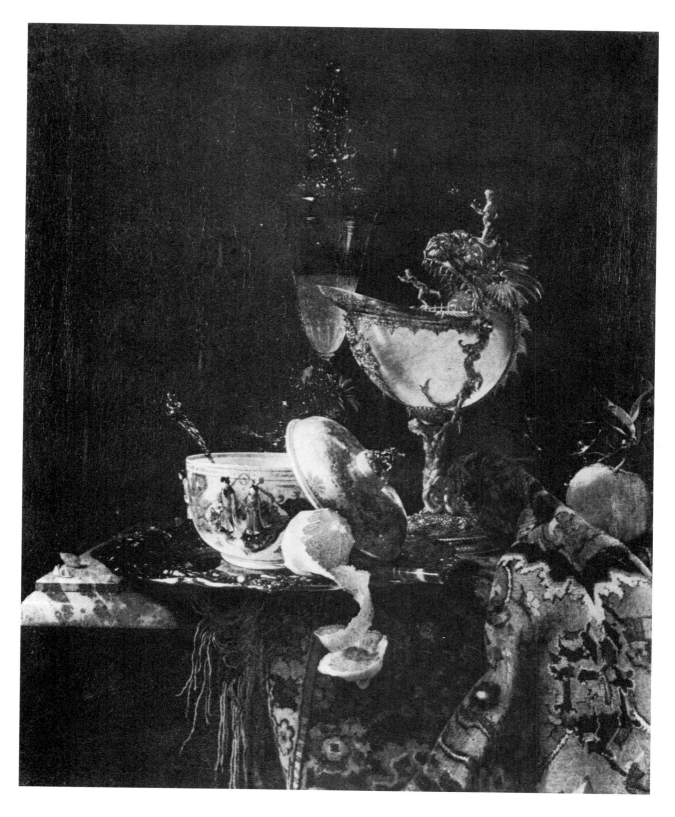

WILLEM KALF (1619-1693).
The Nautilus Cup. Canvas, 31 1/2 × 25 1/2.
H. E. Ten Cate Collection, Almelo, Holland.

33

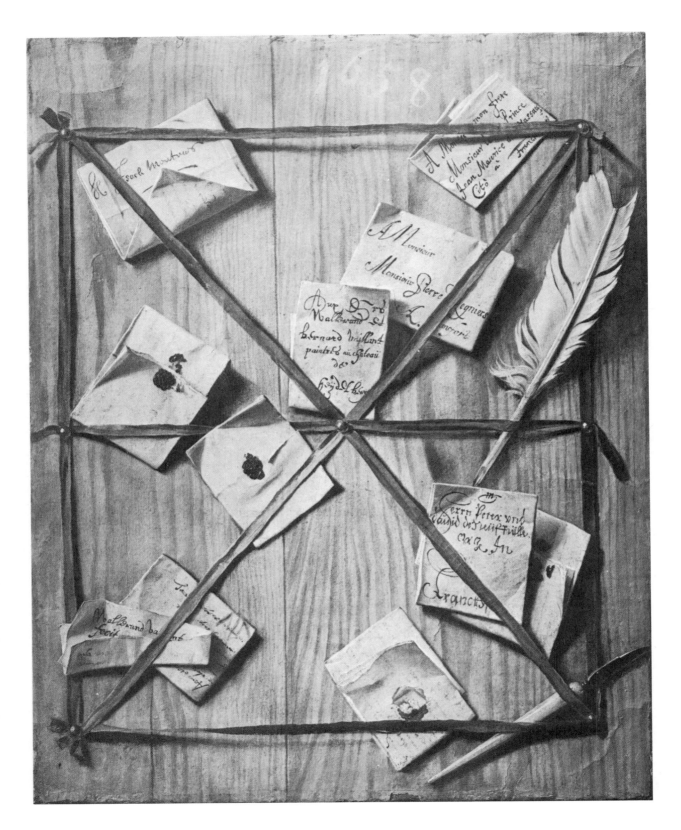

WALLERAND VAILLANT (1623-1677).
34 Trompe-l'œil : Letters. Signed and Dated 1658. Canvas, 20 × 15 3/4.
Gemäldegalerie, Dresden.

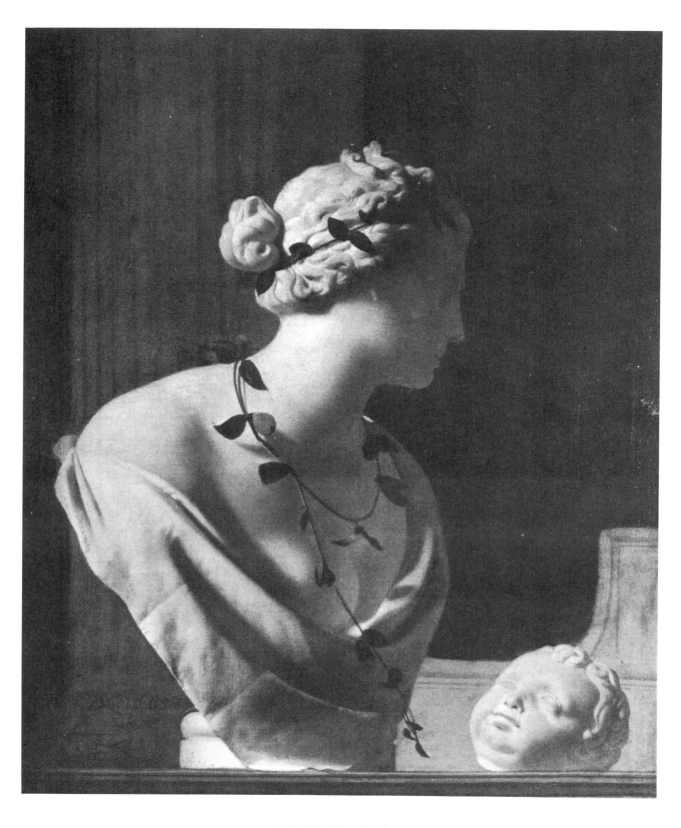

CAESAR BOETIUS VAN EVERDINGEN (ca. 1610-1678).
Bust crowned with Laurel. Signed and Dated 1665. Canvas, 29 1/2 × 24 3/8.
A. Staring Collection, Wildenborch Castle, Vorden, Holland.

35

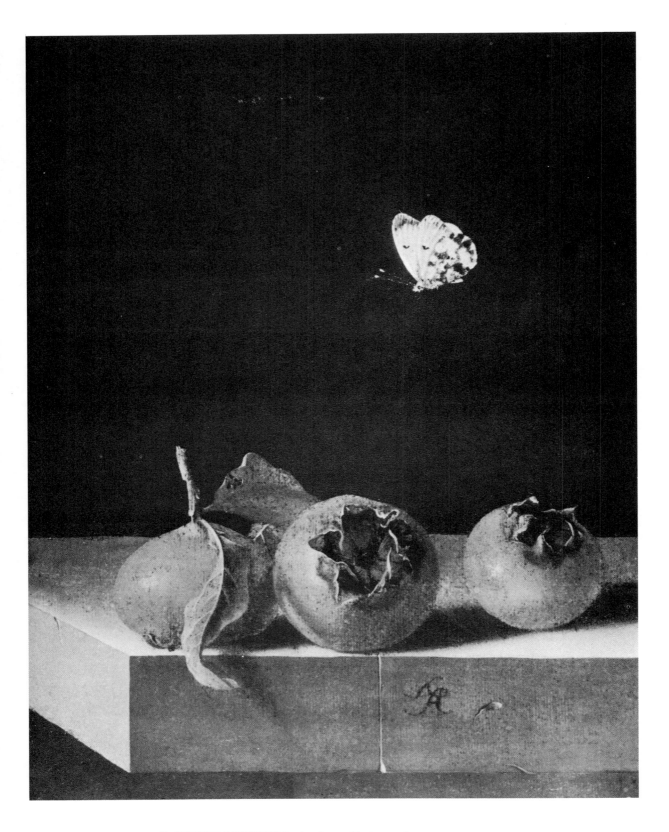

S. ADRIAEN COORTE (active from 1683 to 1723).
Medlars and Butterfly. Signed and Dated 1698. Paper pasted on wood. 10 3/8 × 7 7/8.
V. de Stuers Collection, Holland.

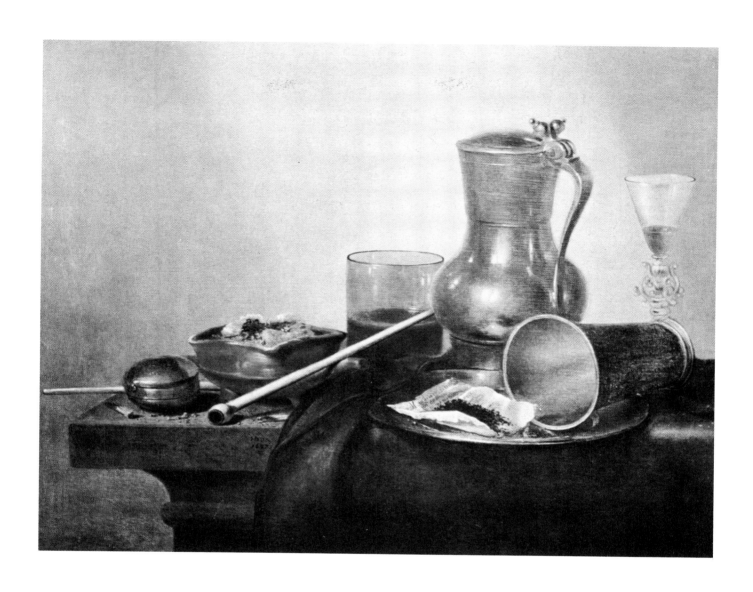

WILLEM CLAESZ. HEDA (1593 - between 1680 and 1682).
Wine, Tobacco and Watch. Signed and Dated 1637. Wood, 16 1/2 × 21.
J. M. Redelé Collection, Dordrecht.

37

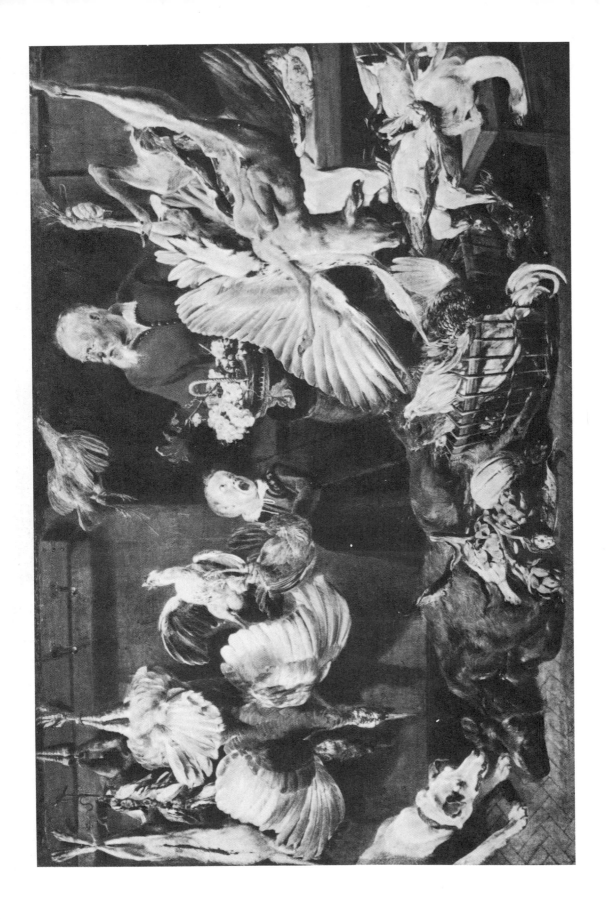

FRANS SNYDERS (1579-1657).
The Game Vendor. Canvas. 69 5/8 × 107 7/8.
Nasjonalgalleriet, Oslo.

38

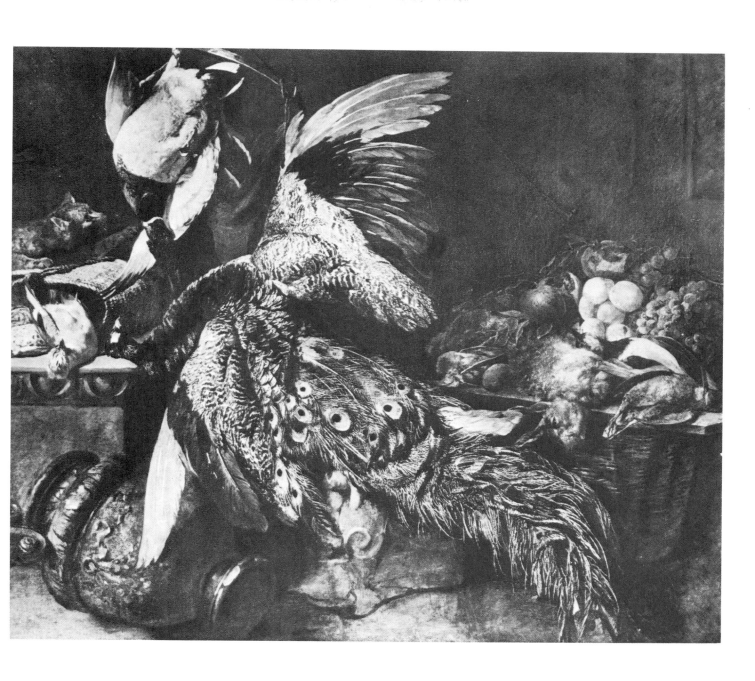

JAN FYT (1611-1661).
The Dead Peacock. Canvas, 52 × 58 5/8.
Museum Boymans-Van Beuningen, Rotterdam.

39

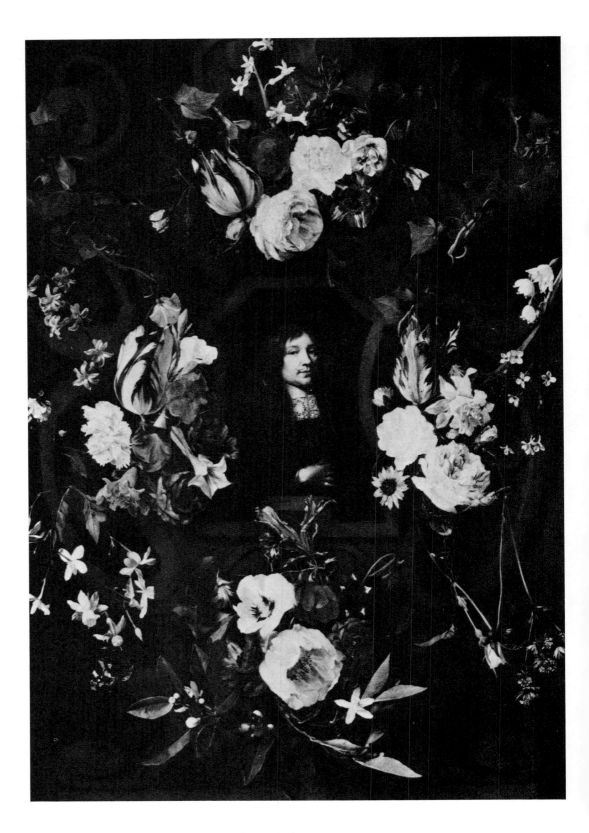

DANIEL SEGHERS (1590-1661).
Flowers around a Portrait. Signed. Copper, 32 5/8 × 23 1/4.
Musée des Beaux-Arts, Antwerp.

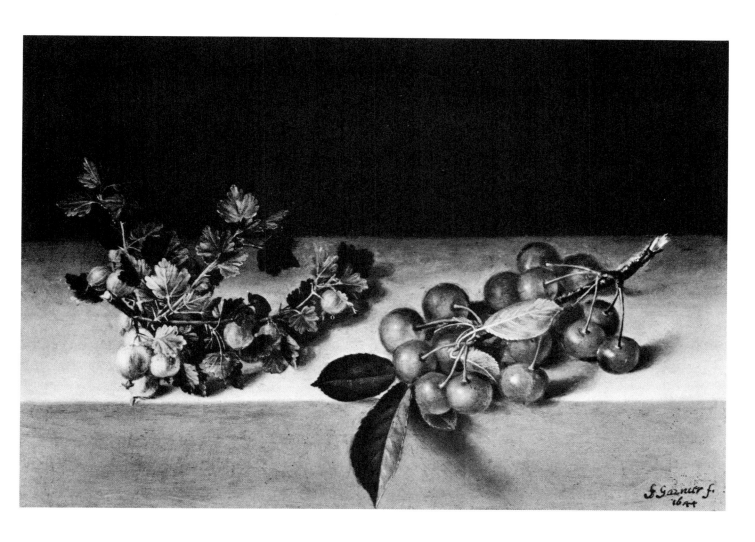

FRANÇOIS GARNIER (active from 1627 - before 1658).
Gooseberries and Cherries. Signed and Dated 1644.
Wood, 9 1/2 × 13 3/4. *Musée du Louvre, Paris.*

41

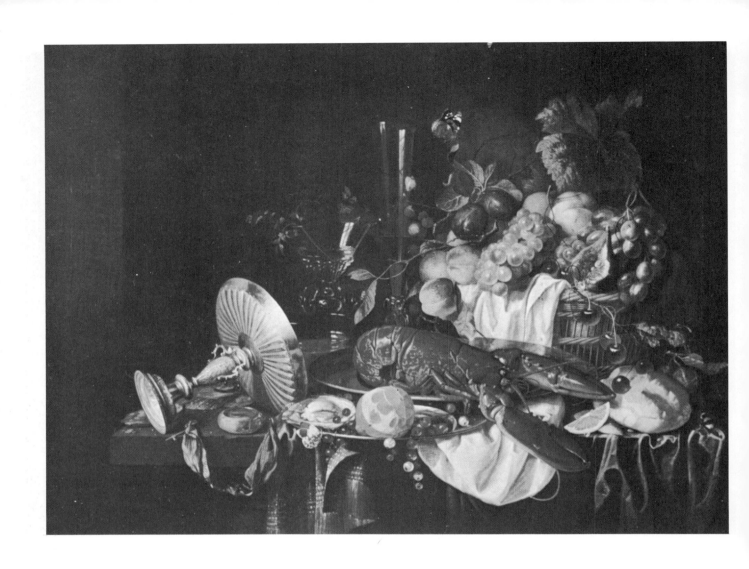

JAN DAVIDSZ. DE HEEM (1606-1684).
Lobster and Fruit. Signed. Canvas, 25 1/8 × 33 1/4.
Museum of Art, Toledo, Ohio.

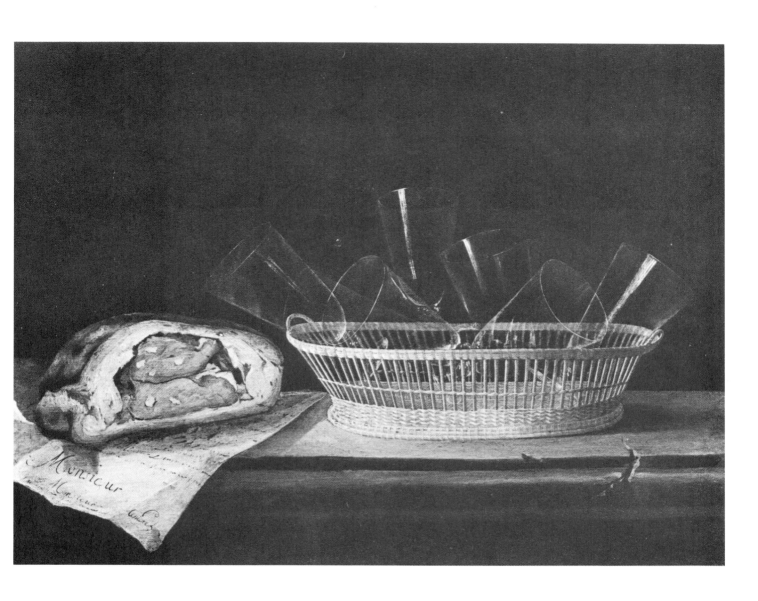

SÉBASTIEN STOSKOPFF (1597-1657).
Pâté and Basket of Glasses. Signed. Canvas, 19 1/2 × 25.
Musée des Beaux-Arts, Strasbourg.

43

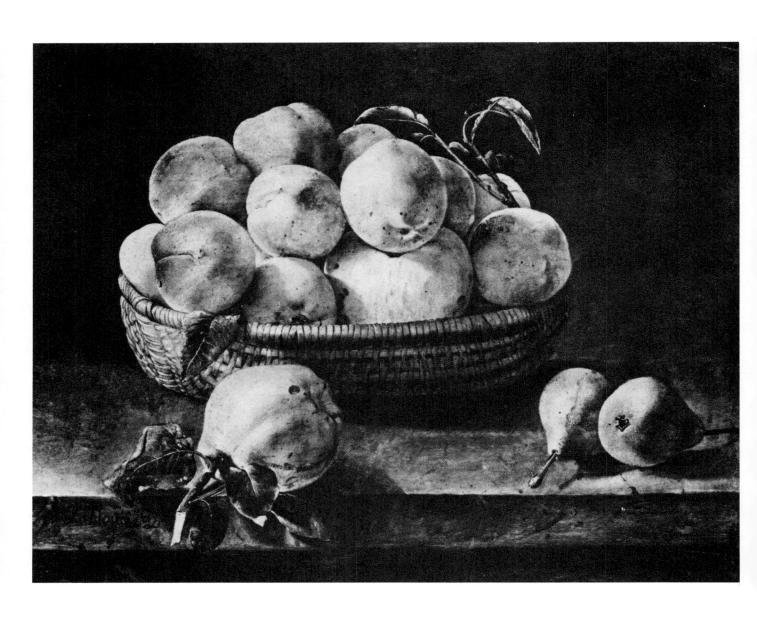

RENÉ NOURRISSON (active from 1644 to 1650).
Basket of Fruit. Signed. 13 3/8 × 17.
Private Collection, Germany.

44

FRENCH FOLLOWER OF LOUIS LE NAIN. Ca. 1640-1650.
The Overturned Wheelbarrow. Canvas, 26 3/4 × 22.
Musée du Louvre, Paris.

LOUISE MOILLON (1610-1696).
Grapes, Apples and Melon. Signed and Dated 1637. Canvas, 24 3/4 × 38 1/8.
Private Collection, U.S.A.

46

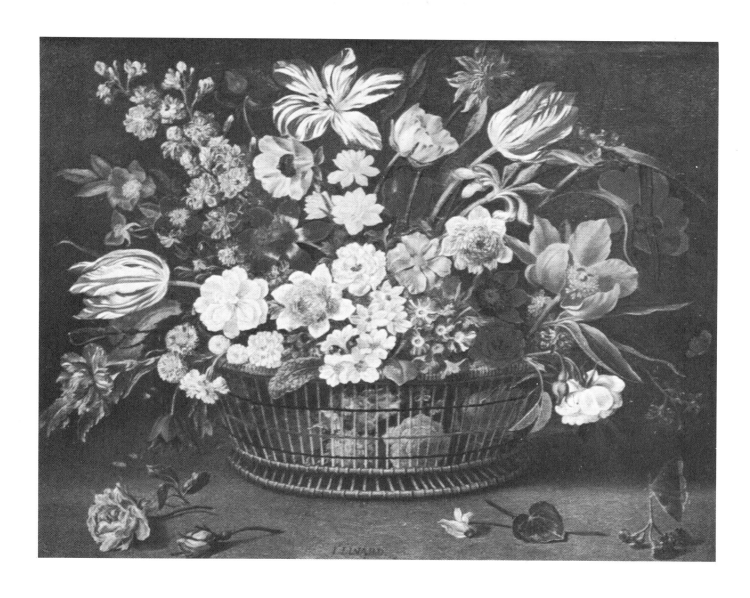

JACQUES LINARD (ca. 1600-1645).
Basket of Flowers. Signed. Canvas, 18 1/8 × 24.
Musée du Louvre, Paris.

47

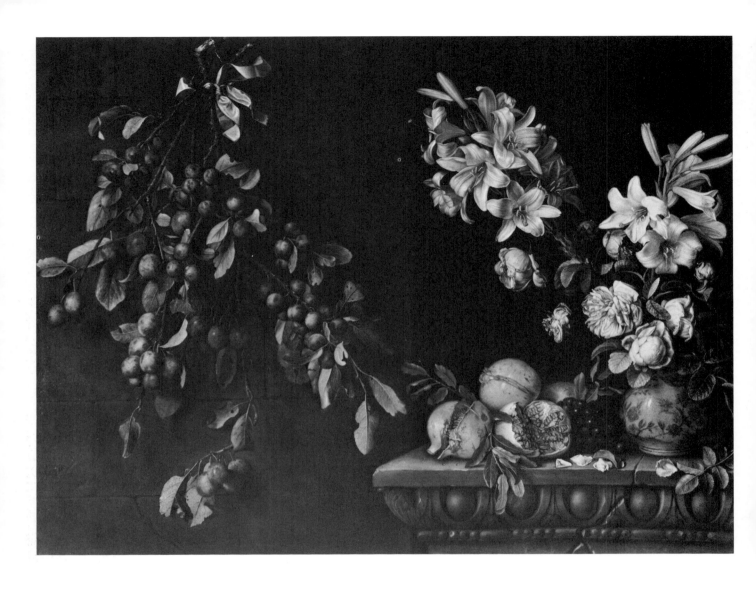

PIERRE DUPUIS (1610-1682).
Prunes, Grenades and a Vase of Lilies. Painted in 1663. Canvas, 35 × 45 1/2.
Private Collection, Paris.

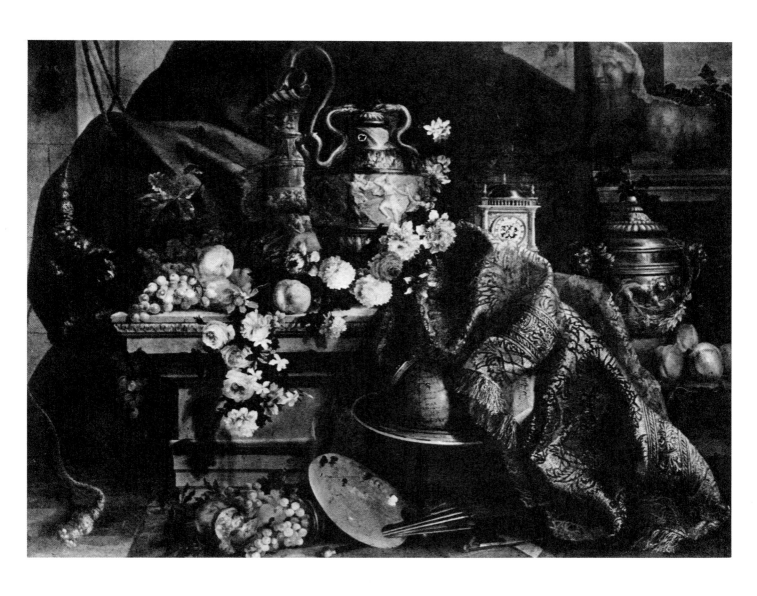

JEAN-BAPTISTE MONNOYER (1634-1699).
Flowers, Fruit and Art Objects. 1665. Canvas, 55 1/8 × 71 5/8.
Musée Fabre, Montpellier.

49

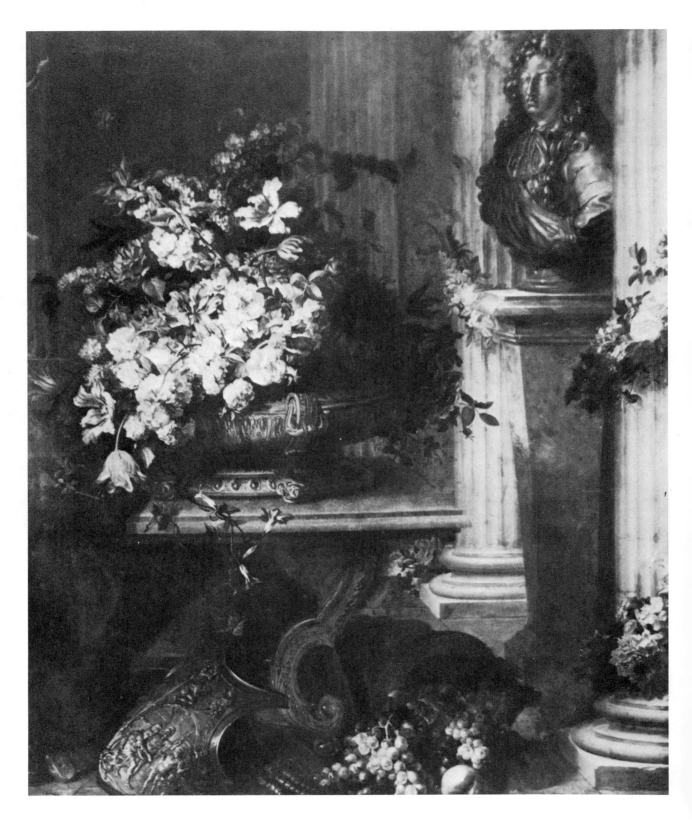

JEAN BELIN DE FONTENAY (1653-1715).
50 The Bust of Louis XIV. 1687. Canvas, 74 3/4 × 64 1/2.
Musée du Louvre, Paris.

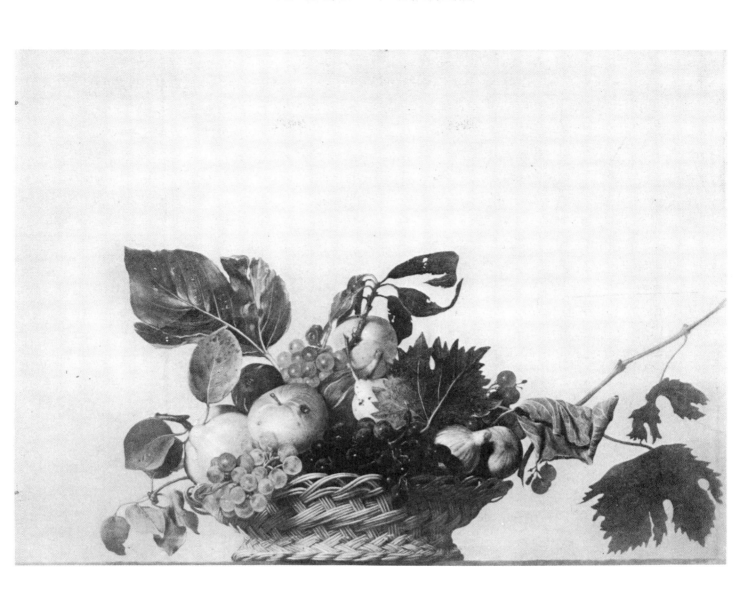

MICHELANGELO MERISI, called IL CARAVAGGIO (1573-1610).
Basket of Fruit. Canvas, 18 1/8 × 25 3/8.
Pinacoteca Ambrosiana, Milan.

51

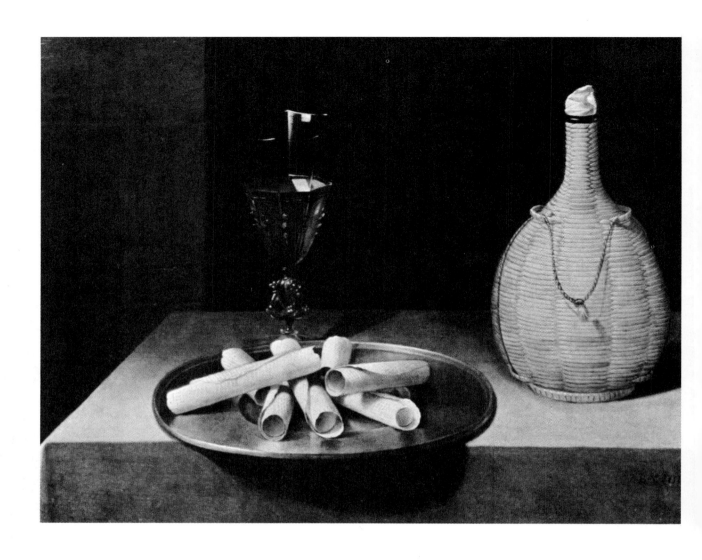

LUBIN BAUGIN (ca. 1611-1663).
Dessert with Wafers. Signed. Wood, 20 1/2 × 15 3/4.
Musée du Louvre, Paris.

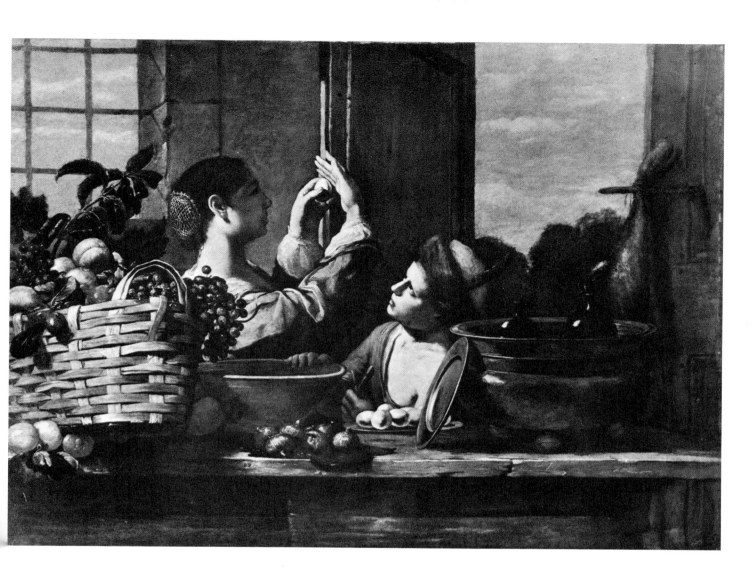

SIMONE DEL TINTORE (ca. 1630-1708).
Woman buying Eggs. Canvas, 46 × 63 3/4.
Institute of Arts, Minneapolis.

53

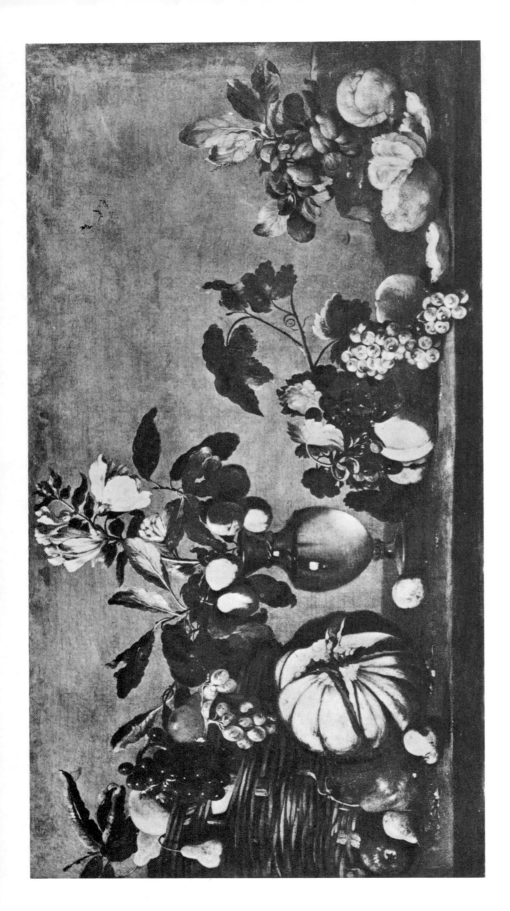

54

TOMMASO (called MAO) SALINI (ca. 1575-1625).
Fruit and Vase of Flowers. Signed. Canvas, 28 × 52 3/8.
Private Collection, Milan.

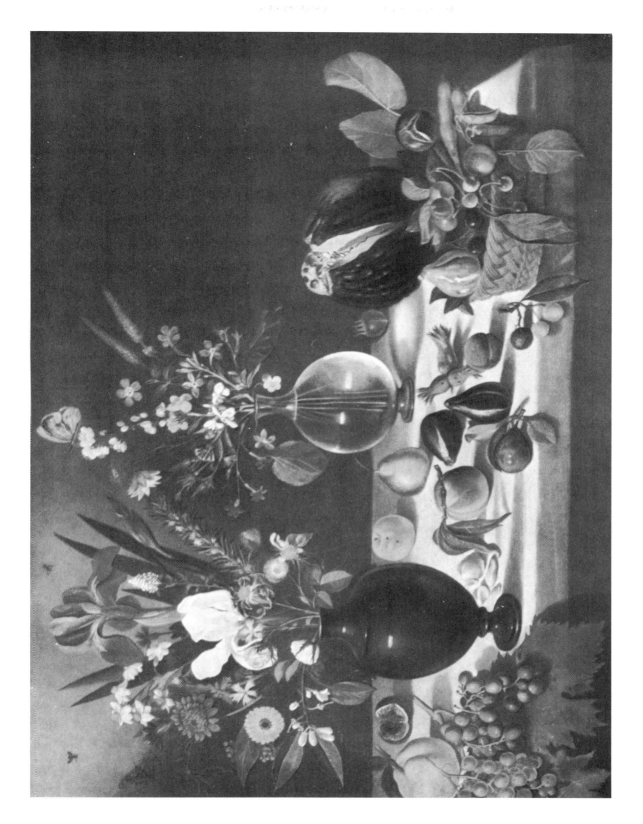

FOLLOWER OF CARAVAGGIO.
Flowers and Fruit. Canvas, 28 × 38.
Wadsworth Atheneum, Hartford, Conn.

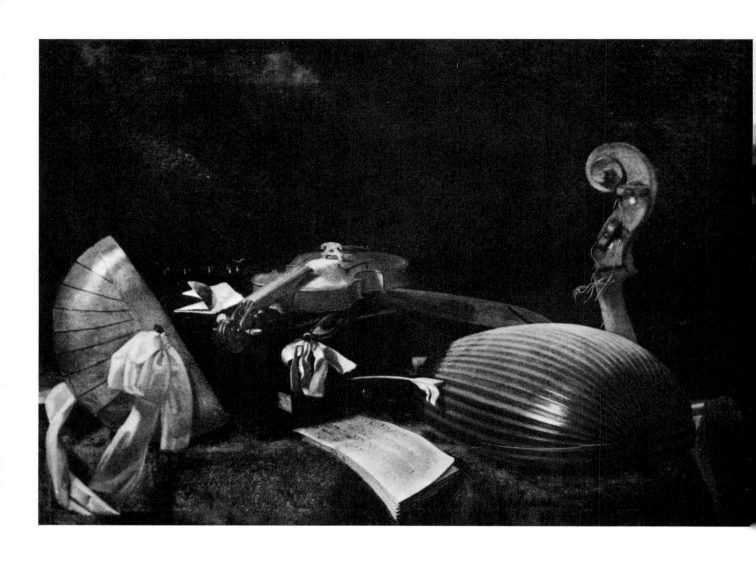

EVARISTO BASCHENIS (1617-1677).
Musical Instruments. Signed. Canvas, 29 1/2 × 42 1/2.
Accademia Carrara, Bergamo.

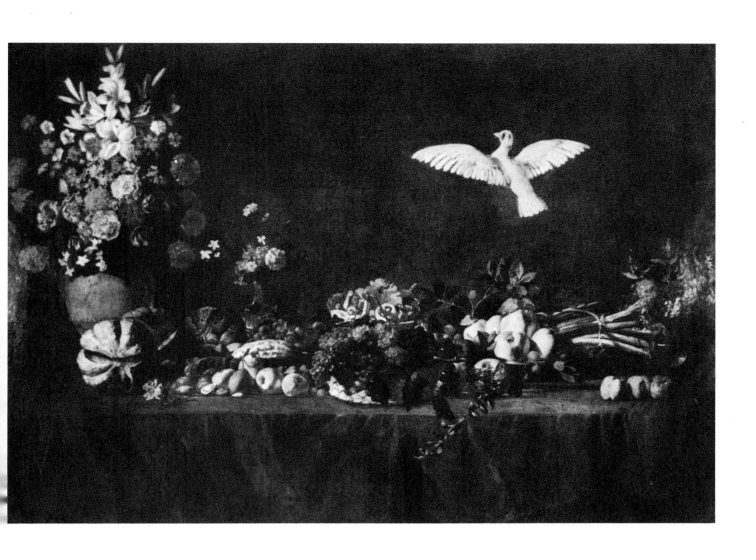

PAOLO PORPORA (1617-1673).
Flowers, Fruit and Dove. Canvas, 59 × 83 1/8.
Pinacoteca Civica, Palazzo San Gervasio (Province of Bari).

57

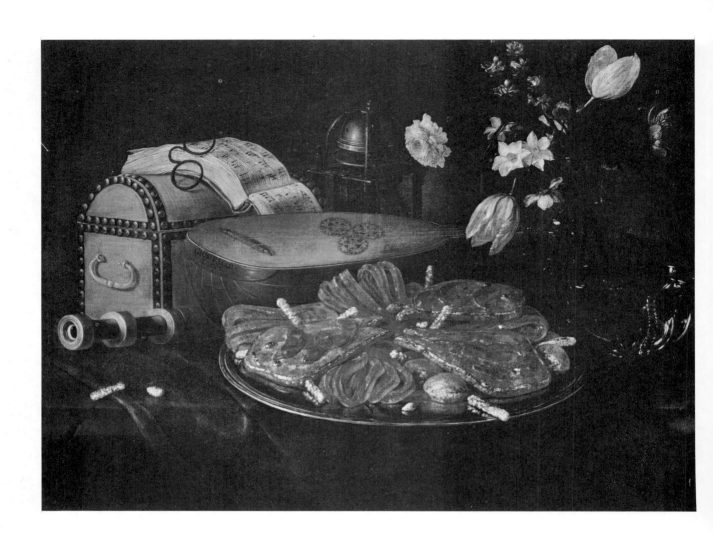

GIUSEPPE RECCO (1634-1695).
57 *bis* The Five Senses. Signed and Dated 1676. Canvas, 29 × 40.
Private Collection, London.

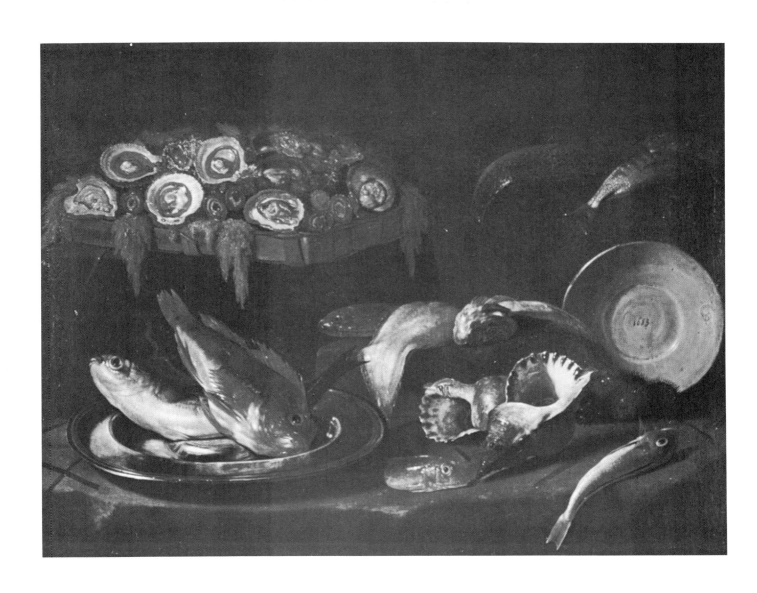

GIOVANNI BATTISTA RECCO (ca. 1628-ca. 1675).
Display of Seafood. Signed and Dated 1653. Canvas, 39 3/8 × 49 1/4.
Nationalmuseum, Stockholm.

58

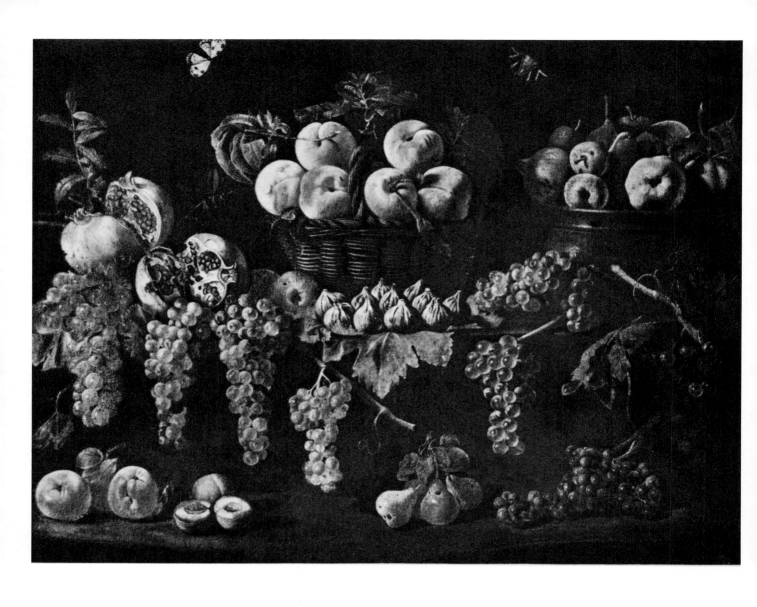

PIETRO PAOLO BONZI, called GOBBO DEI FRUTTI (1575 or 1576 · 1636).
Fruit Display. Signed Canvas, 43 1/4 × 55 1/8.
Formerly Dr. H. Wetzlar Collection, Amsterdam.

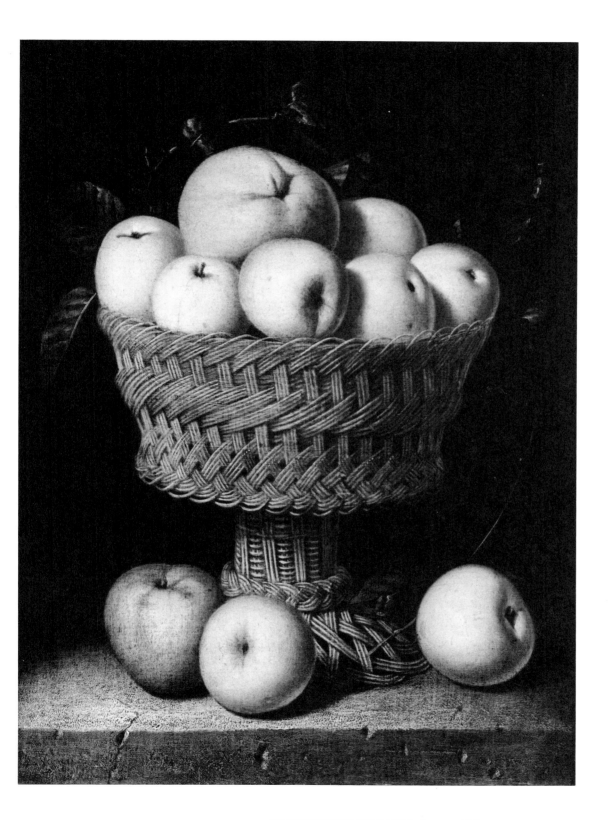

FRANCISCO DE VARGAS (active ca. 1680).
Basket of Apples. Signed and Dated 1679. Canvas, 21 1/2 × 15 3/4.
David Koetser, Zurich.

60

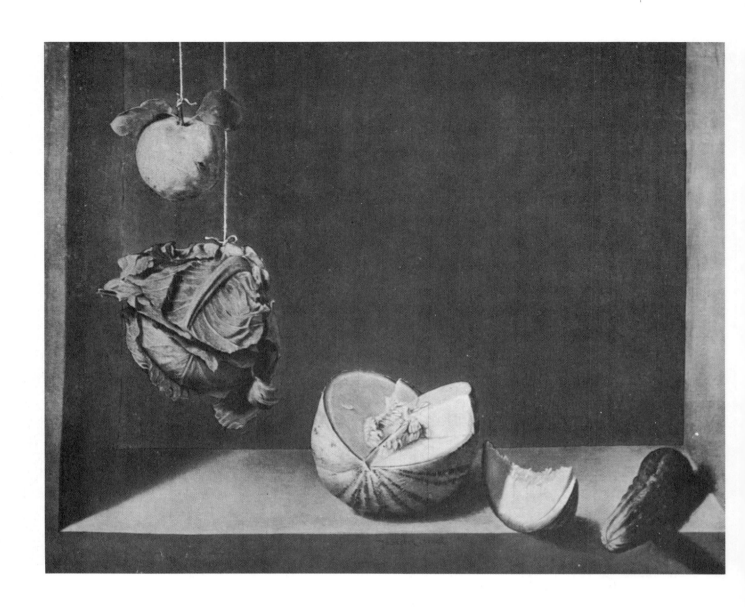

JUAN SANCHÉZ COTÁN (1561-1627).
Quince, Cabbage, Melon and Cucumber. Signed. Canvas, 25 1/2 × 31 7/8.
Fine Arts Gallery, San Diego, Calif.

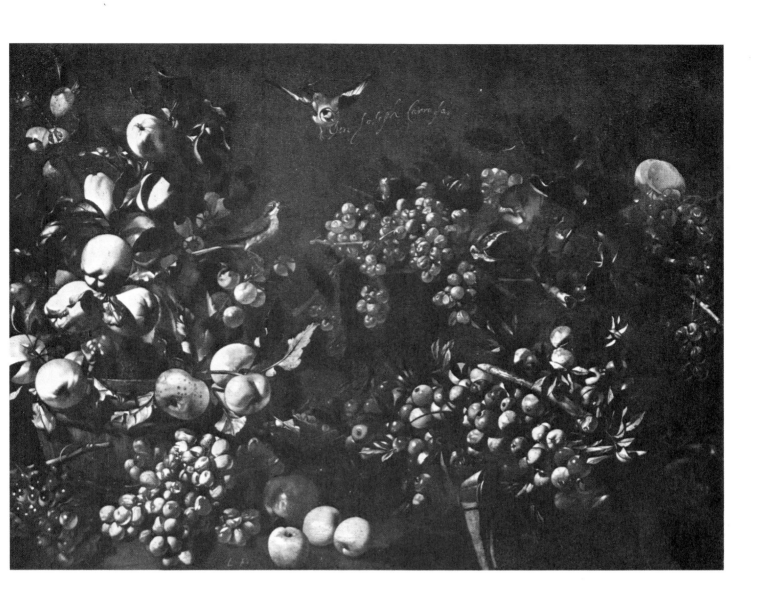

LUCA FORTE (active ca. 1640-1670).
Fruit and Bird. Painted for " Don Joseph Carrafa ". Signed. Canvas, 29 7/8 × 40 1/2.
Mortimer Brandt Collection, New York.

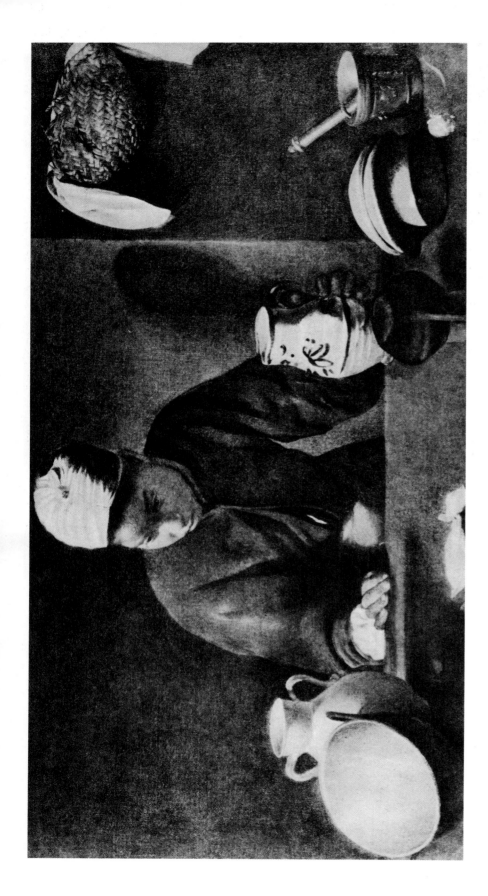

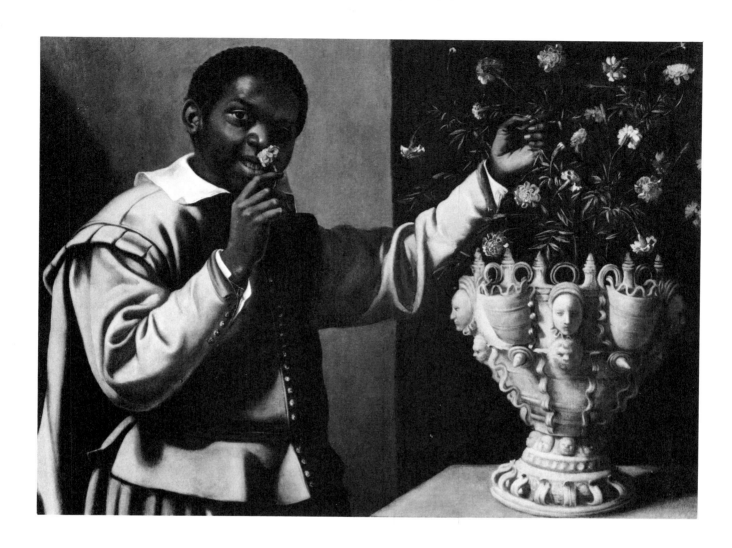

SPANISH PAINTER. Middle of the 17th Century.
Allegory of Scent. Canvas, 28 1/4 × 38.
Collection J. and D. de Menil, Houston.

63 *bis*

JUAN VAN DER HAMEN Y LEÓN (1596-1631).
Fruit and Crystal Vases. Signed and Dated 1626. Canvas, 33 × 44 1/8.
Museum of Fine Arts (S. H. Kress Collection), Houston.

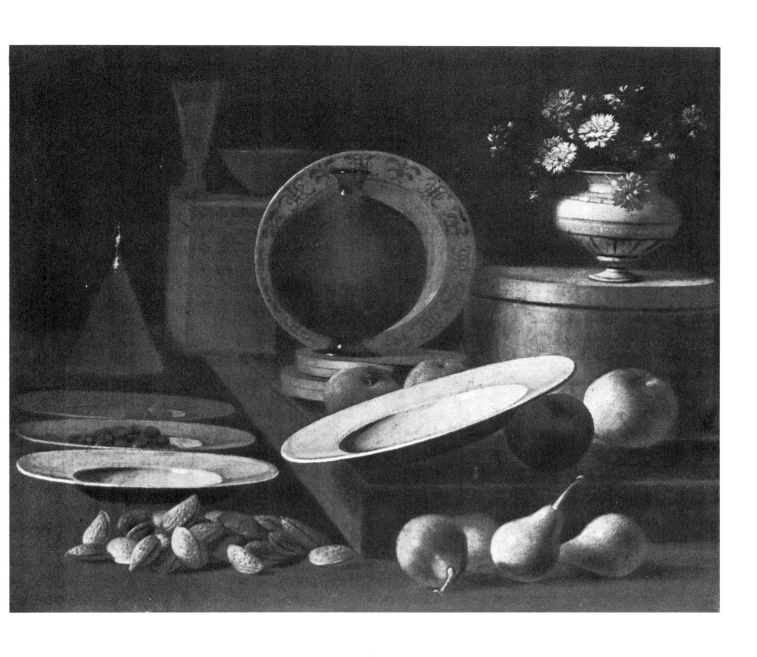

FOLLOWER OF ZURBARAN. Ca. 1640-1650.
Plates, Boxes and Fruit. Canvas, 23 5/8 × 28 3/4.
Private Collection, Holland.

65

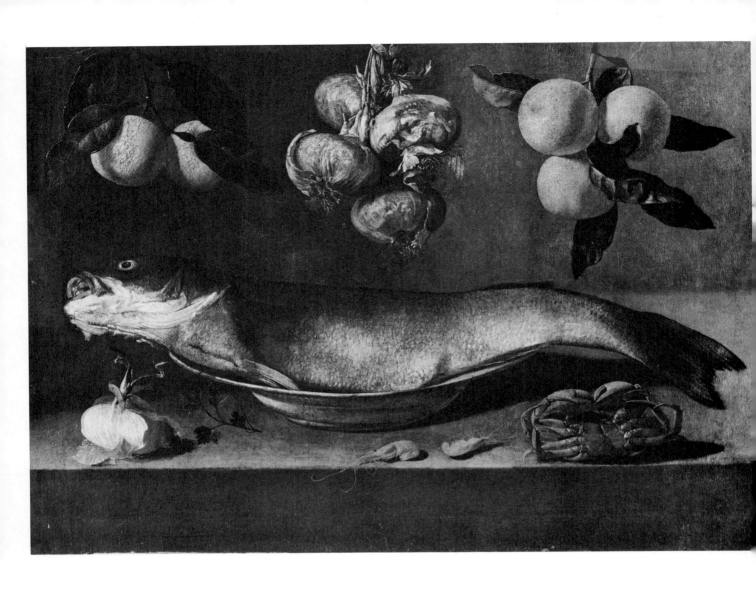

BALTASAR GOMEZ FIGUEIRA (ca. 1621-1675).
65 *bis* Oranges, Onions, Fish and Crab. Signed and Dated 1645. Canvas, 21 1/8 × 29 1/8.
Private Collection, Paris.

FRANCISCO DE ZURBARAN (1598-1664).
Lemons, Oranges and a Rose. Signed and Dated 1633. Canvas, 23 5/8 × 42 1/8.
The Norton Simon Museum, Pasadena.

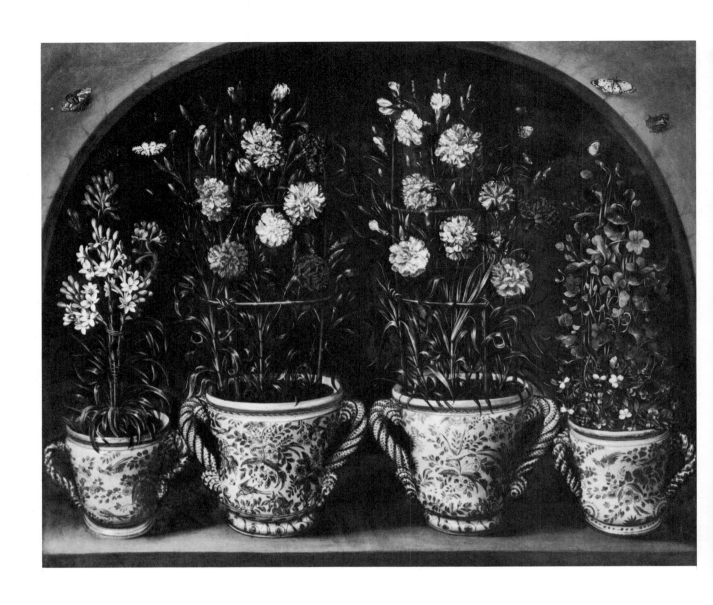

66 *bis* TOMAS YEPES (or HIEPES) (known activity 1643-1674).
Four Pots of Flowers in a Garden Niche. Canvas, 47 × 58.
Collection J. and D. de Menil, Houston.

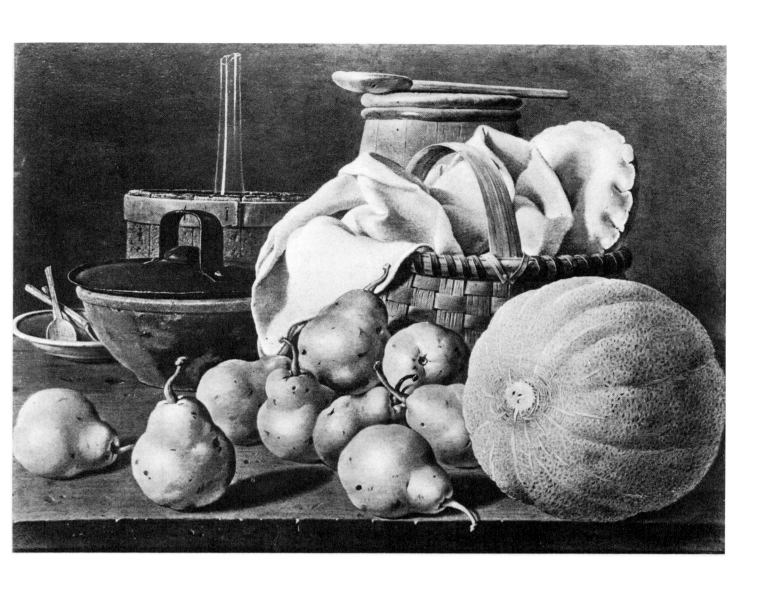

67

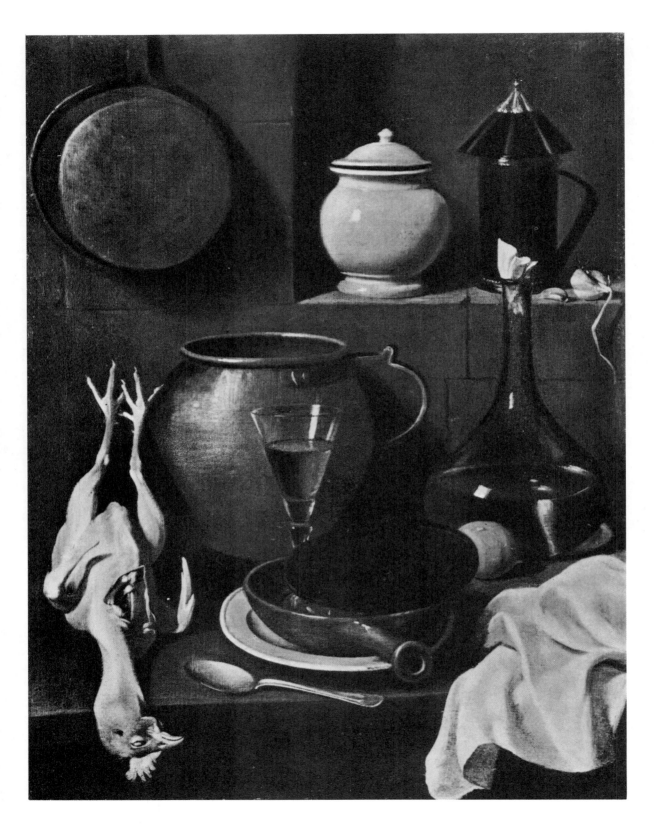

CARLO MAGINI (1720-1806).
White Jar and Chicken.
E. Wolf Collection, New York.

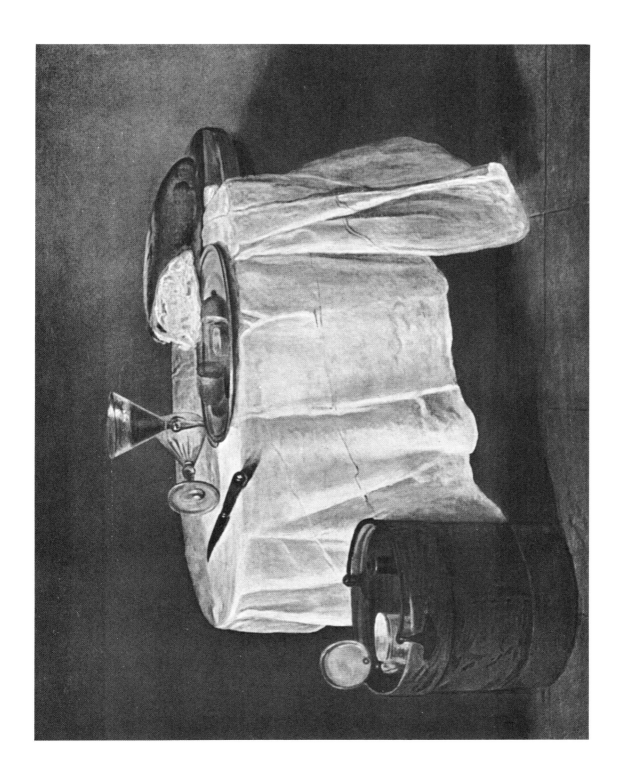

JEAN-BAPTISTE SIMÉON CHARDIN (1699-1779).
The White Tablecloth. Canvas, 38 × 48 3/4.
Art Institute of Chicago.

GIUSEPPE MARIA CRESPI (1665-1747).
Shelves in a Library. Ca. 1710-1715. Canvas, 62 1/2 × 29 1/8.
Conservatorio di Musica G. B. Martini, Bologna.

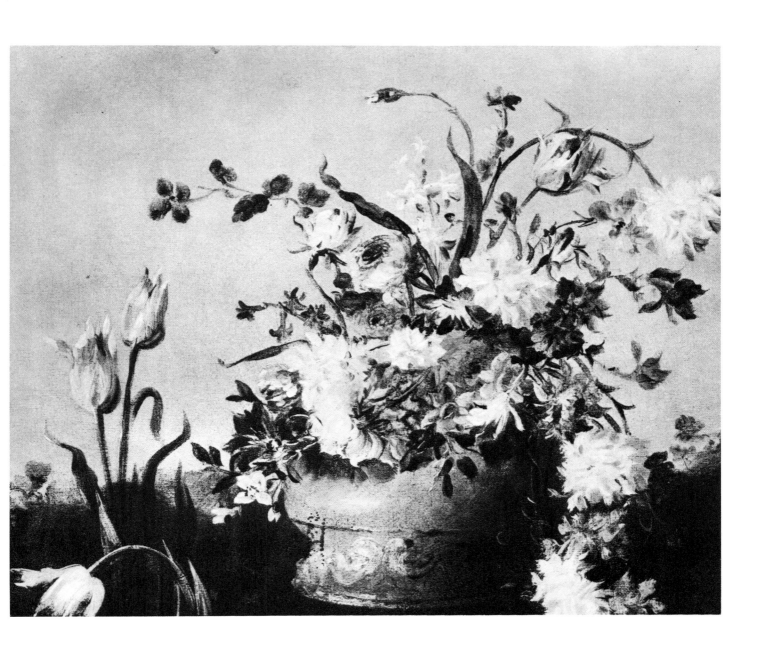

FRANCESCO GUARDI (1712-1793).
Flowers. Canvas, 18 1/8 × 21 5/8.
Maximo Sciolette Collection, Paris.

71

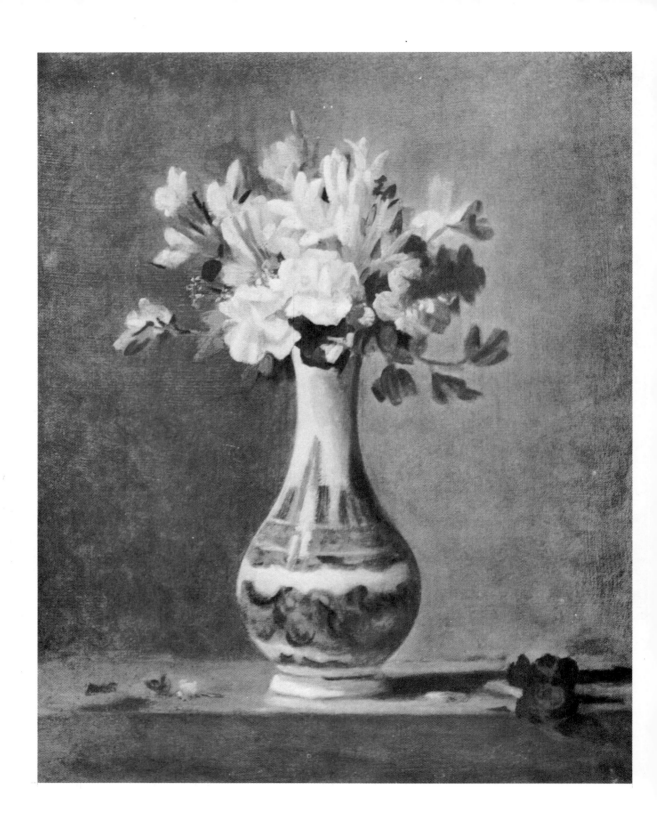

JEAN-BAPTISTE SIMÉON CHARDIN (1699-1779).
Vase of Flowers. Canvas, 17 1/4 × 14 1/4.
National Gallery of Scotland, Edinburgh.

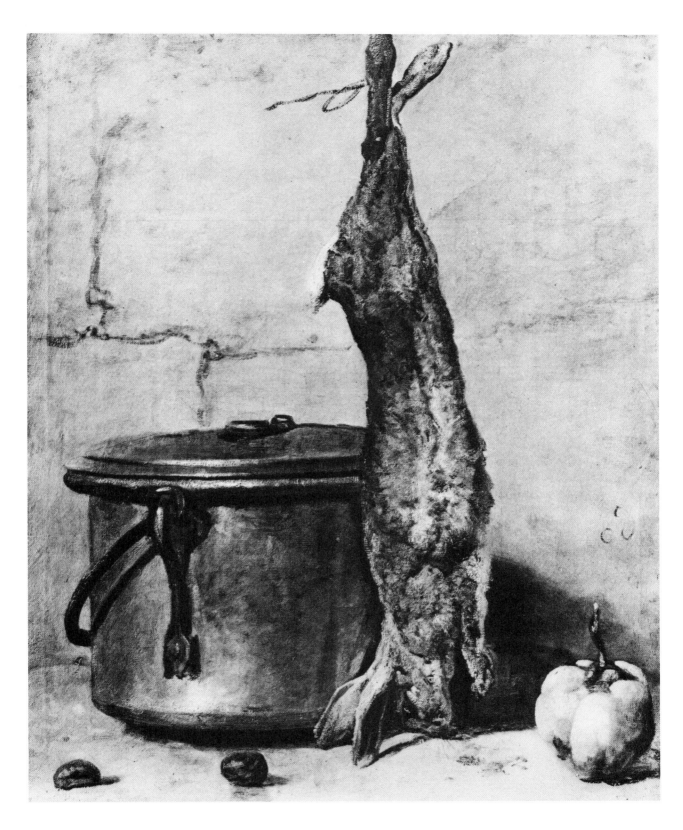

JEAN-BAPTISTE SIMÉON CHARDIN (1699-1779).
Hare and Copper Cauldron. Signed. Canvas, 26 3/4 × 22 3/8.
Nationalmuseum, Stockholm.

73

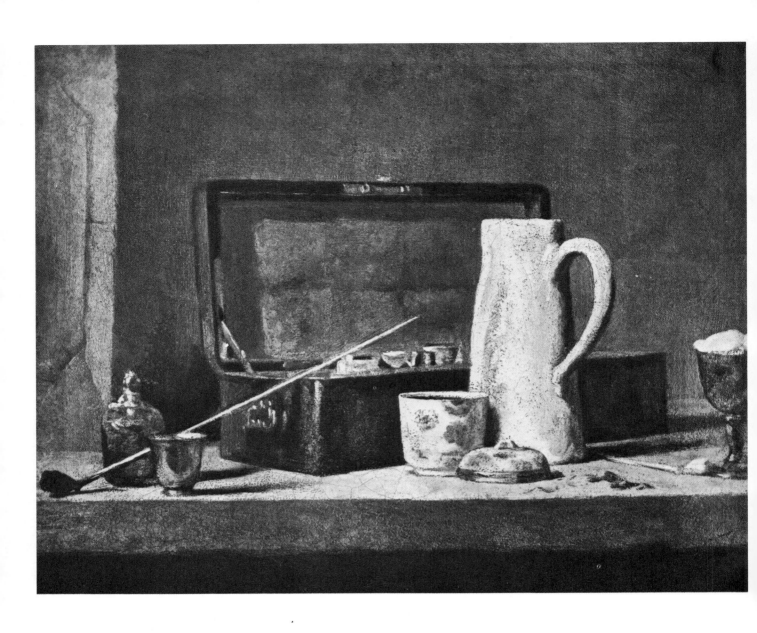

JEAN-BAPTISTE SIMÉON CHARDIN (1699-1779).
The Pipe. Signed. Canvas, 12 5/8 × 16 1/2.
Musée du Louvre, Paris.

74

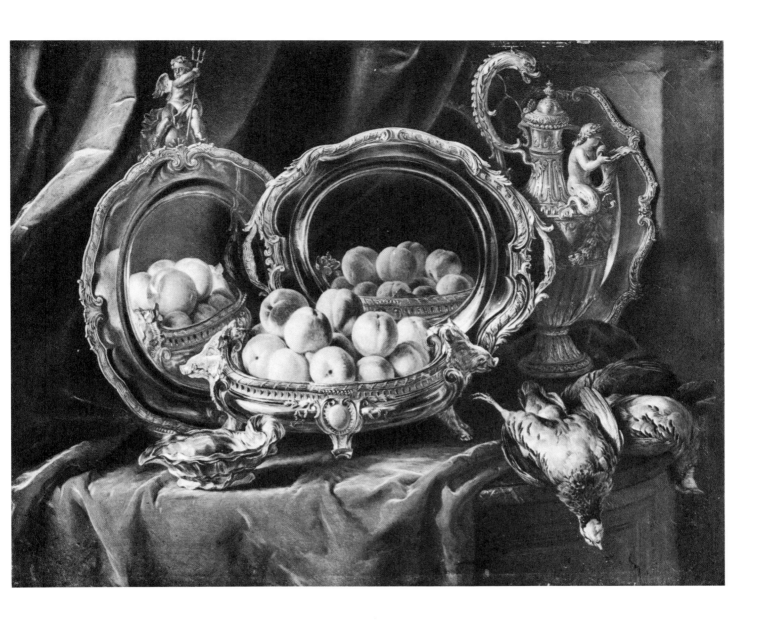

FRANÇOIS DESPORTES (1661-1743).
Peaches and Silver Platters. Signed. Canvas, 35 7/8 × 46 1/2.
Nationalmuseum, Stockholm.

75

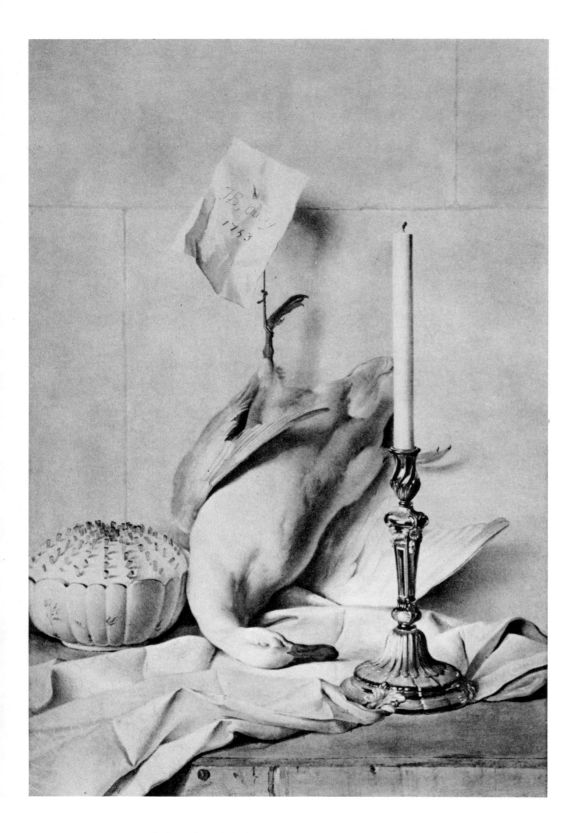

JEAN-BAPTISTE OUDRY (1680-1755).
The White Duck. Signed and Dated 1753. Canvas, 38 1/2 × 25 1/8.
Formerly Sir Philip Sassoon Collection, London.

76

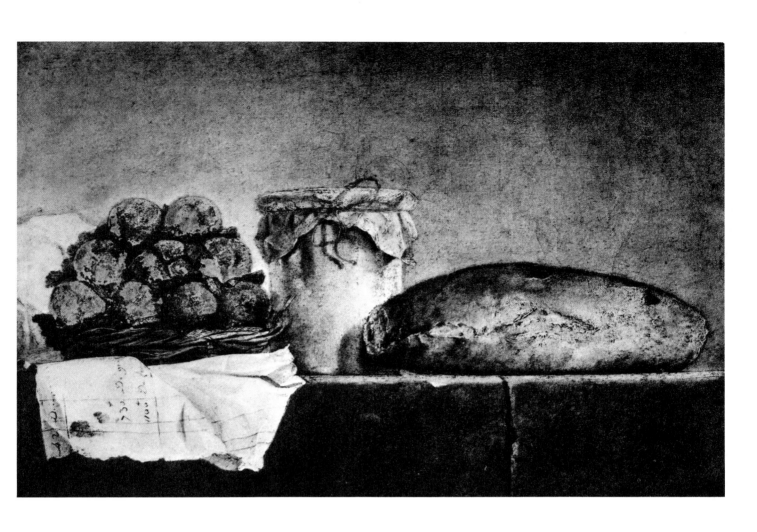

FOLLOWER OF CHARDIN. Ca. 1770-1780.
Basket of Peaches. Canvas, 17 1/2 × 24 3/8.
Museum Boymans - Van Beuningen, Rotterdam.

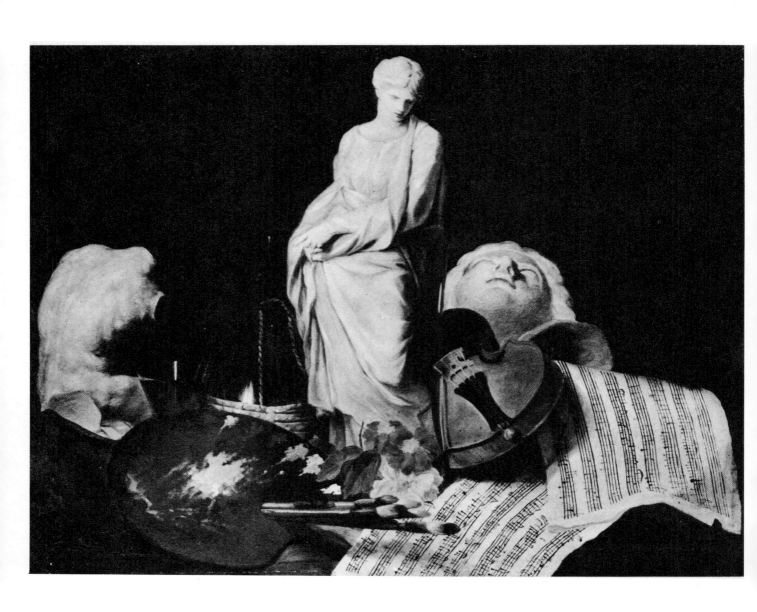

PIERRE SUBLEYRAS (1699-1749).
The Attributes of the Arts. Canvas, 28 3/8 × 37 3/4.
Musée des Augustins, Toulouse.

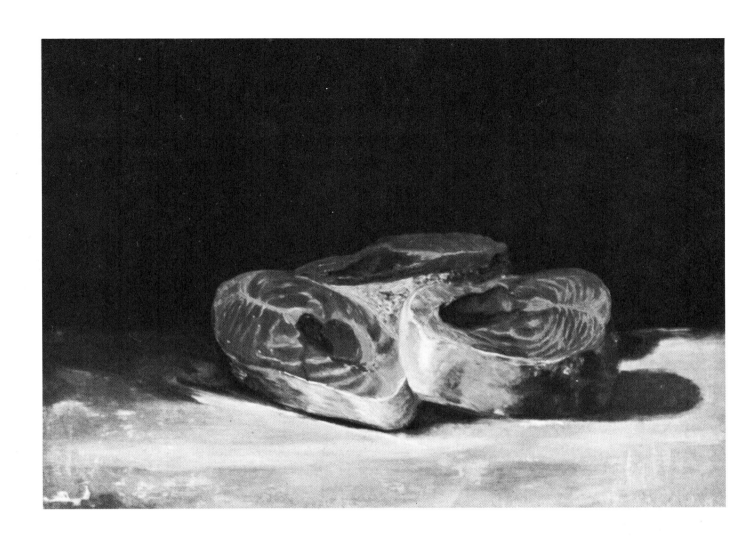

FRANCISCO DE GOYA (1746-1828).
Slices of Salmon. Canvas, 17 3/4 × 24 3/8.
Oskar Reinhart Collection, Winterthur, Switzerland.

79

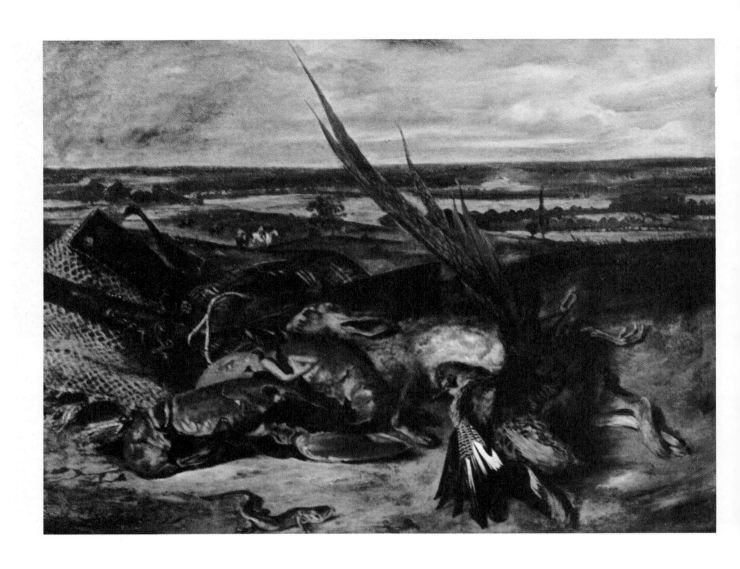

EUGENE DELACROIX (1798-1863).
Game and Shellfish. Signed. Canvas, 31 1/2 × 39 3/8.
Musée du Louvre, Paris.

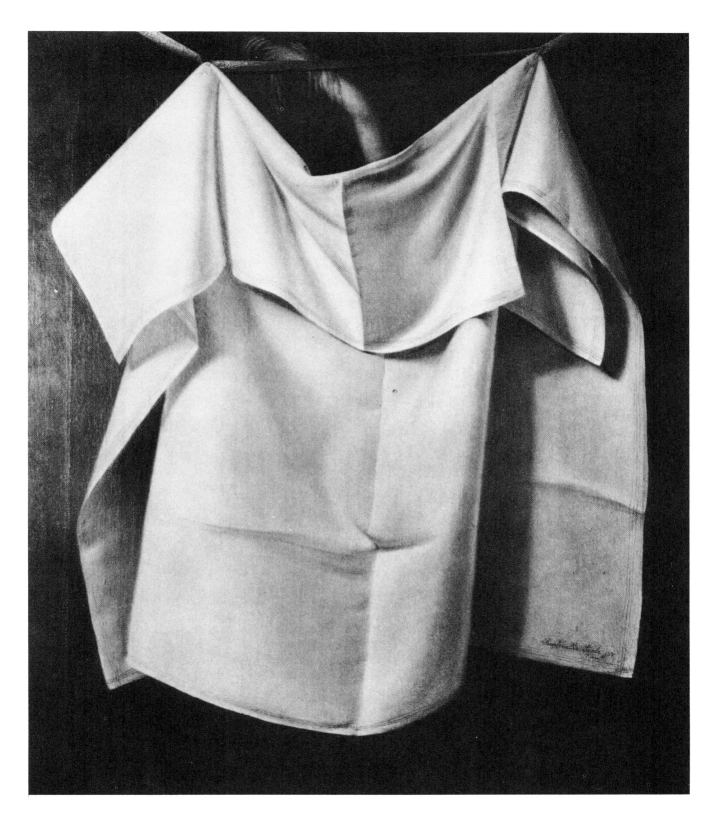

RAPHAELLE PEALE (1774-1825).
Trompe-l'œil : Hanging Sheet. Signed and Dated 1823. Canvas, 29 1/8 × 27 1/8.
William Rockhill Nelson Gallery, Kansas City.

81

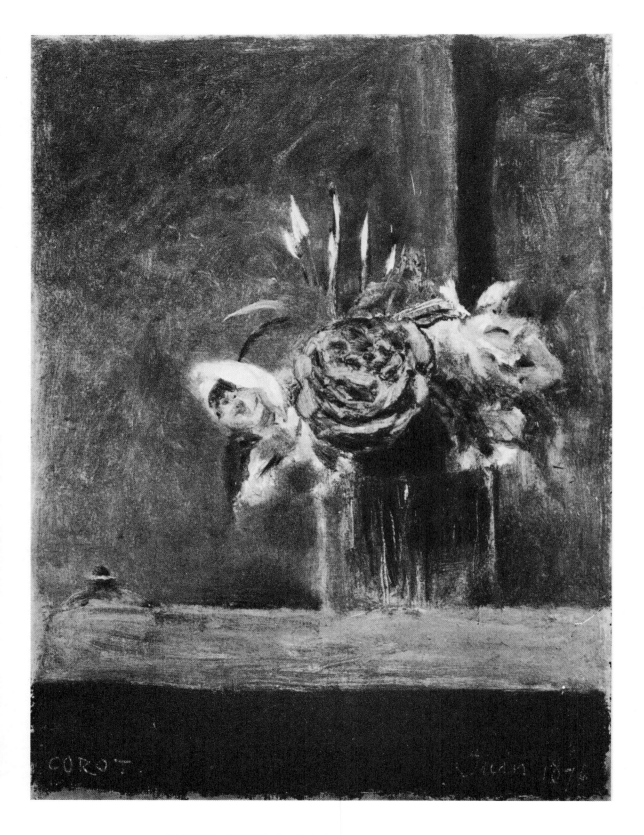

CAMILLE COROT (1796-1875).
82 Roses in a Vase. Signed and Dated : June 1874. Canvas, 12 5/8 × 9 1/2.
Chateaubriand Collection, São Paulo, Brazil.

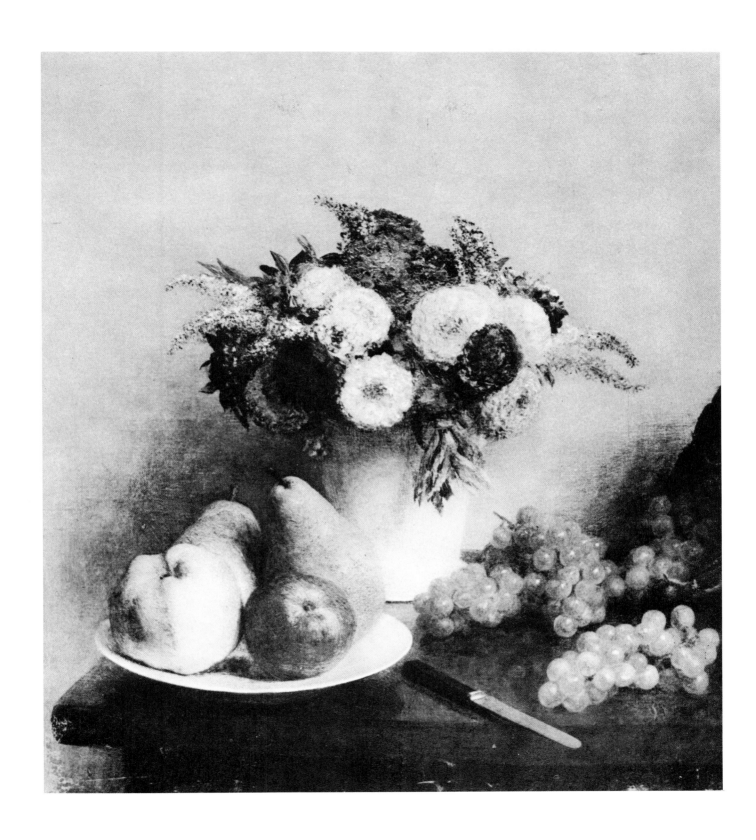

HENRI FANTIN-LATOUR (1836-1902).
Flowers and Fruit. Signed and Dated 1865. Canvas, 25 1/2 × 17 3/4.
Musées Nationaux, Paris.

83

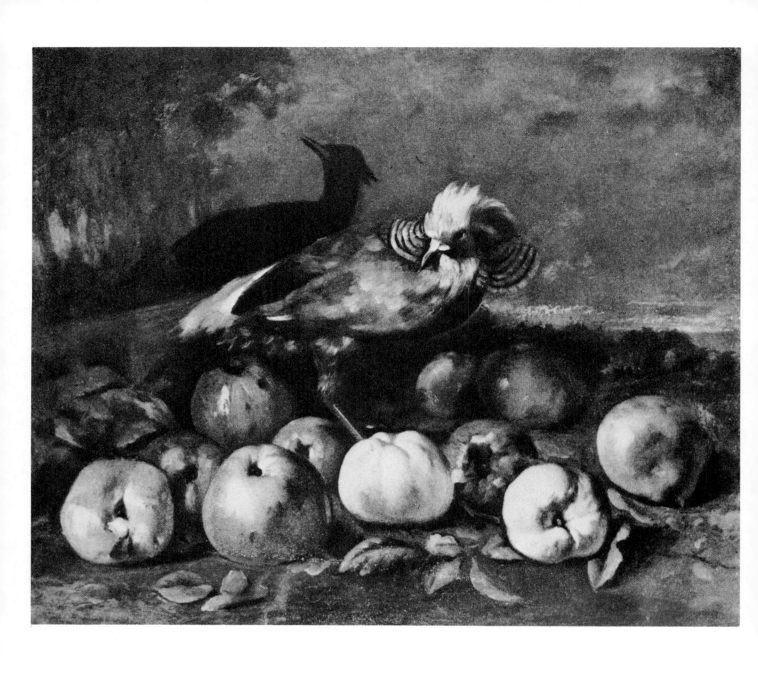

GUSTAVE COURBET (1819-1877).
Pheasants and Red Apples. 1871 or 1872. Canvas, 21 1/4 × 26.
Emil Bührle Collection, Zurich.

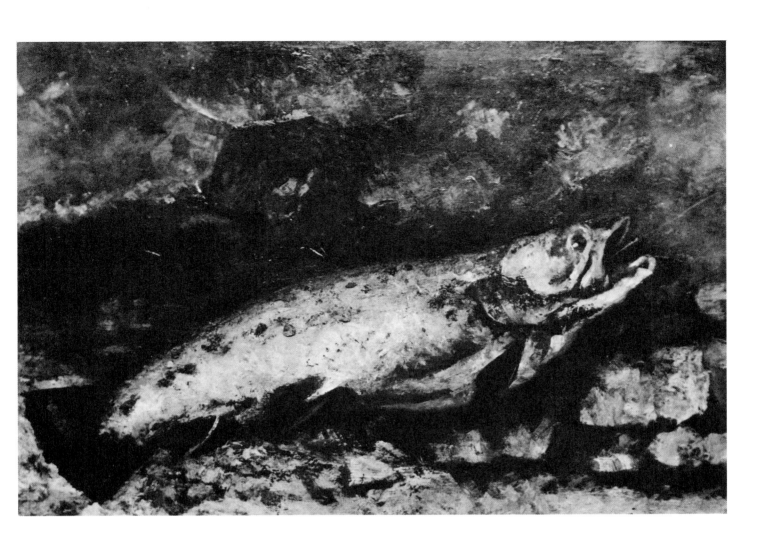

GUSTAVE COURBET (1819-1877).
The Trout. Signed and Dated 1873. Canvas, 25 1/2 × 38 1/2.
A. Dunoyer de Segonzac Collection, Paris.

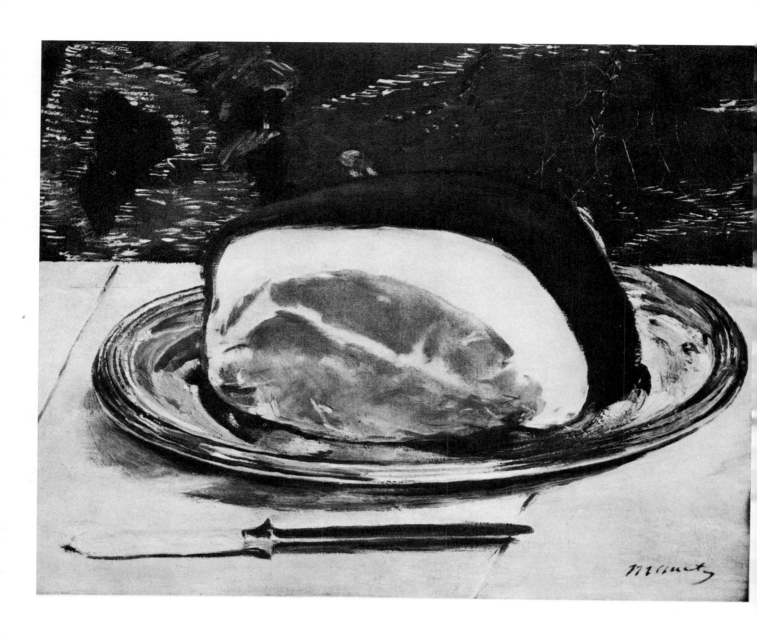

ÉDOUARD MANET (1832-1883).
The Ham. Signed. Canvas, 12 5/8 × 16 1/2.
Formerly Leonard Gow Collection, Glasgow.

86

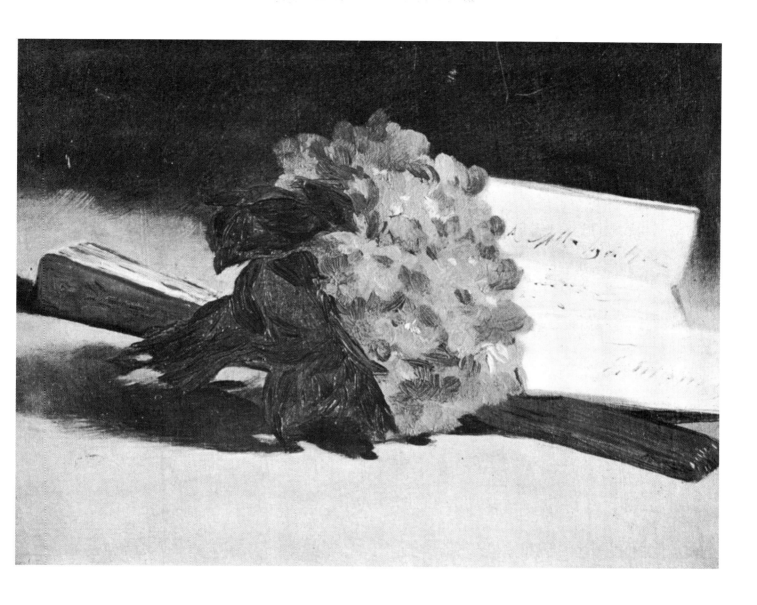

EDOUARD MANET (1832-1883).
Bouquet of Violets and Fan. Canvas, 8 1/4 × 10 5/8.
Private Collection, Paris.

87

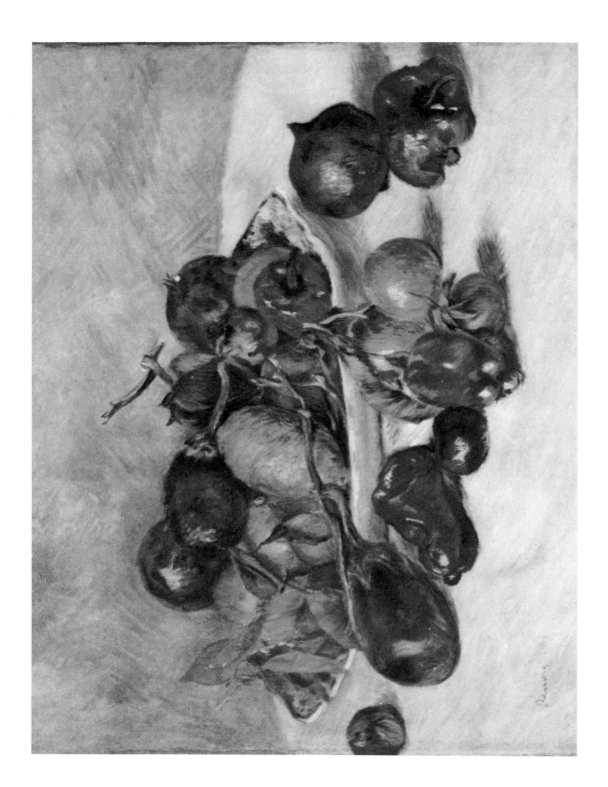

AUGUSTE RENOIR (1841-1919).
Fruit from the South. Signed and Dated 1881. Canvas, 20 × 27 1/8.
Art Institute of Chicago.

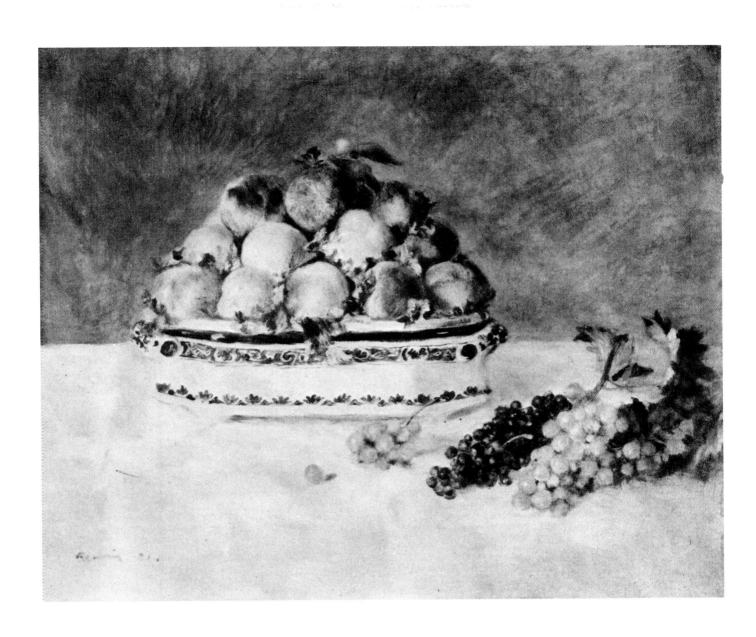

AUGUSTE RENOIR (1841-1919).
Peaches and Grapes. Signed and Dated 1881. Canvas. 21 5/8 × 25 1/8.
Private Collection, U.S.A.

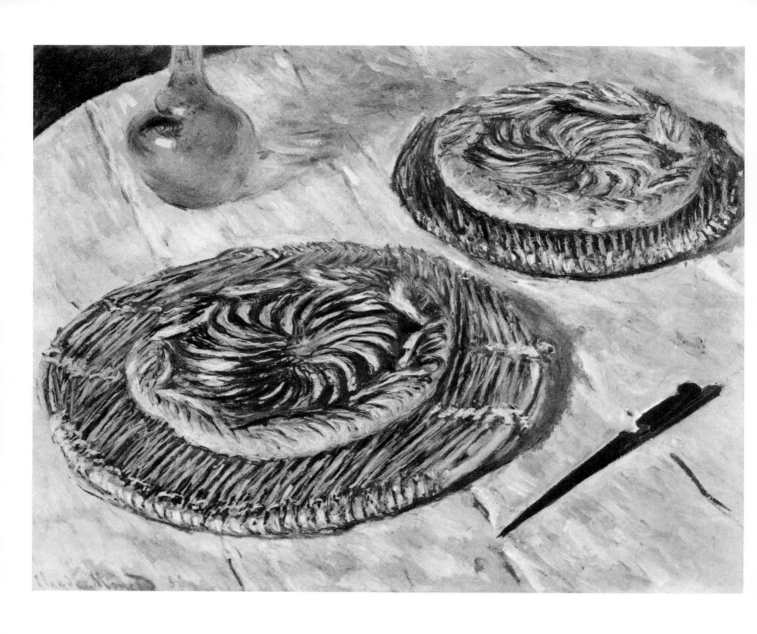

CLAUDE MONET (1840-1926).
Pies. Signed and Dated 1882. Canvas, 25 1/2 × 31 7/8.
Pierre Durand-Ruel Collection, Paris.

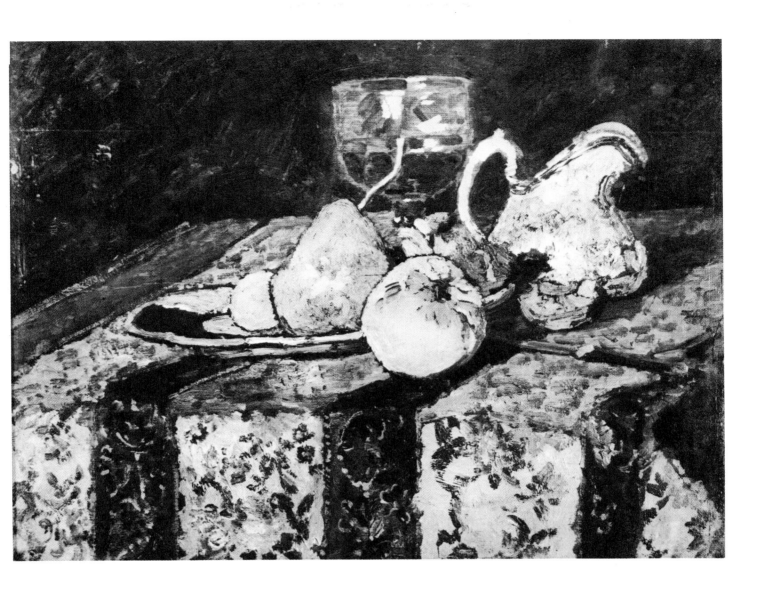

ADOLPHE MONTICELLI (1824-1866).
The White Pitcher. Canvas, 18 7/8 × 24 3/4.
Musée du Louvre, Paris.

91

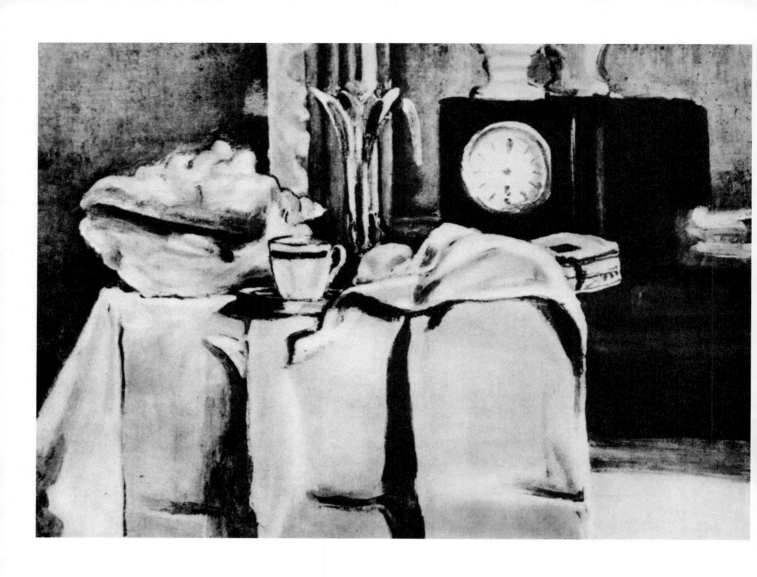

PAUL CÉZANNE (1839-1906).
92 The Black Marble Clock. 1869-1870. Canvas, 21 5/8 × 29 1/2.
Formerly Edward G. Robinson Collection, Los Angeles.

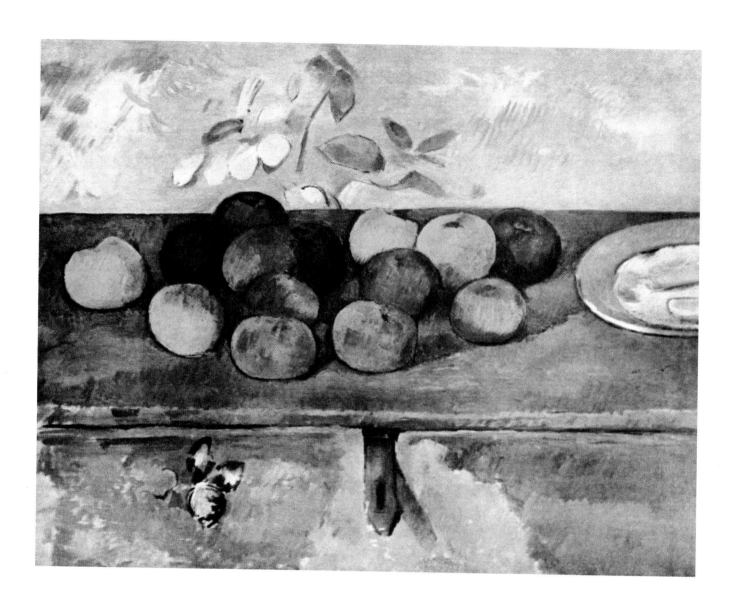

PAUL CÉZANNE (1839-1906).
Red Apples. Canvas, 18 1/8 × 21 5/8.
Madame J. Walter Collection, Paris.

93

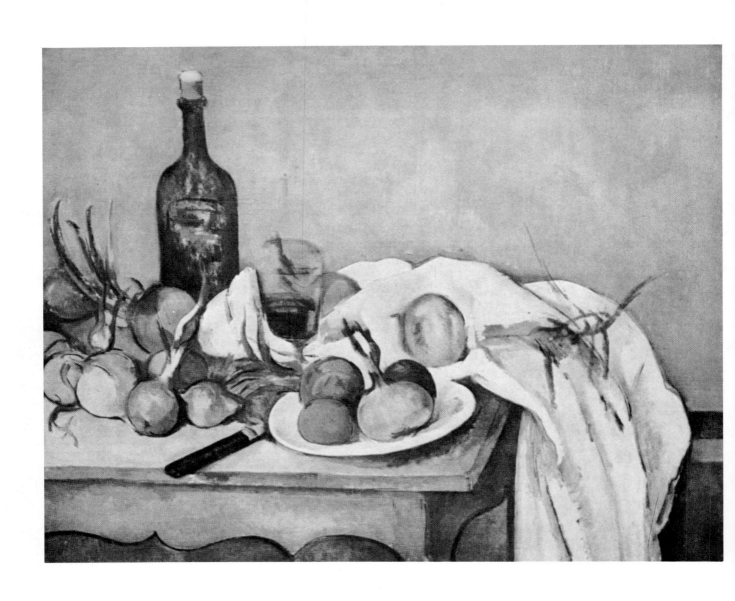

PAUL CÉZANNE (1839-1906).
Pink Onions. Canvas, 26 × 31 7/8.
Musée du Louvre, Paris.

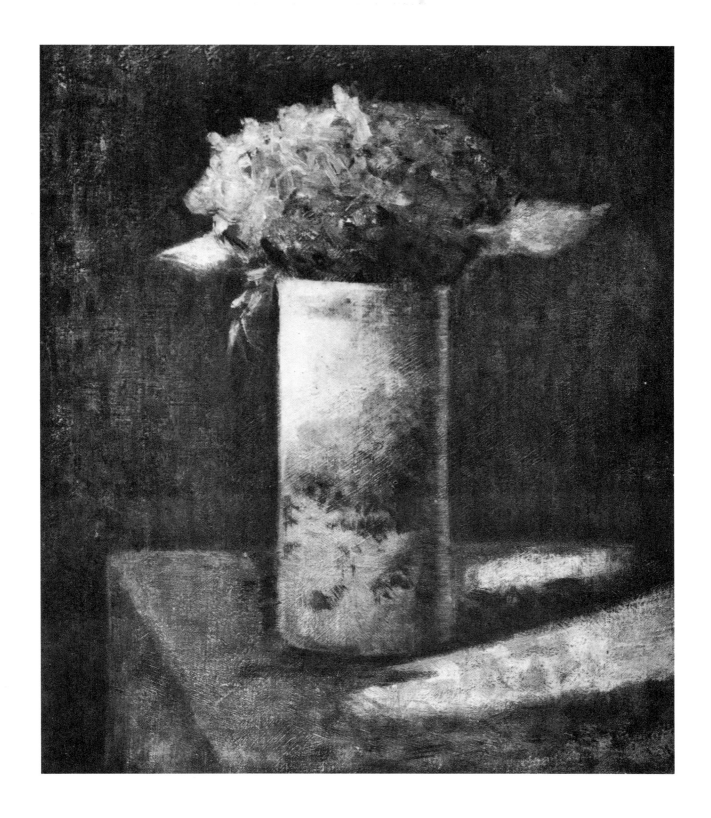

GEORGES SEURAT (1859-1891).
Vase of Flowers. Ca. 1880. Canvas, 18 1/2 × 15 1/4.
Mrs. Wertheim Collection, New York.

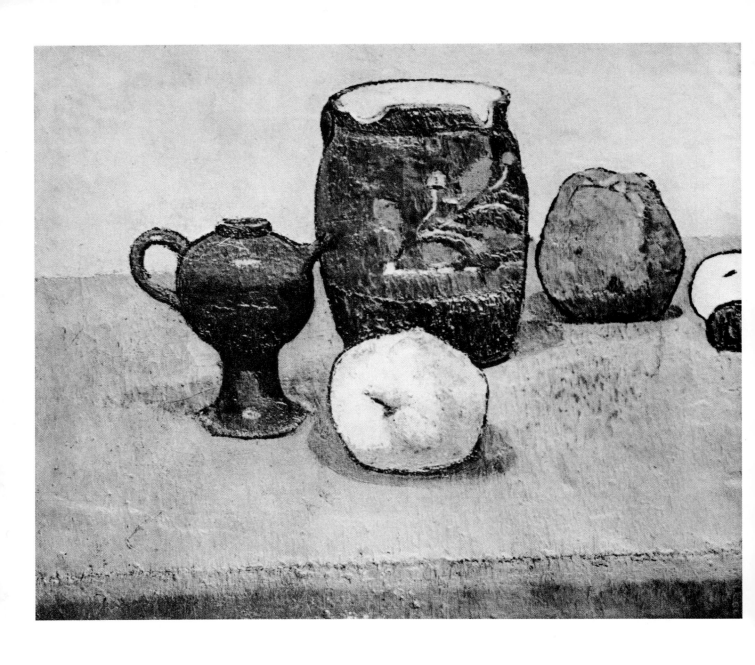

EMILE BERNARD (1868-1941).
Stone Jug and Apples. Signed and Dated 1887. Canvas, 18 1/8 × 21 5/8.
Musée d'Art Moderne, Paris.

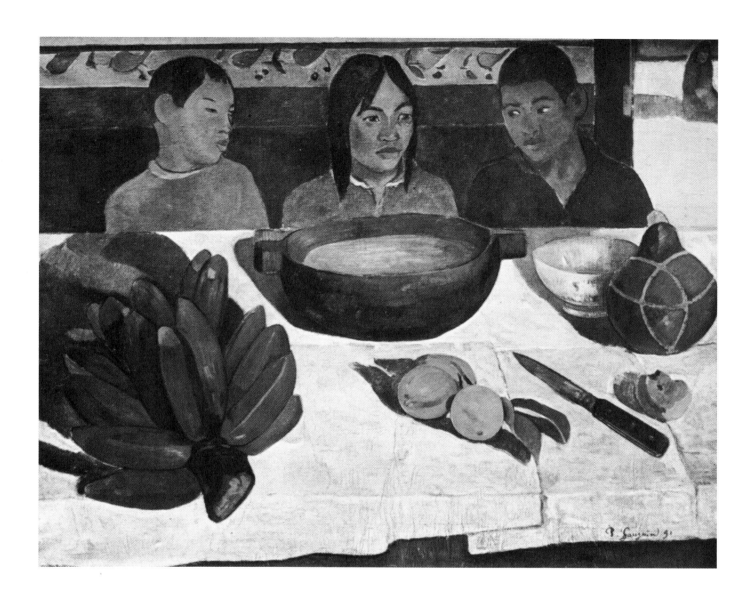

PAUL GAUGUIN (1848-1903).
The Tahitian Meal. Signed and Dated 1891. Canvas, 28 3/4 × 36 1/4.
Private Collection, Paris.

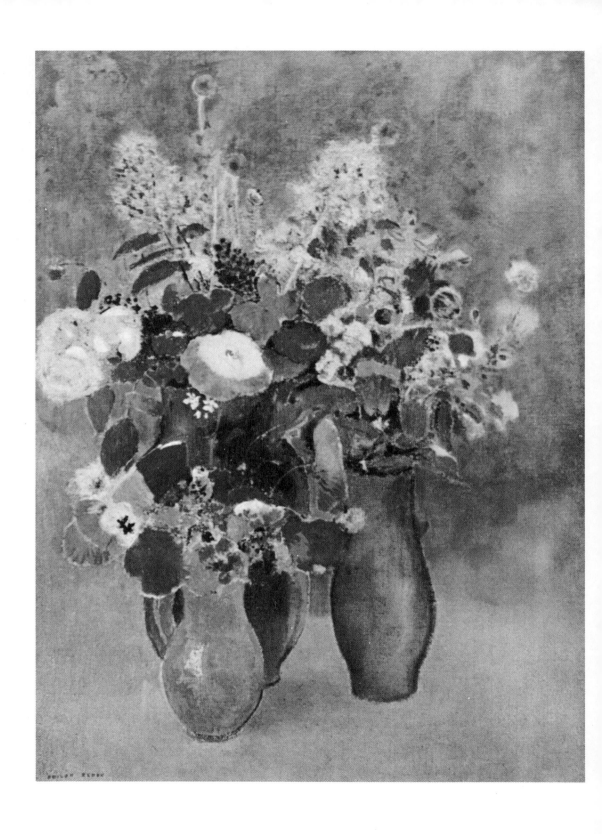

ODILON REDON (1840-1916).
Three Blue Vases.
98 *Collection of Baron von der Heydt, Ascona, Switzerland.*

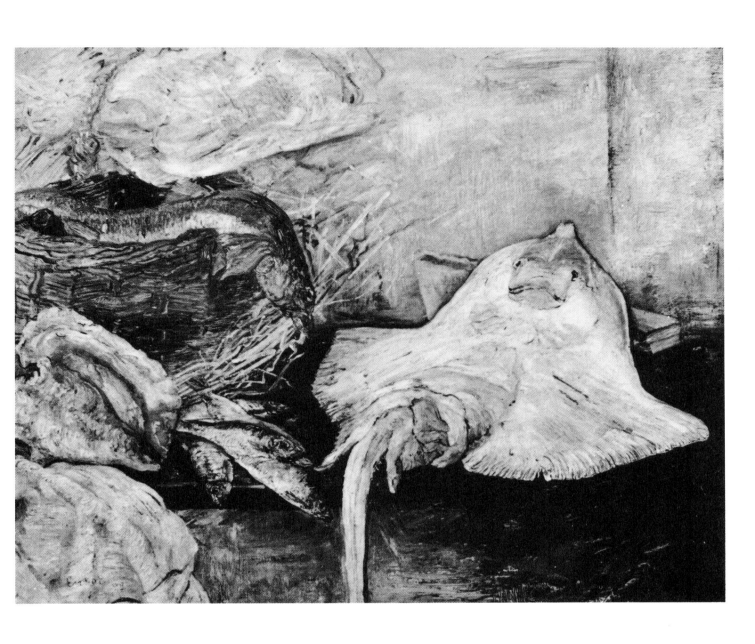

JAMES ENSOR (1860-1949).
The Skate. Signed and Dated 92. Canvas, 31 1/2 × 39 3/8.
Musée des Beaux-Arts, Brussels.

99

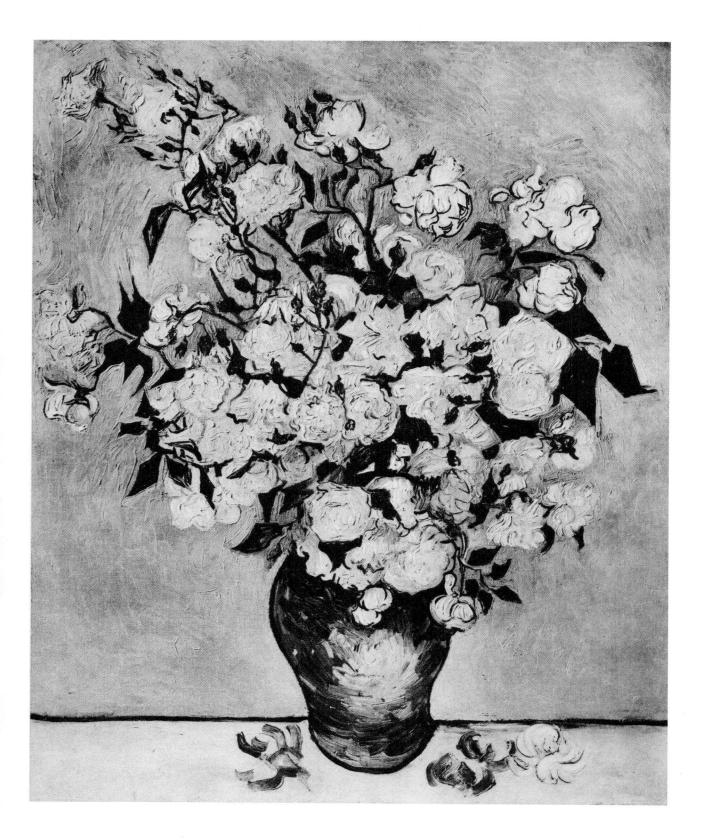

VINCENT VAN GOGH (1853-1890).
100 White Roses. 1890. Signed. Canvas, 36 5/8 × 28 3/8.
Mrs. Albert D. Lasker Collection, New York.

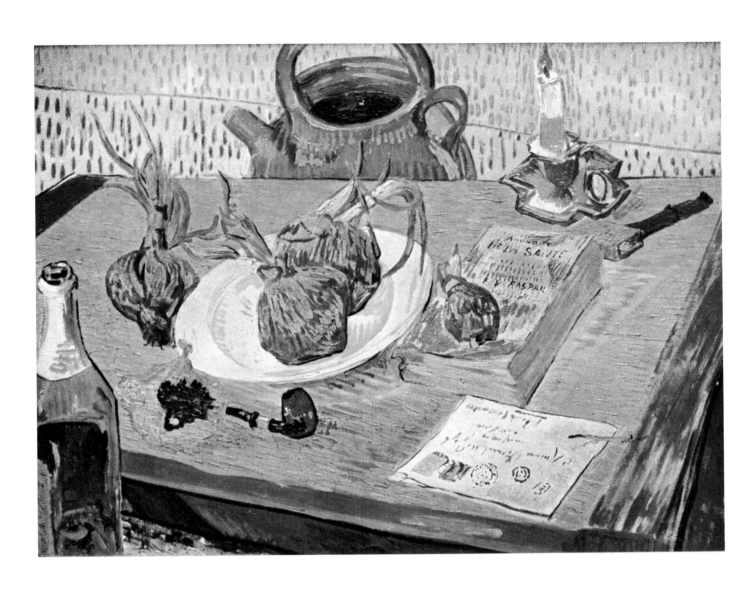

VINCENT VAN GOGH (1853-1890).
Drawing Board, Onions, etc. Canvas, 19 5/8 × 25 1/8.
Rijksmuseum Kröller-Müller, Otterlo, Holland.

101

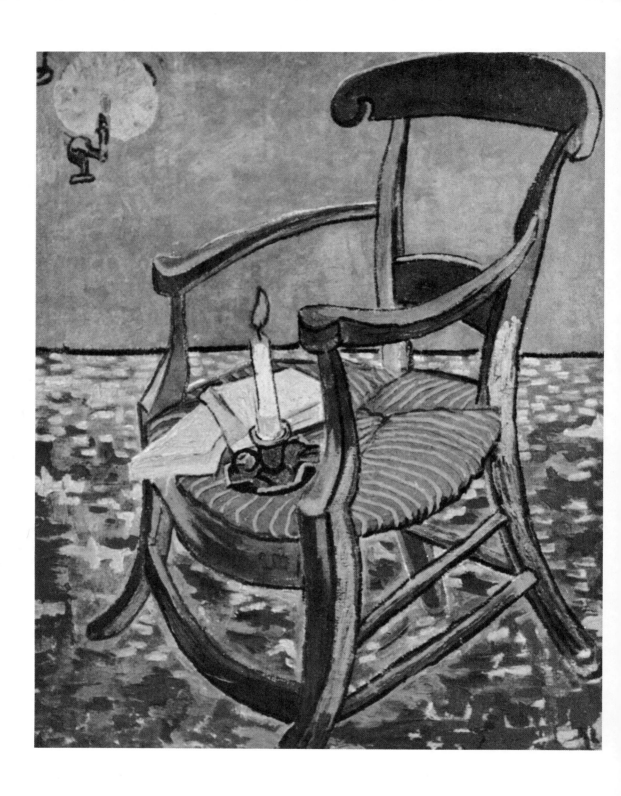

VINCENT VAN GOGH (1853-1890).
Gauguin's Chair. Canvas, 35 5/8 × 28 3/8.
V. W. van Gogh Collection, Laren, Holland.

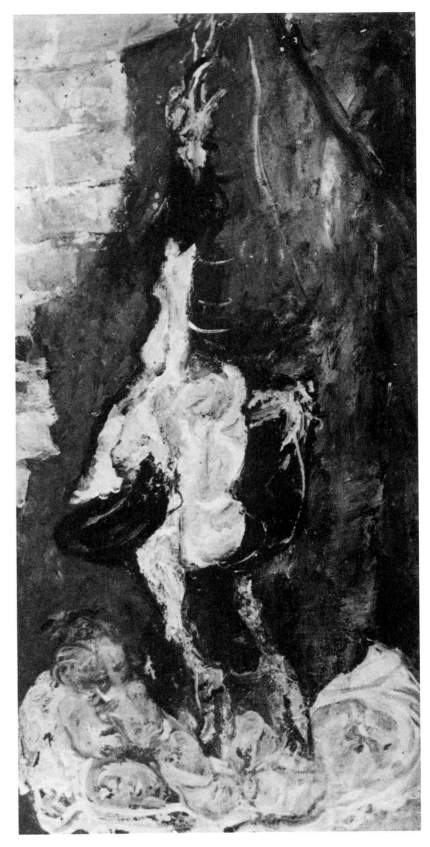

CHAIM SOUTINE (1894-1943).
Plumed Cock and Tomatoes. Signed. 1925-1926.
Canvas, 39 3/8 × 17 3/4. *Private Collection, Paris.*

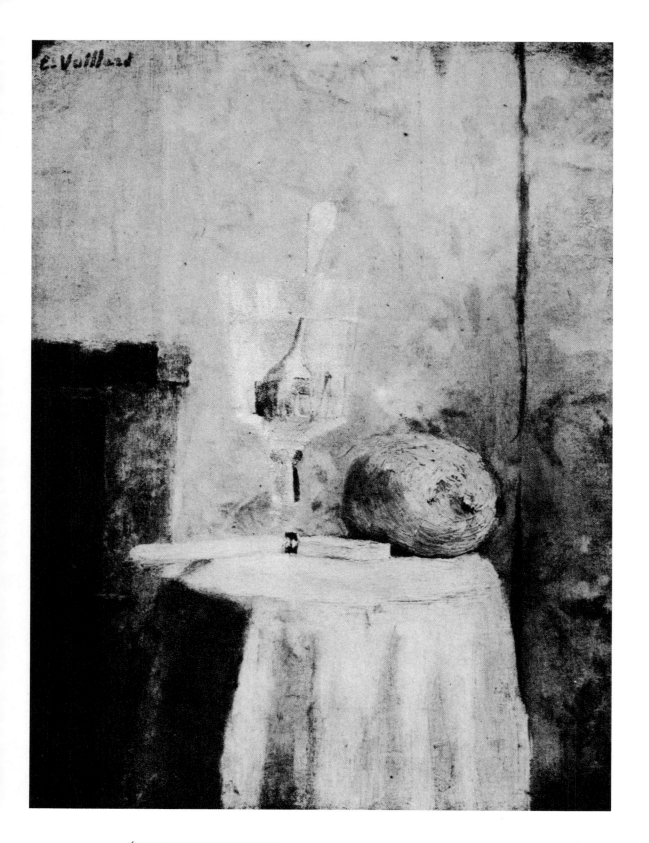

ÉDOUARD VUILLARD (1867-1940).
The Lemon. Signed and Dated 1890. Canvas, 13 3/4 × 11.
Collection of Mr. and Mrs. Arthur Sachs, Paris.

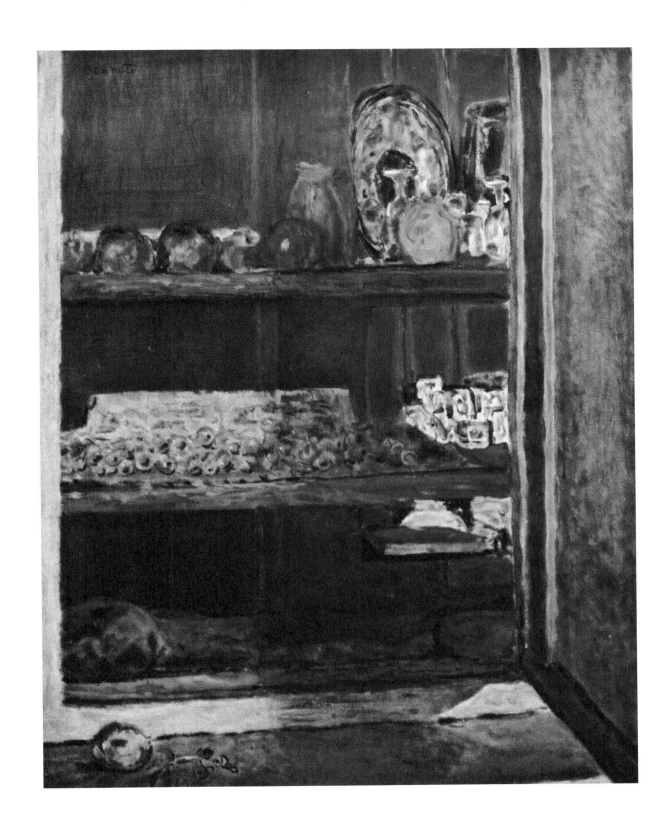

PIERRE BONNARD (1867-1947).
Closet : Harmony in Red. Signed. Canvas, 31 1/8 × 25 1/8.
Private Collection, Paris.

105

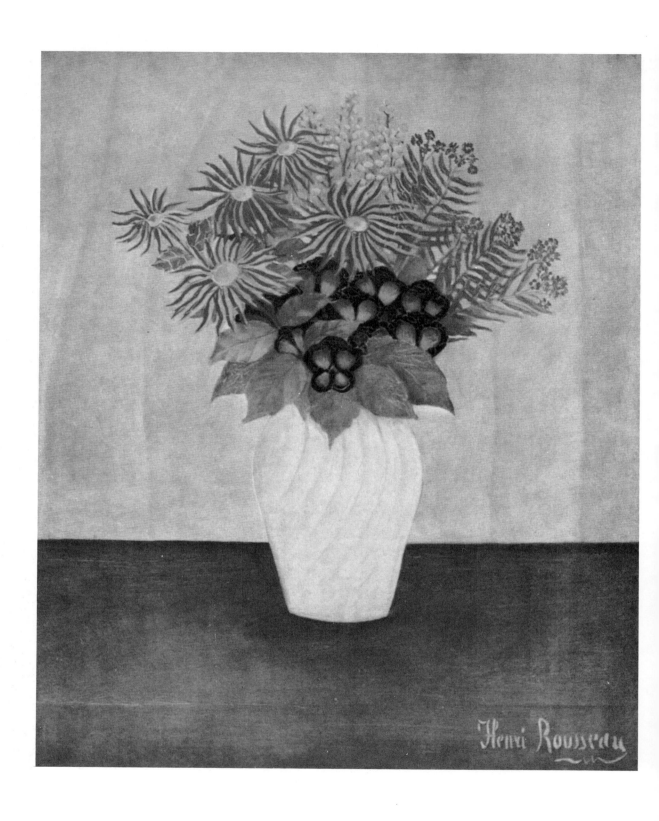

HENRI ROUSSEAU (Le Douanier) (1844-1910).
Vase with Flowers. Canvas, 23 1/4 × 18 1/2.
Tate Gallery, London.

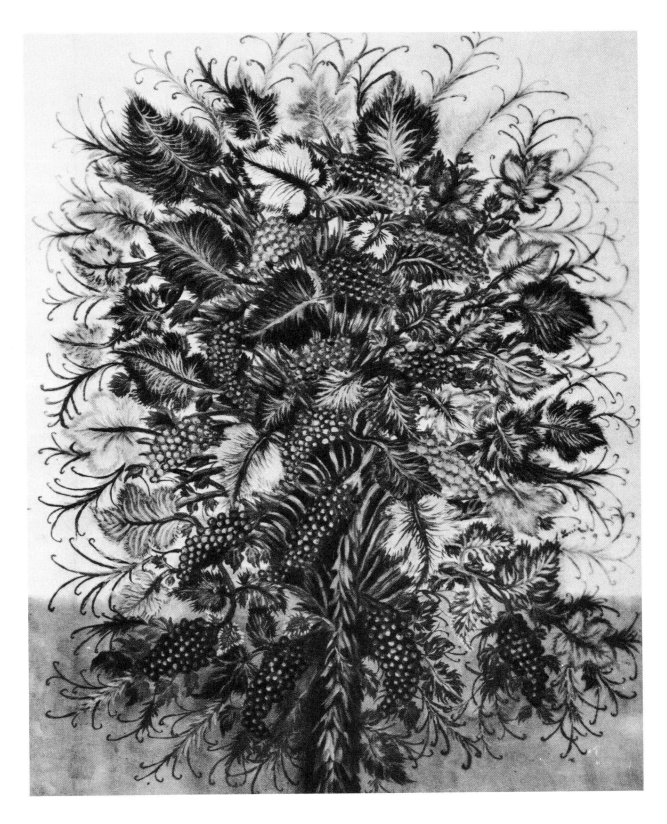

SÉRAPHINE (1864-1934).
The Vine. Canvas, 57 1/2 × 38 1/8.
Mlle A. M. Uhde Collection, Paris.

107

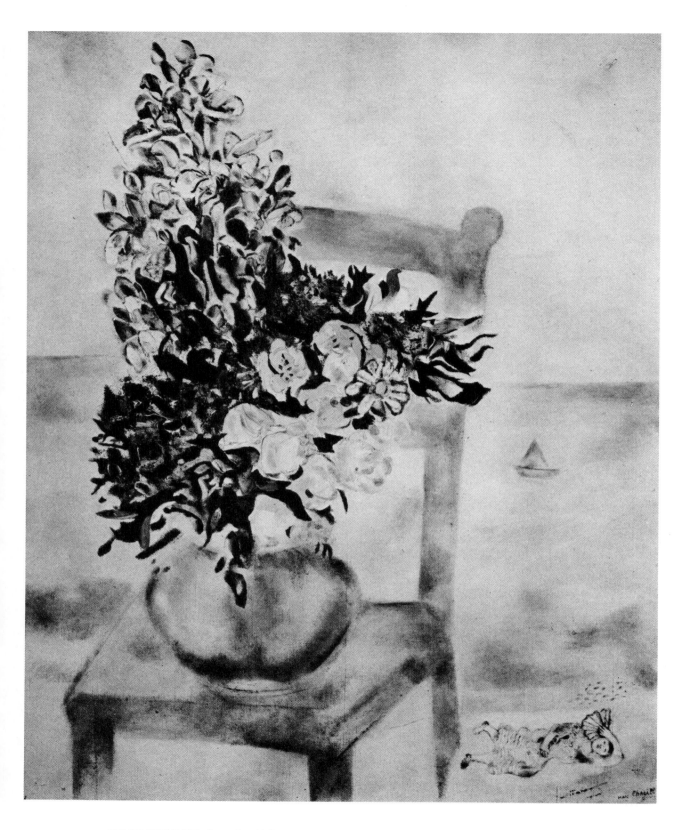

MARC CHAGALL (born in 1887).
108 Flowers on a Chair. Signed. Canvas, 39 3/8 × 31 7/8.
Private Collection, Paris.

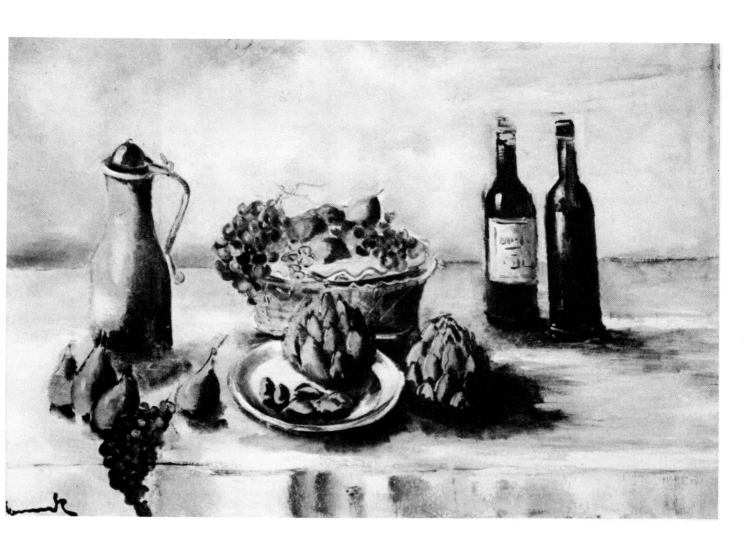

MAURICE VLAMINCK (1876-1958).
Bottles and Artichokes. Signed. Canvas, 35 × 45 5/8.
Private Collection, Paris.

109

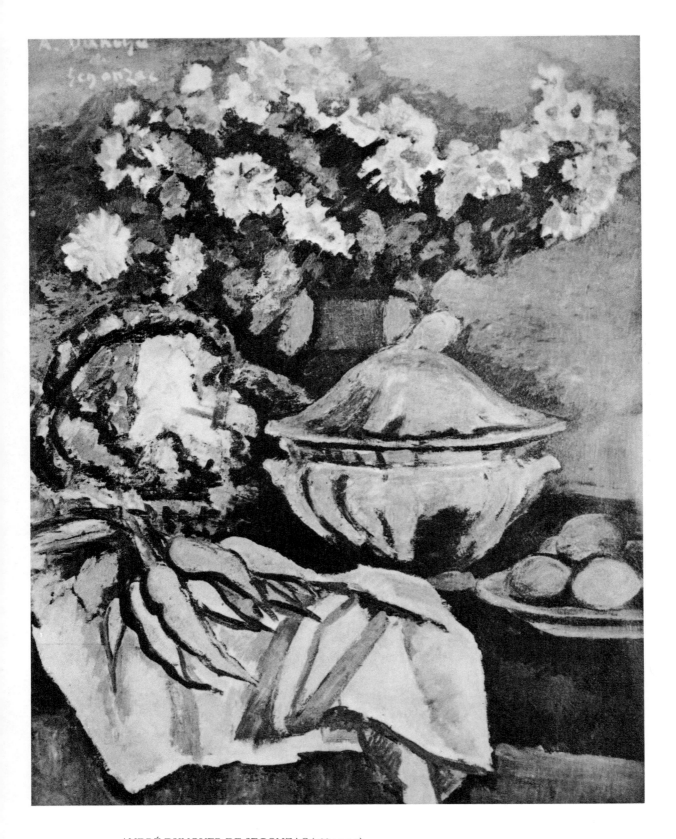

ANDRÉ DUNOYER DE SEGONZAC (1884-1974).
110 The Moustiers Soup-Tureen. Signed. 1939. Canvas, 31 7/8 × 25 1/2.
Private Collection, Paris.

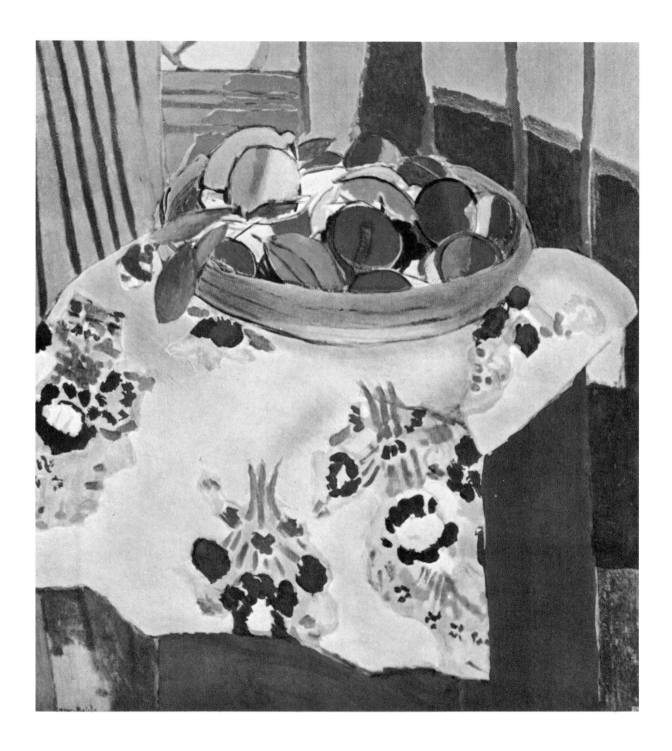

HENRI MATISSE (1869-1954).
Pink Tablecloth and Oranges. Signed. Canvas, 37 × 33.
Musée du Louvre, Paris. 111

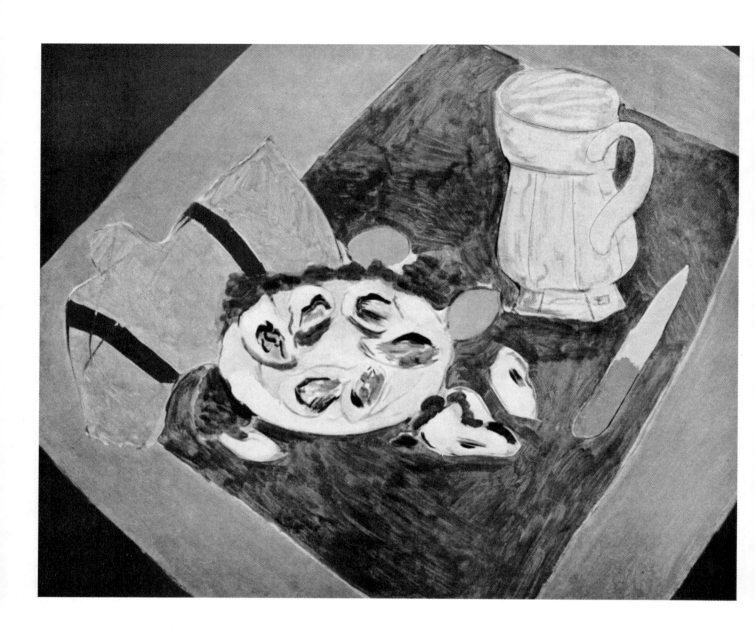

HENRI MATISSE (1869-1954).
Dish of Oysters. Signed. Canvas, 25 1/2 × 31 7/8.
Öffentliche Kunstsammlung, Basel.

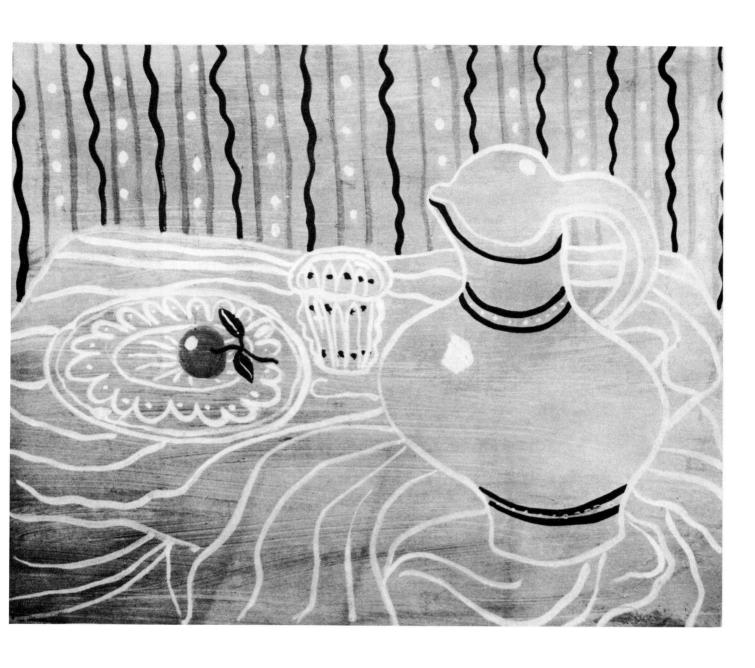

ANDRÉ DERAIN (1880-1954).
The Pitcher. Signed. Canvas, 33 1/2 × 47 1/4.
Private Collection, Paris.

113

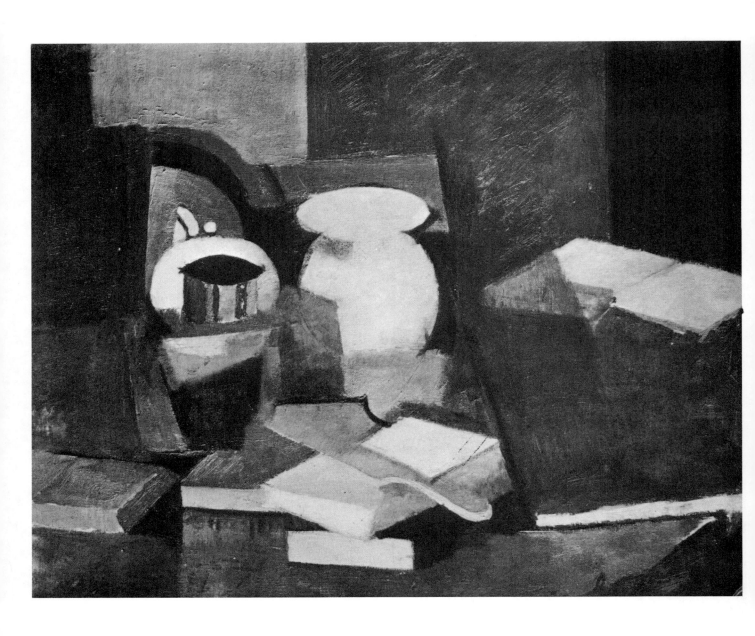

ROGER DE LA FRESNAYE (1885-1925).
Books. Signed and Dated 1915. Canvas, 23 5/8 × 28 3/4.
A. L. Collection, Paris.

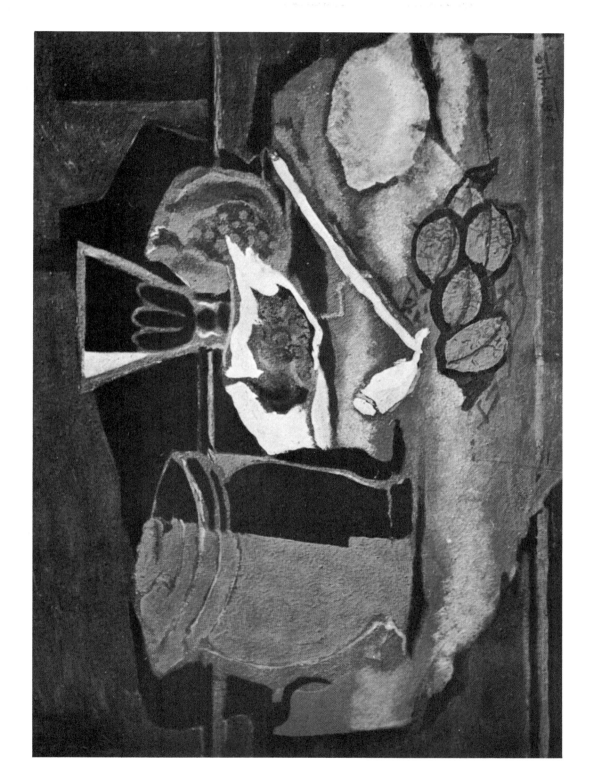

GEORGES BRAQUE (1882-1963).
Tobacco Jar, Walnuts and Lemons. Signed. Canvas.
Collection of Baronne Gourgaud, Paris.

115

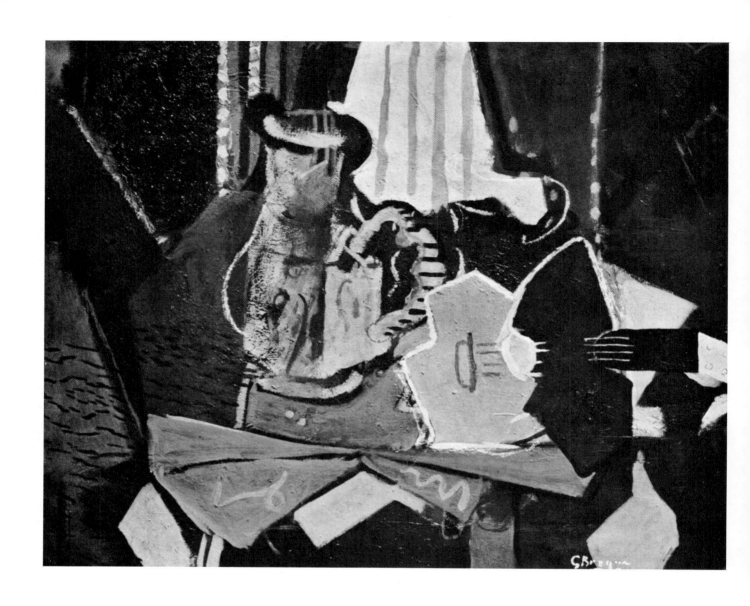

GEORGES BRAQUE (1882-1963).
The Lamp on the Table. 1952. Signed. Canvas, 25 1/2 × 31 7/8.
Maeght Collection, Paris.

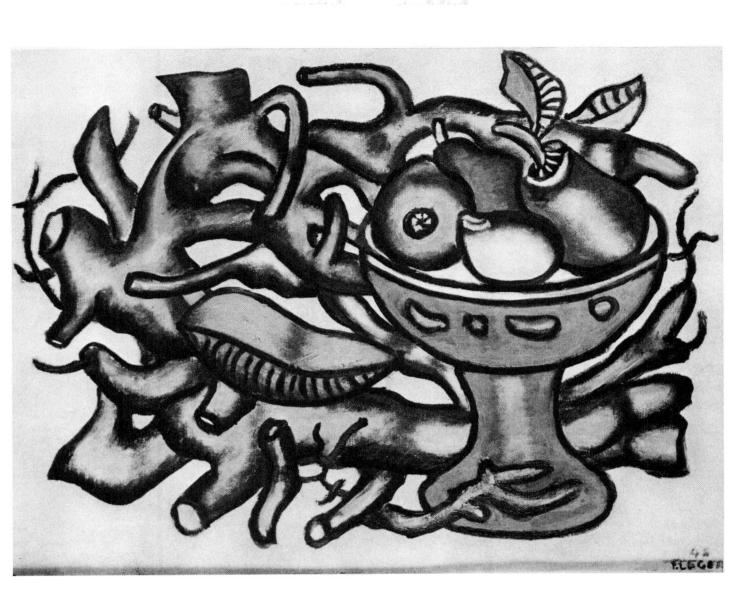

FERNAND LÉGER (1881-1955).
The Blue Fruit Dish. Signed and Dated 1948. Canvas, 19 5/8 × 25 1/2.
Private Collection, Paris.

117

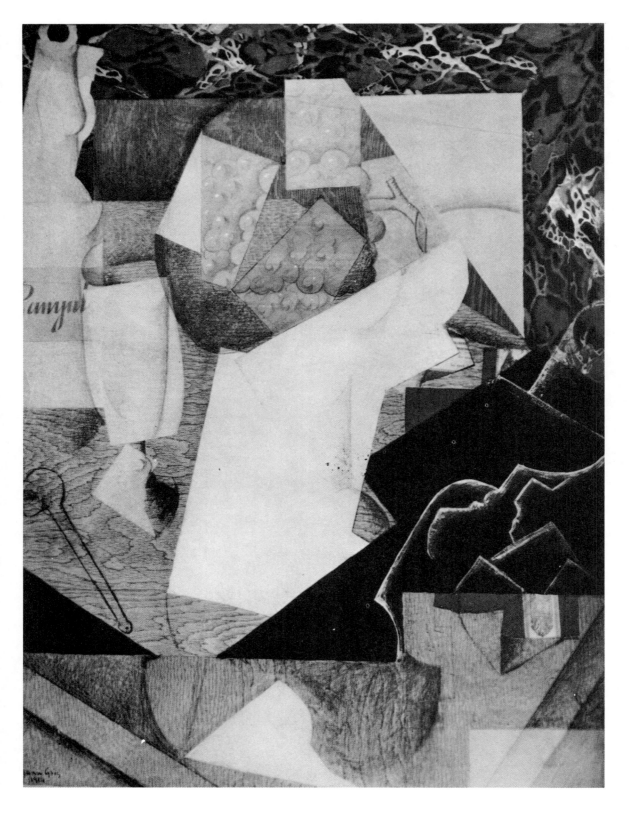

JUAN GRIS (1887-1927).
Basket of Grapes (papier collé). Signed and Dated 1914. Canvas, 31 7/8 × 23 5/8.
A. L. Collection, Paris.

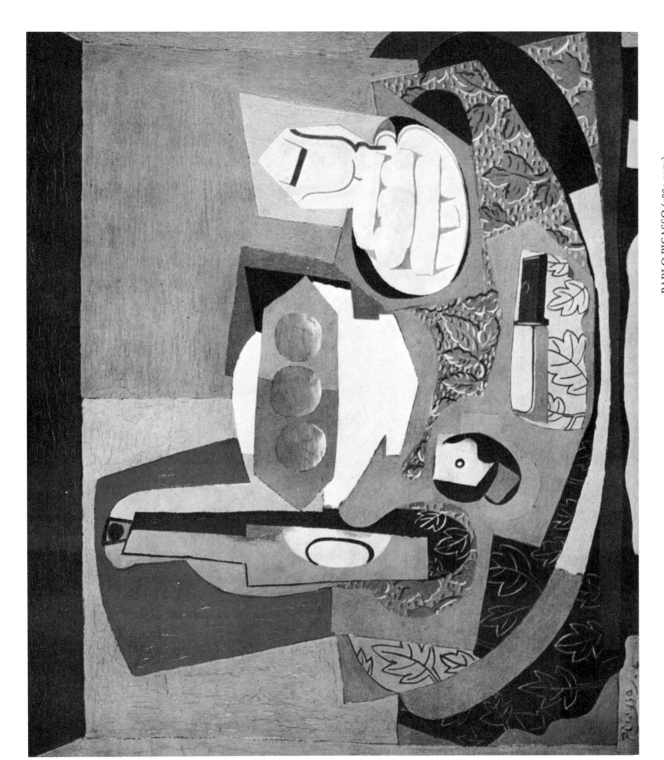

119

PABLO PICASSO (1881-1973).
Biscuits. Signed and Dated 1924. Canvas, 31 1/2 × 39 3/8.
Private Collection, New York.

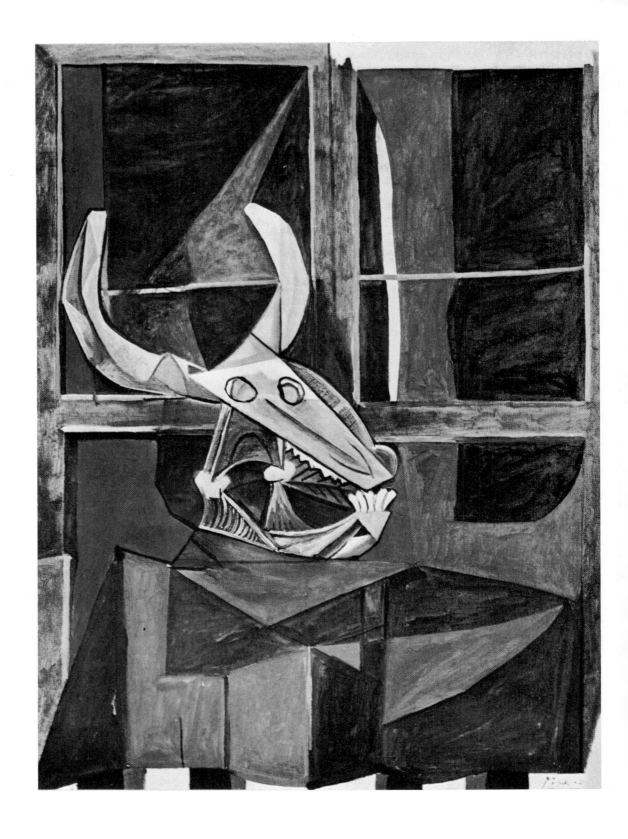

PABLO PICASSO (1881-1973).
The Bull's Skull. Signed and Dated 1942. Canvas, 51 1/8 × 38 1/8.
A. L. Collection, Paris.

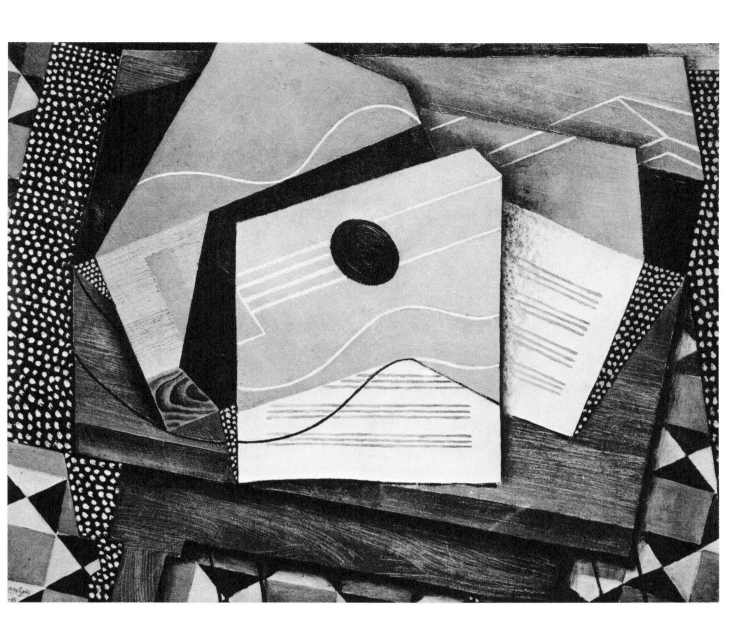

JUAN GRIS (1887-1927).
The Palette. Signed and Dated 1915. Canvas, 28 3/4 × 36 1/4. 121
Rijksmuseum Kröller-Müller, Otterlo, Holland.

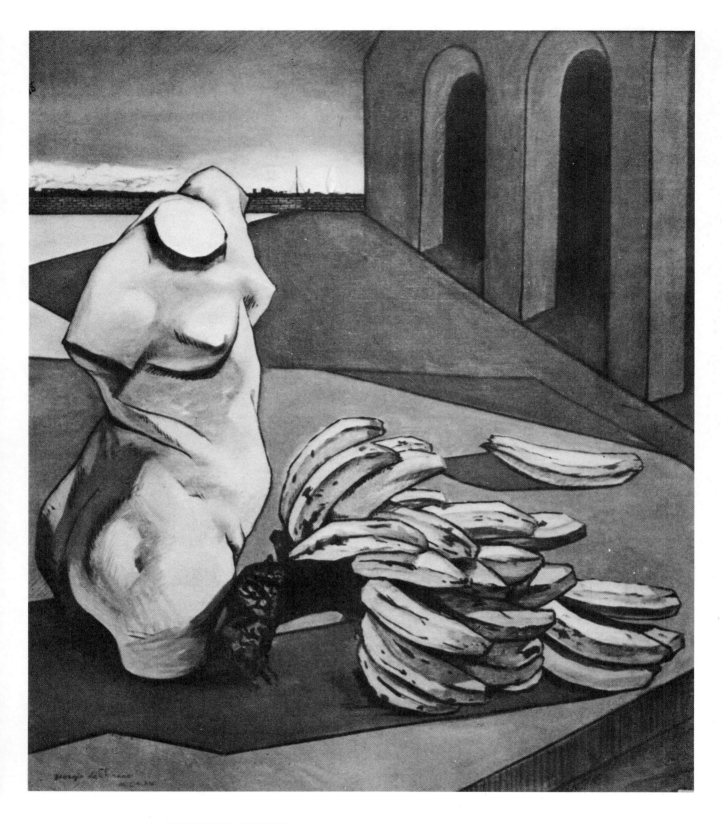

GIORGIO DE CHIRICO (1888-1978).
122 The Uncertainty of the Poet. Signed and Dated 1913. Canvas, 41 3/4 × 37.
Roland Penrose Collection, London.

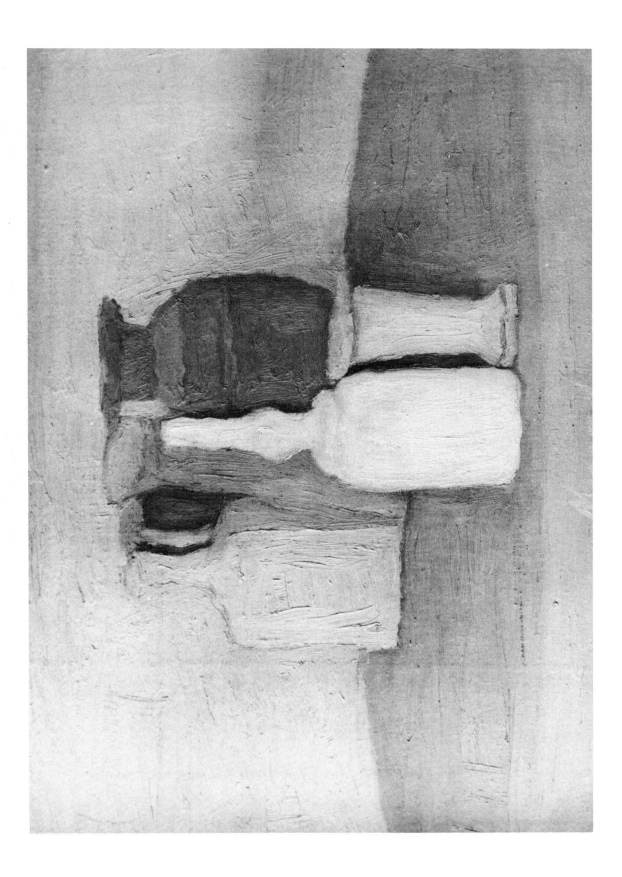

GIORGIO MORANDI (1890-1964).
Bottles and Vases. Painted in 1947. Canvas, 12 1/4 × 17.
Museum Boymans-Van Beuningen (Vitale Bloch Collection), Rotterdam.

122 bis

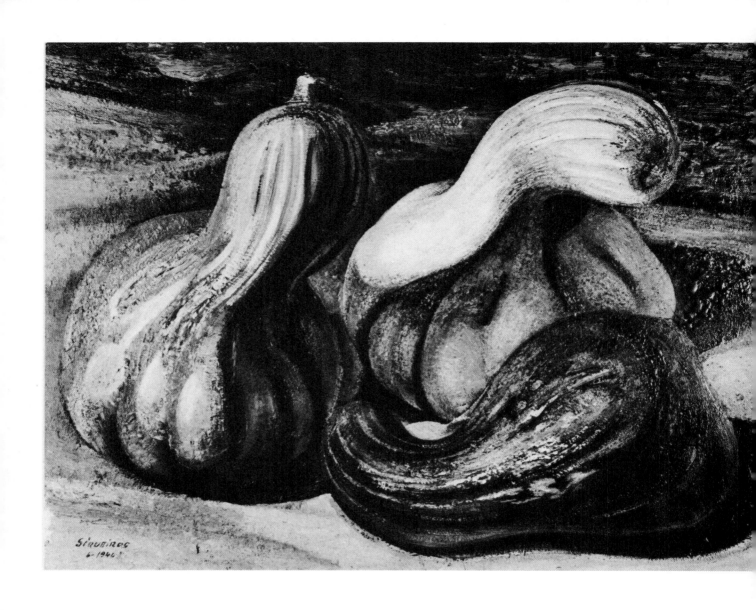

DAVID-ALFARO SIQUEIROS (1898-1974).
Gourds. Pyroxylin on Masonite, 35 7/8 × 47 1/4.
Dr. Alvar Carillo Gill Collection, Mexico City.

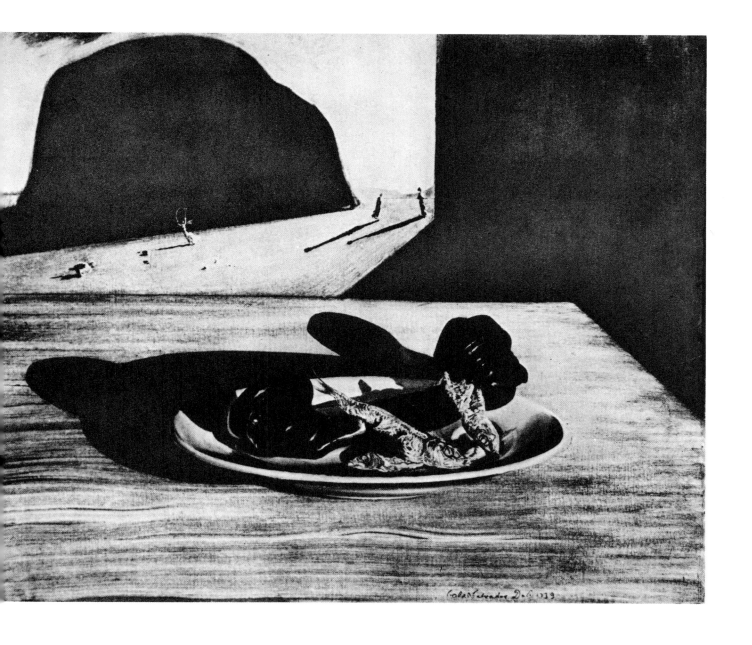

SALVADOR DALI (born in 1904).
Telephone, Grilled Sardines and Late September.
Signed and Dated 1939.

124

BIBLIOGRAPHY

BIBLIOGRAPHY

GENERAL WORKS
dealing with several periods or several schools

P. R. ADAMS. In Defense of Still-Life, in: Catalogue de l'Exp. Still-Life Painting since 1470, Milwaukee Art Institute, Sept. 1956; – Cincinnati Art Museum, Oct. 1956.

MAURICE ALLEMAND. Natures mortes de l'antiquité au XVIIIᵉ s., Cat. de l'Exp. Musée d'Art et d'Industrie, Saint-Étienne 1954.

NIETTA APRA. I Fiori nell'Arte, Milan 1954.

JEANNINE AUBOYER. Fleurs et oiseaux d'Extrême-Orient, *Jardin des Arts*, No 3 (1955), p. 169-176.

E. BADELT. Das Stilleben als bürgerliches Bildthema und seine Entwicklung von den Anfängen bis zur Gegenwart, Thesis, Munich 1938.

J. BALTRUSAITIS. Anamorphoses ou perspectives curieuses, Paris 1955.

HAROLD BAYLEY. The Lost Language of Symbolism, London 1912.

INGVAR BERGSTRÖM. Historical Introduction, p. 1-41, in: Dutch Still-Life Painting, London 1956.

INGVAR BERGSTRÖM. Konst och naturvetenskap, *Paletten* (Göteborg), IV (1948), p. 2-12.

INGVAR BERGSTRÖM and B. RAPP. Iconographica, Stockholm 1957.

VITALE BLOCH. Silent Life, *Maandblad voor beeldende Kunsten*, No 5, May 1946, p. 55-60.

VITALE BLOCH. Still-Life at the Orangerie, *Burlington Magazine*, Vol. 94 (1952), p. 208.

V. BLOCH. Four Centuries of Still-Life in France at the Boymans Museum, *Burlington Magazine*, Sept. 1954, p. 286-289.

W. BLUNT. The Art of Botanical Illustration, London 1950.

STEFANIA BOSIA. Valore e significato della « natura morta » nella tradizione critica, *Acme*, Vol. V (1952), p. 329-347.

ARTHUR EDWIN BYE. Pots and Pans or Studies in Still-Life Painting, Princeton 1921.

ANDRÉ CHASTEL. De Natura Rerum, *Médecine de France*, No 34, (1952), p. 41-42.

ANDRÉ CHASTEL. Nature Morte Coming Alive in Paris, *Art News*, Vol. 51 (1952-53), No 4, p. 78-81.

J. DENUCÉ. De Antwerpsche "Konstkamers". Inventarissen van kunstverzamelingen te Antwerpen in de 16ᵉ en 17ᵉ eeuwen, The Hague 1932.

G.-F. DOLLFUS. Recherches sur l'histoire de la conchyliologie, 1-2, *Journal de conchyliologie* (1927), p. 155-184; (1932), p. 217-252.

A. DUHAU. La Nature morte de l'antiquité a nos jours à l'Orangerie, *Le Peintre*, No 46 (1952), p. 14-15.

T. W. EARP. Flower Still-Life Painting (*Studio* Special Number), London 1928.

CARL FEHRMAN. Diktaren och döden. Dödsbild och förgängelsetanke i litteraturen till 1700-talet, Stockholm 1952.

HANS FLOERKE. Studien zur niederlaendischen Kunst- und Kulturgeschichte. Die Formen des Kunsthandels, das Atelier und die Sammler vom 15-18. Jahrh., Munich and Leipzig 1905.

MAX J. FRIEDLAENDER. On Art and Connoisseurship, 3rd ed. London 1944.

MAX J. FRIEDLAENDER. Landscape, Portrait, Still-Life, 1949, p. 277-284.

MAX J. FRIEDLAENDER. Essays über die Landschaftsmalerei und andere Bildgattungen, The Hague 1947.

HERBERT FURST. The Art of Still-Life Painting, London 1927,

R. GAVELLE. Aspects du trompe-l'œil, *L'Amour de l'Art*, 1938. p. 231.

J. G. VAN GELDER. Van Blompot en Blomglas, *Elseviers Geillustrerad Maandschrift*, 1936, p. 73-82, 155-166.

KURT GERSTENBERG. Das Bücherstilleben in der Plastik, Deutschland-Italien, *Festschrift fur Wilhelm Waetzoldt*, Berlin 1941, p. 135 et seq.

MAURICE H. GRANT. Flower Paintings through Four Centuries. A Descriptive Catalogue of the Coll. formed by Major the Hon. Henry Rogers Broughton, Leigh-on-Sea 1952.

HERMINE VAN GULDENER. Les Fleurs, Paris 1949.

ALLAN GWYNNE-JONES. Introduction to Still-Life, London 1954.

ELISABETH HAIG. The Floral Symbolism of the Great Masters, London 1913.

G. F. HARTLAUB. Zauber des Spiegels. Geschichte und Bedeutung des Spiegels in der Kunst, Munich 1951.

HANS HAUG. Natures mortes, Catalogue de la Collection du Musée des Beaux-Arts de Strasbourg, Strasbourg 1954.

G. HOOPER. New Ideas on Still-Life Painting, in: *Artists*, Sept. 1955, p. 128-130 and April-May 1955, p. 15-6, 44-46.

EDUARD HUTTINGER. Der Mensch als Stilleben, *Schweizer Monatshefte*, 1954, No 5, p. 304 et seq.

GEORGES ISARLOV. L'exposition de la nature morte à Amsterdam, *Formes*, 1942, p. 360-362.

G. ISARLO. De la Nature morte, *Combat-Art*, 3 October 1954.

K. LINDESMITH. Good Things in Life, *Toledo Museum News*, No 3, p. 16-18, 1957.

LOIR-MONGAZON. Fleurs et peinture de fleurs, 1885.

ROBERTO LONGHI. Un momento importante nella storia della natura morta, *Paragone*, No 1, 1950, p. 34-39.

ROBERTO LONGHI. La Mostra della Natura morta all Orangerie, *Paragone*, No 38, 1952, p. 46-52.

R. VAN LUTTERVELT. Schilders van het Stilleven, Naarden 1947.

J.-R. MARTIN. Review of I. Bergström's: "Dutch Still-Life Painting in the Seventeenth Century", *Art Bulletin*, No 40, Sept. 1958, p. 272-274.

Métaphysique du trompe-l'œil, *Art et Industrie*, No 29 (1955), p. 29-32.

R. MICHAU. Le trompe-l'œil dans la nature morte au Musée de l'Orangerie, *Le Peintre*, No 47 (1952), p. 12-13.

LUDWIG MÜNZ. Akademie d. bild. Künste in Wien : Meisterwerke der Tier-und-Stillebenmalerei. Katalog, Vienna, Spring 1952.

P. PIZON. Sur les peintures en trompe-l'œil, *Le Peintre*, No 49 (1952), p. 8.

MARIO PRAZ. Studies in Seventeenth Century Imagery, 2 Vols. (Studies of the Warburg Institute, 3), London 1939-1947.

ROBERT REY. Objets inanimés, *Nouvelles Littéraires*, 15 Jan. 1952.

ROBERT REY. Les Vies Encloses, *Revue des Arts*, Sept. 1952, p. 131-136.

FELIX ROSEN. Die Natur in der Kunst, Leipzig 1903.

N. RYNDÉL. Döremal och fond, *Paletten*, 1952, p. 58-59.

MARGARETTA M. SALINGER. Flowers: the Flowerpiece in European Painting, New York 1949.

A. SOREIL. La Fleur dans les arts, *La Vie Wallone*, T. 24 (1950), p. 137-138.

CHARLES STERLING. En préparant l'exposition de la Nature Morte, *La Revue des Arts*, Paris, 1952, p. 31 et seq.

CHARLES STERLING. La Nature Morte de l'Antiquité à nos jours, 1952 (First edition).

CHARLES STERLING. Préface du Catalogue : Vier Eeuwen Stilleven in Frankrijk, Boymans Museum, Rotterdam 1954.

CHARLES DE TOLNAY. Review of « Nature morte de l'Antiquité à nos jours », by Ch. Sterling, *G. B. A.*, March 1955, p. 182.

J. TOUGENDHOLDT. Problème de la nature morte, *Apollon*, Moscow 1912.

A. A. TROUBNIKOFF. Les Peintres de la nature morte, etc., *Apollon*, Moscow 1911.

JEAN-LOUIS VAUDOYER. La vie silencieuse, cat. de l'Exp. Galerie Charpentier, Paris 1946.

JEAN-LOUIS VAUDOYER. Pain et Vin, cat. de l'Exp. Galerie Charpentier, Paris 1954.

PH. VERDIER. Natures mortes philosophiques, *Table Ronde*, October 1949, p. 1639.

JULIE VOGELSTEIN. Interieur und Stilleben, Berlin 1913.

A. P. A. VORENKAMP. Bijdrage tot de Geschiedenis van het Hollandsch Stilleven in de zewentiende euw, Thesis, Leyden 1933.

RALPH WARNER. Dutch and Flemish Flower and Fruit Painters of the XVIIth and XVIIIth centuries, London 1928.

F. PARKES WEBER. Aspects of Death and Correlated Aspects of Life in Art, Epigram and Poetry. Contributions towards an Anthology and an Iconography of the Subject, 3d ed., London 1918.

H. WICHMANN. Meister des Stillebens, Leipzig 1926.

H. WICHMANN. Flower and Still-Life Painting, *Studio*, Special Winter Number, 1928.

JACQUES WILHELM. *Silhouettes and Trompe-l'œil Cut-Outs*, The Art Quarterly, Winter 1953, p. 294-304.

JACQUES WILHELM. Des Galeries de tableaux sur mesure, *Connaissance des Arts*, Nov. 1958.

ALICE WINCHESTER. Looking at Still-Life, *Antiques*, October 1952, p. 296-299.

R. WITTKOWER. Death and Resurrection in a Picture by Marten de Vos, *Miscellanea Leo van Puyvelde*, 1949, p. 117-123.

B. WIPPERT. Problema i razwitje natiurmorta, Kazan 1922.

B. WIPPERT. Das Problem des Stillebens, *Zeitschrift für Aesthetik und allgemeine Kunstwissenschaft*, Vol. 25, Stuttgart 1931.

EXHIBITIONS
covering several periods or several schools.

Cent ans de nature morte, Galerie Bernheim-jeune, Paris 1907.

Exh. La Fleur, Galerie J. Charpentier, Paris 1930.

Exh. Still-Life, Fogg Art Museum, Harvard University, 1931 (Preface by GORDON B. WASHBURN).

A Hundred and Fifteen Still-Life Paintings from 1480 to 1933. Boymans Museum, Rotterdam 1933.

Still-Life Painting, Goudstikker Gallery, Amsterdam 1933.

Fleurs et Nature morte au XVIIe et au XVIIIe siècle, Galerie Manteau, Paris 1935.

Bloomenstukken van Oude Meesters, P. de Boer Gallery, Amsterdam 1935.

Trompe-l'œil, Galerie Montaigne, Paris 1937.

La Nature morte du XVIIe siècle à nos jours, Galerie Montaigne, Paris 1938.

Still-Life, Mathiesen Gallery, London 1938.

Still-Life Paintings, Knœdler Galleries, New York 1958.

Exh. Malarze Martwej Natury (Still-Life Painters), Warsaw 1939 (Cat. : M. WALICKI).

Exh. Nature morte des XVIIe et XVIIIe siècles, Galerie Guy Stein, Paris 1939.

Still-Life in the XVIIth century, Durlacher Gallery, New York 1944.

La Vie Silencieuse, Galerie Charpentier, Paris 1946.

Exh. Nature morte, Galeria Athena, Rome 1947 (Cat. : Giuliano BRIGANTI).

La Nature morte du XVIIe siècle, Galerie de l'Elysée, Paris 1950.

Exh. Natures mortes des écoles espagnole, francaise, flamande et hollandaise, Galerie de l'Élysée, Paris 1950.

Exh. Natures mortes, Galerie Jacobs, Brussels 1951.

Natures mortes francaises du XVIe siècle a nos jours, Galerie Charpentier, Paris 1951.

Meisterwerke der Tier-und Stillebenmalerei, Vienna, Academie, Spring 1952 (Cat. : LUDWIG MÜNZ).

Chefs-d'œuvre de la coll. D. G. van Beuningen (Petit-Palais, Paris), Rotterdam 1952 (Cat. : D. HANNEMA).

La Nature morte de l'antiquité a nos jours, Musée de l'Orangerie, Paris 1952 (Cat. : Ch. STERLING).

Illusionism and « trompe-l'œil », California Palace of the Legion of Honor, San Francisco 1949 (Cat. : THOMAS C. HOWE, Jr., JERMAYNE MAC AGY, A. FRANKENSTEIN, DOUGLAS MAC AGY).

Marie Berhaut, « Natures mortes anciennes et modernes », Musée de Rennes 1953.

The Art of Still-Life, 1600-1700, Arcade Gallery, London 1953 (Preface by V. BLOCH).

Flower Pictures, Wildenstein Galleries, New York 1954.

Vier Eeuwen Stilleven in Frankrijk, Boymans Museum, Rotterdam, 10 July-20 Sept. 1954 (Cat. : BEGEMANN-HAVERCAMP).

Exh. Natures mortes du Musée des Beaux-Arts de Strasbourg, Musée de Strasbourg 1954 (Cat. : H. HAUG).

Exh. Still-Life Painting in the 17th C., Rapps Gallery, Stockholm 1954.

Exh. Holenderska i Flamandzka Martwa Natura 17-go W. Dutch and Flemish Still-Life Painting in the 17th c., National Museum, Warsaw 1954 (Cat. : Andrzej CHUDZIKOWSKI).

Four Centuries of Dutch Still-Life Painting, Dordrecht 1954.

Stilleben Schweizerischer Maler, Kunstsammlung, Thun 1954.

Flower Pictures, Wildenstein Galleries, New York 1954.

Pain et vin, Galerie Charpentier, Paris 1954.

Exh. 30 tableaux de maîtres anciens, Galerie Heim, Paris 1955.

Exhibition of Dutch and Flemish Masters, E. Slatter Gallery, London 1955.

Still-Life Painting since 1470, Milwaukee Arts Institute, Sept. 1956; — Cincinnati Art Museum, Oct. 1956.

Exh. Tableaux de maîtres anciens, Galerie Heim, Paris 1956.

Exh. Dutch and Flemish Masters, Eugène Slatter Gallery, London 1956.

Exh. Natures mortes d'hier et d'aujourd'hui, Musée des Beaux-Arts de Besançon, 1956.

Exh. La Natura morta italiana dal sec. XIII ai nostri giorni, Galleria dello Zodiaco, Rome 1956.

Exh. Wintertentoonstelling, P. de Boer Gallery, Amsterdam 1956-1957.

Exh. Pictures for the Collector, A. Brod Gallery, London 1957.

Exh. Nineteenth-century Still-Life at the Nework Museum, 1958.

Exh. Natures mortes française du XVIIe au XXe siècle, Galerie Daber, Paris 1959.

ANTIQUITY

A. REINACH. Recueil Milliet. Textes grecs et latins relatifs a l'histoire de la peinture, Paris 1921.

H. G. BEYEN. Über Stilleben aus Pompeji und Herculaneum, The Hague, 1928.

H. G. BEYEN. Über ein Fragment einer Wanddekoration mit Stilleben aus Pompeji, in : *Jahrbuch des deutschen archaelogischen Instituts*, Berlin and Leipzig 1928, Vol. XLII, p. 41-62.

THE MIDDLE AGES AND THE RENAISSANCE

FRANCESCO ARCANGELI. Tarsie, *Quaderni d'Arte*, 3, 2nd edition, Rome 1943.

LUDWIG BALDASS. Sittenbild und Stilleben in Rahmen des Niederländischen Romanismus, *Jahrbuch der Kunsthist. Sammlungen des Kaisershauses*, Vienna 1923, Vol. 36, p. 15 et suiv.

LUDWIG BALDASS. Jan Van Eyck, 1952.

INGVAR BERGSTRÖM. Revival of Antique Illusionistic Painting in Renaissance Art, Göteborg 1957.

INGVAR BERGSTRÖM. Disguised Symbolism in « Madonna » Pictures and Still-Life, *Burlington Magazine*, October 1955, p. 303-308, November 1955, p. 342-349.

PHYLLIS PRAY BOBER. Drawings after the Antique by Amico Aspertini, London 1957.

WALTER BOMBE. Une reconstitution du studio du duc Frédéric d'Urbin, *G. B. A.*, 72nd year, 6th period, Vol. IV (1930, 2), p. 265-275.

KJELL BOSTRÖM. De corspronkelijke bestemming van Ludger Tom Rings Stillevens, *Oud-Holland*, LXVII (1952), p. 51-55.

H. BUNEMANN. Das frühe Stilleben. About the Still-Life Exhib. at the Orangerie, *Die Kunst*, No. 50 (1951-52), p. 441-448.

A. CHASTEL. La mosaïque à Venise et à Florence au xve siècle, *Arte Veneta*, 1954, p. 122.

ANDRÉ CHASTEL. Cités idéales, *L'Œil*, n° 36, Noël 1957, p. 32-39.

T. H. COLDING. Aspects of Miniature Painting: its Origins and Development, Copenhagen 1953.

PAUL DURRIEU. La miniature flamande au temps de la cour de Bourgogne, Paris and Brussels 1927.

M. DVORAK. Ein Stilleben des Bueckelaer oder Betrachtung über die Entstehung der neuzeitigen Kabinettmalerei, *Jahrbuch d. Kunsthist. Sammlungen*, Vienna, Vol. 36 (1923).

MICHEL FARÉ. Les origines de la nature morte dans la peinture d'objets du Moyen Age et de la Renaissance, S. I., 1952, in-4°, XV, 381 (Thesis, Paris, 1952).

MAX J. FRIEDLAENDER. Der Hl. Hieronymus van Reymerswale, *Pantheon*, XIII (1934), p. 33-36.

R. GENAILLE. L'œuvre de Pieter Aertsen, *G. B. A.*, Vol. XLIV (1954), p. 267-288.

A. DE HEVESY. Jacopo de' Barbari, le Maître au caducée, Paris and Brussels 1925.

HENRIETTE s'JACOBS. Idealism and Realism, a Study of Sepulchral Symbolism, Leyden 1954.

C. H. DE JONGE. Vroege werken van Maerten van Heemskerck, *Oud Holland*, XLIX (1932), p. 145-160.

CHARLES JORET. La rose dans l'antiquité et au moyen âge : histoires, légendes et symbolisme, Paris 1892.

E. KRIS, Der Stil « rustique ». Die Verwendung des Naturabgusses bei Wentzel Jamnitzer und Bernard Palissy, *Jahrb, d. kunsthist. Samml. in Wien*, N. F. Vol. I (1926), p. 137-208.

ERNST KRIS. Georg Hoefnagel und der wissenschaftliche Naturalismus, *Festschrift für Julius Schlosser*, Zurich, Leipzig, Vienna, 1927, p. 243-253.

F. C. LEGRAND and F. SLUYS. Giuseppe Arcimboldo, joyau des Cabinets de Curiosités, *Les Arts Plastiques*, Brussels, No. 4, 1953.

F. C. LEGRAND and F. SLUYS. Arcimboldo et les Arcimboldesques, 1955.

G. MARLIER. Erasme et la peinture flamande de son temps, Brussels 1954.

RENZO H. MONTINI and RICCARDO AVERINI, Palazzo Baldassini e l'arte di Giovanni da Udine, Istituto di Studi romani, Rome 1959.

W. J. MÜLLER. Der Maler Georg Flegel und die Anfänge des Stillebens, 1956, 1st part, p. 7-58.

OTTO PÄCHT. The Master of Mary of Burgundy, London and Glasgow 1948.

E. PANOFSKY. Early Netherlandish Painting, its Origin and Character, 2 Vol., Cambridge, Mass., 1953.

A. E. POPHAM. On a Letter of Joris Hoefnagel, *Oud Holland*, LIII (1936), p. 45-151.

J. Q. VAN REGTEREN ALTENA. Jacques de Gheyn. An Introduction to the Study of his Drawings, Thesis, Amsterdam 1935.

Preston Remington. The Private Study of Federigo da Montefeltro. A Masterpiece of xvth C. Trompe-l'Œil, *The Metropolitan Museum of Art Bull.*, 1941, p. 3-13.

B. J. A. Renckens. Een ikonographische aanvulling op "Christus bij Martha en Maria" van Pieter Aertsen, *Kunsthistorische medelingen van het Rijksbureau v. kunsthist. Documentatie*, 4 (1949), p. 30-32.

Herbert Rudolph. "Vanitas", die Bedeutung mittelalterlicher und humanistischer Bildinhalt in der niederländischen Malerei des 17. Jrh., *Festschrift Wilhelm Pinder*, Leipzig 1938, p. 405-433.

Julius von Schlosser. Die Kunst – und – Wunderkammern der Spätrenaissance, Leipzig 1908.

Luigi Servolini. Jacopo de' Barbari, 1944.

Joh. Sievers. Pieter Aertsen. Ein Beitrag zur Geschichte der niederl. Kunst im xvi. Jahrh., Leipzig 1908.

Joh. Sievers. Joachim Bueckelaer, *Jahrb d. preuss. Kunstsammlungen*, XXXII (1911), p. 185-212.

Anna Strümpell. Hieronymus im Gehäuse, *Marburger Jahrbuch für Kunstwissenschaft*, Vol. 2 (1925-26), p. 173-252.

Alberto Tenenti. La Vie et la Mort à travers l'Art du xve siècle, Paris 1952 (*Cahiers des Annales*, 8).

Charles de Tolnay. Les Origines de la nature morte, *La Revue des Arts*, 2nd year 1952, p. 151 et seq.

Charles de Tolnay. Notes sur les origines de la nature morte, *La Revue des Arts*, 3rd year (1953), p. 66 et seq.

A. Venturi. D'alcune opere d'arte nella Collezione Messinger, *L'Arte*, 1913, p. 146 (Passerotti).

S. Vries. J. Chimenti da Empoli, *Rivista d'Arte*, XV (1933).

Paul Wescher. Sanders and Simon Bening and Gerard Horenbout, *The Art Quarterly*, IX (1946), p. 191-209.

F. Winkler. Die flaemische Buchmalerei des xv. und xvi. Jahrh. Kuenstler und Werke von den Brudern van Eyck bis zu Simon Bening, Leipzig 1925.

XVIIth CENTURY

FRANCE

G. de Batz. French Cuisines, *The Art Quarterly*, IX (1946), p. 307-312.

C. Benedict. A propos de quelques natures mortes de l'époque Louis XIII, *Maandblad voor beeldende Kunsten*, No 2, Febr. 1948, p. 29-34.

J. Bligne. Natures mortes francaises, *Le Peintre*, No 37 (1952), p. 12-13.

Jean Boyer. Ephrem Comte, *Combat-Art*, 5 March 1956.

C. Z... Rotterdam : La natura morta nella pittura francese, *Emporium*, Vol. 121 (1955), p. 90-93.

Mme Dreyfus-Brühl. Précisions nouvelles sur Jacques Linard, *Arts*, 17 Sept. 1948.

Michel Faré. La nature morte française, *Arts*, 28 Dec. 1951, No 339.

M. Faré. La Nature morte en France, son histoire et son évolution du xviie au xxe s. (Thesis, Paris 1952).

Michel Faré. Meiffren Conte et Michel Gobin, in : *Bull. de la Soc. de l'Hist. de l'Art Français*, 1956, p. 41-59.

Michel Faré. Jean-Michel Picart (1600-1682), peintre de fleurs et marchand de tableaux, in : *Bull. de la Soc. de l'Hist. de l'Art Français*, 1957, p. 91-102.

Michel Faré. Nature et nature morte au xviie siècle, *G. B. A.*, April 1958, p. 254-266.

Michel Faré. Attrait de la nature morte au xviie siècle, *G. B. A.*, March 1959, p. 129-144.

H. Haug. Un nouveau tableau de Jacques Linard, *Bull. des Musées de France*, 1935, p. 63.

H. Haug. Sebastian Stoskopff, in : *Trois siècles d'art alsacien*, 1648-1948, Archives alsaciennes d'histoire de l'art, Strasbourg-Paris 1948.

H. Haug. Trois peintres strasbourgeois de natures mortes (Seb. Stoskopff, Jean Boriman, Albrecht Kauw), *La Revue des Arts*, 2nd year (1952), 13-7150.

Georges Isarlo. Baugin portraitiste et la nature morte disposée, *Arts*, 11 April 1947.

M. L. B. Natures mortes françaises du xviie s. à nos jours, *Revue des Deux Mondes*, 1952, Vol. I, p. 755-756.

A. P. de Mirimonde. Deux natures mortes du xviie s. français aux musées de La Fère et de Chaumont, *Revue des Arts*, 7, p. 218-224, Sept. 1957.

Charles Sterling. Les Peintres de la Réalité en France au xviie siècle, Introduction et Catalogue, Orangerie, Paris 1934.

Charles Sterling. Francois Garnier, Communication du 2 février 1952, Soc. de l'Hist. de l'Art français.

Jean-Louis Vaudoyer. Natures mortes françaises du xviie s. à nos jours, Cat. de l'Exp. Galerie Charpentier, Paris 1951.

Jacques Wilhelm. Louise Moillon, *L'Œil*, Sept. 1956, p. 6-11

SPAIN

P. R. Adams. Still-Life with Game by an Unknown Spanish Master, *Cincinnati Museum Bull.*, May 1957, p. 4-5.

Karl H. Birkmeyer. Realism and Realities in the Paintings of Velazquez, *G. B. A.*, July-Aug. 1958, p. 63-77.

J. Cassou. La Nature morte espagnole, *Verve*, No 27-28, p. 95-104 (1952).

Julio Cavestany. Pintores españoles de flores, *Rev. esp. de Artes*, Vol. IV, No 3, 1922.

Julio Cavestany. Floreros y Bodegones en la Pintura Española, *Cat. ill. Exp. Palacio de la Biblioteca Nacional*, Madrid 1936 et 1940.

Paul Guinard. Zurbarán, le ténébrisme et la tradition espagnole, *Cat. Exp. Bordeaux*, Vol. II, 1955, p. 45-51.

E. Lafuente-Ferrari. La peinture de Bodegones en Espagne, *G. B. A.*, XIV, 1935, p. 169.

A. Mayer. Über einige Velazquez zu unrecht zugeschriebene Stilleben und Genrebilder, *Monatshefte für Kunstwissenschaft*, 1915.

North Carolina State Museum, Raleigh, *Art News*, April 1956. p. 37, 43-45 (Reproductions of Spanish Still-Life Paintings),

Gelasio Oña Iribarren, 165 Firmas de Pintores tomadas de cuadros de Flores y Bodegones, Preface by E. Lafuente-Ferrari, Madrid 1944.

H. P. G. Seckel. F. de Zurbarán as a Painter of Still-Life, *G. B. A.*, 1946, Oct.-Dec., p. 279.

Spanish Still-Life in the Walker Art Gallery, *Art News*, May 1957.

Exh. Floreros y Bodegones, Madrid 1935.

Exh. Floreros y Bodegones (XVIº, XVIIº, XVIIIº, XIXº C.) de colecciones barcelonesas, Parès Gallery, Barcelona, May 1947.

ITALY

L. ANGELINI. E. Baschenis, Bergamo, sec. ed. 1946.

G. BRIGANTI. Catalogo di nature morte del' 600-700, Galleria Athena, Rome 1947.

G. BRIGANTI, Michelangelo Cerquozzi, pittore di nature morte *Paragone*, No 53, May 1954, p. 47-52.

RAFFAELLO CAUSA. Paolo Porpora e il primo tempo della natura morta napoletana, *Paragone*, 15 (Arte), March 1951, p. 30-36.

RAFFAELLO CAUSA. Pittura Napoletana dal XVº al XIXº sec., Bergamo, 1957.

G. DELOGU. Pittori Minori, Venice 1931.

WALTHER FRIEDLAENDER. Caravaggio Studies, New Jersey 1955.

BENNO GEIGER. I dipinti ghiribizzosi di Giuseppe Arcimboldi, 1954.

R. HINKS. Michelangelo Merisi da Caravaggio. His Life, his Legend, his Works. London 1953.

G. Y. HOOGEWERFF. Nature morte italiane del Seicento e del Settecento, *Dedalo*, 1923-1924, p. 599-624, 710-730.

GEORGES ISARLO. Le Caravagisme, *L'Amour de l'Art*, 1955, p. 115.

M. MARANGONI. Valori mal noti e trascurati della pittura italiana del seicento di alcuni pittori di natura morta, *Rivista d'Arte*, 1917-1910, X.

MATTEO MARANGONI. *Natura morta*, in : *Arte Barocca*, 1953, p. 3-35.

SCHAFFRAN-BALASSI. Die Barock Stillebenmalerei in Ober Italien, *Die Weltkunst*, Vol. 22 (1952), No, p. 4.

H. SWARZENSKI. Caravaggio and Still-Life Painting. Notes on a Recent Acquisition. *Bull. of the Museum of Fine Arts*, Boston, L. II, 1954, p. 26.

GIOVANNI TESTORI. Nature morte di Tommaso Salini, *Paragone*, No 51, March 1954, p. 20-25.

L. VENTURI. Studi su Michelangelo da Caravaggio, *L'Arte*, 1910, p. 199.

F. ZERI. Giuseppe Recco : Una natura morte giovanile, *Paragone*, No 33, Sept. 1952, p. 37-38.

Exh. Italian Painting in the 17th c., Palazzo Pitti, Florence 1922.

Exh. Mostra del Seicento Europeo, Rome 1956.

FLANDERS

P. BAUTIER. Jean-Antoine van der Baren et les peintres de fleurs, Brussels 1941.

INGVAR BERGSTRÖM. Osias Beert the Elder as a Collaborator of Rubens, *Burlington Magazine*, April 1957, p. 120-124.

C. BENEDICT. Un peintre oublié de natures mortes : Osias Beert, *L'Amour de l'Art*, Oct. 1938, p. 307-314.

PIETER DE BOER. De Bosschaerts, Helsche en Fluweelen Brueghel, Exhib. cat., P. de Boer Gallery, Amsterdam, 1934.

KJELL BOSTRÖM. A Still-Life Painting by Joachim Beuckelaer, *Oud-Holland*, LXIII (1948), p. 122-128.

A. BREDIUS. De Bloemschilders Bosschaert, *Oud-Holland*, XXXI, 1913, p. 137-140.

J. G. VAN GELDER. Ashmolean Museum, Introduction to the Cat. of the Coll. of Dutch and Flemish Still-Life Pictures Bequeathed by Daisy Linda Ward, Oxford 1950.

OLOF GRANBERG. Ambrosius Bosschaert, le monogrammiste AB, *Oud-Holland*, IV (1886), p. 265-267.

G. GLUCK. Les Peintres d'animaux, de fruits et de fleurs, Trésor de l'Art belge au XVIIe siècle, *Mémorial de l'Exp. d'Art ancien à Bruxelles en 1910*, Brussels-Paris, 1912.

EDITH GREINDL. La nature morte chez les peintres flamands, *Les Arts plastiques*, 1948, p. 289-301.

EDITH GREINDL. Jan Fyt, peintre de fleurs, *Miscellanea Leo van Puyvelde*, Brussels, 1949, p. 163-165.

EDITH GREINDL. Les Peintres flamands de nature morte au XVIIe siècle, 1956.

M. L. HAIRS. Osias Beet l'Ancien, peintre de fleurs, *Revue belge d'Archéologie et d'Hist. de l'Art*, Vol. XX, 1951, p. 237-251.

M. L. HAIRS. André Daniels, peintre de fleurs anversois, vers 1600, *Oud-Holland-Mededelingen van het Rijksbureau voor Kunsthistorische Documentatie*, LXVI, 1951, 3, p. 175-179.

M. L. HAIRS. Deux tableaux de fleurs attribués à l'atelier d'Osias Beert, *Bull. des Musées Royaux de Belgique*, No 5, March 1953, p. 21-26.

M. L. HAIRS. Les peintres flamands de fleurs au XVIIe siècle, Paris-Bruxelles 1955.

EDWARD S. KING. Notes on a Still-Life by Jean Soreau, *The Journal of the Walters Art Gallery*, Baltimore 1954, Vol. XVII, p. 35-43.

AXEL SJÖBLOM. Die koloristische Entwicklung des niederländischen Stillebens im 17. Jahrh., Würzburg 1917.

CH. STERLING. Rubens et son temps, Catalogue, Musée de l'Orangerie, Paris 1936.

Exh. Helsche en Fluweelen Brueghel, P. de Boer Gallery, Amsterdam 1934 (Cat. : G. BURCHARD).

HOLLAND - GERMANY - ENGLAND - SWEDEN

KURT BAUCH. *Ausstellung hollandischer Stilleben des 17. Jahr.*, in *Belvedere*, 1929.

D. BELL. Review of Bergströms, *Museums Journal*, March 1957.

A. BENGTSON and H. OMBERG. Structural Changes in Dutch XVII-th c. Landscape, Still-Life, etc., *Figura* (Upsala), Vol. I-1951, p. 13-56.

INGVAR BERGSTRÖM. Ottmar Elliger och Willem Kalf, *Konsthistorisk Tidskrift* (Stocholm), XII (1943), p. 41-45.

INGVAR BERGSTRÖM. Holländskt Stillebenmaleri under 1600-talet, Göteborg 1947.

INGVAR BERGSTRÖM. Studier i holländskt Stillebenmaleri under 1600- talet. (Thesis). Göteborg 1947.

INGVAR BERGSTRÖM. Twee onbekende Stillevens van François Ryckhals, *Oud Holland*, LXIV (1949), p. 18 and 20-24.

J. BERGSTRÖM. Jan Olis as a Still-Life painter, *Oud Holland*, LXVI (1951), p. 56-58.

I. BERGSTRÖM. The Ward Collection at Oxford, in : *Konsthistorisk Tidskrift*, 2-4, 1951, p. 78-81.

INGVAR BERGSTRÖM. Djur-och Stillebenmaleri i karolinsk tid *Konsthistorisk Tidskrift* (Stockholm), XXI, 1952, p. 78-82.

INGVAR BERGSTRÖM. Dutch Still-Life Painting, London 1956.

JOHN BERNSTRÖM och Bengt Rapp, Malningar av Jan Fyt Abraham van Beijeren, Isaack van Duijnen, Michiel Simons, Giuseppe Recco, Edwaert Colyer och Charles Field, *Iconographica*, Stockholm 1957.

JOHN BERNSTRÖM och Bengt Rapp, Malningar av Dabid Klöcker Ehrenstrahl, Jan Fyt, Jacob Xaver Vermeulen, Johannes Leemans, Edwaert Colyer, Jacob Gillig och Per Kraft d. Y., *Iconographica*, Stockholm 1958.

WALTHER BERNT. Die Niederlaendischen Meister des 17. Jahrh., 3 Vol., Munich 1948.

IMA BLOK. Het Nederlandsche Stilleven, *Onze Kunst*, 1917, June, p. 1-6; July, p. 11-17.

IMA BLOK. Abraham van Beyeren, *Onze Kunst*, Amsterdam, 1918, p. 113, 121, p. 159-165.

IMA BLOK. Willem Kalf, *Onze Kunst*, Amsterdam, 1919, p. 85-94, p. 137-145.

WILHELM BODE. Das holländische Stilleben, *Die graphischen Künste*, 1888, Vol. II.

W. BODE. Die Meister der hollaendischen und flaemischen Malerschulen, Berlin 1919.

PIETER DE BOER. Jan Jansz. den Uyl, *Oud Holland* (1940), p. 49-64.

L. J. BOL. Bartholomäus Assteijn, Dordts Schilder van Blommen en Fruyten, *Oud Holland*, L. XVIII (1953), p. 136-148.

L. J. BOL. Adriaan S. Coorte, Stillevenschilder, *Nederlandsch Kunsthistoris Jaarboek*, The Hague, Vol. 4 (1952-3), p. 193-232.

L. J. BOL. Een Middelburgse Brueghelgroep, *Oud Holland*, LXX (1955), p. 1-20, 96-109, 138-154.

KJELL BOSTRÖM. Kring Caravaggios efterföljd i holländsk Stillebenkonst, *Konsthistorisk Tidskrift*, XIII (1944), p. 1-16.

KJELL BOSTRÖM. David Bailly's Stilleben, *Konsthistorisk Tidskrift* XVIII (1949), p. 99-100.

KJELL BOSTRÖM. Jan Vermeer van Delft en Cornelis van der Meulen, *Oud-Holland*, LCVI (1951), p. 117-122.

KJELL BOSTRÖM. "Peep-show or Case ?", *Kunsthistorische Medelelingen van het Rijksbureau voor Kunsthistorische Documentatie*, 4 (1949), p. 21-29.

A. BREDIUS. De Schilders Pieter en Harmen Steenwyck, *Oud-Holland*, VIII (1890), p. 143-148.

A. BREDIUS. Nederlandsche Kunst in provinciale musea van Frankrijk, *Oud Holland*, XIX (1901), p. 1-14; XXII (1904). p. 92-110; XXIII (1913), p. 74-82.

A. BREDIUS. Kuenstler Inventare. Urkunden zur Geschichte der hollaendischen Kunst des 16., 17., und 18. Jahrh., 6 Teile, Nachtraege, Register, The Hague, 1915 1922.

A. BREDIUS. Jan Jansz. den Uyl (een nalezing), *Oud Holland*. XXXV (1917), p. 1-11.

A. BREDIUS. Nog Eens : Jan Jansz. den Uyl, *Oud Holland*, XXXVIII (1920), p. 126.

A. BREDIUS. Een en ander over Willem Kalf, *Oud Holland*, XLII (1925), p. 208-209.

A. BREDIUS. Een testament van Jan Baptist Weenicx, *Oud Holland*, XLV (1928), p. 177-178.

A. BREDIUS. Rembrandt : Gemaelde, Vienna 1935.

J. BRUYN. David Bailly, « fort bon peintre et en pourtraicts et en vie coye », *Oud-Holland*, LXVI (1951), p. 148-164; 212-227.

THOMAS S. BUECHNER. Glass Vessels in Dutch Painting of the XVII-th c., 1952, 7 plates (Study published in connection with the Exhib. on this theme, field at the Corning Museum of Glass, Corning, N. Y.).

E. C. CORTI. Die trockene Trunkenheit. Ursprung, Kampf und Triumph des Rauchens, Leipzig 1930.

FRANK DAVIS. "Prince of flower painters", *Ill. London News*, 1955. I, p. 564 (Review of a book on Jan van Huysum by Colonel M. H. Grant, with detailed catalogue).

J. DENUCÉ. Kunstuitvoer in de 17e eeuw te Anwerpen. De Firma Forchoudt, The Hague 1932.

V. DIRKSEN. Das holländische Stilleben des 17. Jh., Hamburg 1921.

H. E. VAN GELDER. Heda, Beyeren, Kalf, Amsterdam 1945.

J. G. VAN GELDER, Ashmolean Museum; Cat. of the Coll. of Dutch and Flemish Still-Life Pictures Bequeathed by Daisy Linda Ward, Oxford 1950.

H. GERSON, Ausbreitung und Nachwirkung der holländischen Malerei d. 17-ten Jahrh., 1942.

J. GOUDSTIKKER. Een cranium door Hercules Seghers, *Oud Holland*, XLVI (1929), p. 279-281.

M. H. GRANT. The Twelve Months of Flowers by Jacob van Huysum (1687-1740), Leigh-on-Sea 1950.

G. C. HELBERS. Abraham van Beyeren, Schilder tot Overschie, *Oud Holland*, XLV (1928), p. 27-28.

G. J. HOOGEWERFF. De Noord-Nederlandsche schilderkunst, 5 vol., The Hague 1936-1947.

J. HUIZINGA. Hollaendische Kultur des siebzehnten Jahrh. Ihre Grundlagen und nationale Eigenart, Jena 1933.

J. B. KNIPPING. De Iconografie de Contra-Reformatie in de Nederlanden, 2 Vols., Hilversum 1939-1940.

G. Wsz. KNUTTEL. Het Nederlansche Stilleven, *Mededeelingen van den Dienst voor kunsten en wetenschappen der gemeente's* — The Hague, Part II, Afl. I (March 1926), p. 1-37.

A. C. DE KRUYFF. Iets over den schilder Jacob Marrell, *Oud Holland*, X (1892), p. 57-60.

R. VAN LUTTERVELT. Schilders van het Stilleven (Kunst van Nederland), Naarden 1947.

W. MARTIN. Tentoonstelling van Stilleven in de Rotterdamschen Kunstkring, *Bull. v. d. Nederl. oudheidk. Bond*, 1909.

W. MARTIN. Gerard Dou (Klassiker der Kunst, XXIV), Berlin 1913.

W. MARTIN. De Hollandsche Schilderkunst in de zeventiende eeuw, 1935-196.

CLOTHILDE MISME-BRIÈRE. A Dutch Intimist, Pieter Janssens Elinga, *G. B. A.*, vol. XXXI (1947.1), p. 89-102, 151-164; vol. XXXII (1947.2), p. 159-176.

W. J. MULLER. Der Maler Georg Flegel und die Anfänge des Stillebens, 1956.

R. A. PELTZER. Copper-mark in Dutch Pictures, *Monatsheft f. Kunstwissenschaft*, Berlin 1911.

R. A. Peltzer. Georg Hinz (Hainz), der Pseudo-V. van der Meer, *Munchener Jahrbuch der bildenden Kunst*, N. F. XL, Vol. 3-4 (1936), p. 1-7.

B. Rapp. Djur och Stilleben i karol inskt maleri, Stockholm 1951.

R. Renraw. The Art of Rachel Ruysch, *The Connoisseur*, XCII (1933), p. 397-399.

B. W. F. van Riemsdijk. Twee zeldzame Meesters. 2. Franciscus Gijsbrectsz., *Oud Holland*, XLIII (1926), p. 105-107.

N. I. Romanov. Dutch Still-Life Painting in the Moscow Museum of Fine Arts, *Art in America*, 1932, No 6.

Axel Sjöblom. Die koloristische Entwicklung des niederländischen Stillebens im 17. Jahrh., Würzburg 1917.

M. L. Sstcherbaczewa. Hollandskij Natiurmort, Leningrad 1928.

W. Stechow. Salomon van Ruysdael, Berlin 1938.

A. Stheemann. Het Stilleven en zijne Evolutie, *Maandblad voor beeldende kunst*, p. 99-106, Amsterdam 1933.

Frans Vermeulen. De ontwikkeling van het Stilleven in de Hoilandsche Schilderkunst, *Elsevier's Geillusteerd Maandschrift*, Jaarg. XXII, Vol. XLIII (1912), p. 352-356, 451-462.

N. R. A. Vroom. De Schilders van het monochrome banketje. Amsterdam 1945.

W. Weisbach. Rembrandt, Berlin and Leipzig 1926.

H. F. Wijnman. De Stillevenschilder Jacob Rotius, *Oud Holland*, XLVII (1930), p. 60-67.

E. Zarnowska. La nature morte hollandaise. Ses principaux représentants, ses origines, son influence, Brussels and Maestricht 1929.

Exh. of Dutch Still-Life, Rotterdam 1909.

Exh. of Netherlandish Still-Life, The Hague 1926.

Exh. of Dutch Still-Life, Brussels 1929.

Tentoonstelling geschiedenis Bloembollencultur, Frans Hals Museum, Haarlem 1935.

Exh. La Hollande en fleurs, château de Rohan, Strasbourg 1949 (Cat. : R. van Lutterwelt).

Exh. Glass Vessels in Dutch Painting of the XVIIth c., The Corning Museum of Glass, Corning Glass Center, N. Y., 1952.

Exh. Adriaen Coorte, Dordrecht Museum, 1958 (by L. J. Bol).

XVIIIth CENTURY

Giuseppe De Logu. Novità su Carlo Magini pittore fareal, in : *Emporium*, December 1954, p. 247-258, 9 figures.

L. Dimier ((sous la direction de). Les Peintres francais du XVIIIe siècle, 2 Vols., 1930.

Giuseppe Fiocco. Francesco Guardi pittore di Fiori, *Arte Veneta*, IV, 1950, p. 76-85.

Michel Florisoone. Le Dix-huitième Siècle, Paris 1948.

Kurt Gerstenberg. Naturwissenschaftliche Richtung in der deutschen Blumenmalerei des 18. Jhr., *Zeitschrift für Kunstwissenschaft*, 1953, Vol. VII.

Maurice H. Grant. The Twelve Months of Flowers by Jacob van Huysum (1687-1740), Leigh-on-Sea 1950.

G. Isarlo. Magin c'est Maggini..., *Connaissance des Arts*, April 1955, p. 57.

G. de Lastic Saint-Jal. Un portraitiste des biens de la terre, *L'Œil* (No 9), Sept. 1955, p. 202-22.

J. Locquin. Catalogue raisonné de l'Œuvre de Jean-Baptiste Oudry, 1912.

A.-P. de Mérimonde. Jacques Smets et la nature morte archaïque au XVIIIe siècle, *Revue des Arts*, No 6, July 1958, p. 185-188.

Marianne R. Michel. Une académicienne du XVIIIe siècle : Anne Vallayer-Coster. Essai sur sa vie. Catalogue de son œuvre (diplôme d'études supérieures d'histoire, à la Sorbonne, 1. June 1959).

Marcel Proust. Chardin in : Contre Sainte-Beuve, suivi de Nouveaux Mélanges, préface de Bernard de Fallois, Paris 1954, p. 363 et seq.

Luigi Servolini. Carlo Magini pittore fanese del settecento, in : *Commentari*, April-June 1957, p. 125-137, pl. XLV-XLVIII.

Luigi Servolini. Postilla sul pittore Carlo Magini, in : *Arte Figurativa*, 1957, No 2, p. 31, 2 figures.

Luigi Servolini. Una postilla sul pittore settecentista Carlo Magini, in : Festschrift für Hans Vollmer, 1957, p. 179-182, 2 Figures.

Georges Wildenstein. Chardin, Paris 1933.

Luigi Zauli Naldi. Carlo Magini pittore di nature morte del secolo XVIII, *Paragone*, No 49, 1954, p. 57-60.

XIXth AND XXth CENTURIES

American Still-Life Painting, in : *American Artist*, June 1958, p. 70-71.

Roseline Bacou. Odilon Redon, 2 Vols., Geneva 1956.

A. H. Barr. Matisse, New York 1951.

Klaus Berger. Géricault und sein Werk, Vienna 1952.

G. Bazin. L'Epoque Impressionniste, Tisné, Paris 1947.

Wolfgang Born. Still-Life Painting in America, New York 1947.

J. Cassou. Picasso, 1947.

Charles Clément. Géricault, 1868; 2nd ed., 1879.

Raymond Cogniat and Waldemar George. Œuvre complète de Roger de La Fresnaye, 1950.

P. Courthion. Courbet, 1931.

Charles C. Cunningham. Some Still-Lifes by Eugène Boudin, in : *Studies in the History of Art Dedicated to William Suida*, 1959, p. 382-392.

B. Dorival. Cézanne, Tisné, Paris 1948.

M. Drucker. Renoir, Tisné, Paris 1955.

E. H. Dwight. Recent Still-Life Painting, in : Exh. cat. Still; Life Painting since 1470, Milwaukee Art Institute, Sept. 1956-Cincinnati Art Museum, Oct. 1956.

311

Karl Einstein. Die Kunst des 20. Jahrh., 1926.

Iris Elles. Das Stilleben in der französischen Malerei des 19. Jahrunderts, Zurich 1958.

J.-B. de La Faille. Vincent van Gogh, 1939.

Henri Focillon. La Peinture au xixe siècle, 1927.

Henri Focillon. La Peinture aux xixe et xxe siècles, 1928.

A. V. Frankenstein. After the Hunt, William Hernett and other American Still-Life Painters, 1870-1900, 1953.

G. Geoffroy. Monet, 1941.

H.F. Geist. Giorgio Morandi, Erinnerungen an eine Ausstellung, *Werk*, July 1957, No 44, p. 255-258.

Waldemar George. L'œuvre de Pierre Roy, *La Renaissance*, March 1931.

Waldemar George. Les 50 ans de Picasso et la mort de la nature morte, *Formes*, Paris 1931, No 14, p. 15 et seq.

R. Giolli. Nature morte italiane di xixo sec., *Emporium*, Bergamo 1936.

Henri R. Hope. Georges Braque, 1949.

René Huyghe. Les Contemporains, Tisné, Paris 1939.

René Huyghe. Préface du Cat. de l'Exp. Gauguin, 1950.

Jamot-Wildenstein-Bataille. Manet, 1932.

Harriette and Sydney Janis. Picasso, the Recent Years, 1939-1946, 1946.

D. H. Kahnweiler. Juan Gris, sa vie, son œuvre, ses écrits, 1947.

Ch. Léger. Courbet, 1929.

J. Leymarie. Cubisme, in : *Dictionnaire de la Peinture Moderne*, 1954, p. 64-66.

M. Malingue. Gauguin, 1948.

G. Raimondi. La Congiuntura Metafisica Morandi-Carrà, *Paragone*, No 19, July 1951, p. 18-27.

J. Rewald. Gauguin, 1938.

J. Rewald. The History of Impressionism, New York 1946.

Cl. Roger-Marx. Vuillard, sa vie et son œuvre, Paris 1946.

Cl. Roger-Marx. Dunoyer de Segonzac, 1951.

A. Tabarant. Manet et ses œuvres, 1947.

K. L. Usener, Cl. Monets Seerosenwandbilder in der Orangerie, *Wallraf-Richartz Jahrbuch*, Westdeutsches Jahrbuch für Kunstgeschichte, Vol. XIV (1952), p. 216 et seq.

L. Venturi. Cézanne, 1936.

Christian Zervos. Pablo Picasso, 1952.

xixth c. Still-Life at the Newark Museum, *Antiques*, Aug. 1958, p. 154.

Exh. Still-Life Painting after 1850. Matthiesen Gallery, Berlin 1927.

Exh. Pierre Roy. Brummer Gallery, New York 1930.

Exh. Nineteenth Century Still-Life, Newark Museum 1958.

ADDITIONAL BIBLIOGRAPHY

The most important books, articles and exhibition catalogues published in the years 1959 to 1979.

GENERAL BIBLIOGRAPHY

Encyclopedia of World Art, XIII, 1967, cols. 432–434.

Natura in Posa. La grande stagione della natura morta europea, Rizzoli, Milan, 1977. Chapters by I. Bergström, C. C. Grimm, M. Rosci, M. and F. Faré, J. A. Gaya Nuño. Bibliography, p. 221 et seq. (Hereafter Natura in Posa, 1977.)

Catalogue of the exhibition Nature morte de Brueghel à Soutine, Galerie des Beaux-Arts, Bordeaux, 1978, pp. 215–220.

Catalogue of the exhibition Les Peintres de fleurs en France du XVIIe au XIXe siècles, Petit Palais, Paris, 1979. Bibliography, last two pages (unnumbered) and passim.

Catalogue of the exhibition Stilleben in Europa, Westfälisches Landesmuseum für Kunst und Kunstgeschichte, Münster, 1979–1980, and Staatliche Kunsthalle, Baden-Baden, 1980. Edited by Gerhard Langemeyer and Hans-Albert Peters. This most important catalogue lacks a general bibliography, but the notes contain a wealth of references to old and quite recent literature.

TERMINOLOGY, CONCEPTION, ICONOLOGY

E. H. GOMBRICH. Tradition and Expression in Western Still Life, *Burlington Magazine,* CIII, 1961, pp. 175–180. Reprinted in E. H. Gombrich, Meditations on a Hobby Horse, London, 1963, p. 95 et seq.

M. SCHAPIRO. The Apples of Cézanne, An Essay on the Meaning of Still-life in the Avant-garde, *Art News Annual,* XXXIV, 1965.

M. BATTERSBY. Trompe l'oeil, The Eye Deceived, New York and London, 1974.

M. L. D'OTRANGE MASTAI. Trompe l'oeil, A History of Pictorial Illusionism, New York, 1974.

G. DE LOGU. La natura morta italiana, Bergamo, 1962. Introductory observations, pp. 7–23.

Encyclopedia of World Art, XIII, 1967, cols. 407–434. See in particular S. Bottari's scattered observations in a general survey of the history of the occidental still life, cols. 410–430, and M. Busagli, Aspects of Far Eastern Art Comparable with Western Still Life, cols. 430–432.

Natura in Posa, 1977. See in particular I. Bergström, Preistòria di un gènere, pp. 9–36.

M. FARÉ. De quelques termes désignant la peinture d'objects, in Etudes d'art français offertes à Charles Sterling, Paris, 1975, p. 265 et seq.

For exemplary iconographic interpretations of symbolism in still life that avoid all arbitrary speculation, see the studies by A.-P. de Mirimonde in *Revue de l'Art,* 1963, Nos 4–5, p. 167 et seq.; 1970, No 3, p. 145 et seq.; and L'Iconographie musicale sous les rois bourbons, La musique dans les arts plastiques, XVIIe et XVIIIe siècles, Paris, 1975. See also the study by I. Bergström in *Art Bulletin,* June 1975, p. 287 et seq., in which earlier important interpretations of this writer are cited.

E. M. VETTER. Die Maus auf dem Gebetbuch, in Ruperto Carola, Heidelberg, XVI, 36 December 1964, pp. 99–108.

A.-P. DE MIRIMONDE. Les Vanités à personnages et instruments de musique, *Gazette des Beaux-Arts,* October 1978, pp. 115–131.

I. BERGSTRÖM. Interpretationes Selectae, Acta Universitatis Gothoborgensis, Göteborg, 1978.

ANTIQUITY

J. M. CROISILLE. Les Natures mortes campaniennes, Brussels, 1965 (with bibliography).

J. J. POLLITT. The Art of Greece, 1400–31 B.C., in Sources and Documents in the History of Art, series edited by H. W. Janson, 1965.

J. J. POLLITT. The Art of Rome, c. 753 B.C.–337 A.D., in Sources and Documents in the History of Art series, 1966.

REVIVAL OF STILL LIFE PAINTING IN THE MIDDLE AGES AND RENAISSANCE

G. DE LOGU. La natura morta italiana, Bergamo, 1962, pp. 7–23.

I. BERGSTRÖM. Preistòria di un gènere, in Natura in Posa, 1977, pp. 9–36.

For the *Tarsie,* see Amalia Mezzetti and Otello Caprara, Il coro del Duomo di Modena restaurato, Modena, 1972 (the work is dated 1965). Excellent illustrations.

K. P. F. MOXEY. The "Humanist" Market Scenes of Joachim Beuckelaer: Moralizing Examples or "Slices of Life," in Jaarboek van het koninklijk Museum voor Schone Kunsten, Antwerp, 1976, pp. 109–187.

XVIITH AND XVIIITH CENTURIES

ITALY

G. DE LOGU. La natura morta italiana, Bergamo, 1962.

Catalogue of the exhibition La natura morta italiana, Naples, Zurich, Rotterdam, 1964 (late XVIth-XXth centuries). Fundamental; excellent bibliography; abundant illustrations.

M. ROSCI. Italia, in Natura in Posa, 1977, pp. 83–113. The latest synthesis of the subject; abundant and good illustrations.

On Evaristo Baschenis (and his circle and school), see A. Gaddo, Evaristo Baschenis, Bergamo, 1965 (many color illustrations), and the interesting and quite comprehensive M. Rosci, Baschenis, Bettera e Co, Produzione e mercato della natura morta del Seicento in Italia, Milan, 1971, as well as the review of the latter by I. Bergström in *Art Bulletin,* June 1975, pp. 287–288.

313

F. ZERI. Sull'esecuzione di "nature morte" nella bottega del Cavalier d'Arpino e sulla presènza ivi del giovane Caravaggio, Diari di lavoro 2, 1976, pp. 92–103, and Nota a Tommaso Salini, pp. 104–108. On Caravaggesque still life problems.

M. GREGORI. *Paragone,* XXIV, No 275, 1973, p. 36 et seq., for the problems of Giovanni Battista Crescenzi, Tommaso Salini and Simone del Tintore.

C. DEL BRAVO. Lettera sulla natura morta, in Annali della Scuola Normale Superiore di Pisa, Pisa, 1974, pp. 1566–1591. Interesting observations relative to Giovanni Martinelli.

FERDINANDO ARISI. Felice Boselli, Piacenza, 1973. A comprehensive and well-illustrated monograph, with an interesting introductory discussion of a comprehensive general bibliography, pp. 15–22.

M. CHIARINI. Filippo Napoletano, pittore di natura morta, *Antologia de Belle Arti,* No 4, 1977, pp. 354–356.

FRANCESCO ARCANGELI. Il fratello del Guercino, *Arte Antica e Moderna,* 1961, pp. 5–23. A basic study of Paolo Antonio Barbieri.

FLANDERS

C. GRIMM. Fiandre Olanda Germania, in Natura in Posa, 1977, pp. 37–83.

R. WARNER. Dutch and Flemish Flower and Fruit Painters, London, 1975 (a reissue of the 1928 work).

A.-P. DE MIRIMONDE. Les Natures mortes à instruments de musique, *Jaarboek van het Koninkljk Museum voor Schone Kunsten,* Antwerp, 1964, pp. 119–126, and Les Peintres flamands de trompe-l'oeil et de natures mortes du XVIIe siècle et les sujets de musique, *Jaarboek,* Antwerp, 1971.

J. FOUCART. Un peintre flamand à Paris, Pieter van Bouckle, in Etudes d'art français offertes à Charles Sterling, Paris, 1975, pp. 237–256.

P. MITCHELL. European Flower Painters, London, 1973.

M.-L. HAIRS. Les Peintres flamands de fleurs au XVIIe siècle, second edition, Paris-Brussels, 1964.

M.-L. HAIRS. Jan Brueghel le Jeune, peintre de fleurs, *Revue belge d'archéologie et d'histoire de l'art,* 1967, pp. 57–74.

J. LAUTS. Stilleben alter Meister I: Niederländer und Deutsche, Karlsruhe, 1969, pp. 49–68. Interesting text, excellent illustrations.

E. DE WILDE. "Stilleven" door Clara Peters, *Bulletin des Musées Royaux des Beaux-Arts de Belgique,* XVI, 1967, p. 35 et seq.

L.-J. BOL. The Boschaert Dynasty, Painters of Flowers and Fruit, Leigh-on-Sea, 1960.

FRITZ BAUMGART. Blumen Brueghel, Cologne, 1978.

W. COUVREUR. Daniel Seghers inventaris van door hem geschilderde Bloemstukken, *Gentse Bijdragen,* XX, 1967, p. 87 et seq.

HOLLAND

C. GRIMM. Fiandre Olanda Germania, in Natura in Posa, 1977, pp. 37–83.

P. MITCHELL. European Flower Painters, London, 1973.

P. GAMMELBO. Dutch Still Life Painting from the 16th to the 18th Centuries in Danish Collections, Amsterdam, 1960.

J. LAUTS. Stilleben alter Meister I: Niederländer und Deutsche, Karlsruhe, 1969, pp. 13–48. Interesting text, excellent illustrations.

L. J. BOL. Holländische Maler des 17. Jahrhunderts nahe den grossen Meistern, Brunswick, 1969.

L. GRISEBACH. Willem Kalf, Berlin, 1974.

Catalogue of the exhibition Ijdelheid der Ijdelheden (Vanitas theme), Leyden, 1970.

Gollandskij Natiurmort 17 veka iz Sobrannij Gosudarstvennogo Muzeja Sverina (Dutch Still Life of the 17th Century in the Collections of the Schwerin Museum), exhibition catalogue by JURSS, Tallin, 1977.

M. KLINGE, Gross. Herman Saftleven als Zeichner und Maler bäurlicher Interieurs. Zur Entstehung des südholländischen Bildtypus mit Stilleben aus ländlichem Hausrat und Gerät, *Walraf-Richartz Jahrbuch,* XXXVIII, 1976, pp. 68–91.

A. POLAK. Glass in Dutch Painting, *Connoisseur,* CXCIII, October 1976, pp. 116–125.

L. J. BOL. Adriaen Coorte, A Unique Late 17th Century Dutch Still Life Painter, 1978. See also the review of this book by R. Mandle in *Burlington Magazine,* May 1979, pp. 326–327.

S. A. SULLIVAN. The Dutch Gamepiece, Dissertation abstract, Case Western Reserve University, 1978.

GERMANY

C. GRIMM. Fiandre Olanda Germania, in Natura in Posa, 1977, pp. 37–83.

S. BOTTARI. La natura morta della scuola di Francforte, J. Soreau, Peter Binoit e Francesco Codino, Pantheon, 1964, pp. 107–114.

G. BOTT. Stillebenmaler des 17. Jahrhunderts: Isaak Soreau–Peter Binoit, *Kunst in Hessen und am Mittelrhein,* Nos 1–2, Darmstadt, 1962, pp. 27–93.

J. LAUTS. Stilleben alter Meister I: Niederländer und Deutsche, Karlsruhe, 1969. Interesting text, excellent illustrations.

L. J. BOL. Holländische Maler des 17. Jahrhunderts nahe den grossen Meistern, Brunswick, 1969.

FRIEDHELM FISCHER. Georg Flegel, Nächtliches Küchenstilleben (1630–1635), *Karlsruher Fächer,* 10, 1961, pp. 3, 12 et seq.

SPAIN

G. KUBLER AND M. SORIA. Art and Architecture in Spain and Portugal and Their American Dominions, 1500–1800, Pelican History of Art, London, 1959.

A. PÉREZ-SANCHEZ. Pintura madrilena, primer tercio del siglo XVII, Madrid, 1969.

D. ANGULO INIGUEZ AND A. PÉREZ-SANCHEZ. Pintura toledana de la primera mitad del siglo XVII, Madrid, 1972.

I. BERGSTRÖM. Bodegones y Floreros del siglo XVII, Insula, Madrid, 1970. Good bibliography; solid, fundamental synthesis.

J. A. GAYA NUÑO. Spagna, in Natura in Posa, 1977, pp. 139–160.

M. S. SORIA. Notas sobre algunos bodegones españoles del siglo XVII, *Archivo Español de Arte,* XXXII, 1959, pp. 273–280.

R. TORRES MARTIN. Blas de Ledesma y el Bodegon Español, Seville, 1978. Fundamental; good bibliography.

J. GUDIOL RICART. Natures mortes de Sanches Cotán (1561–1627), *Pantheon,* XXXV, No 4, October-December 1977, pp. 311–318.

E. J. SULLIVAN. Josefa de Ayala, A Woman Painter of the Portuguese Baroque, J. Walters Art Gallery, Baltimore, 1978, pp. 22–35.

W. JORDAN. Juan van der Hamen y Leon, A Madrilenian Still Life Painter, *Marsyas,* XII, 1964–1965, pp. 52–69.

E. YOUNG. New Perspectives on Spanish Still Life Painting of the Golden Age, *Burlington Magazine,* April 1976, pp. 203–214. Remarkable and important study; several unpublished paintings.

J. BATICLE. Bodegon ou "la vérité dans le naturel," Preface to the catalogue of the exhibition Nature morte de Brueghel à Soutine, Bordeaux, 1978, pp. 49–63. Interesting synthesis, particularly on the spiritual background of the *bodegon.*

E. M. TUFTS. Luis Melendez, Documents on His Life and Work, *Art Bulletin,* 1972, pp. 63–68.

E. YOUNG. Two Signed Spanish Bodegones of the 17th Century, *Actas del XXIII Congreso Internacional de Historia del Arte,* III, Granada, 1973 (published in 1976), pp. 299–303. Two signed early pictures by Pedro de Camprobin.

J.-R. TRIADO. La influencia flamenca en los bodegones de Juan van der Hamen y Leon, *Actas del XXIII Congreso Internacional de Historia del Arte,* III, Granada, 1973, pp. 285–291.

FRANCE

M. FARÉ. La Nature morte en France, son histoire, son évolution, du XVIIe au XXe siècles, Geneva, 1962.

M. FARÉ. Le grand siècle de la nature morte en France, le XVIIe siècle, Fribourg-Paris, 1974.

M. AND F. FARÉ. La Vie silencieuse en France, la nature morte au XVIIIe siècle, Fribourg-Paris, 1976.

M. AND F. FARÉ. Francia, in Natura in Posa, 1977, pp. 113–139.

Exposition Chardin, Paris, 1979. Catalogue by P. Rosenberg, biography by S. Savina, bibliography (very good) with the collaboration of M.-P. Durand.

Catalogue of the exhibition Les Peintres de fleurs en France du XVIIe au XIXe siècles, Petit Palais, Paris, 1979.

On Largillière as still life painter, see G. de Lastic in *Revue du Louvre,* No 4–5, 1968, p. 233.

M. ROLAND-MICHEL. Anne Valayer-Coster (1744–1818), Paris, 1970.

M. AND F. FARÉ. Le Trompe-l'oeil dans la peinture française au XVIIIe siècle, *L'Oeil,* December 1976.

S. H. PAVIÈRE. Jean-Baptiste Monnoyer, Leigh-on-Sea, 1966.

J. LAUTS. Stilleben alter Meister II: Franzosen, Karlsruhe, 1970. Interesting text, excellent illustrations.

XIXTH AND XXTH CENTURIES

W. H. GERDTS AND R. BURKE. American Still Life Painting, Praeger, New York, 1971.

W. BORN. Still Life Painting in America, Hacker, New York, 1974.

M. POCH-KALOUS. Das Trompe-l'oeil Stilleben, *Mitteilungen der Gesellschaft für vergleichende Kunstforschung in Wien,* XXVIII, Nos 1–2, September 1975, p. 7.

A. F. FRANKENSTEIN. After the Hunt, William Harnett and Other American Still Life Painters, 1870–1900, University of California Press, Berkeley, 1975.

J. N. FILONOVIC. Natjurmort (Still Life), *Hudoznik* R.SFSR, Leningrad, 1975, 350 illustrations, text in Russian, English, French. On modern Russian still life.

E. HARDOUIN-FUGIER AND E. GRAFE, The Lyon School of Flower Painting, Lewis, Leigh-on-Sea, 1978.

E. TUFTS. The Veristic Eye, Some Contemporary American Affinities with Luis Melendez, Spanish Painter of Still Life, *Arts Magazine,* LII, No 4, December 1977, pp. 142–144.

M. AND F. FARÉ. Saveurs de la vie silencieuse au XIXe siècle, *L'Oeil,* Nos 276–277, 1978, pp. 10–17.

J. KISDEGI-KIRIMI. Stilleben in der Ungarischen National Gallery (Magyar Nemzeti Galéria), Budapest, 1977. Hungarian still life from the XVIIIth to the XXth centuries.

J. WEICHARDT. Vielfalt des Stillebens, *Weltkunst,* XLVIII, No 7, 1978.

G. B. WEISBERG. The Traditional Realism of François Bonvin, *Bulletin of the Cleveland Museum of Art,* No 9, 1978, pp. 280–298.

J. V. BRINDE AND S. SECREST. Catalogue of the exhibition American Cornucopia: 19th Century Still Lifes and Studies, Carnegie-Mellon University, 1976.

Exhibition, The Eternal "Still-life": 19th Century Still Life Paintings from the George Haller Collection, Springfield, Massachusetts, 1976.

Exhibition, The Chosen Object: European and American Still Life, Joslyn Art Museum, Omaha, Nebraska, 1977.

Catalogue of the exhibition Das Stilleben: Beispiele aus dem Besitz der Kunsthalle Bremen, Kunsthalle, Bremen, 1978. Mostly modern examples.

Exhibition, Der stille Dialog: Das Stilleben im 20. Jahrhunderts, Beyeler Gallery, Basle, 1978.

INDEX

INDEX